THE POWER OF ART

THE POWER OF ART

RICHARD LEWIS
MARIST COLLEGE

SUSAN I. LEWIS
BINGHAMTON UNIVERSITY

HARCOURT BRACE COLLEGE PUBLISHERS

Fort Worth San Diego New York Orlando Austin San Antonio
Toronto Montreal London Sydney Tokyo

For our parents
James Warren Ingalls
Flora Salvador Ingalls
Henry L. Lewis
and Joan Lewis
who first opened our eyes to the power of art

PUBLISHER **Ted Buchholz**

ACQUISITIONS EDITORS **Barbara Rosenberg, Janet Wilhite**

SENIOR PROJECT EDITOR **Kay Kaylor**

SENIOR PRODUCTION MANAGER **Ken Dunaway**

ART DIRECTORS **Sue Hart, Pat Bracken**

PHOTO RESEARCHER **Susan Holtz**

ELECTRONIC PAGE LAYOUT **Duo Design Group**

Cover: Andy Warhol, *Mona Lisa*, 1963. Silkscreen ink on synthetic polymer paint on canvas, 10' 5¾" x 6' 10⅛". Courtesy Thomas Ammann. © 1993 The Andy Warhol Foundation for the Visual Arts, Inc.

Part Captions

Part I Facade of the Louvre with I.M. Pei's pyramid entrance, Paris

Part III Mayan temple complex, Tulum, Mexico, *c.* 1400

Part IV Judy Pfaff, 3-D, 1983. Detail of installation using mixed materials, 22' x 35'. Holly Solomon Gallery, New York.

Requests for permission to make copies of any part of the work should be mailed to: Harcourt Brace & Company, Permissions Department, 6277 Sea Harbor Drive, Orlando, FL 32887-6777

Address for Editorial Correspondence: Harcourt Brace College Publishers, 301 Commerce Street, Suite 3700, Fort Worth, TX 76102

Address for Orders: Harcourt Brace & Company, 6277 Sea Harbor Drive, Orlando, FL 32887; 1-800-782-4479 or 1-800-433-0001 (in Florida)

ISBN: 0-15-502063-3

Library of Congress Catalog Card Number: 93-78968

Printed in the United States of America

3 4 5 6 7 8 9 0 1 2 O48 9 8 7 6 5 4 3 2 1

PREFACE

"As we wrote *The Power of Art*, a quote attributed to Albert Einstein neatly summed up our most important challenge. "Everything should be made as simple as possible — but no more so." We believe that an art *appreciation* textbook is not meant to impress scholars with the erudition of its authors, but to inspire in its readers a lifelong love of art. It has been our goal to write a clear, concise, coherent, yet enjoyable book that educates by pleasure.

A second challenge we faced was to select, from the astonishing treasures of visual art produced over the centuries, several hundred images that could represent the sweep of our Western art heritage in a global context. Many works of art that we love had to be sacrificed in order to present appropriate variety. It was a painful process, one shared by anyone who has ever taught an art appreciation course.

We wrote *The Power of Art* because we believe that current textbooks have become unbalanced—offering extensive coverage of artistic media and methods and limited coverage of the historical tradition of visual art. While information on the language and methods of art is, of course, necessary, we felt no more should be included than is absolutely essential for students beginning to understand art. Why dwell on the distinction between a conté crayon and pastel or between trusses and balloon framing? Such information is rarely retained, because it does not connect with students' other studies or interests. Therefore, in Part I, *The Language of Art*, and Part II, *The Artist's Materials and Tools*, we introduce the fundamental vocabulary of art, then go on to employ this language in discussions that focus on specific works of art.

What students really respond to is the *story* of art—a blend of visual, biographical, and cultural information that places art within the context of history and culture. *The Power of Art* sees the story of art as part of the accumulated experience of humankind, a connection between our contemporary world and the past. Part III, *A Global Heritage*, presents the historical tradition — with background information in religion, philosophy, science, and politics—making it possible for students to integrate their study of art with their other studies. Timelines and maps add to students' knowledge of history and geography and provide another way to make connections between art and other disciplines.

The Power of Art devotes the five chapters in Part IV, *The Modern Era*, to an explanation of modern and contemporary art. In many art appreciation courses, this exciting material is scattered throughout the term, or worse, squeezed into the end of the semester. Because modern and contemporary art require a serious effort at explanation, we believe that understanding the historical background is the way to illuminate art that may seem strange and obscure at first. Modern Artists made art with the history of art in mind; contemporary artists are continuing this tradition.

We often hear how the communication revolution has produced a truly global consciousness. Unfortunately, this consciousness has been slow to move into the teaching of art appreciation. While other textbooks limit non-Western art to a single chapter, often at the end of the book, *The Power of Art* chooses integration. For example, the art *and* beliefs of Islamic, Hindu, Buddhist, and African cultures are discussed together. In addition, boxes throughout the text called "A Global View" compare non-Western and Western art.

After students learn about the principles of design, media and techniques, our global heritage, and modern art, they are prepared for a final chapter on "Contemporary Issues in Art." The topics included there should stimulate exciting classroom discussion of some important current controversies facing the art world. Can art be obscene? Should public funds be spent on controversial art? What are the challenges faced by women artists in gaining recognition from museums and galleries? Boxes called "Art News" throughout the text also bring contemporary issues into historical perspective.

Ultimately, we hope *The Power or Art* is a textbook teachers will enjoy teaching from and students will enjoy reading and learning from. It is meant to open doors for students, making

available a rich, marvelous new world to be enjoyed and discovered for a lifetime. There are galleries and museums all over the world with little or no admission charges. The wealth of visual art is not meant to be hoarded, but to be shared. We hope that after this course, students will go to museums with friends and, later, with their children. And, if inspiration strikes, perhaps they will make art themselves. There can never be too much art in our world.

ACKNOWLEDGMENTS

This book is the product of years of teaching our own as well as that we received as students. We would like to acknowledge the excellence, dedication, and influence of Abe Ajay, Rudolf Arnheim, George Bayliss, Antonio Frasconi, Al Hinton, Gerome Kamrowski, Leonard Stokes, and Donald Suggs, as well as Paul Berry, Dorothea Fisher, Eugenia Janis, Kenworth Moffet, and Clara Tucker. The following colleagues at Marist College were especially helpful with the development of *The Power of Art*: Richard Atkins, Linda Cool, Jeptha Lanning, James Luciana, John McGinty, Rosemary and Andrew Molloy, Vincent Toscano, and Marc vanderHeyden. The unfailing support, encouragement, and inspiration provided by Warren Roberts of the State University of New York at Albany were always appreciated.

During the development of the manuscript, many readers offered perceptive comments and analysis that aided us immensely. We are indebted to Michelle Rowe-Shields of the Evanston Art Center, and the following reviewers:

Clark V. Britto, Jr., Wichita State University; Pamela A. Lee, Washington State University; Jean E. Loy-Swanson, North Hennepin Community College; David E. Pactor, Broward Community College; David Raizman, Drexel University; Jim Rocha, University of San Diego; Bruce Walters, Teikyo Marycrest University.

One of the pleasures of writing a textbook is the opportunity to work with many talented individuals. We want to thank our acquisition editors at Harcourt Brace, Julia Berrisford and Cynthia Kumagawa, who were both pleasures to work and negotiate with; our developmental editor, Terri House, who pleasantly but firmly kept us on track; our project editor, Kay Kaylor, who always kept her end of the bargain and was willing to go the extra mile; our copyeditor, Jan Ross Duffala, who saved us more than once from ridicule and knows how to turn a phrase, our designers, Sue Hart and Pat Bracken, who translated a thick pile of manuscript into an example of the power of art, and our knowledgeable and resourceful picture editor, Susan Holtz, who was able to bring together the extensive collection of illustrations.

Finally, we would like to thank our students, many of whom brought us articles and catalogs, but more importantly who showed us the way to create a book that could transmit the power of art. The enthusiastic love for art of Anthony Alberico, Debbie Amato, Michele Bassett, Lauren Brooks, Tricia Burger, Joe Concra, Matt Daly, Beth Fogarty, Brian Goldsborough, Reggie Ho, Christie Ingrassia, Lori Iversen, Jonathan Kiselik, Kevin McKiernan, Joe Molloy, Amy Pavlovsky, Amy Rogers, Richard Santiago, Lori Stella, Joanne Witpen, Helen Zarouhliotis, and many more students like them, is what encouraged us in the many years it took to bring this text to completion.

Richard and Susan Lewis

Contents

PART
I

THE LANGUAGE
OF ART

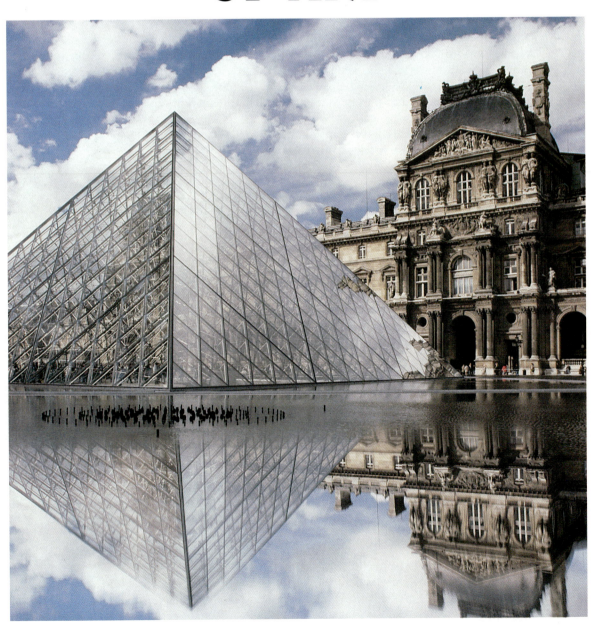

THE POWER OF ART

Among the treasures of the Louvre Museum in Paris is probably the best known work of art in the Western world, Leonardo da Vinci's *Mona Lisa* (1-1). Signs are posted throughout the vast museum, marking the way to its most famous masterpiece. In the gallery where it hangs, the walls are covered with paintings by some of the most talented artists in history, but viewers surround only one, jostling each other to get better views. Tourists treat the painting like a famous landmark, posing for their pictures beside it. Guards are always nearby; velvet ropes keep viewers at a distance. Deep within a grand, velvet-covered case of bulletproof glass that dwarfs the small painting, the same elegant woman who has captivated generations of art lovers regards them with her inscrutable smile.

Painted at the height of the Italian Renaissance, this fascinating portrait of a woman has attracted attention for hundreds of years. Poems and songs have been written, essays and scholarly works composed, about an oil painting that measures less than 2 feet x 3 feet. Even in our contemporary world of space travel and video images, the power of da Vinci's portrait continues to transcend time. Legends have grown up around the picture—for instance, that the *Mona Lisa*'s eyes follow one around the room. Another legend suggests that the painting on display is no longer the genuine *Mona Lisa* (see "Art News").

What is it about this painting that has elevated it, not simply to the height of a masterpiece but to the symbolic pinnacle of Western art? How can a work of art become so valuable that it is seen as "priceless"? What gives the

Mona Lisa its power over people from different centuries and cultures? While many have often spoken of the air of mystery that surrounds the picture of the woman with the haunting smile, on first viewing it is common to find the picture a disappointment. The glass

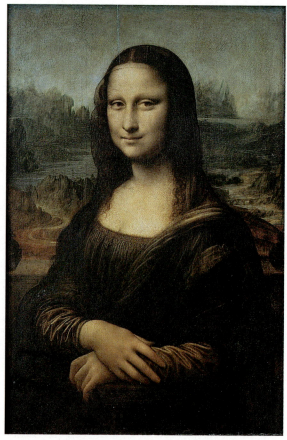

1-1 Leonardo da Vinci—*Mona Lisa, c.* 1503–1505. Oil on wood, approximately 30″ x 21″. Louvre, Paris.

◆ART NEWS

THE *MONA LISA* HAS BEEN STOLEN!

The *Mona Lisa was* actually stolen from the Louvre in 1911, causing a national scandal. While the complete story will never be known, it is believed that the theft was an attempt not only to sell the *Mona Lisa* but also many forged copies. The forger's plan was that upon the shocking announcement of the painting's theft, unscrupulous wealthy collectors around the world could be easily duped into buying his or her forgeries of the masterpiece.

The forger contacted a former employee of the Louvre, Vincenzo Peruggia, to arrange the theft. Peruggia and his accomplices, dressed as staff, entered the museum as it closed Sunday afternoon, August 20, 1911. The museum would not open again until Tuesday. The thieves slept overnight in the museum. Early the next morning, they carried the painting through the many galleries, planning to tell anyone who saw them that they were bringing the *Mona Lisa* to the staff photography lab. The only one who did see them was a plumber who helped them open a stuck exit door.

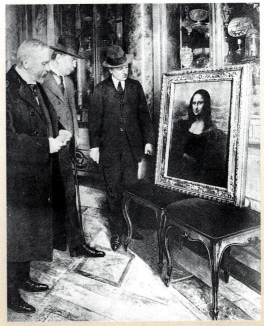

1-2 French officials examine the *Mona Lisa* after its return.

It wasn't until the next day anyone knew it was missing and it took two years for it to reappear in Italy. Vincenzo Peruggia had tried to sell it and was turned over to the authorities. At the trial, the thief, who was born in Italy, claimed that he had stolen Leonardo's masterpiece to return it to its rightful place in his own country. A sympathetic Italian jury sentenced Peruggia to only a few months in jail. After the trial, the *Mona Lisa* was displayed briefly in Florence (where Leonardo had begun it in 1503) and then was returned to its home in the Louvre (1-2).

makes it difficult to see, and what we see is not exactly what Leonardo painted. The art historian Kenneth Clark described the *Mona Lisa* as "the submarine goddess of the Louvre," a phrase that accurately reflects the dominant greenish tone of the painting as well as its aquarium-like casing. Yet the earliest known description of the portrait raves about the warmth of the colors, the rosy nostrils and red lips, as well as the overall tone of the face that "seemed not to be colored but to be living flesh." Not only has the color faded, but also at some point in its history the painting was made smaller, probably to fit into a frame, with portions of its left and right sides sliced off.

LOOKING AT ART

LEARNING HOW TO SEE

Still, despite these ravages of time, it is possible to consider what makes the *Mona Lisa* a masterpiece. Whatever the type of art in question, the first step in learning to appreciate art is simply learning to *look*. This is more challenging than is usually believed. Often we think of looking as a passive act, as in watching TV or flipping through pictures in a magazine. But studying the visual arts requires more than empty viewing; seeing can be *active* rather than passive. When primitive people looked at the

world, they had to *observe* nature because they were hunters and gatherers; they depended on their eyes for survival. In their world everything was natural and real; very little was made by man. We, on the other hand, live among literally millions of images, not only in books or on a screen but also on almost everything we touch—from cereal boxes to printed T-shirts. And, as opposed to primitive cultures, most of what we see and interact with is human-made. This bombardment by literally millions of printed and video images has made us visually sophisticated, but can also leave our eyes "numb."

Artists often say that someone can really "see" as if most people cannot. What an artist means by "seeing" is hard to explain, but it is something like the totally involved gaze of a newborn child, hungrily looking at everything as if it had never been seen before, not blinded by preconceptions. All of us like to see new things, but in the midst of a busy life our seeing becomes stale, our eyes jaded. Art can renew the pleasure of seeing and help us feel more alive. Many people have had the exhilarating experience after leaving a museum of noticing that the world outside looks much more interesting and beautiful.

Let's return to the *Mona Lisa* and look at her carefully. First, the image is beautiful. It is not simply that this is the portrait of a beautiful woman—in fact, *La Gioconda* (Lisa del Giocondo) looks less than ideal to contemporary eyes. Although it is safe to assume that she was considered attractive by the standards of the 16th century, Leonardo did not give her face (see detail, 1-3) the same perfect beauty he gave to his drawings of angels, for example. But what makes a work of art famous is less the quality of the subject than the way it is interpreted by the artist. The *Mona Lisa* is beautifully and gracefully painted. Viewers are attracted to da Vinci's work through the power of his skill as a draftsman and painter and his remarkable ability to bring his subject to life.

It was this lifelike quality that made the *Mona Lisa* famous in its own time. According to Giorgio Vasari, another Renaissance painter:

> Altogether this picture was painted in a manner to make the most confident artists—no matter who—despair and lose heart. . . in this painting of Leonardo's there was a smile so pleasing that it seemed divine rather than human; and those who saw it were amazed to find that it was as alive as the original.

As Vasari recognized, the *Mona Lisa* revolutionized the art of portraiture, adding movement and life to what had previously been a static exercise in realism.

METHODS AND MATERIALS

Leonardo wrote in his notebooks, "moderated light will add charm to every face," as anyone who has been with a date in a candle-lit restaurant knows. Leonardo used oil paint to recreate this effect, which he called **sfumato lighting** (in Italian, "the soft mist of a fountain"), a soft light that dissolved edges and made details unclear. The *Mona Lisa*'s eyes (1-4) and mouth (1-5) were bathed in sfumato light by Leonardo because he knew those are the two most important areas we look at on a face. Because they are left unclear, our imagination fills them in; the lack of definite edges makes her eyes and

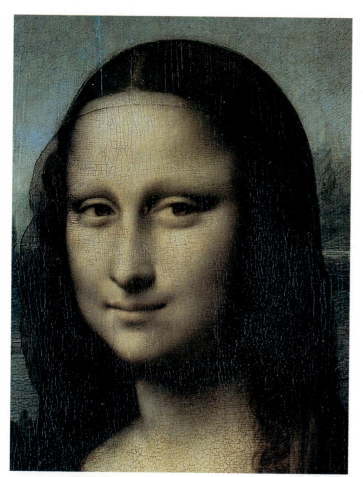

1-3 Detail of figure 1-1

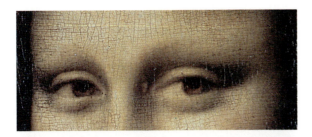

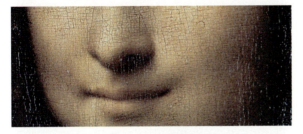

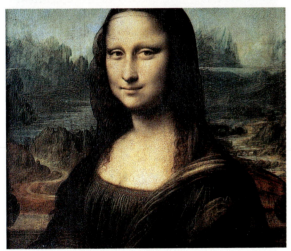

1-4 (top), 1-5 (middle), 1-6 (bottom) Details of figure 1-1: eyes, mouth, and background of *Mona Lisa*

PLACING ART AND ARTIST IN HISTORICAL CONTEXT

Great art reveals the spirit of the age that produced it. Therefore, we need to know when and who made a work of art so we can begin to consider how this affected its form. The grace and beauty of Leonardo's *Mona Lisa*, for example, reflects the value placed on these qualities during the Italian Renaissance. She also illustrates the highly prized attribute of aloofness—what the Italians called "sprezzatura," a kind of aristocratic refinement and calm.

The life of Leonardo da Vinci represents many other Renaissance values as well. Leonardo was an independent thinker, a scientific observer of nature, an imaginative inventor, and a delightful conversationalist, as well as a talented artist. He filled vast notebooks (1-7) with his observations, drawings, poems, and philosophical theories. Above all, he exemplifies a crucial Renaissance idea credited with giving birth to the modern age—*individualism*. Renaissance thinkers conceived of human beings as potentially godlike creatures with immense physical, intellectual, and creative powers. Part of the mystique of Leonardo's art is that it was done by one of the first individuals to be considered a creative genius in the modern sense.

lips seem to move and gives the *Mona Lisa* life. So it is Leonardo's use of sfumato lighting that is responsible for the legends surrounding this painting—her inscrutable smile, the eyes that look at you and then away.

Leonardo generated a sense of movement in another way. Notice how the background (1-6) does not line up on either side of the *Mona Lisa*'s shoulders. Leonardo wanted to create the illusion that his subject has shifted her shoulder while we are looking at her. Leonardo understood how people *see*, perhaps better than anyone who had ever lived, and he used this knowledge in subtle ways to create the illusion that his *Mona Lisa* was a real person. In fact, this is how viewers have always responded to her.

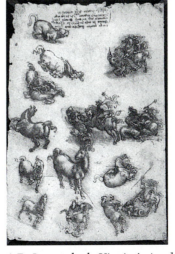
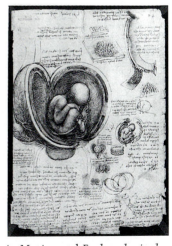

1-7 Leonardo da Vinci, *Animals in Motion* and *Embryological Study* from the notebooks, *c.* 1510. Pen and ink, each approximately 11¾" x 8½". Royal collection, Windsor Castle. © Her Majesty Queen Elizabeth II. Not to be reproduced without written permission from Royal Collection Enterprises.

No one can really be sure why Leonardo painted this portrait of twenty-four-year-old Lisa del Giocondo, the wife of an important Florentine merchant, at the same time the artist was refusing paid commissions from more notable persons. We do know that Leonardo worked on the *Mona Lisa* for decades and never considered it finished. Since he reworked the image over and over, carrying it with him on his travels, the painting must have exerted the same endless fascination over the artist himself as it has over its viewers. Because Leonardo died in France, the guest of King Francis I (who moved his mother and sisters out of a chateau so da Vinci could take up residence there), the *Mona Lisa* became part of the royal art collection. That is how it came to be in the Louvre Museum in Paris, and why it eventually became identified as not only a part of Italian culture but French culture as well.

ART AND CULTURE

Western cultures are not the only ones to see works of art as priceless. The Japanese, for example, have an elaborate system of rating works of art and their value to national heritage. The most valuable artworks are designated as Japanese "National Treasures," while other significant works of art are categorized as "Important Cultural Properties." Because of their historic and aesthetic importance, National Treasures (ranging from huge statues and painted screens to fragile decorated boxes and ceramic vessels, such as teacups) cannot be sold or taken out of the country. In Japan, even people—such as the most famous and accomplished living artists—can be given the official title of National Treasure.

One of the works of art designated as a Japanese National Treasure is the wooden statue of the *Amida Buddha* (the Buddha of the West, 1-8) carved by the sculptor Jocho in the eleventh century. This statue is just part of an entire sculptured environment, a grouping of many gilded wooden figures, that decorate the central hall of a Buddhist temple designed for an aristocratic family of the period. Because of their great age and the high quality of their design and carving, all of the figures in this sculptural group qualify as National Treasures—considered as valuable to Japanese heritage as the Statue of Liberty is to Americans.

Even if we know little about Buddhism, we can be impressed by the elaborate carving and huge scale of this sculptural group. The *Amida Buddha* on his throne is almost twelve feet high, and the music-making angels (1-9) that hang on the walls number in the dozens. One is also impressed by the excellent preservation of statues that will soon be a thousand years old. But imagine how powerful this vision of paradise must have seemed to the followers of the Pure Land Buddhist sect, who believed that when they died their God would descend and lead their souls to a blissful paradise. It is this very descent, the floating of the Amida to earth, and the celestial paradise of dancing and music-making angels, that Jocho brought to life in the Phoenix Hall.

Just as the *Mona Lisa* reflects the ideals of Renaissance Italy, this Japanese sculptural group reflects the taste and beliefs of the world in which it was created. Eleventh-century

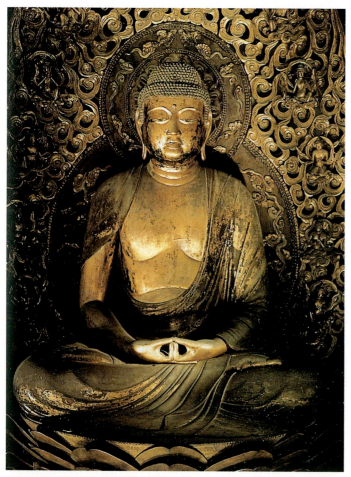

1-8 Jocho, *Amida Buddha* (from the interior of the Ho-o-do or Phoenix Hall), 1053. Gilded wood, 9'4" high. Byodo-in Temple at Uji, Japan.

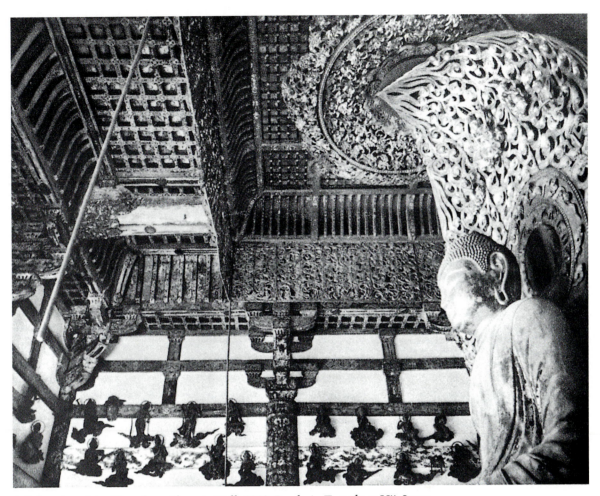

1-9 Interior of the Ho-o-do or Phoenix Hall, 1053. Byodo-in Temple at Uji, Japan.

Japan was dominated by a ruling class that valued elegance and courtly manners above all. The Amida cult appealed particularly to the upper classes because its promised paradise resembled a continuation of the luxurious life of beauty and ease they knew on earth. The Buddha, as seen by Jocho, is as refined and aloof as a prince who looks down graciously at his worshippers; the dancing angels are like so many well-bred royal attendants. The slimness and delicacy of the carvings, the richness of the shimmering gold with which they were painted (now somewhat worn), were perfectly in tune with both the subject they represented and the patrons for whom they were made. Yet even today, in a completely changed world, embracing different religious beliefs, brought up in a different culture, we can appreciate the skill and genius that make Jocho's sculptural grouping a great work of art.

THE POWERS OF ART: BRINGING FAITH TO LIFE

Through art, the deepest and most intangible beliefs of a culture can be translated into powerful images, images that communicate specific spiritual messages to the people who view them as part of their religious rituals. From the beginning of humanity, people have expressed their beliefs in material form. They pictured their gods and goddesses in statues and paintings; they built places for worship and religious rites. The *Amida Buddha* is an excellent example of how art brings religious beliefs to life. In some periods, such as the Middle Ages in the Western world, *all* art was religious in character. So much visual art is related to human beliefs and rituals of worship that it would be easy to fill an entire library

with books exploring the relationship between art and faith in different cultures.

PREHISTORIC ART AND MAGICAL POWERS

Art need not be as beautiful as the *Mona Lisa* or as elegant and sophisticated as Japanese sculpture to be considered "great art." Some of the most powerful art ever made was done more than ten thousand years ago by the prehistoric hunting tribes who inhabited Europe before and during the last Ice Age. One of the very earliest known artworks of this period is a tiny (4⅛ inch) carved stone figurine known as the *Venus of Willendorf* (1-10): *Venus* because it is obviously female, *Willendorf* after the town in Austria where it was found. Although its exact purpose and meaning remain shrouded in the mists of time, scholars have

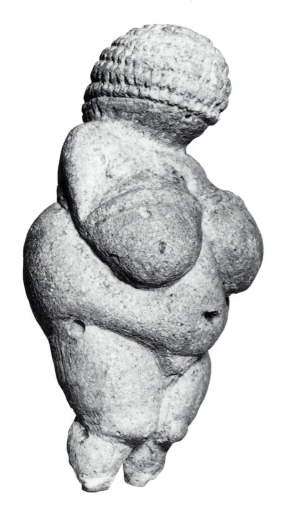

1-10 *Venus of Willendorf, c.* 30,000–25,000 B.C. Limestone, 4⅛" high. Naturhistorisches Museum, Vienna.

surmised that this female fertility figure was used as some kind of magical charm. With her exaggerated breasts, belly, and buttocks, this faceless Stone-Age Venus provides a powerful visual image of the life-giving earth mother. Such fertility symbols were repeated in many different materials and locations throughout Europe and were probably associated with rituals that associated human fertility with the survival of the Ice-Age clan or tribe. For the Stone-Age people who made and used them, these were not "works of art" in the same sense we understand the term. These amulets were made to be touched, held, carried, stroked, and worshipped—not to be viewed as beautiful objects in a glass cabinet, or admired as the works of individual artists.

The earliest known paintings (1-11) were also creations of European hunting peoples, but they date from a period ten to fifteen thousand years later than early sculptures. Popularly known as "cave paintings," these dramatic prehistoric pictures were done by Ice-Age tribes living in areas of what is now France and Spain around 15,000 B.C. When the decorated caves at Lascaux, France were discovered (accidentally in 1940 by some boys looking for an underground entrance to an old chateau), they caused a sensation throughout the worlds of history, archeology, and art. On these rocky walls, viewers can gaze back at the handiwork of peoples whose world remains shrouded in mystery. Entering into the eerie, dark caves, viewers find pictures of huge Ice-Age beasts. The primary subjects of these early cave paintings are animals—most often bulls, horses, and bison, sometimes mammoths and woolly rhinoceros. Humans were shown very rarely. The depiction of these wild animals was not simplified or awkward; the cave paintings do not resemble the art of children. They are *naturalistic*, because the animals were drawn in motion, as if they were alive. Even without photographic details, contemporary viewers have no problem telling that one form is a horse, another a bull (1-12).

Were these images meant as records of successful hunts, or were they part of magical rituals meant to assure success for future hunting parties? While we cannot be absolutely sure of their purpose, the most common explanation for the cave paintings is that they were used by their creators in magical rites. It is certainly unlikely that these pictures were simply decoration for people's living quarters.

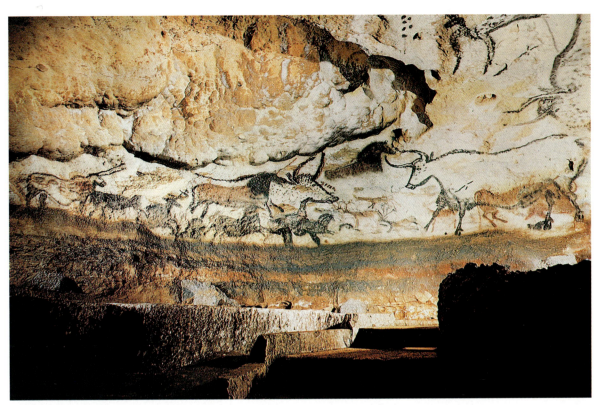

1-11 *Hall of the Bulls* (left wall), Lascaux, *c.* 13,000 B.C. Dordogne, France.

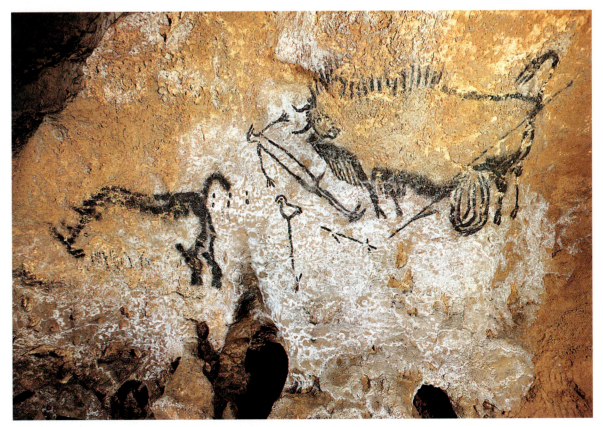

1-12 *Well Scene*, Lascaux, *c.* 13,000 B.C. Bison 55″ high. Dordogne, France.

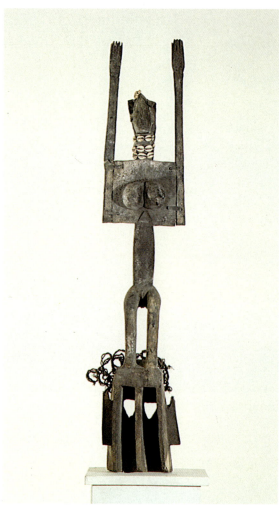

1-13 Satimbe mask, Dogon, Mali. Carved wood, fiber, shells, approximately 5' high. Private collection.

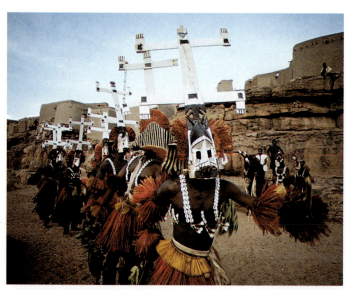

1-14 Dogon ceremony, Mali

Most are painted in dark, difficult to reach parts of the caves, portions that show no archeological evidence of having been lived in. We do know that the artists came to these special caves to paint on scaffolds by the light of oil lamps; remnants of the lamps and their palettes, along with the holes for their scaffolds, have been found. After the paintings were completed, the caves and their images seem to have been used in ceremonies for thousands of years.

THE POWER OF ART FOR TRIBAL PEOPLES

The importance of art in the rituals of tribal peoples continues into the twentieth century. Some tribal peoples still live virtually in the Stone Age. What art historians once called "primitive" art is the art of any area of the world where people still live in a preindustrial or preagricultural state—generally without permanent buildings, written language, or modern technology. Such art was originally considered crude and uncivilized by Western Europeans and Americans who came in contact with the "undeveloped" cultures that produced it. But at the turn of the last century, their attitude changed. Tribal art was seen as new and exotic, valued by collectors and artists for its immediacy and impact. More recently there has been an attempt to appreciate and understand so-called "primitive" arts of tribal peoples living around the world as an expression of the cultures and beliefs that produced them.

For instance, African masks have been popular with European and American art collectors for almost a century and had a dramatic impact on the development of modern art. In Western museums, these sculptural masks are usually displayed as isolated art objects (1-13), hung in tasteful arrangements on white gallery walls. Because of their strong sense of design, masks exhibited even in this static way retain their visual power—but the power of their original meaning has been lost. Within the culture and religion for which they were created, masks convey a variety of complex messages that are unknown to most museum viewers and are often obscure even to the collectors who purchase them. The mask is meant to be worn in association with an elaborate costume, during ceremonies where

 A Global View

JOURNEYS TO THE SPIRIT WORLDS

Although it is not possible to travel back in time to research the mythology of early humans, we can look at the beliefs of tribal societies today. For example, the Eskimos of the Arctic Circle live in an incredibly harsh environment, surrounded by many natural dangers. According to their beliefs, everything—animate beings like animals and inanimate objects like stones—has a spirit. These spirits can be contacted by a *shaman*, or magician/priest. Eskimos believe in an undersea kingdom of supernatural beings as well as a heavenly realm. Their gods include both helpful and destructive spirits, such as the kindly spirit of icebergs and the goddess Sedna, who controls all marine life. Shamans, besides acting as spiritual advisers and doctors to the community, intercede in times of trouble on behalf of the community with the spirits who control the Eskimo world. Illustrated here is a shaman's mask showing a shaman riding the spirit of a beaver (1-15). It is most likely a report of a shaman's spiritual adventure. Shaman stories often tell of flying to distant lands, the moon, and the Land of the Dead. The beaver is the personal helping spirit of the shaman who made the mask. These helping spirits are the source of a shaman's power and, if never offended, will protect and defend their masters.

Mythological animal spirits are often pictured in the artwork of hunting cultures. It is not so much the animal itself that is worshipped, but its powerful spirit, a symbol of the natural forces of the universe. The tribe believes that to assure the continuing survival of the tribe or clan, these spirits must be placated. Their images must be reproduced and treated with respect.

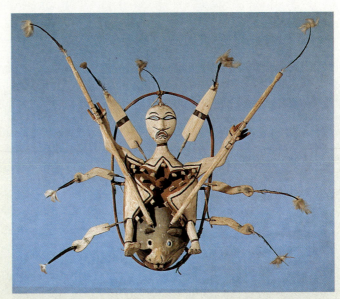

1-15 Eskimo mask depicting the spirit of a shaman sitting astride a beaver's spirit, Alaska(?), late nineteenth century. Wood, feathers, paint, thongs, fur. Museum für Völkerkunde, Hamburg, Germany.

traditional songs and dances are performed (1-14). Within these ceremonies, which can last for several days, the masks have magical functions. For instance, some masks are supposed to transmit the spirits of the gods or ancestors they represent to the dancers, enabling them to dance for hours (see box).

The peoples of New Guinea, in the South Pacific, still create elaborate costumes that include face and body painting (1-16). Like African masks, these self-decorations are part of ceremonies that have magical implications for the people who participate in them. Costumes include both headdresses and "aprons"; the traditional dances require that both headdress and apron sway in time to the music. If viewers see the dance and decorations as pleasing—if the plumes are shiny, the furs glossy, the face paint bright—they are pleased. But if the dance is badly done and the decorations are second rate—the feathers and face seem dull and dusty, for instance—it is considered a

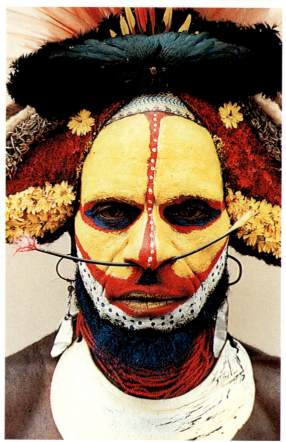

1-16 Face painting, Huli tribesman, from the Southern Highlands Province, Papua, New Guinea

with art. Such temples or churches are designed to convey particular religious messages and spiritual values. These places of devotion often share some of the magical quality of prehistoric caves. Both "magical" and religious art express human belief in a spiritual world. Magical art, however, supposes that images have a living power, while religious art is more often simply the visual expression of an inner belief.

The Gothic cathedral of Notre Dame (1-17) in Paris is a visual expression of the Christian faith of the medieval era. With its soaring vertical lines, it seems to lift the soul heavenward, toward God. Its stained glass windows tell biblical stories (1-18); its paintings and statues can instruct and even inspire the viewer. By transforming a material as dense and heavy as stone into a structure of such grace, the cathedral becomes a visual representation of the Christian belief in a spiritual existence beyond and above the limitations of physical reality. This heavenly realm is visually symbolized as the viewer's eye is drawn up the soaring lines of the gothic arches to the very top of the pointed vaults and into a space bathed in

sign of very bad luck, of coming troubles, even death.

The magical powers attributed to art by prehistoric peoples and "primitive" tribes are not generally accepted in our modern scientific and industrialized world. Still, even if we do not believe that works of art can cure sickness, placate dead spirits, assist us in predicting and controlling the future, or put us in direct touch with supernatural forces, we are not totally unaffected by the magical power in art. Imagine how you would feel if you discovered someone had poked holes in a photograph of your grandmother. Is it only a damaged piece of paper with some markings on it?

THE POWER OF RELIGIOUS ART

Religious art gives visual expression to inner belief and has the ability to raise people's spirits above the problems of daily life. For centuries, humans have created special places to worship

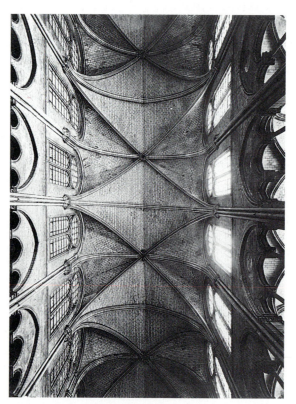

1-17 Looking up into the nave vaults of Notre Dame, Paris, begun 1163, modified 1225–1250

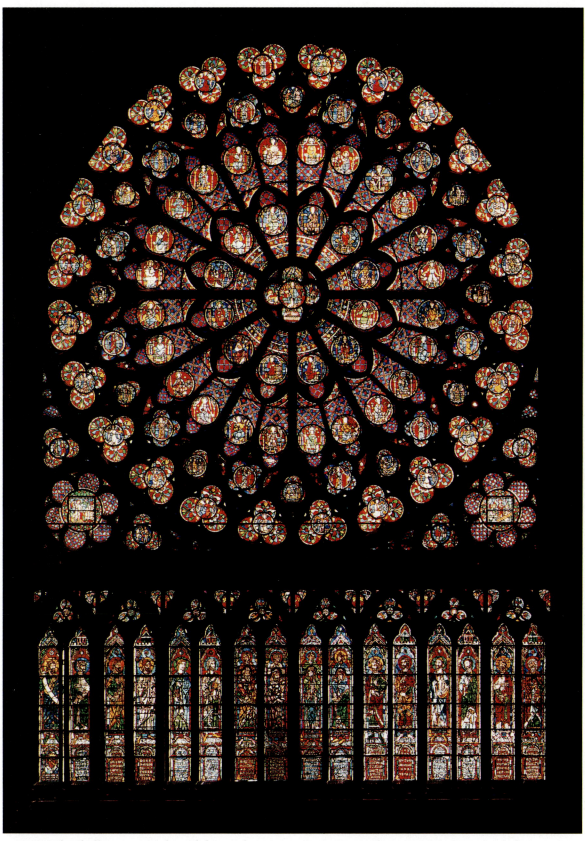

1-18 Jean de Chelles, rose window of the north transept, Notre Dame, Paris, 1240–1250. Stained glass, iron, and lead stone-bar tracery, diameter 43′.

colored light. Within Notre Dame cathedral, we can experience the power of art to transform the physical act of viewing into the spiritual act of worshipping.

ART REPRESENTS IDEALS

Statues of gods and goddesses also have the power to physically express the ideals of a particular culture. The art of classical Greece, for example, expresses their cultural ideals of physical beauty and athletic strength, as in the statue *Hermes with the Infant Dionysus* by the great sculptor Praxiteles (1-19). For the Greeks, a strong and healthy body was ex-

tremely important, since physical development was considered equally as important as mental and spiritual growth. They sought a perfect balance between body and mind, a natural harmony between muscular prowess, grace, mental vigor, and physical beauty.

Greek art also aspired to another balance—a balance between realism and idealism. Greek statues are immediately recognizable as lifelike, accurate representations of the human form. Yet, as in the figure of *Hermes* illustrated here, they idealize the human body, making it more graceful and perfect than any real person could be. Greek sculptures are not portraits of individuals but ideal types. The Western conception of great art as a fusion of the real, or truthful, with the ideal, or beautiful, is descended from the aesthetics of ancient Greece. This philosophy was expressed succinctly by the English Romantic poet John Keats in these famous lines from *Ode on a Grecian Urn*:

> Beauty is truth, truth beauty—that is all
> Ye know on earth, and all ye need to know.

ART AS A DECLARATION OF POWER

Besides expressing spiritual beliefs or cultural ideals, art from the earliest times has been used to declare the power of rulers. The pharaohs of Egypt erected huge structures to declare their strength; Roman emperors constructed triumphal arches in conquered territories. For thousands of years, artists served kings and queens. During the Renaissance, royal portraits were not just stylized versions of majesty (as seen in Egypt) but true portraits. One of the finest of the Renaissance court painters was Hans Holbein the Younger, and our image of *Henry VIII* (1-20) is forever that of an enormous, insatiable powerhouse because of Holbein's portraits. His *Henry VIII* stands before us seeming larger than life, almost bursting the edges of the picture frame. He is dressed in stunning garments, made of the finest materials sewn with golden embroidery and jewels. Another Holbein portrait (now lost) hung over the king's throne and according to visitors "abashed and annihilated" them when they stood before it. That was the purpose of all the king's portraits— to glorify a man who had supreme power.

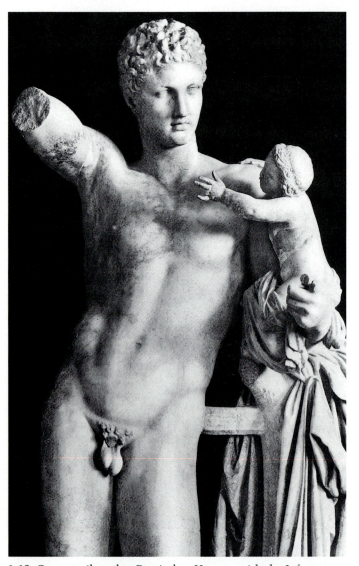

1-19 Once attributed to Praxiteles, *Hermes with the Infant Dionysus* (detail), from Olympia, *c.* 340 B.C. (?). Marble, approximately 7' high. Archeological Museum, Olympia.

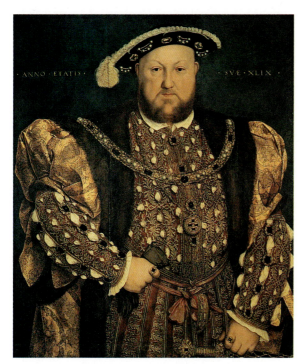

1-20 Hans Holbein the Younger, *Henry VIII*, 1540. Oil on panel, 32 ½″ x 12 ½″. Galleria Nazionale d'Arte Antica, Rome.

THE POWER TO CONVEY IMMORTALITY

A century after Holbein painted *Henry VIII*, an artist named Bichitr was painting the emperor of India. Jahangir, who ruled during the Mughal period of the 1600s, was one of the greatest royal patrons of arts in history. The important events of his life, his dreams, and the exotic animals he collected all appear in books of miniature paintings commissioned by him. Unlike Henry VIII, Jahangir directed his artists to portray him as honestly as they could. Yet he did not totally renounce flattery. While the faces are naturalistic in *Jahangir Preferring a Sufi Shaikh to Kings* (1-21), the setting and events are not. The Emperor Jahangir is surrounded by a brilliant light, too bright even for one of the cupids. Great men have come to pay homage to Jahangir: a wise old saint, the Sultan of the Ottoman Empire, King James I of England, and the artist Bichitr himself.

The Emperor Jahangir sits on a throne supported by an hourglass whose sand has almost run out. Yet, on the glass, cupids are painting a prayer that he might live for

a thousand years. What could resolve this contradiction? It must be the act of painting itself, one of the great passions of the cultured emperor. There were many signs of Jahangir's special love during his reign. For example, he provided studios in the palace for his court artists and gave them the finest and most expensive materials to work with. The artists rewarded him with immortality.

THE POWER TO CHANGE OUR BELIEFS

Art also has the power to change the way we think, the way we understand the world around us. In the twentieth century, many

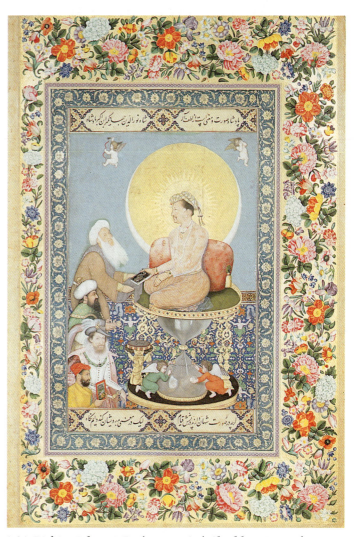

1-21 Bichitr, *Jahangir Preferring a Sufi Shaikh to Kings*, from the Leningrad Album, Mughal, India, early seventeenth century. Color and gold on paper, 10 ⅞″ high. Freer Gallery of Art, Smithsonian Institution, Washington, D. C.

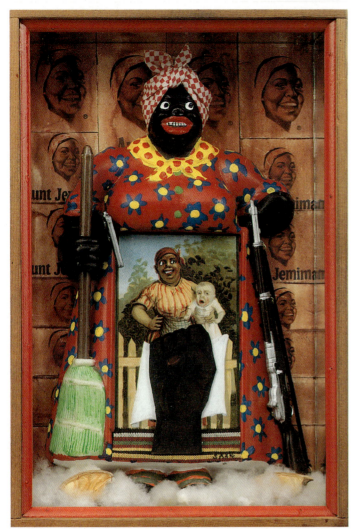

1-22 Betye Saar, *The Liberation of Aunt Jemima*, 1972. Mixed media, 11¾" x 8" x 2¾". University Art Museum, University of California at Berkeley (purchased with funds from the National Endowment for the Arts).

artists continue to use their work to express political viewpoints, to lead their viewers to a moral lesson. In *The Liberation of Aunt Jemima* (1-22), Betye Saar comments on the stereotyping of African-American women in advertising and the media. Saar creates her work by incorporating so-called "found objects" like the mammy doll and cutout pictures of Aunt Jemima from pancake packages. These are arranged inside a box as if the artist were creating a diorama; the doll holds a broom in one hand, and a small print of another happy mammy holding a wailing white baby is propped up in front of her. But the familiarity and friendliness of these images is radicalized by the incorpora-

tion of a black power fist in the foreground of the box, as well as a rifle and pistol. Here Aunt Jemima seems to express some of the anger Saar herself felt—but never expressed—when she experienced discrimination as a young black woman growing up in California. (For instance, Saar won several prizes for her designs for floats in the Tournament of Roses parade before the judges realized she was an African-American. After her race was disclosed she was given only honorable mentions.) By using "real" mementos of contemporary culture like the advertising imagery of Aunt Jemima, Saar creates a visual satire that shows how photographic reproductions tend to reinforce racial stereotypes in our society.

THE POWER TO SHOCK

Related to art's power to change our point of view is its power to shock us. In the early twentieth century, many artists wanted to

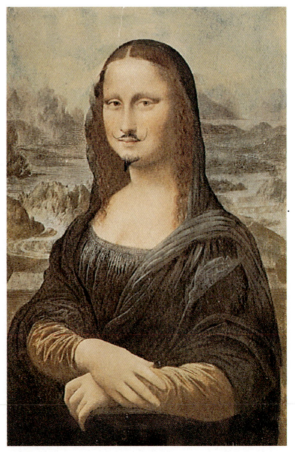

1-23 Marcel Duchamp, *L.H.O.O.Q.*, 1919. Pencil on print, 7¾" x 4¾". Private collection.

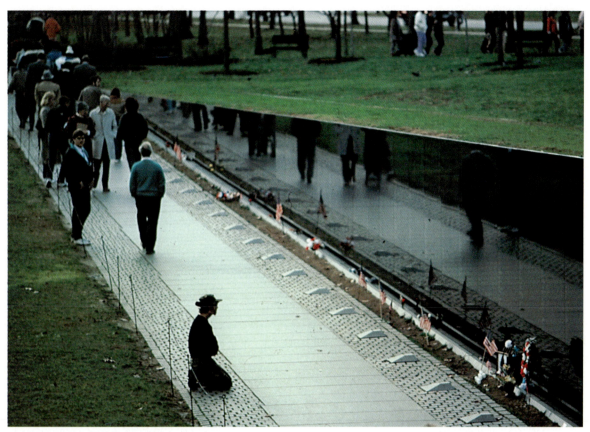

1-24 Maya Ying Lin, *Vietnam Veterans Memorial,* Washington, D. C., 1981–1983. Marble, each wing 246' long.

create works that would wake viewers up and shake them out of their preconceptions about art. One such artist was Marcel Duchamp, and one of his most disturbing pictures was *L.H.O.O.Q.* (1-23), a satire of Leonardo da Vinci's *Mona Lisa.* Duchamp chose to make fun of the *Mona Lisa* especially because it was so beloved and had become almost like a sacred image to people who cared about art. What he did was take a postcard reproduction of the painting, added a moustache, beard, and dark pupils in pencil, then printed a few initials at the bottom. When pronounced in French, these initials sound out the vulgar phrase, "she has a hot ass."

Duchamp's parody was upsetting on several levels. First, he was making light of Leonardo's great masterpiece. Because the *Mona Lisa* had come to symbolize the best in Western art, he was symbolically rejecting centuries of tradition. Second, Duchamp was taking a reproduction of a painting by another artist, changing it slightly, and claiming that it was a new work of art that belonged to

him—that is, he seemed to be stealing someone else's creative work, then (figuratively) spitting on it. A beautiful image was made ugly, even silly. A picture that had come to symbolize the mystery and ideal nature of all women was turned into a joke. Worst of all, he was suggesting that the *Mona Lisa* was "hot stuff."

The creation of artworks *meant* to upset the viewing public is a recent development in the history of art. In earlier times, the purpose of art was to please the person who commissioned and paid for it—the patron.

THE POWER TO TOUCH OUR EMOTIONS

Art can also touch the emotions of the viewer in a profound way. The *Vietnam Veterans Memorial* (1-24) in Washington, D.C., was designed especially to reach out to the American people and assist in healing the wounds left by the Vietnam War. The architecture student who designed it, Maya Ying Lin, called her concept "a visual poem." When asked what

◆ ART NEWS

CONTROVERSY OVER THE VIETNAM MEMORIAL

The *Vietnam Veterans Memorial* was commissioned in the 1980s by the Vietnam Veterans Memorial Fund (VVMF), founded by an independent group of Vietnam veterans. But since money was raised by donations from throughout the country, and the site on the mall in Washington D.C. was contributed by the government of the United States, the patrons for this monument included all Vietnam veterans and in some sense all the citizens of the country. The choice of the design was given to a jury of prominent artists, who looked at more than fourteen hundred entries (all reviewed anonymously, so the judges would not be influenced by the name or reputation of the artist). Surprisingly, their unanimous choice was the submission of a young architecture student, Maya Ying Lin. Although the selection generated little negative comment at first, problems began to develop as the ground-breaking ceremony neared. Many Americans expected a realistic monument like ones seen in parks and town greens around the United States and were shocked by a design that was highly abstract. Some veterans and prominent contributors united to mount a political campaign against the monument, which was described as a "black gash of shame." A lively, and even bitter debate developed in the press and the halls of Congress. The official patrons—the VVMF—began to fear that the memorial would never be built at all. In the end, the detractors of Lin's winning entry managed to block government approval for a building permit unless the memorial included a realistic statue (1-25) and a flag.

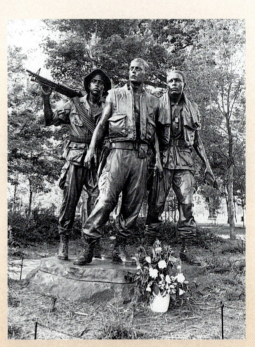

1-25 Frederick Hart, *Statue for Vietnam Veterans Memorial*, Washington, D. C., 1984. Bronze, life-size.

Maya Lin was disillusioned by the pressure for these additions, which she felt would ruin the simplicity of her design and compromise the purity of the site. However, although she was the artist, because the patrons had purchased her design, she had no further control over it. Interestingly, Lin compared the addition of a traditional statue to her monument with the disrespectful way Duchamp treated the *Mona Lisa* in *L.H.O.O.Q.*: "I can't see how anyone of integrity can go around drawing mustaches on other people's portraits," she said. To her, to place a realistic statue in the center of the wall would be a mustache, a desecration of her work. She described the statue as "trite." Frederick Hart, the sculptor of the realistic statue, showed as little respect for her memorial design, comparing it to a "blank canvas," claiming that it was "intentionally not meaningful" and "contemptuous of life."

Eventually a compromise was reached; the statue was erected in an entrance plaza a little distance away from the wall, not in front of it. For her design, Maya Lin had won $20,000 and national fame; she had also experienced criticism, rejection, and a loss of control over her own work. Frederick Hart, a professional sculptor, was paid ten times as much for his statue. Despite public debate, the memorial immediately became one of the most popular attractions in the nation's capitol. In the process, it has more than satisfied the original goals of its patrons, which were to list the name of every soldier lost in Vietnam, to honor those who fought there, to make no political statement for or against the war, and to promote reconciliation.

effect the memorial would have on the public, she thought to herself, "They'll cry" (although she didn't say this out loud until after the project was finished). And visitors do cry at the wall, even those who did not personally know any of the soldiers whose names are listed among the dead and missing in action. No one can doubt that the *Vietnam Veterans Memorial* is the most moving monument on the mall in Washington D.C. and perhaps the most moving war memorial ever built. What makes it so effective?

The memorial interacts with the site in a unique and powerful way. Instead of building a structure on top of the land, Maya Lin cut into it and edged the cut with a V-shaped black granite wall—one arm pointing toward the Washington Monument, the other toward the Lincoln Memorial. Into this wall more than fifty-five thousand names of all Americans who died or remain missing in the Vietnam War are incised in date order, as if on a mass gravestone. The black granite is polished to reflect its surroundings: the sky, clouds, trees, and land, as well as each person who has come to remember.

As many as ten thousand visitors visit the memorial each day. Many are looking for the names of specific loved ones; others are there simply to pay tribute to all of those who lost their lives. From the first, visitors have interacted with the memorial in unique ways. People reach up to touch the names and make rubbings to carry home as souvenirs. Others leave flowers, photographs, letters, and memorabilia. The memorial is a place for surviving veterans to be reunited with friends, for friends to remember the classmates who never returned, for family members to "meet" the dead father, brother, sister, or cousin who they do not remember, or perhaps never met. Lin's memorial seems to allow people to experience their loss, while comforting them at the same time. The *Vietnam Veterans Memorial* is a superb example of the power of art (even when very abstract) to reach out to the public.

THE POWER TO AWAKEN OUR SENSES

Art has the power not only to reveal eternal truths but also to awaken us to realities that we may not have recognized before, to literally open our eyes to new ways of looking. In the modern world, the art of photography has

1-26 Joel Meyerowitz, *Truro 1984*. Ektacolor (chromogenic development) print. Courtesy Museum of Fine Arts, Boston.

become a vehicle for this kind of artistic revelation. Joel Meyerowitz is a photographer who specializes in translating the visual poetry of everyday life into photographic images. Looking through a book of his photographs, such as *Truro 1984* (1-26), the viewer realizes that scenes such as this surround us with their sumptuous and surprising beauty—yet in real life we tend to move right past them, considering them ordinary. Through his art, Meyerowitz has the power to slow us down, to make us stop and really look.

Photographic art also has the power to concentrate our vision, to focus on reality in a new way. Imogen Cunningham was a photographer who spent much of her career exploring the abstract patterns created by natural forms such as plants. Where Meyerowitz is interested in capturing an entire scene, as we might remember it, Cunningham focuses on a close-up detail of her subject (1-27). By presenting just a leaf or a flower in sharp focus, her pictures almost seem to increase our vision, to enable us to see their subjects with a kind of superrealism. In this way, her pictures almost seem to stop time, reminding us of these lines by the English poet William Blake:

> And a heaven in a wild flower;
> Hold infinity in the palm of your hand
> And eternity in an hour.

1-27 Imogen Cunningham, *Leaf Pattern*, before 1929. Gelatin silver print. © 1978 The Imogen Cunningham Trust.

Cunningham's photographs act as powerful reminders that the smallest aspect of nature reflects an infinity of possibilities; there are wonders worth studying all around us.

THE POWER OF ART FOR THE ARTIST

Without artists, of course, there would be no art. While we have been exploring the many powerful ways that art can affect and benefit us, we have yet to consider why someone would choose to make art. While a cynical observer might say artists make art to make money, those knowledgeable about art know (despite the headlines about the high prices being paid for art) that few of the thousands of artists at work today will ever make a living strictly from sales of their art. The satisfactions of such a difficult and often painful occupation, then, must be more substantial than dreams of wealth.

SELF-EXPRESSION

One of the most obvious and important reasons that artists make art is to satisfy the need for self-expression. Through their art, painters, sculptors, architects, photographers, printmakers, designers, and craftspeople are all able to express their personal vision. Mexican painter Frida Kahlo used self-portraits in the style of native folk art to express her own suffering. As a teenager, she suffered a terrible injury when the bus she was riding was smashed by a trolley. Her spine and pelvis were shattered, and she spent the rest of her life in constant pain, despite thirty-five operations. In her self-portrait, *The Little Deer*, (1-28) the many insults to her body are displayed in fantastic imagery, yet there is great strength in her face. Kahlo's willingness to use art to reveal her inner life gives her work great power. For Kahlo herself, the act of creating such a picture must have had a cathartic, healing power.

THE ARTIST AT PLAY

Visual art has often been used to record personal and artistic suffering, yet it can be an equally effective record of the artist's joy, such as the simple joy of being creative. A sense of spontaneous playfulness, amusement, and imagination were trademarks of the German Modern Artist Paul Klee. Both the title of the watercolor *Dance You Monster to My Soft Song!* (inscribed in ink as part of the picture itself; 1-29) and the way Klee drew his picture are whimsical. The gigantic monster, shaped rather like a bird cage with a bulbous red nose but tiny arms and legs, hovers precariously above the ground, while a strange piano-machine plays on. With legs akimbo and a nervous, cross-eyed look, the monster seems to fear that when the music ends he will crash to earth once more. Like many of Klee's works, the drawing has the quality of a doodle. We sense that Klee enjoyed the activity of creating this image, of using lines and colors to build these make-believe figures that could never exist in the "real world."

THE ARTIST'S MEMORY

Visual art can also provide a vehicle for memory, a means of recording past experiences. One of the best known artists to use art as a way of

reliving the past was the Russian-born painter Marc Chagall. Chagall was influenced by the most advanced art movements of the twentieth century. As an impoverished young art student, he traveled to Paris and met daring artists who were experimenting with new ideas, like Pablo Picasso. Refusing to be bound by the limits of visual reality, artists like Chagall wanted to reach beyond what they saw to paint what they felt, and beyond that to what they dreamed. Yet, even though his style is modern, the work of Chagall is filled with a love for the rural scenes of his childhood in Russia.

In his pictures, time and gravity have no power, people and animals whirl through the heavens regardless of the rules of nature. Looking at *I and the Village* (1-30), we see a friendly cow and a man holding a flowering twig in his fingers, looking face to face, united

visually by a red disc. The huge cow seems benign and almost as if it is about to speak to the green man, or kiss him. Smaller figures also appear: a young woman milking, a man with a scythe walking to the harvest, a woman placed upside down who seems to be gesturing him forward, a child's face peeking over the edge of a hill behind which the tiny buildings of the village appear both right side up and upside down.

Throughout his long career (he lived to be ninety-six), Chagall used art to create a magical land of love and wonder—remarkable for a man whose life encompassed two world wars, the Russian Revolution, and the Holocaust (in the 1940s Chagall, who was Jewish, was forced to flee from his home in France to the United States). In this sense, Chagall's work is a tribute to the power that art has to transcend political

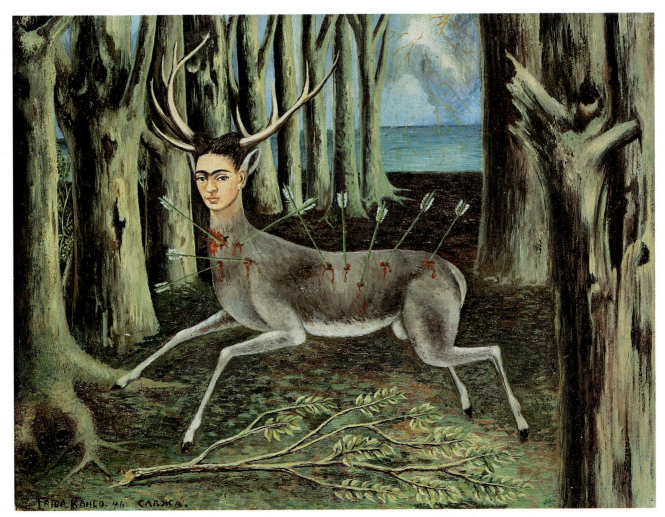

1-28 Frida Kahlo, *The Little Deer*, 1946. Oil on canvas, 8¾" x 11¾". Collection of Carolyn Farb, Houston.

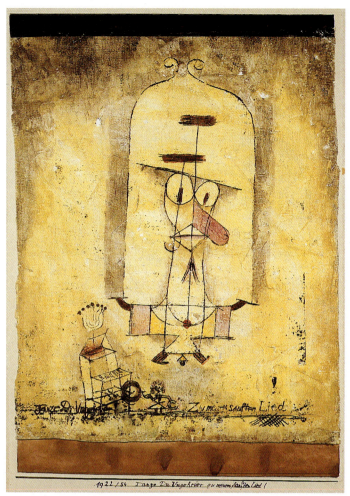

1-29 Paul Klee. *Dance You Monster to My Soft Song! (Tanze Du Ungeheuer zu meinem sanften Lied)*, 1922. Watercolor and oil transfer drawing on plaster-primed gauze bordered with watercolor on the paper mount, 17¾" x 12⅞". Solomon R. Guggenheim Museum, New York (gift, Solomon R. Guggenheim, 1938).

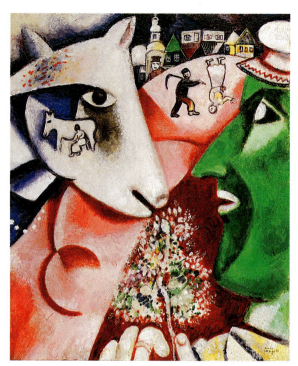

1-30 Marc Chagall, *I and the Village*, 1911. Oil on canvas, 21¾" x 18¼". The Philadelphia Museum of Art (given by Mr. and Mrs. Rodolphe M. de Schauensee).

realities and allow the artist to regain a lost world with memory and imagination.

DEFINING ART

The source of the term *art* is the Latin word *ars*, which meant "skill." Although this is the oldest meaning of "art," it is no longer the most common meaning. For us, the realm of "the arts" suggests *creative* endeavors and includes an entire range of activities classified as *cultural*. These creative arts are often subdivided into the broad categories of the *performing arts* (such as theatre, music, and dance), the *literary arts* (such as poetry, essays, and novels) and the *visual arts*.

In everyday conversation, however, most people assume "art" means "visual art," art that we experience primarily through our sense of sight. Saying that someone is an "artist" usually suggests that he or she draws, paints, sculpts, or designs. This is the meaning of art that this book will be using. We define the visual arts to include the artistic media of painting, sculpture, and architecture, as well as outstanding examples of drawing, printmaking, photography, design, decorative arts, and crafts. They are usually subdivided into the **fine arts** (such as painting, printmaking and sculpture), and the **applied arts** (such as architecture and design). For centuries, in Western art, paintings and sculptures have often been seen as a "higher" form of artistic production than *applied* (or useful) arts, such as book illustration or wallpaper. However, for the last one hundred years or so, the distinction has not been as important. In Eastern art, there has never been such a distinction. For example, in the Chinese master Han Kan's *Night Shining White* from the eighth century

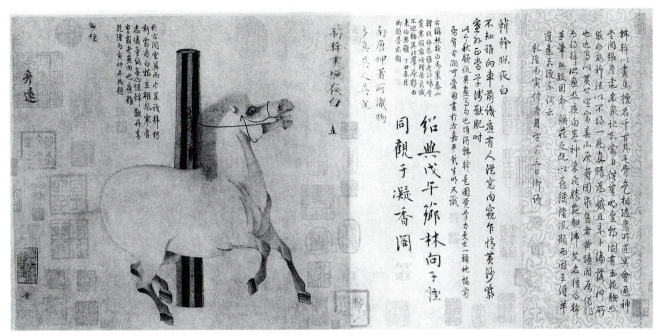

1-31 *Night Shining White,* attributed to Han Kan, 740–756. Album leaf, ink on paper, 11¾" high. Metropolitan Museum of Art, New York.

(1-31), the calligraphy on the scroll was considered just as expressive and as much pure art as the painting of the horse.

A work of fine art is usually an original, or one of a kind, creation. Each work of art is the result of the artist's personal effort, the touch of his or her hands, the fresh invention of the artist's mind, spirit, and talent. There are exceptions to this rule. Prints, for instance, are produced in a series from an original "plate" designed by the artist. Photographs, which were once thought of as mere mechanical reproductions of reality, have also been elevated to the status of "fine art." Although their artistic merit has been recognized, however, prints and photographs are usually less valued (and less expensive) than drawings, paintings, or sculptures by the same artists. This reflects the fact that the work is not unique; it can be duplicated. A black-and-white print by a great photographer, however, is far more valuable than the painting of a mediocre artist.

Art is generally considered to be "folk art" rather than "fine art" when it is the work of untrained artists working in rural areas. Folk art includes painting, sculpture, and all the decorative arts, but where a "fine art" chest may be made of ebony inlaid with ivory, the folk chest will be a simple wood box painted in bright colors. American folk art has become very popular in recent years and commands high prices in antique stores and galleries; whole museums and galleries are devoted to folk art collections.

A good example of a folk (sometimes called "naive") artist is Grandma Moses, who was born on a farm in New York State in 1860 but did not really begin painting until the 1930s, when she was almost eighty. Although she had no formal training, her pictures (1-32) became so popular that by the time she died in 1961 she was a household word in the United States, and her scenes were reproduced on everything from greeting cards to kitchen curtains. Although she is perhaps not as well known today as she was at the height of her popularity in the 1950s, Grandma Moses's talent transformed an elderly farm widow, suffering from arthritis, into a nationally famous personality.

The power of her art lies in its freshness and vitality. Through her pictures, Anna Mary Robertson Moses had the chance not only to recreate and in a sense relive her own past but also to share that world with her viewers. Her most popular subjects included maple sugaring,

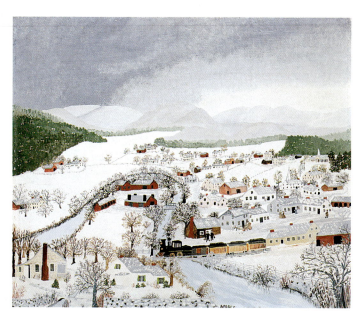

1-32 Grandma Moses, *Hoosick Falls*, winter 1944. Oil on masonite, 19¾" x 23¾". The Phillips Collection, Washington D. C. © 1987 Grandma Moses Properties Co., New York.

winter sleighing, scenes of old-fashioned farm life, celebrations of holidays, and the seasons. As she concludes in her autobiography:

> In my childhood days life was different, in many ways, we were slower, still we had a good and happy life, I think, people enjoyed life more in their way, at least they seemed to be happier, they don't take the time to be happy nowadays.

Functional objects, such as ceramic pots, glass vases, silver bowls, woven rugs, even wooden chairs, belong to the category of crafts or decorative arts if they were produced individually, or "by hand."

A good example is a Navaho "eye-dazzler" rug (1-33). Woven and designed by Native American women in the late nineteenth century, these blankets have a strong visual impact because of their bold use of color and simple geometric designs. These weavings were named "eye-dazzlers" because of their use of new, brighter yarn that became available to the American Indians during this period. Although purists and collectors tended to prefer American Indian blankets made with native vegetable dyes, the weavers themselves embraced the new colors. It is not surprising that modern artists in search of a purely visual art have been inspired by these blankets and other decorative

arts, such as quilts, because the decoration of useful objects has been a source of visual pleasure for viewers in many ages and cultures.

The term "crafts" is also often used to describe contemporary objects that are handmade. Craft art is perhaps the most popular way of appreciating and practicing art in our society. Many people who would be afraid to invest in an original sculpture are perfectly comfortable buying a hand-thrown pot, while individuals who insist that they "can't draw a straight line" enjoy classes on weaving or wood carving. While some art historians and critics still think that such things as jewelry should not be considered art at all, attitudes are changing. For example, the imaginative jewelry of British artist Wendy Ramshaw (1-34) is now included in international surveys of design.

What about functional items that are mass produced? Are they part of the world of visual arts? A broad definition of art would certainly include manufactured objects that are well designed—in fact, the Museum of Modern Art in New York devotes an entire section to out-

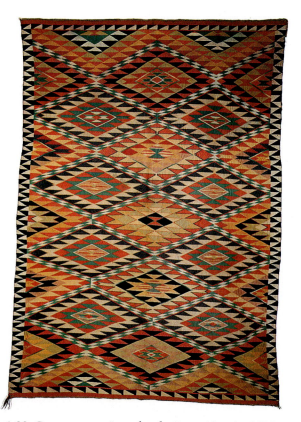

1-33 Germantown "eye-dazzler" rug, Navajo, 1880–1890. Split wool yarn, 2, 3, and 4 ply, 72"x 50". Museum of Northern Arizona, Flagstaff.

standing examples of such objects as telephones, typewriters, even helicopters (see 1-35). This field of art is known as **industrial design**. **Graphic design**, sometimes called *commercial art*, includes two-dimensional designs that are mass-produced, such as decorative posters, magazine layouts, and the cover of this book. Walt Disney, who became a beloved figure in America, was a very successful commercial artist who designed not only cartoon characters but also later full-length animated films (1-36) and two entire imaginary cities, Disneyland and Walt Disney World.

ART IS BEAUTY

Many people think art must be beautiful to qualify as great art. For them, the primary power of visual art is its ability to delight the eye. Art that is visually pleasing seems to justify itself and needs no other reason to exist. "A feast for the eyes" is one way to describe

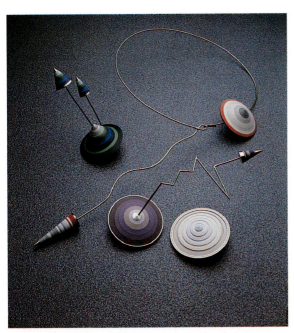

1-34 Wendy Ramshaw, *Jewellery*, 1985. Formica colorcore. Courtesy Tony Gilbert Studios.

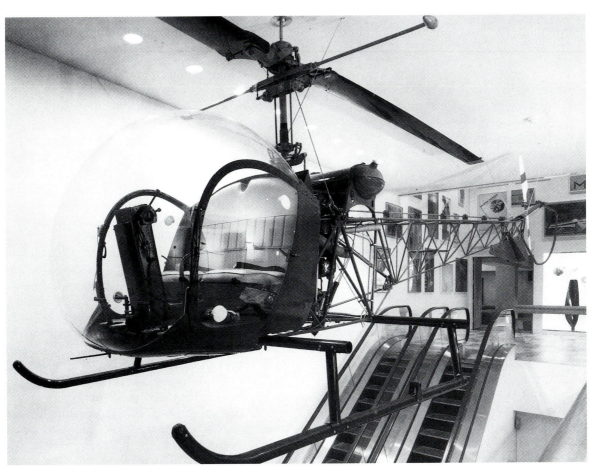

1-35 Arthur Young, *Bell-47D1 Helicopter* (manufactured by Bell Helicopter), 1945. The Museum of Modern Art, New York (Marshall Cogan Purchase Fund).

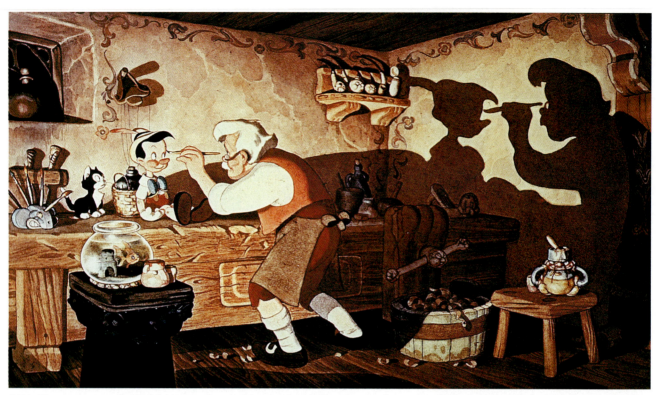

1-36 Geppetto puts the finishing touches on his wooden doll as Figaro, the cat, and Cleo, the goldfish, look on admiringly, from *Pinocchio*, 1940. © The Walt Disney Company.

this type of artwork. This *was* the chief criteria for several centuries but is no longer accepted as the only or even main one today. As we begin our study of art, it is also important to keep in mind that standards of beauty are not universal. Aesthetic taste can vary with different cultures and time periods.

For example, when the **Impressionists** first exhibited their work in late nineteenth-century Paris, it was rejected as hideously ugly. In fact one critic accused them of "making war on beauty!" To the ordinary viewer of 1874, pictures like Pierre-Auguste Renoir's *La Loge* (1-37) seemed unfinished and crude. Today people flock to see the same work, which looks to the modern eye not only beautiful but also impossibly sweet, romantically ideal.

Although many people assume that visual art should be beautiful, or at least realistic (and preferably both), you will find many artworks in museums which do not fit this mold. Some great works of art get their power from the depiction of "ugly" subjects or the distortion of forms. The subjects are not beautiful or

realistically portrayed. Willem de Kooning's *Woman and Bicycle* (1-38) is a good example of the kind of painting that upsets some people today as much as the Impressionists did a hundred years ago. "My child (or dog) could do a better job" is not an uncommon reaction to this type of artwork. Viewers are often upset by what they consider the gratuitous ugliness of such modern art.

As different as they appear at first glance, upon reflection Renoir's and de Kooning's pictures of women do share certain attitudes about art. Both are committed to loose, expressive brushstrokes (see details, 1-39, 1-40). Neither feel it is necessary to be absolutely precise and descriptive; they feel that art can hint rather than be dogmatic. Both believe in the use of colors to communicate emotion. Even though they are painting eighty years apart, the artists share a philosophy of art that stresses expressiveness. De Kooning's paintings can be seen as a more radical development of the ideas that made Renoir's approach seem unique in the nineteenth century.

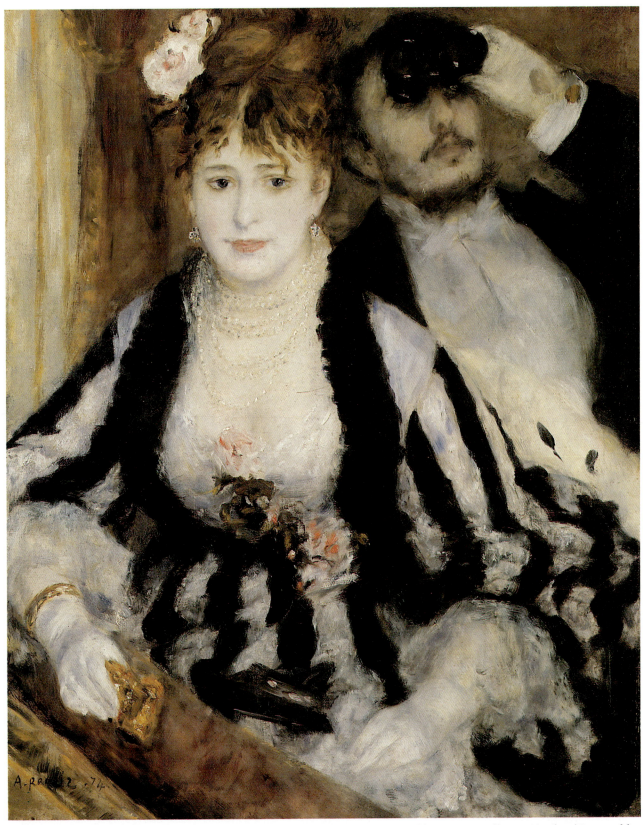

1-37 Pierre-Auguste Renoir, *La Loge,* 1874. Oil on canvas, 31″ x 25″. Courtauld Institute Galleries, London (Courtauld Collection).

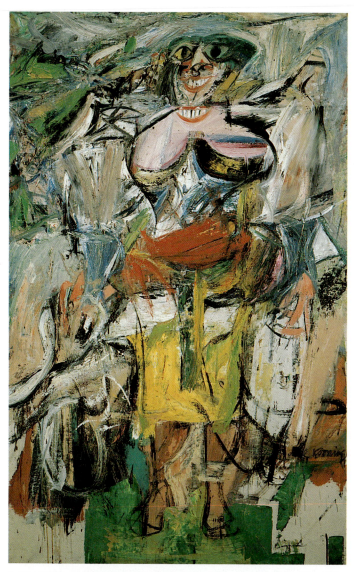

1-38 Willem de Kooning, *Woman and Bicycle*, 1952–1953. Oil on canvas, 6'4½" x 4'1". Collection of the Whitney Museum of American Art, New York (purchase 55.35).

ART IS ORIGINALITY AND CREATIVITY

The pictures of Renoir and de Kooning share not only a belief in expressiveness but also a belief in the value of originality. It is often said that the one thing that sets great art apart is its originality. The accepted idea is that a work of art should be an unique creation, the expression of the individuality of the artist. Those artists whom we consider greatest, like Pablo Picasso (1-41), kept developing from one successful style to another, always searching for a new mode of visual expression. The photograph (page 29) shows him experimenting with drawing with light, something only possible to see in a photograph. He is in his pottery studio, ceramics being only one of the many media he explored. This constant striving for newness and originality sets us apart from the artists of the cave paintings and the Ancient Egyptians, who repeated the same style for centuries according to a strict set of rules, or artistic formulas.

Generally, in the twentieth century, the word "imitation" is usually associated with unoriginality rather than superior art. But in the last thirty years, even the idea of originality has been challenged by contemporary artists. As aware residents in a world of mass production, mass consumption, and mass media, some artists have created a kind of mass-produced art. Andy Warhol, for instance, became famous for his multiplication of images, as in *30 Are Better Than One (Mona Lisa)*, 1-42. Using a stenciling technique, Warhol appropriated someone else's design—in this

1-39 Detail of figure 1-37

1-40 Detail of figure 1-38

case Leonardo's *Mona Lisa*—and repeated it to create a new work of art. He created similar pictures using such popular images as Campbell's soup cans or identical photographs of Marilyn Monroe. It is rather amusing to see art collectors today attempting to sort out the "genuine" Warhols from the work of his followers and fakes. This is especially difficult since Warhol's work was done in his studio, known as "The Factory," where assistants often made art while Warhol acted out his role as a famous artist, going to parties and talking to the press.

WAYS TO UNDERSTAND ART

If our goal is to achieve a fuller knowledge and appreciation of art, we should avoid utilizing only one theory and excluding much of what might be relevant to a work of art. We have already seen that art has a variety of purposes and aspects. No single theory has yet been able to encompass them all in a useful way. To try to fence art in for the sake of any theory seems senseless. No one can determine in advance which questions or information might increase

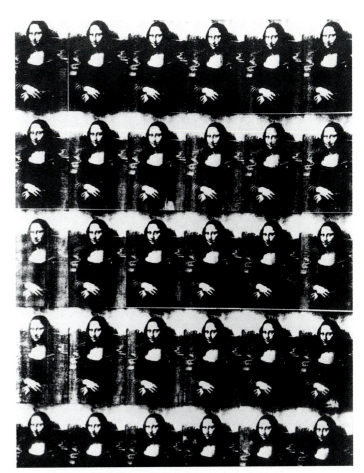

1-42 Andy Warhol, *30 Are Better Than One (Mona Lisa)*, 1963. Silkscreen ink on synthetic polymer paint on canvas, 9'2" x 7'10½". © 1993 The Andy Warhol Foundation for the Visual Arts, Inc.

our understanding of a particular work of art. To understand art, our primary question should be, *Why does it look this way?*

THE OBJECT ITSELF IS PRIMARY

The viewer begins, of course, with the object itself. The main function of works of art are to provoke aesthetic interest. But art should also be intelligible to the viewer. Integral to its success are formal concerns: its design and composition. In Chapter 2, we will study the elements of art and design to understand the structural language of art objects. Examination of the work of art should yield a sense of the artist's mastery of design principles like harmony, balance, rhythm, and pattern. No one element is essential, but if one is missing, its neglect must be justified by a special reason. For example, a chaotic effect might be

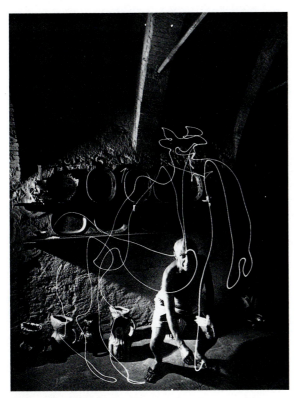

1-41 Gjon Mili, Pablo Picasso drawing a centaur with light, 1950

explained by the artist's desire to reflect the nature of modern life or simply might be a lack of the skill necessary to control the subject matter. In Chapters 3 through 9, the materials and techniques used by artists will be studied. One generally expects an artist to control the necessary means to reach his or her goal. However, skillful handling of materials is what a philosopher would call "a necessary but not sufficient condition." In other words, its presence does not mean it is necessarily a work of art, but its absence would require an explanation, like "I am rejecting traditional concepts of skill, which I associate with a dead tradition." As we will see, it is common in the Western art of the last 150 years for artists to invent new techniques rather than follow traditions.

THE ARTIST AND THE ART

This textbook accepts the notion (not universal, but generally accepted) that the more we know about the conditions under which an art work was produced, the better we will see it. This includes exploring aspects of an artist's biography that might be relevant. When was the work of art made? What were the artist's previous works? Can we see a progression? What ideas were current then? Was it left unfinished, or can we assume that it was meant to be seen this way? Can we determine the artist's intentions? What did the artist believe in? Even personal questions like, "Who were the artist's friends?" could have an impact on a particular work if some of an artwork's conception was influenced by

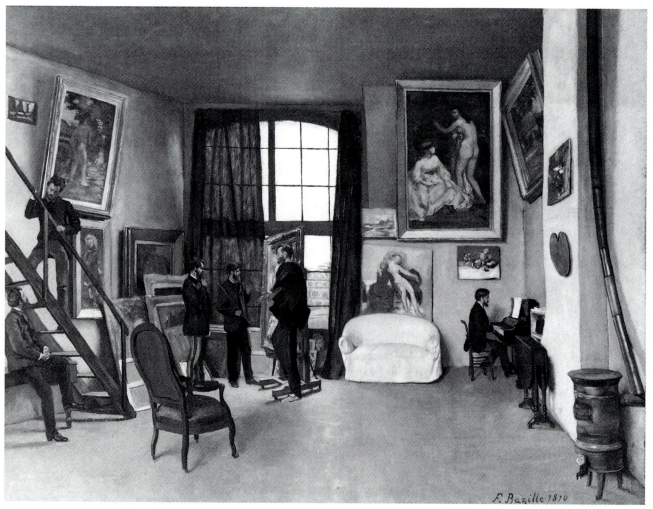

1-43 Frédéric Bazille, *The Artist's Studio.* 1870. Oil on canvas. Louvre, Paris.

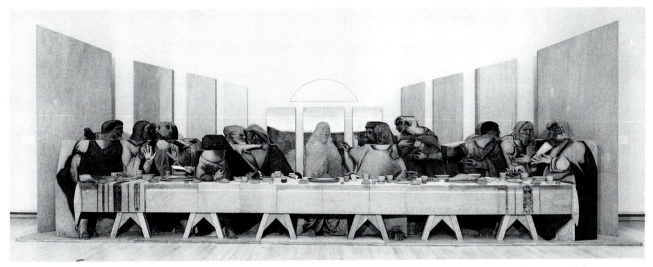

1-44 Marisol, *Last Supper*, 1984. Painted and drawn wood, plywood and brownstone, plaster and aluminum, life-size. Metropolitan Museum of Art, New York.

discussion with a group of artists. For example, the Impressionists (see Chapter 14), like many other members of art movements, met regularly in cafes and studios, sharing and arguing over ways of making art. In *The Artist's Studio* (1-43), the painter Frédéric Bazille is showing his new painting to fellow Impressionists Édouard Manet and Claude Monet while Renoir, just a few years before he painted *La Loge*, talks to a writer on the stairs. Bazille's approach to art cannot be fully understood without considering his friends in art and literature. In this picture, in fact, it is crucial because it was Manet who added the figure of Bazille to finish it.

ART AND ART HISTORY

The relation of a work of art to art history can be a significant matter in determining whether a work of art is significant or inconsequential. Even an artist's rejection of tradition requires an understanding of the tradition—since the artist is still conducting a dialog with it. This is why an artist is often described as "naive" if he or she is unaware of art history. Like all of us, the artist is conditioned and affected by the past. This is no weakness or sign of lack of originality. If there could ever be an entirely original artistic genius, this individual would most likely be a sad genius indeed. The art theorist R. G. Collingwood has written eloquently on Modern Art's love of novelty:

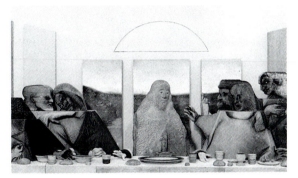

1-45 Detail of figure 1-44

If an artist may say nothing, except what he has invented with his own sole efforts, it stands to reason he will be poor in ideas. . . . If he could take what he wants wherever he could find it, as Euripedes and Dante and Michelangelo and Shakespeare and Bach were free, his larder will always be full and his cookery . . . be worth tasting. . . . Let all artists . . . plagiarize each other's works like men . . . modern artists should treat each other as Greek dramatists or Renaissance painters or Elizabethan poets did. If anyone thinks that the law of copyright has fostered better art than those barbarian times could produce, I will not try to convert them.

Marisol's *Last Supper* (1-44, 1-45) can certainly be understood through formal analysis, but one of the main pleasures of looking at it is comparing it mentally with Leonardo's

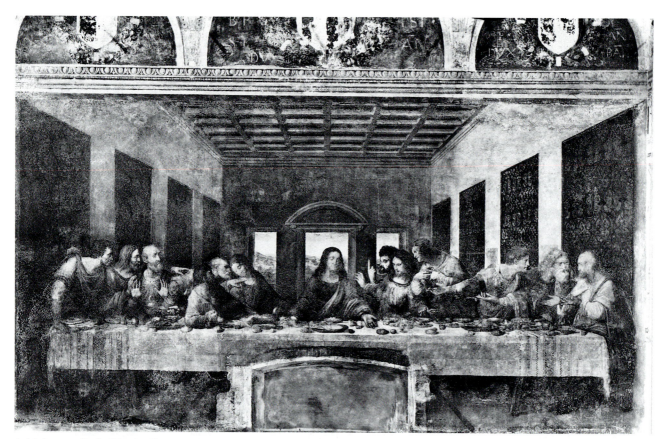

1-46 Leonardo da Vinci, *The Last Supper, c.* 1495–1498. Fresco (oil and tempera on plaster). Refectory, Santa Maria delle Grazie, Milan.

Renaissance masterpiece (1-46 and Chapter 12). Marisol has turned the famous scene into a three-dimensional environment, so the viewer can walk into the painting and experience it in a new way.

WHEN WE KNOW MORE, WE SEE MORE

This chapter presents ways to better understand and judge art. It is important to remember that a work of art need not be perfect; even a great work of art can fail in some ways and still be a masterpiece. Understanding art is similar to understanding people; the process is never finished but continually deepens as more is discovered. This is part of the power of art. The serious viewer studies the background of a work, which is far more than the white walls and polished wood floor of a gallery. The background can include the artist's biography, inner psychology, and the traditions and society that influenced the artist. All these elements can tell us why the

artist chose to make the work of art look the way it does. While no background is absolutely necessary (just as we can appreciate people without knowing everything about them), the appreciation of a work of art is certainly increased by awareness of the context in which it was produced. It helps us see more than we could before.

BEGINNING THE JOURNEY

As you begin your study of art, think of it as you would a trip to another country. Dedicate yourself to expanding your horizons and remaining open to the many things you will be introduced to in this course. This kind of openness may be difficult when confronted with a work of modern art for the first time. For many viewers who are not familiar with contemporary art, their negative response is probably based on an immediate "gut" reaction. Nothing is wrong with having a strong, personal reaction to visual art—in fact, modern artists hope to create such reactions; most would rather have people hate

their work than be bored by it. But viewers who take a quick look and react to art, without really trying to understand it, are missing a rich world of visual experience.

During this course, you will wander around the globe to see art from many countries and continents. Time will be no barrier as we move across the centuries. We will explore many ways of looking at and understanding art. At our journey's end, when you finish this course, you will be in a better position to say whether you think the *Mona Lisa*'s reputation is deserved, whether de Kooning had any talent, or whether Duchamp should be considered an artist. And your decision will be based on knowledge rather than prejudice or "gut" feelings.

After the course is over, keep in mind you have begun a lifelong journey, one in which you will never be alone. As the French novelist Marcel Proust wrote:

Only through art can we get outside of ourselves and know another's view of the universe which is not the same as ours and see landscapes which would otherwise have remained unknown to us like the landscapes of the moon. Thanks to art, instead of seeing a single world, our own, we see it multiply until we have before us as many worlds as there are original artists. . . .

That is the power of art.

THE FUNDAMENTALS OF ART AND DESIGN

For many viewers, one of the most frustrating aspects of art is trying to describe what they see. It is as if they were trying to explain something in a foreign language. This chapter introduces the vocabulary of the language of art, which revolves around the basic visual elements that all artists use: space, line, shape, light, texture, and color. With these elements, artists are able to create incredibly diverse images, from Egyptian pyramids to the *Mona Lisa*. The fundamentals of art and design provide a way to describe the various forms of art; they are the basis of the simple language in which all art is discussed.

SPACE

In the Old Testament we are told, "In the beginning . . . the earth was without form and void." Empty space is the most fundamental of the elements of art and design. Each artist has a profound sense of the void as he or she stares at the piece of paper, the canvas, the block of marble, or the empty site before beginning work. Space is the field of action on which all artists do battle. Many artists feel as Rembrandt does in *The Artist in His Studio* (2-1), a little overwhelmed as they begin.

Artists work within two kinds of space. **Two-dimensional space** is flat and can only be viewed from one side. Anything that exists in this space, like the space itself, will have height and width but no real depth. However, two-dimensional art forms such as drawings or paintings often create the *illusion* of depth. **Three-dimensional space** contains objects that can be viewed from all sides, objects that have height, width, and depth. This is the kind of space we actually live in. Sculpture and architecture are examples of three-dimensional art forms.

Defining space and controlling it with the other visual elements is what making art is all about. The process begins with the artist choosing from the range of elements. In many cases, the first choice is the simplest of elements—the line.

LINE

To a mathematician, a line is the shortest distance between two points. To an artist, a line is much more than that. It is an element of infinite potential, capable of conveying a wide variety of emotions and meanings. Vincent van Gogh's drawing *Fishing Boats at Sea* (2-2)

shows the versatility of a line. By varying length and width, or by choosing various types of lines (straight, curved, or angular), the artist creates a seascape of great complexity, reflecting the many forms of nature.

All lines are the result of an artist's movement. When they particularly reveal the action of drawing, the motion of the hand and arm, they are described as *gestural*. Van Gogh's gestures are what make his drawing exciting. Notice how different kinds of lines convey different moods. Horizontal lines seem calm, verticals inspiring, and diagonals and curves energizing. A line's texture, whether it is scratchy or smooth, for example, can imply feelings as well. The many and various lines in van Gogh's drawing almost "sound" different. One can imagine the crash of the swirling lines in the foreground as opposed to the calm, bold lines of the sea. Wc can hear the sails pulling taut in a stiff breeze because of the tight geometry of their lines.

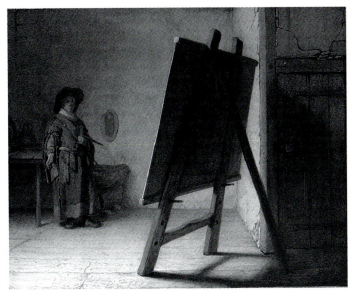

2-1 Rembrandt van Rijn, *The Artist in His Studio, c.* 1628. Oil on panel, 9¾" x 12½". Museum of Fine Arts, Boston (Zoe Oliver Sherman Collection, given in memory of Lillie Oliver Poor).

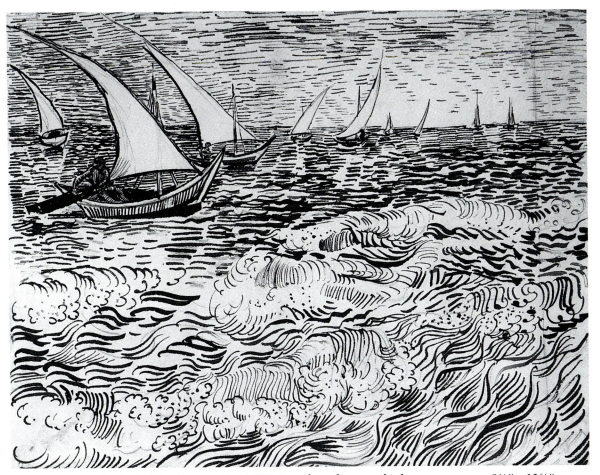

2-2 Vincent van Gogh, *Fishing Boats at Sea,* 1889. Pencil, reed pen, and ink on wove paper, 9½" x 12⅝". Staatliche Museen, Berlin.

By varying a line's width (or *weight*) as it is drawn, an artist can make a line seem to twist and turn as if it were moving in space. The viewer sees the line as if it has depth, as if it were curling. Artists also use this technique to create the illusion of a solid form. In Hokusai's drawing from the *Manga* (2-3), the solidity of his people are created by effective and economical shifts in each line's weight. A line that begins with a broad sweep of the brush can describe the edge of a kimono's sleeve, while the end of the same line might trail away to a mere flick of the brush and describe a fold at the armpit. These kinds of lines are called **contour lines**, because they describe the edge of a form.

The imaginative use of line in Japanese art and calligraphy interested many of the Abstract Expressionist artists of the 1950s. Franz Kline, a friend of de Kooning's (see Chapter 1), made expressive lines the focus of his pictures. In *New York, New York* (2-4), he used a wide brush loaded with paint to make powerful

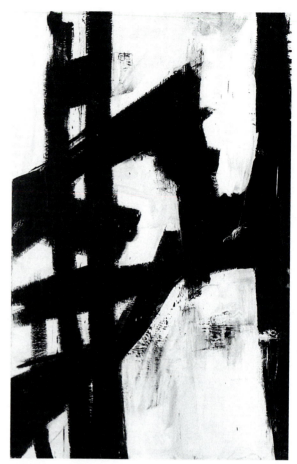

2-4 Franz Kline, *New York, New York*, 1953. Oil on canvas, 79" x 51". Albright-Knox Art Gallery, Buffalo (gift of Seymour H. Knox, 1956).

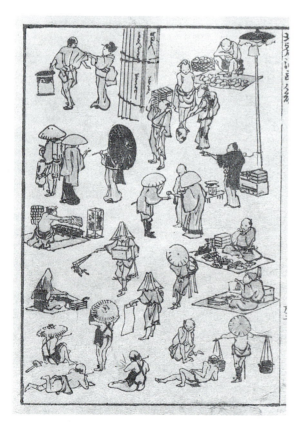

2-3 Katsushika Hokusai, page from the *Manga*, Street People, vol. 8, 1760–1849. Ink on paper, 7" x 5". The Cleveland Museum of Art (Ingalls Library, gift of James Parmelee).

gestural lines that carved up the space of the huge canvas. Kline's title tells us he felt the result had the impact of a city crowded with skyscrapers.

While lines are technically two-dimensional elements, three-dimensional artists like sculptors use them also. Materials that are significantly longer than they are wide—for example, string, sticks, or steel bars—are considered linear elements in sculpture. For example, in *Romulus and Remus*, Alexander Calder (2-5) draws in true three-dimensional space by using linear forms, in this case wire. Edges or contours are also perceived as lines in sculpture. If you look at the corners of a room, you can observe that this is also true in architecture. Three lines converge at each corner in most rooms. Dramatic edges or lines on all kinds of things often elicit comments like, "Look at the lines of that boat!"

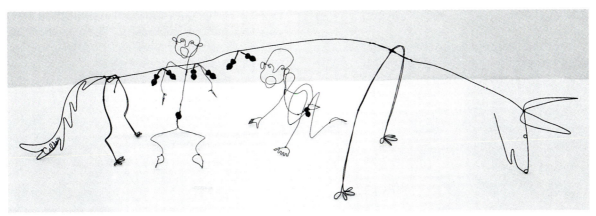

2-5 Alexander Calder, *Romulus and Remus*, 1928. Wire and wood, 30½″ x 124½″. Solomon R. Guggenheim Museum, New York.

SHAPE

By their very nature, lines divide space. As a line twists along its path, you may have noticed it begins to seem as if it is tracing the border of a shape, an enclosed space. In fact, while it is more common for them to be built from several lines, it only takes one line that turns around and connects to its beginning to make a shape.

Shapes come in all sizes and types, both two-dimensional and three-dimensional (called *volumes* or *masses*), but are usually described into four ways: **geometric, organic, abstract, and nonrepresentational**.

Geometric shapes (2-6) are formed by straight lines or curved ones that progress evenly. Squares, rectangles, triangles, and circles are all examples of this kind of two-dimensional shape. The three-dimensional equivalents are the solid geometrical masses called the cube, box, pyramid, and sphere.

Organic shapes (2-7) are formed by uneven curves. They are sometimes called *naturalistic* or *biomorphic*. Shapes that look like amoebas or treetops would be included in this category.

Abstract shapes are representational shapes that have been simplified. Even when they have been reduced to their basic underlying forms, distorted or exaggerated, the original sources of the shapes will remain recognizable.

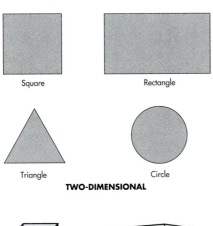

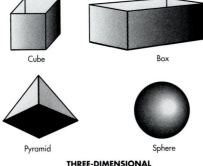

2-6

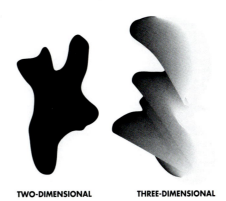

2-7

Abstract shapes can be either organic or geometric.

Nonrepresentational shapes are those that are not meant to refer to anything we can see in the real world. They arc sometimes called *non-objective* or *totally abstract*. These shapes can also have either organic (*soft-edged*) or geometrical (*hard-edged*) qualities.

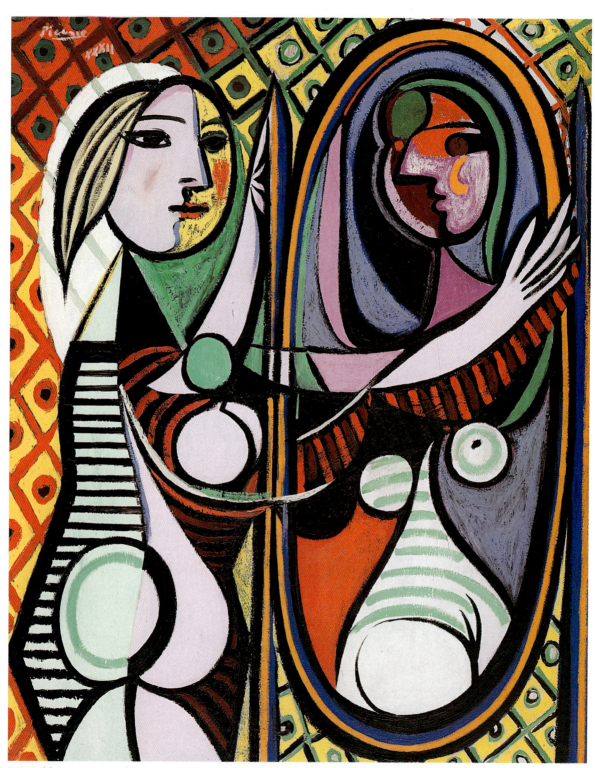

2-8 Pablo Picasso, *Girl before a Mirror*, 1932. Oil on canvas, 63¾″ x 51¼″. The Museum of Modern Art, New York (gift of Mrs. Simon Guggenheim).

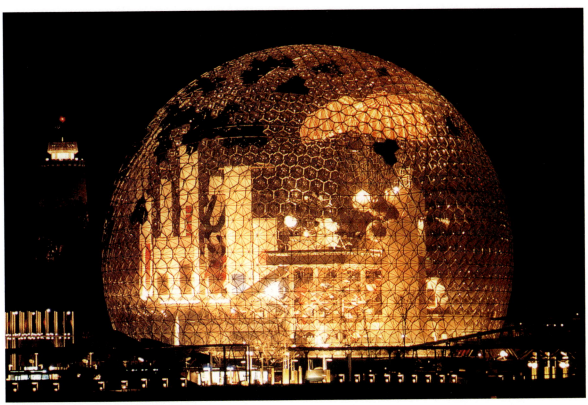

2-9 Buckminster Fuller, United States Pavilion, EXPO 67, Montreal, 1967. Steel and Plexiglas geodesic dome, shown under construction, 137' high, 250' diameter.

In *Girl before a Mirror* (2-8), Picasso creatively employs all types of shapes and even shows how one shape may share the qualities of two different kinds. The young woman's face, for example, is recognizable but it is missing many of the details. Because it has been simplified, we say it has been *abstracted.* It has also become more geometrical. The curve of her belly has also become an abstract form because it has been simplified and exaggerated. Still, it remains a naturalistic abstract shape. Behind her are nonobjective shapes that form a colorful pattern in the background. We do not have to identify them to enjoy their rhythm and bright colors.

THE SPIRIT OF THE FORMS

All geometrical forms, whether two- or three-dimensional, suggest order, mathematics, and reason. Buckminster Fuller's *United States Pavilion, EXPO 67* (2-9) utilizes these implications of geometry. His building seems perfect and ideal. The absolutely consistent repetition of one basic element gives it unity and

coherence. Yet it is not without a sense of movement. Most curved geometrical forms, like circles and spheres, convey a feeling of motion. On the other hand, "squared off" geometric shapes, like a square or a cube, generally imply perfect calm and stability. This is why most architects prefer them for their buildings.

The sculptures of Louise Bourgeois (2-10) are more difficult to categorize. Works like *Blind Man's Buff* seem to include shapes that fit all categories at once. Each part seems like a living creature, but none that we can recognize. They crowd together, as if in a precarious huddle, and the outside forms seem on the verge of tumbling off the sculpture. Are these abstractions parts of people or actually nonobjective shapes?

Soft curves like these are often found in naturalistic sculpture. Compared to Fuller's dome, this identification seems correct. However, compared to a realistic sculpture by Michelangelo, we would have to say Bourgeois's work looks very geometrical. It reminds us that categories in art are useful for discussion but their meaning is often relative.

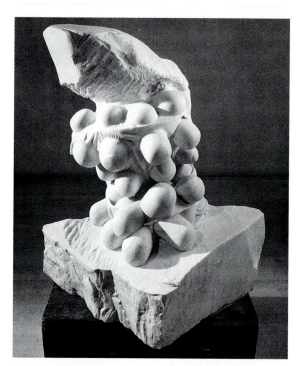

2-10 Louise Bourgeois, *Blind Man's Buff,* 1984. Marble, 36½″ x 35″ x 25″. Courtesy Robert Miller Gallery, New York.

LIGHT, SHADOW, AND VALUE

Artists working in two-dimensional media (like drawing or painting) often want to create the illusion of three-dimensional masses. This can be done by recreating the effects of light and shadow as they move around a solid object.

Light, of course, obeys certain physical laws. A mass that is lit by a single source of light will be brightest where it is closest to the source, while other parts of the mass will be less and less bright (or more and more in shadow) in relation to their distance from the light. Sections that do not face the light at all will be in complete darkness, as will anything directly behind the object. These are blocked from the light and will have a *cast shadow.*

Art students who follow a traditional course of study will spend a great deal of time learning to draw such things as drapery in light because the illusion of three dimensions can be very powerful. Volume is created by drawing the contrasting areas of lightness and darkness.

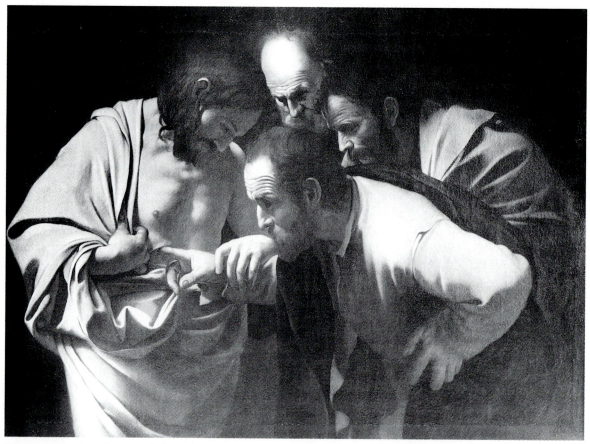

2-11 Caravaggio, *The Incredulity of Saint Thomas, c.* 1605. Now lost, formerly at the Neues Palast, Potsdam.

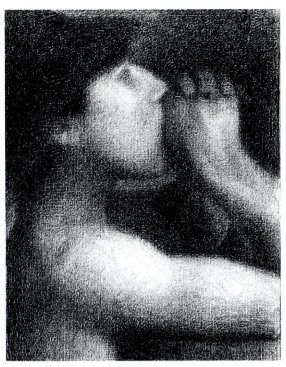

2-12 Georges-Pierre Seurat, *L'écho*, 1883–1984. Conté crayon, 12" x 9¼". Yale University Art Gallery, New Haven (bequest of Edith M. Wetmore).

The dramatic contrast between light and dark in Caravaggio's *The Incredulity of Saint Thomas* (2-11) is called **chiaroscuro** and makes the figures and forms come dramatically alive. The light focuses our attention exactly where Caravaggio wants it; even if we are disgusted by the act of poking in a wound, we are forced to see it.

As a student's "eye" becomes more experienced at seeing subtle changes in lightness and darkness (or value), his or her drawings of real things will seem more and more convincing. Few artists were ever better than Georges-Pierre Seurat at translating the subtle aspects of the effects of light. While most artists use a combination of line and shading to model forms, his drawings use only changes in tonal values. *L'écho* (2-12), without a single line, remains a persuasive and satisfying image of a young boy calling out to produce an echo. The boy's solidity is evoked by the soft contrasts in tones.

If the illusion of light and shade are an important part of two-dimensional art, the actual effects of light are vital to our appreciation of the three-dimensional art forms of sculpture and architecture. Real highlights and shadows define the shape of a statue or building. For instance, in the *Tempietto* by Renaissance architect Donato Bramante (2-13), light falling on the pure geometrical forms of the building heightens our sense of perfection. Light accents the crisp corners of rectangular window frames and the edges of the steps while softly modeling the columns.

TEXTURE

The sensitivity of our fingers is used from birth to understand our environment. When we "cannot believe our eyes," we will use touch to confirm what our eyes have told us. We will touch something to see if it is warm or cold, soft or hard. Many textures can be pleasurable; for example, soft velvet, smooth marble, and silky water are three very different pleasing textures. Sculptors find deep satisfaction in

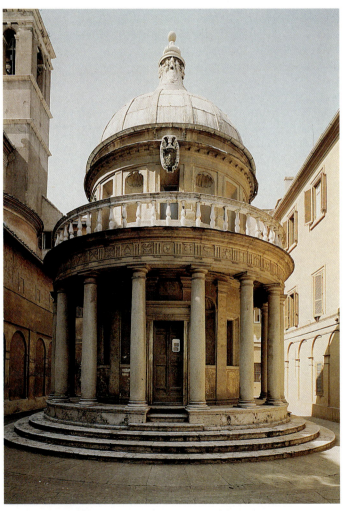

2-13 Donato Bramante, Tempietto, 1504 (?). San Pietro in Montorio, Rome.

plunging their hands into wet clay and manipulating it. Some textures are disturbing, even painful, like the coarseness of sandpaper or the jagged edge of broken glass.

Artists who work in three dimensions create *tactile* textures, textures that can actually be felt. Most sculptors, despite what a museum guard might tell you, intend their art to be understood both visually and tactilely. For example, when Henry Moore designed his *The Archer* (2-14) for the city hall in Toronto, he expected visitors to bend down beneath the large sculpture, to run their hands along its smooth, metallic forms. Viewers can get a sense of its substantial weight when they lean against it, its great size when they put their arms around it. Artists like Moore think barriers between art and viewers are arrogant and pretentious. He has even made a large sculpture for sheep to rub their backs against in a meadow near his home.

One does not need to touch all art objects to enjoy their textures. The African craftsman who made the *Oath-Taking Figure* (2-15) pro-

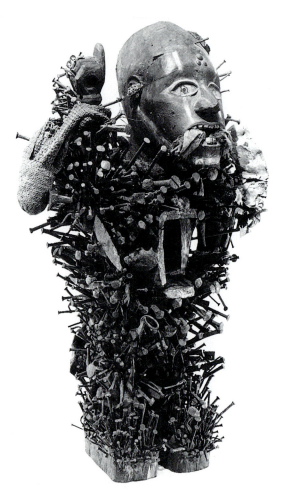

2-15 *Oath-Taking Figure,* Congo. Wood, nails, cloth, tacks, glass, paint , 26″ high. Collection Musée de l'Homme, Paris.

vided a visual feast of textures. The ritual figure mixes hard metal nails, coarse cloth, soft animal hide, and smooth pieces of mirror. While it may not be inviting, this strange (to Western eyes) combination of materials provides contrasts that are visually and tactilely interesting.

Creating the illusion of texture has been an interest of two-dimensional artists for centuries. For a Northern Renaissance artist like Jan van Eyck, it bordered almost on obsession. In his desire to re-create visual reality and demonstrate his accomplishments, he would crowd his pictures like *The Virgin with the Canon van der Paele* (2-16) with all sorts of objects having a variety of textures. With the use of delicate brush strokes, difficult to detect, and smooth transitions of light and dark, van Eyck shows us soft skin, curly hair, shiny armor made of many metals, smooth marble tile floors, an ornately carved stone throne, and

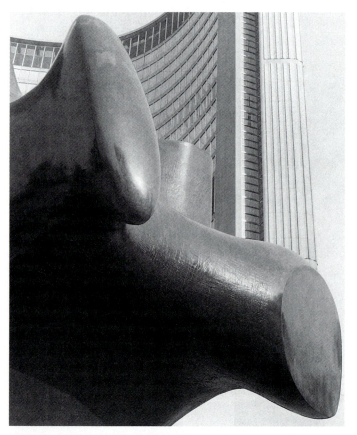

2-14 Henry Moore, *The Archer,* 1964–1965. Bronze, 10′8″ long. Nathan Phillips Square, Toronto.

fabrics of all kinds, including elaborate rugs. Van Eyck's dedication to visual truth, as seen in the lavish simulation of surfaces, shows not only his skill but also his religious devotion. He worked many hours to surround the Madonna and her child with a gorgeous and sumptuous setting.

COLOR

Why do we love color? Color affects us unconsciously, emotionally; we are drawn to it instinctively. In any electronics store, notice the crowds around the color televisions, while the black-and-white ones will seem very lonely by comparison. Color has been an integral part of artwork since prehistoric times. Using earth and minerals, cave artists made their pictures of bisons more vivid by the addition of reds and browns. Small prehistoric figurines that are tens of thousands of years old show signs that they were originally decorated with colors. Even the marble statues of the Greeks, admired for centuries for their pure white surfaces, were originally colored to resemble flesh. Today, artists use new artificial colors that can glow like phosphorous. Throughout history, color has remained a constantly fascinating and important tool for artists.

DESCRIBING COLOR

Because of the complexities of color, and in order to describe colors clearly, artists have developed a sophisticated vocabulary.

Hue refers simply to the name of a color on the color wheel or in the spectrum (see p.44). For example, violet and green are two different hues.

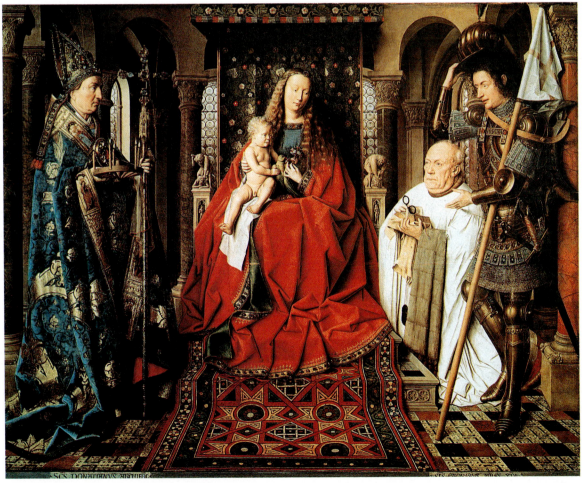

2-16 Jan van Eyck, *The Virgin with the Canon van der Paele,* 1436. Tempera and oil on wood, approximately 48″ x 62″. Musées Communaux, Bruges, Belgium.

Tints are hues that have been lightened by white. Pink is a pale tint of red.

Shades are hues that have been darkened by black. Navy blue is a very dark shade of blue.

The **neutral colors** are white, black, and gray. They make tints and shades but do not affect the hue of any color. For example, no matter how much black, white, or gray is mixed into blue, it could not change it into purple. Neutral colors do, however, change the value of any hue that they are mixed with. Value means the relative lightness or darkness of a color. It is not the same as color **intensity**. Intensity refers to the vividness of a particular hue. For example, when you turn up the color dial on your color television, you increase the intensity of the colors. The relative values between the colors remain the same. The darks are still darks; the lights are still lights. Colors that have a high level of intensity are sometimes described as **saturated**. Any addition of a neutral color will diminish a hue's intensity. In other words, pink is lighter in value than a pure red, but not nearly as intense.

COLOR WHEEL

Artists employ a wide variety of colors made by mixing other colors. However, three colors cannot be made from any others. As in mathematics, where a prime number cannot be divided, in art they are called the **primary colors**: red, yellow, and blue. These are the sources for all other colors. When two primaries are mixed, they create the **secondary colors**. These are orange, green, and purple. It is the mixing of primary, secondary, and neutral colors that accounts for the almost limitless range of colors in art.

Many artists have found it useful to think of primary and secondary colors arranged in a circle called the **color wheel** (2-17). On the color wheel, the primaries are placed equidistant from each other, with their secondary mixtures placed between them.

Part of the vocabulary of color is based on the color wheel. **Complementary colors** are directly across from each other on the color wheel. Red and green, yellow and purple, orange and blue are considered opposites, or *complements*. They have unique properties when they are paired: They accentuate each other's intensity, at times causing painful clashing. **Analogous colors** such as green, blue-green, and blue are adjacent on the color wheel;

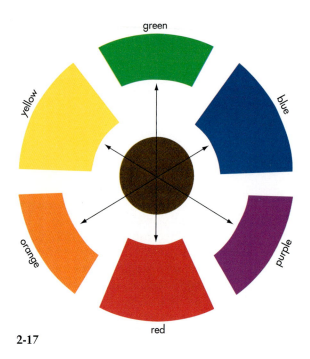

2-17

when paired they form more pleasant harmonies because they are more closely related.

Half of the colors on the color wheel are called **warm colors** and the other half **cool colors**. The warm colors are the family of colors based on yellow, orange, and red—colors associated with extreme emotions, chaos, fire, and the sun. Part of the power of Jennifer Bartlett's *Spiral: An Ordinary Evening in New Haven* (2-18) is our instinctual fear of intensely warm colors. The cool colors are those based on blue, purple, and green—colors that are associated with calm, order, the sky, and the ocean. The nineteenth-century Romantic Caspar David Friedrich's painting, *The Wreck of the Hope* (2-19), is a symphony of cool colors. It tells the story of an explorer's ship crushed by polar ice. The world is icy, cold, and silent, a vast universe to which man and his pitiful attempts to conquer nature mean nothing. Clearly, our association of these colors with temperature is very powerful. In fact, people instinctively feel a change in warmth when they walk from a blue to a yellow room.

THE SCIENCE OF COLOR

Like artists, scientists have been interested in color for a long time. In the 1600s, Isaac Newton noticed how a beam of light passing through a glass of water created a rainbow on a wall. He theorized that the water, acting as a prism, refracted the light, breaking it up into its differ-

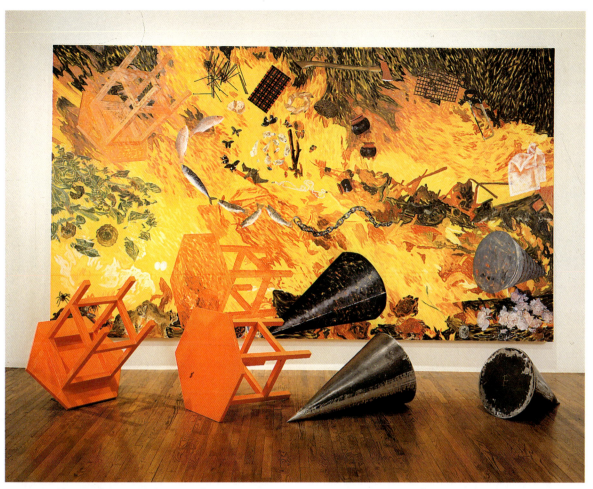

2-18 Jennifer Bartlett, *Spiral: An Ordinary Evening in New Haven*, 1989. Installation with oil on canvas, 108″ x 192″, painted tables and hot-rolled welded steel cones. Private collection.

ent components. These components, seen in the rainbow, are called the *color spectrum*. He discovered that white light is actually made up of all the colors.

We see a white piece of paper because when light strikes it, none of the light is absorbed; the paper reflects all the light back to us. On the other hand, a black piece of paper absorbs all the light cast on it. This explains why a black room is very difficult to make bright. Almost all the light rays produced by lamps will be absorbed into the walls, leaving darkness. A colored piece of paper like red seems red because it absorbs all the colors from light *except* red, reflecting only that color back to our eyes.

We begin learning the names of colors when we are very young. It begins not long after we learn to identify a cow and a rooster. We are

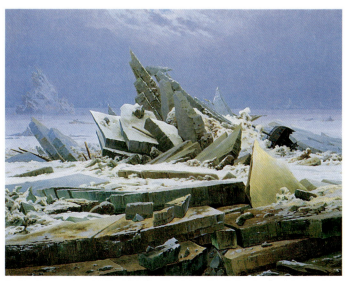

2-19 Caspar David Friedrich, *The Wreck of the Hope*, 1823–1825. Oil on canvas, 38″ x 50″. Hamburger Kunsthalle, Germany.

asked over and over again, "What color is this?" If our parents show us an orange circle on a white background (2-20) and we say "red!," our parents will look disappointed and tell us to try again. When we finally say "orange," they smile and tell us how smart we are.

What our parents were teaching us is how to name **local colors**. A local color is the general color nature of anything that we see. But colors in the real world are not so simple or definite. For example, if a tree is green, are all trees the same color? Is each tree always the same color? What color is it at noon? Is it still the same color at sunset? What color is it when it is wet with rain? Local color is useful for identification but is not specific enough for artists. Colors are much more variable than our parents ever told us.

In real life, we never see one color alone. Even if we enter a room painted entirely green, because of the lighting we see many different shades of green. *Color is affected by changes in the light cast on it.* An incandescent lamp would bring out the yellows in the greens; a florescent bulb would make the greens seem more blue.

A color is affected not only by light but also by what it is next to or surrounded by. For example, if we move the orange circle we saw on a white background to a red background (2-21), it will hardly seem orange at all, but closer to yellow. This change is known as **simultaneous contrast**. Think of this first in black and white. A polar bear in a snow storm is almost impossible to see, but a black bear would have a difficult time hiding. When two colors meet they also accentuate the differences between them; their similarities will not be apparent. In fact, when that orange circle is on a yellow background (2-22), visually it is no longer orange (even though we know that is its local color). Visually, it is red. While artists need to be aware of both local colors and visual ones, they usually focus on what might be called the visual truth.

An analysis of Kees van Dongen's *Modjesko, Soprano Singer* (2-23) will give us an opportunity to use our new vocabulary of color. The painting combines warm and cool colors, but the warm colors dominate and make the strain of singing seem intense. That is because warm colors tend to excite, while cool colors relax the viewer. This is particularly noticeable in the singer's face—as the

2-20

2-21

2-22

bright yellow changes to red, we feel the blood rush to her face as she reaches for a high soprano note.

Warm colors tend to advance towards the viewer, while cool ones recede. Van Dongen takes advantage of these special properties. The singer's intensely yellow chest seems to expand against the pale blue dress, as does her throat, constricted by the cool ribbon around her neck.

In the background, around the figure, van Dongen uses red at its highest intensity. Shades of red become progressively lighter in value as they move away from the figure. Her hair, eyebrows, and eyes are painted in a dark tint of blue, so dark that at times they approach black. The painting's three-dimensional forms are created not by shading, as you would find in a drawing, but by changes in color value and intensity. For example, the face is shaped by shades of orange and red, with more intense colors reserved for the areas in deepest shadow.

This combination of intense and pale, warm and cool colors creates the emotional, dramatic flavor of a singing performance.

NATURALISTIC VERSUS ARBITRARY COLOR

Modjesko, Soprano Singer is an example of the deliberate use of **arbitrary colors**. The subject's skin, hair, and costume are not painted in realistic colors; these colors are the invention of the artist. Invented colors can accentuate the meaning of a picture and give it an emotional content. Arbitrary colors were also used in Picasso's *Girl before a Mirror* (2-8).

For many centuries, however, European artists rarely used arbitrary colors. From the end of the Medieval period to the late 1800s, artists preferred to use colors that imitated those in the real world, or **naturalistic colors**. John Constable's *The Glebe Farm* (2-24) is, as the artist described it, "very rich in color, and fresh and bright." Despite the fact that he limited his palette to realistic hues, the painting also uses many of the properties of color we discussed in van Dongen's picture. The warmth of the earth with its reddish browns helps bring the path towards us. The cool blue sky is far away and gives the picture great depth; the hints of red in the lower clouds bring the sky just above the trees forward. As they move back in the distance, the trees have more blue mixed into the greens so they seem to recede.

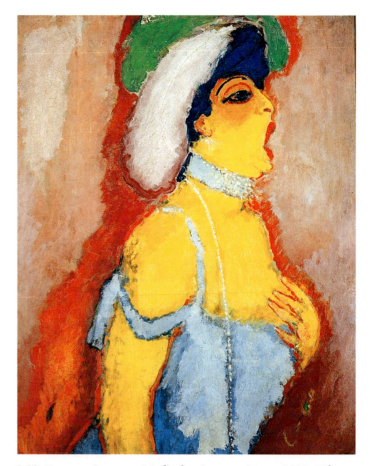

2-23 Kees van Dongen, *Modjesko, Soprano Singer*, 1908. Oil on canvas, 39⅜" x 32". The Museum of Modern Art, New York (gift of Mr. and Mrs. Peter A. Rubel).

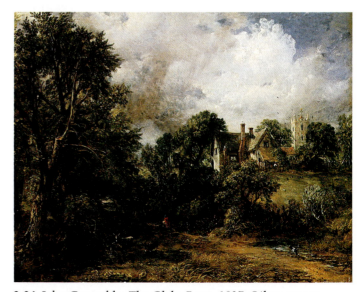

2-24 John Constable, *The Glebe Farm*, 1827. Oil on canvas, 18" x 23⅝". © The Detroit Institute of Arts (gift of Mrs. Joseph B. Schlotman).

Colors can help direct the viewer's attention. Notice how the red coat of a traveler draws us to the center of the picture. While Constable uses colors imaginatively, all of them, whether the white and brown markings of a dog or the pale yellow-green of a lawn, remain naturalistic. Throughout the history of art, one of color's most important uses has been to help the viewer identify subjects by use of their naturalistic colors. John Constable, like many artists before him and many since, follows that tradition.

EMOTIONAL RESONANCE

In the twentieth century, many artists have explored more directly the ability of color to affect our emotions. Some modern artists have felt that if used without reference to specific objects in the real world, color could create its own visual language of emotion, an art of pure feeling, like music.

Vasily Kandinsky's *Light in Heavy* (2-25) experiments with the expressive potential of the visual weight of different colors. While each part is flat and should seem weightless, we feel

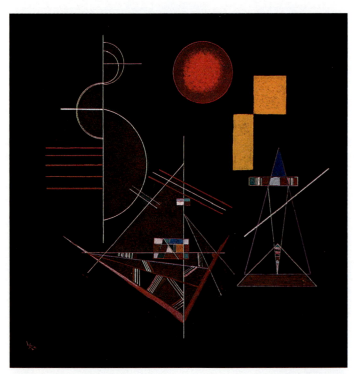

2-25 Vasily Kandinsky, *Light in Heavy*, 1929. Oil on board, 19¼″ x 19¼″. Collection Museum Boymans-van Beuningen, Rotterdam.

the pull of gravity downwards. The dark and heavy browns seem serious and massive. The large yellow and red areas float as if buoyant and unaffected by gravity. They are pure, simple, and free. However, when these colors reappear in smaller areas, they are literally boxed in and their strength is limited by their proximity to colors of equal strength, which neutralizes their energy. The world around them conspires to deprive them of their freedom.

This picture has its own inner life; the feelings we receive from it come from colors and shapes that do not need to refer to things we recognize in the ordinary world. Kandinsky created his own totally abstract characters, with what he called

> these unique beings we call colors—each alive in and for itself, independent, endowed with all the necessary qualities for further independent life and ready and willing at every moment to submit to new combinations, to mix among themselves and create endless series of new worlds.

PRINCIPLES OF DESIGN

Vasily Kandinsky, when he described colors mixing among themselves and creating endless series of new worlds, could also have been describing any of the other elements of art. Kandinsky thought of his elements as if they were living creatures, expressing a belief that many artists share: that in a successful work of art every point, every line, every element should be a living thing.

Kandinsky also wrote, "in art, as in nature, the wealth of forms is limitless." The challenge for an artist is to select and organize the many possible elements into a **design** that most suits the artist's intentions and is also visually satisfying. Human beings have a limited tolerance for disorganized things; we are made uncomfortable by chaos and prefer order. Organization provides a sense of security; it is part of our desire to control our environment. We are not alone in the animal kingdom in our desire for regular meals, regular sleep, or regular hours, as anyone who owns a pet knows.

The artist reflects these basic instincts when he or she controls or **designs** the environ-

ment of the work of art. While there are any number of possible strategies for a successful design, almost all incorporate at least some of what can be called the *principles of design.* These have proven over time to be capable of organizing a coherent work of art from the wide range of ingredients at an artist's disposal.

SPACE FOR THE TWO-DIMENSIONAL ARTIST

As discussed at the beginning of this chapter, all artists deal first with empty space. In nature, large open spaces that seem endless are beautiful, but most humans do not choose to make their homes in the midst of them. We like to limit an area, put up fences, and then populate it with buildings. For the two-dimensional artist, the first important design decision is also how to limit space and define its borders. The boundaries demarcate what is known as the **picture plane**, the playing field of the art elements. Its frame establishes a separate arena for artistic activity from the whole world that surrounds it. Its proportions will influence the effect of whatever is within its borders.

PLACEMENT

The very first element added to the picture plane has a profound effect. Now the field is no longer neutral; it is actively involved in a dialogue with what has entered it. The arrival of the first element actually produces two shapes in a picture plane. The empty space around the element becomes an important shape, too, and must be consciously dealt with. The element itself is called the **positive form**, and the altered space is the **negative form**. They are also called the **figure** and the **ground**.

Artists are particularly aware of the effect each element has on negative form. To an artist, space is never really empty; it is more like space in physics, as described by Albert Einstein, an invisible solid. By placing different elements within it, the artist manipulates space. The arrangement of elements in the picture plane is not only a design of lines and shapes but also a design of the negative space, or the ground. The artist must control both subjects and the space around them to create a successful design.

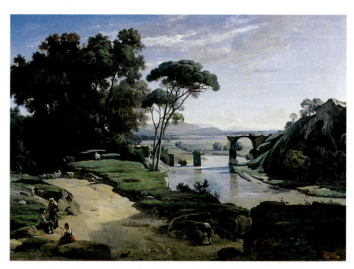

2-26 Jean Baptiste Camille Corot, *The Bridge of Narni*, 1827. Oil on canvas, 26¾" x 37¼". The National Gallery of Canada, Ottawa.

THE ILLUSION OF DEEP SPACE

So far we have been discussing a flat, two-dimensional space, but many artists working in two dimensions attempt to create an illusion of the third dimension, or *depth.* One of the simplest ways to achieve the illusion of depth is by overlapping shapes, so one seems to be in front of the other.

Another way to create a sense of depth is by changing the relative size of objects. Because in real life objects appear to get larger as they get closer to us, we also tend to perceive large objects as closer to us than small ones. We have all seen photographs where people in the distance are much smaller than those closer to the camera. If one of the subjects reaches out at the camera to block out the image, the size of the hand seems enormous compared to the relatively tiny figures behind it.

To create a sense of extremely deep space, artists (Western and Eastern) have used **atmospheric perspective**. It is based on the effect our atmosphere has on things seen at a great distance. Even the most farsighted among us have difficulty seeing distant forms as clearly as those near to us, because the forms tend to get lighter. If you look across any landscape as Corot did while painting *The Bridge of Narni* (2-26), the distant mountains lose their true color and begin to disappear in the blue of the sky. Imitating nature, Corot created the

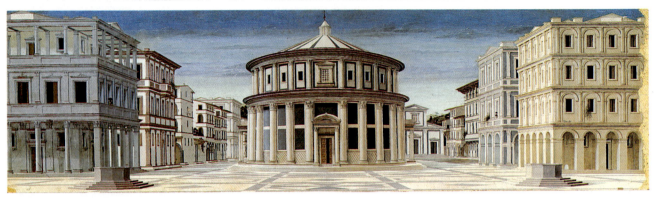

2-27 Piero della Francesca, *View of an Ideal City*

illusion of deep space by progressively diminishing detail and blurring objects in the painting the further they are from the foreground. He also accentuated depth by having the large remnants of the bridge overlap the smaller ones. Corot's keen sensitivity to changes in color while painting directly from nature allowed him to take advantage of another characteristic of atmospheric perspective as well. Notice how the painting uses warmer colors in the foreground and cooler ones towards the mountains. Because distant forms become bluer or cooler, we tend to assume warmer colors are closer to us. Corot's use of a warm red clay color in the foreground and cool blue-greens in the distant mountains accentuates his picture's depth.

LINEAR PERSPECTIVE

A more mathematically precise form of perspective was discovered by the Italian Renaissance sculptor and architect Filippo Brunelleschi in the fifteenth century. It is called **linear perspective** and has evolved over time into the principle means of creating the illusion of the third dimension.

In his experiment, Brunelleschi studied the reflection of a building behind him (the Florence baptistery—a building that would loom large in his career; see Chapter 12) on a flat mirror. He then carefully painted the mirror image on a board that had the same proportions as the mirror. By copying this image faithfully, he was able to recreate the image in perspective.

Brunelleschi had a flair for the dramatic; to reveal his new discovery, he arranged an elaborate demonstration. A hole was drilled through the painting's center. Friends were told to look through the hole from the back and hold a mirror in front of them so they could see the picture. Brunelleschi turned them so they were facing in the direction of the original building. When he told them to lower the mirror, they could see the real building and were shocked to see it was identical to the painting.

He had discovered the rules of **one-point perspective**. He noticed that all parallel lines in the direction of the object being viewed converge at one point in the distance. You may have seen the same thing looking down a highway or railroad tracks. This is the rule of *convergence*. The point where the lines end is called the **vanishing point**. It is exactly at your eye level or **horizon** line. You may have noticed that at the beach the horizon is identical to your eye level. If you look out across the water and move your head (eye level) up and down, the horizon will move up and down, too. The whole effect of a picture is determined by the choice of the eye level. As you might imagine, the view of a table is quite different for a basketball player and a toddler. Visually, they would be two different tables. Brunelleschi, aware of the impact of eye level, made sure when he drilled his peephole that those who viewed his painting were at the same eye level he had been when he painted it.

Because linear perspective can organize what we see in a logical, coherent way, its discovery was greeted with great enthusiasm by Renaissance artists. Piero della Francesca's *View of an Ideal City* (2-27) is one of many works in the 1400s that explores the new

method. It is not hard to identify the central vanishing point; the artist has the lines of the plaza and the sides of the buildings all pointing in its direction.

The sides of these buildings also demonstrate a special characteristic of linear perspective. Their size shrinks as they increase in distance from the viewer. In reality, of course, the buildings have square corners on all sides and are rectangular. But visually we see **foreshortening** taking place, their forms diminishing as they move away from the eye. Foreshortening can produce seemingly unnatural distortions of familiar forms.

A MODERN WAY OF SEEING: CUBISM AND NON-PERSPECTIVE SPACE

As realistic as linear perspective seems, it is not really a recreation of the way we see. It actually is based on a fixed viewpoint, one eye (not two) looking in one direction only, with neither the head or the eye moving. It is a good approximation of the view of a one-eyed cyclops who is totally paralyzed—not a bad description of a camera but unlike most human beings.

By the beginning of the twentieth century, many artists felt that in a modern world, a modern way of seeing art was needed. Linear perspective seemed limited and a hindrance to progress in art. While more conservative artists might admit it was a lie, they could also show that, over centuries of use, it had proved to be a very useful one. The challenge for modern artists was to develop a new method of organizing space.

In Paris, two young artists, Georges Braque and Pablo Picasso, did just that. Their approach would come to be known as **Cubism,** though it was not, as the critic who named the movement thought, really a method based on simplifying forms into solid geometry. Cubism was a more profound change than that would have been; it was a fresh look at the world and opened up new ways to organize space.

Despite its confusing look, in some ways Braque's *Violin and Palette* (2-28) presents a truer "picture" of the way we actually see. When we look at a still life, we do not stand riveted to one point, not moving a muscle, not even our eyes. We certainly do not use only one eye. Instead we look at a scene like this—bit by bit, moving our head, looking around. Our sense of the table and its objects is constructed from the many "snapshots" we take.

Cubism is also built from a collection of observations. In Braque's painting, the violin (like all the elements in the still life) is seen from several angles at once, revealing more than any single viewpoint could. Each part comes forward to be observed and each is equal in importance—there is no conventional foreground and background. The result is a

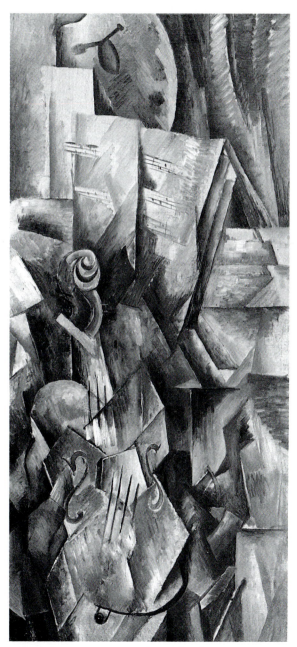

2-28 Georges Braque, *Violin and Palette,* autumn 1909. Oil on canvas, 36⅛″ x 16⅞″. Solomon R. Guggenheim Museum, New York.

significantly shallower space compared to linear perspective. The designer in Braque arranged the different parts into a dynamic composition of angled planes.

At the top of his picture, Braque "hammered" a nail painted in conventional perspective, as if it held his painting up on the wall. It is a joke, but it is also a message that the old perspective is now just one among many perspectives available to artists.

NON-WESTERN APPROACHES TO SPACE

As modern as Cubism seems, most cultures throughout history have employed an essentially flat treatment of space. Even in the West,

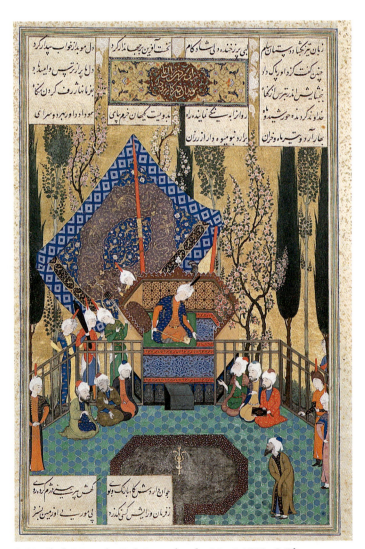

2-29 Shah-Nameh, *Zal Consults the Magi*, 1522. © The Metropolitan Museum of Art, New York, 1980 (1970. 30.8).

linear perspective is a relatively recent phenomenon. Medieval, Japanese, Indian, Chinese, and even Greek art do not use linear perspective.

In Persian illuminated manuscripts such as *Zal Consults the Magi* (2-29), no illusion of three-dimensional space is attempted. Things that we would normally see in profile, like Prince Zal's decorated canopy, are not drawn in perspective, but turned so that we can conveniently see more of them. Forms are not modeled and there are no shadows. Notice how all the figures are the same size no matter how distant they are supposed to be from the viewer.

Depth is implied in other ways. We can tell which figures are meant to be behind others when they are overlapped. In the Persian tradition, as well, closer forms are placed towards the bottom, the more distant towards the top. This particular painting shows the young, lovesick prince asking his wisemen for advice on winning the daughter of a rival leader. It is worth noting that this picture was a collaboration between a court painter and a sultan. Artistic accomplishment was admired by the great princes in Persia, many of whom were given a formal training themselves.

In Hiroshige's color woodcut *Maple Leaves at the Tekona Shrine* (2-30), other methods of implying space are used. Like the Persian painting, Japanese art (until Western influences took hold) had no modeling or shadows; each form was basically flat. However, Hiroshige does recognize that forms diminish as they get further from the viewer. Notice how the subject of the picture, a religious shrine, is actually one of the smallest elements. It is the tiny wooden structure positioned just left of the center in the middle ground. It seems especially insignificant because of its contrast with the relatively gigantic branches and leaves across the top. The difference in their sizes helps give the illusion of great depth.

Because the branches, leaves, and cliffs are cut off by the edge of the picture, a great deal of *implied space* is also created. Since we are very familiar with photography, we are not surprised to see parts of subjects *cropped* at the border. However, Western artists of the 1800s were astonished and very excited when the first Japanese prints using this technique arrived in Europe. Before then, with the exception of portraits, all elements were neatly composed

is fascinating, but perhaps ultimately disturbing because one is forced to distrust what was once taken for granted. What else do we believe in that is not true?

SPACE FOR THE THREE-DIMENSIONAL ARTIST

Of course, the illusion of three-dimensional space is unnecessary for a sculptor or architect. Our three-dimensional world is the field in which they work. For them, there is a constant dialogue between the forms they create and the space around them. A three-dimensional artist limits the space not with a border but by defining the height, width, and depth of the work of art.

Tony Smith's *Moses* (2-32, 2-33) shows how a sculpture can activate the space it inhabits. The sculptor must be aware of both the

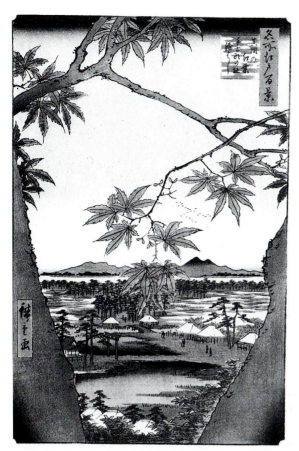

2-30 Utagawa (Ando) Hiroshige, *Maple Leaves at the Tekona Shrine*, Mamma, 1857. Color woodcut, 13¾″ x 9⅜″. Courtesy of the Trustees of the British Museum, London.

within the picture plane, rarely touching a border. Implying that forms continue past the edges is a very effective way to suggest deep space without resorting to conventional linear perspective.

Our belief in mathematical perspective as a representation of the real world can actually betray us. Used unconventionally, it can create seemingly natural worlds that are actually completely impossible. M. C. Escher, a Dutch artist, utilized apparently logical methods in many of his pictures to produce startling results. *Waterfall* (2-31) seems at first a straightforward depiction of a mill that uses a waterfall for power. On closer examination, we see that the waterfall has no source. The water is able to feed itself in a never-ending cycle, to rise after it falls and ignore the force of gravity. Escher's spatial construction takes advantage of our easy acceptance of the illusion of linear perspective. The marvelous absurdity of the scene

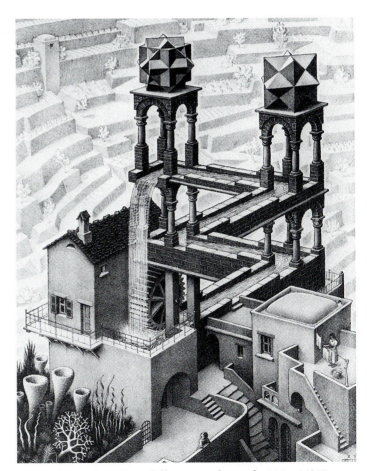

2-31 M.C. Escher, *Waterfall*, 1961. Lithograph, 15″ x 11¾″. Gemeentemuseum, The Hague. © 1961 M.C. Escher Foundation-Baarn-Holland. All rights reserved.

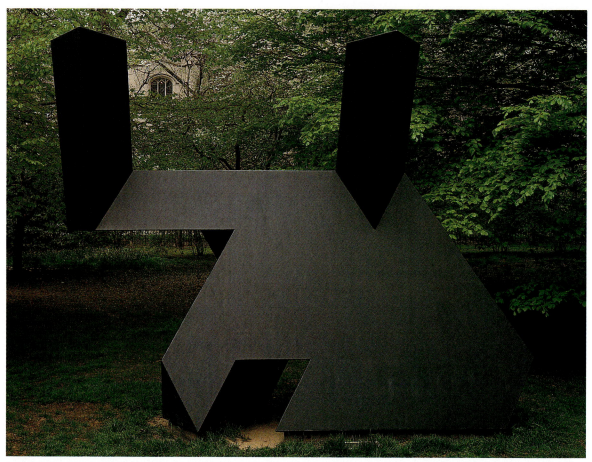

2-32 Tony Smith, *Moses,* number 1 of edition of 2 (model executed, 1967–1968; fabricated and installed, 1969). Painted mild steel, 15'1" high x 11'6" long. The Art Museum, Princeton University, Princeton, New Jersey (the John B. Putnam Jr., Memorial Collection).

positive forms created and the way they carve out the negative space. The two upper projections, besides being upward thrusts, describe an almost rectangular empty space between them. The notch at the bottom draws a parallelogram, as does the projection on the left. Unlike the two-dimensional artist, a three-dimensional one has to consider spatial issues from every possible vantage point. Part of the experience of viewing a sculpture is moving around it freely (which two flat photographs like our illustrations only show poorly). A three-dimensional form should be a new encounter every time we shift our position.

Architects also must define negative spaces, like the windows or doorways of their buildings. By decorating the portal (2-34) with a carving of a giant's face, the architect of the Palazetto Zuccari provides an animated

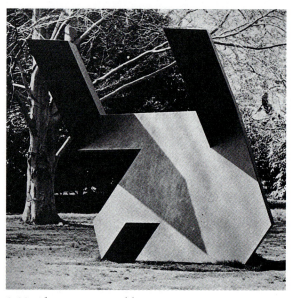

2-33 Alternate view of figure 2-32

but rather forbidding entrance to his palace. One is forced to walk through the large mouth of a monster if one wants the privilege of entering.

Inside the "gullet" or entrance hall, one would encounter another kind of space that three-dimensional artists must design, a *confined space*. Architects must control both the exterior and interiors of their buildings. A good architect will make every room and every corridor into an aesthetic experience, even taking into account the experience of progressing from room to room.

BALANCE

Balance is a natural human desire. We admire people who are "well-balanced" and tend to avoid those who are not. A loss of our ability to balance is disturbing, as anyone who has had an inner ear infection will know. Without it, we lose our state of well-being. Visually, we also find that achieving balance is an essential property in a satisfying work of art. The oriental symbol for *yin and yang* (2-35) is an example of perfect balance. It is also a good example of

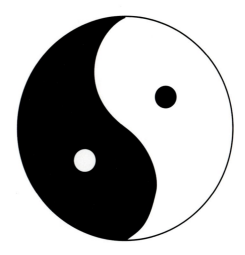

2-35 Yin/Yang Symbol

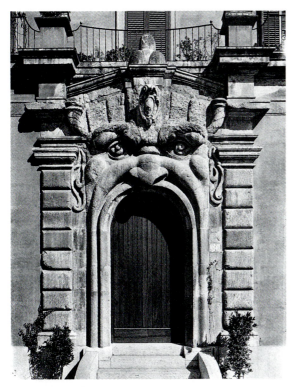

2-34 Portal of Palazetto Zuccari, Rome

figure-ground ambiguity, where it is unclear which part should be called *figure* and which should be called *ground*. Like in a checkerboard pattern, one can see either black or white as the subject. For someone from the Eastern world, however, this is not simply an interesting illusion but a meaningful symbol of the correct way of living. The perfect balance portrayed is the balance of the life forces of yin and yang, the resolution of opposites. It is a symbol of an ideal world where night and day, work and play, emotions and logic, male and female, hot and cold, activity and rest all exist together in equivalence. One's life is out of balance when any of these things is stressed more than its opposite.

In complex environments or on an empty sheet of paper, a mark as simple as a dot can affect the whole *equilibrium* or balance of a work of art. It may unsettle the balance, thereby requiring a change of position or another element to return the field to equilibrium. When each element is added, a new balance needs to be struck. Depending on its placement, a new shape can dominate its neighbor, be its equal, or seem overwhelmed by it. The importance or **visual weight** of each element in a picture plane is always relative; it competes with its neighbors and is affected by the entrance of any new form. The visual weight also varies as its own position, color, size, shape, or texture changes. As elements increase, the relationships become more and more complex and maintaining equilibrium in the design is a greater challenge.

SYMMETRY AND ASYMMETRY

While art has taken many forms throughout its history, the basic solutions to the problem of composition have remained surprisingly stable. Three basic methods of maintaining balance have proven effective. In **symmetrical balance** (sometimes known as *bilateral symmetry*), there is a general equivalence of shape and position on opposite sides of a central axis; if folded in half, the forms would match. With minor exceptions like the position of our hearts, all humans are designed bilaterally symmetrical. Ancient Cycladic idols (2-36) illustrate the special qualities of symmetrical balance. Their smooth, simplified forms and perfect symmetry provide a sense of calm and order—qualities appropriate to images of the "mother goddess."

When all elements revolve around a central point, **radial balance** is created. As we saw in Bramante's *Tempietto* (2-13), a sense of order and perfection is based on a series of pure circular elements sharing the same center. The whole world itself seems to pivot around the center in *Shamsa* (2-37) or "sunburst," which draws our attention irresistibly. The elaborate

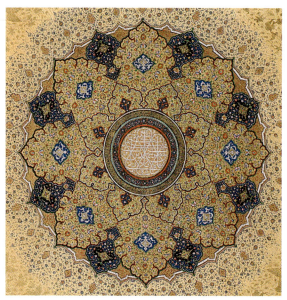

2-37 Ex Libris page from an album *Shamsa* ("sunburst," inscribed with the titles of Shah Jahan), *c.* 1640, colors and gilt on paper, 15 3/16" x 10 7/16" wide. The Metropolitan Museum of Art, New York (purchase Rogers Fund and The Kevorkian Foundation Gift, 1955).

and beautiful details combined with the sumptuous use of gold paint creates a heavenly image, similar to the **mandalas** that Buddhists use for meditation. The titles of the Indian shah who sponsored this work (and built the Taj Mahal) are inscribed in the calligraphy at the center, along with the words, "May God make his kingdom last forever!"

Unlike symmetrical or radial, **asymmetrical balance** is much more dependent on an intuitive balance of visual weights. The parts do not revolve around a center or form a mirror image around an axis but could be positioned anywhere and be any size. Unlike symmetry which is basically fixed and static, asymmetry is active. So, while it is more challenging to balance an asymmetrical artwork, when achieved, the equilibrium will be much more dynamic than in symmetrical or radial compositions. The twisting and turning forms in Pieter Paul Rubens's (and Frans Snyders's) *Prometheus Bound* (2-38) create a sense of violent movement. It is a portrayal of the Greek mythological hero who stole fire from heaven and gave it to mankind. As a punishment, Zeus chained him to a mountaintop where he was endlessly tortured.

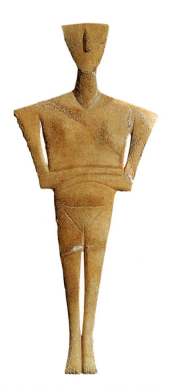

2-36 Cycladic idol, Syros, *c.* 2500–2000 B.C. Marble, 8 1/2" high. National Archeological Museum, Athens.

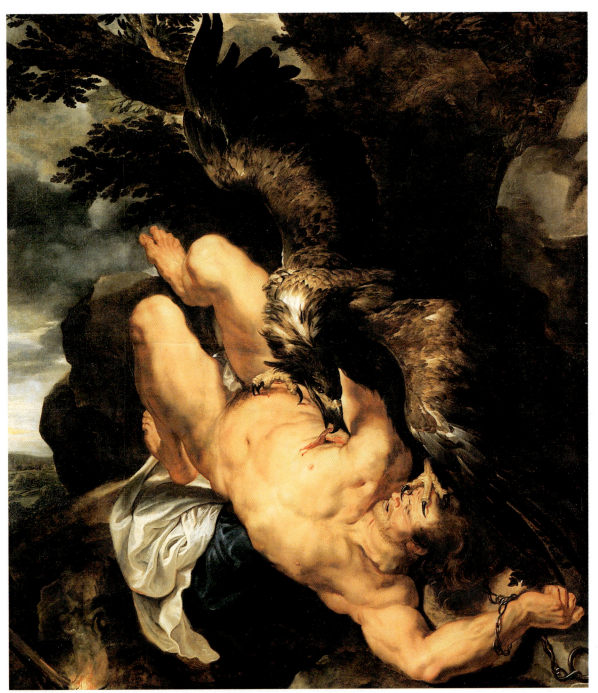

2-38 Pieter Paul Rubens (and Frans Snyders), *Prometheus Bound*, 1611–1612. Oil on canvas, 95⅞" x 82½". The Philadelphia Museum of Art (W.P. Wilstach Collection).

EMPHASIS

Emphasis in a work of art is essential for its success; if every part is of equal value, either confusion or monotony will numb the viewer. *Prometheus Bound* provides a good study of ways to create emphasis: *relative size, lines of force, focal point,* and *contrast.*

While the picture was a collaboration, the brilliant design of the composition was by Rubens. Snyders, an expert on animal subjects, painted the magnificent eagle. The eagle and Prometheus are obviously the main characters because of their great *relative size* compared to all other elements. The main thrust or *line of force* in the picture is the diagonal body of

Prometheus, which is falling towards the viewer. The eagle that swoops down from the right creates an opposing diagonal that crosses Prometheus at his bloody liver, which is torn out every day. The crossing lines of force *emphasize* the cruel act, making it the *focal point* of the picture. Lines that converge on one location are a powerful artist's tool. They irresistibly draw the eye of a viewer. In a picture of this complexity, it is especially important for the artist to control the viewer's gaze, to choose which parts dominate. To make doubly sure that the main subject is the center of our attention, Rubens also bathes it in a bright light that *contrasts* with the general darkness.

UNITY AND VARIETY

A radial image like the *Shamsa* or a symmetrical sculpture like the Cycladic idol has a strong sense of **unity** or coherence. Unity is created by repetition of shapes, textures, patterns, or

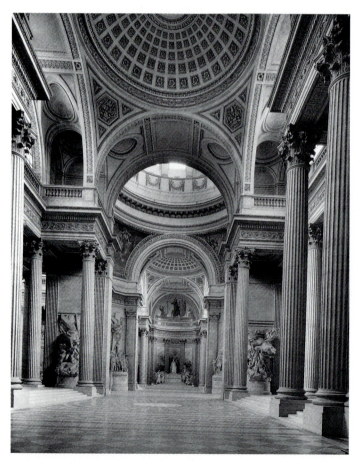

2-39 Jacques Germain Soufflot, Pantheon (Sainte Geneviève), Paris, 1755–1790

colors. While no work of art can succeed without it, unity alone is unlikely to sustain the interest of a viewer. The challenge for a designer is to balance unity with variety.

In the painting *Prometheus Bound*, there is plenty of variety. We see the contrasting areas of light and dark, many different textures, and items of different sizes. Tension is created by the precarious visual balance and the violent subject. With all the variety, how did Rubens prevent total chaos and preserve a sense of unity? While it is not readily apparent because of the complexity of the action, Rubens used *repetition*. Throughout the canvas, circular lines and shapes are repeated over and over again. The curves of Prometheus's muscles, the wings and neck of the eagle, the leaves, the rocks, the chains, and even, if we could see the original, the brushstrokes share the same form.

Repetition is much more apparent in the interior of the Pantheon in Paris, designed by the Baroque architect, Jacques Germain Soufflot (2-39). One can easily see how a series of similar shapes being repeated (in this case arches) creates a sense of **rhythm**. Rhythm is very satisfying. Our breathing, our heartbeat, the sound of waves breaking on a shore—all these things soothe us because of their orderly repetition. While a hiccup can be startling, in art some variation in rhythm is necessary to avoid monotony. Soufflot's design does this by interspersing domes of varying heights between the archways. He also fills open areas with different *patterns*, which are the simplest form of repetition. Patterns are created by evenly distributing a shape over a surface. They are instantly seen as a unified field; after looking at one part, one never examines the other parts separately. In the Pantheon, a sense of orderliness because of the repetition of forms is combined with a sense of opulence because of a richness in surface decoration.

Harmony is another important way to unify a composition, and *harmonious* is a good word to describe the impression made by Georgia O'Keeffe's *Two Calla Lilies on Pink* (2-40). Her painting demonstrates the two ways harmony can be created. The first is by the *sympathy of the forms*, often a byproduct of repetition. The soft curvilinear shapes are repeated just as often as the curves in the Rubens, but here they seem to almost nuzzle each other. That is because there are very few hard contrasts; all shading is done gradually and gently. Colors also can create harmony. Red and green colors usually clash,

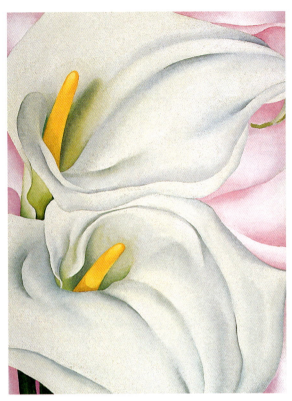

2-40 Georgia O'Keeffe, *Two Calla Lilies on Pink*, 1928. Oil on canvas, 40″ x 30″. © 1993 The Georgia O'Keeffe Foundation/ARS, New York.

but notice how O'Keeffe harmonizes those colors by adding white to them, using pastel versions. The most intense color is yellow-orange, a color that works well with the others but is still strong enough to provide the two focal points of the picture. Their verticality against the generally horizontal elements elsewhere also help draw our attention to them.

PROPORTION AND SCALE

O'Keeffe's painting is more than 3 feet high, much bigger than any calla lily flower. By enlarging the blossoms, or changing their **scale**, we see them in a new light and can understand the abstract beauty of their structure. **Proportion** and scale are related because they both refer to size, but they do not mean the same thing. Proportion compares the parts of one thing to each other. Scale has to do with the relation between something and a constant, usually the size of the average person.

The impact and meaning of Alberto Giacometti's *Walking Man II* (2-41) has to do with its difference from the normal proportions

of man. It is part of a series that occupied the sculptor for decades. His figures are so thin that they hardly exist at all. They are faceless. Moving along without grace, it takes all the effort their skin and bones can muster to drag along on large heavy feet, almost rooted to the earth. Through their unique proportions, therefore, they speak about the fate of modern man, anonymous, exhausted, and feeble, soon to be buried in the ground.

"Larger than life" is a common expression that means something is larger than an average person or *large scale*. Anything that large tends to attract our attention. Religious buildings and shrines are often built as large as possible, either

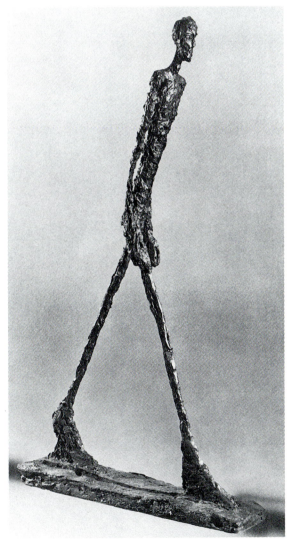

2-41 Alberto Giacometti, *Walking Man II*, 1960. Bronze, 73⅝″ high. © ADAGP/Paris and Cosmopress/Geneve.

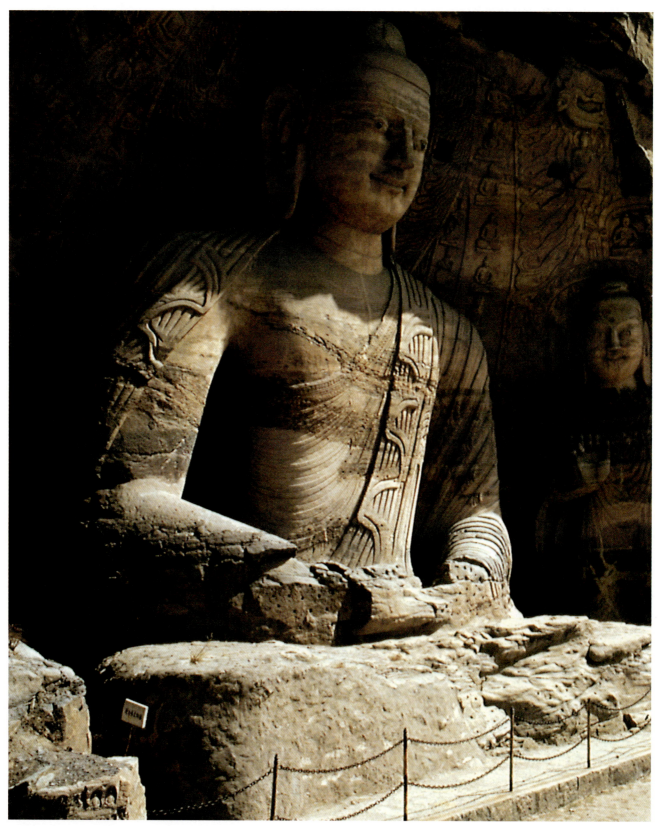

2-42 Colossal Buddha, Cave XX, Yungang, Shansi, China 450–500. Stone, 45' high.

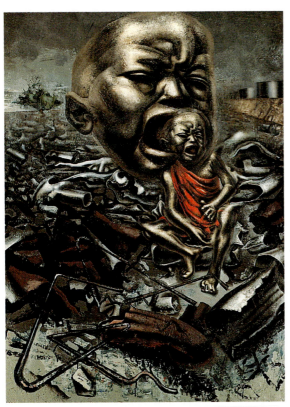

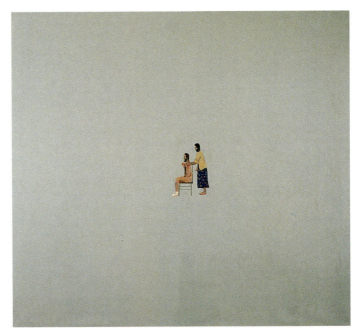

2-44 Nicolas Africano, *The Scream*, 1976. Acrylic, wax, and oil on canvas, 72 1/2″ x 85 1/2″.

2-43 David Siquieros, *Echo of a Scream*, 1937. Duco on wood, 48″ x 36″. The Museum of Modern Art, New York (gift of Edward M. M. Warburg).

to impress a god with the people's devotion or to impress a people with the greatness of their god. Gothic cathedrals, Greek temples, and Islamic mosques all follow this idea of the power of enormous buildings, but few temples and statues (it is both) can compare to the *Colossal Buddha* of China (2-42), which was carved out of solid rock and is 45 feet tall. Believers go inside the Buddha to worship at elaborate shrines at human scale. Scale is the reason viewers come away with a sense of an all-seeing and powerful god. If this statue were only 6 inches tall, the effect, of course, would be entirely different.

Scale also accounts for the effect of David Siquieros's *Echo of a Scream* (2-43). The repetition of the baby's head until it reaches an enormous scale convinces us of the power of the scream. The baby's body, however, seems weak and helpless because of its relation to the mass of surrounding garbage. Shapes in the foreground might remind us of bent paperclips, but compared to the baby, they are twisted pipes. An

infant's cry in a bleak world has an entirely different impact than the one in Nicholas Africano's *The Scream* (2-44).

Africano, a contemporary Chicago artist, shows a bearded man attacking from behind a man in shorts. Because of the figures' tiny scale in relation to the large neutral field that surrounds them, one can hardly "hear" the scream of the victim. Still, we cannot help noticing the two characters because there is no competition in this scene for our attention, except the large words above their heads, "The Scream," reported simply and matter-of-factly. Since the violent encounter is so miniscule it cannot affect the viewer. It is a violent act lost in bigger surroundings, much like a crime in a big city.

All artists work with the elements of art and produce works affected by art's underlying principles. But it would be a mistake to think that artists are always conscious of these rules. At times the art process is intuitive, and analysis comes later. But conscious decisions do have to be made when beginning a work of art about what materials and techniques an artist will use for his or her conception. Those materials and techniques will be discussed in the next chapters.

PART II

THE ARTIST'S MATERIALS AND TOOLS

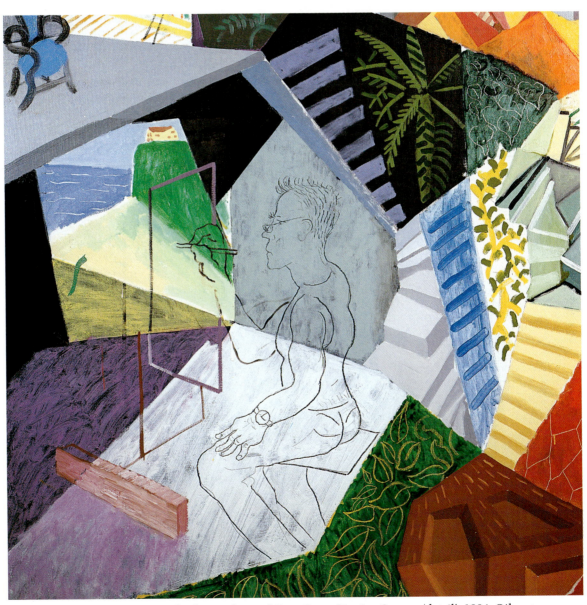

3-4 David Hockney, *A Visit with Christopher and Don, Santa Monica Canyon* (detail), 1984. Oil on two canvases, 6′ x 20′. © David Hockney.

DRAWING

Any good craftsperson needs to know what materials and tools are appropriate to the job ahead, and this is also true for an artist. In fact, many of the materials and tools used by artists are also used for more ordinary purposes. Artists use paper, paint, steel, and fabric; chisels, hammers, cameras, and welding torches. Artists' materials, like oil paint or clay, are referred to as **media**. Each **medium** has its own unique characteristics, demanding the knowledge of special techniques and requiring specific tools. By learning about the tools and materials artists use, we will discover another way to understand art, because these can influence the creation of an artwork just as much as historical and social factors.

From the first scribbles of a child to the sophisticated rendering of an adult, the most common measure of artistic talent is drawing. In many people's minds, the wildest, most abstract artworks cannot be viewed seriously without first knowing whether an artist can "draw." They mean the capability of recreating objects in the visible world accurately with a pencil, although this is a limited use of the word. Still, many artists have shared this view of ordinary art observers. For example, the great nineteenth-century draftsman, Jean-Auguste-Dominique Ingres, told the young artist Edgar Degas (see Chapter 14), "Draw lines, lots of lines, and you will become a good artist."

Drawing *is* important for just about every artist. Whether a painter, sculptor, printmaker, designer, or architect, every artist draws. For many, a drawing is a way to plan a work in another media, or simply a way to play with ideas. Sketches can range from studies of forms in nature to copies of another artist's work. But a drawing can also be a finished picture by itself. Drawing is not limited to using ordinary pencils on white paper. There are a variety of tools and materials that fall under the category of drawing.

GRAPHITE

The most common instrument for drawing is a *graphite,* often inaccurately called "lead," pencil. The term "lead pencil" persists as a reminder of the drawing tool graphite replaced in the late sixteenth century. For the previous two hundred years, artists who were interested in pure, precise lines had used **metalpoint**, which was actually a thin metal wire in a holder. While silver was the preferred metal, other metals including lead were also used. Rogier van der Weyden's *Head of the Virgin* (3-1) is an example of the delicate beauty of metalpoint drawings. Because it is made with the scrapes of light-colored metal on pale paper, a vision of the Virgin Mary appears to have materialized rather than to have been drawn.

Graphite sticks became a favored drawing tool after 1560, when the finest graphite in Europe was discovered in a mine in Cumberland, England. More and more artists were attracted to the advantages of the new material. While metalpoint produces delicate lines that are fairly light, graphite is able to make similar lines *and* bold, dark, dramatic ones. Metalpoint lines are nearly impossible to erase, but

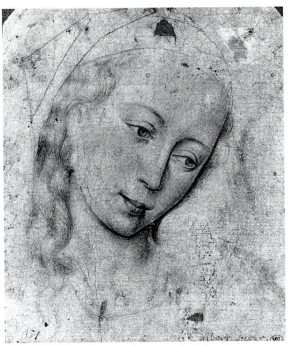

3-1 Rogier van der Weyden, *Head of the Virgin*, *c.* 1455. Silver nib on prepared paper with light applications of red to the lips and cheeks, 5¼″ x 4½″. Louvre, Paris.

graphite lines are easily erased. This permitted a less methodical and more experimental kind of drawing.

Graphite *pencils* were first created when the splendid English graphite was in short supply on the European continent during a war in the 1750s (in fact, it was considered so valuable there was concern about an invasion of French artists). An inferior grade of graphite was ground into a powder and compressed into rods. The rods were slipped into wood cylinders, usually cedar. Even though the graphite deposit was mined out in the 1800s, graphite sticks continue to be used today. However, the less messy pencils have become the most popular drawing tool of artists and art students.

Few, if any, artists have ever displayed greater mastery of graphite than the nineteenth century Frenchman Ingres. His stunning portrait of his wife, Madame Delphine Ingres (3-2), shows in its delicacy the influence of metalpoint drawings by the great masters he so admired. But the variety of tones and widths in Ingres's lines are unique to graphite. Notice how one line will change its weight, beginning thin and almost invisible, gradually thicken-ing, then thinning again. These subtle changes require tremendous skill and produce a convincing illusion of three-dimensional form within one line. In addition to superbly crafted lines, Ingres also creates soft tones that add to the illusion of solidity.

Dottie Attie is a contemporary master of graphite who pays tribute to past artists in her works. Her drawings, like *An Adventure at Sea* (3-3), are finished works of art rather than studies. They tell dreamlike stories using fragments of drawings and paintings she has studied. While she is copying from master-pieces, the result is entirely original because of her selection and combination of these pieces. Because of the beauty and clarity of her technique, one is lulled into believing her dreams are sweet and easily understood. But, beneath the surface, as in dreams, all is threatening and ambiguous.

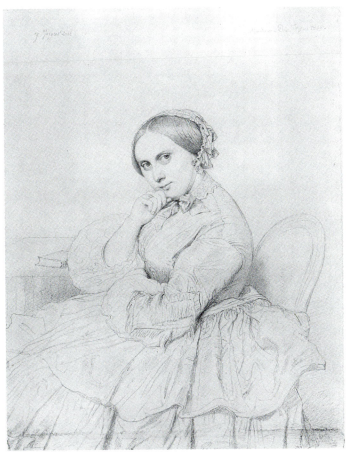

3-2 J. A. D. Ingres, *Portrait of Madame Ingres*, 1855. Graphite on white wove paper, 13¾″ x 10¾″. Courtesy of The Fogg Art Museum, Harvard University Art Museums (gift of Charles E. Dunlap).

3-3 Dotty Attie, *An Adventure at Sea,* 1977. Pencil on paper, 67¾" x 20½", each square 5¼" x 5¼". National Museum of Women in the Arts, Washington, D.C. (The Holladay Collection).

CHARCOAL

After a stick tracing lines in the sand, *charcoal* is probably the oldest drawing medium. Prehistoric man used pieces of burnt wood to sketch on cave walls. Today, charcoal is manufactured in two ways. *Stick* or *vine charcoal* is made when wood is heated until only carbon remains. It is light and fragile, making lines and tones that are easily wiped away (even a good sneeze will erase parts of a stick charcoal drawing). *Compressed charcoal* is not as easy to erase and is made from ground charcoal compressed into short squared sticks. It is better at creating rich black tones. Because of its ease of application and removal, charcoal has long been a favorite of artists and students. In the Renaissance, it was used to draw preliminary outlines for paintings. A feather or dried bread was used to erase such charcoal sketches until only a faint hint of them remained.

More recently, artists like Käthe Kollwitz, *Self Portrait* (3-4), have used charcoal for finished drawings. A dramatic range of dark and light shaded areas can be seen in her self-portrait. Fine lines made with a sharpened stick bring out the details of her face; bold ones made with its side are used to delineate her body and help create variety. Together, they form an image of the artist at work, a combination of the discipline seen in her stare and underlying intensity evident in her body.

The *grain*, or texture, of the paper is visible in most charcoal drawings (3-5). This is because no substance in charcoal helps it adhere to the paper, so it is up to the grain to catch and hold the microscopic jagged edges of charcoal dust. To ensure a permanent bond, charcoal drawings must be sprayed with a **fixative** of shellac or plastic polymer.

CHALK AND PASTEL

Natural *chalk* is another drawing material that is soft and requires fixative to be permanently bonded to paper. It is often used along with charcoal. Like graphite, it is cut from the earth. A combination of minerals and clay, chalk was first used by artists in the Middle Ages. However, its real popularity began in the Renaissance when artists started working on large-scale projects. Metalpoint had worked beautifully on a small scale, but chalks could be

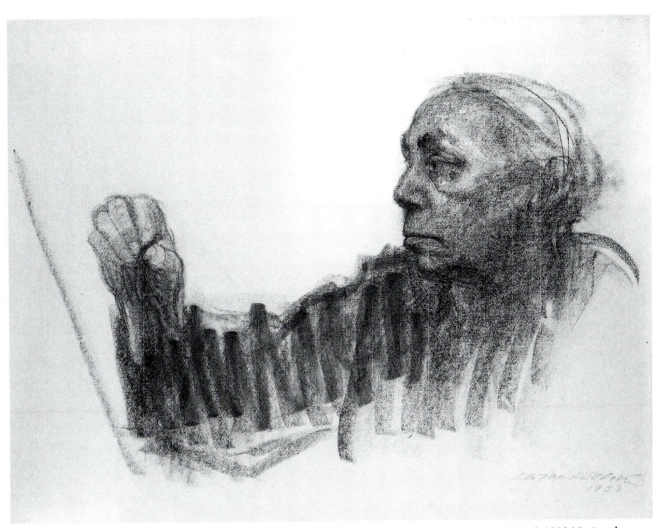

3-4 Käthe Kollwitz, *Self Portrait*, Drawing, 1933. Charcoal on brown laid Ingres paper, 18¼″ x 25″. © 1993 National Gallery of Art, Washington D.C. (Rosenwald Collection).

3-5 Charcoal on paper

used for huge drawings. At first, red chalk (sometimes referred to as *sanguine*) was preferred, but natural chalks of black, gray, and white were also used. Because of the compressed nature of the material, neat, clear lines could be made with it.

Jean Antoine Watteau used black, red, and white chalk in combination for his drawings of a young boy's head, *Three Studies of a Youth* (3-6). By rarely blending the strokes of each color, but placing them side by side, the autonomous colors are more vivid. The drawing seems almost in full color rather than in

just red, black, white, and gray. Because of the rich, bold darks of black chalk, a confident, freely executed effect is created.

It is said that Watteau kept the first modern sketchbook, because his was not a collection of preparatory plans for larger finished works but a collection of his current ideas and interests. Sometimes he would browse through old sketchbooks, years later, looking for inspiration for a current project. In fact, these heads appear in several later Watteau paintings.

Compared to Watteau's time, a much wider variety of colored chalks or **pastels** are

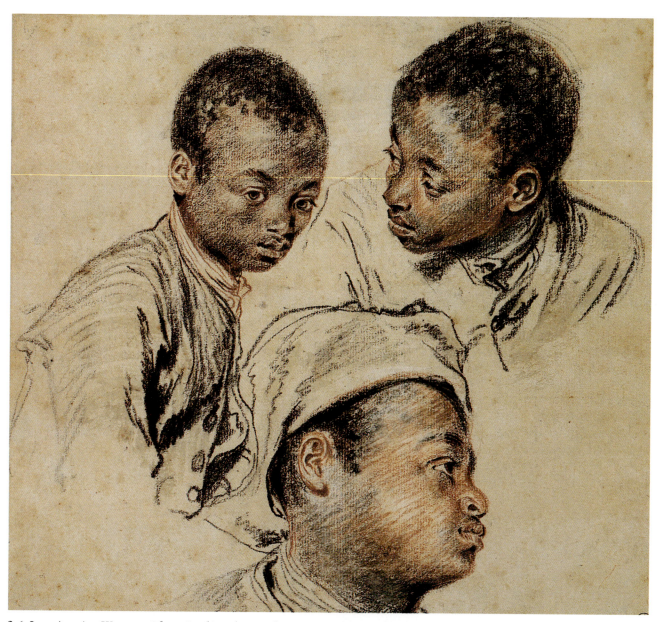

3-6 Jean Antoine Watteau, *Three Studies of a Youth, c.* 1710. Sanguine, black, and white chalks and watercolor, 9½" x 10⅝". Louvre, Paris.

available today. These fabricated chalks are a combination of loose dry pigment and a substance that holds the pigment together, called a **binder**. Binders are used in all the colored media and determine what the media is called. For example, oil paints are made from the same pigments as pastels, but they use oil as a binder. In the case of pastels, the pigment and binder form a paste that is rolled into a stick and then dried. A modern chemical product (methylcellulose) is used as a binder now, but in the past more ordinary materials have been used such as beer, milk, honey, and sugar candy.

The range of colors available in pastels is as wide as in paints; in fact, pastel pictures are sometimes called "pastel painting." However, Francesco Clemente chose to work in pastels because of the special characteristics that differentiate them from painting. Control is simpler and more direct with pastels than any of the liquid media; the soft sticks of color are easily blended. Even more importantly, since pastel is a dry media, it is closest to working with pure pigments; few media can show brilliant color better. In *Furniture* (3-7), a self-portrait that explores his own evil side, Clemente utilizes the radiance of pastels. He portrays himself as the dark black base of a lamp. The shade has a radioactive yellow glow. His eyes are in luminous green; black lines project out of them like a dark light. At the lines' ends are skulls with bat wings. Like Dotty Attie, Clemente's images are not easily interpreted and are unsettling.

CRAYON

Artist's **crayons** also provide the artist with an extensive menu of colors but do not require fixative. Like children's crayons, they have a waxy or oily binder that adheres better than charcoal to paper. This does, however, make them more difficult to erase. Unlike children's crayons that fade quickly, artist's crayons use more permanent pigments. **Conté crayon**, developed in the late 1700s, is one of the most versatile drawing materials. Like charcoal and pencil, it comes in a variety of degrees of hardness. Seurat's *L'écho*, seen in Chapter 2 (2-12), demonstrates conté's capacity to show subtle variations in tone. Because of the dense blacks that can be created with conté crayons, artists often use them when they want to model forms softly.

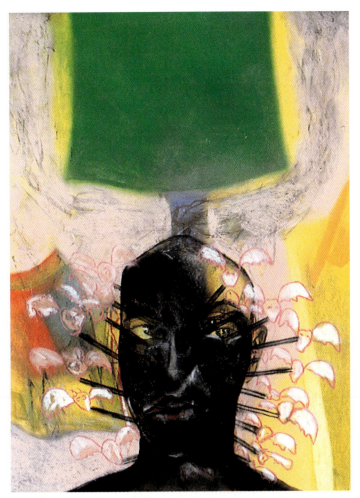

3-7 Francesco Clemente, *Furniture*, 1983. Pastel, 25″ x 19¼″. Private collection.

PEN AND INK

Pens have been in use since ancient times. The oldest pens were made from tall grasses gathered along lakes and streams, reeds in the West and bamboo in the East. Because these grasses are hollow, they can hold ink. Some artists today continue to draw with such instruments, which are prepared by cutting the grass stalks on an angle. The width of the point determines the thickness of the mark.

A more flexible and finer line is available from **quill** pens. Compared to reed or bamboo pens, they glide almost effortlessly on paper. A variation in the pressure applied to the pen will smoothly change a line's width. Quill pens have been popular since the Medieval period, when monks used them to letter manuscripts. They are made from bird feathers; goose quills are the most commonly used, but

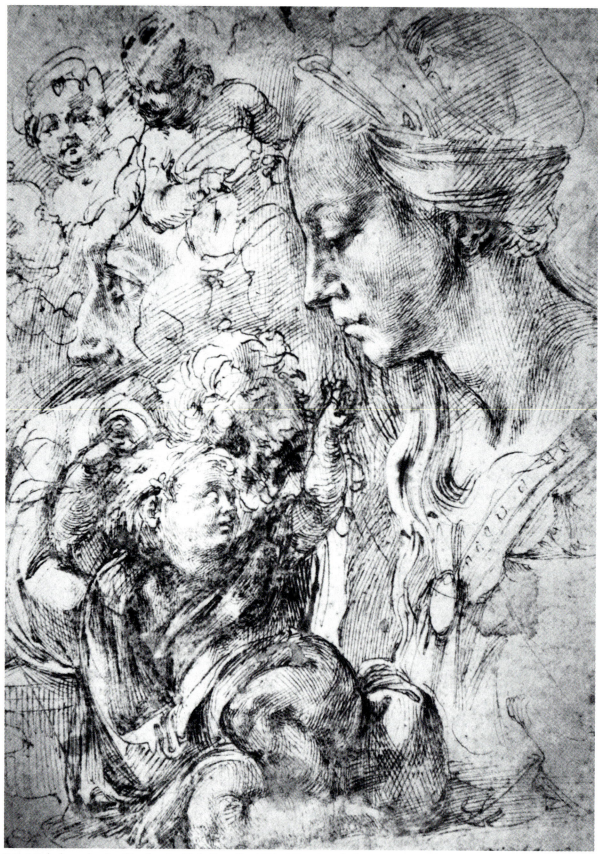

3-8 Michelangelo, *Studies for the Holy Family*, 1503–1504. Staatliche Museen, Berlin.

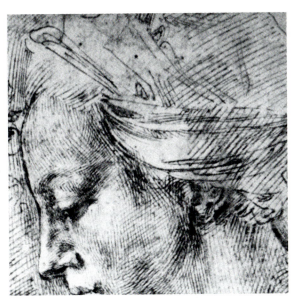

3-9 Detail of figure 3-8

crow, turkey, or even sea gull quills make fine pens.

Michelangelo's page of studies for a planned painting of the Holy Family (3-8) was most likely done with a quill pen. By increasing or decreasing the downward pressure on his pen, Michelangelo used the flexibility of quills to create many kinds of line. To make his forms seem three-dimensional, he uses a technique called **cross-hatching** (detail, 3-9). In cross-hatching, series of parallel lines cross in a netlike fashion as they describe the contours of the subject's surface. Notice that it is not necessary to cover the whole figure with these lines to create solidity; crucial junctures, usually where the figure is in shadow, are used. By narrowing or increasing the spaces between his lines, Michelangelo could create differences in the relative darkness of the shadows at the

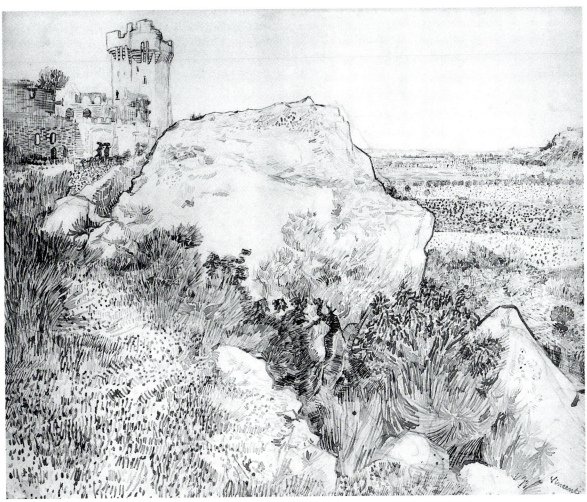

3-10 Vincent van Gogh, *Hill with the Ruins of Montmajour*, 1889. Pen, 18⅞"x 23¼". Rijksmuseum, Amsterdam.

same time he is creating volumetric (three-dimensional) forms. Volume is also implied by the varying width (or *weight*) of the lines. Quick gestural lines define the infants at the top, while heavy, powerful lines form the folds of fabric on the child near the bottom.

The versatility of pens made from natural materials can be seen in Vincent van Gogh's drawing of the abbey of Montmajour in southern France (3-10). Van Gogh would work outdoors on drawings like this, despite the strong sun, the wind, and the mosquitoes; this particular one took a whole day to finish. Instead of concentrating on creating a sense of volume, van Gogh used his pen's ability to create a variety of marks to delineate the many textures in the landscape. The drawing's complexity is meant to reflect the infinite diversity of nature.

Manufactured steel point pens became available in the nineteenth century. *Nibs* with

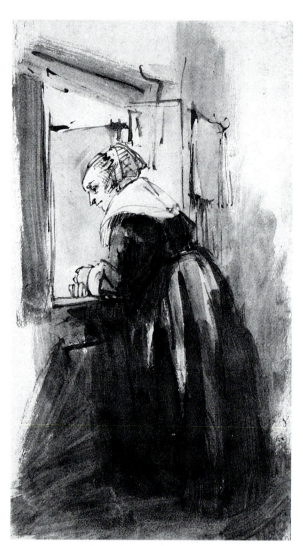

3-12 Rembrandt van Rijn, *Woman at a Window*, 1655. Pen and ink and bistre, 11½″ x 6⅜″. Louvre (Department of Graphic Arts), Paris.

different points and angles are inserted into a holder, depending on the kind of line wanted. These pens are also responsive to variations in the pressure of an artist's hand. Because they require no skill for cutting and have uniform quality, many artists today prefer them to reed, quill, and bamboo.

BRUSH AND INK

In the West, pencils and pens are familiar to everyone because of writing. In the East, however, writing is done with brushes. Handling a brush well is a highly prized skill. In the hands of a master, one wet, pointed brush can produce a delicate, fine line or a wide, dramatic

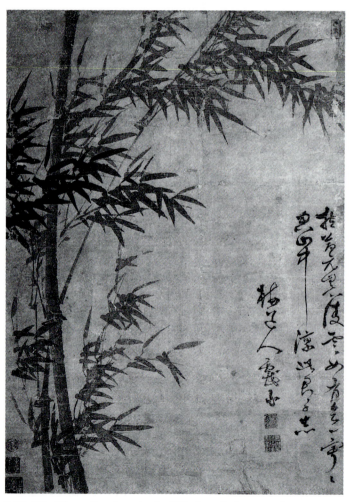

3-11 Wu Chen, *Bamboo in the Wind*, early fourteenth century. Hanging scroll, ink on paper. Museum of Fine Arts, Boston (Chinese and Japanese Special Fund).

stroke quickly and elegantly. The flexibility of a line made with a brush has been seen already in a drawing by Hokusai (2-3).

Modern Chinese and Japanese artists continue to be trained in centuries-old brush techniques, requiring years of study. One of their models is the fourteenth-century master, Wu Chen. His seemingly effortless strokes for the bamboo leaves were practiced thousands of times before his teacher permitted him to attempt one in a drawing. There were two reasons for such a long training period. First, a line made with ink cannot be changed or erased—one mistake and the drawing is ruined. Second, to be convincing, a long bamboo stalk has to be brushed on quickly with confidence. Any hesitation would be revealed, but in Wu Chen's lovely *Bamboo in the Wind* (3-11), none can be found. Wu Chen also did the beautiful calligraphy on the right; it reads, "He painted and wrote with joy." The quote shows that for practitioners of this Eastern technique, the Western division between drawing and painting is meaningless.

WASH

The division becomes blurred even in the West when artists use **washes**—diluted ink applied with a brush to add tonal values to a drawing. Rembrandt was particularly adept at this technique. In *Woman at a Window* (3-12), he added several layers of wash on top of a pen drawing to give solidity to the form of the woman. By using a mixture of pale and dark gray washes, he was also able to describe the effect of outdoor light coming from the open window illuminating his subject. The broad shadows give his drawing much more depth than it had in its first, linear stage.

Rembrandt's dramatic gestures give the viewer a vicarious sense of the act of drawing, so we can almost share the experience of dashing off the quick wash seen below the window. One of the great pleasures of examining a drawing is a sense of intimacy with the artist. We can see the artist's imagination at work. Many drawings provide us with a look at the creative process, enabling us to see the early ideas, the changes, and the final decisions. In Richard Diebenkorn's abstract work *Untitled (Ocean Park),* 3-13, erasures are intentionally left in, the pale memories of earlier lines and shapes giving texture and weight to the draw-

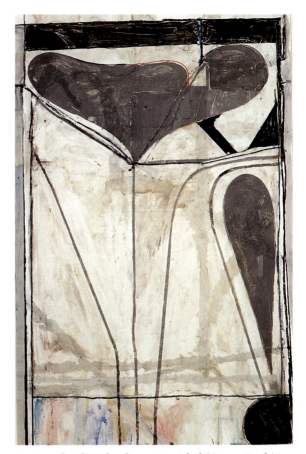

3-13 Richard Diebenkorn, *Untitled (Ocean Park),* 1986. Acrylic, gouache, and crayon on paper, 17" x 29". Collection of Bud Yorkin, Los Angeles.

ing. It would be cleaner but emptier without them.

Like many contemporary artists, Diebenkorn was not hesitant about mixing types of media. He used traditional drawing materials like crayon and charcoal but also used paint to erase lines and add small panels of color. His picture is balanced on the border between drawing and painting, making the distinction seem irrelevant. His drawing exposes, too, the lack of imagination in the question, "Can he draw?" It ignores the possibility of nonrepresentational drawings. Realistic rendering is not the only type of drawing; even the masters of past centuries sketched abstract diagrams of planned works. Artists have always drawn for a variety of reasons and produced a wide diversity of work. As we will see in the following chapters, the limitations of every media are far less important than the power of the imagination of the artist.

CHAPTER

4

PAINTING

When most people think of art, they think of painting. This seems to be true of both the layperson and the connoisseur. Our museums devote more space to painting then any of the other art forms. In the Renaissance, there was a great deal of discussion about whether painting was the highest of the arts. Leonardo da Vinci thought it was, placing it above sculpture and poetry. He wrote:

> if the painter wishes to see enchanting beauties, he has the power to produce them. If he wishes to see monstrosities, . . . he has the power and authority to create them . . . if in the hot season he wants cool and shady places, or in the cold season warm places, he can make them . . . Indeed whatever exists in the universe, whether in essence, in act, or in the imagination, the painter has first in his mind and then in his hands.

A questionnaire on this issue was actually sent out to the many of the important artists of the time. A painter, Pontormo, responded that the complexities of his medium were much more challenging than the others. He wrote:

> there are the various modes of working— fresco, oil, tempera . . . all of which require great practice in handling so many different pigments, to know their various results when mixed various ways, to render lights, darks, shadows, high-lights, reflections, and many other effects beyond number.

The painting media are certainly more complicated than the drawing media discussed in the last chapter. Many formulas for paint have been used over the centuries, and some artists have almost become chemists in their desire to create the perfect paint. However, all paints share a general formula that is not difficult to remember: They are a combination of powdery pigments combined with a liquid *binder* (a glue-like substance), also called a *medium*, that holds the paint to the surface (called the **ground**). What differentiates the painting media from each other, and gives each one its special qualities, is the type of medium used.

FRESCO

Traditional **fresco** is one of the most permanent of the painting media. It is a wall painting technique that has been in use since ancient times. Beautifully preserved examples can still be seen on the walls of homes at the excavations at Pompeii and Herculaneum, Roman towns buried in volcanic ash around A.D. 79 (4-1). The paintings by Michelangelo on the Sistine ceiling (see Chapter 12) were done in fresco. In fresco, the painter combines colored pigment with water and brushes it directly onto fresh, wet plaster (fresco means "fresh" in Italian). As the plaster dries, the pigment becomes bound into it and literally becomes part of the wall itself. This chemical process is what makes fresco painting so permanent.

Because the painting has to be done while the plaster is wet, the fresco painter must work rapidly. Much planning is usually necessary, and often an artist will make many sketches on paper. Large wall paintings are done in sections; a life-size figure alone might take two days to complete. While some minor

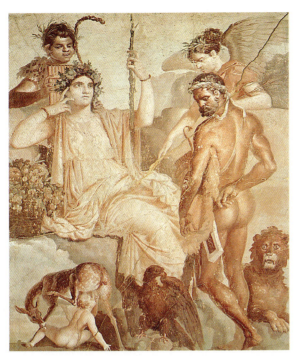

4-1 *Herakles and Telephos*, Herculaneum, *c.* A.D. 70, after an original from the second century B.C. wall painting, approximately 7'2" x 6'2". Museo Nazionale, Naples.

changes are possible, major revisions require lifting out whole sections of plaster and beginning again. Heavy scaffolding must usually be set up next to the wall, which makes it difficult for artists to see their work from a distance. Michelangelo was not alone among the artists who, in deep concentration, have taken one too many steps backward on the scaffolding while viewing their work. Some have even been killed.

The demands of this medium, and the increasing use of more flexible media like oil painting, made fresco painting rare after the Renaissance. However, in the twentieth century, in an effort to create murals that spoke to and were accessible to ordinary people, Mexican artists like Diego Rivera revived the ancient art. His *The Making of a Fresco, Showing the Building of a City* (4-2) took almost three months to paint. Because it was intended for an art school, the San Francisco Art Institute, Rivera designed a painting of painting, illustrating the fresco process. The artist showed himself sitting in the center, a brush and plate (being used as a palette) in hand. Four assistants are with him on the painted scaffolding. One looks down to Rivera for direction, while

another is applying fresh plaster. Like the fresco that these "painters" are painting, many of Rivera's murals depict workers in our industrial society. Here, Rivera deliberately eliminated any clear borders between the painters and the workers they portray, expressing his belief in the solidarity of mural painters with all working people.

TEMPERA PANEL

In **tempera**, a media developed in the Early Renaissance, pigments are usually mixed with egg yolks (which is why it is sometimes called **"egg tempera"**). Yolks are a powerfully adhesive medium, as anyone who has tried to remove eggs left on a plate for a day or two can attest. In tempera, each color must be premixed in light, medium, and dark toned versions before beginning. Shading is done by placing small strokes of these colors side by side. Like crosshatching in drawing, the accumulation of lines creates a modeling effect. Wood, rather than canvas, is the customary support for tempera paintings because it is rigid and tempera has a tendency to crack when flexed. In past centuries, wood panels were prepared for the paint by adding several layers of **gesso**—a thick paste of gypsum and animal glue. Gesso produces a bright white surface.

The most famous tempera painter today is Andrew Wyeth, an American realist. His *Christina's World* (4-3) was painted in the traditional manner; Wyeth prepared a panel with gesso before beginning. By looking closely at the grass in the foreground, one can see many fine strokes of paint applied one over another. Tempera dries quickly, so it is sympathetic to building up painted areas in this way. Because its method of application is similar to that of drawing, many artists who have a strong background in representational drawing skills use tempera.

OIL PAINTING

While in the past Jan van Eyck was given credit for inventing oil paint in the fifteenth century, this is not really true. As early as the eleventh century there are records of oil-based paint. A medieval monk mentioned it in his writings but did not recommend it. He felt

one of oil painting's properties—its slow drying time—made it unsuitable for most paintings. In the Renaissance, however, artists like van Eyck and da Vinci took advantage of that special property to create paintings of unsurpassed detail and depth. They can be given credit for showing their fellow artists the wonderful capabilities of oil painting, making it the dominant medium in Western painting since then.

As might be assumed, oil paint is a combination of ground pigments and oil. The oil is usually linseed oil, but other kinds have been used by artists. Oil paint can be used on many

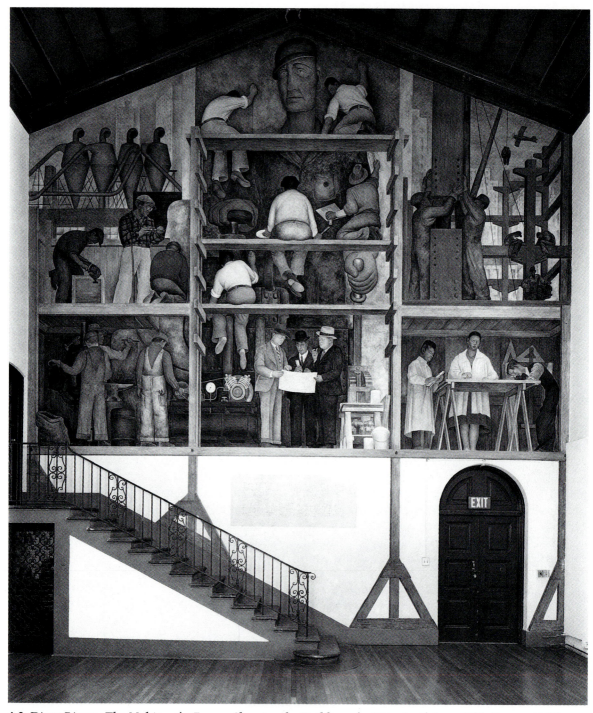

4-2 Diego Rivera, *The Making of a Fresco, Showing the Building of a City,* April–June 1931. Fresco, 18′ 7″ x 32′6″. San Francisco Art Institute.

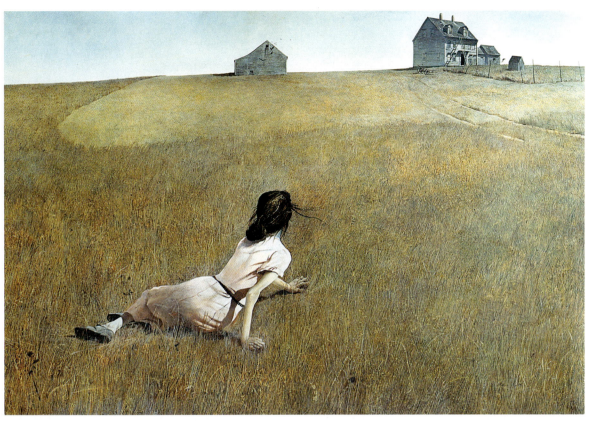

4-3 Andrew Wyeth, *Christina's World,* 1948. Tempera on gessoed panel, 32¼″ x 47¾″. The Museum of Modern Art, New York (purchase).

different kinds of grounds: paper, wood, and one that particularly excited Renaissance artists—**canvas**. This was a new portable support, one that, because of its light weight, could be used for much larger paintings than those on wood panels. The flexibility of the oil medium when dry makes it even possible to roll a large canvas up for transport without cracking the paint. Oil paint allows a less methodical and freer approach to painting than fresco and tempera. Oils can be applied in layers, and an oil painting can be reworked over and over again. Because oil paint can cover up earlier versions, van Eyck was able to change the position of his subjects even days after they were initially painted. Oil paint can also be diluted with oil medium or solvents like turpentine and made into transparent **glazes**. In the detail shown of his *Giovanni Arnolfini and His Bride* (4-4; see Chapter 12 for the complete picture), van Eyck first applied opaque strokes called **underpainting** in all but the white and flesh colored areas, then added transparent strokes on top to build up the softly blended illusion of three-dimensional forms.

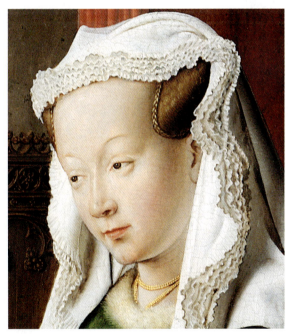

4-4 Detail of Jan van Eyck, *Giovanni Arnolfini and His Bride,* 1434. Tempera and oil on wood, entire painting approximately 32″ x 23½″. Reproduced by courtesy of the Trustees of the National Gallery, London.

The luminosity of the bride's face is from the white ground that can still be seen below thin strokes of pink and brown. The exquisite details of the fur on her collar, the chain on her neck, and the edging of her head cloth are all extremely realistic and would have been impossible to create in earlier mediums. To heighten the painting's realism, he eliminated all marks of his brush, leaving no sign of the human gesture or act of painting on the smooth surface.

Not all artists in oil try to conceal their hand. One of the most daring and inventive masters of oil paint was J. M. W. Turner. His pictures, like the *Snow Storm* (4-5), are an orchestration of a variety of techniques. Thin blue washes of underpainting that established the basic composition can still be seen to the right, but in most areas, thick, stiff paint, called **impasto**, has been added. Impasto paint reveals the action of brushstrokes; here it adds to the ferocity of the storm that has trapped a boat (see

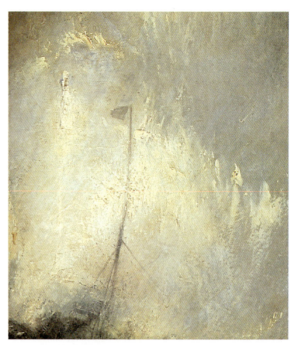

4-6 Detail of figure 4-5

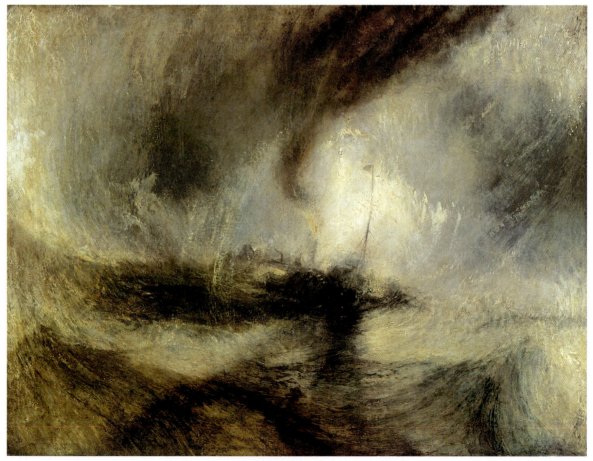

4-5 J. M. W. Turner, *Snow Storm: Steam-Boat off a Harbour's Mouth*, 1842. Oil on canvas, 36" x 48". Tate Gallery, London.

detail, 4-6). Turner used the thickest paint for the glow of the strong central light. In the midst of it, perhaps to dramatize the ship's fragility, he used thin black paint, applied with a fine brush, to delineate the threatened mast. To create the dark, swirling shapes of the storm clouds, below the impasto Turner used a technique called *wet into wet.* As the medieval monk pointed out, oil paint dries slowly. One advantage of this is painters can mix colors directly into the wet paint on the canvas. The final effect of all these techniques is a wild, vivid surface in keeping with an exciting subject.

WATERCOLOR AND GOUACHE

Transparency is the essence of **watercolor**, a quick drying combination of pigment and gum arabic. When diluted with water, it can be brushed smoothly onto a ground (usually paper). As with ink washes, changes are difficult in watercolor, so success depends on a direct, spontaneous application. Because they dry so quickly, many artists like making sketches in watercolors as studies for works in other media. Paul Cézanne, however, considered his watercolors independent finished works as in *Three Skulls* (4-7). To keep his colors fresh, he applied them in thin washes (moreover, thick watercolor paint cracks). Successive transparent layers of color describe the rounded forms. It is the white of the paper that provides the luminosity of watercolors. The more of it that remains uncovered, the more brilliant the effect. Notice how the three skulls that form the main focus are hardly touched by paint. Cézanne was a master of including just enough touches of color for a shape to emerge from the whiteness of the page.

By adding chalk to pigment and gum arabic, watercolor becomes an opaque paint called **gouache**. Unlike watercolor, gouache can be

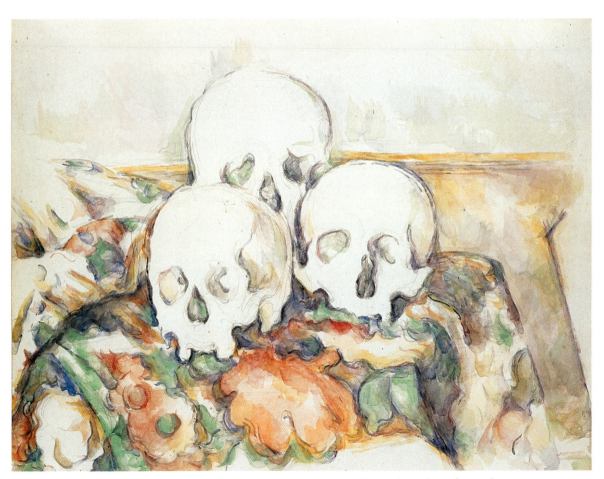

4-7 Paul Cézanne, *Three Skulls*, 1902–1906. Watercolor with graphite and touches of gouache on ivory wove paper, 19″ x 24¾″. The Art Institute of Chicago (Mr. and Mrs. Lewis Larned Coburn Memorial Collection, 1954.183). Photograph ©1993, The Art Institute of Chicago. All rights reserved.

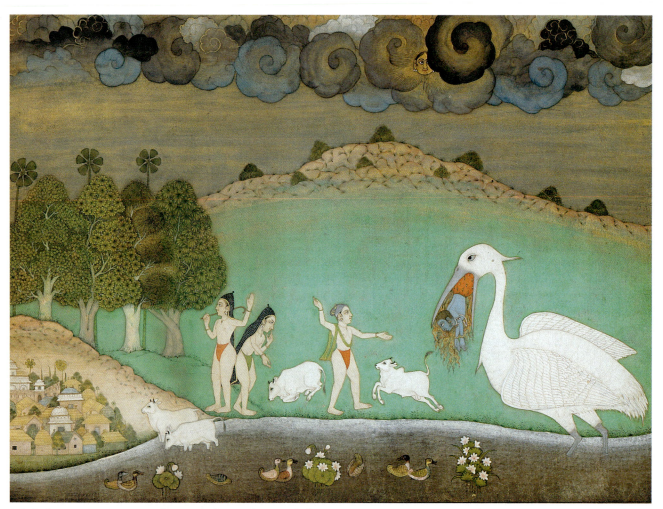

4-8 *Bakasura Disgorges Krishna*, page from a dispersed Bhagavata Purana manuscript, India, *c.* 1690. Opaque watercolor and gold on paper, 8 ¾″ x 12″ excluding border. Kronos Collection, New York.

applied more thickly, covers well, and permits changes without losing the freshness of its colors. It can also be returned to transparency by diluting it with a high proportion of water. In India, opaque watercolor was used on paper for paintings to be bound in books of Hindu stories. These meticulous paintings were done with handmade brushes of the finest hair from kittens or baby squirrels. Artists also fabricated their own paint. The painter would work cross-legged, with a board supporting the picture in his lap. One small painting, like *Bakasura Disgorges Krishna* (4-8), might take months to complete.

The picture shows the god Krishna forcing a demon in the shape of a heron to spit him out by becoming very hot. Notice the bright flames surrounding Krishna. In this painting, gold paint was used, the pigment ground from thin metal foil. It can be seen in the sky and the top of the hill. In addition, gold highlights in the fire and the rays coming from the head of the sun were added as the last stage.

ACRYLIC

In the twentieth century, an extremely flexible, new kind of paint was invented. **Acrylic** is a water-based paint originally made for industrial use in the 1950s. The medium is a plastic polymer, made from resins, that dries quickly and can be applied to just about any surface, whether it has been specially prepared or not. Polymers are very adhesive and make an excellent glue. Because acrylic paint dries quickly,

changes can be made almost instantaneously; or agents can be added to slow drying and permit wet into wet techniques.

Helen Frankenthaler, *The Bay* (4-9), was one of the first artists to explore the possibilities of this new industrial paint. Because it can be applied to unprepared, raw canvas, Frankenthaler was able to let washes of acrylic paint soak into the fabric. With the canvas on the floor, she would pour paint onto it that would be manipulated with sponges or by tilting the canvas. This became known as the *soak and stain* method, in which sensuous, rich veils of color are created.

Applied to a surface that has been prepared with a ground, acrylic paint provides an absolute flat, pure surface. Used more thickly, impastos are possible. Acrylic is available in brilliant, as well as metallic and fluorescent colors. In an extremely diluted state, it can be applied with **airbrush**—a spraying device that uses an air compressor to propel a paint mist through a nozzle. There are no size limits to acrylic painting—it has been used for miniature

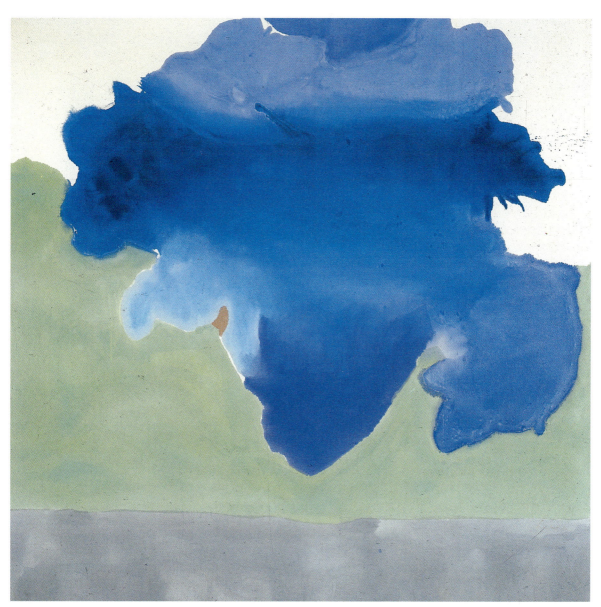

4-9 Helen Frankenthaler, *The Bay*, 1963. Acrylic on canvas. 6′8½″ x 6′9½″. © The Detroit Institute of Art (gift of Dr. and Mrs. Hilbert H. DeLawter).

A Global View

TIBETAN SAND PAINTING

The well-documented permanence of fresco, oils, and acrylic is one of the factors that has attracted Western artists to those mediums. After working weeks, months, or even years on a picture, most artists would find it painful to see it disappear. Some artists have even committed suicide after fire destroyed their studios and their artworks. But Tibetan Buddhist monks deliberately work in a medium that can disappear with a sneeze—colored sand (4-10).

Delicate, detailed sand **mandalas** (an intricate circular, geometrical design where deities symbolically live) are made by three or four monks sitting cross-legged under a brightly colored canopy. They work from the center and progress outward. The sand is colored with the brightest of pigments, following a circular pattern used continuously for twenty-five hundred years. Hundreds of deities are invoked by the creation of the mandala. Iron funnels are lightly stroked to create a thin line of sand and a soothing, rhythmic sound. Sand painting thereby appeals to both the eyes and the ears. Contemplation of the creation of a mandala is believed to have a healing influence and help one move towards enlightenment. According to one monk,

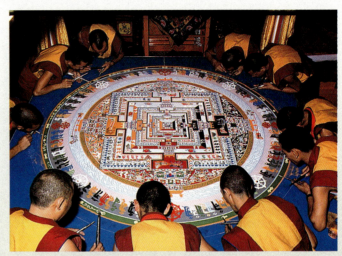

4-10 The Kalachakra (Wheel of Time) Sand Mandala is constructed of grains of colored sand during a twelve-day empowerment ritual by monks from the Namgyal Monastery, the personal monastery of the Dalai Lama of Tibet. From *The Wheel of Time Sand Mandala* by Barry Bryant (Harper San Francisco, 1993).

The sand mandala is an ancient tradition. Working on it manifests peace. And even a person who simply sees it may feel peace from deep inside.

The Tibetan monks believe the few people who see the mandala during its week of creation will increase its positive influence in the world because they have had a moment of pure peace. After it is finished, the sand painting is poured into a river to bring healing to the creatures who live in its waters.

painting and outdoor murals. In fact, because they are made of plastic polymers, acrylic paintings weather well and can even be washed with soap and water.

TWENTIETH CENTURY APPROACHES: MIXED MEDIA

Cutting and pasting paper, parchment, and other materials had been done for more than a thousand years, before the Cubists legitimized

collage as fine art at the beginning of the twentieth century (see Chapter 15). Previously, collage had been known strictly as a folk art. For example, in the eighteenth century, nuns in European convents used butterfly wings to make religious pictures. With the advent of photographic reproductions in the late 1800s, almost any imaginable image became available for collage. Mixing materials, using them in unusual ways, and not respecting the borders between two- and three-dimensional media are all characteristics of a modern art form

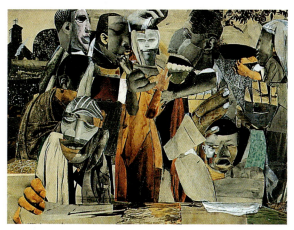

4-11 Romare Bearden, *Prevalence of Ritual: Baptism*, 1964. Photomechanical reproductions, synthetic polymer, and pencil on paperboard, 9 ⅛″ x 12″. Hirshhorn Museum and Sculpture Garden, Smithsonian Institution (gift of Joseph H. Hirshhorn, 1966).

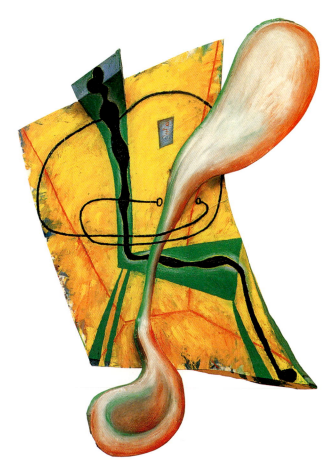

4-12 Elizabeth Murray, *Kitchen Painting*, 1985. Oil on two canvases, 58″ x 81″ x 14″. Private Collection, New York.

known as **mixed media**. Mixed media can include traditional and innovative materials combined in unexpected ways, as well as manufactured and natural "found objects."

Collages like Romare Bearden's *Prevalence of Ritual: Baptism* (4-11) are memories of his childhood in North Carolina. He pieced together magazine reproductions with areas of watercolor, and sometimes fabric, making pictures related to both the fractured space of Cubism and the tradition of African-American quilting (see Harriet Powers in Chapter 9). By making each person in his collage an amalgam of several, he is able to imply a long history of baptisms in the South. The fragments in the scene create a lively syncopation throughout the picture, evoking the free improvisations of jazz.

SHAPED CANVASES

Since the 1970s, Elizabeth Murray, an American artist, has been making paintings with large organic shapes that almost seem to push out at the viewer. In *Kitchen Painting* (4-12) in 1985,

she decided to see what would happen if the abstracted shapes really did project out of the canvas into three-dimensional space. The picture is actually two separate canvases with an overall height of 7 feet. Neither is in a conventional rectangle; instead, both are shaped and beveled to fit the image. A thin, black figure sits on a green chair attempting to grasp an enormous spoon that pushes out two feet into the room. Whether this is now a sculpture or remains a painting is not a question that preoccupies Murray. Speaking for many contemporary artists, she says her goal is to "respond to being alive," not to categorize.

PRINTMAKING

During the Renaissance, so many important changes took place in the Western world that it seems impossible to select the most significant development. However, the invention of the printing press in the 1450s is certainly among the greatest innovations of this period. To use just one example, Martin Luther's Protestant **Reformation** would probably never have occurred if thousands of copies of his ninety-five criticisms of the church, supplemented with cartoons for the illiterate, had not been circulated all over Europe. No wonder Luther said, "Print is the best of God's inventions."

In art, printing's effect was perhaps not quite as dramatic, but its contribution has been very significant. The book you hold in your hands is a product of the print revolution. The modern concept of art appreciation would not be possible without printing presses. Because of art reproductions, art—once the exclusive domain of the very wealthy and powerful—is today virtually available to everyone.

The term "print," however, has a special meaning to the fine artist. It does not mean photographic reproductions like those in this book but reproductions or *multiples* made directly from a block, plate, stone, or screen that an artist created. The number of prints is limited by an artist and is called the **edition**. Once the last print of an edition is "pulled," the block, plate, or other source is destroyed. Usually an artist will sign each print and also number it. For example, "23/100" means the print was the twenty-third out of an edition of one hundred. Even though an edition can number in the hundreds, each individual print is still considered an original work of art.

Before printmaking, there were other precedents for this understanding of what is an "original"—for example, limited sets of bronze casts made from a clay sculpture.

One of the most important effects of printmaking has been making fine art originals available to more people. Because they are multiples, prints are generally less expensive than other art forms. Many artists chose to be printmakers because printmaking seemed less elitist, more democratic than the other media.

RELIEF PRINTMAKING: WOODCUT

In the past five hundred years, many forms of printmaking have evolved. The first in the West was the **woodcut** print. When illuminated (hand painted) manuscripts were replaced by printed books, a way to print illustrations was also needed. Woodcut blocks were found to be the most appropriate since they fit easily in the printing press along with the type. Woodcuts are among the simplest of the print media (5-1). They are made by carving directly into a smooth piece of wood and removing any parts of the surface that are not meant to be part of the image. In essence, the negative spaces of a design are cut away, leaving the positive areas raised up, ready to be printed. Usually a drawing is made directly on the wood and then the background is cut out around it. The carved block is inked with a roller; the uncarved wood remaining on the surface will receive the ink and make an impression on the paper. Because the print's marks are made from inking what is left in

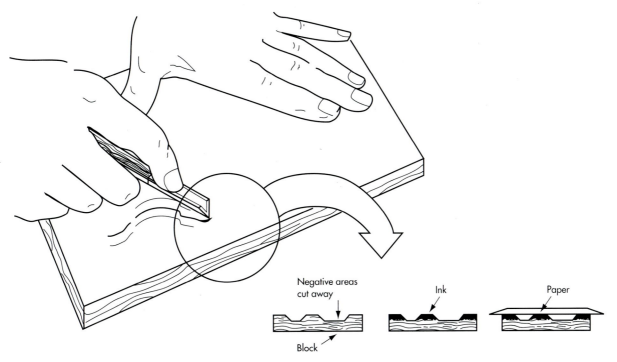

Negative areas
cut away

Ink

Paper

Block

5-1 Woodcut Relief Process

"relief" on the block, woodcuts fall into the category of **relief printmaking**. Linoleum cuts and rubber stamps also fall into this category.

For example, in Albrecht Dürer's *The Four Horsemen* (5-2), all the white areas had to be carved out of the block so the thin black lines in the print could appear. To make the actual print, a piece of paper is placed on top of the inked wood block and either rubbed on the back by hand or passed through a printing press to transfer the image to the paper.

The first woodcut prints in the West had crude, simple images on them. They were owned by ordinary people and most were either playing cards or devotional images, like saints or charms for warding off evil. Albrecht Dürer was the first to show that prints could be the equal of painting or any of the other fine arts. At the time he created *The Four Horsemen*, Dürer had just returned from Italy where he had seen the works of the great Renaissance masters for the first time. He wanted his woodcuts to have the vital force and imaginative compositions he admired in Italian painting. The fine details in this print, the result of elaborate carving, had never been seen by Europeans in a woodcut. By recreating drawing's parallel hatching on his wood block, he was able to model his forms and provide a sense of movement and excitement.

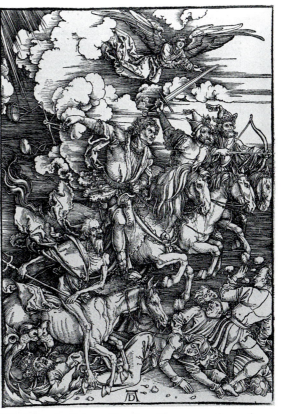

5-2 Albrecht Dürer, *The Four Horsemen,* from the Apocalypse series, *c.* 1498. Woodcut, 15½" x 11". The Art Museum, Princeton University, Princeton, New Jersey (gift of Donald B. Watt).

Woodcuts with fine details and elaborate design were familiar in Asia centuries before Dürer's landmark work. Paper, a necessary material for traditional printmaking, was invented in China approximately a thousand years before it first appeared in the West. So it is not surprising that the first wood block prints also appeared earlier in the orient, around A.D. 800. Buddhist scrolls printed in China found their way to Japan, which eventually produced some of the greatest prints ever made. Even Dürer's superb woodcut seems rather crude next to Kuniyoshi Utagawa's *Various Stages of Making a Color Print* (5-3). As seen in his print, the Japanese woodcut printing process was very different than the one Dürer followed. Dürer designed and carved his blocks himself. In Japan, a color print was the work of several artisans, each with a specialized role. Utagawa was the designer of the print, making the drawing and planning the color scheme. Cutters would then carve the block, while printers would ink and print it. They worked as a team with no member considered more important than another. The Japanese did not share the Western idea that the artist's unique concept is the most valuable part of an artwork. The Japanese characters at the sides of the print are the marks of the various workers, much like the credits in a film.

In a color print like this one, each separate color is the product of a different carved wooden block. As in all color prints, each color must line up correctly with the previously inked color images as it is added to the print (known as proper **registration**) or the print will be ruined—blurred or mismatched. This registration requires skill and planning by both artist and printer. We will see later in this chapter and in Chapter 14 that Japanese print design was extremely influential in the development of both modern printmaking and Modern Art.

WOOD ENGRAVING

Another relief process is **wood engraving**, first used in the 1800s. It is similar to woodcut but uses the endgrain on blocks of hard wood. Because endgrain is so hard, tools designed to cut metal are needed. The wood's hardness permits very fine, precise lines to be created, and, compared to woodcuts, many more prints can be made before the block begins to deteriorate. These two properties made wood engraving particularly useful for book illustration.

Gustave Doré was the preeminent illustrator of Paris in the mid-1800s. It was his aim to illustrate all the great books in Western literature. Figure 5-4 shows one page from his

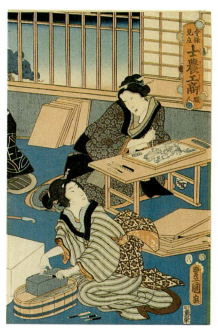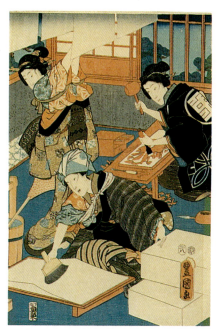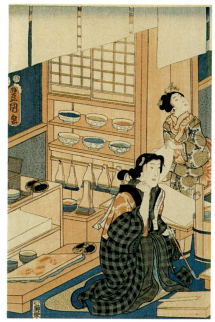

5-3 Kuniyoshi Utagawa, *Various Stages of Making a Color Print*, 1857. Color woodcut, 9¾" x 14½". Victoria & Albert Museum, London.

illustrated edition of the English Romantic poet Samuel Coleridge's famous poem *The Rime of the Ancient Mariner*. Doré would work on several blocks at once, first drawing directly on each block and then moving around his studio making careful cuts on one, then another until they were all finished. The section of the poem illustrated by this engraving tells of a boat sent off-course by a storm and reads:

> And now there came both mist and snow,
> And it grew wondrous cold:
> And ice, mast-high, came floating by,
> As green as emerald.

Notice how Doré was able to engrave delicate, almost perfect, parallel lines throughout his print. By varying their width, three-dimensional forms emerge, like the icebergs in the distance. He contrasts the precision of his lines with the natural effect of falling snow made freely with short stabs into the wood.

INTAGLIO PRINTMAKING

Unlike relief printmaking, in **intaglio** printmaking it is what is removed that ends up being printed (5-5). Lines are cut into the surface of metal plates by either sharp tools or

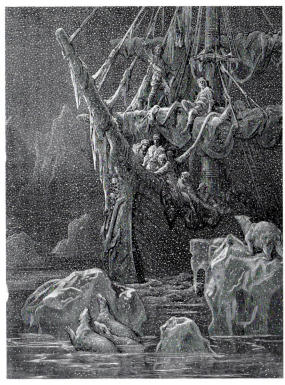

5-4 Gustave Doré, illustration from Samuel Taylor Coleridge's *The Rime of the Ancient Mariner*, 1878. Woodcut, 9¼" x 12". Published by Harper & Brothers, Publishers, New York, 1878.

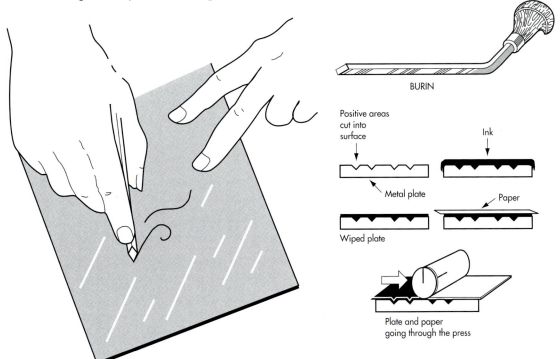

BURIN

Positive areas cut into surface

Ink

Metal plate

Wiped plate

Paper

Plate and paper going through the press

5-5 Intaglio Engraving Process

acids. The cut lines act as little channels that retain the ink after the plate has been inked by a roller and its surface wiped off. Then a piece of moistened paper is placed over the plate. Finally, the paper and plate are run through a press, the heavy pressure of which forces the damp paper into the ink-filled grooves and thereby transfers the image. Like the letters in an engraved invitation, the lines of an intaglio print are raised because each line on the paper was formed by being pushed into a depression in a metal plate.

METAL ENGRAVING

Armorers and metalsmiths during the Middle Ages had been decorating metals in a similar way for thousands of years and knew that prints could be made on cloth in this fashion. **Engraving**, the oldest form of intaglio

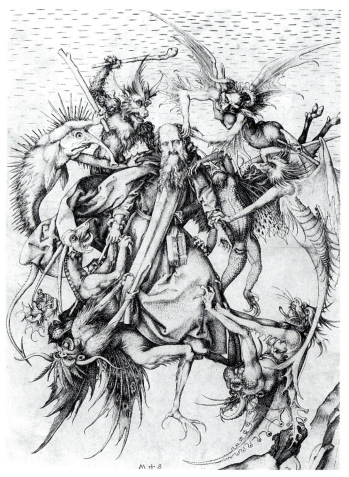

5-6 Martin Schongauer, *Saint Anthony Tormented by Demons*, c. 1445–1491. Engraving. The Metropolitan Museum of Art, New York (Rogers Fund, 1920).

printmaking, was developed when paper became easily available in Europe during the 1400s. In an intaglio process, cuts made on the plate print directly as lines (unlike the relief process of woodcuts or wood engravings, where the cuts remove the background). Special sharp tools called *burins* are the most common engraving tools, but any instrument sharp enough to make a mark on metal can be used. Even a needle can make a small scratch that will be reproduced.

The German artist Martin Schongauer was one of the first to utilize the capability of metal engravings to reproduce delicate, fine lines. In his *Saint Anthony Tormented by Demons* (5-6), Schongauer created a fantastic group of devils whose tails, wings, and claws are drawn in the minutest detail. The sad-faced old saint is lifted off the ground and tortured in many ways—the little fingers of an ugly witch stroke his hair while a furry devil is about to smash the side of his head with a club. From the beard of Saint Anthony to the spikes on an elephant-nosed devil, the precise hatched lines create convincing textures and solid forms.

William Hogarth, a British painter of the 1800s, began making engravings of his work and selling them cheaply because he wanted to make "art accessible to all." The purpose of his pictures, he said, was "to teach." *Gin Lane*'s (5-7) message was to warn the poor about the evils of gin—a new, cheap liquor. At the time, gin was sold unlicensed and by the barrel. A riot at a distillery can be seen to the right. If one looks closely at Hogarth's carefully constructed print, one can see many more "dreadful consequences of drinking." Hogarth was not opposed to all drinking; on his companion engraving *Beer Street* "all is joyous and thriving" and he calls beer the "happy produce of our isle." Hogarth's efforts were not in vain; the Gin Act passed Parliament in the next year.

ETCHING

Etching is another intaglio process that requires the use of acids to cut the metal plate (5-8). First, a wax coating, or **ground**, that resists acid is applied to the plate. The printmaker then draws by cutting through the ground. The plate is then put in a tray of acid that "bites" into the metal in any places where

the wax ground was removed, forming lines. After the plate is washed with water, it is inked and printed just like an engraving. Lines can be made lighter (thinner) or darker (thicker) by the amount of time the plate is left in acid.

Besides being a great painter and draftsman, Rembrandt van Rijn is known for his fine

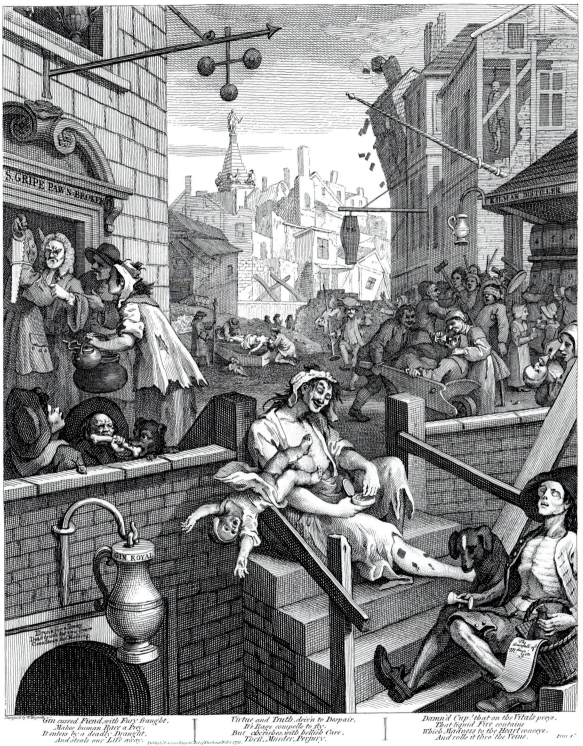

5-7 William Hogarth, *Gin Lane*, from *Beer Street and Gin Lane*, c. 1734. Third state engraving, 14″ x 11⅞″.

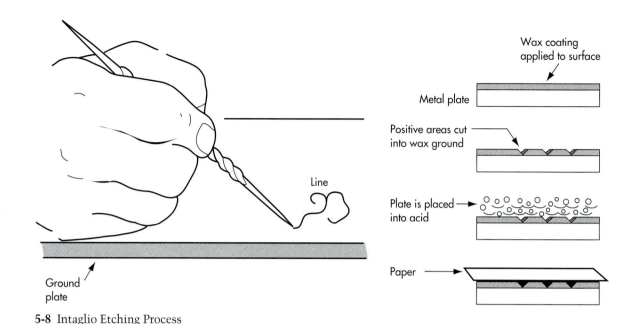

Wax coating applied to surface

Metal plate

Positive areas cut into wax ground

Plate is placed into acid

Paper

5-8 Intaglio Etching Process

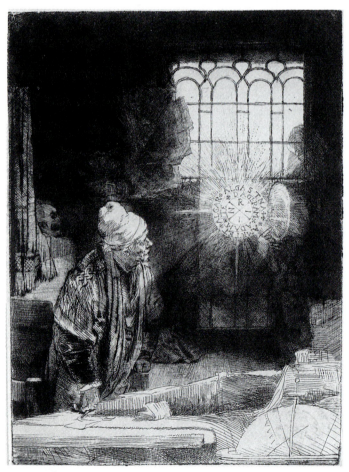

5-9 Rembrant van Rijn, *Faust in His Study Watching a Magic Disc*, 1652. Etching and drypoint, 8⅜″ x 6⅜″. Rijskmuseum, Amsterdam.

etchings. His *Faust in His Study Watching a Magic Disc* (5-9) is based on the story of a man who sold his soul to the devil to learn the secrets of nature. The print was made with a variety of etching techniques. Lines of varying widths were created by placing the plate in acid several times. As each section developed lines that would print dark enough, Rembrandt covered it in a solution that stopped the action of the acid. The darkest areas around the window were originally a tight network of cross-hatched lines but were left in the acid bath until they became an almost solid black field. The final result is the vision of a scholarly figure lit by a mysterious light.

Aquatint

Although the lines were etched as described above, the tonal areas in Mary Cassatt's *The Letter* (5-10) are the result of a different method than the deeply bitten line used by Rembrandt. **Aquatints** are tonal areas made by applying powdered resin to the plate and then heating it. The heat melts the resin, and each particle becomes a dot that will resist acid. As with etched lines, the longer an area of aquatint is in the acid bath, the deeper the etch and the darker the tone in the final print. Cassatt, an American who exhibited in Paris with the Impressionists, demonstrates a mastery of aquatint and color. The white of

the envelope and the letter on the desk are actually the white of the paper the print was printed on. Carefully protecting these areas of the metal plate from the aquatint and the acid allows the objects to emerge from the surrounding colors. Within the small flowers that decorate the wall, we can see subtle variations of tones. Like her fellow Impressionists, Cassatt was influenced by Japanese prints. One clear sign of this is the woman's desk, which deliberately ignores mathematical perspective, unknown to printmakers like Utagawa.

LITHOGRAPHY

Lithography was invented as a commercial process in Bavaria in 1798 and was first used to reproduce sheets of music cheaply. Within three years, artists began using the new print medium and discovering its unique properties. In lithography, no cutting is involved. Images are drawn or painted directly in grease on a flat stone or plate (5-11). While any substance with enough grease in it will work (such as lipstick), *litho crayons* (made of wax, soap, and black pigment) and *tusche*, a greasy liquid that can be applied with a brush or sprayed on, are the most common materials used to make

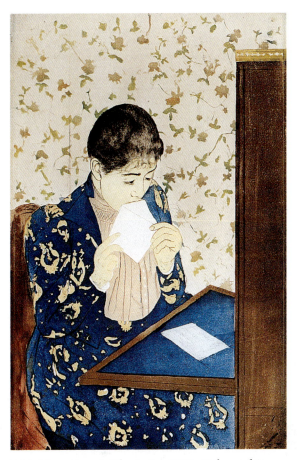

5-10 Mary Cassat, *The Letter*, 1891. Color etching, 13⅝" x 9". Bibliothèque Nationale, Paris.

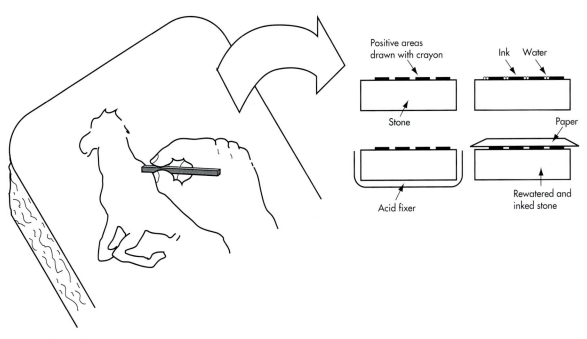

5-11 Lithographic Process

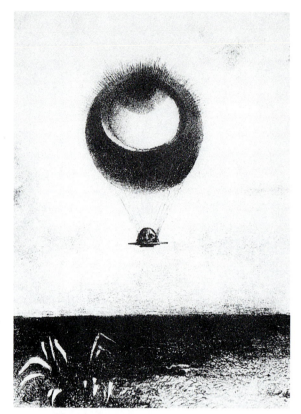

5-12 Odilon Redon, *The Balloon Eye,* from the series *À Edgar Poe,* 1882. Lithograph.

not have the same creamy surface that makes drawing on a stone a sensual pleasure.

As a printmaker, Odilon Redon was known for his velvety blacks, once causing the Impressionist painter Edgar Degas (see 5-17) to exclaim, "Oh! His blacks . . . impossible to pull any of equal beauty." For most observers, however, it is his strange images that are most memorable. Prints like *The Balloon Eye* (5-12) have been described as "the nightmare transported into art." The picture is dedicated to Edgar Allan Poe, the American author of macabre stories. While it makes no logical sense, few can resist being fascinated by its haunting image. Redon described his method as "putting the logic of the visible at the service of the invisible."

Jane Avril (5-13) is a color poster of a well-known dancer and close friend of the French artist Henri de Toulouse-Lautrec. She was one of the most popular entertainers in Parisian cabarets at the turn of the century. Lautrec was, along with Redon, responsible for the later acceptance of lithography as an artistic

images in lithography. The lithographic stone or plate is then treated with a chemical so only the areas that have grease on them will attract the ink when it is rolled on. A sheet of paper is placed on the stone or plate and run through a printing press.

Traditionally, the preferred surface for lithographs has been limestone from quarries in Bavaria. When prepared properly, it has been described as the premier drawing surface in the world. Every kind of mark made by lithographic grease crayons can be applied and reproduced exactly. Even though each stone can be used many times (by regrinding the printing surface), the intense demand for Bavarian limestone has made the stones increasingly rare. Printers around the world consider them their most valuable possessions; dropping and cracking a Bavarian stone is considered a tragedy. Because of the difficulty in obtaining such stones, specially prepared metal plates (usually zinc or aluminum) are being used more and more often in lithography. Metal plates are much lighter and much cheaper than stones. But they do

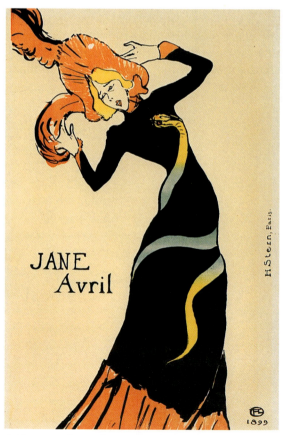

5-13 Henri de Toulouse-Lautrec, *Jane Avril,* 1899. Lithograph, 22″ x 14″. Bibliothèque Nationale, Paris.

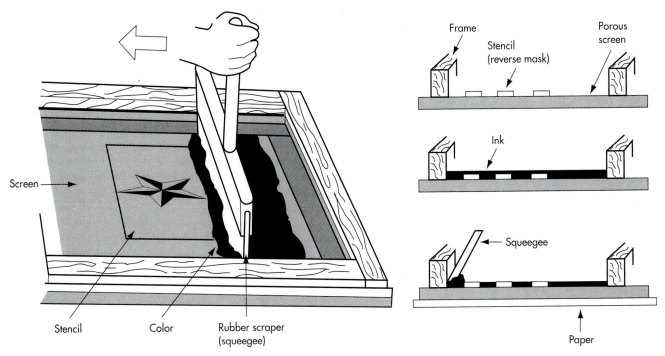

5-14 Silkscreen Process

medium. His posters, once plastered all over the city of Paris (and now priceless), with their innovative design and brilliant colors, helped make Lautrec an immediate celebrity. The treatment of her dress with its flat, bold shapes and serpent are a result of a fascination with Japanese art that he shared with Mary Cassatt.

But Japanese prints are made with small, light blocks of wood. The colors in this lithographic print are a tribute to the dedication and imagination of Lautrec. As in all color prints, each color must be printed separately by a different stone or plate. Even though registration is *always* a challenge, remember Lautrec had to use several heavy stones to complete *Jane Avril*.

SILKSCREEN

Silkscreen printing (or *serigraphy*) is one of the newest of the printmaking media, developed originally for industrial printing of patterns on fabrics. It is an inexpensive method of producing very large editions of prints and is often used for posters and T-shirts. Silkscreen is based on the ancient technique of stenciling. A stencil is attached to a screen of silk that has been tightly stretched over a wooden

frame (5-14). After a piece of paper is placed underneath the screen, ink is spread across the screen with a rubber blade or squeegee. The open areas of silk (those not covered with a stencil) let the ink come through and print onto the paper. As in woodcut prints, no press is necessary.

Bridget Riley chose silkscreen to print *Untitled (Blue)*, 5-15, because stencils make it easy to repeat a precise shape. As an **Op Artist**, Riley explores how lines can create optical

5-15 Bridget Riley, *Untitled (Blue)*, 1978. Color silkscreen, 26½″ x 37″.

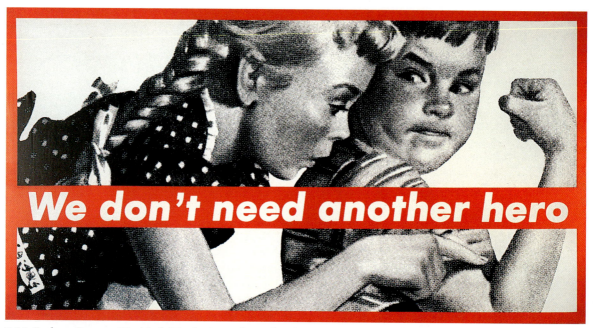

5-16 Barbara Kruger, *Untitled (We don't need another hero)*, 1987. Photographic silkscreen and vinyl, 109″ x 210″. Collection of Emily Fisher Landau, New York.

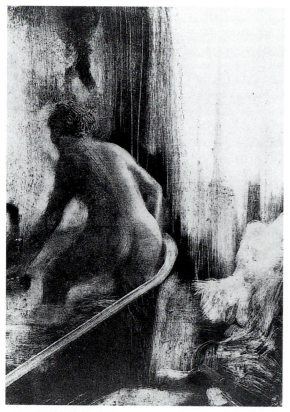

5-17 Edgar Degas, *Woman Standing in Her Bath*, c. 1879–1883. Monotype in black ink on cream-colored heavy laid paper, slightly discolored, 15″ x 10⅝″. Cabinet de Dessins, Musée du Louvre (Orsay), Paris.

illusions. In her silkscreen print, the lines seem to undulate and the colors move. It is almost impossible to stop them and focus on the lines that are actually soft shades of aqua, pink, and yellow separated by bands of white.

A silkscreen stencil can be created with anything that will block the ink. Heavy paper stencils produce shapes that will print with crisp edges as seen in Riley's print, or glue can be painted directly onto the silk for looser effects. With the use of photosensitive chemicals, it is also possible to create stencils from photographic sources, as in Barbara Kruger's *Untitled (We don't need another hero)*, 5-16. Here, Kruger combined two kinds of subjects: photographs and written words. She utilized a photo-stencil to borrow (or **appropriate**) imagery from another source—an illustration from the 1950s. Her statement "We don't need another hero" is a strong condemnation of the "macho" tendencies in men that the era glorified.

UNIQUE PRINTS

While it seems almost a contradiction in terms, modern artists have used the printing press to create nonmultiple, or unique, one-of-a-kind prints. A **monotype** is made by applying

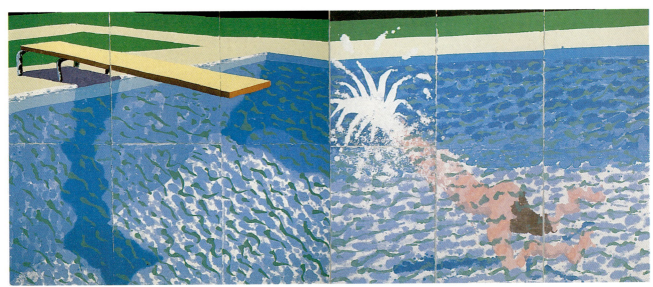

5-18 David Hockney, *A Large Diver (Paper Pool 17)*, 1978. Colored, pressed paper pulp, 72″ x 171″. © David Hockney/ Tyler Graphics Ltd.

ink or paint directly to a metal plate and then running it with paper through a press. It can also be made without the press by rubbing the back of the paper. Only one print is made (hence the name). The Impressionist Edgar Degas was a lover of the process because it allows a quick, instinctual approach, compared to the more time-consuming and methodical approach necessary in most printmaking. Like a drawing, monotypes openly reveal the artist's hand. In *Woman Standing in Her Bath* (5-17), Degas used two methods. In the *dark field* method, ink or paint is wiped on the whole plate with a rag and then removed to build the picture. It can provide deep blacks like those Degas admired in the lithographs of Redon. In the *light field* method, the artist draws images directly on the plate. The result is both a lovely study of sunlight, shadow, and reflection and an intimate look at a woman just stepping into her bath.

One of the pleasures of printmaking is working with and handling fine paper. *Papermaking* is a centuries-old craft that interests many contemporary artists. Hand-made papers are produced by immersing pieces of cotton or linen in water, literally beating them into a pulp, then squeezing and flattening the pulp into sheets in paper presses. The challenge of

re-creating the ever-shifting colors in swimming pools has interested David Hockney for many years. Hockney was able to come up with an answer to this challenge by manipulating the papermaking process. In his series called *Paper Pools* (5-18), he added colored pigments directly to paper pulp and placed moist masses of colored pulp directly into the press. Hockney applied the rich colors with spoons, brushes, and even a turkey baster. When the paper was pressed and dried, the image became an integral part of the fabric of the paper. The final picture is actually several sheets of paper. By "painting" with wet pulp that contained pure pigment, Hockney was able to achieve a shimmering liquid quality, characteristic of pools, with unusually brilliant color.

Despite the intermediary of a machine in the creative process, we have seen in this chapter that printmaking is an extraordinarily flexible media. Prints can reveal a human touch or provide a mechanical look. Images can be stark black and white or lavishly colored. Almost from its beginning, printmaking has been accepted as one of the art media with little or no controversy. But, we will see in the next chapter, this is not true of a more modern tool of the artist—the machine known as the camera.

PHOTOGRAPHY AND COMPUTER ART

I n this century, there has been a huge in-crease in the number of pictures produced and reproduced, largely due to the invention of *photography*. Realistic images that would have awed Michelangelo are seen every day on calendars and magazine covers. The impact of photography has been as significant as that of the printing press, and it has changed the world in a very short time. Almost from the moment of its invention in the mid-1800s, the photograph was greeted with enthusiasm and awareness of its historical importance. It would be several decades, however, before it was fully accepted as one of the art media.

TECHNIQUE AND DEVELOPMENT

The long road to the photograph began around the eleventh century when the first **camera obscura** (6-1) was developed. Literally meaning "dark room," such room-sized cameras were first used to study eclipses. By preventing all light from entering a room and then cutting a small hole in a window shade, a person could project an inverted image of the sun onto the opposite wall. However, an astronomical event is not a necessity. A camera obscura will also project an upside-down image of the outside world using just ordinary daylight. By the 1600s, a lens helped focus images more clearly. Then in the 1700s, a table model of the camera obscura became available. With the help of a small mirror inside, it projected a

right-side-up image on a screen that artists could use for tracing. The lens could be moved inward and outward depending on whether a close-up or long view was required. In fact, there was really only one thing that separated this camera obscura from our modern camera— the lack of photographic film.

The search for a way to permanently cap-ture a camera's image took place during the new scientific age of the late 1700s and early 1800s, a period of intensive scientific investiga-tion of the world. Botanical artists, for example, were making extremely detailed drawings of plants but were well aware that the artist's eye was technically limited. A more scientific method of observation was felt to be needed.

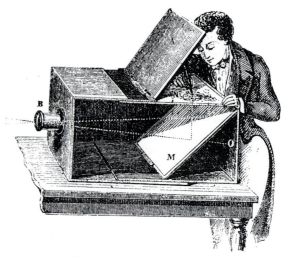

6-1 Camera Obscura

The first photographic film using the "negative–positive principle" was invented by an Englishman, William Henry Fox Talbot. His development of *negatives* made copies possible and created the field of photography that we know today. Talbot's photograph of the *Reading Photographic Establishment* (6-4) from 1844 shows how quickly entrepreneurs realized the commercial possibilities of the new medium. Meanwhile, scientists in Europe

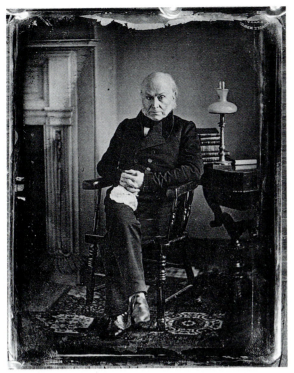

6-2 Philip Haas, *Portrait of John Quincy Adams*, 1843. Daguerreotype. The Metropolitan Museum of Art, New York (gift of I. N. Phelps Stokes, Edward S. Hawes, Alice Mary Hawes, Marion Augusta Hawes, 1937).

6-3 Jacques Louis Mandé Daguerre, *Collection of Fossils and Shells*, 1859. Daguerreotype. Conservatoire Nationale des Arts et Métiers, Paris.

A series of discoveries and inventions by scientists (mostly amateur) around Europe finally resulted in the first permanent photographic image—the **daguerreotype** (6-2), invented by a French painter, Jacques Louis Mandé Daguerre in 1839. His pictures were produced by using silver foil that had been made light sensitive with chemicals. After the foil was exposed to light, the image was *fixed* (made permanent) by bathing it in a solution of salt. He would be world famous and the toast of Paris by the end of the year. "Daguerreomania" swept Paris, then Europe and the United States. His pictures were said to have defeated time.

There were, however, technical limitations to the daguerreotype. Portraits were the most popular kind of early photographs but because an exposure of thirty minutes might be required, they tended to show very grim people trying desperately not to move. The most successful of Daguerre's images were still lifes, as in his *Collection of Fossils and Shells* (6-3). These early pictures did not use film, and only a single image could be printed.

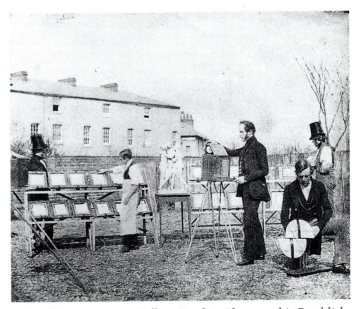

6-4 William Henry Fox Talbot, *Reading Photographic Establishment*, 1844. Reproduced by permission of the Trustees of the Science Museum, London.

and the United States continued working on improvements. By 1880, film that needed only to be exposed for 1/1000 of a second was available. The daguerreotype had long since been eclipsed.

All cameras share five basic parts (6-5): a *light-tight box,* which forms the structure of the camera and prevents any unwanted light from hitting the film; a **lens,** which focuses the light onto the film; a **shutter,** which is triggered by the photographer and controls the time of the exposure; an **aperture** (or diaphragm), an adjustable opening that controls the amount of light entering the camera; and the *viewfinder,* which permits the photographer to see what the camera sees.

In the earlier years of photography, camera equipment was rather cumbersome and expensive, but, in 1887, an American named George Eastman introduced a simple box camera called the *Kodak.* This camera would soon make taking a photograph as common as taking a train ride. Eastman's slogan was "you press the button, we do the rest." After shooting a roll of one hundred exposures on the Kodak (which reportedly got its name from the sound the shutter made), the photographer would send the entire camera to the factory in Rochester, New York. At the factory, the film would be removed and developed, and a new roll would be loaded into the camera. Within twenty years of the first Kodak camera, George Eastman was in charge of the world's largest photographic manufacturing company. In the years since then, Kodak and other companies have introduced new precision lenses, electronic flashes, 35mm film, color film, instant photography, and many other advances that make up modern photography.

STYLES OF PHOTOGRAPHY: STRAIGHT PHOTOGRAPHY

One way the new invention called photography (literally "drawing with light") was first used was to make images of distant, exotic lands available to the public. Expeditionary photography, the precursor to *landscape photography,* was a field for adventurous artists. Timothy O'Sullivan, one of the pioneers of this medium, began his career as a Civil War photographer. After the war he traveled with geological survey groups through-

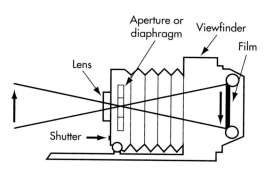

THE BASIC PARTS OF A CAMERA

6-5

out the Western United States. O'Sullivan had to bring his camera, chemicals, and plates with him, all of which were very heavy. He also brought along a portable darkroom in an ambulance pulled by mules. Despite these handicaps and the newness of the medium, his photographs of the Canyon de Chelly in Arizona (6-6) are among the most beautiful landscape photographs ever made. The immense scale of the canyon is made apparent by seemingly tiny ruins of buildings (just one of the many clearly depicted details). Opposed to the overall feeling of great height are the many tilting horizontal parallel lines, which provide variety and help unify the whole composition.

The huge camera that O'Sullivan carried out West was similar to one used by many fine art photographers today. However, the smaller format 35mm camera—lightweight and with lenses capable of taking pictures with very fast exposures—is overwhelmingly the camera of choice for contemporary photographers. Its portability has opened up many subjects for the photographic eye, from the top of Mount Everest to the depths of the sea.

Henri Cartier-Bresson utilized the 35mm camera's speed to capture what he called "the decisive moment," an instant that reveals the truth. His *Seville, Spain* (6-7) shows the unique ability of photographs to allow the viewer to analyze the meaning of a passing moment. Taken in a Spanish neighborhood that had been bombed during the Spanish Civil War, we see both the havoc that war plays on an innocent population and the brutality that is a part of childhood.

Cartier-Bresson is categorized as a *"straight"* photographer, one who does not

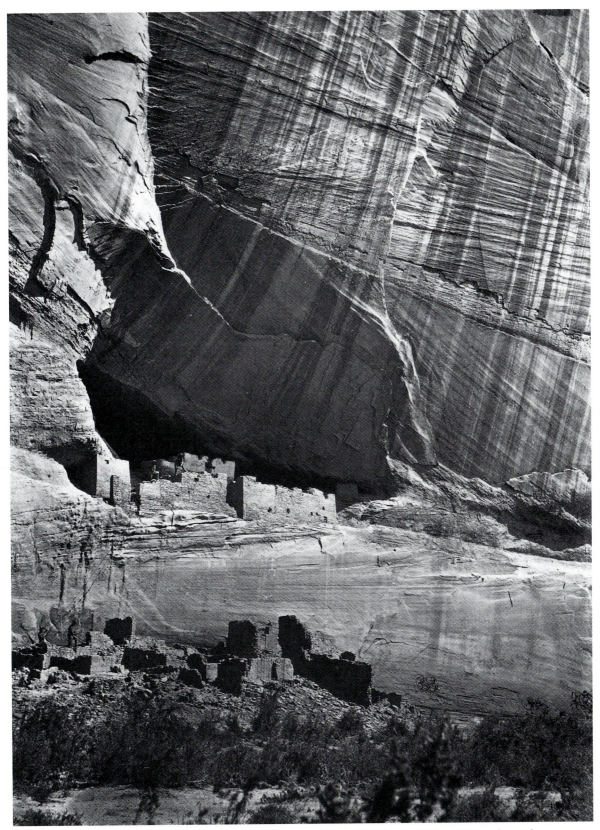

6-6 Timothy O'Sullivan, *Ancient Ruins in the Cañon de Chelle, N. M., in a Niche 50 Feet above the Present Cañon Bed* (now Canyon de Chelly National Monument, Arizona), 1873. Albumen print. George Eastman House, Rochester, New York.

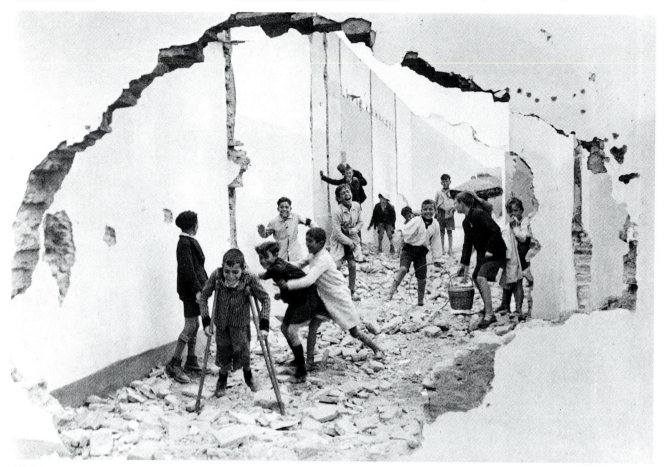

6-7 Henri Cartier-Bresson, *Seville, Spain,* 1933. Gelatin silver print.

tamper with the negative or image in any way once it has been taken. "Straight" photographers value honesty above artistry.

DOCUMENTARY PHOTOGRAPHY

A type of "straight" photography that became increasingly important in the twentieth century was *documentary photography*— authentic, unretouched photographs that record important social conditions and political events. In the United States, during the Great Depression, the government hired photographers like Dorothea Lange to provide evidence of the miserable circumstances in the lives of many Americans. In her picture of an impoverished mother and children from a migrant family (6-8), the composition draws our attention to the mother's face, ensuring that we become conscious of her worry and pain. Lange was among a group of photographers hired by the Department of

Agriculture to report on conditions and to help build public support for government programs. Lange's notes for this photograph read:

> Camped on the edge of a pea field where the crop had failed in a freeze. The tires had just been sold from the car to buy food. She was thirty-two years old with seven children.

BEYOND REPRODUCTION: FINE ART PHOTOGRAPHY

It wasn't until Alfred Stieglitz founded the *Photo-Secession* group in 1902 that American photography began to be accepted as a fine art medium. Stieglitz was a man of great energy and vision. He edited the magazine *Camera Work* to promote photography. In its first issue, he promised to show "only examples of such work as gives evidence of individuality and artistic worth, regardless of school." His

291 Gallery in New York City exhibited photography alongside painting, prints, and sculpture and was one of the most advanced galleries in America. The first in this country to show Modern Artists like Matisse and Picasso, the 291 Gallery became a gathering place for young artists. Stieglitz believed that the eye of the photographer was more important than

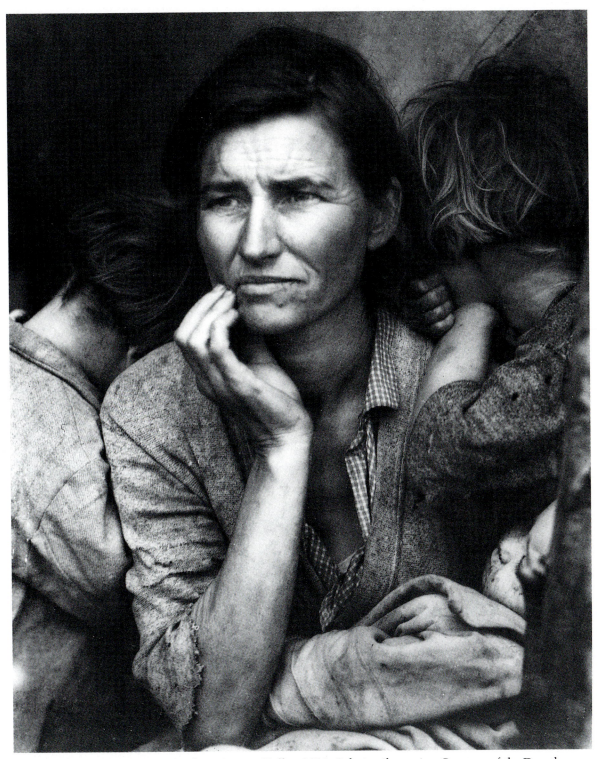

6-8 Dorothea Lange, *Migrant Mother, Nipomo Valley*, 1936. Gelatin silver print. Courtesy of the Dorothea Lange Collection, The Oakland Museum (gift of Paul S. Taylor).

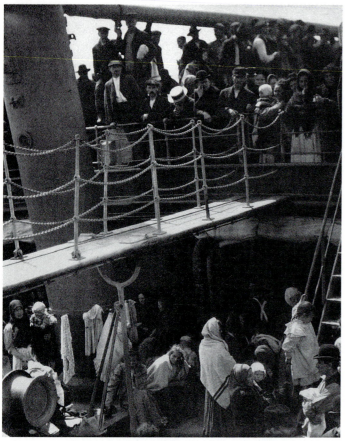

6-9 Alfred Stieglitz, *The Steerage,* 1911. Gravure print. The Metropolitan Museum of Art, New York (The Alfred Stieglitz Collection, 1933).

the sophistication of his equipment. His own photographs, like *The Steerage* (6-9), which he called a "picture of shapes," reveal his ability to find design and life in unposed images. His patience was legendary; he would stand for hours, no matter what the weather, waiting for the right moment.

His own eye for the work of other photographers was also of the highest quality. *Camera Work* introduced the finest and most advanced photographers to the public. One was Edward Steichen, whose long and varied career in photography began as Stieglitz's assistant. Like his mentor, Steichen believed photographers should be free to manipulate their images. His portrait of the French sculptor Rodin (6-10) pondering his famous *Thinker* (see Chapter 14) is actually the combination of two separate images taken in the sculptor's studios. Steichen played with the chemistry of photography to achieve more painterly effects.

By the 1930s, artists had begun to approach photography as a purely artistic media. For instance, Man Ray grasped that the supposedly "realistic" medium of photography

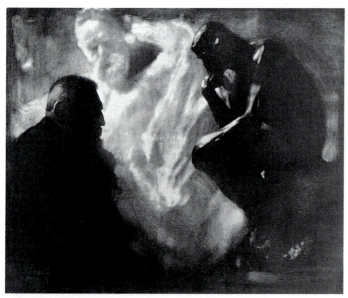

6-10 Edward Steichen, *Le Penseur,* 1902. Gum print. The Art Institute of Chicago (Alfred Stieglitz Collection).

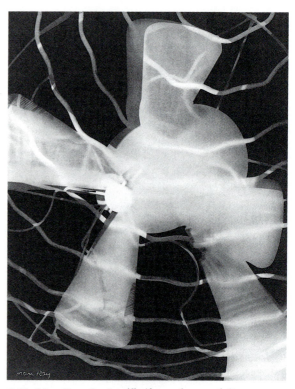

6-11 Man Ray, *Le Souffle* (from the portfolio *Electricité*), 1931. Rayograph.

was actually much more subjective than most people realized. Its images could be very deceptive. By varying position and lighting, a photographer could present a subject in many different ways and produce contradictory "truths." Ray also realized that photography had the power to show worlds that were not even part of ordinary visual reality. Experimenting with the medium as a purely artistic form, Man Ray invented a new kind of photograph that did not require a camera. He called it a "rayograph," made by placing objects on photographic paper in a darkroom and then exposing the paper to light. In *Le Souffle* (6-11), mysterious waves seem to penetrate a transparent machine. The image is bizarre and otherworldly, using effects not possible in any other medium. Today, many contemporary photographers, like Sandy Skoglund, take advantage of the commonly held faith in

the "truthfulness" of photographs to confuse the viewer's sense of reality. Her *Radioactive Cats* (6-12) is anything but a "straight" photograph. Every part of what we see has been carefully planned and arranged. Yet, of course, this scene did exist and was photographed. Part of the artistic process Skoglund follows is the construction of her subject, including posing and costuming her models and applying fluorescent colors to ceramic cats she created. Following the lead of pioneer artistic photographers like Man Ray, Skoglund does not respect or believe in the neutrality of photography. Instead, she uses its power of deception for creative purposes. The result is a vivid fantasy of what the world might be like after a nuclear war.

The ambitious and theatrical photographs of Cindy Sherman are such elaborate productions that they almost constitute performances.

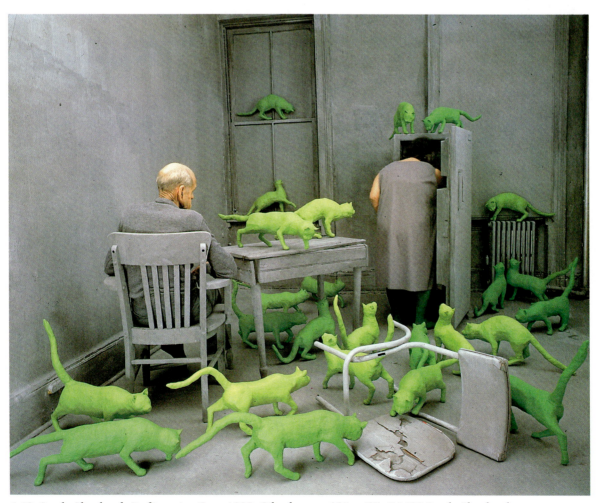

6-12 Sandy Skoglund, *Radioactive Cats*, 1980. Cibachrome, 30" x 40". © 1980 Sandy Skoglund.

For them, Sherman stars in an endless assortment of roles, from innocent hippie to tired housewife, young girl at her first ballet recital to an autistic patient in an asylum.

Many critics have seen her pictures as studies of women's roles in the popular media. But as her pictures have become more complex visually, they have also shown less stereotypical women and situations. *Untitled* (6-13) shows Sherman as an apparent murder victim on what appears to be an isolated forest floor. Her throat is cut, her clothing soaked and stained. Flecks of dirt on her head and neck imply a struggle took place. Insects are hovering over her bruised face. The viewer is drawn magnetically toward the brightly lit blond-wigged head with glazed blue eyes. Notice how her head is set at the crossing point of the diagonals made by her body and

the line of green moss. To produce such a carefully composed and complex image, Sherman had to become a special-effects wizard, controlling lighting, sets, makeup, and costumes. Her most successful images evoke setting and subject without making us aware of how they were constructed. In other words, while totally artificial, they seem natural.

PHOTOMONTAGE

The widespread reproduction of photographs has given artists new materials for collages, providing an enormous palette of realistic images. The imaginative combination of photographic images is called **photomontage**. With this twentieth-century medium, artists can create impossible pictures that still seem connected to the real world.

Between the world wars, the German photomontage artist Hannah Höch used found images from publications like newspapers and magazines—what has been described as the debris of modern life. By connecting heads, bodies, and machines, Höch's photomontages showed how people were becoming dehumanized cogs in the industrial process. In *Cut with the Kitchen Knife…* (6-14), machinery overwhelms the characters, creating confusion. Who is responsible for this world? In the upper right corner, we see top-hatted figures of respectability along with an old general, symbolizing bankrupt authority. The artist pokes fun at this type of authority figure toward the center of the image by setting the head of a proper bourgeois gentleman on top of the body of a belly dancer. Hoch's photomontages are satirical, even funny, but her political message is quite serious.

COMPUTER ART

At the beginning of the twentieth century, photomontage was largely a matter of scissors and glue. Today, however, with the advent of computer technology, artists can **digitize** (translate into numbers that a computer can read) two-dimensional images (with scanners) and three-dimensional objects (with video cameras) so such pictures will appear on the computer's screen. Once they are in the computer memory, these images can be combined and manipulated by the artist.

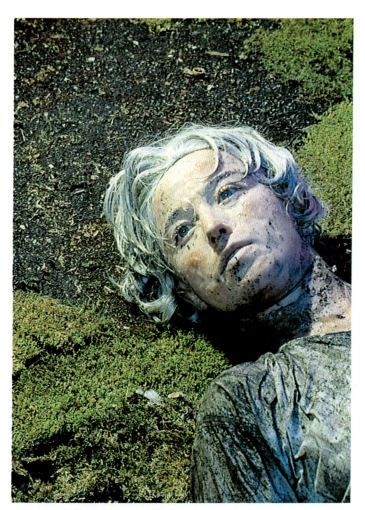

6-13 Cindy Sherman, *Untitled*, 1985. Color photograph, 67¼" x 49½". Courtesy Metro Pictures, New York.

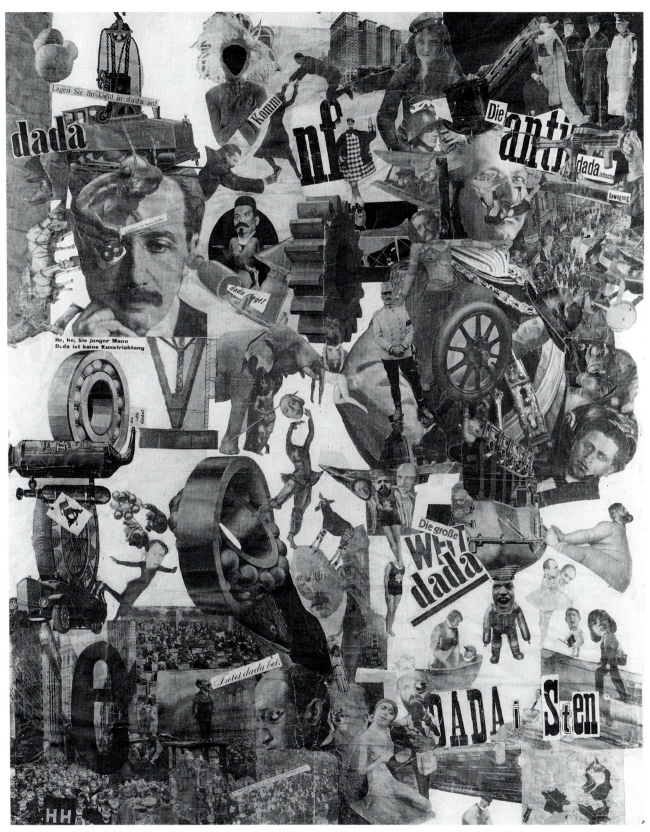

6-14 Hannah Höch, *Schnitt mit dem Küchenmesser Dada durch die erste Weimarer Bierbauchkulturepoche Deutchlands (Cut with the Kitchen Knife through the Last Weimar Beer Belly Cultural Epoch)*, 1919. Staatliche Museen Preussbischer Kulturbesitz, Nationalgalerie, Berlin.

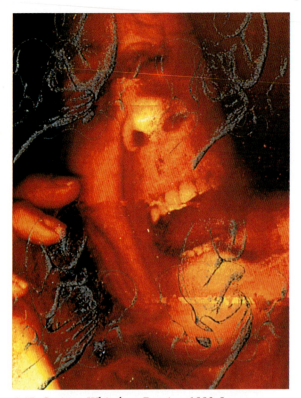

6-15 Corinne Whitaker, *Destiny*, 1993. Image created with Macintosh Quadra 950 with 72 mb RAM, Fujitsu 2.2 gig hard drive, radius 20″ monitor, Wacom tablet, and HP Scan Jet IIc with 24-bit color and scanned photographic image. © Corinne Whitaker 1993.

Not since the advent of the camera has any new technology offered so many fresh possibilities for art. Corinne Whitaker, once a photographer, was so impressed after she bought a computer in 1981 that she sold all her photography equipment. *Destiny* (6-15) electronically blends a digitized photograph of a screaming woman and a medical illustration of childbirth. Whitaker also used her computer to add colors and manipulate the photograph's shape to produce this unique and powerful image. In her work, Whitaker tries to turn the "awesome power of the computer" to intimate concerns, steering technology away from detached, rational matters and toward becoming a tool for self-expression.

Sophisticated "paint" programs can both re-create realistic subjects and develop unique, imaginary imagery. Some computer systems allow artists to choose from more than sixteen million colors, and computer animation can now achieve amazing feats of illusion. In *Luxo Jr.* (6-16), programmers and artists collaborated to create two lamps (parent and child) that bend and twist while they kick a small ball around a table. The objects are seen from many angles, rotating and moving as if they actually existed.

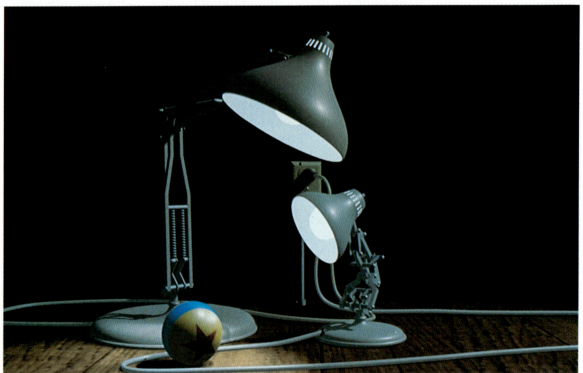

6-16 John Lasseter, Bill Reeves, Eben Ostby, Sam Leffler, and Don Conway, *Luxo Jr.*, 1986. Frame from film. Copyright 1986 by Pixar. All rights reserved. "Luxo" is a trademark of Jac. Jacobson Industries.

6-17 Don Shields, stills from *The Lizard and the Fly*, 1992. Computer animation. Courtesy Don Shields of Z Animation.

The making of *Luxo Jr.* required a large and expensive computer, as well as a team of artists and engineers writing powerful programs (for example, programs to enable the computer to calculate how shadows change as objects alter their position). Since its production, however, sophisticated three-dimensional programs for smaller personal computers have become available. Independent artists like Don Shields can now make computer animated films that would have required an investment of tens of thousands of dollars just a few years ago. Shields, a respected painter who has won both a Guggenheim Fellowship and a Rome prize, is now able to use advanced techniques like **texture mapping** on his home computer. Texture mapping was first used by the Jet Propulsion Laboratories to create visualizations of information from the NASA Voyager missions; it makes possible the wrapping of a texture around a wire-grid form drawn by an artist. In Shields's *The Lizard and the Fly* (6-17) each part of the fly was created as a separate three-dimensional shape, then wrapped with a texture selected by the artist. Such surface patterns and textures can be selected from an assortment that comes with a program, copied with a video camera, or created by the artist from scratch. For example, the texture of the tree in the background at top is from an old tree in the artist's backyard.

Although computer graphics is just in its infancy, it is apparent that we are on the verge of a future where making computer images will be almost as common and inexpensive as making photographs today. Electronic cameras that do not use film at all are already available. Kodak, whose camera made photography readily available at the beginning of the century, will now develop pictures digitally, on compact discs, for playback on a television or computer. Makers of video games offer simple paint programs that allow children to make pictures and short animations on their own television sets. The democratization of art seen in this century with photography will continue into the next with computer art.

CHAPTER

7

SCULPTURE

The art of sculpture is believed to be as old as human culture. Carved charms, amulets, and fertility figures such as the *Venus of Willendorf* (1-10) were created by Ice-Age tribes described in the first chapter. Most of these magical objects were relatively small and easily carried from place to place by nomadic hunters. At the other end of the scale, some prehistoric civilizations raised huge stones and arranged them in mysterious patterns. These sculptural monuments, like the famous one at Stonehenge in England (7-24), seem to have been used to plan dates for religious or fertility rites. Sculptural decorations and statues were also part of the tombs of the Ancient Egyptians. Greek sculpture was a glory of the classical world, though little of it has survived to the present day. However, magnificent sculptural works still remain from the early period of Indian, Chinese, and pre-Columbian civilizations.

Many of the techniques and tools of the sculptor have been used for centuries. When we see Edward Steichen's photograph of the modern sculptor Constantin Brancusi in his studio wielding a heavy axe and surrounded by rough hewn stones (7-1), we are reminded of the ancient, even prehistoric, lineage of sculpting. Sculpture has traditionally been divided into two major categories—what is called *relief sculpture* and *freestanding sculpture* (sculpture *in the round*). In the twentieth century, three new categories were introduced—*kinetic sculpture* (art that moves), *performance art*, and *installation*.

RELIEF SCULPTURE

A **relief sculpture** grows out of a flat, two-dimensional background, and its projection into three dimensional space is relatively shallow. The back of a relief sculpture is not meant to be seen; the entire design can be

7-1 Edward Steichen, *Constantin Brancusi in His Studio*, 1925. Photogravure from plates by Jon Goodman and Richard Benson, 10³⁄₁₆″ x 8″. The Museum of Modern Art (gift of Aperature, Inc.). Reprinted with permission of Joanna T. Steichen.

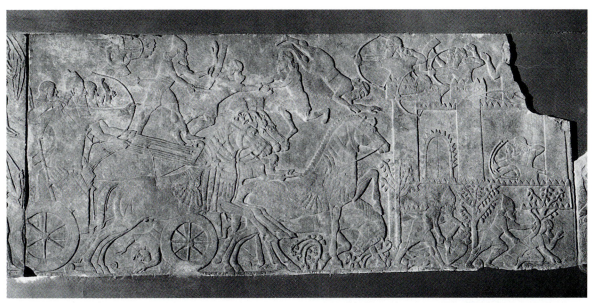

7-2 *Ashurnasirpal II at War,* Nimrud, *c.* 875 B.C. Limestone, approximately 39″ high. British Museum, London.

understood from a frontal view. Relief sculptures are often used in conjunction with architecture, as wall decorations. For instance, the stone walls of Assyrian palaces were carved with designs that protrude only slightly into three-dimensional space (7-2). The outlines of the figures are sharply cut, rather than modeled, so they appear almost like thick paper dolls stuck onto the backing of the wall. The linear quality of these low reliefs—the rhythm and pattern of the lines—is their most striking aesthetic feature. If we look closely, however, we can see sculptural effects in the curve of a cheek or the muscle on a thigh.

Most Assyrian reliefs commemorate the military victories and hunting expeditions of the kings who ruled some twenty-eight hundred years ago in what is now Iraq. Carved in limestone, these sculptured pictures lined the walls of royal habitations. Words praising the king and his accomplishments were generally carved over the figures.

The plaque showing a king mounted with attendants (7-3) from the Court of Benin, Nigeria, also decorated a royal palace. It is one of nearly a thousand that covered pillars in the many courtyards and galleries. When they were made in the sixteenth century, Benin was a vast empire in West Africa and was trading with Europe. On the brass plaques, size signifies power; ornaments identify status. The

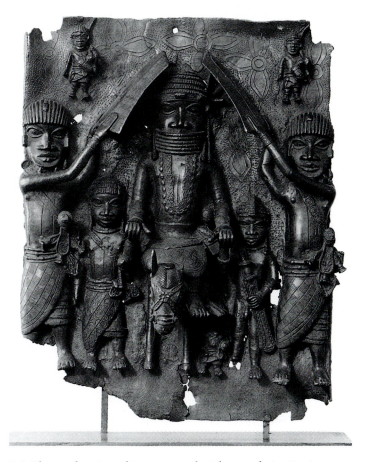

7-3 Plaque showing a king mounted with attendants, Benin, Nigeria. Bronze, 19½″ x 16½″. The Metropolitan Museum of Art, New York (gift of Nelson A. Rockefeller, 1965).

central warrior chief is in *high relief* (or almost in the round); he seems about to ride out of the plaque. His warriors carry shields held out in high relief to protect him from the sun. His two small attendants in shallow relief are there simply to support the king's hands.

SCULPTURE IN THE ROUND

In contrast to sculptural reliefs, **freestanding** sculpture inhabits three-dimensional space in the same way that living things do. Sculpture in the round cannot be appreciated from only a single viewpoint but must be circled and explored. As the poet Donald Hall has written, "If there can be one best picture of a sculpture, the sculptor has failed." The *Rape of the Sabine Women* by Giovanni da Bologna (7-4, 7-5) is a powerful example of sculpture in the round. The twists and turns of the muscular bodies reach up over 13 feet. Bologna has created a truly three-dimensional experience; there is no predominant view. The three

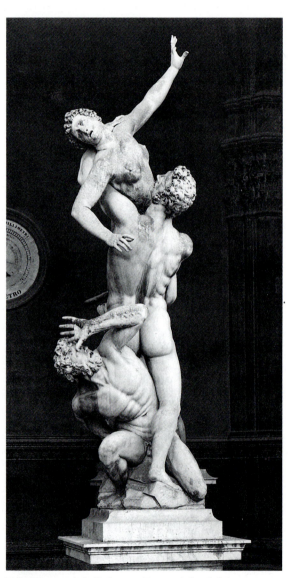

7-4 Giovanni da Bologna, *Rape of the Sabine Women*, completed 1583. Marble, approximately 13′6″ high. Loggia dei Lanzi, Piazza della Signoria, Florence.

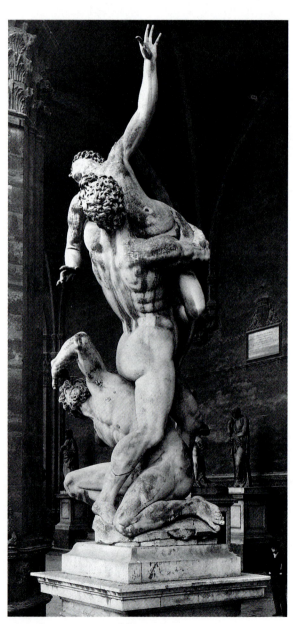

7-5 Alternate view of figure 7-4

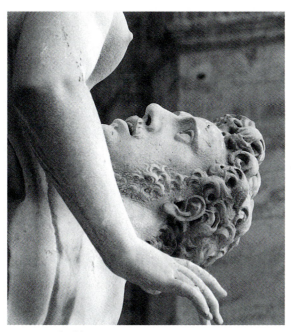

7-6 Detail of figure 7-4

varies, different parts will move at different speeds. Therefore, the relationship of the parts is constantly changing. No photograph can do these moving sculptures justice.

Jean Tinguely's kinetic sculptures of the 1960s were not nearly as pleasant. His infamous *Homage to New York* (7-8) was a mass of junk, including bicycle wheels, fans, many motors, and metal tubes. A comment on modern life and the machine age, it was a machine designed to destroy itself. Turned on at night before private guests (including the governor of New York) in the sculpture garden of the Museum of Modern Art in New York City, the sculpture made horrible noises, smoked, and, after several malfunctions, burned to a heap in a half hour. Besides being a kinetic sculpture, *Homage to New York* could also be described as a staged event and thus included under another new category of sculpture, performance art.

figures flow into each other as you walk around the sculpture. Closer up, Bologna provides the viewer with many exceptional vignettes (7-6), too. As was common in late sixteenth-century Italy (see Chapter 11), the statue was intended only as a *tour de force* of artistic skill, and the subject was truly unimportant. In fact, the name of the sculpture was given by Bologna only after the piece was finished, when he was asked for a title.

KINETIC SCULPTURE

In the 1930s, while in Paris, the American sculptor Alexander Calder had begun working nonrepresentationally, making organic, simple forms out of metal. Because he wanted to see these forms float and turn in space, Calder invented the **kinetic sculpture** or **mobile** (a name given to his work by Marcel Duchamp). The first mobiles used machinery to move the shapes that dangled from wires. Soon, however, Calder came to the happy idea of using the wind to move his dangling shapes, as in *Snow Flurry I* (7-7).

By using air currents, these works feel absolutely natural, although they are made of totally abstract shapes. Their delicate balance makes each part seem weightless. Because the wind resistance and weight of each piece

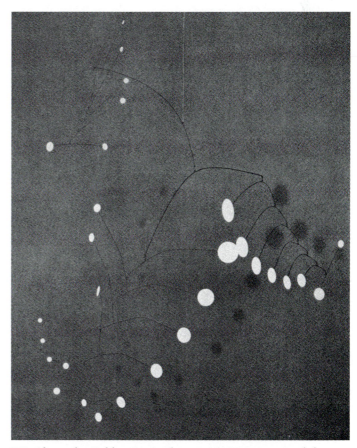

7-7 Alexander Calder, *Snow Flurry I,* 1948. Hanging mobile (sheet steel and steel wire, painted), 7'10" x 6'10¼" diameter. The Museum of Modern Art, New York (gift of the artist).

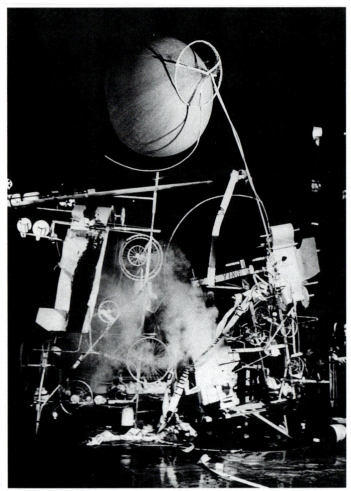

7-8 Jean Tinguely, *Homage to New York*, 1960, just prior to its self-destruction in the garden of The Museum of Modern Art, New York.

PERFORMANCE ART

Beginning around the 1960s, artists began to challenge the whole concept of art being the production of lasting physical objects. A movement called **performance art** created living sculptural events that were ephemeral, art experiences made for the moment, intended only to last in memory. Few contemporary performance artists have *not* been influenced by the German artist Joseph Beuys. His performances were always an unpredictable kind of gallery experience. In a 1965 performance *How to Explain Pictures to a Dead Hare* (7-9), for example, Beuys entered an exhibition of his drawings and paintings with his head covered in honey and gold leaf. Carrying a dead hare in his arms, he walked from picture to picture and touched the rabbit's paw to each

one. Then he sat down in a corner of the gallery and proceeded to discuss the meaning of his pictures with it. He said that he did this "because I do not really like explaining them to people" since "even in death a hare has more sensitivity and instinctive understanding than some men with their stubborn rationality."

Laurie Anderson has been a leading innovator in combining electronics, music, and performance art. Her recent work is autobiographical and complex. *United States Part II* (7-10) was developed in performances over six years and gave Anderson a celebrity status that is without precedent in performance art. In front of a huge screen, Anderson played a synthesizer keyboard that controlled her music and voice. The screen's images constantly changed during the eight-hour piece, a fluid stream of a map of the United States, photographs, drawings, and the video game "Space Invaders." Her voice changed constantly, too, gliding between various personae from a clichéd mother to a corporate executive.

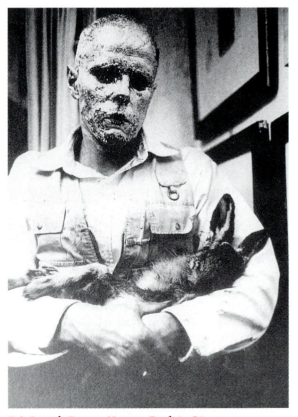

7-9 Joseph Beuys, *How to Explain Pictures to a Dead Hare*, 1965. Performance at the Galerie Schmela, Dusseldorf. Photograph © 1986 Walter Vogel.

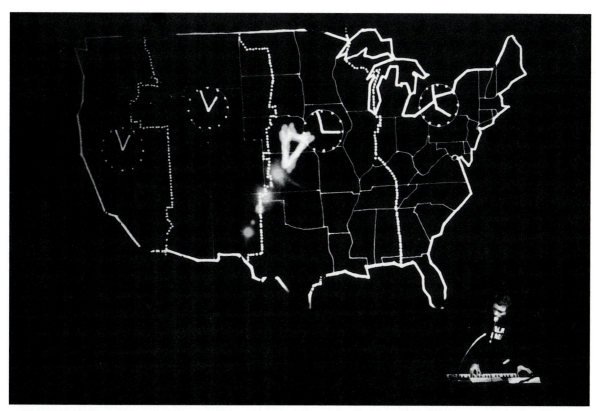

7-10 Laurie Anderson, *Let X = X*, a segment of *United States Part II*, 1980. Performance at the Orpheum Theater, New York, and presented by the Kitchen. Photo courtesy of Paula Court.

There are both instrumentals and songs in *United States*; one song, "O Superman," contains the chilling lines: "Well, you don't know me but I know you, and I've got a message to give you. Here come the planes." At that moment, the theater is filled with the roar of aircraft.

After *United States Part II*, Anderson was signed to a recording contract; in fact, "O Superman" rose to number two on the British pop charts. While most performance art is meant to be seen only once, *United States* was booked for scheduled runs like a play. Theatre critics even began reviewing Anderson's work. Some have said that Anderson has left the arena of fine art and crossed the line into entertainment. However, the goal of performance art has always been to break down the traditional boundaries of art and to confront viewers as directly as possible. Anderson's mesmerizing cross-disciplinary works have reached people who rarely see avant-garde art and has influenced the worlds of popular music, opera, film, and theater.

INSTALLATIONS

One of the newest artforms is the mixed-media **installation** or **environment,** which can be constructed in galleries, museums, or even public spaces. This large-scale art takes over a space and provides a complete and unique artistic experience for anyone who enters. For example, the installations of Judy Pfaff provide a raucous, overwhelming atmosphere for the viewer. There is no restraint, just colors and shapes struggling to be released from gravity's chains.

Pfaff works day and night on her installations, surrounded by piles of raw materials of every kind, from tree limbs to barbed wire. In a process that could take weeks, an entire gallery is ultimately transformed into an unearthly extravaganza. The reproduction of *3-D* from 1983 can only suggest what it is like to be in a Pfaff installation (7-11). Day-glo colored objects come at you from every direction. One's sense of space is disoriented. Trashbins are on the ceiling, bizarre walkways lead up walls.

Pfaff is particularly concerned with engaging not only your focused sight but also your peripheral vision: "If you look and see it all at once—then there is a false sense that you know it." One can never see a Pfaff installation at a glance. It exists above, below, and behind, as well as in front of you. She is "pursuing a deeper and denser space, an intensified feeling of vertigo, and something of the terror of that sense of placelessness . . ."

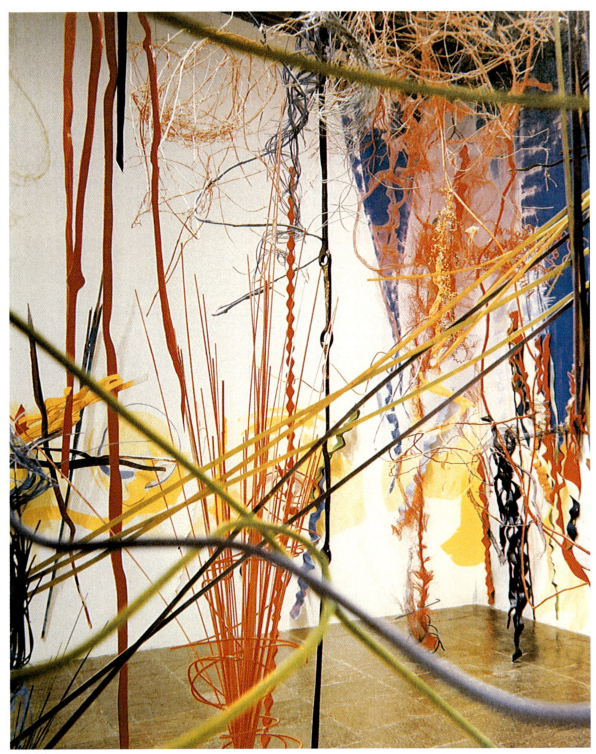

7-11 Judy Pfaff, *3-D,* 1983. Detail of installation using mixed materials, 22' x 35'. Holly Solomon Gallery, New York.

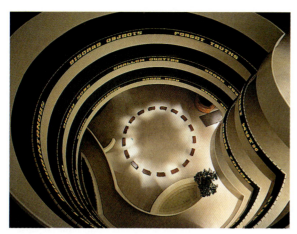

7-12 Jenny Holzer, *Untitled (Selections from Truisms, Inflammatory Essays, The Living Series, The Survival Series, Under a Rock, Laments, and Child Text)*, 1990. Extended helical tricolor L.E.D. electronic display signboard, 16½″ x 162′ x 6″. Solomon R. Guggenheim Museum, New York (partial gift of the artist, 1989).

Jenny Holzer's installations use no images at all, only words printed on paper, cut into stone, or—more often—displayed electronically on light emitting diode (LED) displays. In 1989, the Guggenheim Museum in New York City became a backdrop for an electronic sign wrapped around the museum's central spiral ramp (7-12). On it were displayed "truisms" of her own composition, such as "Everything that's interesting is new" and "Expiring for love is beautiful but stupid," that raced around the spiral strip, then disappeared to be replaced by new text. Holzer's truisms are themselves interesting commentaries on the possibility of originality in the modern age: They sound like clichés, but are actually written by the artist. The speed at which they come at the viewer is meant to reflect the barrage we all experience living in the information age.

SCULPTURAL METHODS

To discuss the sculptural media, it is most important to understand sculptural methods. These can be broken down into two basic categories: **additive** and **subtractive**. In additive methods, the sculpture is *built up*, such as modeling a flexible material like clay or plaster or building an installation; in subtractive methods, it is carved out of hard materials such as wood or stone.

MODELING

Most of our childhood experience in making sculpture was with modeling statuettes out of the familiar material of clay (or clay substitutes, such as Play-Doh). Sculptors may also use clay to make sculpture, but they often build the clay form around a metal skeleton, or *armature*, for added strength.

Modeling materials, like clay or wax, sometimes perform the same function for sculptors that drawing media do for painters, enabling them to sketch out their ideas quickly in three dimensions. Such a model is called a **maquette**. Auguste Rodin's *Walking Man* (7-13) was originally made in clay as a study for a figure of John the Baptist. In its textured surface, we can see the marks of the sculptor's strong hands modeling clay, push-

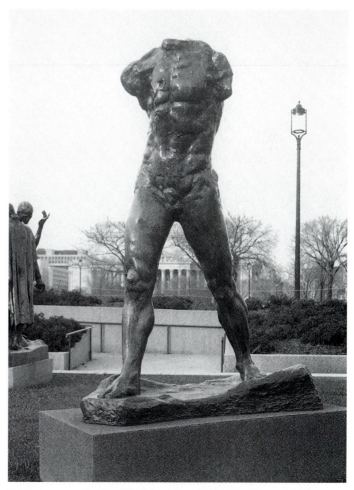

7-13 Auguste Rodin, *Walking Man*, 1900–1905 (cast 1962). Bronze, 84½″ x 61⅝″ x 28⅞″. Hirshhorn Museum and Sculpture Garden, Smithsonian Institution (gift of Joseph H. Hirshhorn, 1966).

ing in below the ribs and adding a clump to form a muscle. Although they are a crucial stage in the design process, few clay studies survive. Left alone, clay will dry and become brittle; any contact with water will cause it to disintegrate. However, if baked or *fired* in a kiln, clay hardens to a rich red-earth tone and is called **terra-cotta**. For his *Walking Man*, Rodin utilized another, more permanent, way of preserving clay studies called **casting**.

CASTING

The centuries-old method of casting is an important, if complicated, sculptural process that allows the sculptor to make a lasting copy of his work or to create multiple copies of one design. Since ancient times, the most common material for casting has been the metal bronze, though other metals or plaster may be used.

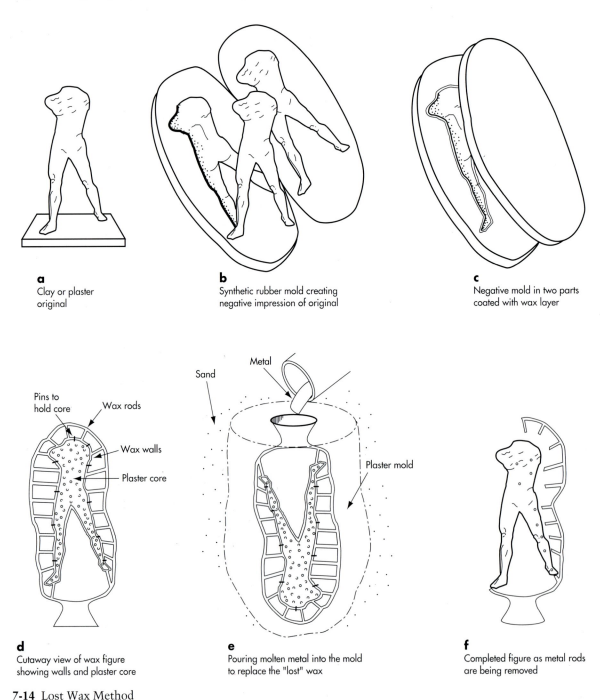

a
Clay or plaster
original

b
Synthetic rubber mold creating
negative impression of original

c
Negative mold in two parts
coated with wax layer

Pins to
hold core

Wax rods

Wax walls

Plaster core

Sand

Metal

Plaster mold

d
Cutaway view of wax figure
showing walls and plaster core

e
Pouring molten metal into the mold
to replace the "lost" wax

f
Completed figure as metal rods
are being removed

7-14 Lost Wax Method

Casting sculpture requires a series of steps in contrast to the more direct method of modeling. Most cast metal sculptures are made to be hollow, by what is called the **lost wax method** of casting (7-14). Once the original sculpture is created, a plaster or rubber mold is then made that can fit snugly around it and retain all the details of its shape and surface texture. After it is made, the original sculpture is removed from the mold, and a thin layer of wax is applied inside the mold, of exactly the thickness desired for the final metal sculpture. This layer of wax is, in essence, a hollow wax model of the original sculpture. The inside of the wax model is next filled with a material like plaster, while an outer covering of plaster is placed around the wax maquette's exterior. The whole plaster/wax arrangement is then baked in a kiln. During the baking, the plaster becomes hard and the wax melts out. That is why this is referred to as the "lost wax" method of casting. The hollow area that had contained wax is now open to hold the molten bronze, which is poured in and allowed to dry. When the bronze is hard and cool, the mold is broken off. A hollow metal version of the original sculpture can finally be seen.

WOOD CARVING

If our first experience in creating sculpture was with an additive technique such as modeling, many of us have also experimented with primitive forms of the subtractive technique of carving—as in carving a shape out of bar of soap or learning to whittle. If so, we discovered the difficulty of trying to shape materials by this method. In carving, as in preparing a woodcut, it is the background—the negative space—that is removed or peeled away, allowing the form to emerge. The tools used usually mirror the wood-cutting tools of one's society and include saws, mallets, and chisels. Once the wood has been shaped, abrasives such as sandpaper can be used to finish and polish the surface.

Wood carving is the most important sculptural art of Africa (7-15). African carvings range from highly polished to rough-cut pieces; some depend on the natural beauty of the wood, some are painted, and some are decorated with shells, feathers, and beads. One special type of African sculpture is the making

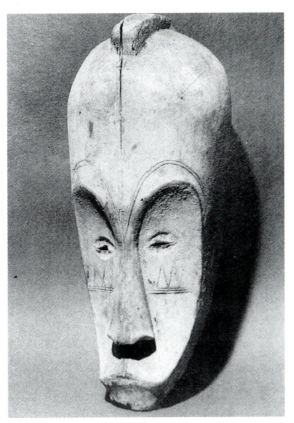

7-15 Fang tribe, mask, Gabon, nineteenth century. Painted wood, 19⅝" high. Vérité Collection, Paris.

of masks. As discussed in Chapter 1, such masks are not really perceived of as art by the people who make and use them but instead as vital parts of their tribal rituals. Most African sculpture in wood is carved from a single piece of a tree, chosen while it is still living, so the shape of the sculpture is limited by the shape of the trunk.

Most sculptors do not usually limit themselves in this way and may join several pieces of wood together to create the effect they want, as in the *Kongorikishi*, a guardian figure that stands at the entrance of a Buddhist temple in Nara, Japan (7-16). It almost bursts into the space it inhabits; one of a pair, it was meant to drive away evil spirits by its fierceness. This dramatic "Guardian King" stands 26½ feet tall and was made in 1203 by Unkei, the most famous Japanese sculptor of his age, with the help of many assistants. The guardian's furious expression and violent pose seem threatening to us but were reassuring to the worshippers who entered the Buddhist temple he protected. It is as if the Buddhist artist attempted to capture the

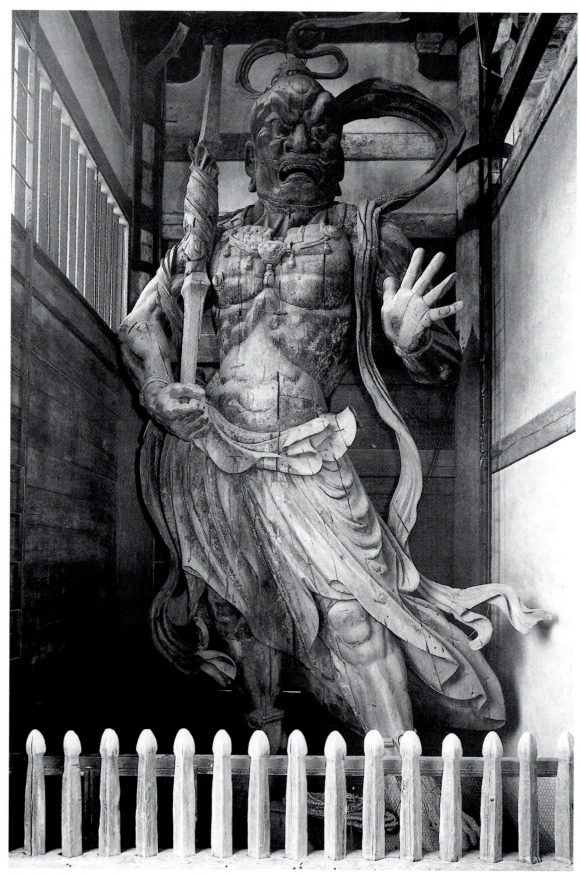

7-16 Unkei, Kongorikishi (guardian figure), 1203. Wood, 26′ 6″ high. Todaiji Temple, Nara, Japan.

frightening, demonic forces in the universe and turn them to a positive end.

STONE CARVING

The most famous sculptures in the Western tradition, like Michelangelo's *David* (12-18) or the *Aphrodite of Melos* (10-21), are examples of master carving in stone. Sculptors working on stone use metal tools of three types: the *point*, the *claw*, and the *chisel*. The point is used to cut into the stone block, the claw to continue shaping the form, and the chisel to add detail and finish to the stone surface. Few artists have equaled the skill of the Italian Baroque sculptor Gianlorenzo Bernini. He had the ability not only to unlock complex figural groups from huge blocks of stone but also to finish the stone surface so beautifully that the illusion of texture, such as skin or hair, is created. His *Apollo and Daphne* (7-17) seem not only like living creatures but also seem to be moving. In the ancient myth on which the statue is based, the god Apollo fell in love with the lovely nymph Daphne. As he was chasing and just about to overtake her, Daphne called out to the Earth goddess to save her from Apollo's unwanted advances. Gaia heard her cries and came to her rescue: The instant Apollo touched her, Daphne was transformed into a laurel tree. Bernini shows this miraculous moment. Although Apollo's hand grasps her side, he is soon to be disappointed. Daphne's fingers are sprouting branches and leaves (7-18); her toes are taking root. The fine details of the statue are miraculous, too. Marble is very brittle at this scale; one slip of a chisel and a branch would be lost. Notice how the smooth perfection of Bernini's carving contrasts with Rodin's more robust modeling. In choosing this subject for his work, Bernini is deliberately demonstrating his own godlike power to transform marble into flesh, bark, and hair—just as the Goddess Gaia changed Daphne into a tree.

MODERN SCULPTURAL METHODS: CONSTRUCTING AND ASSEMBLING

Like modern painters, modern sculptors have explored new media and techniques, some of which have been borrowed from industrial

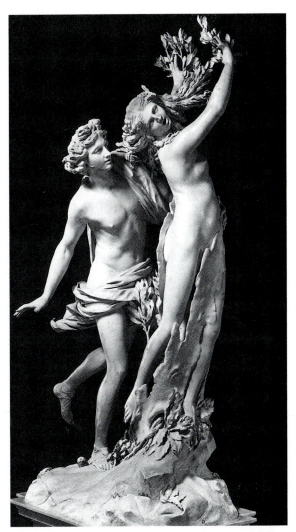

7-17 Gianlorenzo Bernini, *Apollo and Daphne*, 1622–1625. Marble, life-size. Galleria Borghese, Rome.

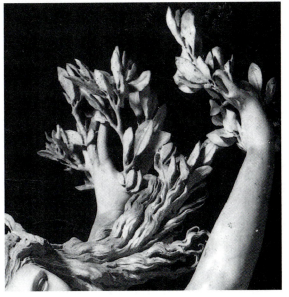

7-18 Detail of figure 7-17

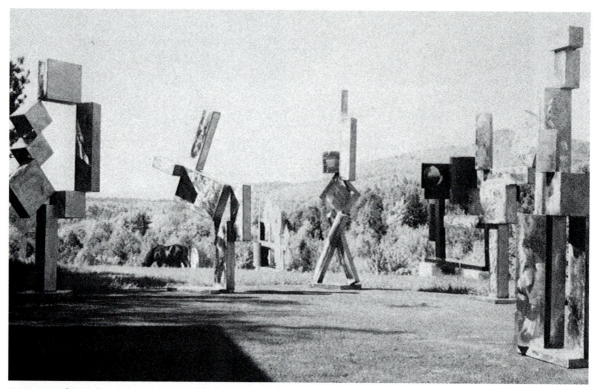

7-19 David Smith, *Cubi* series in field at Bolton Landing, New York, © 1965. Photo by David Smith.

technology. Sculptor David Smith (7-19) used methods of *welding* and *soldering* he learned while working as a young man in an automobile factory to build large stainless steel structures where simple geometrical forms are balanced against each other. The strength of welded steel connections allowed Smith to use forms of enormous weight in an almost light-handed way. The steel rectangles, cylinders, and bars are arranged so the open areas between them become part of the design. Smith felt strongly that his work should be seen outside, in bright sunlight. He often added color by painting or texture by burnishing the surface of his finished composition.

Cantileve (7-20) by Nancy Graves makes use of several sculptural processes. Looking slowly through the sculpture, you can identify shapes like fans, sticks, leaves, bones, branches, and berries that Graves collected and from which she made bronze casts. These individual casts were next assembled by the artist like a three-dimensional collage into the 8-foot-tall sculpture, then welded together and painted in a variety of colors. Like David Smith, part of Graves's intention is to capture and enclose empty spaces. The interlaced lines of the sculpture vary from thick

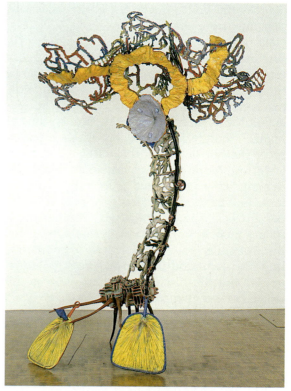

7-20 Nancy Graves, *Cantileve*, 1983. Bronze with polychrome patina, 98″ x 68″ x 54″. Collection of Whitney Museum of American Art, New York (purchase with funds from the Painting and Sculpture Committee 83.39). © 1983 Nancy Graves.

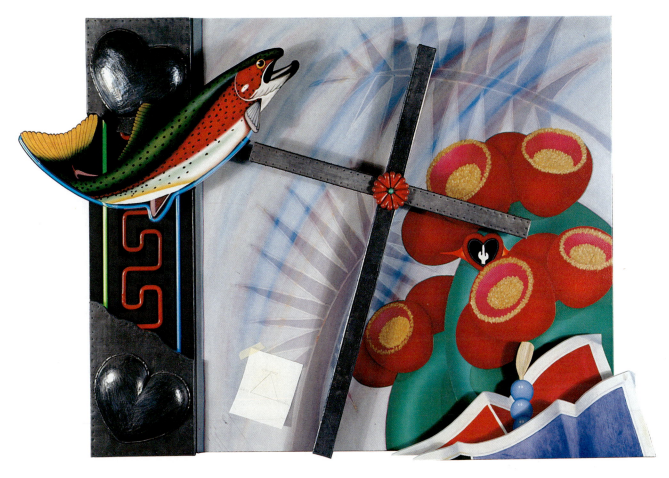

7-21 Rudy Fernandez, *Pyramid V (Birth of a New Race)*, 1991. Mixed media, 46" x 60" x 9". Collection of Dr. Delwin Worthington and Diana Worthington, Phoenix.

to thin, straight to curly, reaching out and making the space around the sculpture part of the design. The whole sculpture seems to be animated, capable of coming to life and moving, reversing the process of Daphne's transformation into a tree.

MIXED MEDIA

Rudy Fernandez's *Pyramid V (Birth of a New Race)*, 7-21, is a work of art categorized as **mixed media**. As discussed in Chapter 5, mixed media, not surprisingly, refers to art that combines more than one of the media. It is most often used in reference to art that has both two- and three-dimensional media. In *Pyramid V,* the frame is made out of lead with raised hearts, colored neon tubing arranged in a pattern, and painted wood. The image has both flat illusionistic painting, like the prickly pear cactus, and actual three-dimensional objects, like the fish and the cross.

The mix of media is appropriate to Fernandez's theme: the mixing of the Spanish and Indian cultures after the conquest of Mexico. The subtitle of the work refers to the *mestizos* who came from the melding of cultures, quoting a plaque Fernandez saw in a square in Mexico City. It read, "This was not the conquest of one race over another but the birth of a new race." A *mestizo* himself, Fernandez creates work that also relates the blend of influences, both past and present, that formed the artist. Fernandez grew up in the Southwest; his Catholic upbringing and Chicano heritage have also influenced his art. His construction's format is borrowed from traditional images of saints surrounded with elaborate frames. Even his "signature" is a combination of symbols. Rather than signing his work, he places a heart design. As an art student, his signature was only black, reflecting his mood at the time. The red surrounding it came with the birth of his first child;

A Global View

EARTH ARTISTS OF A THOUSAND YEARS AGO

Earth Art is not just a contemporary phenomenon. In India, long before modern machinery was developed, temples were carved directly out of mountainsides. This is the subtractive method of sculpture taken to the ultimate degree. Majestic and elaborate spaces hollowed out of solid rock, Chaitya hall at Karli (7-23) are both sculptural and, of course, architectural. By placing their temples in the earth itself, the ancient Indians established a deep bond with nature, sheltering themselves in the womblike shape of the human-made cave and thus satisfying a desire of Earth Artists throughout the centuries.

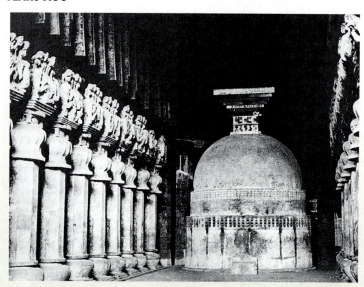

7-23 Chaitya hall, Karli, India, A.D. 50–70

7-22 Nancy Holt, *Sun Tunnels*, near Lucin, Utah, in the Great Salt Lake Desert, 1973–1976. Four concrete pipes, each 18″ long, 9½″ diameter; "X" configuration, 86′ from end to end across axis. The tunnels are aligned with the sun on the horizon (sunrises and sunsets) on the solstices.

the wings represent the female side of the universe. The cactus points to the central influence of the Southwest in his life and art.

EARTHWORKS

Earth Art is an outgrowth and expansion of installation art—art that not only provides an environment but also leaves the gallery and interacts directly with nature. Nancy Holt, like many contemporary Earth Artists, is interested in restoring humanity's connection to nature and the heavens. Her *Sun Tunnels* (7-22) are four concrete tubes that are 17 feet long and 9 feet in diameter. They were positioned carefully in the Great Salt Lake Desert in Utah so visitors inside of them can see sunrises and sunsets at both summer and winter solstice. They are therefore related to ancient earthworks like *Stonehenge* (7-24) in England. Those monolithic stones are believed to have been used for observation of the

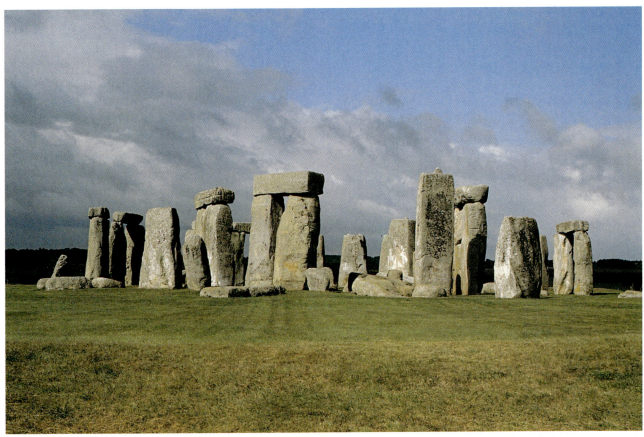

7-24 Stonehenge, Salisbury Plain, Wiltshire, England, *c.* 2000 B.C. Stone, 97′ in diameter x approximately 27′ high.

heavens, to calculate astronomical cycles, and for the purpose of timing religious ceremonies. *Sun Tunnels* also provides beautiful views of the desert landscape through its circular openings. On a more practical level, it also provides relief from the intense heat of the desert in its shady interior. From inside, small discs of light in the shape of constellations can be seen. These are the result of holes cut in the concrete tubes.

Many contemporary Earth Artists have actually carved the earth with bulldozers, treating it as a material for enormous sculptural works. Others have built up huge con-

structions of stone. Earthworks utilize the subtractive and additive methods of sculpture on the grandest scale.

We have seen in this chapter that sculpture is a dynamic field, retaining methods used in the Ice Age but also developing new media and approaches. It is not hard to be swept up in the excitement over the possibilities for contemporary artists when one hears the installation artist Judy Pfaff say, "What's happening now in sculpture seems really wide open and generous." One of the pleasures of art today is to see artists take "all sorts of permission and run . . . with it, full out."

ARCHITECTURE

THE ART OF ARCHITECTURE

Architecture has been called both the greatest and the least of the arts. The architect Walter Gropius called it "the most public of arts." Because important buildings often incorporate sculpture, paintings, murals, frescos, or mosaics, as well as decorative objects, architecture is also known as the "Queen of the Arts," uniting and ruling over a kingdom of different media. Architecture is also simply the largest art form, with pyramids, fortresses, and skyscrapers rivaling the drama of mountains and other natural wonders. A city like New York, Tokyo, Paris, or Rome—a collection of structures designed and built by humans—is as much a "wonder of the world" as the Grand Canyon.

Yet architecture is sometimes considered less "pure" than the arts of painting and sculpture because, like the decorative arts and design, it is meant to be *useful*. We do not put buildings or bridges on pedestals or hang them on gallery walls—we live in them, we move through them, and often we do not see them as art at all. But architecture is the most omnipresent form of art. Since it is experienced by nearly everyone on our planet, architecture can be said to be a universal art form.

Instead of needing to search it out, all we need to do is open our eyes, because architecture of some kind surrounds us wherever we live.

Like sculpture, architecture is a three-dimensional art form; it cannot be comprehended in a single glance or understood by standing in only one spot. Yet architecture seems to exist in more than three dimensions. Because most structures are designed to have both an outside and an inside, to really appreciate a work of architecture, we must walk not only around it but also *through* it. As we relate interior to exterior views in our minds, structures exist in memory as well as space and therefore acquire the fourth dimension of *time*.

THE ARCHITECT AS ARTIST AND ENGINEER: PLANNING

The architect must be a cross between a pure artist and an engineer, because a building is not meant only to be seen—it must be functional. Buildings have to match the purpose for which they are constructed. A train station must funnel thousands of people in and out; a home should be comfortable and hospitable. Floors must support each other; walls should not fall in or out. Skyscrapers should be able to stand in high winds and even earthquakes. In modern buildings, the architect must also

plan for services such as heating, cooling, electricity, and the circulation of air. Besides aesthetics and engineering, there is also a business side to architecture. As in all commissioned art, the architect must consider the needs of the patron and the cost of materials in any design decision.

As part of their design process, architects make drawings and models. Some architectural drawings, like Frank Lloyd Wright's, are as beautiful as the final buildings. In 1936, the great American architect made a preliminary visit to a site for a client's new home in the woods of Bear Run, Pennsylvania. After seeing a mountain stream with a waterfall, he came up with the inspired idea of placing the house over the cliff and letting the water pass underneath it. He made *floor plans* or flat views from above (8-1); **elevations** or views from the sides (8-2); and **perspectives**, views that give a three-dimensional impression of the new building in its setting (8-3). These were shown to the client and, with minor

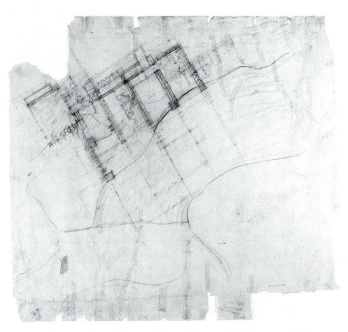

8-1 Frank Lloyd Wright, Kaufman House (Fallingwater), Bear Run, Pennsylvania, 1936–1939. Preliminary study of the floor plans; different levels are drawn in different colors.

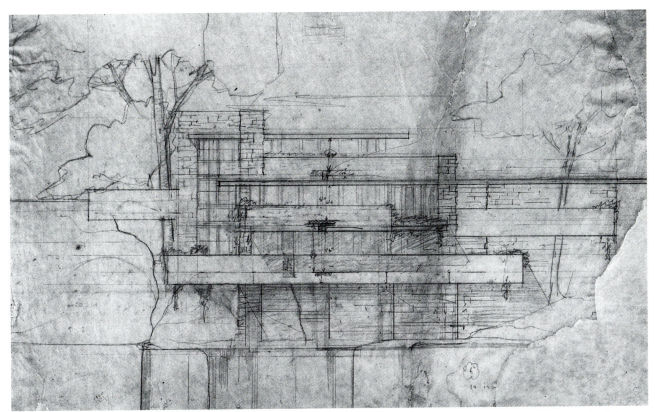

8-2 Frank Lloyd Wright, Kaufman House (Fallingwater), Bear Run, Pennsylvania, 1936–1939. Preliminary sketch of the south elevation.

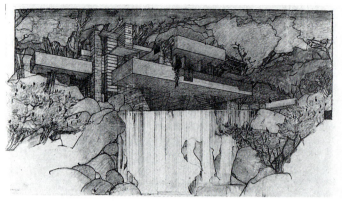

8-3 Frank Lloyd Wright, Kaufman House (Fallingwater), Bear Run, Pennsylvania, 1936–1939. Presentation drawing.

modifications, became a modern masterpiece, the *Kaufman House (Fallingwater).* By comparing the drawings to a photograph of the finished building (8-4), you can see how close it is to Wright's original conception.

HARMONY OF EXTERIOR AND INTERIOR DESIGN

Wright was one of the leading exponents of the importance of harmonizing the interior and exterior design of a building. When Wright planned the V. C. Morris gift shop in San Francisco (8-5), he wanted to create a spe-

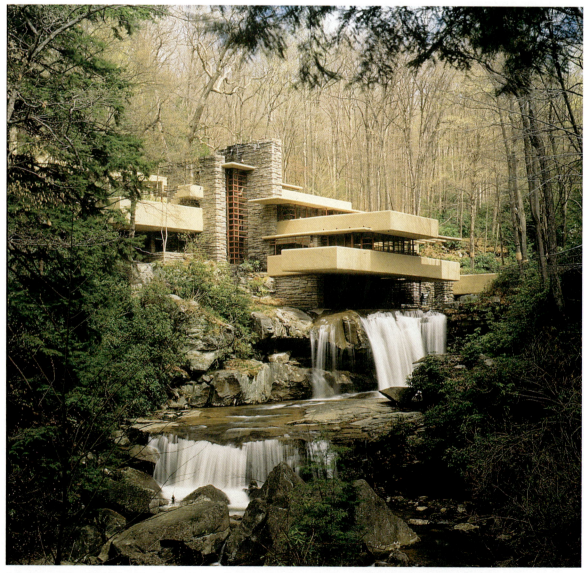

8-4 Frank Lloyd Wright, Kaufman House (Fallingwater), Bear Run, Pennsylvania, 1936–1939. Ezra Stoller © Esto.

cial setting for the display of glass objects. Both its **facade** (the side of the building facing the street) and its interior (8-6) reflect the rounded shape of the glass displayed and sold there. This building is now a gallery, aptly renamed "The Circle Gallery" because the theme of the circle is everywhere. Visitors enter through a round, arched doorway that leads into a tunnel and echoes the circular shape of the floor plan, the design of the interior furnishings, the curving staircase that hangs in midair, and the "porthole" display cases.

HARMONY WITH NATURAL SETTING

The natural setting of each building also has an effect on its appearance and often influences the way it is designed. As in Wright's Fallingwater, to plan a successful building, an architect must take into consideration local climate, available building materials, the

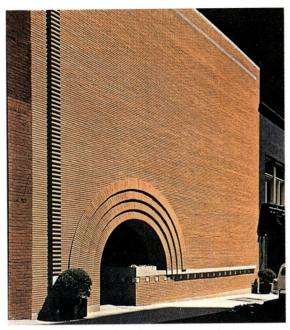

8-5 Frank Lloyd Wright, V. C. Morris gift shop, San Francisco, 1947.

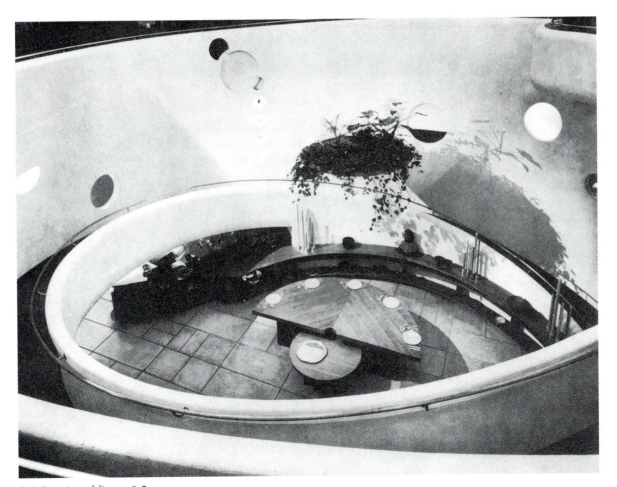

8-6 Interior of figure 8-5

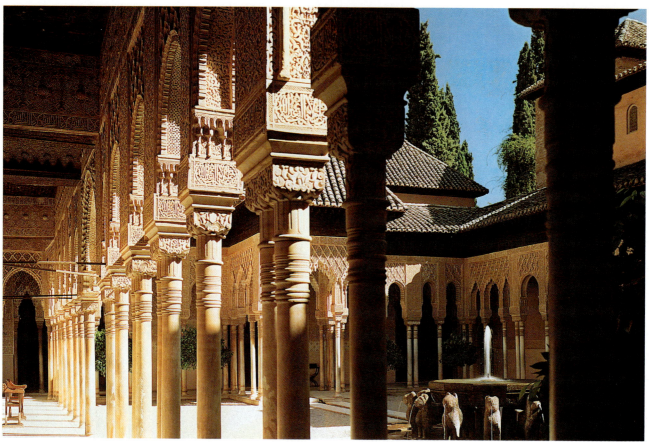

8-7 Court of the Lions, the Alhambra, Granada, Spain, 1354–1391

building site, and its surroundings. The architect must also consider how to orient a building to take advantage of natural light, attractive views, and prevailing wind patterns. In certain climates, the design of exterior spaces such as patios, courtyards, and **arcades** (covered walkways) can be just as important as that of the buildings themselves. A beautiful example of the power of these spaces is the fourteenth-century *Court of the Lions* in the Alhambra palace in Spain (8-7). While light pours into the center of the king's private courtyard, the covered walkways provide both cool shelter from the hot sun of Spain and a glorious visual spectacle of pattern and rhythm through the harmony between the latticed light and the decoration of the columns and ceilings.

ART TO BE LIVED IN

Architecture is different from the other arts because it is lived in. Although some people might think of painting or printmaking as a luxury, pleasant but peripheral to our struggle for existence, a shelter is considered one of the necessities of life. Like a womb, architecture protects and encloses us from the hostile forces of the outer world.

Early humans found shelter in caves, made simple tents from animal hides, or built huts from locally available materials like mud, sticks, grass, bamboo, and the bones of large animals. Even today some people live in traditional, handmade dwellings. Such indigenous shelters are rarely given the name of architecture, although they often reflect a sensitivity to the artistic principles of proportion, rhythm, and harmony. These types of buildings might be called "primitive," but they are often ideally suited to the climate and materials of a particular location. Developed over centuries, what has been called "non-pedigreed" architecture is the result of communal efforts. That result can be both practical and aesthetically satisfying, as can be seen in the rounded and symmetrical forms of a traditional Dogon village in Africa (8-8).

But when historians look back to the beginnings of architecture as an art, they usually think of the magnificent structures of the "great" civilizations of the past. In the ancient world, temples, palaces, monuments, and tombs were the most important art forms. Also, because they are the most visible and lasting remnants of their era, their importance has actually been magnified by the passage of time. No examples of Greek mural painting remain; many statues of the golden age of Greece exist only in later Roman copies. But the architecture of the Athenian *Acropolis* (8-9) lives on as a symbol of Greek culture, equivalent to the *Iliad* and the *Odyssey*—the works of the great Greek dramatists and philosophers. The Greeks built edifices that speak of human intellect separate and above earthly concerns. *Architecture, like all art, reflects the needs and ideals of its time.*

THE PARTHENON

The word *acropolis* means simply "high place," and the Greeks chose such a hill in Athens as a setting for their most important religious center. In 480 B.C., during the Persian Wars, the original buildings and statues were destroyed, but the Athenians decided to rebuild the temples to be even more magnificent. The centerpiece of the new design was the famous *Parthenon* (8-10, and seen at the top of 8-9), a temple devoted to Athena, the patron goddess of the city. Its marble exterior enclosed a magnificent 40-foot statue of the goddess in ivory and gold by Phidias, the most famous sculptor of the day. The fame of the temple's architects has lasted, too. Almost twenty-five hundred years later, we still know their names—Iktinos and Kallikrates.

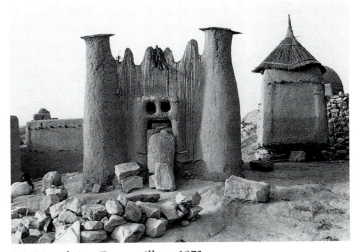

8-8 Binu shrine, Dogon village, 1972

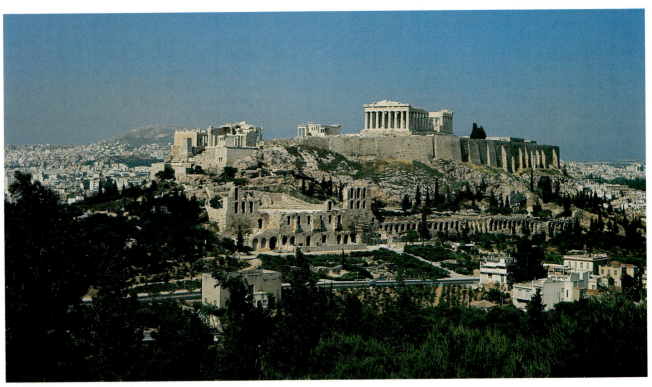

8-9 Acropolis, Athens, Greece

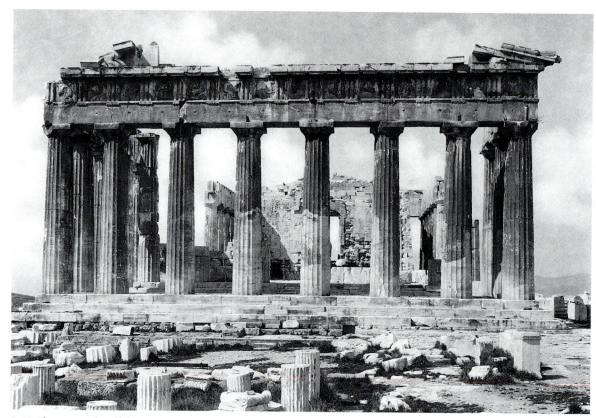

8-10 Iktinos and Kallikrates, rear view of the Parthenon, Acropolis, Athens, Greece, 448–432 B.C.

Like any building with a long history, the Parthenon has had many different occupants and functions over the centuries. It became a Christian church during the era of the Holy Roman Empire and an Islamic mosque in later centuries. For two thousand years, it remained largely intact, not the ruin we see today. Then, in 1687, while being used by the Ottoman Turks to store gunpowder, it suffered a direct rocket hit from the forces of the warring Venetians, and much of the interior was blown up. In 1801, a British aristocrat found many of the priceless marble statues lying about in a state of disrepair. According to one's viewpoint, Lord Elgin either saved or stole these statues by shipping them off to England, where they remain, known as "The Elgin Marbles" in the British Museum. Despite all its troubles, the Parthenon is probably the most famous, and most studied, human-made structure in the world.

THE GREEK ORDERS

The *Doric* column used in the design of the Parthenon (8-11) was the earliest and simplest of the *Greek orders* (column style). Doric columns were unornamented, almost severe in their plainness. This purity was characteristic of early Greek art. For the Greeks, beauty was to be found in perfection of line, shape, and proportion, not excess decoration. It is this simplicity, this harmony and repose, that gives the Parthenon its universal appeal. Indeed, because of the abstract geometrical beauty of their designs, Greek temples have been compared to works of sculpture by many art historians. This is certainly demonstrated by the exquisite design of the *Temple of Athena Nike* (8-12), also on the Acropolis. In this little temple, slim *Ionic* columns (8-13), their **capitals** (tops) adorned with graceful **volutes** (spirals), harmonize with the delicate proportions of the structure. A more decorative order, the *Corinthian* column (8-14), was rarely used by the Greeks. It was more consistent with Roman tastes, and such columns can be seen supporting ornamental archways at the emperor Hadrian's private villa at Tivoli (8-15). Hadrian was a master builder. He is said to have designed one of the most beautiful buildings in the world, the famous

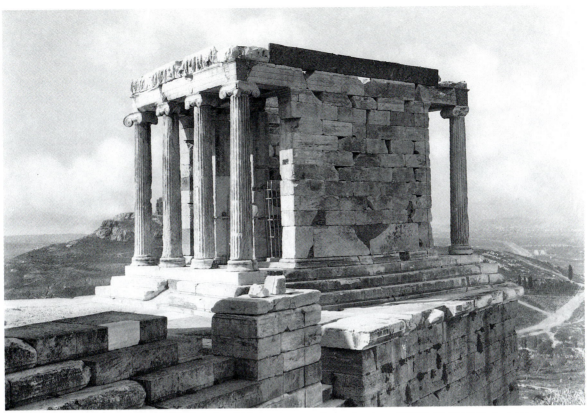

8-12 Kallikrates, the Temple of Athena Nike, Acropolis, Athens, Greece, 427–424 B.C.

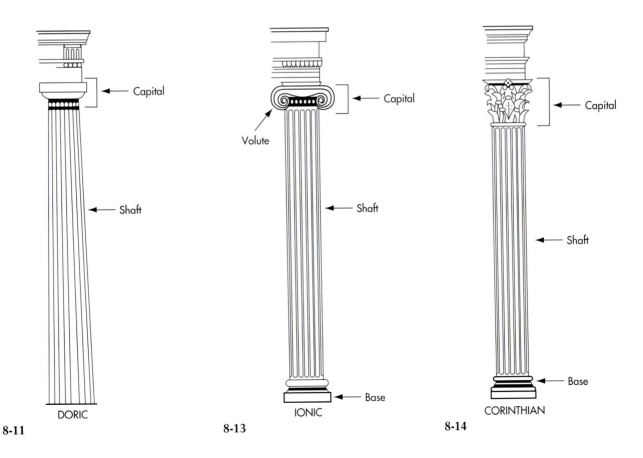

Capital

Shaft

DORIC

8-11

Capital

Volute

Shaft

Base

IONIC

8-13

Capital

Shaft

Base

CORINTHIAN

8-14

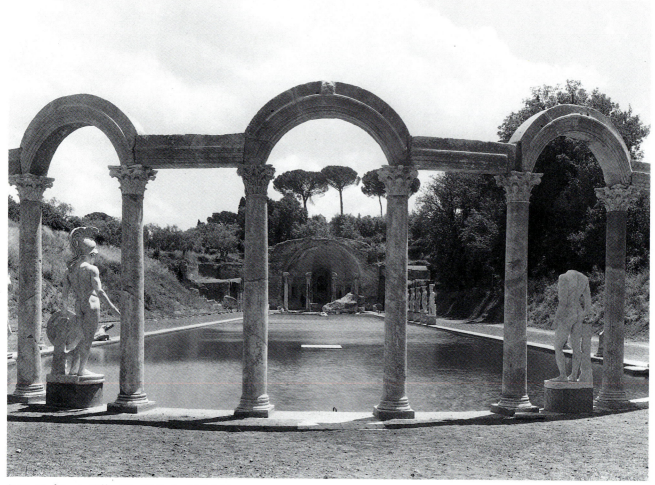

8-15 Hadrian's Villa, Tivoli, Italy, 118–134

Pantheon (10-31), which uses Corinthian columns both outside and inside.

MATERIALS AND METHODS

Architectural structures have been categorized and described in many different ways. Just as two- and three-dimensional art forms can be discussed in terms of both their materials (or media) and techniques, so various types of architecture can be organized by building matter—such as stone, wood, clay, brick, glass, and steel—and their method of construction. Each material has different visual, tactile, and tensile qualities; each produces a different "impression"; and each is capable of constructing structures of different sizes and shapes.

EARTH, CLAY, AND BRICK

One simple way to build is to pile up dirt, mud, or clay to form walls. The Dogon village was built this way. *Bricks* are blocks made of clay, usually hardened by being baked in ovens or kilns. Kiln-fired bricks can be glazed in different colors and arranged in interesting patterns. During the early years of the American republic, or what is called the *Federal period* in architecture, many attractive American mansions such as Thomas Jefferson's *Monticello* (see 8-41) were constructed of brick.

Adobe is a kind of sun-dried brick, made of clay mixed with straw, which was used by Native American tribes in the southwest to build their settlements. In Taos, New Mexico, traditional adobe *pueblos* (8-16), first con-

structed about five hundred years ago, are still in use and utilize the **bearing wall** method, where the walls themselves support the weight of the roof and floors above. The sun-dried mud bricks are stacked to form thick walls, which are stuck together with a "mortar" of wet mud. Each building is topped with logs that protrude from the outer wall. Branches and grass are laid over these logs to form a roof, which is then covered with another thick layer of mud. Finally, the outlines of the bricks are hidden by a hand-smoothed coating of mud, or adobe "plaster," that can be refreshed every year. In adobe construction, the window openings must necessarily be small, since the walls are what hold these structures up. This is actually an advantage in a desert climate, where it is beneficial to keep light, and heat, out of the buildings. The massive mud walls act as natural temperature regulators, providing shade and coolness during the heat of the day as the walls absorb the sun's energy. At night, as the environment cools, these same walls release their heat slowly and keep interior temperatures relatively stable and comfortable.

STONE

Buildings made of brick are sometimes referred to as being constructed of *masonry*, but that term is more commonly used when talking about structures built of blocks of stone, such as marble or granite. Stone or masonry construction has historically been associated with strength. Castles, fortresses, and the protective walls around settlements were typically built out of stone. Masonry construction was preferred for buildings meant to last.

The history of stone buildings is also a story of efforts to open wider and wider areas on the exterior and inside them. The Greeks perfected a form of construction called **post-and-lintel** (8-17), where posts or columns support horizontal lintels or cross beams. The Parthenon's entrance (8-18) provides a clear example of this method. The heavy weight of stone lintels keeps the columns steady. This method permits more open buildings than those constructed by bearing-wall methods and is just as permanent. Temples built of stone thousands of years ago, like those on the Acropolis, are still standing.

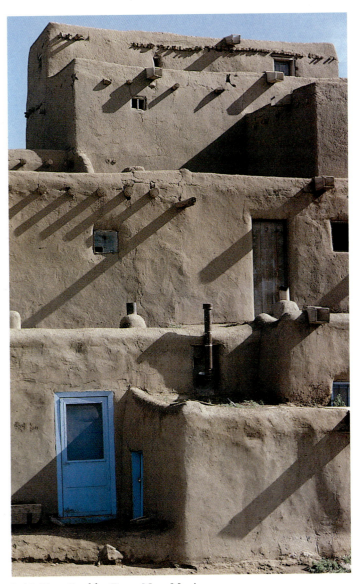

8-16 Taos Pueblo, Taos, New Mexico

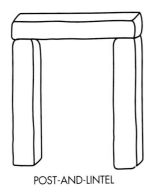

POST-AND-LINTEL

8-17

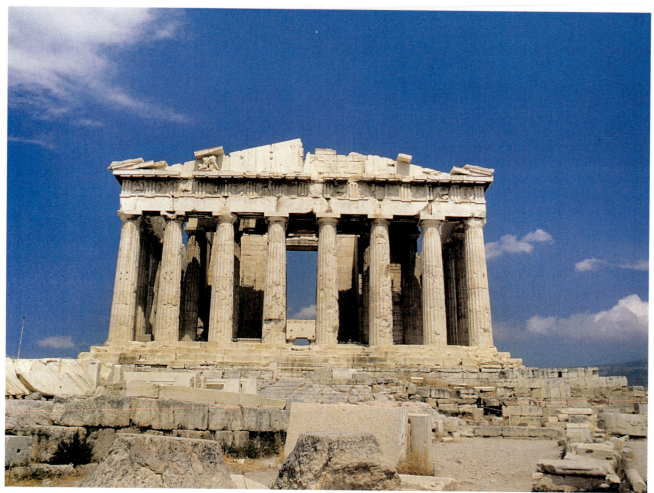

8-18 Entrance to the Parthenon, Acropolis, Greece

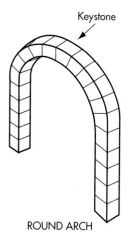

Keystone

ROUND ARCH

8-19

A later development in stone construction was the **arch** (8-19), used extensively for the first time during the Roman Empire. The arch allowed far wider spaces between columns than post-and-lintel construction. The huge entrances into the Colosseum in Rome (Chapter 10) are rounded arches. Triumphal arches like the *Arch of Titus* (8-20) are excellent examples of the huge openings permitted by arches.

Such triumphal arches were constructed by the Romans throughout the Mediterranean world, symbols of victory to mark their territory and reminders of their governing authority. Carved into the arches were relief sculptures illustrating military scenes and inscriptions that hailed the conquering heroes. The great size of the arches was necessary because of their part in one of the most popular Roman events—the triumphal march.

In these parades, trumpets would announce the arrival of their victorious generals on chariot, followed by Roman legions, slaves, conquered treasures, and humiliated enemies.

The use of the arch was expanded during the Middle Ages. **Barrel vaults** (8-21), as seen in the nave of the *Church of Sainte-Madeleine at Vézelay* in France (8-22), opened up large and long public spaces in stone buildings, particularly cathedrals. **Groin vaults** (8-21) are made by crossing two barrel vaults at right angles. Buildings made with barrel and groin

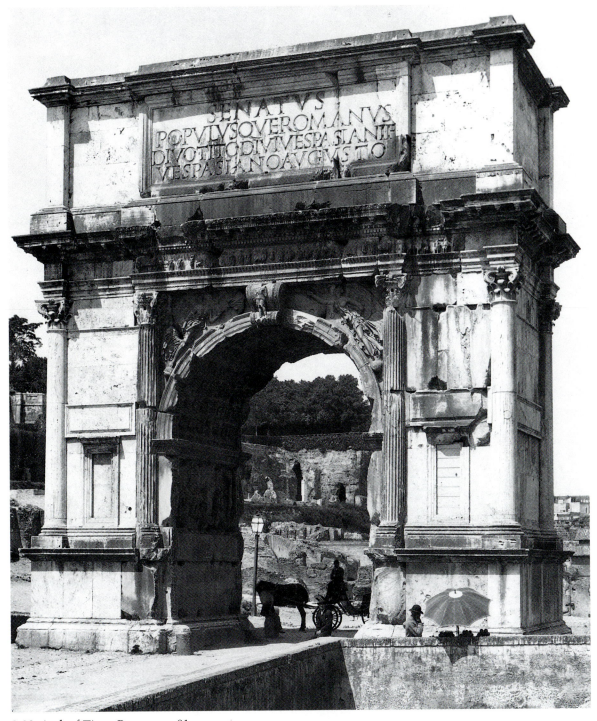

8-20 Arch of Titus, Rome, A.D. 81

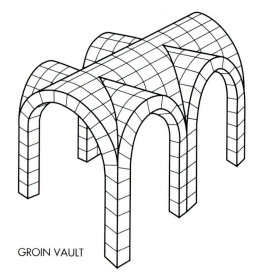

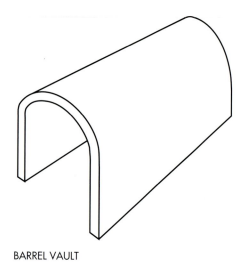

BARREL VAULT GROIN VAULT

8-21

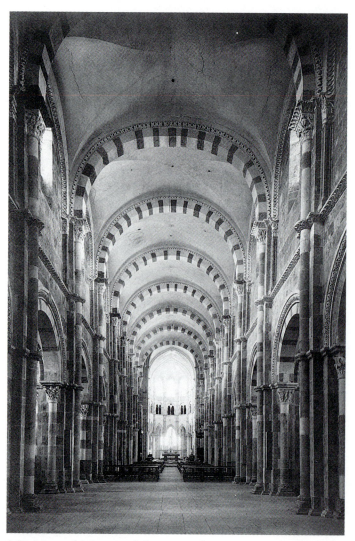

8-22 Nave of Sainte-Madeleine, Vézelay, France, twelfth century

vaults were, however, limited in height by the width of each arch. Only small windows were possible without weakening the stability of the arches. The awe-inspiring impression of Gothic cathedrals, like *Amiens Cathedral* in France (8-23), is a direct result of the desire to let more light into cathedrals, which led to the invention of the **pointed arch** (8-24). This allowed higher ceilings in the interior and large openings in the outer wall that were filled with glorious stained glass.

Stone has remained a popular and enduring material for building. Great mansions and palaces, as well as important public and religious buildings such as museums, churches, schools, and centers of government, were usually built of stone well into the twentieth century. An architect who really exploited the possibilities of natural stone was the American H. H. Richardson. For the *F.L. Ames Gate Lodge* (8-25), built in 1880 as both a gatehouse and guesthouse, his friend and patron F. L. Ames gave Richardson unusual freedom to express himself architecturally. The walls, built of local stone, blend harmoniously with the surroundings and seem to grow out of the landscape. The rough-cut stones are graduated in size from the huge boulders at the base of the gatehouse to smaller, cobblestone-sized rocks at the top of the tower. The result is a bold structure that seems to have as much in common with a geological formation like a mountain or a natural bridge as it does with an ordinary house.

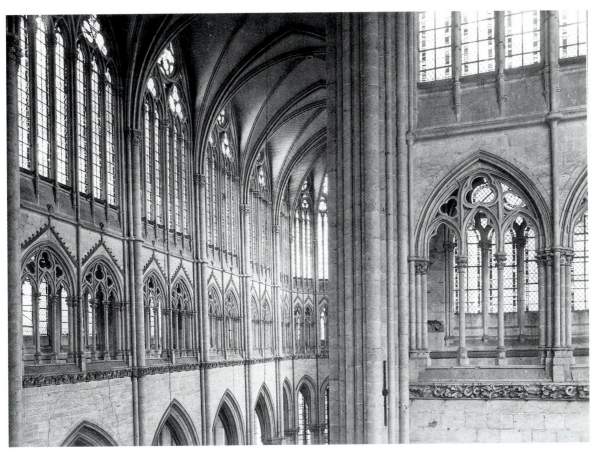

8-23 View of the triforium from the transept, Amiens Cathedral, France, begun 1220

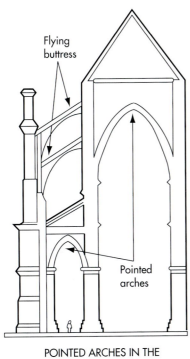

Flying buttress

Pointed arches

POINTED ARCHES IN THE
GOTHIC STYLE

8-24

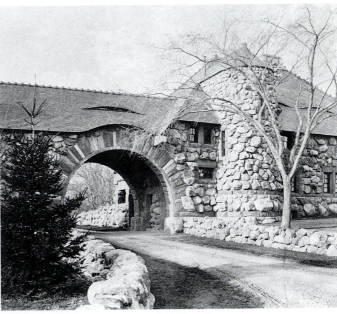

8-25 H. H. Richardson, F. L. Ames Gate Lodge, North Easton, Massachusetts, 1880–1881. View from the southwest.

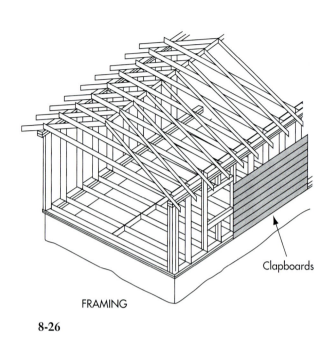

Clapboards

FRAMING

8-26

WOOD

Because of our vast forests, Americans have traditionally made more buildings of wood than any other material. From the rustic "log cabin" to the suburban ranch, wood has been the common material for houses people live in, or what is known as *domestic* architecture. Typical dwellings in colonial New England were built from vertical wooden supports and sturdy horizontal wooden beams, in what is known as **frame construction** (8-26), variations of which are still used today for most homes. The sides of the buildings were enclosed in *clapboard*, boards split or sawed so one edge was thinner than the other. These boards were then laid horizontally, overlapping so the thin edge was under the board above it in order to close out the harsh elements of a New England winter.

An excellent early example of one of these wooden houses is the *Parson Capen House* (8-27), still standing in Topsfield, Massachusetts, after more than three hundred

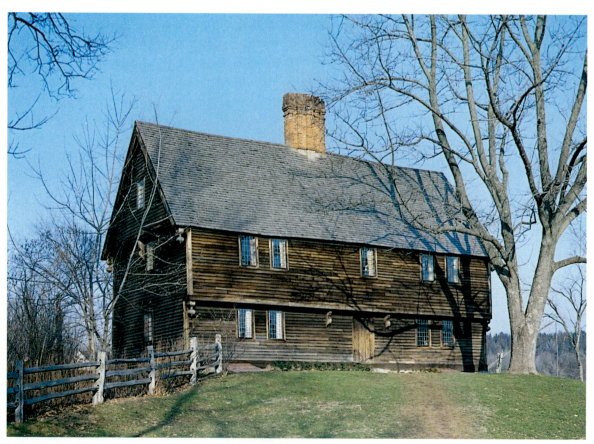

8-27 Parson Capen House, Topsfield, Massachusetts, 1683

years. Since the parson was the most important person in a Puritan town, this was the most imposing house in the area. It stood across from the community's meeting house on the town common.

The American use of wood seems to have been dictated primarily by convenience, rather than aesthetic preference. In contrast, the Japanese have always constructed in wood because they valued its natural beauty. Traditionally, the wood in Japanese buildings is not painted or finished in any way. For example, because its wood is unprotected, the Japanese Shinto *Ise Shrine* (8-28) has been rebuilt every twenty years for the last fifteen hundred years. The shrine is located in a forest setting, and the wood of the building is in harmony with both the site and the Shinto worship of natural forces. For the Japanese, the symbolic and aesthetic value of the natural wood outweigh the expense and inconvenience of regular rebuilding.

The Greene brothers were two California architects who, influenced by Japanese architecture as well as American traditions, developed a style of domestic housing that exploited the warmth and polish of natural wood for both interiors and exteriors. Their *Gamble House* (8-29, 8-30) has built-in wooden cabinets, closets, mantels, and stair railings, all with a beautiful hand-rubbed finish.

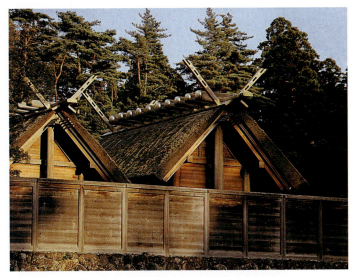

8-28 Ise Shrine, Japan. Rebuilt in 1973, reproducing third-century type.

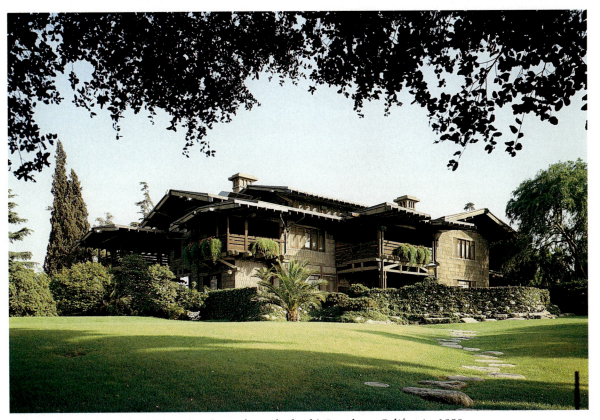

8-29 Greene Brothers, Gamble House (view from the back), Pasadena, California, 1908

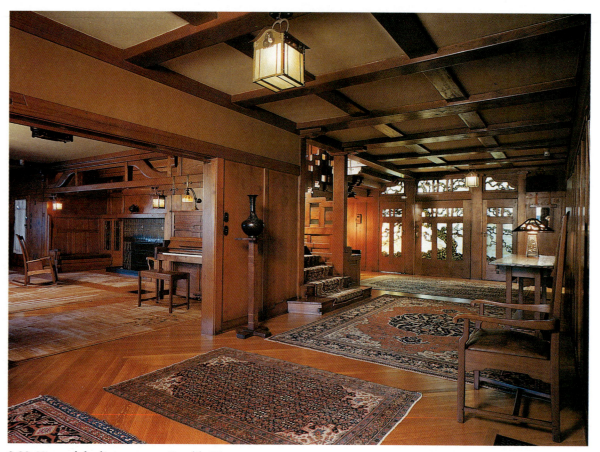

8-30 View of the living room, Gamble House

IRON AND GLASS

Until the nineteenth century, almost all buildings were made of clay, brick, stone, or wood. The industrial revolution created new techniques that made innovative building materials available. With the advent of coal furnaces and mass production, iron became one of the important "new" materials of the industrial age. This modern building material was often preferred for new types of buildings, such as factories, warehouses, railroad sheds, and large exhibition halls. Since iron was stronger than wood and lighter than stone, the pillars could be thinner and spaced further apart than wood or stone posts. Cast iron columns were combined with large panels of glass to make dramatic, airy exhibition halls, such as the famous *Crystal Palace* (8-31), built for the Great Exhibition of 1851 in London. Glass panels allowed the entry of unlimited sunlight—especially important in the era before electricity. The building, which resembled a gigantic greenhouse, was supported by a skel-

eton of iron. Its simplicity and efficiency, the streamlined shape and lack of historical ornamentation, foreshadowed the character of modern architecture.

The most famous and dramatic structure ever built of iron is the *Eiffel Tower* in Paris (8-32). At the time it was built, and for more than twenty-five years afterwards, the Eiffel Tower was the tallest building in the world—1,000 feet high. The tower was built not by an architect but by an engineer and builder of bridges, Gustave Eiffel, who had previously designed the metal skeleton for the Statue of Liberty. Eiffel's tower was constructed as the focal point for the Paris Exhibition of 1889, one of the many popular international trade exhibits of the second half of the nineteenth century.

The Eiffel Tower was largely an experiment in the potential of iron as a building material. In fact, it was built over the objections of many of the successful artists and writers of the time, who considered its design to be hideously ugly. Later, however, modern

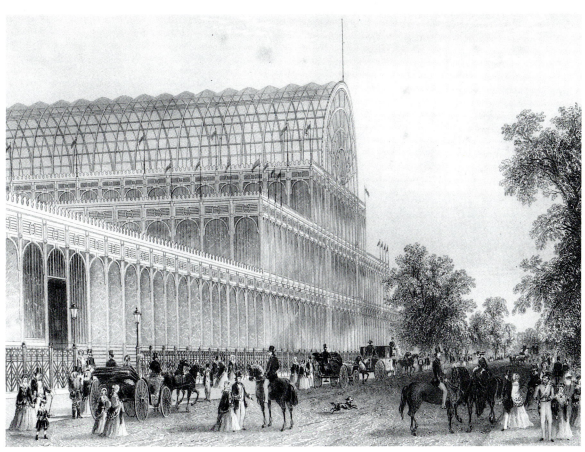

8-31 Crystal Palace, London, 1851

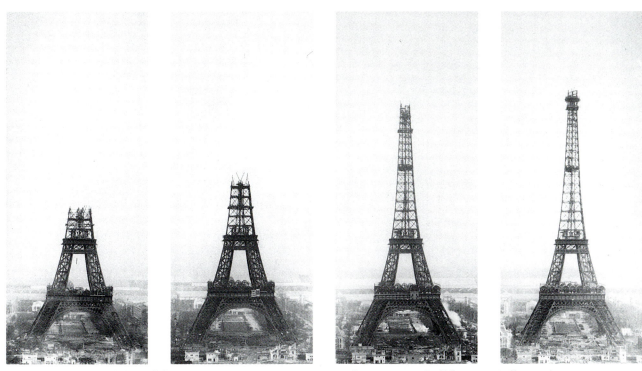

8-32 Construction of the Eiffel Tower, August 1888–1889. Musée d'Orsay, Paris (Eiffel Tower Collection).

artists became fascinated by the tower as a symbol of advanced technology, the machine age, and modern life.

STEEL AND GLASS

Despite its advantages, cast iron enjoyed a relatively brief period of popularity. Although it had been touted as fireproof, the dramatic Chicago fire of 1871 (and, ultimately, the burning of the Crystal Palace itself in 1936) proved otherwise. Iron actually melted at high temperatures, totally destroying the building it was meant to support. Yet something like iron was needed to hold up the new, taller buildings being constructed in large American cities.

Luckily, a better material was available for the support of the new tall buildings—*steel.* Steel is both stronger and lighter than iron, and with the development of the steel industry in the 1890s, it became affordable for builders. With a new kind of construction, **steel frame** or **cage** (8-33), which employs an interior skeleton for the structure, neither stone walls nor wooden beams are needed for support. Therefore, what we see as the exterior "walls" of a steel frame building are often simply a "skin" of glass. This dramatic innovation in structural design is reputed to have been invented when an architect noticed his bird cage could support a heavy stack of books.

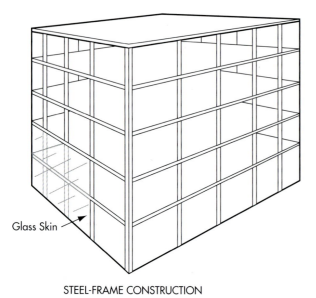

Glass Skin →

STEEL-FRAME CONSTRUCTION

8-33

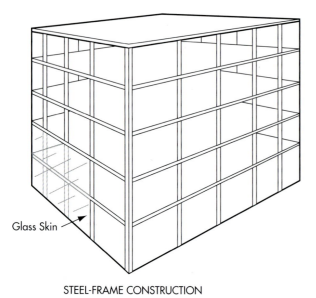

8-34 Ludwig Mies van der Rohe and Philip Johnson, Seagram Building, New York City, 1956–1958

With a better material and a new building method, the way was cleared for an American invention—the *skyscraper.* The best of these tall steel-and-glass towers, or skyscrapers, convey a strong impression of lightness, refinement, and elegance. Such buildings were often used as giant symbols of corporate money, power, efficiency, and modernity during their heyday in the mid-twentieth century. Companies vied with each other as they commissioned new headquarters by the foremost architects of the period, attempting to outdo their neighbors in sheer size. One of the most notable, and well-designed, commercial structures was the *Seagram Building* (8-34) in New York by architects Ludwig Mies van der Rohe and Philip Johnson. Built from 1954 to 1958, its exterior is made of amber-colored glass with bronze frames, or *mullions.* Because of this sensitive and unusual combination of materials, the building at night has been described as a giant "golden crystal."

REINFORCED CONCRETE

Reinforced concrete (or **ferroconcrete**) is another exciting new building material. Although concrete (a mixture of cement, sand, and gravel) was a favorite material of the ancient Romans, reinforcing that material with small iron rods enabled architects to make structures that were not only strong but also shaped in dramatic new ways. Most buildings in the past were designed of intersecting geometric forms, such as boxes, cubes, and half-spheres. Buildings of reinforced concrete can be shaped organically as well as geometrically, with walls and roofs like swelling waves instead of straight lines. The *Trans World Airlines (TWA) Terminal* at Kennedy Airport in New York (8-35, 8-36), designed by Eero Saarinen in the late 1950s, is an excellent example of the radical potential of reinforced concrete. The building's lines, both interior and exterior, suggest dynamic motion. Looking at its swooping silhouette, one can imagine that the entire terminal has just landed and is almost ready to take off again. Interior features such as ticket and information

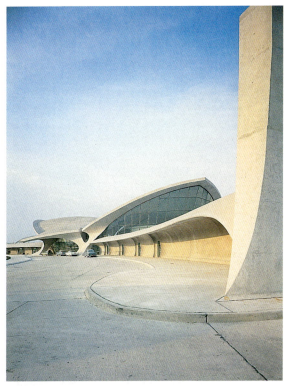

8-35 Eero Saarinen, Trans World Airlines Terminal, Kennedy Airport, New York, 1956

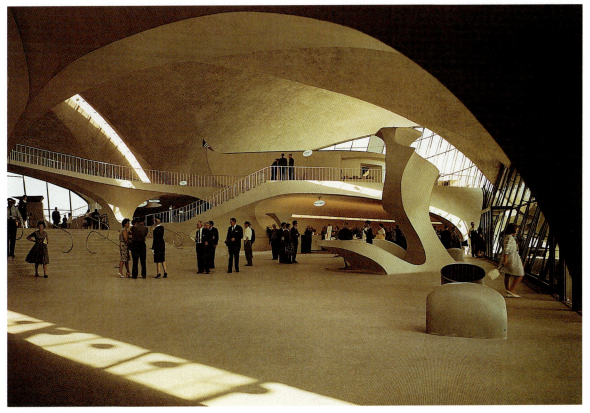

8-36 Interior of figure 8-35

booths, signboards, and stairways, resemble organically shaped abstract sculptures. While it remains a practical building, travelers are treated to a fascinating experience as they walk through the terminal. It seems more like a living creature rather than an anonymous and prosaic box. Far more than most structures, Saarinen's Trans World Airlines Termi-

nal exploits the symbolic possibilities of architecture as a three-dimensional art form. Every aspect of the building is meant to be "all of one thing," speaking of movement, flight, and escaping the bonds of gravity. Going beyond the idea of "form follows function," his buildings are functional not merely in a practical sense but in a spiritual one as well.

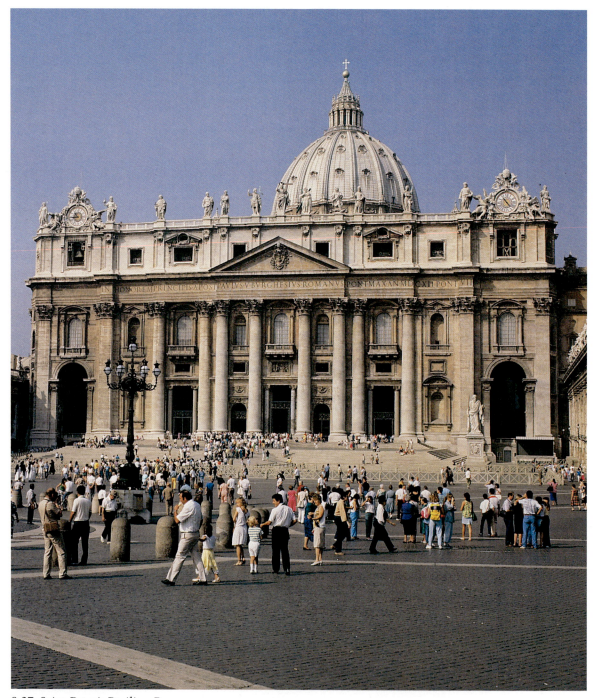

8-37 Saint Peter's Basilica, Rome

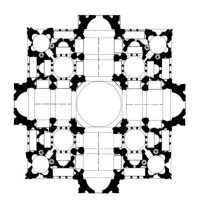
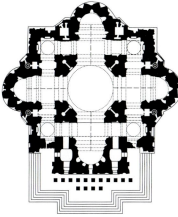
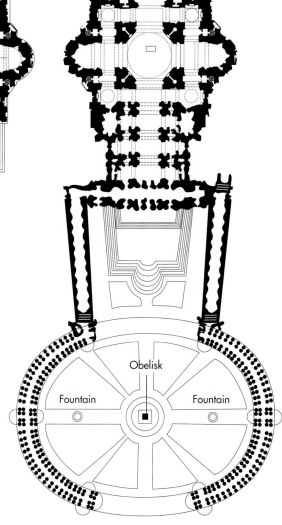

ARCHITECTURE IS A PRODUCT OF ITS TIME AND THE PAST

Great architecture is a combination of many things. It is a powerful marriage of materials and structure, a dialogue with its natural setting, a solution to practical considerations, and an expression of ideals. It is built on a knowledge of contemporary methods and an awareness of forms of the past. Like all art, architecture is the tangible expression of the needs and ideals of the time period in which it was created. We will end this chapter with two closer studies of buildings. One, Saint Peter's Basilica in Rome, was the work of several architects over one hundred fifty years. The second was the personal vision of one man, Thomas Jefferson's home at Monticello.

SAINT PETER'S

Some of the greatest monuments of the past are the result of many years, several generations, or even centuries of work. *Saint Peter's Basilica* in Rome (8-37), the center of Catholicism and for centuries the largest church in the world, was constructed by four major (and several minor) architects over a period of a century and a half. In the early Renaissance, Pope Julius II decided to rebuild the decrepit and very ancient Saint Peter's Basilica. The pope wanted to create a new monument that would rival in size and splendor the Roman ruins that remained in the city. In 1506 the project was given to Donato Bramante, who designed a large church in the form of a cross, the center of which marked the spot where Saint Peter (an apostle of

8-38 *(Left)* Bramante, 1506; *(Center)* Michelangelo, 1547–1564; *(Right)* Bernini, 1656–1663

Christ and the first bishop, or pope, of Rome) was supposed to have been buried. The ambitious interior *floor plan* (8-38, left) was actually based on a complex pattern of nine intersecting crosses, eight small domes, and one huge dome. Because of the mammoth scale of his plan, when Bramante died in 1514 very little of the building had been finished.

Michelangelo took charge of the project thirty-two years later. He criticized much of the work that had been done since Bramante's death and tried to return to the overall original plan, though with some simplifications. For example, he changed the interior space

from many crosses into a single cross intersecting with a square (8-38, center). He redesigned the exterior, adding colossal columns. Michelangelo also planned a high central dome but later changed his mind in favor of a lower dome, more like Bramante's. But Michelangelo, too, did not live to see Saint Peter's built. After his death an architect named Giacomo della Porta was given the job of building the dome and chose Michelangelo's earlier conception, probably because the higher dome was easier to build (8-39).

In 1603, almost one hundred years after work on Saint Peter's had begun, Carlo Maderno was given the job of enlarging and finishing the basilica. Maderno was directed

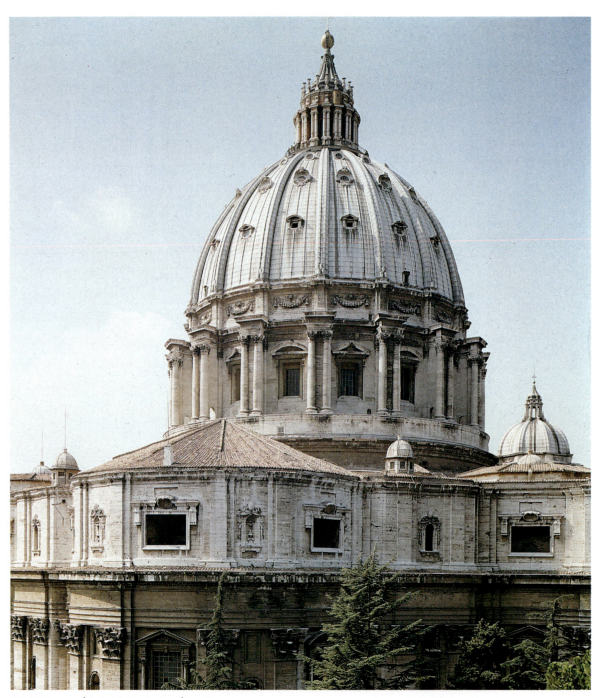

8-39 Dome of Saint Peter's Basilica, Rome

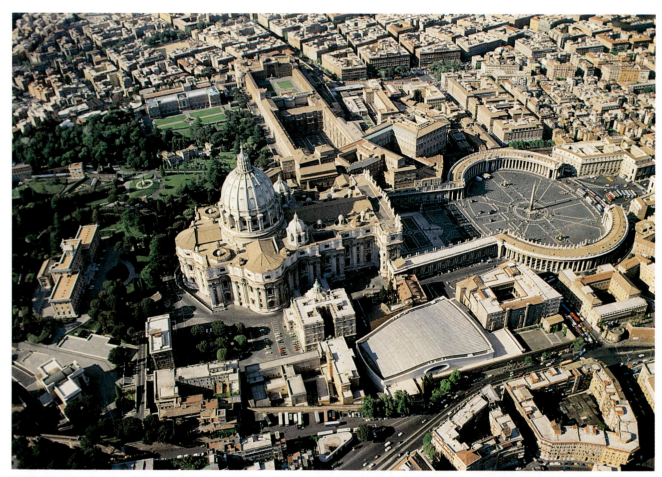

8-40 Saint Peter's Basilica and the Vatican, Rome. Apse and dome by Michelangelo, 1547–1564; dome completed by Giacomo della Porta, 1588–1592; nave and facade by Carlo Maderno, 1601–1626; colonnades by Gianlorenzo Bernini, 1656–1663.

to add a nave, or rectangular-shaped room, to the front of Michelangelo's Saint Peter's. He broke into the main facade of the building and projected out, changing the shape of the structure and bringing it forward into Saint Peter's square. This new facade (see 8-37) destroyed the perfectly symmetrical proportions of the Renaissance building and obscured the dome.

The last major architect to contribute to Saint Peter's was Gianlorenzo Bernini, the most famous sculptor of his time. Once surrounded by noisy, narrow streets with wandering animals, Saint Peter's was given a more appropriate environment by Bernini. He sculpted the space in front of the building by means of a **colonnade,** or row of columns, and the addition of a **piazza,** or courtyard (8-38, right; 8-40). His colonnade is like a pair of great arms that shelter a quiet, orderly courtyard from the distractions of everyday life and

draw pilgrims into the entrance. Thus the building's surroundings became self-contained and harmonious.

MONTICELLO

Thomas Jefferson was a man of diverse talents and interests—a farmer, statesman, and scholar as well as an inventor and architect. Heir to a comfortable Virginia estate, he can be described as a gentleman-amateur architect, a type common in the eighteenth century. While serving as the American ambassador to France, he had visited Italy and had seen the ancient ruins. But even before visiting Europe, Jefferson had studied classical architecture through English books. Jefferson was attracted to Greek and Roman architecture because of its historical associations of good government, as well as its style and simplicity. Now that

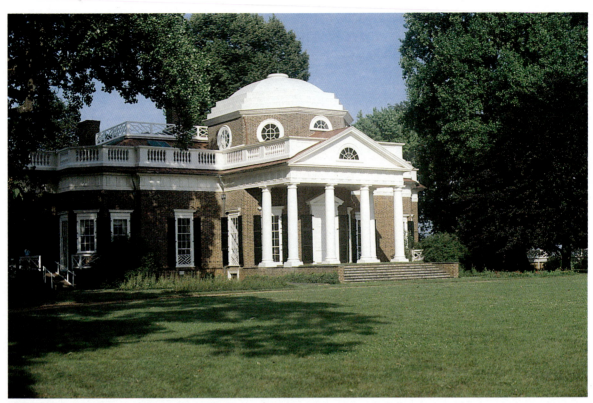

8-41 Thomas Jefferson, Monticello, Charlottesville, Virginia, 1770–1806

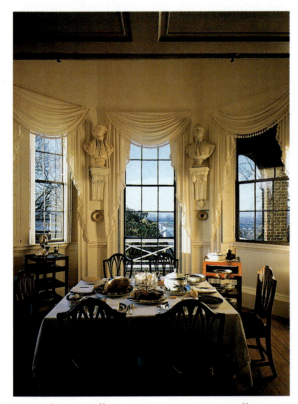

8-42 Thomas Jefferson, tearoom at Monticello

America was independent, he was eager to replace the British-influenced colonial style.

In *Monticello* (8-41, 8-42), Jefferson had the chance to design his own dream house. The home took more than thirty years to complete to his satisfaction. Set on top of a mountain (unlike other Southern plantation manors of the period), Monticello reveals an eighteenth-century taste for combining classical architectural elements, like columns, domes, and simple geometric shapes, with a natural, romantic setting. As a classical scholar, Jefferson was particularly fond of Roman poets who described the delights of country life in a villa, and he himself wrote about the view from his home:

> Where has nature spread so rich a mantel under the eye? mountains, forests, rocks, rivers. With what majesty do we there ride above the storms! How sublime to look down into the house of nature, to see her clouds, hail, snow, rain, thunder, all fabricated at our feet! and the glorious sun, when rising as if out of a distant water, just gilding the tops of the mountains, and giving life to all nature!

Stripped of excess ornament and conveying a sense of purity, Monticello is harmonious and calm. Its beauty can be appreciated at first glance; carefully designed in human scale, the building does not overwhelm or awe the visitor. Monticello looks like what it is—a building meant to encourage a mood of speculation and intellectual pursuits, as well as gracious family living.

THE INFLUENCE OF GREAT ARCHITECTURE OF THE PAST

The powerful expression of ideals in architecture can influence building for decades, even centuries to come. Monticello, itself a reflection of the endurance of classical Greek and Roman architectural ideals, had a profound and powerful effect on American architecture. Saint Peter's has also influenced countless buildings throughout the Western world. The style of our own *United States Capitol* building (8-43) owes as much to Michelangelo's dome as to Jefferson's promotion of neoclassicism for the government buildings of the new republic. It is just one example of the power of architecture to both express and transmit cultural values.

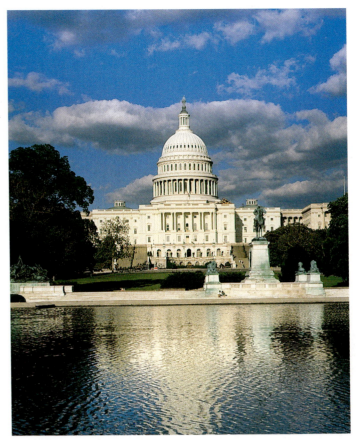

8-43 Benjamin Latrobe, United States Capitol, Washington, D. C., designed *c.* 1815

CHAPTER

9

CRAFTS AND DESIGN

Everyday, useful objects—either handcrafted or designed to be mass produced—are an immediate, accessible way for most of us to enjoy the power of art. Just as architecture is an art form we can experience directly, even live in, so *crafts* and other *applied* or *decorative arts* are things we live with. Attractive and functional, such decorative items can be made of almost any material. Ceramics, glass, wood, metal, and fiber are some of the most common craft media, while the *design arts* can be reproduced in materials ranging from paper to steel. Because both crafts and design interact with us in our normal lives, they occupy a special place in people's hearts, giving pleasure that is both aesthetic and nostalgic.

When we study the decorative arts, we are really looking at both art and history. These objects can tell us about the lifestyle of the people who used them, as well as about their artistic taste. That is why museums often display decorative arts in reconstructed *period rooms*, where viewers can glimpse a scene from a different lifetime. For instance, the *Port Royal Parlor (Chippendale Period Room)* from the Winterthur Museum (9-1), designed for the country estate of a rich Philadelphia merchant, reflects the gracious, aristocratic life enjoyed by the American upper classes before the Revolution. Although the furnishings came from many different sources—many were imported from England— the effect is coherent and harmonious. The rich textures, gentle curves, and elaborate

carving of the furniture convey their owners' taste for luxury and elegance.

Just as the fine arts have produced a series of styles and movements, so the decorative and applied arts are the result of developing philosophies of art and design. The advent of mass production has had a particularly dramatic impact on artists' attitudes toward crafts and design. The modern taste of the twentieth century is revealed in the furniture showroom displayed by Knoll International in San Francisco in 1957 (9-2). Designed by Florence Knoll, this brightly colored interior appears far more pared down and functional

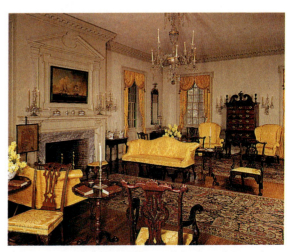

9-1 Port Royal Parlor (Chippendale Period Room) from the Edward Stiles home, Philadelphia, 1762. Courtesy of The Henry Francis du Pont Winterthur Museum, Philadelphia.

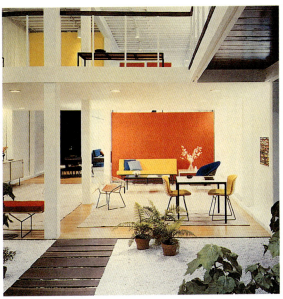

9-2 Florence Knoll, showroom in San Francisco, 1957

than the Chippendale room. The chair frames are made of metal instead of wood; the tables are pure rectangles as compared to the decorative, rounded tables in the Chippendale style. The sharp lines, simple shapes, clear colors, and subtle textures reflect the influence of modern art on items as diverse as pillows and ashtrays. Compare this room to a painting by Mondrian (Chapter 16), and the relationship between decorative and fine arts will become evident.

Another, key difference between these two rooms is the way the objects were produced. Everything in the Chippendale room is a unique piece of decorative art, made by individual craftspeople. The items displayed in the Knoll showroom were designed by an artist, then manufactured by machines. Today, the term *crafts* is generally reserved to describe objects made by hand, while the word *design* refers to the process by which functional articles are created by an artist in order to be mass produced.

THE CRAFT MEDIA: CERAMICS

Clay, used by sculptors to model statues, is also the media used to make what is known as **ceramics**. Clays are types of earth that have

the property of becoming moldable, or **plastic**, when wet, then more rigid again as they dry. Such material is transformed into *pottery* when it is heated in a closed oven, or **kiln**, until it becomes permanently hard. The art of ceramics, or pottery, is the result of two distinct processes—the molding of the object and the decoration of its surface. The final color and texture of a ceramic piece is affected by the variety of clay and the type of fire used. But the most important way of coloring and decorating anything made of ceramics is by glazing. A **glaze** is somewhat like paint, but ordinary paint would disintegrate under the high temperatures of the kiln. Glazes melt into and actually fuse with the clay of the ceramic while being heated. Usually ceramics are fired at least twice—once to set the shape of the piece, the second time to incorporate the glaze onto its surface. Over the centuries, special methods of glazing have been discovered, each creating a different effect on the surface of the fired clay.

For instance, the Chinese, who considered ceramics one of the highest forms of art, experimented with both firing temperatures and glazes to achieve exquisite results. Baking at a high temperature transformed their clay objects into a material of glasslike hardness called **porcelain**, or what Europeans simply called "china." Chinese porcelain vases were prized for their elegance, their purity of design, and their delicacy, which symbolized their expense. The perfection of the silhouette, the thinness of ceramic walls, and the subtle color of the glaze transformed simple clay vessels such as this stoneware bottle (9-3) into aristocratic status symbols in twelfth-century China.

The process of glazing is important for practical as well as decorative reasons. Not all pottery is fired at the high temperatures required to produce the glassy hardness of porcelain. More porous earthenwares require a glaze to become sealed. This is particularly important because the primary use of pottery has always been for making *vessels*, or containers. Before the development of plastic, or the manufacture of glass and metals in large quantities, ceramic vessels performed vital functions for the societies that created them. Used in such everyday activities as eating and drinking, as well as in special religious rituals

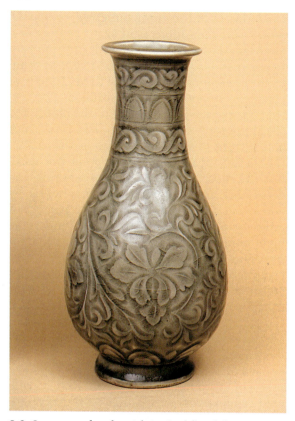

9-3 Stoneware bottle with incised floral decoration under an olive-green colored glaze, Northern Sung Period, China, eleventh–early twelfth century. Northern celadon ware, 9¼" high. Victoria and Albert Museum, London.

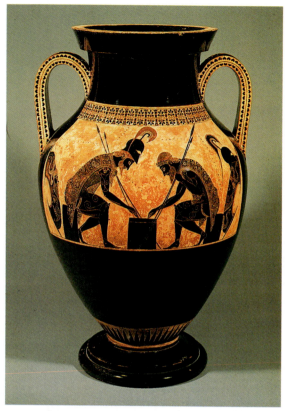

9-4 *Exekias, Ajax and Achilles Playing Droughts,* black figure amphora, 550–525 B.C. Terra-cotta, amphora 24" high. Vatican Museums, Rome.

and ceremonies, vessels were both a necessity of life and a means of artistic expression.

Greek pottery, for example, served as vessels for storing and serving both foods and liquids but was also painted with scenes from the myths of the Greek gods and heroes. The *Exekias* amphora (9-4) of the sixth century is named after an ancient artist, both potter and painter, who signed his work prominently. Decorated with a scene from Homer's epic poem the *Iliad,* this amphora shows the heroes Achilles and Ajax intent on a game somewhat like modern checkers.

Several methods are possible for making vessels out of clay. The easiest is by simply pinching and shaping the clay into the desired shape. Another technique is to build the container by flattening clay like cookie dough and cutting out slabs that can be pressed together to form boxlike shapes. Another common way to make pottery containers is by coiling long ropes of clay and forming them into the

desired shape, then smoothing out their sides by hand. This is the method used by Native Americans. Such ways of building pots by hand allow the artist great freedom in determining the size and contours of the vessel, which can be rounded or rectangular, asymmetrical, or any shape at all.

Maria Martinez and her husband Julian were twentieth-century potters who worked in the traditional Native American methods (9-5); she built pots by hand, and he decorated them. Almost by accident, they also developed a totally new style of ceramics. During an archeological dig near their home, the San Ildefonso pueblo in New Mexico, Maria was approached by scholars who asked her to re-create a type of black pottery that had been found only in fragments. After studying the pieces, she reconstructed the shape of an entire pot, while Julian attempted to copy the black color by smoking the pots in a fire. When the experimental pottery was admired

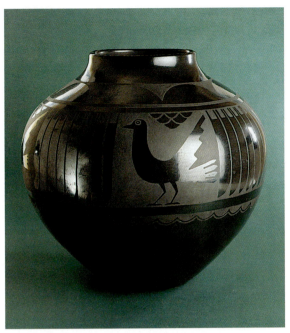

9-5 Maria Martinez, *Black on Black Jar*, 1930–1940. Earthenware, 7⅜″ high. School of American Research Collections in the Museum of New Mexico, Santa Fe.

CONTEMPORARY APPROACHES

While many of the practitioners of contemporary ceramics, as in the craft media, retain their love of material and continue to handcraft their pieces, they have also moved away from making functional objects. This direction towards the fine arts and away from the practical is called the *American Studio Craft Movement.* A leading figure in this movement is the ceramicist Peter Voulkos. He influenced a whole generation with works created primarily for aesthetic interest, rather than for use. As a teacher in California, Voulkos began in the 1950s to make large clay objects that questioned the form of traditional vessels. For example, in his sculptured vase (9-8), Voulkos takes a fresh look at a bottle, almost as if he is seeing one for the first time and trying to understand it. As in Japanese **raku** (see "A

by visitors, the couple began to try out different methods of black-on-black decoration. The final result was a unique type of pottery in which the shiny black pot is painted with a design in **matte** (or dull) black. Julian Martinez adapted these designs from historic American Indian patterns.

THE POTTER'S WHEEL

The invention of what is called the potter's wheel was a technical advance on the laborious methods of forming ceramic vessels. The wheel is actually a horizontal disc mounted on a vertical pole; the speed at which the wheel whirls is controlled by the potter. As the wheel turns, a lump of clay can be lifted and shaped by hand into a vessel, in an action called **throwing**. There is something fascinating about watching a potter at work, live or on film, and observing the drama of the craftsperson creating a vase, cup, or bowl out of a clump of earth (9-6). The sides of the vessel actually seem to grow up from the moving wheel as if springing to life. In contrast to clay vessels made by hand building, thrown pots are always rounded and symmetrical.

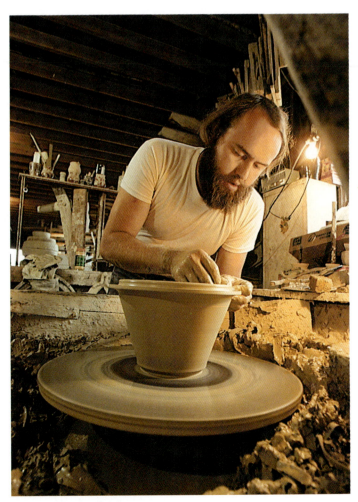

9-6 A potter's wheel in use

A Global View

THE TEA CEREMONY

The art of ceramics is judged to have reached its highest level in Asia. Chinese porcelains are valued by collectors all over the world for their elegant shapes and glazes. The Japanese have used pottery to express a different aesthetic. While Chinese ceramics tend to look fragile and perfect, the Japanese stress a rustic simplicity in their pottery, especially vessels associated with the *tea ceremony*.

The tea ceremony is a unique and interesting part of Japanese culture. Developed during the political upheavals of the sixteenth century, the *Cha-no-yu* (cha is the Japanese word for tea) is a kind of ritual performance in which the audience takes part. The host, or tea master, will invite a small group of friends to a modest teahouse of unpainted wood, located in a secluded garden. The purpose is not so much to drink green tea as to contemplate art—usually a hanging scroll decorated with painting or calligraphy, and a simple flower arrangement. The utensils in which the tea is made, such as teabowls and water jars, are considered part of the artwork to be admired. The setting, the ceremony, the artwork, and the utensils are all supposed to conform to the principles of harmony, respect, purity, and tranquillity, and above all to *wabi,* the principle of quiet simplicity.

Over the centuries a certain style of pottery has come to be associated with the tea ceremony. Called **raku** (9-7), these tea utensils are made of hand-shaped earthenware. The shapes of the teabowls are irregular and asymmetrical, the glazes thick and rough. Their very imperfection is prized as a mark of the masters who formed them. Just as the line of a great artist can be seen in a drawing or painting, so the spontaneous, personal touch of the potter is valued by the Japanese. Names of great potters of history are well known, and their pots are extremely valuable. Some of the ceramic vessels associated with the tea ceremony are so famous that they have individual names, like *Mellow Persimmon, Gold Moon,* and *Five Mountains,* and have been designated as national treasures of Japan. Contemporary American potters have been greatly influenced by Japanese aesthetics and techniques.

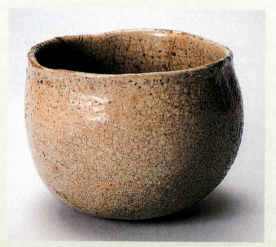

9-7 Raku teabowl in the style of Kōetsu, Japan, seventeenth century

Global View," above), whose aesthetic influenced Voulkos, the vase bears the rough marks of the artist's process. We can see thick slabs of clay pushed together, the impressions of Voulkos's fingers left unsmoothed, the crude cuts of a knife forming the lip. The vase is now more like a Cubist sculpture than a container for liquids.

A fellow Californian, Robert Arneson was even more daring in breaking down the distinctions between contemporary ceramics and sculpture. His pieces are both filled with humor and totally nonfunctional, as in his self-portrait *California Artist* (9-9). Putting himself on a shabby pedestal, Arneson is casually dressed in an open blue denim shirt that reveals a hairy belly. Far from an expression of an enormous ego, Arneson's piece mocks typical comments about Californians. Beer bottles litter his monument. If one gazes past his dark tan and into his sunglasses, one can see that his head is empty.

Marilyn Levine's humor is more subtle but also subversive. Her subject matter is

unexceptional, utilitarian objects found in most homes. But the shock comes when the viewer realizes that a carefully crafted leather briefcase (9-10) is actually made of clay. Thus an honest approach toward materials, a hallmark of the crafts, is abandoned along with the old definition of functionality. Still, Levine's work reflects past concerns as well. It retains the traditional craftperson's love of material and care for making things well by meticulously re-creating the colors and texture of worn leather. Her choice of mundane objects also reminds us of the roots of all crafts in everyday objects.

9-8 Peter Voulkos, sculptured vase, 1961. Wheel-thrown, carved, slashed with pass-throughs of darker clay, cobalt slips, and celadon and copper glazes, 18¾″ high. Private collection.

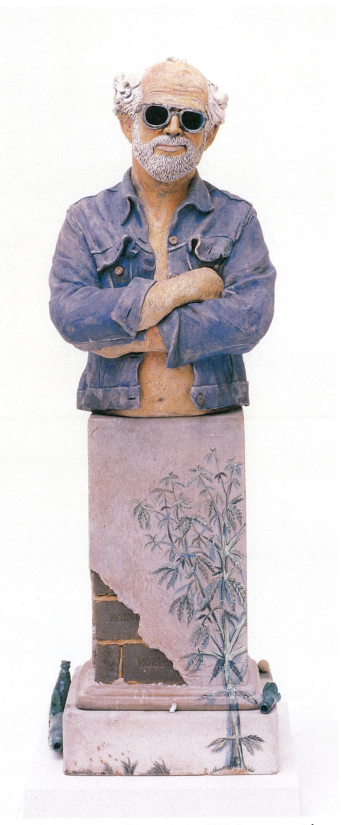

9-9 Robert Arneson, *California Artist*, 1983. Stoneware with glazes, 68¼″ x 27½″ x 20¼″. San Francisco Museum of Modern Art (gift of the Modern Art Council).

9-10 Marilyn Levine, *HRH Briefcase*, 1985. Ceramic and mixed media, 16″ x 17″ x 6¾″.

GLASS

The medium of glass has a different quality than the other materials discussed in this chapter. Unlike clay, metal, wood, or fiber, glass is usually transparent. That means that light becomes an integral part of glass objects. Glass is made primarily of silica, or a kind of sand, plus other minerals that add color. Once heated until it becomes viscous (or the consistency of jelly), glass can be shaped by blowing or molding and pressing. The glass surface can be decorated by cutting, engraving (with a tool), etching (with acid), enameling, gilding, and painting—but often the most beautiful glass is decorated by the colors and bubbles within the glass itself. Thus the pattern is an integral part of the glass object, as is seen when you look into the center of a glass paperweight. In the decorative arts, glass is used primarily in two ways: stained glass for windows, lampshades, and screens, or blown glass for vessels such as goblets, vases, bottles, and pitchers.

STAINED GLASS

The greatest period of stained glass artistry is considered to be medieval times, when multicolored glass paintings were used to fill the long windows of Gothic cathedrals. Of all these cathedrals, that of Chartres in France (9-11) has the most beautiful, best preserved,

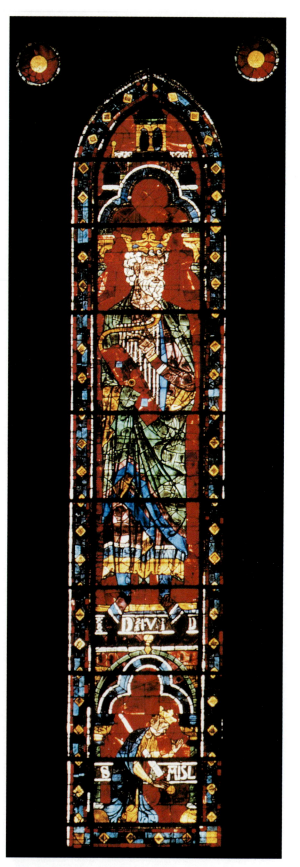

9-11 Leaded glass window, Chartres Cathedral, France, *c.* thirteenth century

and complete set of original windows. Unfortunately, photographs cannot re-create the transparency and glow of the colors or the way that light passing through the windows reflects their multicolored patterns on the interior of the cathedral. Although stained glass windows are divided into decorative narratives that tell religious stories in a visual form, inside the cathedral you would not experience these scenes separately but as part of a vibrant whole, an almost abstract balance of colors and shapes.

Chartres was the center of a famous glass workshop. The deep, brilliant blue of the windows is justly famous and has never been duplicated. The glass pictures were built up of almost pure colored shapes—only such details as faces were actually painted. As in other medieval paintings, the pictures were very flat, with no shading, modeling, or attempt to portray the illusion of space.

During the nineteenth century, a revival of interest in both the Gothic period and the decorative arts occurred. One American painter, John La Farge, particularly admired the French medieval stained glass he had seen on his European travels. As La Farge began to experiment with making his own paintings in colored glass, he developed new techniques unknown to medieval craftspeople. La Farge looked for glass that was irregular, streaked, textured, or imperfect. Soon he was supervising the manufacture of glass with unusual colors and textures. He particularly liked to use glass that was *opalescent,* or reflective of many different colors. Eventually he placed pieces of glass behind each other to create richer and deeper hues—essentially mixing new colors by combining two shades of glass. Instead of limiting himself to the flat effects of medieval glass, La Farge used glass to create the illusion of shading and depth, just as in a nineteenth-century painting.

Where medieval stained glass had been used only in churches, to tell religious stories, the stained glass designed by La Farge and other artists in the late nineteenth century was often used to decorate private homes. For instance, La Farge created a series of windows for the bedrooms of a Newport mansion. The windows, one of which is *Peonies Blown in the Wind* (9-12), were inspired by the artist's love of Japanese art. Thus La Farge translated an oriental theme into a medieval medium for an American collector.

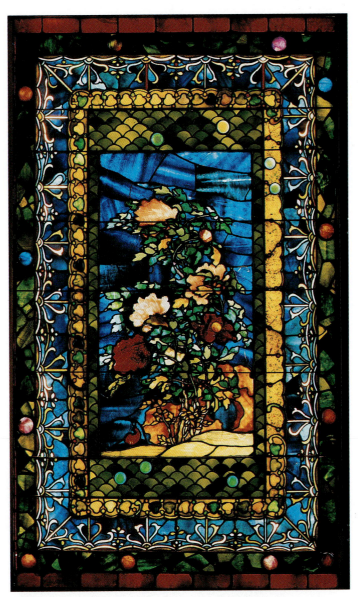

9-12 John La Farge, *Peonies Blown in the Wind,* made for the Henry G. Marquand house, Newport, Rhode Island, *c.* 1880. Leaded glass, 75″ x 45″. The Metropolitan Museum of Art, New York (gift of Susan Dwight Bliss, 1930).

BLOWN GLASS

Glassblowing is a craft requiring both skill and strength. Because it is heated to a molten state, glass cannot be shaped by hand as other materials are. Instead, it is picked up in a small spherical blob at the end of a long metal pipe, then blown into bubbles of various shapes. The bubble is quickly shaped with a variety of tools, sometimes rolled against a hard surface. If the glassblower is not pleased with the result, he or she can simply reheat the glass to a molten state and try again.

When the glassblower is satisfied with the shape that has been created, it must be removed from the pipe to cool slowly. Thin threads of glass can be wrapped around the basic shape to add interest to the design and smaller pieces added for handles.

In America, the name most associated with glassmaking is that of Louis Comfort Tiffany. Tiffany was strongly influenced by French Gothic stained glass, especially the windows of Chartres. Tiffany's studio produced not only beautiful stained glass windows, wall panels, and screens but also blown-glass vessels. For instance, his glassblowers produced the remarkable designs illustrated here (9-13). The swirling iridescent patterns are actually part of the glass itself. Note the organic contours of the glassware, sometimes stretching up from a base almost as if it were a living plant.

The American Studio Movement in glass is said to have begun with Harvey Littleton. Like Peter Voulkos, he did not believe that crafts should be primarily functional or merely decorative but could be the equal of painting and sculpture. *Red-Orange Pair* (9-14) does not

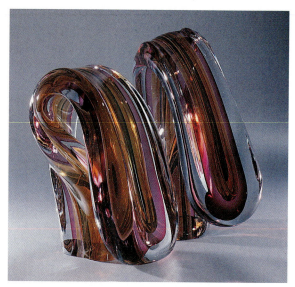

9-14 Harvey Littleton, *Red-Orange Pair*, 1983. Barium/potash glass with multiple cased overlays of Kuger colors, 12½″ x 12″ x 14″.

not even pretend to be a functional vessel; it is a beautiful abstract sculpture of blown glass. Its streamlined organic forms mark it as a product of the modern era; its transparent veils of color reveal its maker's love of glass.

METALWORK

Humans have used many types of metal to shape beautiful decorative objects—gold, silver, iron, bronze, lead, and copper. The items made range from the giant iron gates for a palace to the most delicate jewelry. Metal can be cast or welded, but it can also be **forged** (or heated) and **wrought** (or hammered) into shape. This latter method is used by blacksmiths to make everything from horseshoes to door hinges and kitchen pots. Metal can also be hammered into sheets, which are then cut and built into the desired shapes. This is the method used by the native peoples of South America before the arrival of Columbus.

The pre-Columbian civilizations of Peru produced expert silver- and goldsmiths. The most famous of these cultures is that of the Incas. The Incas valued gold and silver for their artistic qualities rather than their monetary worth. In fact, they used no coins or money. Precious metals were reserved for the noble class because of their beauty. Gold was especially important because it symbolized the color and warmth of the sun, and the

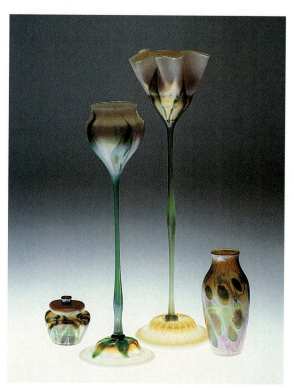

9-13 Louis Comfort Tiffany, four pieces of favrile glassware in the Art Nouveau style, *c.* 1900. Left to right, 2⅞″ high, 15½″ high, 18¹¹⁄₁₆″ high, 4¹⁄₁₆″ high. The Metropolitan Museum of Art, New York.

Incas considered themselves to be descendants of the sun god.

The Spanish conquistadors, led by Francisco Pizarro, found entire Incan cities decorated in gold. However, they were not particularly interested in the aesthetic value of the South American ornaments, although they admired them as curiosities. Almost all the golden artwork collected by the Spanish in the new world was eventually melted down into gold ingots before or after it was taken to Europe.

Luckily for posterity, the Peruvians had a cult of the dead somewhat like that of the ancient Egyptians (see Chapter 10). They mummified bodies, wrapped them in precious woven cloth, and buried them with golden ornaments. Sculpted golden masks were often placed over the faces of the dead, who were accompanied by ceremonial golden daggers called *tumi* (9-15). Such daggers are often decorated with the heads or figures of stylized people, shown in elaborate headdresses and jewelry. In this tumi, the golden head has been *inlaid* with turquoise stones that form the eyes and highlight the jewelry. Two little gold and turquoise birds dangle from the *filigree* headdress (made of fine golden wires),

each holding a lapis lazuli bead at the end of its beak. The body of the knife is made of silver overlaid with gold foil in a kind of checkerboard pattern.

Although the Spanish conquerors may not have appreciated the aesthetic qualities of American metalwork, European goldsmiths created elaborate works of art according to their own standards of beauty. As in Peru, such craftspeople usually worked for the nobility. In 1884, Czar Alexander III of Russia called on the master jeweler Carl Fabergé to design an Easter present for his Empress. Easter is the most important holiday of the Eastern Orthodox Church. For the gift, Fabergé made a golden egg, the egg traditionally symbolizing the resurrection of Christ. Inside the egg he placed a surprise, a golden hen with rubies. The Easter egg so delighted the empress that the czar and his son Czar Nicholas II would order Imperial Easter Eggs for the next thirty years (until the Russian Revolution removed the czars from power). These "fantastic objects," as Fabergé called them, are some of the most famous examples of the jewelmakers' art. The *Lilies of the Valley Egg* (9-16) is a wonderful illustration of Fabergé's fertile imagination. Presented by

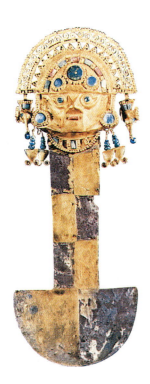

9-15 Chimu ceremonial knife, Peru. Gold with inlaid turquoise.

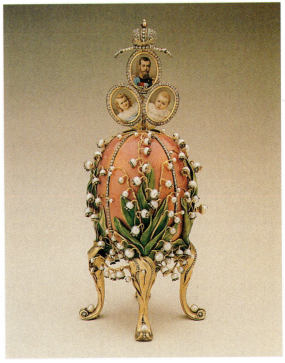

9-16 House of Fabergé, *Lilies of the Valley Egg*, 1898. Gold, enamel, diamonds, rubies, pearls. The FORBES Magazine Collection, New York.

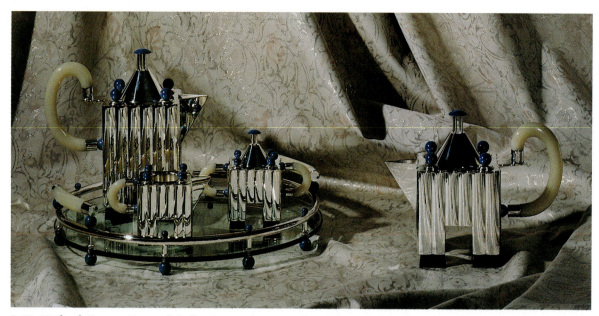

9-17 Michael Graves, *Tea and Coffee Service* (prototype), 1980–1983. 800 silver, lacquered aluminum, Bakelite; tray 3½″ high x 16″ diameter. The Metropolitan Museum of Art, New York (promised gift of Diane, Daniel, and Mathew Wolf).

Nicholas II to his mother in 1898, the pink egg (made of gold but enameled) is surrounded by bands of diamonds and mounted on legs designed as golden leaves. Growing up its sides are lilies of the valley whose flowers are pearls topped with gold and diamonds. At the top of the egg is a crown covered with diamonds and rubies. To discover the surprise, Nicholas's mother had to find the key: One of the pearls is a button. When turned, miniature portraits of her son and her two granddaughters in jeweled frames rose up from beneath the crown.

Opulence with precious materials is not unknown today, though sometimes manufactured materials are substituted. For example, Michael Graves's *Tea and Coffee Service* (9-17) is a splendid serving set, but its handles are made of mock ivory since ivory is a product of an endangered species. Graves is an architect and one of many contemporary artists who have begun working in traditional craft territory. In addition to buildings, he designs carpets, wallpapers, plates, and jewelry. Not surprisingly, his *Tea and Coffee Service* has an architectural spirit. It looks both high-tech and historical. The tea and coffee pots are constructed of polished silver columns, decorated with aluminum globes glazed deep blue, and crowned with small cupolas.

FIBER ARTS: WEAVING

Weaving, like pottery, is a very ancient form of decorative art; according to Homer's *Odyssey*, Penelope, the faithful wife of the hero Odysseus, spent the ten years of his absence weaving. Cloth can be woven out of fibers, such as wool, cotton, flax, and silk, into many different patterns, textures, and strengths. Most weaving is done on a **loom**, where one set of parallel threads, the **warp**, is held in a tense position. To make fabric, another set of parallel threads, the **weft** or *woof*, is arranged at right angles to the warp. The fabric is filled in by bringing these weft threads in and out, moving them back and forth, interlacing them with the warp. By using threads of different colors and textures, elaborate designs can be created. Although most cloth is used for making clothing, weaving can also provide decorative items such as carpets and wall hangings.

TAPESTRY

One of the most famous types of woven wall hangings are those called *tapestries*. These large, woven pictures were an important art form during the middle ages, a kind of portable interior decoration to provide warmth and color in dark, drafty fortresses.

They were commissioned by aristocrats and handwoven in special studios from preparatory drawings called **cartoons**. A particularly well-preserved set of tapestries are the seven *Unicorn Tapestries* made to celebrate the wedding of King Louis XII of France to Anne of Brittany, which took place in 1499. If you look carefully, you can see the first and last initials of Anne's name (an *A* and a reverse *E*) woven into the lower corners of the tapestry, as well as across the central fountain.

The *Unicorn of the Fountain* (9-18) is the second in this series of tapestries illustrating a fable in which the Unicorn is captured and killed but miraculously returns to life. Although it might seem that the woven pictures merely illustrate a fantastic legend, scholars have discovered that these tapestries

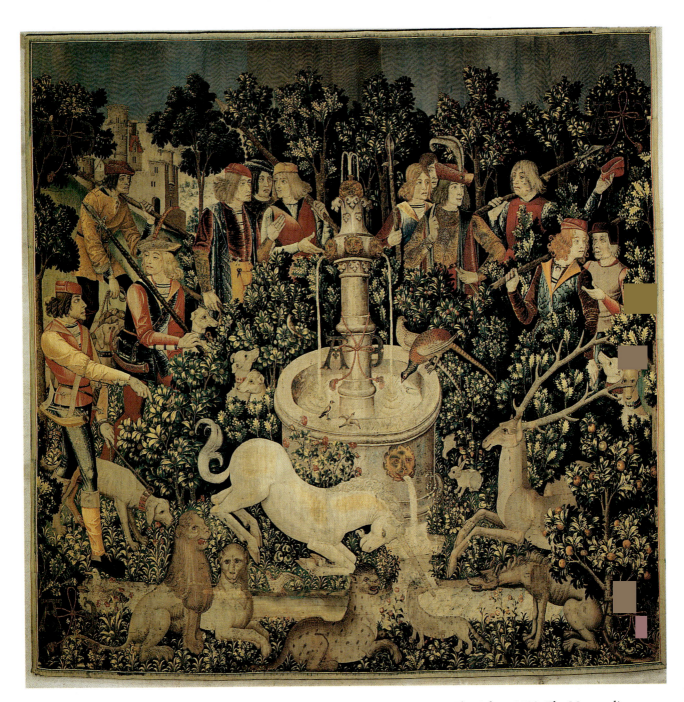

9-18 The *Unicorn of the Fountain* (II of VII) from the *Unicorn Tapestries*, Franco-Flemish, *c.* 1500. The Metropolitan Museum of Art (Cloisters Collection).

include a wealth of meanings. Each plant and animal is part of a symbolic language, familiar to any educated medieval viewer but unknown to us today. However, we can still marvel at the skill with which the weavers created a complex picture in silk and woolen threads.

EMBROIDERY AND QUILTING

Quilting and embroidery have historically been done by women who did not have the freedom to become professional artists. The feminine "needle arts" provided an opportunity for women to express themselves creatively, "painting" their designs in thread and fabric. Such designs have ranged from pictorial and narrative, as in embroidered samplers showing people and places, to completely nonrepresentational, as in geometrically patterned quilts.

Some women have consciously used fabric and thread to make pictures that tell stories. This was the case with Harriet Powers (9-19), a former slave who designed several quilts based on biblical themes. Her method for making these quilts is one called **appliqué**, in which fabric silhouettes are cut out and stitched onto the background of another fabric. Such an appliqué technique is common in West Africa and may have been passed on to Powers by her forebears. What she did with

this medium, however, was quite unusual. Instead of making attractive patterns, Powers used the squares of her quilts to vividly illustrate stories from the Bible. In this quilt she told the stories of Jonah and the whale, Adam and Eve, and the Day of Judgment, among others. While her silhouettes are simple, their arrangements demonstrate her sophisticated sense of design. Each panel is both a clear and visually interesting picture.

CONTEMPORARY FIBER

The Studio Craft Movement has affected the fiber media just as profoundly as in ceramics and glass. Imaginative new types of fiber objects have been made that cannot be categorized as wall-hangings, baskets, or quilts, or any other traditional form. Works by innovative craftspeople like Claire Zeisler have helped expand the possibilities of fiber art. In *Tri-Color Arch* (9-20), brightly colored synthetic fibers form a graceful 6-foot arch from which long, thin tendrils of rope hang down and spill in a mass to the floor. The arch is

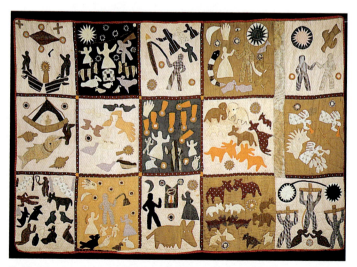

9-19 Harriet Powers, *Pictorial Quilt*, Athens, Georgia, c. 1895–1898. Pieced and appliqued cotton embroidered with plain and metallic yarns, 69″ x 105″. Museum of Fine Arts, Boston (bequest of Maxim Karolik).

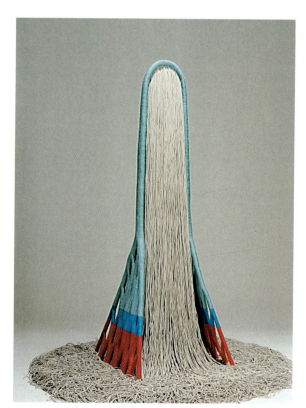

9-20 Claire Zeisler, *Tri-Color Arch*, 1984. Hemp and synthetic fiber, 6′2″ x 5′6″ x 3′8″.

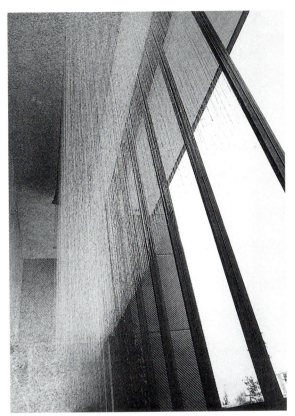

9-21 Lenore Tawney, *Cloud Series*, 1979. Strands suspended from canvas, 16' x 30'. Commissioned for the Federal Building, Santa Rosa, California.

WOOD AND FURNITURE

Wood has been used over millennia for many objects: simple containers, tableware, utensils, and furniture. Handcrafted wooden objects and furniture were common to the most modest homes in colonial America. Most of us have seen sturdy old wooden chests and tables in antique shops that have lasted more than a hundred years. Just being handmade, however, does not automatically make an object artistic or beautiful. The craftsperson must be sensitive in shaping materials, in creating a design that is visually pleasing. Like other materials, wood can be used to create objects that are plain or extremely ornate. A good illustration of the range of possibilities in the design of wooden furniture is the contrast between a simple Shaker *Candlestand* (9-22) and a highly decorated wooden cabinet produced during the **Art Nouveau** movement.

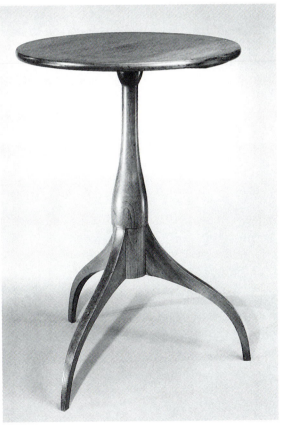

9-22 Shaker shops, *Candlestand*, Hancock, Massachusetts, *c.* 1800–1840. Cherry wood, 25½" high x 18" wide x 18" deep. The Metropolitan Museum of Art, New York (Friends of the American Wing Fund, 1966).

self-supporting and free of the wall. Its elements were not woven on a loom but knotted and wrapped. Zeisler has also invented new meanings for traditional symbols. The arch shape is long associated with military triumphs (see Roman arches in Chapter 10); the use of tricolor reminds one of flags and patriotism. Because of the materials used, however, Zeisler's arch is a large but humane presence in the room, not a massive monument to militarism. Water, hair, food, and trees are evoked, rather than marching and conquering.

Knotting is also used in the hangings of Lenore Tawney, a leading figure in fiber art for more than thirty years. Tawney's *Cloud Series* (9-21) appears inspired by the parallel threads of the looms she has abandoned. Yet its impression is far from a heavy woven tapestry but light and transparent as a cloud. A seemingly infinite number of linen threads are suspended from a piece of canvas on the ceiling. The threads shimmer and stir with air currents, constantly changing.

Here we see not only a difference in style but also in philosophy. The Shakers were a religious community who believed in living simply. The furniture they made for themselves had to be functional and undecorated as well as lightweight and easily moved. This furniture is greatly admired today because it looks so modern. In stripping away unnecessary frills, the Shakers did not lose their sense of design. It is almost as if they reduced each chair, chest, or table to its pure essence, as in abstract art. By creating each piece lovingly, they made the most of their materials and let the shape and texture of the wood itself stand out. Instead of painting their furniture, Shaker craftspeople usually diluted paint to create a stain that allowed the grain of the natural wood to show through.

The ideals of the Art Nouveau movement could not be further from those of the Shaker community. Art Nouveau designers and craftspeople believed that every object one came in contact with should be a beautiful, imaginatively decorated object of art. The *Upright Cabinet* illustrated here was created by French designer Eugène Gaillard (9-23). The basic chest has been ornately carved in a vari-

ety of floral patterns, then decorated with elaborate bronze hinges, keyholes, and pulls that harmonize with the wooden carvings. Art Nouveau was not a style limited to furniture alone but a common language utilized in architecture, interiors (see Victor Horta in the next section), and graphic design. It was the first modern international design style. Its followers believed that good design could reach into every home and even improve society. However, its elaborateness and dependence on handcraft made it financially out of the reach of most people. The ultimate goals of Art Nouveau would be reached only by mass production.

THE BAUHAUS

In 1919, with great ambitions and idealism, the architect Walter Gropius founded a school devoted to the cause of integrating the arts and modern technology and transcending the boundaries among craft, design, and art. He called it the **Bauhaus** (the house of building). This would be a school like no other, a training ground for men and women to make them capable to meet the challenges of the twentieth century. Gropius declared at its opening:

> Together, let us conceive and create the new building of the future, which will embrace architecture and sculpture and painting in one unity and which will one day rise toward heaven from the hands of a million workers, like the crystal symbol of a new faith.

In the new training ground of the Bauhaus, the old manner of academic education was abandoned. There were no professors and students. Those who came to study "joined" the school, and it was open to all ages, social classes, and both sexes. The academic plan was borrowed from the medieval guild system. Master artists and craftspeople, journeymen and apprentices worked together on projects in cooperation.

Gropius was a rare type of individual, a visionary who could also be pragmatic and persuasive. In the midst of hard economic times after World War I, he was able induce the German government to provide enough support so he could eliminate tuition at the Bauhaus by convincing the authorities that his goals were in line with the rebuilding of Germany. His teachers and students worked

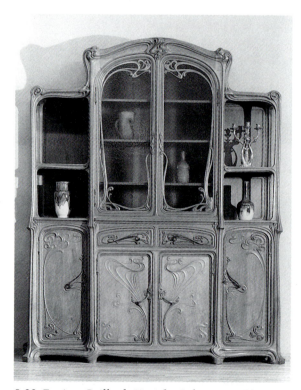

9-23 Eugène Gaillard, *Upright Cabinet*, c. 1900. Wood and bronze fittings. Danske Kunstindustrimuseet, Copenhagen.

on government buildings, worker housing, furniture, and new products for industry.

The Bauhaus teaching stressed that all design must fit its purpose and contain nothing extraneous to it. Bauhaus solutions tended to reject older forms for a clean, modern, geometrical, and simple style. The success of the Bauhaus formula is demonstrated by Marcel Breuer's *B33 Sidechair*, from 1927 to 1928 (9-24), whose elegant, modern look is still being imitated today. Breuer began as a student at the Bauhaus but after graduation ran its carpentry workshop. His chair is easily manufactured because of its simplicity. The tubes slip into one another, so no screws and bolts are required. Even though the chair is made of tubular steel and rugged fabric (designed by textile students at the Bauhaus), it is very comfortable because it flexes with the weight of the person sitting.

The victory of the modern movement in ending any distinction between craft media and the fine arts is demonstrated by the number of artists, architects, and designers working today in clay, wood, fiber, and metals. The young Italian designer, Ettore Sottsass, is one of the founders of the Milan-based *Memphis* group whose work blends all the visual arts

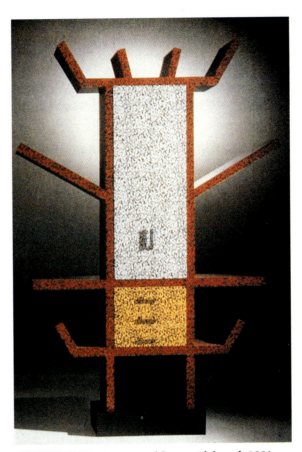

9-25 Ettore Sottsass, *Casablanca* sideboard, 1981

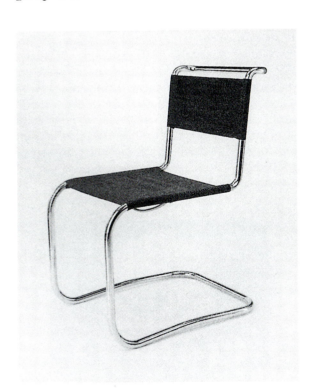

9-24 Marcel Breuer, *B33 Sidechair*, 1927–1928. Tubular steel and the textile Eisengarn, developed at the Bauhaus.

and challenges craftspeople to rethink their usual assumptions. His irreverent *Casablanca* sideboard (9-25) is both furniture and sculpture. It appears to be a sculpture because the printed plastic, covered in spotted patterns of black, bright white, yellow, and red, camouflages the handles. However, the sideboard is actually quite functional. The cabinet opens to store dishes and glasses, and the "arms" hold bottles.

The Memphis style is very different from the Bauhaus's, but it owes a great deal to it. As outrageous as it may seem, the *Casablanca* sideboard was designed for industrial production and, in fact, was available from the Memphis group's catalog.

DESIGN

The products of design, graphic design, illustration, industrial design, interior design, landscape, and environmental design, like crafts, furnish the artistic environment we

live in every day. Artists, in the role of designers, have had a hand in or influenced the magazines we read, the pens we write with, the televisions we watch, the rooms we live in, and the parks we visit. A design, much more than a work of fine art, must be useful to be successful. For example, a graphic design like an advertisement must communicate its message quickly or be a failure. We are much more forgiving of a work of fine art or even crafts; we accept that true understanding may be a time-consuming process.

GRAPHIC DESIGN

Graphic design encompasses several types of design that used to be called "commercial art." Advertisements, magazines, books, posters, packages, logos, and signs are all examples of graphic design. The basic activity of graphic design is **typography,** or the manipulation and selection of styles and sizes of letters. Choices in typography are rarely noticed by most viewers but their effect can be consid-

erable. Compare a page from *The Canterbury Tales,* designed by William Morris (9-26), with the page you are now reading. Morris's page is certainly more beautiful. Morris himself designed the elaborate *type* or letters and the decorative borders and made the illustration. Together they form an elegant harmony that evokes a time, centuries ago, in the early days of printing. Morris's approach is appropriate to a masterpiece of fourteenth-century poetry but not to a contemporary college textbook. Imagine trying to read fifty pages of a text in the style of Morris! The designer of this book wisely chose a simpler and more direct typeface and design, one that would not interfere with communication. The look of the text is said to be cleaner and more modern than Morris's, because its type is less elaborate and the spaces are more open.

When creating a **logo** or trademark, graphic designers will imaginatively alter common letters. Walter Landor modified a simple word, "cotton," to create the instantly recognizable trademark of Cotton, Inc. (9-27). The letters are shaped to suggest ribbon, a cotton product. The *t*'s branch upward to form a healthy, life-affirming boll of cotton. The organic motif reminds us that cotton is a natural fiber, unlike its synthetic competitors. A logo is often the most crucial part of a program of *corporate identity,* where a symbol is used throughout a corporation to identify it to the public. A logo can be used on stationery, clothing labels, uniforms, advertisements, trucks, and packaging. On television, with the aid of computers, a new kind of logo has become omnipresent—the **flying logo** (9-28), which spins and transforms (or **morphs**) in three dimensions as it comes toward the viewer.

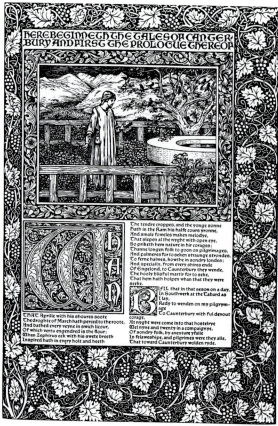

9-26 William Morris, page from *The Canterbury Tales,* published by Kelmscott Press, 1896

9-27 Seal of Cotton, Cotton, Inc., registered trademark

9-28 Animation for NBC's 1992 Olympic coverage, created by Telezign Computer Animation/Design, New York (a division of National Video Center): Robb Wyatt, creative director; Mark Hoffman, designer; Joseph Shingelo, director of animation

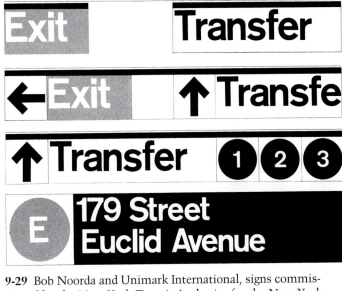

9-29 Bob Noorda and Unimark International, signs commissioned by the New York Transit Authority for the New York subway system, 1980

Typography is often the most important element in *signage*—names, directions, warnings, or advertisements placed for public view. Bob Noorda was given the challenge of communicating directions in the maze of 480 stations in the New York City subway system (9-29). Instant clarity was obviously of the utmost importance. Noorda chose a large *sans-serif* typeface (without any additional decorative lines on the letters, unlike the *serif* type William Morris used) in black, white, or primary colors surrounded by large areas of strongly contrasting color. To draw attention to the information, he used a simple wide black bar at the top. His initially surprising selection of upper and lowercase letters, rather than all uppercase, make the message of the signs calm and direct, an important psychological effect amid the crowds and chaos of the subway. All uppercase letters in a word imply a shout—and more shouting is not needed in New York City.

Modern *package design* goes beyond simply enclosing a product; it is another marketing device to reach a consumer. In most cases, the logo of the company that manufactures the product is featured prominently. One of the most successful packages ever designed is the Coca-Cola bottle (9-30), recognized around the world and used with only modest modification for nearly eighty years. The script Coca-Cola logo implies a product that has been tested by time, but notice the more modern typefaces that surround it, making

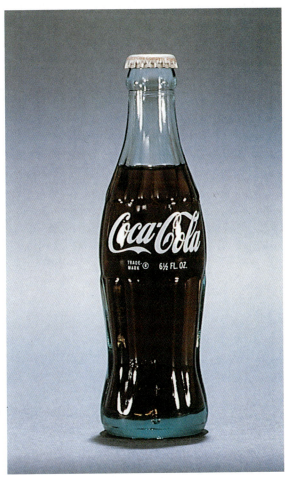

9-30 Alex Samuelson and T. Clyde Edwards, Coca-Cola 6.5-ounce glass bottle, 1896. The Coca-Cola Company.

sure we know it is meant for young and old alike. The ribs on the bottle subtly lead our eyes to the smooth center where the trademark is displayed.

INDUSTRIAL DESIGN

The concerns of bottle design are not just those of a graphic designer; they also concern the *industrial designer.* An industrial designer must understand both art and engineering. **Industrial design** is the aesthetic refinement of products, making functional engineering solutions easy to use, understand, and attractive. The new phrase "user-friendly" neatly conveys the goal of all industrial designers. For example, the Coca-Cola bottle not only must hold soda but dispense it easily and only on demand. The narrow opening provides a continuous but not choking flow. The wide bottom makes sure it rests easily on a table without spilling. The bottle's curvaceous shape allows it to fit comfortably in one hand, the pattern of ribs ensuring that a cold, wet piece of glass does not slip and cheat us of our refreshment.

One might say that the Bauhaus (see last section) created the modern field of industrial design, fabricating products that were aesthetically pleasing and capable of being mass-produced. Marianne Brandt, like Marcel Breuer, was a student at the Bauhaus who later headed a workshop. Her adjustable ceiling lamp (9-31) of 1926 (designed while she still was a student) is characteristic of Bauhaus industrial design and a forerunner of many lamps still in production today. It is a simple and elegant solution to overhead illumination. Its forms are pure and geometrical, like an abstract sculpture. The cylinder counterweight at the center made the lamp easy to raise and lower. This lamp was chosen to be used throughout the Bauhaus workshops. Other Brandt designs (or their descendants), like her bedside lamps, desk lights, and ceiling globes, are in homes throughout the world.

A successful industrial design can transform a fairly mundane product into a new classic. The Eureka *Mighty Mite* (9-32), whose design was a collaboration between Samuel Hohulin and Kenneth Parker, is both sleek and easy to use. Lightweight (it uses modern plastics rather than metal) and small, it is a

vacuum cleaner that can go into tight spots and up the stairs. The cord retracts; the attachments are easily accessible at the back. What elevates the *Mighty Mite* beyond similar products are the bright colors and bold clear shapes that make it a visual, as well as functional, delight.

The gas station is a constant of the American landscape and has changed with the country. In the 1960s, the Mobil Corporation decided that their stations needed a consistent

9-31 Marianne Brandt, counterweighted and adjustable ceiling light, 1926

9-33 Eliot Noyes, petrol pump cylinders for Mobil Oil Corporation, 1960s. Brushed aluminum.

9-32 The Eureka Company, Bloomington, Illinois, *Mighty Mite* vacuum cleaner, 1982. ABS plastic housing, 11½" long.

approach for easy identification. They hired the industrial designer Eliot Noyes to give their stations a new, modern look. His now familiar Mobil Oil Corporation gas station (9-33) uses the circle as a unifying element. It was a natural choice since the wheel symbolizes the automobile. The cylindrical brushed aluminum petrol pumps, the circular lamps, the cans of oil, the signs, and the curving curbs of the pump areas announced speed, cleanliness, and efficiency. Even the logo of Mobil was changed (by another design firm) to reflect the simple geometry of the stations.

INTERIOR DESIGN

We tend to think of *interior design* as decorating: deciding on how to color and fill a room that has already been shaped. But interior design is also an integral aspect of architecture. When an architect designs any building, he or she is thinking as much of the interior as the exterior. The shape of the structure will determine the size and shape of the rooms.

Some architects are careful to design every aspect of the buildings they create, including staircases, windows, light fixtures, and even furniture, curtains, and rugs. Frank Lloyd Wright believed in designing interior details as carefully as interiors, as we saw in his Circle Gallery (8-5). The Greene brothers (8-29) also specialized in harmonizing their interior design with their architecture.

One building that illustrates the relationship between interior and exterior design especially well is *Olana*, the hilltop home designed by Hudson River painter Frederick Edwin Church as his personal studio and family retreat from New York City (9-34, 9-35). The style of the house has been called *eclectic* because it combines the flavor of many different kinds of architecture. Although Church hired a professional architect, Calvert Vaux, to build the house, it was really designed by the painter himself. He was especially involved in planning the interior decor, which included creating a special color scheme and patterned wall decorations for each room. Church also decided exactly where to site his "castle" so he would get the best view of the Hudson River and his own property. A tour through Olana is full of visual discoveries, and the

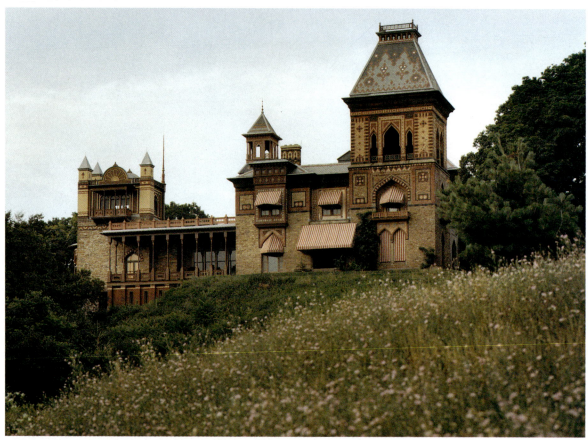

9-34 Frederick Edwin Church, Olana, Hudson, New York, 1872–1874

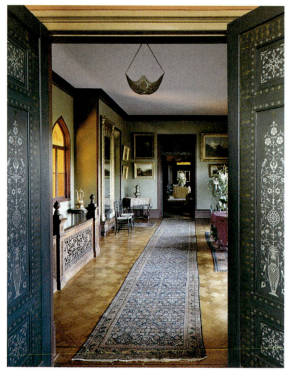

9-35 Interior of Olana

multiplication of ornamentation becomes almost overwhelming (9-36). Yet one senses a guiding spirit that provides a subtle harmony in the midst of what might have become mere vulgar display in the hands of a less talented artist-designer. This guiding aesthetic is evident not only in the building itself but also in the grounds, which Church designed to complement both the house and the view. He even built an artificial lake that mirrored the curves of the Hudson River at that exact spot.

Church was strongly influenced in his design for Olana by the Islamic interiors he had seen when he traveled to the Middle East. It is decorated with oriental rugs, carvings, and tiles, with patterns on the walls and windows reminiscent of traditional homes like *Nur-ad-Din*, a period room at the Metropolitan Museum of Art originally from Damascus, Syria. But the climate of Damascus is quite different from the Hudson Valley and the warmhearted clutter and heavy rugs of Olana would be out of place there. Nur-ad-Din is a cool, quiet, orderly place, a refuge from the

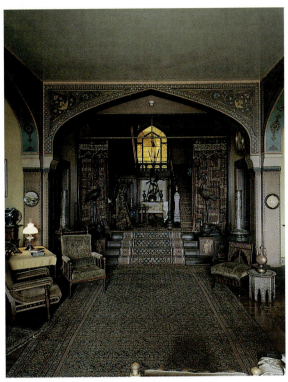

9-36 Court Hall, Olana

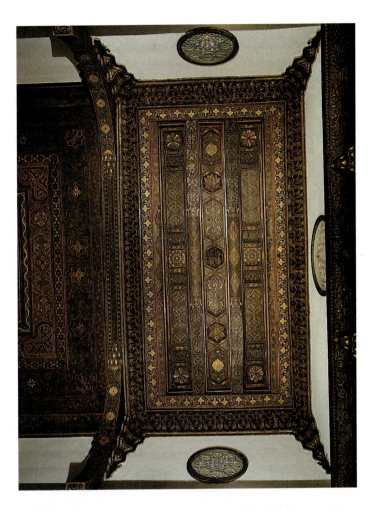

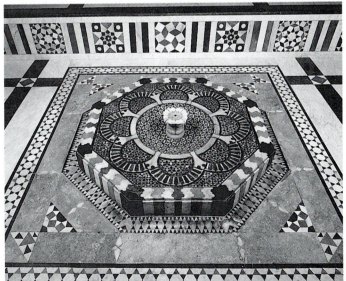

hot sun and the chaos of the streets. Visitors who entered the reception area (9-37) would be peacefully soothed by the small bubbling fountain that rises from a richly patterned marble floor. They would then step up and sit with the master of the house on low velvet-covered benches. There they could contemplate the elaborately carved and painted wooden walls and grand decorative ceilings. The window shades let in only filtered light, colored and traced by the stained glass. Geometrical shapes surround one in substance and shadow.

The late nineteenth-century Art Nouveau interiors of Victor Horta, while certainly as elaborate as Nur-ad-Din, take a more organic approach to decoration. As seen earlier with Gaillard's cabinet, Art Nouveau artists covered their work with flowing swirls and branchlike shapes. Horta's staircase in the *Tassel House* in Brussels (9-38) was a powerful display of that aesthetic. The mosaic floors, wrought iron hand rails, painted walls, and even the steps themselves elegantly bend and curl in harmony like a dance of underwater plants.

9-37 Reception room from the Nur-ad-Din House from Damascus, Syria, eighteenth century. *(a)* Ceiling of the anteroom; *(b)* Fountain. Wood, marble, stucco, glass, mother-of-pearl, ceramics, tile, stone, iron, colors, gold; room 22'½" long x 16'8½" wide x 26' 4¾" high. The Metropolitan Museum of Art, New York (The Hagop Kevorkian Fund, 1970).

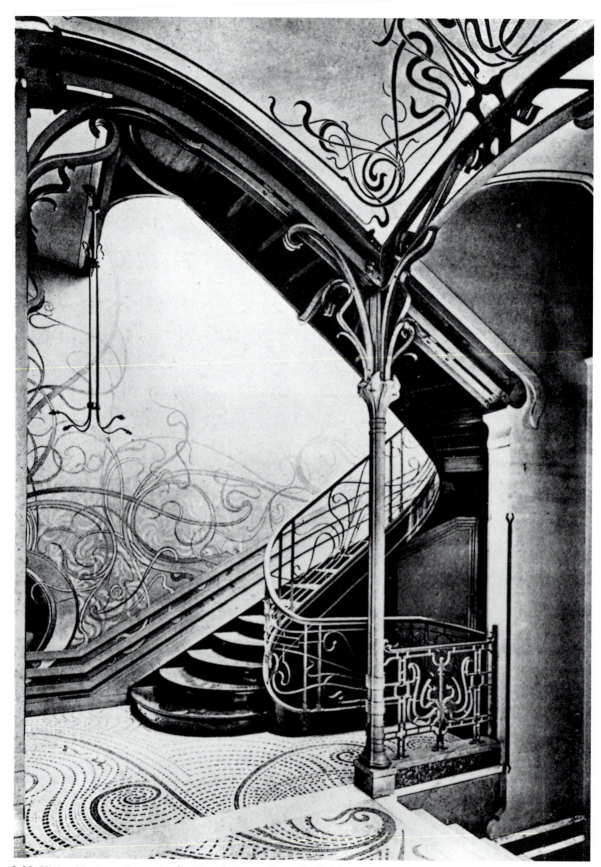

9-38 Victor Horta, staircase in the Tassel House, Brussels, Belgium, 1893

POSTMODERN INTERIOR DESIGN

Though he was trained in architecture in the United States, the Viennese architect and designer Hans Hollein has a far from democratic attitude, and has more in common with the era of Louis XIV (see p. 309) than the twentieth century. For him, "architecture is not the satisfaction of the needs of the mediocre, is not an environment for the petty happiness of the masses . . . architecture is an affair of the elite."

His renovation of the interior of the *Austrian Travel Bureau* (9-39) is a masterful use of a small space, visually open but dense with allusions as is typical of Postmodernism. Once visitors are inside, their minds are directed to voyage to distant lands. The travel bureau's glass ceiling resembles that of a European train station. The ticket counters are familiar from airports worldwide. A broken column reminds you of Greece; the brass palm trees could be references to tropical islands or the Nile valley. The cashier's window should make you think of a luxurious motorcar tour—it is based on the Rolls-Royce radiator grill. The experience of walking through this building is not unlike travel itself, a combination of the familiar and the foreign. The Austrian Travel Bureau is a far cry from the all-encompassing, harmonious designs recommended by Modernist architects like Frank Lloyd Wright. Hollein's design is a virtuoso collage rather than a regimented masterpiece of integration.

LANDSCAPE DESIGN

Landscape design, the alteration of the earth for aesthetic pleasure, is an ancient art practiced all over the globe. It is mentioned in the earliest hieroglyphics of the Egyptians. Gardens and parks were planned as sources of peaceful contemplation of nature by the

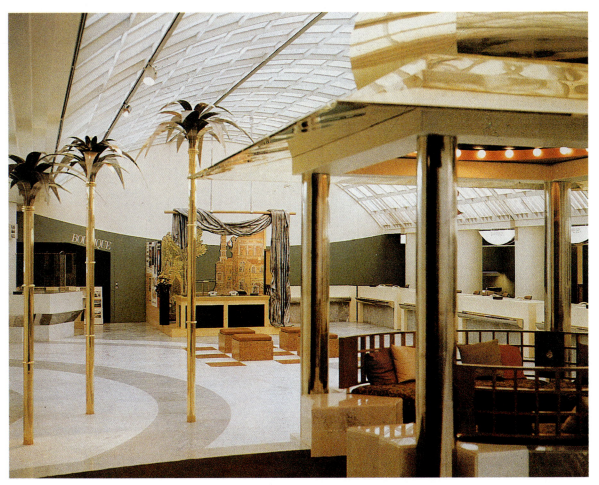

9-39 Hans Hollein, interior of the Austrian Travel Bureau, Vienna, Austria, 1978

Greeks, Chinese, and Muslims thousands of years ago. The ancient gardens, like the famous Hanging Gardens of Babylon, are known to us in legends only, but many magnificent gardens that are centuries old can still be enjoyed today.

The gardens of Versailles, once the private treasure of the kings of France, are now open to the public. Built in the seventeenth century, during the reign of Louis XIV (see Chapter 13), they are so grand and extensive that aerial photographs are required to show their length. The gardens are built around a main central axis nine miles long. A series of *parterres* or terraces lead down to the main axis from the palace. Each level has a fountain dedicated to a classical theme. Marble statues of gods and goddesses line all the walks. The many landscape designers were fervent followers of *classicism*, the revival of the ideals of the ancient Greeks and Romans. Their plan and the actual plantings are very orderly and geometric and are meant to be an extension of the powerful domain of the king.

The key feature of the main axis is the Grand Canal (9-40), which extends for miles beyond what your eye can see. At its head is the *Fountain of Apollo*. The god rides on a chariot drawn by horses leaping out of the water. In Louis XIV's day, the canal had a flotilla of miniature boats that were replicas of ships in his fleet. The boats and Venetian

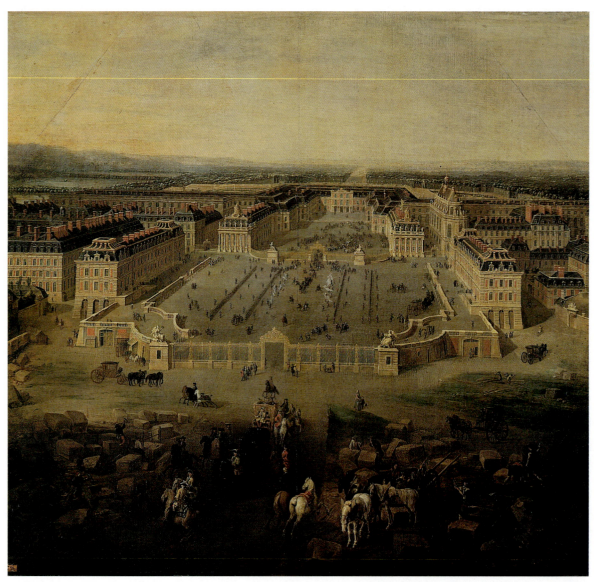

9-40 Park of Versailles, France, 1669–1685

gondolas would take members of the court on gentle romantic cruises along the canal.

Crossing the main axis are a series of secluded paths that lead to more intimate groves designed to accommodate private romantic trysts. Each has its own fountain and theme. For example, the *Fountain of Spring* (9-41) shows Flora, the goddess of spring, surrounded by cupids. Decorating the bronze gilded fountain are carved terra-cotta flowers painted in bright colors. The gardens of Versailles had an important influence on landscape design. Its classical approach is used even today in the gardens of the wealthy and is known as the "French style."

The greatest name in American landscape design is Frederick Law Olmstead. His *Central Park* (9-42) in the center of Manhattan is an island of relief in the midst of an immense metropolis. Its ponds, pleasant walkways, bridle paths, and rolling hills are enjoyed by thousands every day, most assuming that the park is simply the result of a wise act of preservation. This is only partly true. In 1856, a group of citizens concerned that development would soon cover every square inch of

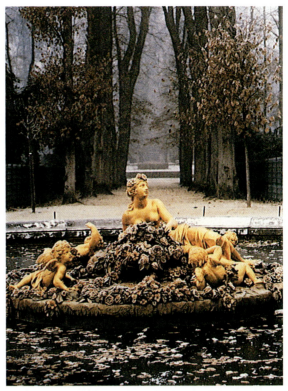

9-41 *Fountain of Spring*, Park of Versailles, France, 1672–1674. Marble, life size.

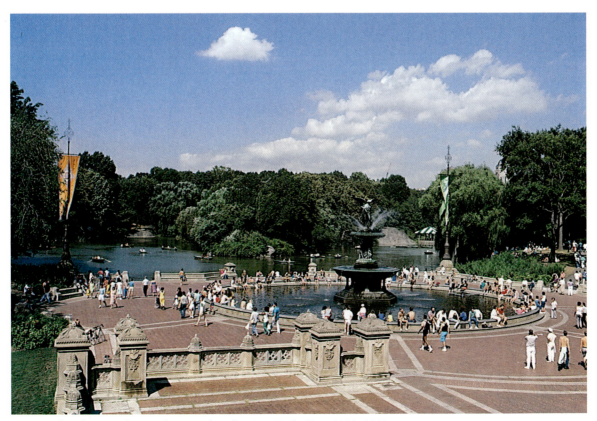

9-42 Frederick Law Olmstead, Central Park, New York City, 1858–1861

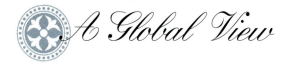

A Global View

THE ZEN GARDEN

The Zen rock garden of Japan (9-43) is an approach to designing a haven of tranquillity that many Westerners find mystifying. One does not walk in the garden but observes it from above on a long, porchlike platform. It appears at first as quite empty and barren. There are few plants; most of the surface is carefully raked sand around large stones. The Zen garden's purpose is to remove us from our insignificant worldly concerns and to stop the constant activity of everyday life.

After sitting down, one can see the pattern in the raked lines, the careful attention paid to the spaces between each rock—rocks placed centuries ago. One can hear the birds, the insects, and the wind. The Zen garden offers the opportunity to regain one's focus in a place that eliminates all distractions. It is a quiet place meant to form, according to a Zen monk, "a lasting impression in your heart."

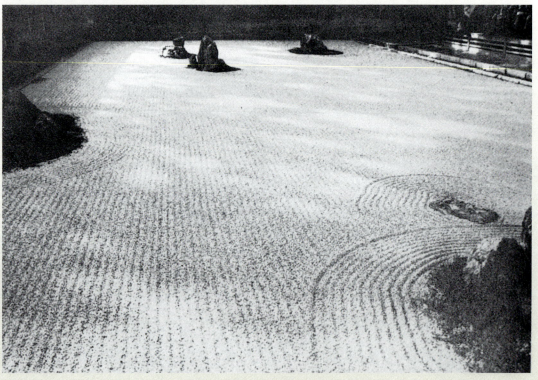

9-43 Japanese flat garden, Kyoto, *c.* 1525. Stones and bare white sand.

Manhattan did convince the New York State legislature to purchase the two-and-a-half-mile parcel. However, Central Park itself is completely designed, the entire length of the park having been torn up, rebuilt, or embellished by Olmstead and his partner, Calvert Vaux (the architect of Olana). The smooth flow of traffic, the bridges, and the refreshing changes in trees, plants, and terrain were orchestrated, not accidental. The mastery of Olmstead is obvious because his design is not.

Isamu Noguchi, sculptor and designer, described his life as "a crossing where inward and outer meet, East and West." Born in the United States, he was the child of a Japanese man and an American woman. He studied in

Paris with the abstract sculptor Constantin Brancusi (see Chapter 15). But his trip in 1930 to China and Japan was, according to him, a "discovery of self, the earth, the place, and my other parentage." While there he learned traditional Eastern methods of sculpting that affected his entire career. For most of his life, Noguchi had studios in both the United States and Japan. Many of his public sculptures and projects were for humanitarian causes. For example, moved by the destruction wrought by nuclear weapons, he designed two bridges for the city of Hiroshima in 1950. They lead to the Peace Park there, a memorial to the dead and a hope for the future.

His interest in the Japanese tradition of rock gardens (see "A Global View," left) is very apparent in his sculpture garden for the United Nations Educational, Scientific, and Cultural Organization (UNESCO) headquarters in Paris (9-44). It took him two years to complete. Individual sculptures made of stone (brought from Japan) exist harmoniously with plants and open spaces. A variety of textures and shapes become an appropriate symbol for the diversity of the United Nations, the mood of serenity the equivalent of its goal of peace. Noguchi said that he turned to garden design and natural materials to free humanity "from the artificiality of the present and his dependence on industrial products."

URBAN PLANNING

Beyond the design of individual buildings or parks, contemporary architects are also concerned with what is called *urban design* or *planning*. The question of how a city of the future should look is a fascinating one that has been answered in many ways during the past fifty years. This question has taken on special importance because many people find today's cities—with their crowding, traffic, crime, pollution, and lack of greenery—an unlivable nightmare.

When what is called the Modern movement in architecture was at its height in the mid-twentieth century, a standard kind of plan was devised to reform the design of cities. One of the major innovators and creators of

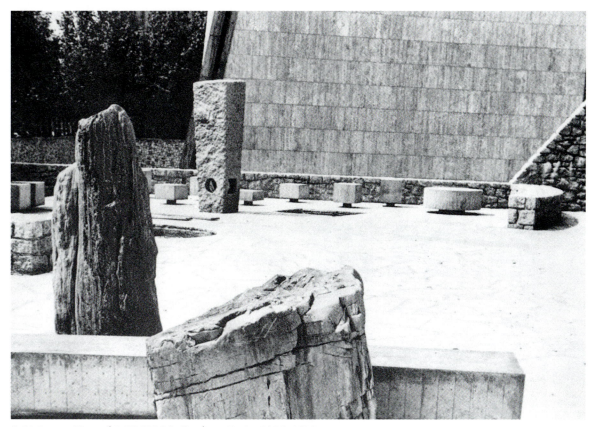

9-44 Isamu Noguchi, UNESCO Gardens, Paris, 1956–1958

the new urban planning was Le Corbusier (9-45), a Swiss-born Frenchman who worked around the world. Le Corbusier designed any number of new neighborhoods and housing projects for cities from Paris to Pakistan; most were never built, but some were, and the ideas behind them became quite influential. The idea of these plans was to house people in highrise apartment complexes, surrounded by parks and recreational areas. It was hoped that such developments would allow for both living and leisure. Pedestrian walkways would be separated from roadways, so people could walk without being bothered by cars, and vice versa.

The designs of Le Corbusier and others looked good on paper, but rarely fit the tastes or needs of ordinary people. Human beings, it seems, prefer smaller, more separate residences and what might be called semiprivate space—like yards and gardens—to huge apartment dwellings surrounded by large, communal parks. One housing complex built on the modern plan, the Pruitt Igoe Housing Project in St. Louis, won an architect's award the year it was built but proved such a failure (because of crime and vandalism) that it was demolished about twenty-five years later. In 1960, a brand new capital was opened in Brazil, called Brazilia (9-46). Built from scratch in an uninhabited portion of the country by followers of Le Corbusier, it was a "perfect" city, planned for the modern world. Only a few decades later, it seems very dated; its concrete is crumbling, its inhabitants attempting to find ways to make the city livable.

Yet all experiments in urban planning and housing have not ended in failure. As part of EXPO 67, a world's fair in Montreal, the Canadian architect Moshe Safdie was asked to design housing for officials and important visitors. His *Habitat* (9-47) is an experiment in designing what the architect called, "houses from factories": a building made of prefabricated and mass-produced apartments. They are made from reinforced concrete. However, it is anything but cold and inhuman because the 354 square modules (each containing at least two apartments) were not stacked in a pure, abstract way but imaginatively and thoughtfully. Today, people live there happily, and there is no thought of demolition. The concrete's edges are worn, perhaps, but ivy has grown along it. Nearby trees have also grown larger since 1967 and cast pleasant shade.

Safdie's Habitat is successful because it is more than a product of a method or material. Its form is not just a design issue—balance between unity and variety—or even the result of a great architect's imagination. As each of us is a unique person, so Habitat is a uniquely twentieth-century answer to our need for shelter. But it is also the child of many parents

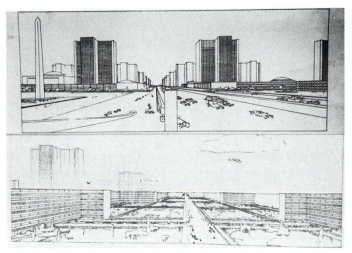

9-45 Le Corbusier, plan for a contemporary city for 3 million inhabitants, 1922

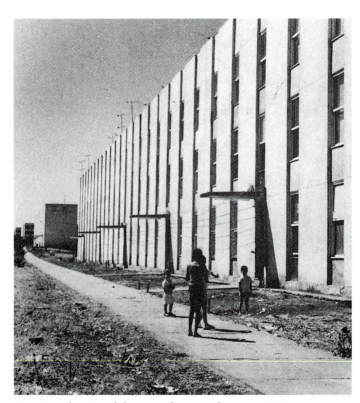

9-46 Brasilia, Brazil, became the capital city in 1960

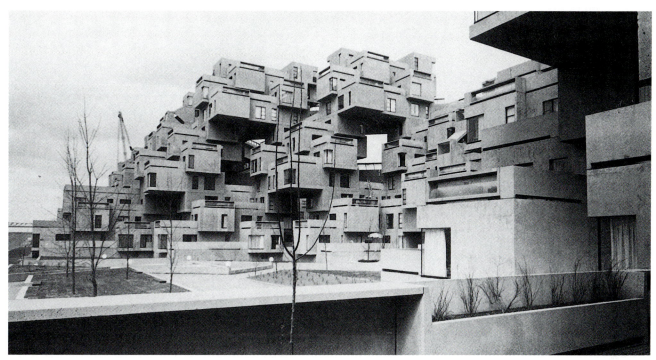

9-47 Moshe Safdie and others, Habitat, EXPO 67, Montreal, Quebec, Canada, 1967

going back through the centuries. It is both a product of our time and of our past. In its form is the ancestral memory of cliff dwellers on the coast of Spain and the many temples on the hills of the Acropolis. In Safdie's building every apartment is a penthouse; each has its own terrace and garden because it is arranged with a knowledge of the pueblos of the Southwest, whose flat-roofed cubes were arranged so the roofs of one level serve as patios for those above them.

There is no greater influence on anyone's life than his or her past; this is true for any artist. In our time, a time where every artist and artisan has access to the entire history of art, our cultural heritage is inescapable. To truly understand Safdie or the work of any artist, we must understand what has influenced him. In the next section of this book, we will begin learning about our collective artistic heritage, so we can understand our past and thereby ourselves.

PART
III

A GLOBAL HERITAGE

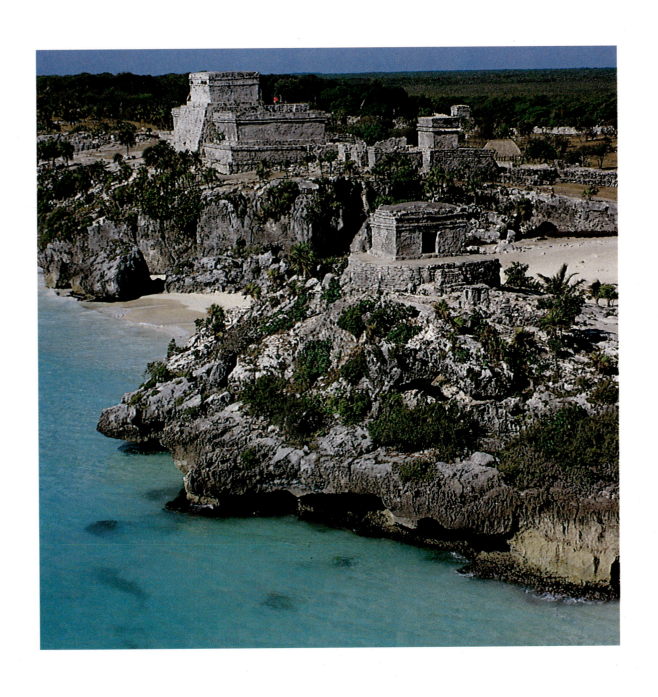

CHAPTER

10

ANCIENT EMPIRES, ANCIENT GODS

PERIOD	HISTORICAL EVENTS		
3000–500 B.C.	Egyptian Empire 3000–500 B.C. Indus Valley Civilizations 3000–1500 B.C. Olmec Civilization in Mezoamerica 1500 B.C. Homeric Age in Greece Old Testament Israel	Reign of Akhenaton 1385–1358 B.C. Reign of Ramses II 1292–1225 B.C. Exodus of Moses c. 1250 B.C. Destruction of Troy 1193 B.C. King David c. 1000 B.C. Prophet Elijah c. 900 B.C.	Homer, *Iliad* and *Odyssey* 800 B.C. First Olympiad 776 B.C. Rome founded 753 B.C. Siddhartha (Gautauma Buddha) preaches his first sermon 521 B.C. First Roman Republic 509 B.C.
500–100 B.C.	Classical Greece 5th century B.C. Ch'in Dynasty in China c. 200 B.C. Mayan Civilization in Mexico	Confucius 500 B.C. Greek and Persian Wars 497–479 B.C. Aeschylus, *Orestia* 458 B.C. Death of Socrates 399 B.C. Age of Pericles and the rebuilding of the Acropolis 460 B.C.	Alexander the Great invades India 327 B.C. India united under Buddhist Emperor Asoka 250 B.C. Great Wall of China built 215 B.C.
100 B.C.–A.D. 330	Hellenistic Greece Roman Empire	Julius Caesar assassinated 44 B.C. Cleopatra c. 50 B.C. Birth of Jesus 4 B.C. Paper invented in China 100	Rule of Trajan, furthest expansion of Roman Empire 98–116 Emperor Hadrian 117–138 Constantine makes Constantinople capital of Roman Empire 331

In every region of the globe, art and artists have flourished within powerful empires and great civilizations. In eras when few people could read or write, art conveyed vital messages about authority and status. At times, ancient art—like the prehistoric painting and sculpture we studied in Chapter 1—also aspired to bridge the gap between the real world and the magical realm of the supernatural. Art gave visual form to gods and goddesses, enabling humans to express their inner beliefs and to focus their worship on specific images. Finally, ancient art attempted to satisfy a timeless human need—the hunger of each culture for visual beauty and majesty.

THE FIRST CIVILIZATIONS

When agriculture gradually replaced hunting as the source of human nutrition, what we call "civilization" began to develop. Fields were planted and harvested; permanent settlements grew up; and a surplus food supply allowed some members of society to take on specialized tasks as rulers, religious leaders, and artisans. Such cultures developed separately in several sites: between the Tigris and Euphrates Rivers in what is now Iraq (c. 3500 B.C.), in the Nile Valley of Egypt (c. 3000 B.C.), in the Indus River Valley of India (c. 2500 B.C.), and along the Yellow River Valley of China (c. 1700 B.C.).

Culturally, civilizations are identified by having organized religion, calendars, systems for writing and recording, metalworking, and a tradition of fine and decorative arts. All of these features marked the three Mediterranean civilizations we will be discussing at length in this chapter—the empires of Egypt, Classical Greece, and Rome. The Mediterranean Sea links three continents—Africa, Europe, and Asia, providing a crossroads for trade and cultural interactions. It was in this

ART

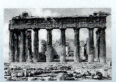

Pyramids and *The Great Sphinx* c. 2530 B.C.

Akhenaton c. 1375 B.C.

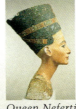

Queen Nefertiti c. 1360 B.C.

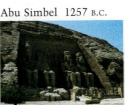

Abu Simbel 1257 B.C.

Exekias amphora 550–525 B.C.

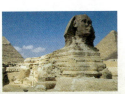

Parthenon c. 448–432 B.C.

Polykleitos, *Doryphoros* c. 450–440 B.C.

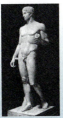

Praxiteles, *Hermes with the Infant Dionysus* c. 340 B.C.

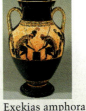

Lion Capital 272–232 B.C.

Tomb of Shi Huang Ti c. 210 B.C.

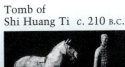

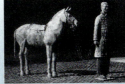

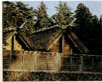

Shinto Ise Shrine 4

Colosseum 70–82

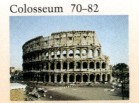

Arch of Titus 81

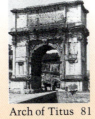

Pantheon 118–125

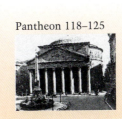

Constantine the Great c. 330

area that the most important cultures for the development of Western art came to life. At the same time, other areas of the globe were developing their own unique civilizations and cultures. Asia, Africa (below the Sahara Desert), the Pacific Islands, and the Americas each evolved its distinctive art forms—forms that had little impact on Western art before the mid-nineteenth century but had an enormous influence on modern art.

In the first civilizations, the artist's role changed from being a kind of priest creating magical images to a life devoted to preserving the power and recording the glory of leaders. It meant a loss of stature for artists, one that they would suffer for centuries. Once maker-magicians, they became anonymous crafts-people doing low-status manual labor. However, this does not mean their work was unimportant to the leaders they served. As Louis XIV of France said to his court artists, "I entrust to you the most precious thing on earth—my fame."

EGYPT

The new role for art and artists can be seen in the ancient Egyptian civilization that emerged along the fertile valley of the Nile River. Here artists worked in large studios near the royal palace, devoting their lives and skills to kings and queens. The studios were almost like factories, making standard images as prescribed by tradition. It was a powerful tradition—the Egyptian style remained fundamentally unchanged for more than three thousand years.

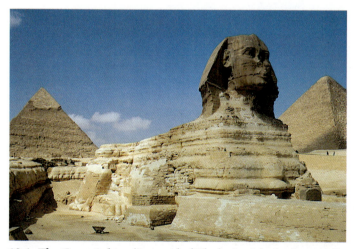

10-1 *The Great Sphinx* (Pyramid of Khafre in right background), Gizeh, *c.* 2530 B.C. Sandstone, 65' high, 240' long.

Artists preserved a continuous tradition through thirty dynasties, showing their obedience to the long lineage of the pharaohs. The role of the artist reflected that of all members of Egyptian society—servitude to the king, who was a god. Individual creativity, like any individuality, was unthinkable. All fulfilled their role as inherited by virtue of family and class. Their success and happiness were dependent on how well they served and obeyed the pharaoh.

The Egyptian focus on death and the afterlife (the so-called cult of the dead) is so well known that most of us associate Egyptian civilization with pyramids and mummies. Pyramids, of course, were the huge tombs constructed to protect the graves of Egyptian rulers, or pharaohs. Mummies were the bodies of the dead, elaborately preserved and encased in beautiful boxes, shaped and decorated to resemble human figures. Both the pyramids themselves and the mummy cases are excellent examples of Egyptian art, but these tombs also contained sculpted and painted wall reliefs, figurines of people involved in everyday tasks, and objects that had belonged to a person in life.

Most of the Egyptian art that remains today is from the great tombs of the kings. Some, like the Pyramids of Giza, are among the greatest structures ever built. These tombs were directed by master-builders under the command of the pharaoh who would be entombed within. During the months that the Nile flooded its banks and made farming impossible, the people worked as a sign of faith in their king. King Chephren directed the building of the second pyramid at Giza. Also built during his reign was *The Great Sphinx* (10-1), carved out of rock found at the site, which stands guard over the city of the dead. Its face is that of Chephren himself, its body a lion. Nearly 65 feet tall, despite weathering over the centuries (see Chapter 18), it still expresses the almighty power of the god-king. No grander display of a ruler's supremacy has ever been constructed.

The Egyptians' preference for formality, even rigidity, in their portraits can be seen in the statue of the King Mycerinus and his wife Kha-Merer-Nebty (10-2). The stiffness of the poses, the symmetry of the faces and bodies, the staring eyes, and the angular outlines of the queen's elbow and the pharaoh's headdress, all create a visual impression of

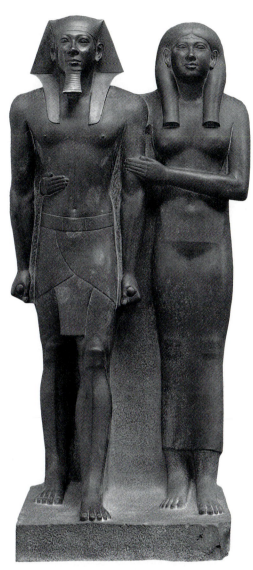

10-2 *Mycerinus and His Queen,* Kha-Merer-Nebty II, Giza, 2599–2571 B.C. Slate schist, 54½″ high.

altars for the proper worship of Aton, the Sun God. The sculptural portraits of this period became far more realistic and human. The pharaoh himself was shown in huge public statues as having a narrow face, long nose, and full lips, as well as wide hips and a pot belly (10-3). His expression is often described as "dreamy" in comparison to the frontal staring of Mycerinus (a thousand years before) and

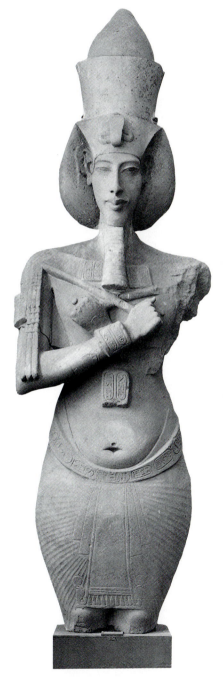

10-3 *Akhenaton,* from a pillar statue in the Temple of Amen-Re, Karnak, c. 1375 B.C. Sandstone, approximately 13′ high. Egyptian Museum, Cairo.

unyielding strength. It is believed that King Mycerinus commissioned many statues identical to this one to line the way to his pyramid tomb. This early example of the Egyptian style (dated about 2600 B.C.) provides a typical illustration of the way Egyptians preferred to see themselves immortalized as rulers and as gods.

Although the traditions of Egyptian art and religion continued for thousands of years, a notable break developed under the pharaoh Akhenaton (1379–1362 B.C.). This revolutionary king attempted to introduce *monotheism,* or the worship of a single god, to the formerly polytheistic Egyptians. For this purpose he erected an entirely new capital with many

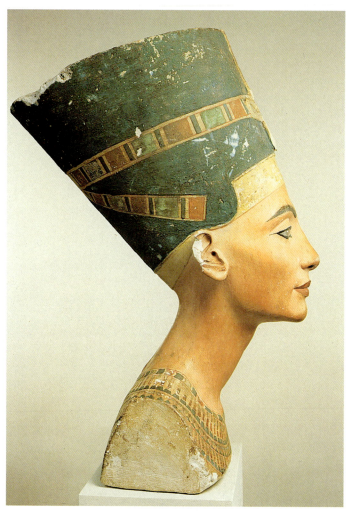

10-4 *Queen Nefertiti,* from Tell el-Amarna, *c.* 1360 B.C. Limestone, approximately 20″ high. Ägyptisches Museum, Berlin.

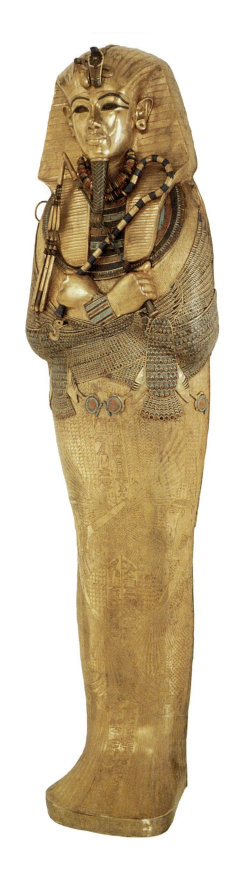

Tutankhamen (a few years later). Instead of the stiff, angular outlines of previous Egyptian art, the statues of Akhenaton and his family feature long, sinuous, curving silhouettes.

This increased emphasis on both elegance and naturalism is seen in the beautiful portrait head of Akhenaton's wife *Queen Nefertiti* (10-4). Carved from limestone and painted to resemble flesh (as were most Egyptian sculptures and wall reliefs), this is undoubtedly one of the most popular examples of Egyptian art among modern viewers. Perhaps it is because the queen's long neck, small head, and dramatically outlined eyes remind us of a contemporary movie star or fashion model. Like a later and even more famous Egyptian queen, Cleopatra, Nefertiti has come to symbolize the idea that feminine beauty transcends time.

10-5 The second coffin of Tutankhamen (ruled 1361–1352 B.C.). Gilded wood inlaid with glass paste, 6′7″ long. Egyptian Museum, Cairo.

But the best known example of the celebrity that art can bring to its subject and patron is that of the Egyptian pharaoh known to the contemporary world as "King Tut." Tutankhamen was a young ruler who enjoyed a brief, six-year reign over the Egyptian empire following the death of the pharaoh Akhenaton, his father-in-law. King Tut won no major battles, united no kingdoms, and built no cities (although during his reign the priestly class demolished Akhenaton's new capitol when a return to polytheism was ordered). Tut lives in popular imagination primarily because his was the only pharaoh's tomb to escape grave robbers until the twentieth century. In 1922, a British team of archaeologists unearthed the priceless treasure, which included the young monarch's mummified remains (encased in a triple coffin) as well as a trove of luxury objects that were buried with the pharaoh for his trip to the afterlife. When it toured the world in the 1970s, the exhibition of these objects drew huge crowds. King Tutankhamen's treasure had come to symbolize the mystery, power, and riches of the ancient Egyptian civilization.

Although viewers were fascinated by King Tut's golden throne and elaborate jewelry, the focus of the exhibit was naturally the coffin itself (10-5). The innermost chamber, which held the mummified body, is crafted of 450 pounds of gold inlaid with lapis lazuli, turquoise, and carnelian. It is not these precious materials but the exquisite workmanship, great age, and historical uniqueness that make Tutankhamen's mummy case priceless. Like the best Egyptian art, King Tut's golden portrait is formal, elegant, and reserved. The face has been simplified, or stylized, into a smooth mask of power, reminding us that the pharaoh was identified with divinity. The design of the sculpted likeness is carefully balanced, conveying a sense of grandeur and permanence—and immortality.

A hundred years after the reigns of Akhenaton and Tutankhamen, the great pharaoh Ramses II further extended the mighty Egyptian Empire, battling to enlarge its borders as far as what is now southern Syria. Traditionally identified as the pharaoh of the Exodus, Ramses demanded an even more powerful, formal style of Egyptian sculpture, as evidenced by the colossal statues of the pharaoh himself (60 feet high) cut directly out of a hillside of solid rock (10-6). Dwarfed by Ramses' majesty, the Egyptian slaves whose

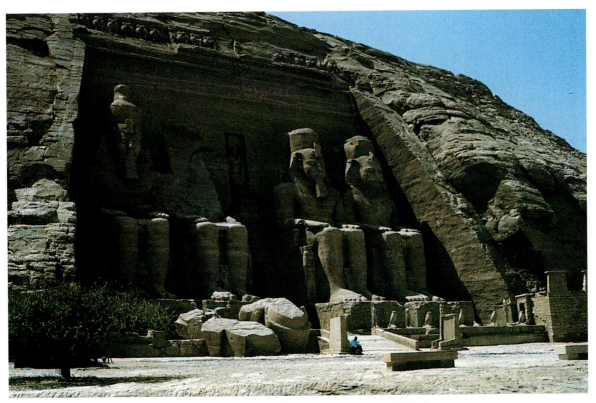

10-6 Temple of Ramses II, Abu Simbel, 1257 B.C. Colossi approximately 60' high.

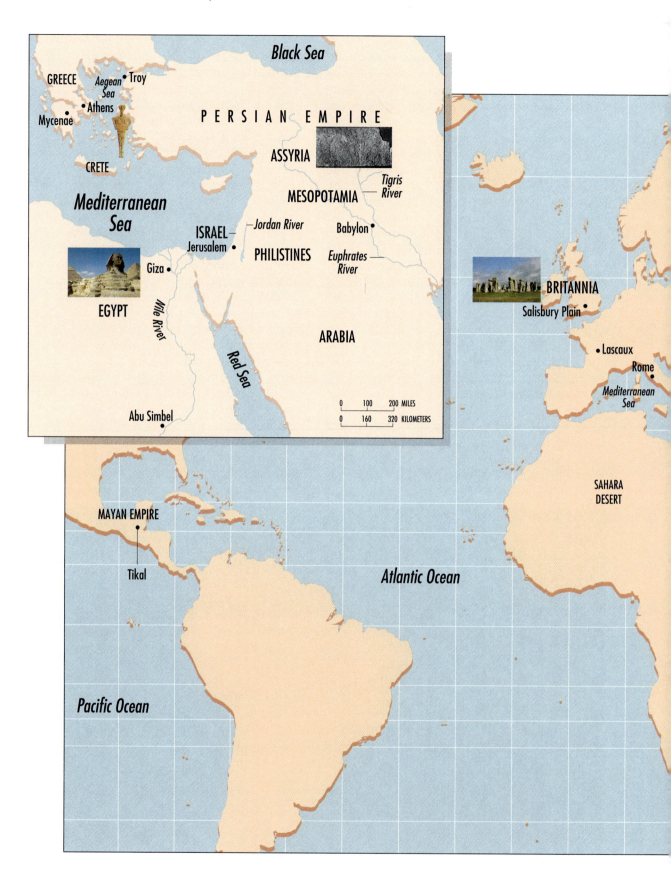

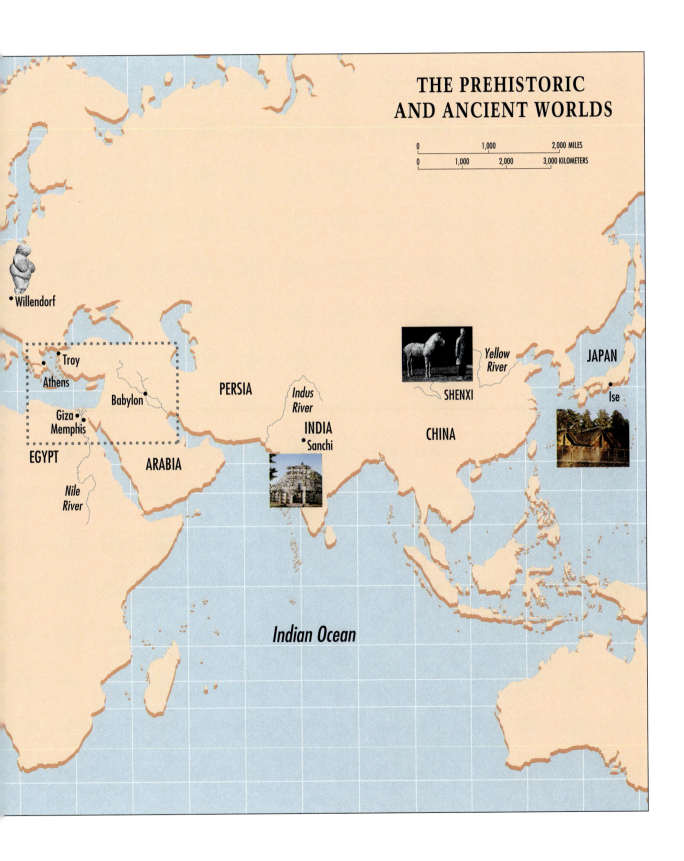

THE PREHISTORIC AND ANCIENT WORLDS

0 1,000 2,000 MILES
0 1,000 2,000 3,000 KILOMETERS

•Willendorf

•Troy
Athens•
Babylon•
Giza•
Memphis•
EGYPT
ARABIA
Nile
River

PERSIA

Indus
River
INDIA
•Sanchi

SHENXI
Yellow
River
CHINA

JAPAN
•Ise

Indian Ocean

labor built this monument must have felt literally crushed by its size and scale. These gigantic statues marked the entrance to an entire temple carved from the stone cliff, including two rows of colossal statue-columns.

But Ramses appears to have had a human side as well. Besides the temple glorifying his power as a god-king, and of course his own tomb, the warrior pharaoh built a beautiful tribute to his favorite wife, Queen Nefertari (10-7). Although its walls were decorated more than three thousand years ago and its contents plundered, with a recent restoration, Nefertari's image is once again fresh and alive. Her tomb illustrates the bright colors and decorative quality of much of Egyptian art. In this painted relief of Nefertari praying, the queen almost seems to be dancing, her long fingers rhythmically curved. Like Nefertiti, Ramses' favorite wife wears an elaborate headdress and dramatic eye makeup. Earrings, a golden collar, and bracelets complete the picture of an elegant, pampered beauty.

ANCIENT CHINA

The ancient Egyptians were not the only people to believe that their rulers would come back to life in another world, where they would require the assistance of their followers and continue to enjoy their earthly possessions. Along the valley of the Yellow River in China, there developed a mighty civilization greatly concerned with the ceremonial burial of the dead—the earliest dynasties actually buried living servants along with their dead rulers. China is the site of one of the most remarkable tombs ever discovered—a burial on the scale of the Egyptian pyramids but completely different in artistic style.

The Ch'in Dynasty of China (221–206 B.C.) was the first to unite a large portion of the country under a single ruler. When the Emperor, Shih Huang Ti, was buried, his tomb was surrounded by more than ten thousand *life-size* figures, constituting an entire sculpted army, complete with horses and chariots. This great army was even arranged in precise order, as if prepared for battle; the ranks of the soldiers can be distinguished by their costumes and weapons. The scope of the project is overwhelming, yet each of the terra-cotta figures represents an individual portrait of a real soldier, each was originally painted, and each carried an actual weapon. This mammoth testament to a ruler's belief in an afterlife—one in which he would need an entire army—indicates the power and wealth of the emperor during this period. The figures themselves are evidence of the high quality of Chinese earthenware sculpture (10-8, 10-9). It is possible to find some of the names of the potters who made them stamped or engraved into the clay. These potters were able to mold clay to create surprisingly realistic portraits; the army is made up of different ranks and racial types.

THE CLASSICAL WORLD: GREECE

Greek and Roman art mark the beginning and set the standard for much of the later art of the West. Although ancient civilizations in Egypt, Assyria (see 7-2), and Asia also produced great art, these styles had much less effect on later Western art than did the Mediterranean styles of Greece and its cultural descendent, Rome.

Greek civilization was not limited to the area now occupied by the modern country of Greece on the mainland of Europe. The Greeks, or "Hellenes" as they called themselves, spread

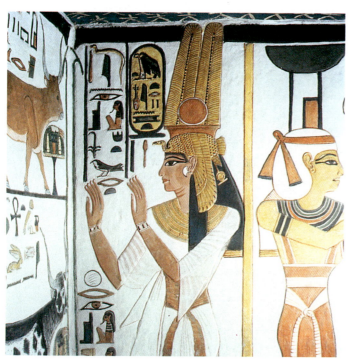

10-7 *Nefertari in Prayer,* wall painting from the tomb of Nefertari, Egypt, *c.* 1250 B.C. Painting on dry plaster.

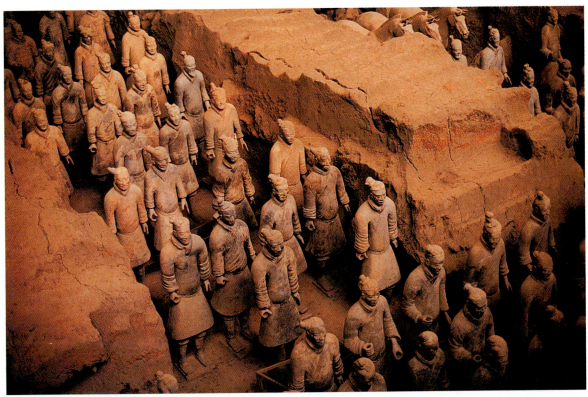

10-8 Terra-cotta army of First Emperor of Qin, Lintong, Shenxi, China, *c.* 210 B.C. Terra-cotta, figures approximately 5'10½" high.

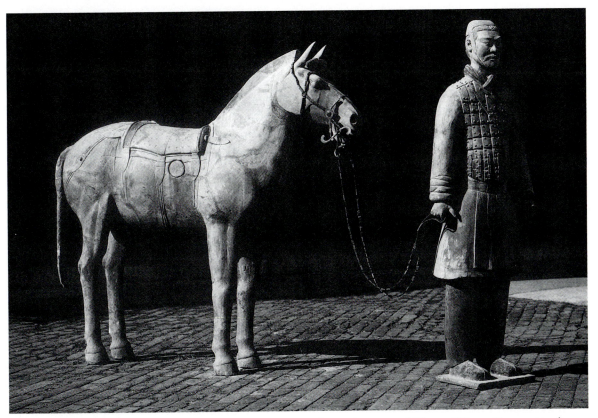

10-9 Cavalryman and saddle horse from terra-cotta army of First Emperor of Qin, *c.* 210 B.C. Terra-cotta, figure 5'10½" high. Shenxi Provincial Museum.

 A Global View

A WORLD APART: MESOAMERICA

On the other side of the globe, the ancient Americas were evolving their own civilization and art forms. Independent of the "Old World," the "New World" developed agriculture, a calendar, a system of hieroglyphic writing, and a complex mythology. The Empire of the *Mayans* (A.D. 300–900) is considered the "classic" period of Mesoamerican art. Like the ancient Egyptians, the Mayans built impressive pyramids—but with a different purpose. These were not tombs but religious sites. The dramatic pyramids at Tikal (10-10) rise out of the Guatemalan jungle; a ladder of steep stone steps leads to a small temple that tops the structure. These pyramids were originally part of a huge plan, surrounded by open spaces, where peasants would come to witness religious rites performed by priests and rulers.

Mayan wall paintings such as those found at Bonampak (done in a fresco technique developed independently in the Western hemisphere) show us these rites. Figures of fierce rulers or priests in animal costumes perform human sacrifices (10-11). It was believed that human blood was demanded by the gods in exchange for their gift of life to human beings. These practices were common throughout Mesoamerica for centuries. When the Spanish arrived in Mexico in the sixteenth century, they saw Aztec priests cutting out the hearts of living captives and offering them to gods like the Aztec earth goddess Coatlicue (10-12), a gigantic serpent-headed monster with a skirt of writhing snakes. Like the Chinese and Egyptians, the

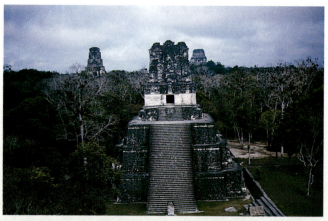

10-10 Temples II, III, and IV from Temple I, Maya, Tikal, El Petén, Guatemala, *c.* 700

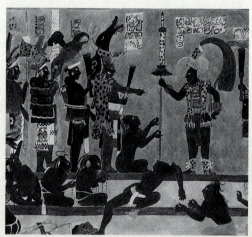

10-11 Mural painting, Maya, Bonampak, Mexico, *c.* sixth century. Watercolor reproduction by A. Tejeda, figures 24″ high. Peabody Museum, Harvard University. Copyright © President and Fellows of Harvard College 1993. All rights reserved.

from their homeland across the Aegean Sea to the coast of Turkey. The Hellenic homeland itself was divided into relatively small states that competed with each other economically and sometimes politically. Despite their political fragmentation, the Greeks were united by their culture: a common language and religion, a sophisticated literature and art, and a love of athletics. Whether living in one of the city-states of the mainland or an island colony, the Greeks thought of themselves as civilized and the rest of the world as barbaric. They developed a rich mythology based on tales about gods and goddesses. According to Greek mythology, the immortal gods lived on Mount Olympus but often

Mayans buried sculpted figurines with their dead. These very human clay sculptures give a far more humane picture of everyday Mayan life. Many of these figures have a playful, almost humorous air (10-13)—a striking contrast with the fearsomeness of Mesoamerican religion. Still, for the Mayans and Aztecs, the gods appeared in a harsh guise.

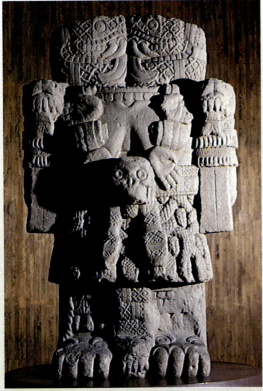

10-12 *Coatlicue (Lady of the Skirt of Serpents)*, Aztec, fifteenth century. Andesite, approximately 8'6" high. Museo Nacional de Antropologia, Mexico City.

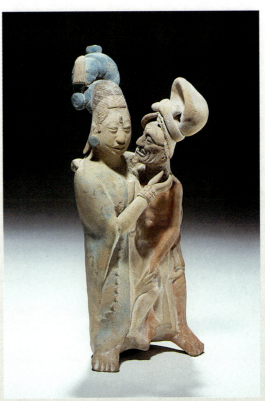

10-13 *Amorous Couple*, Maya, Late Classic, 700–900. Polychromed ceramic, 9¾". Detroit Institute of the Arts, Detroit.

visited earth, interfering in human affairs and interacting with mortal men and women. Mythological and historical stories formed the basis of Greek literature and drama. The epic masterpieces of Homer, the *Iliad* and the *Odyssey*, along with the great plays of Aeschylus, Sophocles, and Euripides, attempted to understand the motivations of men and women by retelling traditional tales of Greek gods, heroes, and ancient rulers.

But the Greeks were not a blindly superstitious people. Their religion did not limit their quest for knowledge. The Western studies of mathematics, science, astronomy, history, and philosophy all began with the Greeks, who attempted to discover and understand the

rules that ordered the universe. The great teacher Socrates reflected Greek attitudes in statements like "The unexamined life is not worth living" and "There is only one good, knowledge, and one evil, ignorance." His student Plato posed important philosophical questions about ideal government, truth, and beauty. Plato's student Aristotle was more practical, collecting data and formulating ideas based on his observation of natural processes. Yet he echoed Socrates' basic tenets when he said: "Educated men are as much superior to uneducated men as the living are to the dead." Greek thinkers placed a premium on logic and rationality. Their desire for clarity and order is also evident in Greek art.

THE CLASSICAL AGE

The Golden or Classical Age of Greek culture took place during the fourth and fifth centuries B.C. All of the arts—literary, theatrical, musical, and visual—flourished during this period. In open-air amphitheaters, the Greeks enjoyed the plays of great dramatists (10-14).

Indeed, the Western world would not see such a convergence of genius again until the Renaissance some two thousand years later. And just as the city-state of Florence was central to the development of the Italian Renaissance, so the city-state of Athens seems to have been most important in formulating what we think of as the ideal Grecian art and architecture. The accomplishments of this period are all the more remarkable because the height of Athenian power lasted only seventy-five years—from the defeat of the Persian Empire by an alliance of Greeks in 479 B.C. to the Athenians' own defeat by other Greek states, led by the rival city of Sparta in 404 B.C.

As discussed in Chapter 8, one of the major accomplishments of this era was the construction of the buildings of the Athenian Acropolis after the original temples had been destroyed by the Persians. This project was directed by the Greek leader Pericles, a statesman who established a new kind of state—a democracy ruled by able citizens rather than dominated by the wealthy. This was the first example in the history of the world where

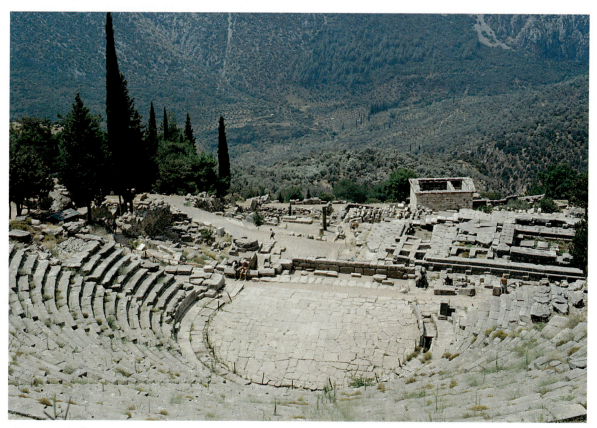

10-14 Greek theatre, *c.* 350 B.C., Delphi, Greece

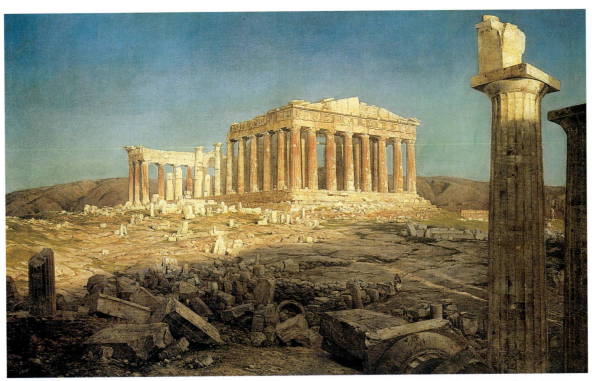

10-15 Frederick Edwin Church, *The Parthenon*, 1871. Oil on canvas, 44½" x 72⅝". The Metropolitan Museum of Art, New York (bequest of Maria DeWitt Jesup, from the collection of her husband, Morris K. Jesup, 1914).

concerned citizens shared in public political discussion and decision making. Although the Athenian experiment in democracy was marred by their acceptance of the institution of slavery and the limitation of citizenship to males, it has served as an exciting example to later, more democratic governments.

Of all the buildings constructed under Pericles, the most important was the *Parthenon* (8-10, 8-14). Meaning "the chamber of the Virgin," it was the temple dedicated to Athena, the patron goddess of Athens, and housed a magnificent, 40-foot ivory-and-gold statue of the goddess. The Parthenon is also one of the most famous architectural wonders of the world and has come to symbolize Greek art and culture. Every aspect of the structure has been measured and analyzed; generations of artists have approached it as a shrine. For instance, the view reproduced here is from a painting by the great American nineteenth-century landscape artist, Frederick Edwin Church (10-15). Church had traveled to Greece to study this monument firsthand and had written back home in a letter: "The Parthenon is certainly the culmination of the genius of

man in architecture . . . Daily I study its stones and feel its inexpressible charm of beauty growing upon my senses."

In America, we are most familiar with places of worship where ceremonies take place inside; this was not true of Greek temples. The Parthenon represents the ideal Greek temple, a religious shrine designed to face outward rather than to draw worshippers inward like a Christian church. The interior chamber, where the magnificent statue of Athena was reflected in a shallow pool of water, was open only to priests and priestesses of the cult. The statue might be glimpsed from the eastern doorway, but the space where religious rituals took place was outside at an altar placed in front of the eastern entrance. There religious processions would stop. Greek worshippers would gaze on the golden marble that rose up against the clear blue sky. Brilliant sunlight cast highlights and shadows on the fluted columns and the marble statues that decorated the triangular pediments at either end of the roof.

The temple was simple in plan. Whereas the inner chambers have been destroyed, we

A Global View

A WORLD MOUNTAIN FOR WORSHIP

With the spread of Buddhism in India came the development of a new religious architectural form that would greatly influence the Eastern world—the **stupa**. Jewish temples, Christian churches, and Islamic mosques are all based on a concept of worship familiar to most of us: A large, impressive building is dedicated to God, who is praised and prayed to by the people who gather within its walls. In contrast, the Parthenon was a temple whose worshippers gathered outside, in the open air. The concept behind a Buddhist stupa is even more foreign to most Westerners. A stupa is actually a mound and cannot be entered like a building. Instead, the Buddhist walks around the stupa in a clockwise direction. This walk symbolizes the Path of Life around the World Mountain, and the walking is a form of meditation and worship.

One of the earliest Indian stupas is *The Great Stupa* at Sanchi (10-16). This mound was finished in the first century A.D. Originally it was covered with brick, then white stucco that was gilded. On the very top is a balustrade within which you can see a mast topped with a three-layered umbrella that symbolizes the three parts of Buddhism—the Buddha, the Buddhist Law, and the Monastic Order. Around the mound are a railing and four exquisitely carved gates. The sculptures on these gates tell stories about the Buddha or contain Buddhist symbols. Entering the gate, the pilgrim climbs stairs to a raised walkway that leads the worshipper on his journey. There is no statue of the Buddha at Sanchi; the burial mound itself is symbolic of the Buddha and his death.

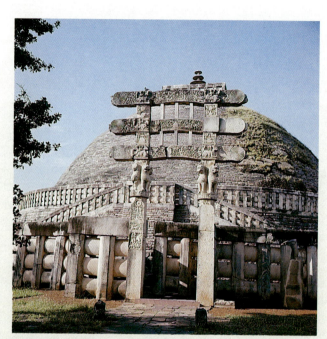

10-16 The Great Stupa, Sanchi, India, third century B.C. to early first century A.D.

can still see the row of columns, or **colonnade**, a kind of open porch that completely surrounded the inner rooms. These simple vertical columns support the horizontal lintels that held up the roof. Thus the form—posts holding up lintels (see Chapter 8), verticals supporting horizontals—is a clear expression of function, or how the building works. The structural skeleton of the temple is immediately apparent to the viewer; nothing is mysterious, hidden, or confused. The exterior design of the Parthenon is symmetrical, perfectly balanced. The Greek values of clarity, order, and unity are simply and powerfully expressed.

Yet the lines of the building are not perfectly straight. The columns swell gradually from their bases and then taper toward their tops (10-17). These slightly curved lines, lines that the human eye does not consciously perceive as curved, relieve the rigidity of the strict horizontal and vertical design, making it more visually pleasing and graceful. Curved lines give an organic, living quality to the

structure. For instance, the swell of the columns has been compared to the muscular support of a human limb, like an arm or leg. Indeed, the Parthenon is a perfect example of the melding of grace with strength, an ideal also expressed in the statues of Greek gods and heroes. Because the Greeks were great builders, they were able to construct the Parthenon with no mortar to hold the stones together. What appear to be solid marble columns are actually built out of marble drums, like round blocks, that have been fit one on top of the other.

It is interesting to note that the Parthenon as it appears today is rather different from that built and used by the ancient Greeks. Obviously, the temple is in disrepair, but other changes have taken place. The sculptures of the pediment were removed by the British Lord Elgin in the early nineteenth century (10-18)—now known as the Elgin marbles—and are housed in the British Museum. In addition, the sculptural elements on the temple were originally painted to look more lifelike so they could be more easily seen by viewers at the ground level.

Despite the fact that we cannot see the Parthenon, or any Greek temple, exactly as the ancient Greeks meant it to be seen, historians, writers, critics, and tourists have all found

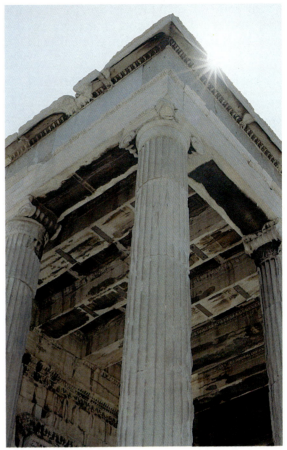

10-17 Iktinos and Kallikrates, the Parthenon, Acropolis, Athens, 448–432 B.C. (view looking up)

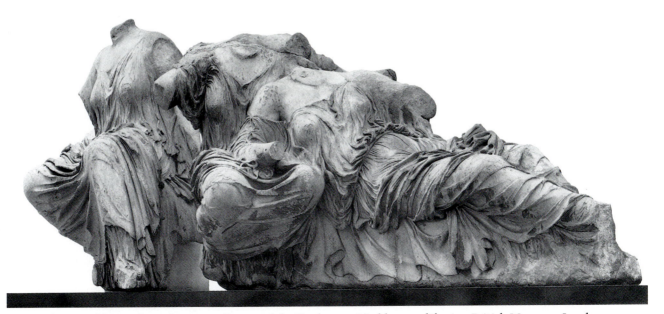

10-18 *Three Goddesses,* from the east pediment of the Parthenon. Marble, over life-size. British Museum, London.

in the remains of the Athenian Parthenon a spur to their imagination, a symbol of the very spirit of the Classical Age of Greece.

CLASSICAL GREEK SCULPTURE

The Greek concern with balance, harmony, and proportion that we saw in the architecture of the Parthenon is also evident in their sculpture. However, when Greek statues represent the ideal beauty of the human form—youth, strength, grace—they do this by appearing more lifelike, or **naturalistic**, than statues of previous cultures such as the Egyptians. Greek sculpture and painting were based on a study of the human body, especially the nude athletic male. This is not surprising, since the Greeks believed that mental health should be balanced by physical exercise. The original Olympic games were part of a sacred festival open to Greeks from every state—in fact, the Greeks counted their history as beginning in the year of the first Olympiad (equivalent to our 776 B.C.). Since the Greeks exercised and competed naked, it was natural for artists to represent them in the nude; the Greeks found nothing "shocking" about seeing people unclothed. But the Greeks tempered their admiration for athletic strength with an equal respect for youthful grace. They sought a perfect balance between body and mind, a natural harmony among muscular prowess, mental vigor, and physical beauty. For the ancient Greeks, ideal men (even more than women) could be seen as beautiful.

Unfortunately, very few Greek statues have survived in their original form. We are left, then, to make judgments about Greek sculpture from secondhand Roman copies. Still, this is perfectly appropriate, since it is these very copies, not the Greek originals, that had such a profound effect on the artists of the Renaissance and later Western art. *Discobolos*, or Discus Thrower (10-19), is a Roman copy in marble of a famous Greek statue by Myron; the bronze original was cast around 450 B.C., at the height of Greece's Golden Age. Here we see the athletic male in the midst of competition, yet he is not grunting or sweating. This perfect young man seems capable of great physical effort without any emotional strain; his face remains perfectly calm. This depiction fits the Greek ideal of dignity and self control, a philosophy that became known as **stoicism**. What was

unusual in Myron's statue was the dramatic motion and dynamic pose of the figure. Compare this to the rigidity of Egyptian statues, such as that of Mycerinus (10-2). The remarkable balance of the moving figure of *Discobolos* is due to the precise moment selected by the artist— the pause between the athlete's upward and downward motion.

Another statue of this period that had a great influence on later Western art is the *Doryphoros*, or Spear Carrier (10-20). Again, what remains is a much later Roman copy of a bronze original cast by the famous artist Polykleitos. The statue has not only lost its spear, but supports have been added in the form of a tree trunk and a brace between the thigh and the wrist. Nevertheless, we can recognize some essential qualities of Greek sculpture: the nude, athletic male; the graceful, natural stance; the well-defined muscles and understanding of human anatomy. Despite its pose of relaxed movement, the figure is shown as balanced and unified.

This statue is particularly important because it was known as the "canon," which

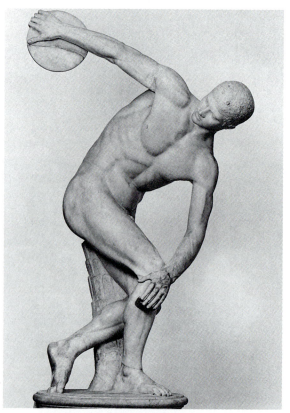

10-19 Myron, *Discobolos*. Roman marble copy after a bronze original of *c.* 450 B.C., life size. Museo Nazionale, Naples.

THE CLASSICAL WORLD: GREECE

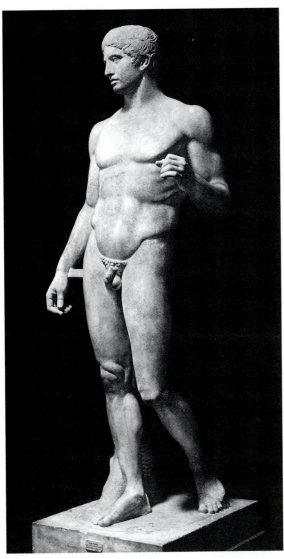

10-20 Polykleitos, *Doryphoros.* Roman marble copy after a bronze original of *c.* 450–440 B.C., 6′6″ high. Museo Nazionale, Naples.

means measure or model. It exemplified, according to the Greeks, the most perfect and pleasing proportions for representing the human figure. Polykleitos was one of the most famous Greek sculptors; after his death, his name even came to mean "sculptor." Artists who followed him studied his ideas and abided by his "perfect" proportions.

HELLENISTIC GREECE

After the classical period, Greek history and art entered what is called the "Hellenistic Age." This was the age of Alexander the Great (356–323 B.C.), when not only all of the Greek city-states were conquered and unified, but

also an attempt was made to conquer the rest of the known world. Alexander, the student of Aristotle, reached as far as India, and athough his empire was divided aftcr his death, cultural connections between the subcontinent and the classical world began to flourish.

Greek sculpture itself became more naturalistic, more illusionistic, and more human during this period. The work of Praxiteles (1-19) and the *Aphrodite of Melos* (known commonly as the *Venus de Milo*),10-21, illustrate how Greek sculptors made marble resemble flesh. While she may be missing her arms, the life-size *Venus de Milo* still illustrates the voluptuous charms of the Greek goddess. Not only are her breasts bare, but also her hips and abdomen. We can imagine this Venus

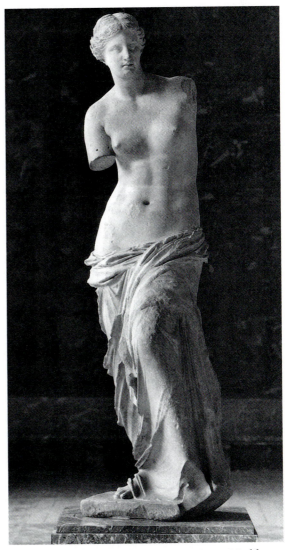

10-21 *Aphrodite of Melos, c.* 150–100 B.C. Marble, approximately 6′10″ high. Louvre, Paris.

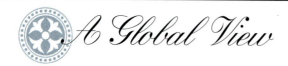

A Global View

FERTILITY GODDESSES

In Chapter 1 we looked at the *Venus of Willendorf*, carved about twenty thousand years ago, a tiny stone figurine in which the female sexual characteristics had been greatly exaggerated. Such early sculpture reflects a natural concern for human fertility and the continuation of the tribe, just as cave paintings were meant to magically ensure a supply of animals to hunt for food. Fertility goddesses continued to be worshipped by many early civilizations. It is not surprising that women, with their power of procreation, were associated with the creative forces in the universe. Throughout the ancient Middle East and Mediterranean basin, these overtly sexual goddesses were worshipped under a number of names: Ishtar (in Babylon), Astarte (in Syria), Isis (in Egypt), and Aphrodite (in Greece). Modern scholars refer to all of these as manifestations of a single powerful concept: "The Great Mother Goddess." Mother of the earth, she symbolized life forces and controlled the heavens, the seasons, and fertility for plants and animals as well as humans.

Today we are most familiar with the name the Romans gave to the goddess of fertility—Venus. But cultures from all over the globe have incorporated female fertility figures into their religious art. In Indian art, the figure of a well-developed woman is known as a *Yakshi* (10-22). Originally part of a primitive system of beliefs, these Yakshis were incorporated into the decoration of both Hindu and Buddhist religious centers. The Yakshi illustrated here, for instance, is from a gateway of the Great Buddhist Stupa at Sanchi (see "A Global View," p. 196).

In Indian as in Greek art, there is no shame in showing the nude body, and Indian artists seem to stress even more the overtly sexual nature of their goddesses. With large breasts, tiny waists, and swelling hips, these represent an exaggeration of the female form much as the Venus of Willendorf does. Notice also how the Yakshi is shown intertwined with a tree—representing vegetation, or the fertility of the earth. While we would never expect this seductive Yakshi to "come to life," still the Indian goddess has a playful quality that seems to be lacking in the Western portraits of goddesses. The attitude toward divinity seems somehow less authoritarian, more joyful.

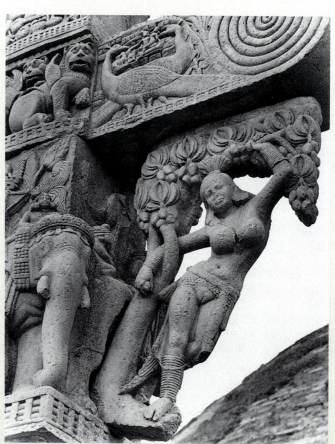

10-22 *Yakshi,* from the East Gate, The Great Stupa, Sanchi, India, early first century B.C.

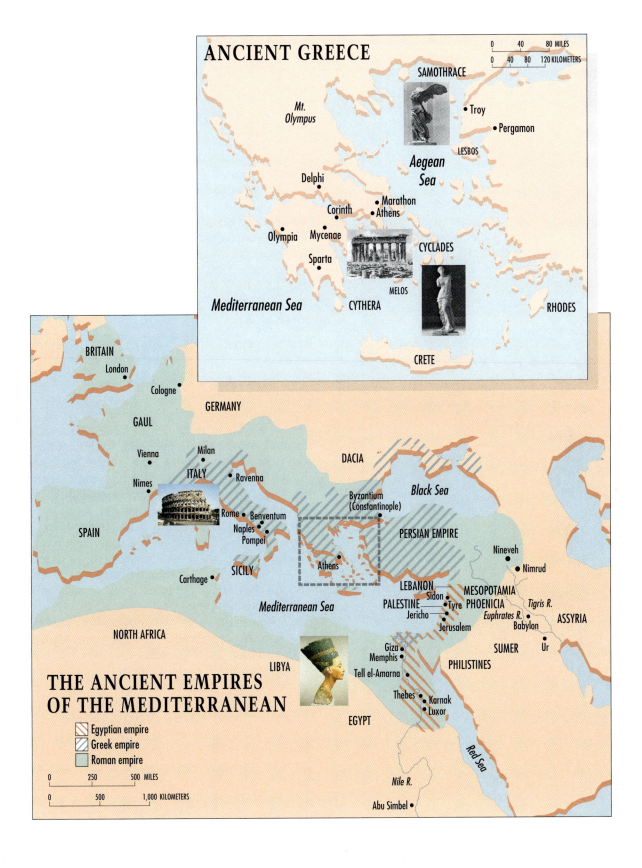

ANCIENT GREECE

0 40 80 MILES
0 40 80 120 KILOMETERS

SAMOTHRACE

Mt. Olympus

Troy
Pergamon
LESBOS

Aegean Sea

Delphi

Marathon
Corinth Athens

Olympia Mycenae

Sparta CYCLADES

Mediterranean Sea CYTHERA MELOS RHODES

CRETE

BRITAIN
London

Cologne

GERMANY

GAUL

Vienna Milan

DACIA

ITALY Ravenna

Byzantium
(Constantinople)

Black Sea

Nimes

Rome Benventum

SPAIN

Naples
Pompei

PERSIAN EMPIRE

Nineveh

Nimrud

SICILY

Athens

Carthage

LEBANON
MESOPOTAMIA
Sidon
PALESTINE Tyre PHOENICIA *Tigris R.*

Mediterranean Sea

Jericho *Euphrates R.* ASSYRIA

NORTH AFRICA

Jerusalem Babylon

Giza SUMER Ur

LIBYA

Memphis PHILISTINES

Tell el-Amarna

**THE ANCIENT EMPIRES
OF THE MEDITERRANEAN**

Thebes Karnak
Luxor

EGYPT

Egyptian empire
Greek empire
Roman empire

0 250 500 MILES
0 500 1,000 KILOMETERS

Nile R.

Red Sea

Abu Simbel

breathing, moving, like a real person. These sculptures appeal less to the rational mind and more to the senses than the restrained works of the classical period. Also during the Hellenistic Age, a more elaborate style of column gained popularity—the *Corinthian order* (see Chapter 8), which was topped with a capital of sprouting leaves.

By the second century B.C., Greek sculptors had begun to sculpt ever more complex and dramatic figures that made bolder use of space. Two examples of this more exciting, less "classical" or restrained sculpture are the *Nike of Samothrace* (10-23) and the *Laocoön* group (10-24).

Nike means goddess of winged victory. Like so many ancient statues, this one no longer has a head, but the spirit of the piece is still evident. It shows the victory goddess landing on the prow of a ship. This portrayal of a moment in time, rather than a timeless universal, is one break with the classical past. Another is the sense of motion, the windswept drapery, the twisted lines of the costume, and the diagonals of the wings. The detailed rendering of the wet, clinging drapery is typical of Hellenistic sculpture, where artists attempted to make marble resemble both cloth and the flesh beneath it.

The *Nike of Samothrace* was carved about 190 B.C.; the *Laocoön* group of the first century A.D. represents the ultimate in Hellenistic theatrics. It illustrates the story of a Trojan priest, Laocoön, who (along with his sons) was squeezed to death by sea serpents as a punishment for displeasing the gods. Compare the writhing, twisting figure of Laocoön to that of the earlier Discus Thrower, the expression of violent suffering on his face (10-25) to the masklike features of the Classical Age; we have come far from the world of perfect beauty and harmony.

THE CLASSICAL WORLD: ROME

The city of Rome in Italy was the center of a second, and related, dynamic civilization that spread throughout the Mediterranean world. As early as the third century B.C., Rome had expanded and conquered Greek settlements on the boot of Italy, and by about 150 B.C. Greece had been annexed into the growing Roman Empire. In fact, the *Laocoön* was sculpted for Roman patrons after Greece had become a Roman province. During this early imperialistic period, Rome operated as a "republic." The government was controlled by a small group of wealthy families by means of a senate and by officials elected from a small pool of eligible aristocrats.

Roman culture was modeled on that of the Greeks: Their gods were variations on the same theme; their literature imitated Greek poetry and drama; their art and architecture grew directly from Greek sources. Educated Greeks were often brought to Rome as slaves for the wealthy, working as clerks and teachers. Greek artists flocked to Rome, attracted by money and patronage, and created many of the surviving "Roman" copies of Greek statues. While the Romans absorbed their artistic ideals from the Greeks, they were more realistic than idealistic, more active than philosophical, more pragmatic than creative.

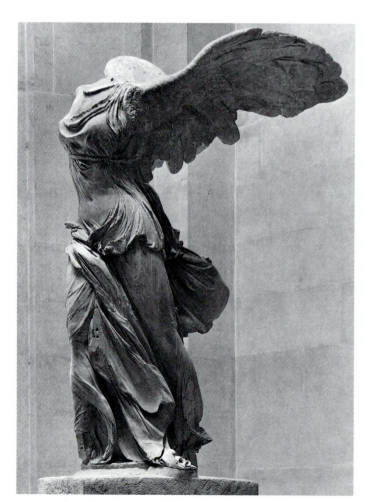

10-23 *Nike of Samothrace*, c. 190 B.C. Marble, approximately 8' high. Louvre, Paris.

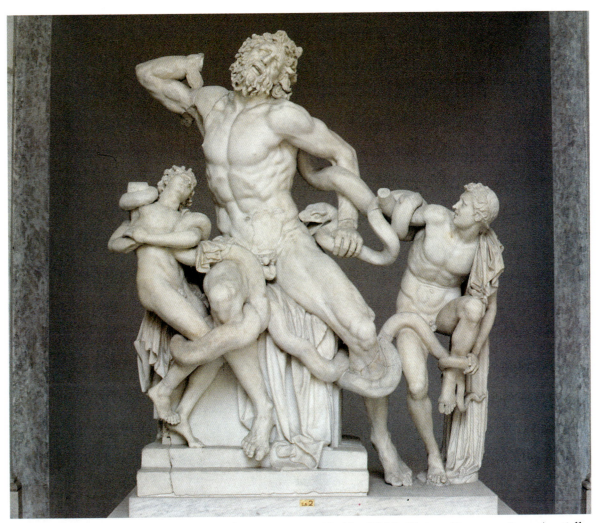

10-24 *Laocoön* group, first century B.C. to first century A.D. Marble, 8′ high. Vatican Museums, Rome (partially restored).

The Romans also contributed something unique to the world of Western sculpture, a tradition of realistic portraits. This school of portraiture developed in response to a specific need that related to Roman religious practices. Roman religion centered around the family and home, where busts of ancestors were given a place of honor. These were realistic and descriptive of all facial features, unattractive though they might be. Compare the Roman portrait busts (10-26) with the head of Hermes by Praxiteles and you will immediately see the contrast between Greek and Roman art. It is inconceivable that the Greeks of the Classical Age would have commissioned such an unflattering image or would have wanted to keep it in their homes. Such unsparing portraits are typical of the virtues that Romans admired during the republican

10-25 Detail of figure 10-24

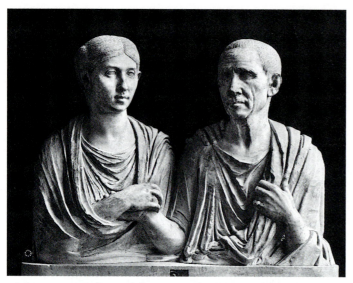

10-26 *Porcia and Cato* (?), portrait of a Roman couple, *c.* first century B.C. Marble, 27" high. Vatican Museums, Rome.

period: discipline, honesty, obedience, courage, strength, and frugality.

IMPERIAL ROME

In 31 B.C., after a long period of civil wars (immortalized by William Shakespeare in *Julius Caesar* and by Hollywood in such epics as *Cleopatra*), Julius Caesar's great-nephew Octavius finally defeated his enemies in battle, and the Roman Empire was born. Given the title of Augustus, Octavius proceeded to consolidate his power. Although he never called himself emperor, he held dicta-torial and imperial powers. For the next one hundred fifty years Rome would be at peace, prospering and expanding, reaching the fur-thest limit of its rule. Eventually the empire would stretch completely around the Mediter-ranean, from Italy to Spain, through North Africa, the near East, Turkey, and Greece, and including all the islands in what Romans called *Mare Nostrum* or "Our Sea." Because of the **Pax Romanus**, or "Roman peace," it was pos-sible for citizens to travel safely anywhere within the far-flung empire. Roman legions also marched northward, conquering Gaul (what is now France) and even the southern end of the island of Britain.

The statue known as *Augustus of Prima Porta* (10-27) stood in the courtyard of the suburban Roman estate of Augustus's wife Livia. The posture is that of a victorious gen-eral addressing his troops, and the emperor is shown in armor. His breastplate is sculpted with scenes of Roman military triumph and the mythological figures of gods and god-desses. The pose of the figure is clearly based on the Greek model of the Spear Carrier (10-20), and the face shown is that of a handsome man in the prime of life. Here Greek idealiza-tion and Roman realism combine to create a convincing portrait of a "real man" and an effective image of the perfect leader. Looking down on his people with calm concern and complete self-confidence, Augustus represents the "pater patriae," the father of his country. The historical scenes on his breastplate illus-trate instances where his armies imposed peace on rebellious provinces. In works of art such as this, Augustus consciously attempted to identify himself with the ultimate author-ity of the state and the beginning of a new, Golden Age of Roman civilization.

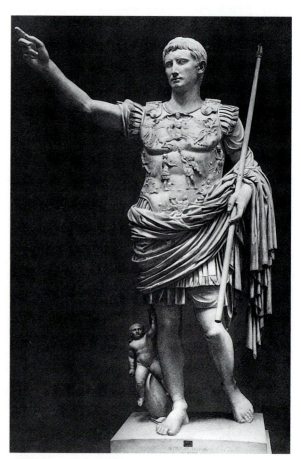

10-27 *Augustus of Prima Porta, c.* 20 B.C. Marble, 6'8" high. Vatican Museums, Rome.

ROMAN ARCHITECTURE

Pomp and glory were needed to impress the masses, Roman citizens, and rival states. It was in architecture that the Romans found a medium most suited to their message. They adopted the language of Greek architecture— the Doric, Ionic, and Corinthian orders. They also borrowed the idea of the arch from the East (where it had been used primarily for drains) and exploited its possibilities to construct public buildings of great size, feats of ancient engineering. The emperor Augustus, who embarked on a major program of renovation in the capital, bragged that he had found Rome a city of brick and left it a city of marble. In addition, the vast imperial building program extended through all areas under Roman control, from Britain to the near East. Distant provinces of the empire were supplied with defensive walls, paved roads for the transport of armies and goods, aqueducts to supply fresh water to cities, and spacious public baths.

One of the most famous structures in Rome, symbolic of the city and imperial Roman architecture, is the *Colosseum* (10-28). This huge arena (known to the Romans as the Flavian Amphitheater) is familiar to generations of American moviegoers because of its legendary association with gladiators and chariot races. To us, familiar with huge sports stadiums, the Colosseum looks almost ordinary. But in the Roman world it was a remarkable achievement. The use of the arch was key to the support of such a structure, which could not have been held up by the simple post and lintel system of the Greeks. Holding up to 50,000 spectators, it was 13 stories tall. The purpose of the Colosseum was to house popular entertainments; for its opening in A.D. 80, the entire field was turned

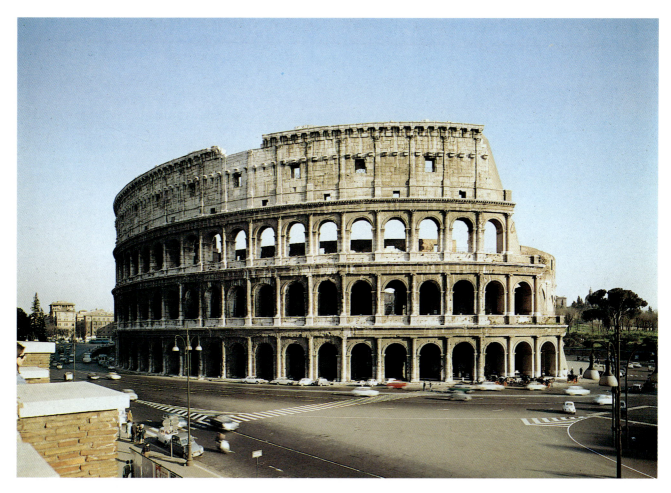

10-28 Colosseum, Rome, A.D. 70–82

into an immense sea of water, where 3,000 participants staged a mock battle. Plenty of blood was shed here: As many as 5,000 wild beasts might be slaughtered in a single day.

Aesthetically, the Colosseum makes a dramatic impression even in its present state of decay. It is like an illustrated essay on the three orders: the first story decorated with simple Doric columns, the second with more elegant Ionic columns, and the third by elaborate Corinthian columns. The columns and the lintels they support, however, are not integral to the structure of the theater—they are simply ornamental, since the weight of the walls is supported by round arches rather than slim columns. The arches served not only to support the structure, but also as conve-

nient exits and entrances for thousands of spectators. Whereas the beauty of Greek architecture was based on honesty and simplicity, Roman architecture was meant to provoke awe in the viewer. In imperial Rome, the human scale of buildings such as the Parthenon was sacrificed to a kind of superhuman scale.

ORGANIZED CONQUERORS

The success of Rome was based on the military might of their highly professional armies and the brilliance of their generals, as well as their powers of organization, their centralized administration, their efficient bureaucracy, and the huge tax base from their conquered territories. Above all, the Romans showed great political finesse, an ability to absorb many different peoples, races, religions, and cultures. One of the means by which Roman imperial authority was displayed was in official, public, and triumphant monuments, such as the *Arch of Titus* (8-20). Another famous victory symbol of imperial Rome is the *Column of Trajan* (10-29). Trajan was a great general who ruled as emperor of Rome during the second century A.D. It was during his reign that the Roman Empire reached its greatest size. This column commemorates his two campaigns against the Dacians, which culminated in the conquest of the area that today still bears the name of Rome, Romania. Erected in Rome in A.D. 113, the column established a format that would be used for centuries. More than 150 tightly packed scenes spiral up its height, reading like the scrolls that were stored in the two libraries on the same site. At the base (10-30), a surprised river god meant to represent the Danube has turned to see the Roman armies crossing his river on a bridge they constructed. At the next level, the soldiers, after being addressed by Trajan, proceed to build fortifications. In fact, it is not battles themselves but the world-renowned engineering and organization skills of the Romans that are accentuated in the stories described. The overall atmosphere is one of calm, methodical planning succeeding over disorganized barbarians. The Romans march in orderly patterns, while the enemy's attacks seem confused; the Romans are cleanshaven, while the Dacians are sloppy and bearded. Trajan himself is always dignified and in control. Still, the Roman

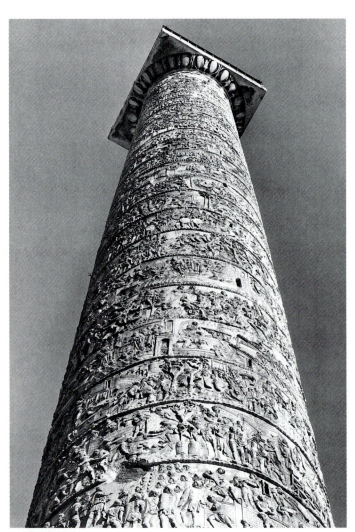

10-29 Attributed to Apollodorus, Column of Trajan, Rome, A.D. 113. Marble, 128' high.

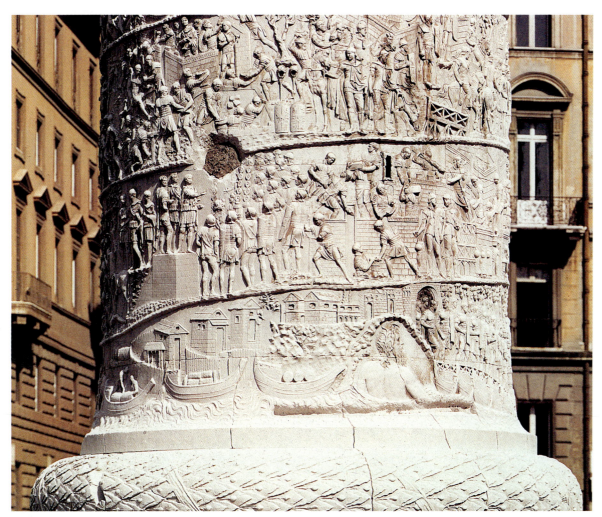

10-30 Detail of figure 10-29

legions must fight long and hard as they move their way up the 125-foot column to ultimate victory.

The sculptor of this immense marble relief must have shared the Roman fascination with building because precise details of constructions are seen throughout. Some believe that he was Apollodorus, the architect of the bridge over the Danube and other wonders of the ancient world. But even though the figures and backgrounds have many naturalistic details, real proportions are not used. Trajan is always larger than his soldiers, his armies always larger than any of the buildings. Size is related to the importance of the element in the story being told.

Inside the column a long spiral staircase leads to a balcony at the top. In ancient times, one could walk up to pay homage to a bronze statue of Trajan and admire a beautiful view of

the city he once ruled. Centuries later, a statue of Saint Peter was put in its place. Beneath Saint Peter's feet, in the base, are Trajan's ashes. It is, perhaps unintentionally, symbolic of the new church supplanting the once all-powerful pagan emperor and how time is the enemy that no one defeats.

ROMAN TEMPLES

In addition to their use of the arch, the Romans developed the architectural feature of the dome. A dome makes it possible to span a dramatic space without columns or supports. But with the dome, as with the arch, we see a convergence of technical means with aesthetic considerations. In other words, the dome was not merely a useful feature—it was developed to be aesthetically pleasing as well. The most beautiful domed monument from

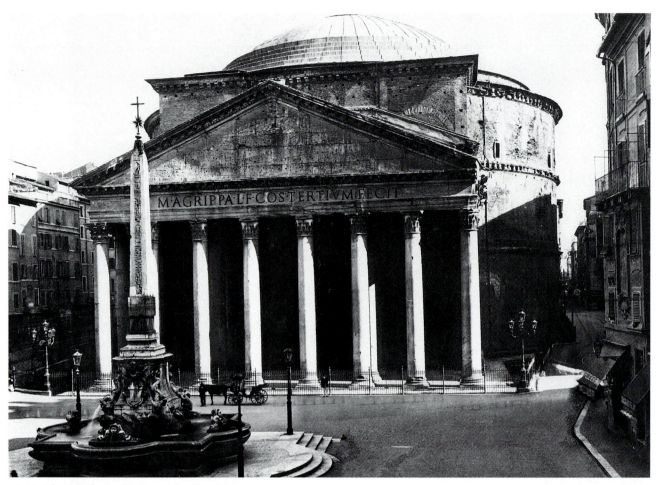

10-31 The Pantheon, Rome, A.D. 118–125

ancient times, perhaps of any age, can also be found in the city of Rome—the Pantheon.

The *Pantheon* (10-31) was a temple dedicated to the worship of all the Roman gods and goddesses, as its name (*pan* means *all, theo* means *god*) suggests. This architectural wonder was begun under the emperor Hadrian (117–138), who may well have been its designer. The size of the huge dome was never surpassed until the twentieth century. Hadrian held the empire together through hard work and strong character and was a great patron of the arts.

Looking at the Pantheon's facade, we immediately recognize Greek influence: It resembles the front of a Greek temple. Behind the rectangular porch, however, is a completely round building, or **rotunda**. The rotunda is topped by half of a sphere that, if it were continued, would just touch the floor of the building. In other words, the diameter of the rotunda is exactly equal to the height of the building at the top of its dome. Thus the space within the Pantheon is perfectly balanced, simply understood, and harmonious. At the very top of the dome is an open **oculus**, or eye, that permits a view of the heavens above.

The Pantheon, which has stood for almost two thousand years, is also a tribute to the engineering knowledge of Roman builders. Whereas the Greeks used solid marble to build their temples, the Romans exploited the potential of concrete as a building material. The dome of the Pantheon is designed of concrete that has been *coffered*; that is, squares have been cut into its surface. This coffering was not only part of the decorative scheme, but also it had the effect of lightening the weight of the dome itself (10-32).

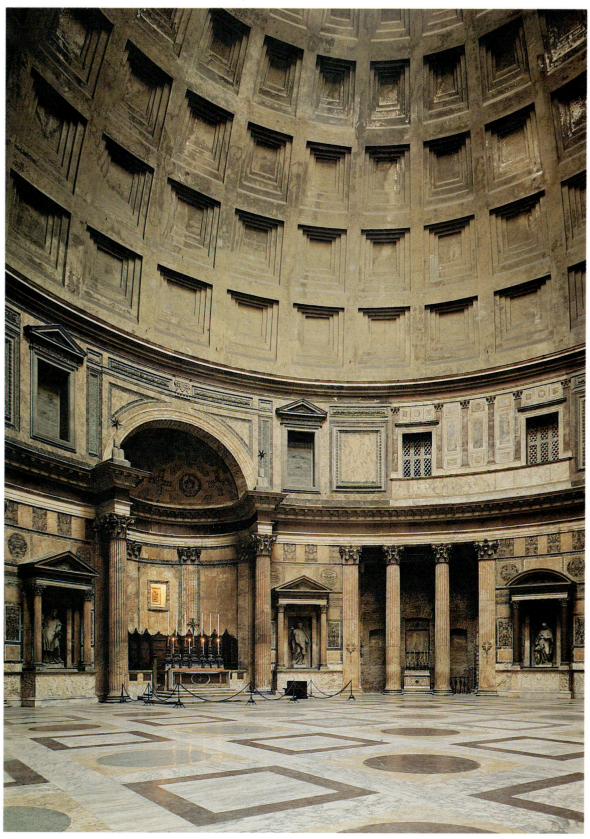

10-32 Detail of the dome, the Pantheon, Rome

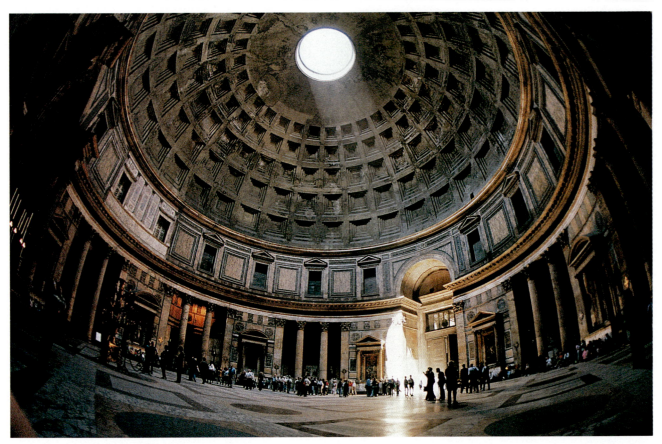

10-33 Interior of the Pantheon, Rome

To the eye, the dome appears so light that it seems to float over the rotunda rather than press down upon the viewer (10-33). On entering the Pantheon one is overwhelmed by a sense of peace and visual satisfaction at the contemplation of its perfectly harmonious proportions. In Roman times, the ceiling was studded with bronze rosettes that looked like stars. For generations since, its refreshing shade and cool stone have provided an escape from the hot Roman sun. Whereas the Greek temple was like a sculpture set in space, meant to be appreciated from the outside, the Pantheon is more like a frame enclosing three-dimensional space, a way of making empty space into the subject of the architecture.

ROMAN PAINTING AND MOSAICS

In addition to public buildings such as the Colosseum and the Pantheon, emperors, generals, and the upper class built expensive palaces complete with beautiful gardens and fountains. As in Hadrian's villa at Tivoli

(8-15), the gardens were filled with Roman copies of Greek sculpture. Roman villas were decorated by wall paintings (see *Herakles and Telephos*, 4-1) and **mosaics.** The few paintings that survive demonstrate the Roman taste for mythological subjects, as well as their ability to model forms in three dimensions. The paintings in stone have stood the test of time better than delicate frescoes. One remarkable mosaic, made during the second century A.D., is known as *Unswept Dining Room Floor* (10-34) because it represents the floor as it might have looked after a Roman banquet. The artist demonstrates complete mastery of the medium of mosaic, a medium that, like so many others, had originally been developed by Greek artists. A mosaic image is built up of tiny pieces, or *tiles*, of colored stone, ceramic, or glass, all fitted together in an intricate puzzle to form the desired pattern or picture. Here small marble tiles are used in different tones to actually *model* forms three-dimensionally; cast shadows add to the illusion of reality, as does the little mouse

gnawing on a bit of food in the left-hand corner. But despite the surprising realism of the individual images, all the remnants of the meal have been designed to create a pleasing pattern against the pale floor.

THE DECLINE OF ROME

Mosaic or fresco, these examples of interior decoration were obviously designed to humor a pampered upper class. Many contemporary observers felt that such aristocratic Romans had become decadent and had lost touch with the values that had enabled them to conquer and dominate so many peoples. As the Roman Empire entered its second century, the age of confidence was replaced by a time of troubles. Historians continue to argue over the reasons, but inflation became rampant and trade diminished. Rome was plagued with a swollen bureaucracy and urban riots. There were also military defeats at the borders of the empire—defeats by the armies of the Persians in the east and Germanic tribes in the northwest.

Roman culture was shaken, changed, and eventually overcome by three forces—the internal crisis described above, conversion to Christianity, and the Germanic invasions. The first two affected the spirit of the Romans, the other the physical integrity of the empire.

10-34 Sosus, *Unswept Dining Room Floor,* detail of later Roman copy of original Pergamene mosaic of second century of B.C. Vatican Museums, Rome.

Christianity, an offshoot of Judaism, was originally condemned as an "Eastern," mystical religion, and its followers were persecuted by the Romans. But, as the empire continued to crumble from within and to be attacked from without, Christian ideals began to appeal to the average Roman citizen. It was almost as if the entire empire experienced a communal spiritual crisis, a crisis of confidence. Early Christianity preached renunciation of the world and concentration on the promise of an afterlife—in opposition to the Roman ideals of practicality and public service. The Christian Church emphasized the spirit and condemned the desires of the body, in direct contrast to Greco-Roman ideals of physical fitness, health, and balance between body, mind, and spirit.

The Roman style itself had changed in the three centuries since the age of Augustus. The technical skill of Roman sculptors had declined, as is evidenced by the *Arch of Constantine* (10-35), constructed between A.D. 312 and 315. In the traditional Roman manner, this monument was dedicated to the most famous victory of Emperor Constantine the Great. What was not traditional was that much of the decoration for the arch was actually stolen from earlier monuments to emperors. There is a dramatic contrast between the naturalism of the older sculpted reliefs and the awkwardness of those created by the artists of the Age of Constantine.

The two circular medallions taken from the Arch of Hadrian illustrate the classical style of the height of imperial power. The figures are graceful and well-proportioned; they are shown in a variety of poses. The medallion at the left conveys the motion of a hunt, with realistic men on rearing horses, and the sculptor even suggests the texture of the wild boar's fur. On the right, an idealized, Grecian-style statue of a god stands on a classical base, and the sculptor is skilled enough to convey the difference between living figures and the immobile stone statue. Both medallions surround the sculpted forms with space and arrange shapes in a pleasing and harmonious way within the round frame.

In contrast to these reliefs, which echo much of the Greek and Roman art we have looked at so far, the depiction of Constantine and his followers below them seems childlike and crude (10-36). The figures sculpted in

 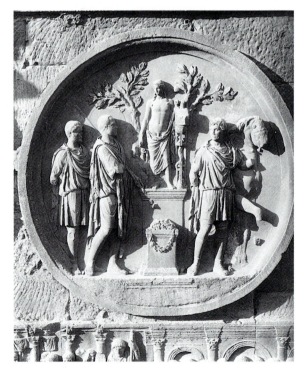

10-35 Medallion reliefs from the Arch of Constantine, A.D. 117–138. Marble, approximately 80" high. Believed to be originally from the Arch of Hadrian.

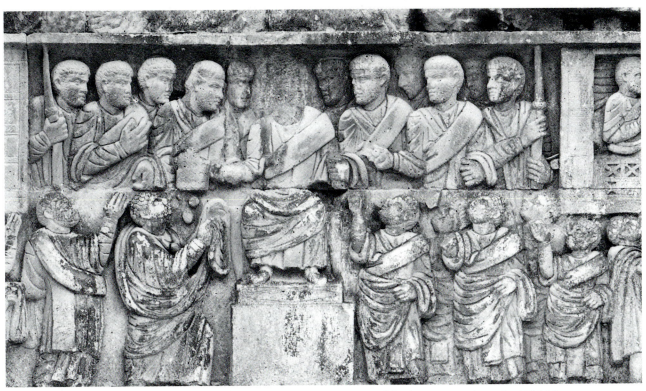

10-36 Frieze from the Arch of Constantine, early fourth century A.D. Marble, frieze approximately 40" high.

the fourth century are squat; their heads seem too big for their bodies. All the bodies face stiffly forward; figures seem to be crowded on top of each other without enough space to move. The figure of the emperor stands, frozen, in the very center (the figure whose head has been damaged), surrounded by identical courtiers, who are flanked on both sides by identical figures in a crowd. There is nothing left here of either realistic Roman portraiture or idealistic Greek beauty.

The classical elegance of the older medallions was not to be seen again for a thousand years, until the Italian Renaissance. Yet it would be wrong to see this change in artistic style merely as the result of a loss of talent or the ability to make art look "real." In fact, this period is the beginning of the Byzantine and medieval styles that will come to dominate Western art in the coming centuries. The Age of Constantine marks the beginning of a period when the symbolic content of a work of art is more important than its naturalism. These fourth-century relief sculptures therefore represent a changing vision, which has not yet reached maturity. Superb works of art would eventually be produced in both the Byzantine and medieval style—art with a different aesthetic, a different purpose, but with no less power than the masterpieces of the Greeks and Romans.

CHAPTER

11

THE AGE OF FAITH

PERIOD	HISTORICAL EVENTS		
A.D. 325–475	Decline of Roman Empire Spread of Christianity through the Roman World Shinto cult in Japan	Constantine declares Christianity official religion of Rome A.D. 325 Division of Roman Empire into east and west 337	Buddhism spreads to Southeast Asia c. 400 Attila the Hun dies after invading Roman Empire 453 St. Patrick converts Ireland c. 475
476–900	Fall of Western Roman Empire West African Kingdom of Ghana c. 400–1230 Arab-Moslem golden age of art and learning Classic Mayan period in Central America 300–900 Dark Ages in West Growth of Christian monasteries Birth of Feudalism	Fall of last Roman Emperor 476 Justinian (527–565) attempts to reunite Eastern and Western Roman Empires Buddhism reaches Japan 6th century Mohammed proclaims the faith of Islam 611 Spread of Islam through Near East and Africa	Omayyad caliphs spread Islam through North Africa and into Spain 750 *Beowulf* composed 8th century Charlemagne crowned Holy Roman Emperor 800 Viking raids throughout Europe 800–1088
900–1400	Medieval period in Western Europe Romanesque Art Song Dynasty in China 960–1279 Gothic Art West African Kingdom of Mali 1230–1340	Norman conquest of England 1066 First crusade 1095–1099 Genghis Khan conquers vast empire in Asia 1162–1227 The Crusades expose Europe to art and culture of Middle East	Growth of towns in Western Europe St. Francis of Assisi establishes Franciscan order 1209 The Hundred Years War between England and France 1337–1453 The Black Death begins to sweep Europe 1348 Chaucer, *Canterbury Tales* c.1390

Constantine the Great (272–337, emperor 306–337) was a uniquely important figure in the history of the late Roman Empire and Western civilization. According to legend, before the crucial battle of the Milvian Bridge, commemorated in the triumphal arch in the last chapter, Constantine saw a miraculous cross in the sky. After his victory, in A.D. 313 he declared Christianity legal and stopped the persecution of Christian believers; in A.D. 325 he made Christianity the official state religion of Rome. The remains of a colossal statue of the emperor from A.D. 330—a head of more than 8 feet, plus broken portions of the body—suggest the direction that Western art will take in the centuries to come (11-1). Moving away from both the naturalism favored by the Greeks and the realism of early Roman portraits, *Constantine the Great* is presented with an awesome face. His huge, staring eyes seem all seeing; it is an image not of a man but of absolute power.

Approximately one thousand years divide Constantine's conversion to Christianity from the Italian Renaissance. If Constantine had been the immortal he appears to be in his statue, he would have seen in those years the destruction of the western half of his empire but also the beginning of an age of faith, with his new-found Christianity coming to dominate Western Europe. The new Middle Eastern creed spread energetically, even beyond the boundaries of the former Roman state, eventually uniting a vast region from Iceland to Russia in the north and Spain to Turkey in the south. At its southern and eastern borders, however, another vigorous Middle Eastern religion rose up to challenge Christian unity and dominance. Born in the desert lands of the Arabian Peninsula, and like Christianity heir to the Judaic tradition of monotheism, Islam expanded across the Middle East in the sixth and seventh centuries, sweeping westward through North Africa and up

ART

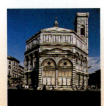

Constantine the Great c. 330

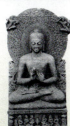

Seated Buddha Preaching the First Sermon, India 5th century

San Vitale 526–547

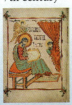

Book of Lindisfarne 7th century

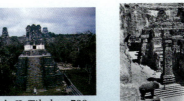

Temple II, Tikal c. 700

Kilasanatha Temple, Ellora, India 8th century

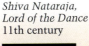

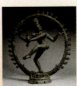

Baptistery, Florence Cathedral 1060–1150

Shiva Nataraja, Lord of the Dance 11th century

Chartres Cathedral c. 1190

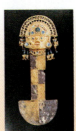

Unkei, Kongorikishi 1203

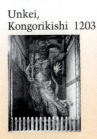

Peruvian chimu

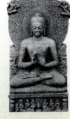

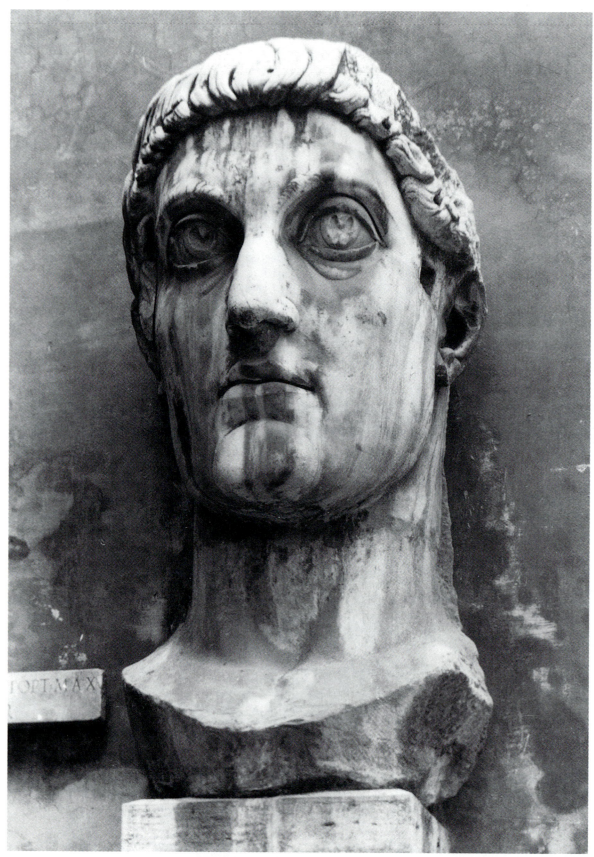

11-1 *Constantine the Great, c.* A.D. 330. Marble, approximately 8′6″ high. Palazzo dei Conservatori, Rome.

into southern Spain. Between the eleventh and fourteenth centuries, Moslem domination of the Christian pilgrimage sites in the Middle East, particularly the city of Jerusalem, led to a series of Crusades in which European Christians attempted to win back their "Holy Land." Finally, in 1453, Moslems captured the remnant of Constantinople, the capital of the Eastern Roman, or Byzantine Empire founded by Constantine a thousand years earlier.

The same period also saw the Indian religion of Buddhism extend its influence throughout China, Southeast Asia, Korea, and Japan. In India itself, however, Buddhism waned due to a resurgence of the older Hindu religion. In this chapter, we will explore art made in the name of all these important faiths—Christianity, Islam, Buddhism, and Hinduism—in the years between A.D. 350 and about 1450, an era when religion replaced the political empires of ancient times as the primary unifying cultural force in most of Europe and Asia.

Religious Images or Sacrilege?

The idea that pictures of gods were sacrilegious is common to several world religions, at least in their earliest phases. Religions that have forbidden or limited the visual depiction of their god include Judaism, Buddhism, Christianity, and Islam.

The Buddhist reluctance to give physical form to the Buddha himself lasted several hundred years after his death in 483 B.C. Instead, Buddhism developed several ways to indicate the Buddha symbolically without actually picturing a human figure. For instance, the lion and the wheel were used to represent the Buddha's royal blood and his teaching on the *Lion Capital* (11-2) erected by the Indian King Asoka around 250 B.C. In the second century A.D., this taboo against showing the Buddha as a person was broken, and statues of the seated, crosslegged Buddha became one of the most powerful and pervasive in all of art (see 11-17). The Moslem faith never overcame its objection to visual representations of Allah. Yet early Moslems went further in forbidding the use of all images because they believed that the act of creation should be reserved for Allah alone. Thus, an artist who attempted to represent reality was a sinner against God and could have no hope

of a heavenly reward. Much Moslem artwork consists only of decorative motifs, geometric or organic patterns (see *Shamsa*, 2-37), without any pictures or statues at all. Because of these limitations, their nonrepresentational decoration and calligraphy, as in a page from the Koran (11-3), became perhaps the most beautiful in the world.

As an outlawed religion, early Christianity produced no architectural monuments,

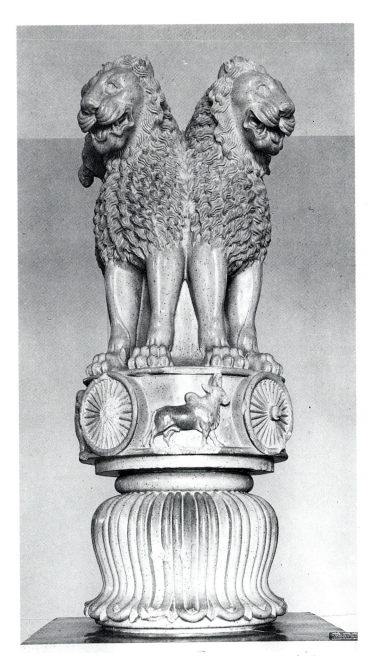

11-2 Lion Capital of column erected by Emperor Asoka (272–232 B.C.), from Patna, India. Polished sandstone, 7' high. Archeological Museum, Sarnath.

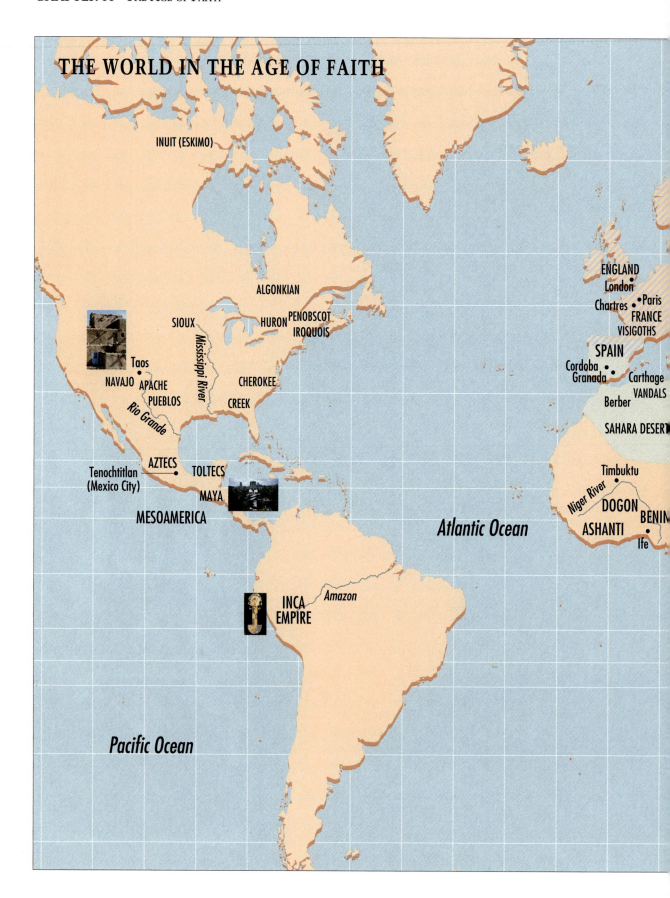

THE WORLD IN THE AGE OF FAITH

INUIT (ESKIMO)

ALGONKIAN

SIOUX

HURON PENOBSCOT
IROQUOIS

Mississippi River

Taos

NAVAJO APACHE

CHEROKEE

PUEBLOS

CREEK

Rio Grande

AZTECS TOLTECS

Tenochtitlan
(Mexico City)

MAYA

MESOAMERICA

Atlantic Ocean

INCA
EMPIRE

Amazon

Pacific Ocean

ENGLAND
London

Chartres • Paris
FRANCE

VISIGOTHS

SPAIN

Cordoba •
Granada • Carthage

VANDALS
Berber

SAHARA DESERT

Timbuktu

Niger River

DOGON BENIN

ASHANTI

Ife

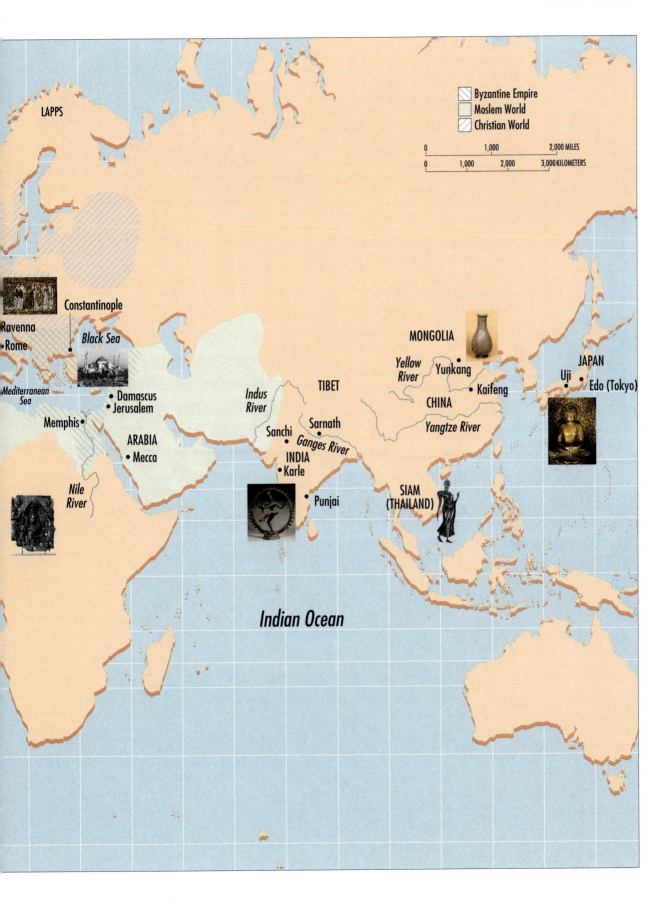

Byzantine Empire
Moslem World
Christian World

0 1,000 2,000 MILES
0 1,000 2,000 3,000 KILOMETERS

LAPPS

Ravenna
Rome
Constantinople
Black Sea

Mediterranean
Sea

Memphis

Damascus
Jerusalem

ARABIA
Mecca

Nile
River

Indus
River

Sanchi
Karle

INDIA

Punjai

Ganges River
Sarnath

TIBET

MONGOLIA

Yellow
River Yunkang

CHINA Kaifeng

Yangtze River

JAPAN
Uji Edo (Tokyo)

SIAM
(THAILAND)

Indian Ocean

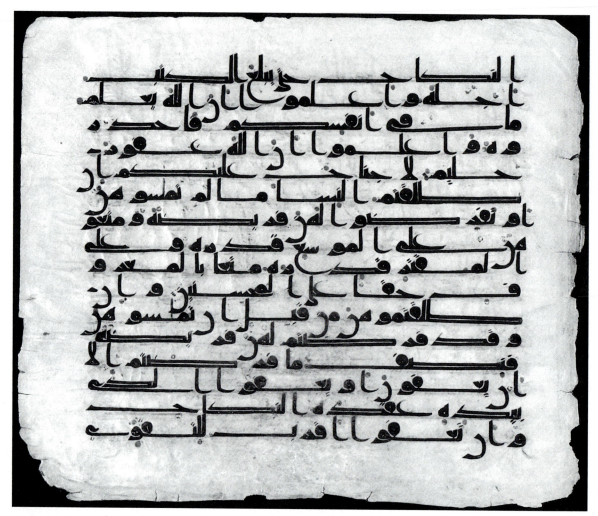

11-3 Ten Leaves from a Koran with Kufic Script, Abbasid Caliphate, tenth to eleventh century. Ink on vellum, 12⅝" x 15⅝". Los Angeles County Museum of Art (The Nasli M. Heeramaneck Collection, gift of Joan Palevsky).

no important sculpture or painting. But even when Christianity was established as the state religion of the Roman Empire, the early leaders of the Christian church felt that statues were too much like pagan images, and forbade their use in churches. The question of whether two-dimensional pictures, such as paintings and mosaics, should be allowed was the subject of much debate in the early church, a debate that was not settled until the sixth century when Pope Gregory the Great finally decided in favor of the visual arts. He approved of painting and mosaic not for their beauty but for their instructional value, saying, "Painting can do for the illiterate what writing does for those who read."

EARLY CHRISTIAN AND BYZANTINE ART

Since they had no alternative artistic tradition of their own to draw from, early representations of Christ often show him as "The Good Shepherd," a young man like the Greek god Apollo. A beautiful mosaic (11-4) done for the fifth-century Tomb of Galla Placidia, Empress of the West, melds late Roman style and early Christian symbolism. Christ is shown as the shepherd of his flock. In one hand he grasps a cross, more like a scepter and symbol of power than a reminder of the suffering of the crucifixion. The other hand reaches out to caress

one of his sheep, suggesting his role as protector and redeemer of mankind.

The tomb of Empress Galla Placidia is in the Italian coastal city of Ravenna, rather than Rome, because her brother, the emperor, had fled there in A.D. 410 to escape a series of barbarian attacks. Since A.D. 376, the western portion of the empire had fallen prey to a continuous process of invasion, starting with the outer provinces, then Italy, and finally, even Rome itself. By the time the last western emperor was deposed by a Gothic king in A.D. 476, the act was simply a recognition that the "fall of the Roman Empire" had already taken place.

In the eastern half of the empire, however, Roman art and culture survived. It was richer and better organized than the west, better able to defend its borders or buy off its attackers. In *Christ as the Good Shepherd*, we can see signs that the Roman artistic style was changing to become less naturalistic, more stylized and symbolic. The plant shapes are

repeated designs, as is the pattern on the coats of the sheep. The art of the eastern half of the empire continued to develop in this direction, and the early Christian-Roman style eventually developed into a new artistic style known as **Byzantine**. Such Byzantine trends came to influence the west through the actions of Emperor Justinian, a remarkable leader and patron of the arts. In one final attempt to reunite the empire that had been divided in 395, the eastern emperor sent his armies to invade Italy in A.D. 540. Briefly successful, Justinian set up a capital in Ravenna and embarked on a building program that would symbolize his authority. One result of this program was the remarkable church of San Vitale.

Decorated in A.D. 547, about a hundred years after the mausoleum of Galla Placidia, San Vitale contains some of the most exquisite and famous mosaics ever created. The simple, almost naive pictures of early Christian times became more courtly, sophisticated, and

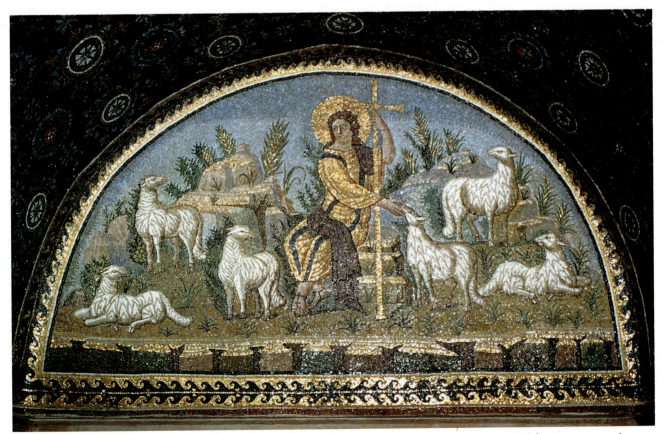

11-4 *Christ as the Good Shepherd,* mosaic from the entrance wall of the mausoleum of Galla Placidia, Ravenna, Italy, 425–450

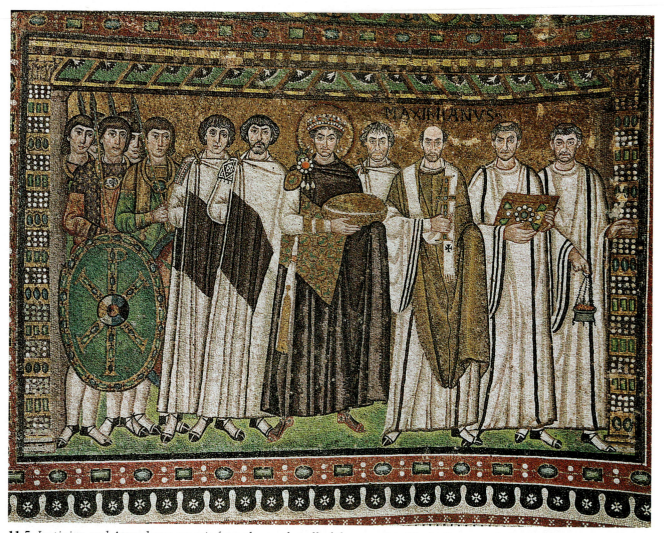

11-5 *Justinian and Attendants,* mosaic from the north wall of the apse, San Vitale, Ravenna, Italy, *c.* 547

stylized, flatter but more decorative. The centerpieces of the decorative scheme were, on one side of the altar, the group portrait, *Justinian and Attendants* (11-5), and on the other, the portrait of Empress Theodora, with hers (11-6). Notice how much more two-dimensional these Byzantine-style figures appear than the late Roman-style Christ of a hundred years earlier. Like the earlier sculpted reliefs on the *Arch of Constantine* (10-35), they are arranged stiffly, facing front, their eyes locked on the viewer. Unlike the awkward figures of the emperor and his court, however, Theodora and her ladies appear sophisticated and elegant. The artist seems to delight in the beautiful patterns of their rich costumes, ignoring the anatomy of the bodies

beneath the robes. Instead of using the medium of mosaic to give the illusion of reality, as we saw in the Roman *Unswept Dining Room Floor* (10-34), or the landscape behind *Christ as the Good Shepherd,* the Byzantine artist manipulates colored stones to create a sparkling and jewel-like effect. The liberal use of gold helps to give the picture an aristocratic and royal feeling.

While Justinian's group portrait shows the two arms of his authority, the church and the military, it was truly Empress Theodora who was his co-ruler from the time he ascended the throne. The daughter of a circus entertainer and a former actress, she seems to have been a strong character and shrewd politician who was better able to

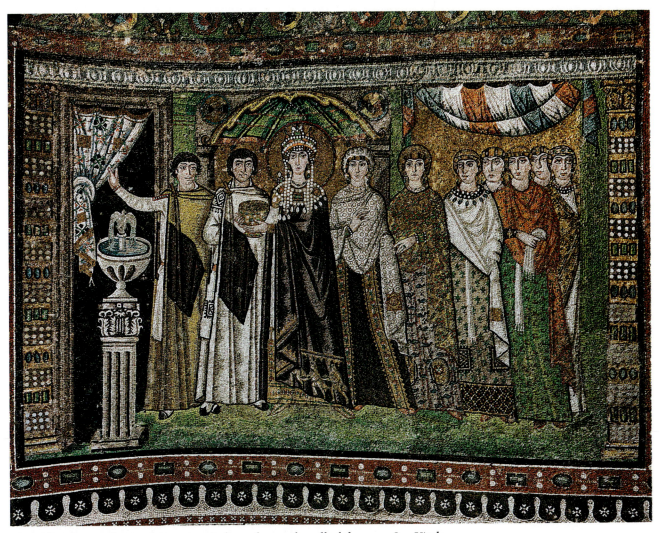

11-6 *Theodora and Attendants,* mosaic from the south wall of the apse, San Vitale

make decisions and act in times of crisis than her husband. All of this—Theodora's imperious personality and personal power, the elegance and formality of the Byzantine court, the close relationship between the state and the church—is perfectly illustrated in these mosaic portraits.

The design of the building that housed these fabulous mosaics can also be used as an example of how architecture was changing. The rationality, logic, and order we saw in classical Greek and Roman architecture was not an appropriate setting for Christian ceremonies and rituals, which were meant to make the worshipper think of otherworldly mysteries. Unlike Greek religious ceremonies that took place outside their temples,

Christian services took place inside, away from the bustle of the world, in a place where the worshipper might turn his or her mind away from everyday life. If we compare the interior and exterior of *San Vitale* (11-7, 11-8) to those of the *Pantheon* (10-31,10-32), we immediately grasp essential differences between the Roman and Byzantine style of religious architecture, between Roman pagan and Byzantine Christian beliefs. While the exterior of the Pantheon is awe-inspiring, San Vitale's is absolutely plain and somewhat confusing. The Pantheon is clearly based on geometrical harmonies, clarity, and simplicity. While San Vitale's basic shape is also round and covered by a dome, the exterior is complicated and seems to sprout a variety of

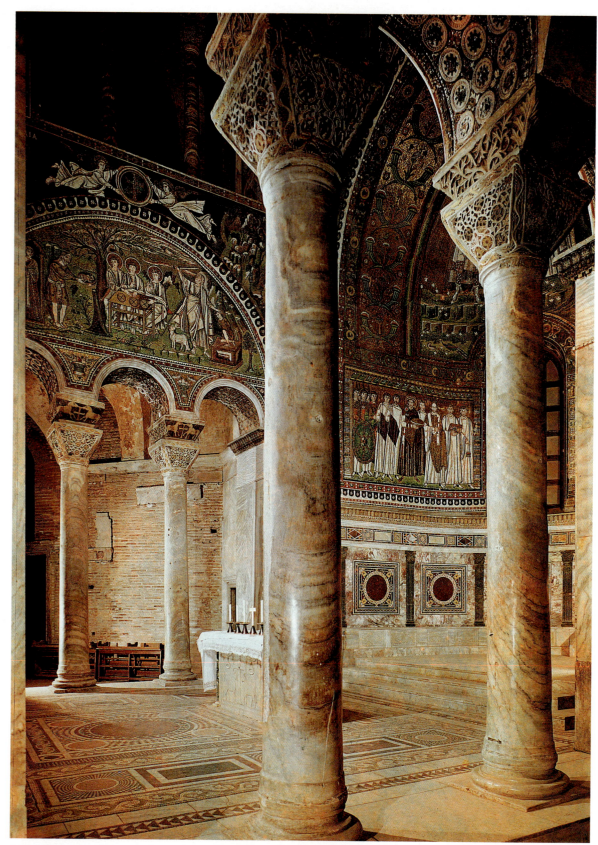

11-7 Sanctuary of San Vitale. Mosaics show in the forechoir (*left*) *Abraham and the Three Angels* and *The Sacrifice of Isaac* and in the apse (*right*) *Justinian and Attendants.*

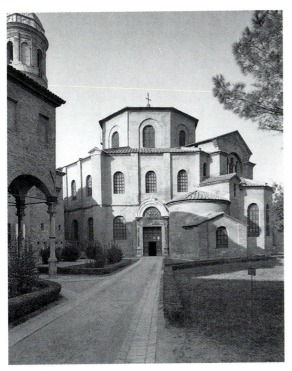

11-8 San Vitale, 526–547

different-shaped appendages. The interior is also intricately divided, almost like a flower with its center surrounded by petals (11-9). Instead of a single, central source of light to illuminate the space, like the Pantheon's oculus, San Vitale's shadowed interior is lit by many small windows. Entering the Byzantine church, the worshipper senses that he or she has wandered into another realm, a world of the spirit. The interior glows with rich, multicolored marble inlays and mosaics.

While Byzantine art continued to evolve in the eastern half of the empire over the next one thousand years, profoundly affecting the art of eastern Europe—especially Greece and Russia—the rest of Europe enjoyed only a brief exposure to the rule of the Byzantine emperor before another wave of Germanic invasions cut them off from the eastern empire.

THE DARK AGES

The "Germanic" tribes who looted Rome and swept across Europe in the fourth and fifth centuries did not bring with them what we would call an "advanced" civilization—they did not have literature or even a written language. Some of their names, like Goths and Vandals, will forever mean barbarians and thieves. The values they stressed were the characteristics needed to win in combat: courage and ruthlessness. There was no concept of loyalty to the state or nation, which did not exist. Instead, warriors (the aristocracy) gave their loyalty to individual warlords who had proven their valor in battle.

After a period of destruction—the looting of cities, burning of libraries—some of these tribes from the borders of the old empire began to settle in distinct areas. A tribe called the Franks settled in Gaul, which would become present-day France. The Angles, Saxons, and Jutes settled in Britain; the language of the Angles developed into English and gave us the name England. The art of these Germanic tribes was dramatically different from that of the Greeks and Romans. These were migratory people organized in warlike bands, not wealthy aristocrats living in cities. Instead of temples to the gods, the Germanic princes built large wooden halls where they could feast and drink with their comrades. When the Angles and Saxons saw the ruins of great stone buildings left by the Romans in Britain, they imagined they were the work of a race of giants.

The art of the Angles and Saxons, like other Germanic tribes, did not depict the human figure at all. It was a decorative art of

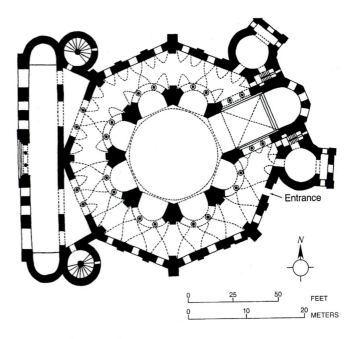

11-9 Plan of San Vitale

small, intricately patterned golden and jeweled objects. The Germans were great metal workers and wonderful makers of weapons; they also used their skills to create elaborate jewelry. For the warrior-aristocracy, such "treasure" was both symbolic of their special status and prized for its own sake. The great Anglo-Saxon epic, *Beowulf*, tells us of their love for bright colors and precious metals, materials that gleamed and glowed. Such treasure had an almost magical fascination for them. Heroes like Beowulf wore rich golden buckles on their costumes and were buried with them as part of a pagan ritual. In the 1930s the remains of an entire seventh-century Anglo-Saxon warship was found buried in England at a place called Sutton Hoo. The treasures unearthed there included an elaborate golden buckle (11-10) about 5 inches long, whose intricate patterning seems incongruous with its "barbarian" source. Three plain golden circles are interlaced with a fine web of serpents. The interwoven pattern and the theme of interlocking animals, especially serpents, is typical of the Germanic style.

Although Rome had ceased to be the center of the empire, it remained the center of the Christian church in the West. In A.D. 597, missionaries were sent by the pope to England to convert the heathen Anglo-Saxons. The conversion of the English to Christianity began a rich period of artistic production, especially the illustration of manuscripts. Book illustration had not been a very important artistic medium in the Roman world but because the Christian New Testament was so central to the new faith, the decoration of the Gospels became worthy of the greatest effort.

Elaborately decorated manuscripts were prepared in monasteries where monks devoted their lives to the glorification of God.

Lindisfarne (or "Holy Island"), on the English coast, was one of the earliest sites of an especially fruitful mingling of the earlier Irish or Celtic traditions, the Anglo-Saxon artistic style, and the Roman-Byzantine. Two pages from the same book of Gospels, the *Book of Lindisfarne* of about A.D. 700, illustrate the dramatically different artistic styles being practiced at this time on the edge of what had once been the Roman world. In the page with an ornamental cross (11-11), we can immediately recognize the same interlaced decorative pattern of lines that the Anglo-Saxons used in their metalwork, in this case twisted dog-headed serpents and wild birds. Here, however, the formerly pagan design is superimposed with the shape of a cross—the most powerful symbolic shape in Christian art. Without sacrificing the amazing richness and complexity of the northern style, the artist-monk has brought order out of chaos by using the shape of the cross to organize the overall page.

The original of this artwork is only a little larger than 9 x 12 inches. Think how different this is from the human scale of Greek art or the superhuman scale of Roman architecture! For centuries, people have been amazed by the delicacy, the imagination, and the fantastic detail of Irish and English manuscripts of this period. Some even thought the work must have been done by angels. For the artist, producing the illumination was probably a kind of religious discipline, like fasting. To paint with such patience demonstrated an almost fanatical devotion and love of God.

In the same book, however, we find pictures of another type. These are portraits of the four Evangelists, or authors of the four Gospels. While the border surrounding *Saint Matthew* (11-12) matches the style of the cross page, the rest is typical of this surprisingly different style. It shows the figure of the saint sitting on a bench, writing his gospel about the life of Christ; above him is an angel. Since the northern tribes had no tradition of human portraiture, what was the source of this image?

Historians suspect that visiting monks from the Mediterranean world brought to Lindisfarne a gospel book or books in the Byzantine style. Notice the similarities

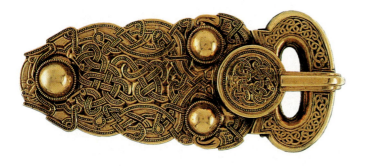

11-10 *The Golden Buckle of Sutton Hoo,* Anglo Saxon, seventh century. Gold and enamel, 5¼" long. British Museum, London.

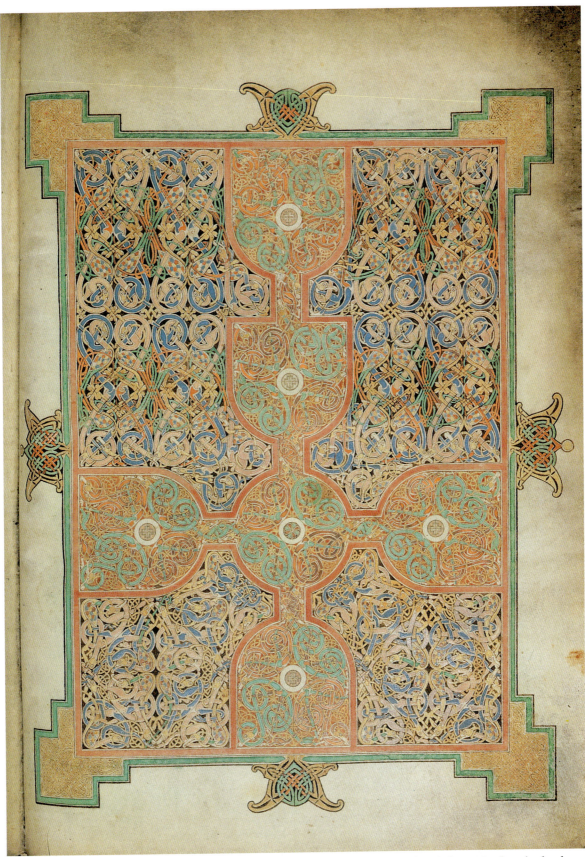

11-11 Ornamental page from the *Book of Lindisfarne* (Cotton MS Nero D IV f 26v), from Northumberland, England, late seventh century. Illumination, approximately 13″ x 10″. British Library, London.

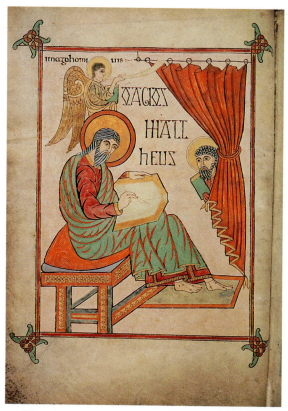

11-12 Saint Matthew, from the *Book of Lindisfarne* (Cotton MS Nero D IV f 25v), from Northumberland, England, late seventh century. Illumination, approximately 11″ x 9″. British Library, London.

ISLAM

In the early 700s, despite the best efforts of the powerful emperor Charlemagne, Spain was conquered by Islamic invaders from North Africa. In most of the Spanish Peninsula, Moslem culture—and art—would flourish for the next seven hundred years. The religion was founded by the prophet Mohammed (A.D. 570–632), who lived on the Arabian Peninsula; it spread through the Middle East with amazing rapidity. The teachings of Mohammed are recorded in The Koran, which tells of the revelations of God through the angel Gabriel. The name "Islam" means "submission to the will of God." The Moslem religion stresses five duties: belief in one God and his prophet, Mohammed; praying each day at appointed hours; charitable giving; fasting during the daylight hours in the holy month of Ramadan; and making a pilgrimage to Mecca, the birthplace of the prophet, once in one's lifetime.

Like the Jews, Moslem Arabs were originally a nomadic, desert people who had no permanent architecture. Eventually, Islamic architecture developed its own particular shape: a rectilinear, walled space with an open

between the figure of Saint Matthew and the mosaics of Justinian and Theodora. Although the mediums and sizes are completely different, the sharp lines of the drapery and the long, thin bodies certainly resemble each other. Still, Saint Matthew is not exactly like a figure in a true Byzantine manuscript or mosaic. The drawing is stiff and awkward, more a collection of patterns than natural forms. This is partly because the artist is copying from another source, a source he considers sacred but does not really understand, never having drawn a human figure from life. During the Dark Ages and early medieval period, monastic artists, like the philosophers and theologians, accepted without question the authority of the past. Christian monasteries attempted to preserve what was left of Roman culture by copying classical manuscripts as well as Christian works. This kind of copying from sacred texts, rather than working from nature, was the rule.

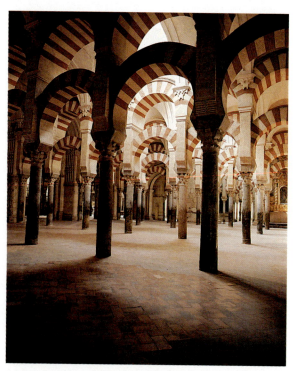

11-13 Interior of the Great Mosque at Cordoba, Spain, eighth to tenth centuries

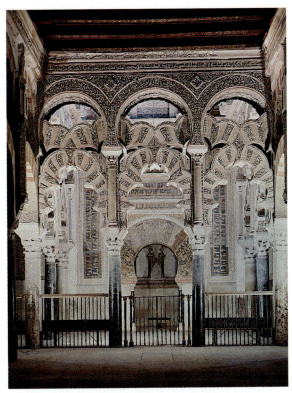

Constructed of marble, stucco, and mosaic, all materials and patterns are fused into an incredibly rich design that is also harmonious and orderly.

The other unique architectural feature of the Islamic mosque, the **minaret**, is well-illustrated by the exterior of the *Hagia Sophia* (11-16), a remarkable Christian church that was transformed into a mosque after the capture of Constantinople by the Moslem Turks in 1453. Originally built by Justinian in the early sixth century, about the same time as San Vitale, the Hagia Sophia was the most famous and dramatic church in the capital of the eastern Roman Empire. Influenced by Roman architecture, the church was topped with a huge dome. To change the magnificent structure from a church to a mosque, the new rulers of Constantinople (Istanbul) simply removed all the Christian mosaics and added four delicate minarets at the building's corners. This combined style of a central dome flanked by minarets then became a new model for Islamic architecture.

11-14 Entrance to the mihrab, Great Mosque, Cordoba, Spain, 962–965

courtyard in the center. The main axis of the building was oriented to face in the direction of Mecca, the holy city, and this direction was visually emphasized by a **mihrab**, or niche. As discussed earlier, there was a ban on representational art but a love of pattern in Islamic art. This is beautifully illustrated by the *Great Mosque* (temple) in Cordoba, Spain. The interior space is marked by a rhythmic repetition of columns and arches (11-13); the original area was built in the late 700s. After three more periods of construction, ending around A.D. 1000, the mosque had quadrupled in size. The visual effect of these multiple columns—more than five hundred in all—is like that of a magical forest. Because the spaces above the arches are open, the effect is far more light and airy than Roman buildings.

The elaborate mihrab and dome above it were completed in the late tenth century, when Cordoba had become a major Islamic city. The arched doorway marks the niche (11-14); the exquisite golden dome (11-15) is located in the chamber in front of the niche.

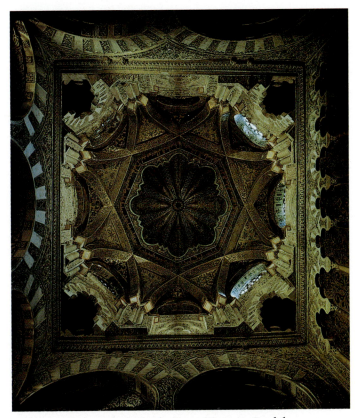

11-15 Dome near the mihrab, Great Mosque, Cordoba, Spain, 962–966

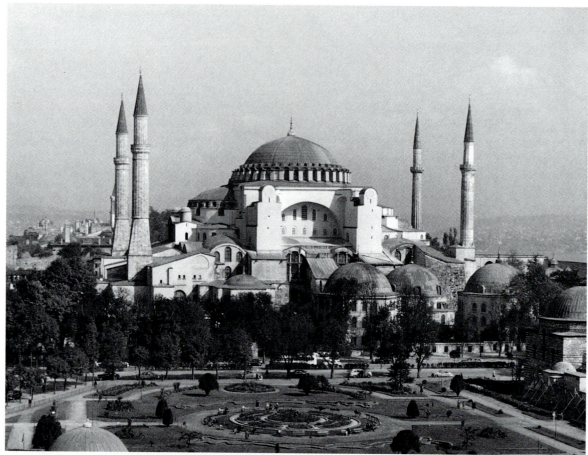

11-16 Anthemius of Tralles and Isidorus of Miletus, Hagia Sophia, Constantinople (Istanbul, Turkey), 532–537

BUDDHISM

Buddhism was founded by Siddhartha Gautama, a prince from Nepal who lived in the sixth century B.C. In his search for the meaning of life and the reason for human suffering, the Buddha experimented with a number of paths to enlightenment and experienced many adventures and temptations. Through the revelation that all life is an illusion, and the only way to escape pain is to renounce all desires, the Buddha was able to escape what Hindus believed was the endless cycle of life, death, and rebirth and attain **nirvana**, a state of endless bliss.

One of the classic representations of the Buddha is the sculptural depiction of *Seated Buddha Preaching the First Sermon* (11-17) from the fifth century A.D. Every element is symbolic. The Buddha is seated like a yogi, or Indian holy man. A beautifully carved halo is behind his head. The position of his hands is known as the teaching gesture, also called

"turning the wheel of the law." Around him are the symbols we saw in the Lion Capital, the wheel of the law behind and stylized lions on either side. Certain features, such as the elongated earlobes from heavy earrings and the stylized arrangement of the hair, show that the Buddha was once a noble Indian prince. The statue balances such finely carved details against smooth, undecorated expanses of stone. The quiet, harmony, and idealization of the figure contribute to a sense of repose, as do the downturned eyelids and calm smile.

The classic figure of this Indian Buddha underwent many transformations as the religion spread throughout Asia. For instance, the dramatically different *Colossal Buddha* from China (2-42) was hewn out of rock at about the same time as the Indian statue. The Japanese *Amida Buddha* (1-8) is more elegant and aristocratic. Buddhism traveled not only east to China and Japan but also into Southeast Asia. The *Walking Buddha* of Thailand (11-18) was done about a thousand years after

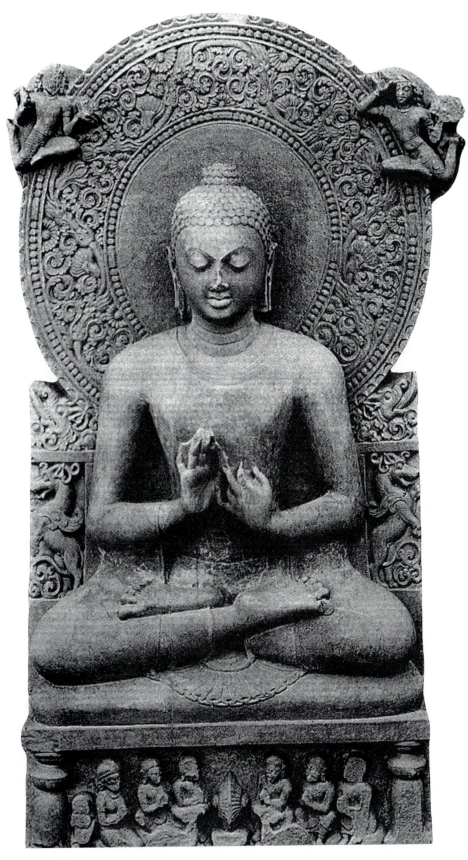

11-17 *Seated Buddha Preaching the First Sermon,* from Sarnath, India, fifth century. Stele, sandstone, 63″ high. Archeological Museum, Sarnath.

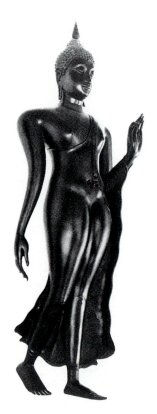

11-18 *Walking Buddha*, fourteenth century. Bronze, 88″ height. Monastery of the Fifth King, Bangkok, Thailand.

the Indian Buddha from Sarnath. This figure represents the Buddha in his role as missionary—a fitting role, considering the vast spread of Buddhism from its original base. The bronze sculpture is more than life-size. Its utterly smooth surface and sinuous curves are typical of Thai art (compare him to Rodin's *Walking Man*, 7-13), and its ideal beauty is described by Thai Buddhists as "arms like the hanging trunk of an elephant." In a way utterly unlike Western art, particularly religious art, the essence of both sexes is reflected in this image of divinity.

HINDUISM

Like Judaism, Christianity, and Islam, Buddhism and Hinduism are also related religions. Hinduism is an earlier system of beliefs, an ancient religion native to India. Hindus believe that humans are fated to experience an unending cycle of birth, life, death, and rebirth, known as reincarnation. The final goal of this cycle is oneness with the absolute, or the Supreme Being who is present in the world in innumerable forms. The concept of

karma determines one's fate: the deeds of one lifetime influence one's status in the next. This idea is reflected in a rigid caste system, where one's social status is absolutely determined by birth into one of five *castes*, or classes: priestly, warrior, producer, menial, and untouchable.

Hinduism is polytheistic, incorporating a great number of major and minor deities. However, the most important god is a three-fold divinity: Brahma, the Creator; Vishnu, the Preserver; and Shiva, the Destroyer. This god includes within itself a number of opposing concepts: light and dark, birth and death, beauty and ugliness, good and evil, male and female. Since the idea of destruction carries within it the seeds of its opposite, rebirth and reproduction, the god Shiva has many faces, from fierce destroyer to calm and caring preserver. His most famous role is that of *Shiva Nataraja, Lord of the Dance* (11-19). The dance of Shiva symbolizes the most powerful forces in the universe, the rhythm of creation, conservation, destruction, and liberation. In this incarnation he is shown surrounded by a halo of fire that represents the universe. This fine copper sculpture was made in the eleventh century and demonstrates that

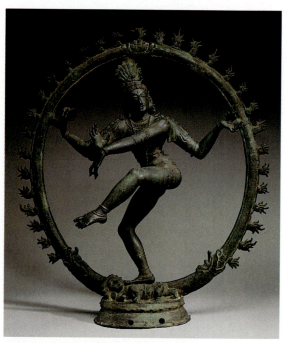

11-19 *Shiva Nataraja, Lord of the Dance*, India, eleventh century. Copper, 43⅞″ x 40″. The Cleveland Museum of Art (purchase from the J. J. Wade Fund, 30.331).

Indian artists excelled in metalwork as well as stone carving. The figure appears both strong and graceful, dynamic and balanced, reflecting the contrasting forces typical of Hindu beliefs.

Hindu religious architecture is not so much constructed as carved, and the temples themselves are often said to be more like huge, complex sculptures than architecture. A most dramatic example is the temple at Ellora, which is completely carved out of a mountain (11-20). Its creation seemed a supernatural marvel even at the time it was built in

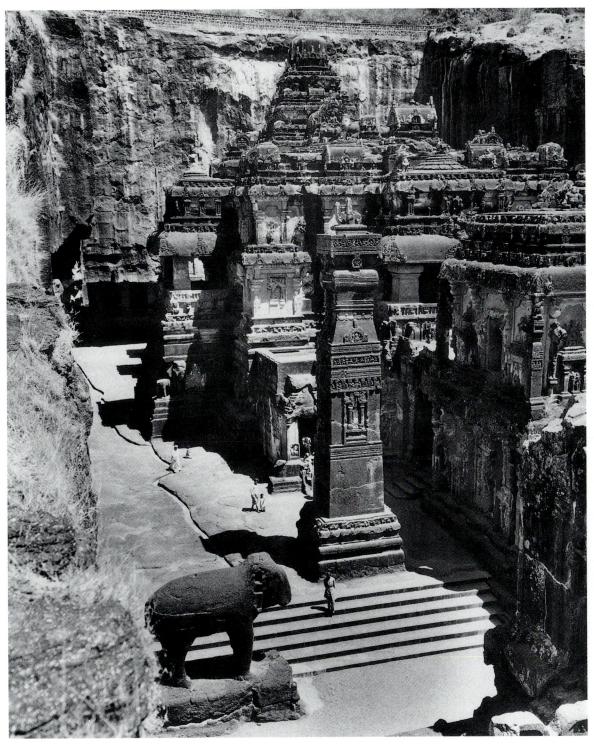

11-20 Kilasanatha Temple, Ellora, India, eighth century, 96' high

the eighth century. The king under whom it was completed, Krishna II, said that it must have been made by magic. More than 100 feet below the original top of the rocky mount, the sculptor-architects created a courtyard 150-feet wide and almost 300-feet long. Within this courtyard stand huge towers, a gathering place, and many shrines. Each stone outcropping is carved with elaborate relief sculptures. As in other Hindu temples, there is a strong contrast between the bright light outside and the cooler light within, because the mountain from which the temple was carved casts deep shadows across the sculptured buildings. The fusing of architecture with sculpture makes this religious city-of-rock unique.

Perhaps the most startling aspect of Hindu art to Christian (or Moslem) eyes is the incorporation of the theme of sexual pleasure into places of worship. We have already seen the voluptuous Yakshi who adorned the Buddhist stupa at Sanchi (10-22); her image was related to native Indian fertility rites. The

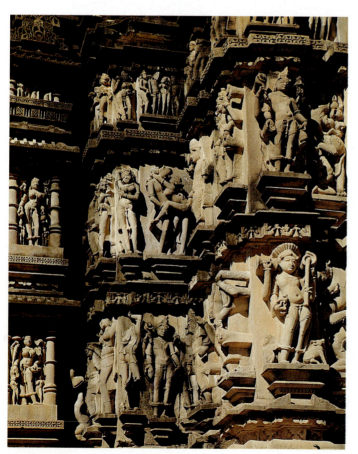

11-21 Celestial deities, Jagadambi Temple, Khajuraho, India, *c.* 1000

carvings on the *Jagadambi Temple* (11-21) in Khajuraho, India, however, go beyond the realm of the voluptuous and into that of the erotic. Rather than rejecting the body and sensual delights, Hinduism incorporates the worship of the youthful human body. Sexual pleasure becomes a symbol of the union of the human with the divine, not a source of guilt or shame.

THE MIDDLE AGES

How different was the attitude toward the human body and sexuality during the early Middle Ages in the West! The art of the Dark Ages appears almost obsessed with the ideas of death and sin. The years between 850 and 1000 were a dark period for the arts in most of Europe. The second wave of invasions disrupted cultural and economic recovery. People found little comfort on earth and concentrated on the prospect of their heavenly reward—or the fear of eternal damnation. One work of art that seems symbolic of this period is a panel from the magnificent bronze doors of the church of Saint Michael's in Hildesheim, Germany, *Adam and Eve Reproached by the Lord* (11-22). This illustrates the Old Testament story where God discovers that Adam and Eve have disobeyed him and eaten from the Tree of Knowledge, committing humanity's "original sin." God, on the left, seems to convict Adam with the pointed finger of condemnation. The cowering Adam passes the blame on to Eve, who tries to hide her nakedness and point to the serpent at the same time.

A comparison of Adam and Eve to any Greek or Roman nude statue immediately illuminates the change from classical to medieval artistic styles and cultural values. In the Hildesheim doors, cast in A.D. 1015, humans attempt to hide their spindly, naked bodies before God. They are ashamed to be nude. These bodies show none of the ideal beauty or athletic grace of Greek and Roman statues. This is not simply because the medieval artist is unskilled—to the contrary, the crafting of these great bronze doors was a complex project that took tremendous artistic talent. But the message of the art is anguish and guilt rather than pride and confidence and thus calls for a new style.

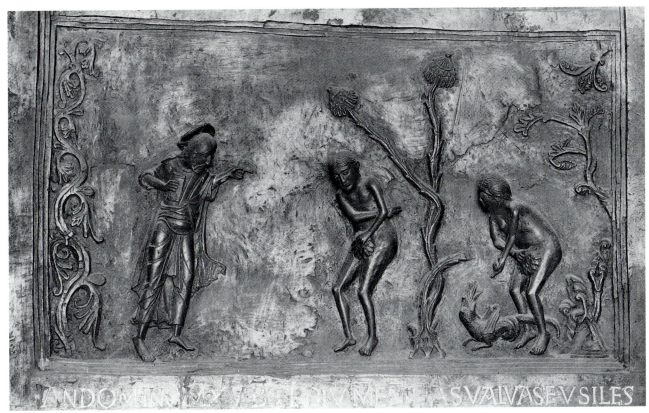

11-22 *Adam and Eve Reproached by the Lord,* from the bronze doors commissioned by Bishop Bernward for Saint Michael's at Hildesheim, Germany, 1015. Bronze, 23" x 43".

THE ROMANESQUE STYLE

By the time the great doors at Hildesheim were made, northern Europe had begun to recover from the period of invasions. The Crusades to the Holy Land were beginning to turn the militancy of warriors away from their European neighbors. Travel within Europe itself became safer and easier. Pilgrims streamed across Europe from shrine to shrine, on foot, in search of salvation. In the eleventh century, a vast building program seems to have begun almost spontaneously, with monasteries erecting magnificent new churches to attract and accommodate pilgrims. One of the important stops on the pilgrimage route through southern France was the church of Saint Pierre at Moissac.

The most famous sculpture at Moissac is the figure of a prophet (11-23), done around 1115, or about one hundred years after the Hildesheim doors. Carved into the **trumeau** (the central pillar of the main doorway) of the church is the emaciated, elongated, and

11-23 *The Prophet Jeremiah (Isaiah?),* from the trumeau of the south portal of Saint Pierre, Moissac, France, *c.* 1115–1135. Stone, life-size.

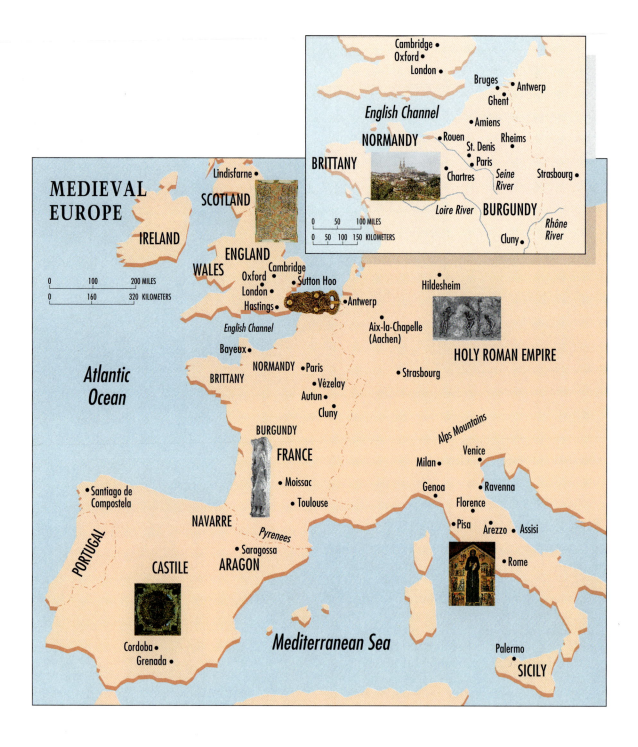

MEDIEVAL
EUROPE

IRELAND

SCOTLAND

Lindisfarne •

ENGLAND
WALES

Oxford • Cambridge •
London • • Sutton Hoo
Hastings •

English Channel

Bayeux •

Atlantic
Ocean

BRITTANY NORMANDY • Paris
 • Vézelay
 Autun •
 Cluny •

BURGUNDY

FRANCE

Santiago de
Compostela •

NAVARRE

PORTUGAL

CASTILE ARAGON

Cordoba •
Grenada •

• Antwerp

Aix-la-Chapelle
(Aachen)

Hildesheim •

HOLY ROMAN EMPIRE

• Strasbourg

Alps Mountains

Milan • Venice •

Genoa • • Ravenna

Florence •

• Pisa Arezzo • • Assisi

• Moissac

• Toulouse

• Saragossa

Pyrenees

Mediterranean Sea

• Rome

Palermo •

SICILY

0 100 200 MILES
0 160 320 KILOMETERS

Cambridge •
Oxford •
London •

Bruges • • Antwerp
 Ghent •

English Channel • Amiens

NORMANDY • Rouen Rheims •
 St. Denis •
BRITTANY • Paris
 Chartres Seine Strasbourg •
 River
 BURGUNDY Rhône
Loire River River

 Cluny •

0 50 100 MILES
0 50 100 150 KILOMETERS

extremely expressive figure of an Old
Testament prophet. The body of this holy
man seems to have been stretched vertically
and twisted horizontally to fit it into the
space of the column. It is almost as if the
prophet were eternally, awkwardly trapped in
a prison of stone. He is not only a man of God,
but the victim of a kind of divine energy. His
gentle face and long, flowing beard, his bony

feet and writhing body all give the impression
of a person who has left physical concerns and
material comforts far behind.

Around the year 1000, the theme of the
end of the world, or the final day of judgment,
became common in medieval art. Many
believed its time was near. A vision of the
Apocalypse, or end of time from the New
Testament Book of Revelations, was carved

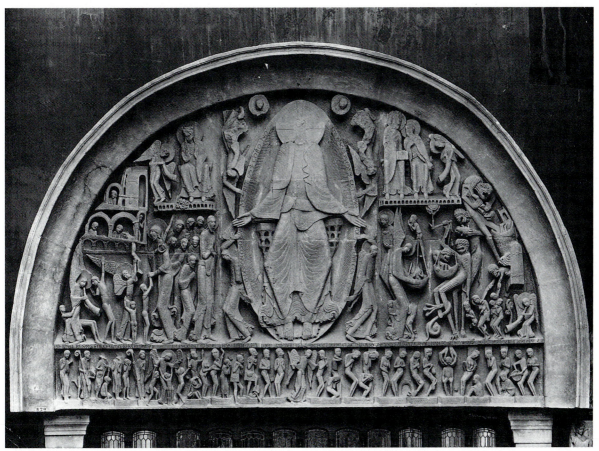

11-24 Gislebertus, *Last Judgment* from the west tympanum of Saint Lazare, Autun, France, *c.* 1130. 11′4″ high, 21′ wide at base.

into the entrance of the Cathedral at Autun. Completed just a few years after the prophet from Moissac, we see the *Last Judgment* (11-24) described in grisly detail. The moment pictured is one where four angels blow their trumpets, and the dead are resurrected to be judged. The angels appear with long, curved horns in the corners of the work. The huge figure of Christ in the center dominates the composition, completely out of scale with the other figures. On the left side, the saved are allowed to enter heaven and worship God. On the right, horrible monsters join the Archangel Michael in the task of weighing souls (11-25). Under the semicircular tympanum, on the horizontal lintel of the doorway, we see the figures of the dead—on the left prepared for heaven, on the right pushed off toward hell. Beneath the earth the damned wait in terror for their punishment; one is in the process of being plucked up by a set of disembodied hands. As in the trumeau at

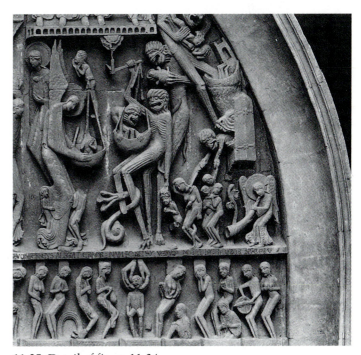

11-25 Detail of figure 11-24

Moissac, angular figures seem to be cramped into the space they inhabit. Classical balance and repose are totally lacking, replaced by energy and tension. As before, nude bodies are objects of shame. The overall message is truly horrifying.

Although fairly typical of the *Romanesque style,* Autun is unusual because most of the sculpture was done by a single artist and one who has left us his name, Gislebertus. The entire sculptural program of the church is the result of his very personal vision and imagination. This is not a case of the artist copying from past models (as in the *Book of Lindisfarne*) but of an artist who is reinterpreting a story in a fresh and immediate way. The work at Autun is proof that by 1100 some medieval artists were allowed to express their individuality.

Individuality and self-expression were not, however, typical of most art done during the eleventh and early twelfth centuries. As befitted the warlike times, architecture tended to be massive, solid, and strong. This was true not only of castles and fortresses, but also of churches and monasteries. The style of these buildings is called **Romanesque**, because they were based on the Roman building principle of the round arch. Medieval building techniques and engineering, however, were not as sophisticated as those of the Romans. Whereas the Romans were able to create multistoried structures like the Colosseum and huge open spaces like the Pantheon, medieval builders were more limited in their abilities. Heavy stone buildings were supported by thick walls. Few windows pierced these massive walls and towers. The interiors of the churches were dark and mysterious, lit with candles. The European feudal economy could not support elaborate marble and mosaic decorations such as those typical of the Byzantine Empire or the richly decorated mosques that filled the Islamic world. Ornament was provided simply by the sculpting of the stone itself, as seen in the trumeau and tympanum above.

There are, however, important similarities to the Classical style. As in Greek and Roman architecture, decoration was confined to certain specific parts of the structure, and the overall structure is clear to the eye and easy to understand. Buildings were made of geometric shapes, combining the rectangle, square, and circle.

By the early Middle Ages, the basic shape of Christian churches had evolved into that of a so-called Latin cross, with a long, rectangular room, or **nave**, crossed by a shorter rectangular **transept** that ran perpendicular to the main space (11-26). The very shape was symbolic of Christianity, Christ's death, and resurrection. In large churches, the central nave was flanked by two narrower *aisles*, running beside the more open space of the nave. Heavy

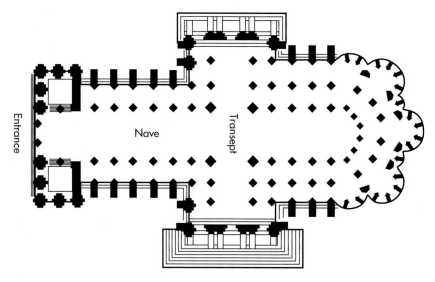

Entrance

Nave

Transept

11-26 Latin Cross Plan (Chartres Cathedral)

Roman-style rounded arches with columns on either side of the nave supported the weight of the roof. The rhythmic repetition of columns and arches created a visual sense of order and stability—but not grace. There is something monumental, solid, and even rather squat and square about the design of most Romanesque churches.

Before William the Conqueror invaded England in 1066, he was already the ruler of a huge duchy in Northern France, as Duke of Normandy. In his native land, William built two abbeys, or monasteries, one for men and one for women. The *Abbaye-aux-Hommes* (Saint Etienne, 11-27, 11-28) was to be his final resting place; the *Abbaye-aux-Dames* was built as the tomb of his wife Matilda. In style, both abbeys are typically Romanesque. On the outside they look relatively plain and one might say, uninteresting. Inside, rows of columns seem to march with heavy tread, like armies, toward the altar. The whole shape of the church is like a rounded tunnel, a round arch extended through space to form a **barrel vault** (see Chapter 8). There is a feeling of utter solidity. Within fifty years, this powerful style would be replaced by something completely different. Born in the region of Paris, the **Gothic** style would express a new, northern European aesthetic.

THE GOTHIC STYLE

The period of the twelfth and thirteenth centuries, when hundreds of Gothic cathedrals were erected, was one of prosperity and growth in western Europe. The Western world was becoming more cultured because of the sophistication of returning Crusaders, growing trade with Islamic Spain, and increasing wealth. Thriving towns vied with each other to build ever larger and more beautiful cathedrals—symbols of civic pride as well as religious devotion. Cathedrals like the one at Chartres cost many fortunes to build. The *Chartres Cathedral* (11-29), in a small town outside Paris, was not the first Gothic cathedral in France but has been considered the most perfect representative of the Gothic style. Indeed, this style developed as Chartres was being built, and the building exhibits the changing taste of several centuries. It is fitting that we view Chartres within the medieval

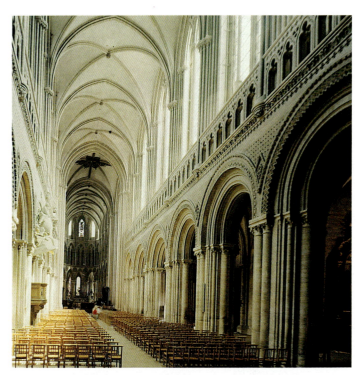

11-27 Nave of Saint Etienne (Abbaye-aux-Hommes), Caen, France, vaulted *c.* 1120

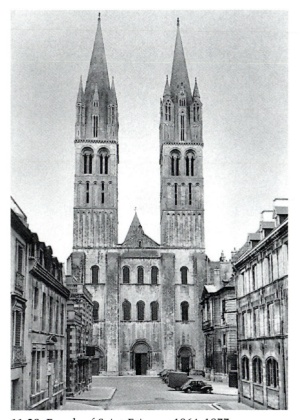

11-28 Facade of Saint Etienne, 1064–1077

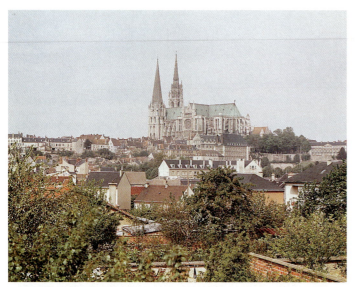

11-29 Chartres Cathedral, from the south, France, c. 1194–1260

town from which it grew. Gothic churches were most often cathedrals built in towns, rather than monasteries out in the countryside. Their worshippers were not primarily monks, nuns, and pilgrims but ordinary working people *and* noble patrons. The building of a Gothic church was a great undertaking accomplished not by the church alone, or by any single class of society, but by all the townspeople, who took great pride in their accomplishment. At Chartres, noble patrons paid for the elaborate sculptural decoration over the doorways and competed with each other to erect ever more beautiful statues and stained-glass windows. Other windows were the gifts of the town guilds (see 9-11).

The unique features of Gothic architecture were the *pointed arch,* the *ribbed vault, exterior buttresses,* and *stained-glass windows.* The pointed arch (see Chapter 8) made it possible for churches to become much taller than had been possible previously. The weight of these dramatically soaring arches was carried not by the walls themselves but by reinforced "ribs" that created a stone skeleton for the structure. To stabilize this skeleton and keep the building from collapsing outward, supports called buttresses were constructed outside of the cathedrals—a decorative exterior scaffolding. This elaborate support system made it possible to replace large expanses of stone walls with brilliant stained-glass windows. In contrast to Greek temples, which are usually horizontal, or Romanesque

churches, which often appear to be based on a square, the lines of Gothic arches and spires seem to soar toward the heavens. This is true of both the exteriors, as in Chartres and *Amiens* (11-30, 11-31), and interiors, as in *Notre Dame* (1-17), *Amiens* (8-23), and *Sainte Chapelle* (11-32).

In contrast to Classical and Romanesque, Gothic decoration was organic—that is, it seemed to be alive. Gothic cathedrals were often covered with intertwined, vinelike curlicues that seemed to sprout from every surface. In cathedrals such as *Amiens* (11-31), the mass of the walls is penetrated by intricate voids and lacy projections that almost dissolve the basic shape of the building. If classical art is geometric, logical, controlled, balanced, and harmonious, Gothic art can be seen as organic, intuitive, teeming with life, free—almost the polar opposite.

The Gothic style was not simply the expression of an anti-Classical taste, however, nor the result of certain technical innovations in architecture. The outer form of a Gothic church was an expression of its spiritual func-

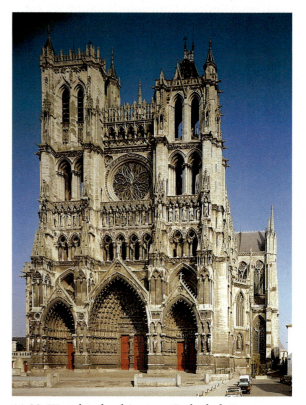

11-30 West facade of Amiens Cathedral, France, c. 1220–1236 (area above the rose window, early sixteenth century)

tion. We know something about this because one of the initiators of the Gothic style, Abbot Suger, left extensive records from the construction of the first Gothic church, Saint Denis. In these records Suger explains exactly what he wanted from the new style of architecture. His idea was that "the wonderful and uninterrupted light of the most luminous windows" would assist the soul in reaching a state of transcendence, that the material beauty of the architecture would provide a bridge to a completely spiritual experience.

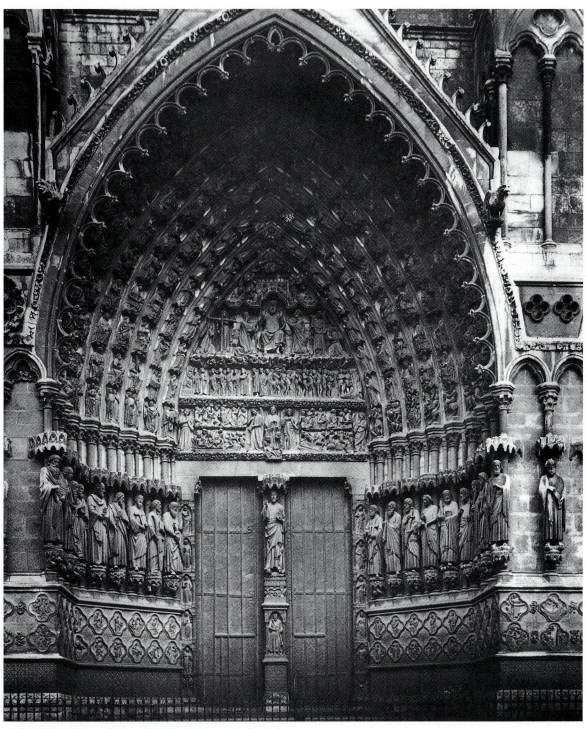

11-31 Central portal, west facade, Amiens Cathedral

The idea of transcendence of the earthly realm was expressed in all the visual elements of Gothic architecture: the soaring, graceful lines of the pointed arches; the breathtaking open space above the heads of the worshipers; the replacement of heavy stone walls by panels of brilliantly colored glass. Here the spirit could fly upward, toward heaven. One of the most glittering examples of the Gothic desire for color, space, and light is the royal

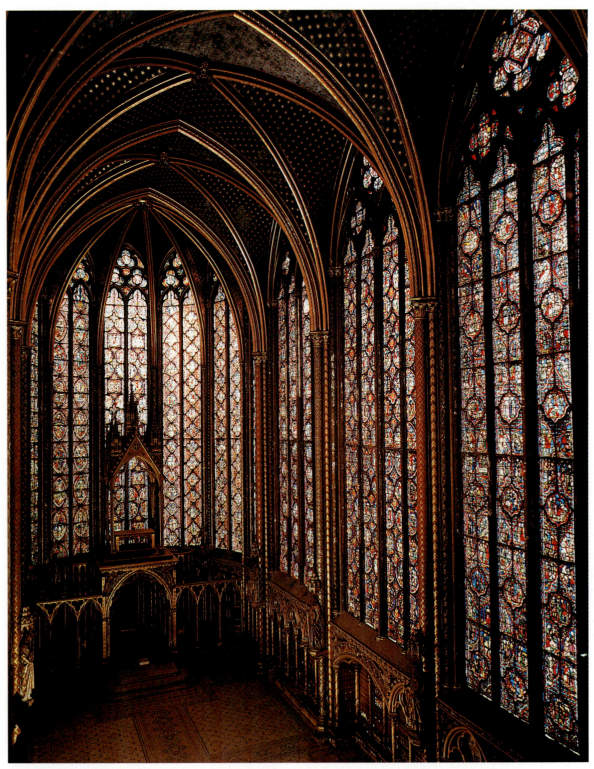

11-32 Interior of Sainte Chapelle, Paris, 1243–1248

◆ ART NEWS

THE DIMMING OF NATIONAL TREASURES

The 50,000 square meters of medieval stained glass in France is more than in the rest of the world combined. The Gothic cathedrals are one of the nation's most precious treasures but, unfortunately, they are also in danger. Centuries of rain and wind have stained them, and now air pollution is having its effect, too. Controversy has surrounded a recent attempt to clean some of the windows of the cathedral at Chartres (11-33), described by the American writer Henry Adams in 1904 as "the most extraordinary creation of all the Middle Ages—a materialization of the most exalted dreams of humanity." An association of artists complained that after cleaning the famous blue glass (detail, 11-34), it had become paler and grayer and lost its ability to reflect light. It was later revealed that one of the cleaning chemicals was one utilized by industry for bleaching. A synthetic resin applied to the exterior was impossible to remove. The government halted the restoration out of fear that more harm than good was being done. No one doubted the pressing need for restoration, but no one had a sure answer to how it should be safely done. More research is needed and time is running out for Chartres. Ninety years earlier, Henry Adams had already realized that there was too little research on stained glass and said, "The French have been shockingly negligent of their greatest artistic glory."

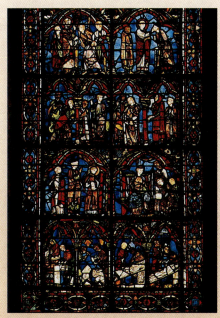

11-33 *Legend of Saint Chéron*, first north radiating chapel of the ambulatory, Chartres Cathedral, France, 1194–1220. Stained glass window.

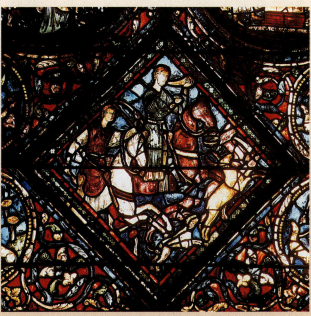

11-34 *Saint Eustace Hunting* from the *Life of Saint Eustace*, north aisle of the nave, Chartres Cathedral, France, 1194–1220. Stained glass window (detail).

chapel of *Sainte Chapelle* (11-32) in Paris. Here the "walls" are gone; the stained-glass windows are interspersed with slim, golden ribs that are more like stems than columns. At Sainte Chapelle we see the ultimate in jewel-boxlike aristocratic elegance.

MEDIEVAL ART IN ITALY

The art of Italy during the Middle Ages was not like the art of northern Europe. The Italians never really developed a taste for the more elaborate excesses of Gothic decoration.

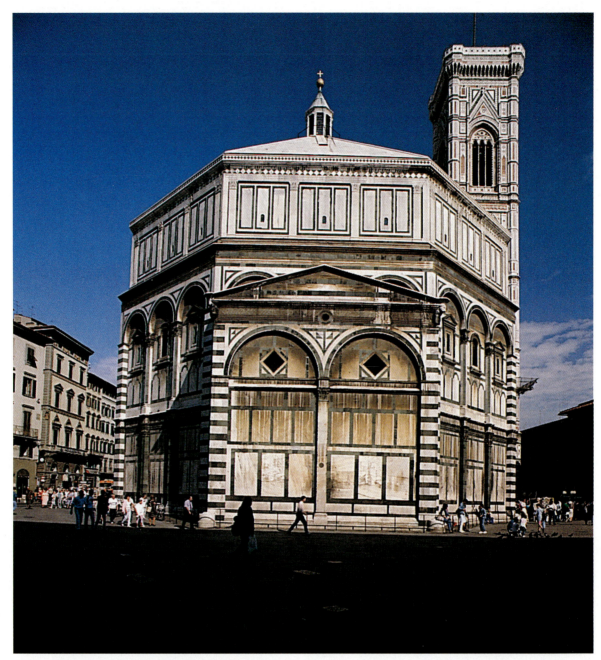

11-35 Baptistery, Florence Cathedral, 1060–1150

In fact, Italy never completely turned its back on the influence of Classical art and architecture. Italian churches tended to be more geometric and solid. The walls did not dissolve into panels of stained glass. This was partly for practical reasons; in the bright light and hot climate of Italy, churches were designed as a refuge of shade and coolness. They were decorated with the Classical media of fresco and mosaic.

The design of the baptistery, *Florence Cathedral* (11-35), built between 1060 and 1150, demonstrates the continuity in Italian architecture as compared to the Gothic cathedrals. The shape of the baptistery is a simple octagon. Its entire exterior is covered with sheets of green and white marble, arranged in a geometrical design. The door and window openings retain Classical details, yet the windows are tiny slits. The interior design has

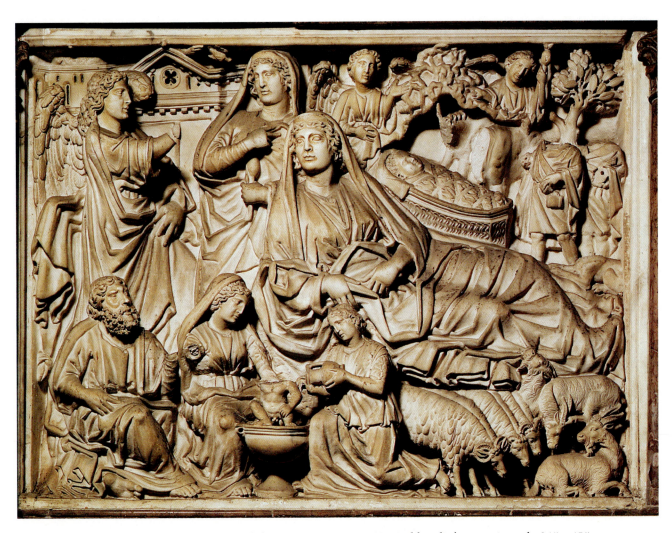

11-36 Nicola Pisano, *The Annunciation and the Nativity*, 1259–1260. Marble relief, approximately 34" x 45".

been compared to that of the Pantheon, with Classical columns, rounded arches, and patterned marble walls. At the very top of the eight-sided "dome," decorated with Byzantine-style mosaic pictures, is an octagonal oculus.

During the Middle Ages, Italian sculpture also continued to be influenced by Classical models. A vivid example is the work of the sculptor Nicola Pisano, done in the mid-thirteenth century. For the baptistery in Pisa, Pisano carved an elaborate marble pulpit that included nude figures. One of the panels illustrates three events from the story of Christ's birth. On the left is a scene of the Annunciation, with the Archangel Gabriel informing the Virgin Mary that she is to have a child. In the center of the relief (11-36), Mary reclines after giving birth in the manger, with

the baby Jesus wrapped in swaddling clothes behind her. The upper-right corner shows angels announcing the birth of the Messiah to shepherds in the fields. Finally, along the bottom Mary and Joseph watch as the child is bathed. The use of many stories within the same frame is typical of Medieval art, but the style of Pisano's carving is clearly influenced by Greek and Roman sculpture. One obvious similarity is the use of Classical costumes and ancient models for the faces and hairstyles. Another is the rounded carving of the figures; there is no doubt that Pisano was inspired by Roman relief sculpture, which, of course, still existed in Italy.

But while Italian architecture and sculpture showed the influence of ancient art, Italian Medieval painting was closer to the art

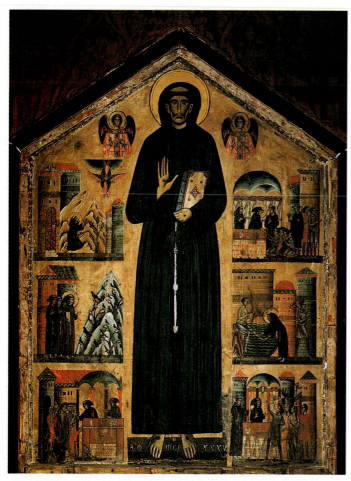

11-37 Bonaventura Berlinghieri, panel from the Saint Francis Altarpiece, 1235. Tempera on wood, approximately 60″ x 42″. San Francesco, Pescia, Italy.

of crucifixions, madonnas, and the lives of saints. The *Saint Francis Altarpiece* of 1235 (11-37) by Bonaventura Berlinghieri is typical of this kind of Italian-Byzantine painting. The center of the composition is dominated by an oversized figure of Saint Francis, the Italian saint noted for his gentleness and renunciation of all worldly goods and powers. The compassionate and human Saint Francis, however, is shown in a stiff pose—looking more like a flat pattern than a real person. This solemn figure is surrounded by smaller scenes that tell stories from the saint's life. The background of the panel is gold, and although the saint is shown in a drab costume, bright shades of blue and red enliven the little scenes. Most of these scenes show Saint Francis's miracles and stress his supernatural powers.

Close examination of one such scene, *Saint Francis Preaching to the Birds* (11-38), reveals the characteristics of the late Medieval style. Because painters in Berlinghieri's time copied the elements of their pictures from pattern books rather than basing them on studies from life, the figures are generic, with no individual qualities. Francis is nearly identical to the other monks; he can be identified only because of his attributes—his halo, signifying his sainthood, and the stigmata (wounds of Christ) on his hands and feet. The birds are also one basic form repeated with little variation. Natural scale and proportion were not considered. The three monks could never fit in the tiny, flat monastery behind them. The space between the figures is inadequate; they seem to be attached to one another like glued paper dolls. The mountain in front of them is hardly a hill, its trees little more than decoration.

Yet it is a mistake to judge the scene by whether it is realistic or not. Berlinghieri's altarpiece is one more example of an art of faith and devotion. Correct proportions or solidity are not his concerns. The "art" of the altarpiece, as in art across much of the globe in the Age of Faith, is in the arrangement of the sacred stories into a satisfying design.

of the Byzantine Empire. Many of the characteristics we observed in the mosaics of Justinian and Theodora in the Church of San Vitale at Ravenna in the sixth century continued to dominate the art of the Byzantine Empire—the stylization and elongation of figures, the flatness and love of color and pattern.

In the eleventh and twelfth centuries, Italian painters began to use a new art form to decorate their churches—painted wooden panels were made to hang behind the altar. Such pictures featured the Christian subject matter

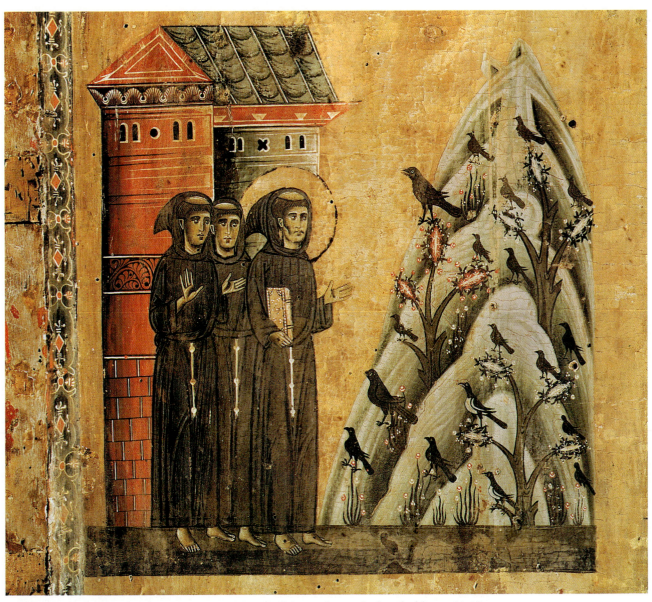

11-38 Bonaventura Berlinghieri, *Saint Francis Preaching to the Birds,* detail of figure 11-37

THE
RENAISSANCE

PERIOD	HISTORICAL EVENTS		
1300–1400	First signs of the Renaissance in Italy End of the Gothic period in Northern Europe Moorish rule in Spanish Granada Yuan Dynasty of the Mongols overthrown by Ming in China 1368 Aztec empire in Mexico begins	Dante, *The Divine Comedy c.* 1310 Papal court moves to Avignon 1309 The Black Death in Europe	
1400–1485	Early Renaissance in Europe	Joan of Arc burned at the stake 1431 The Medici rule of Florence begins Turks conquer Constantinople and Athens Inca rule begins in Peru	The Gutenberg Bible 1455 Portugese mariners round tip of Africa 1488 Dukes of Burgundy rule the Netherlands
1485–1570	High Renaissance in Italy The Renaissance continues in the rest of Europe Age of Exploration	The Protestant Reformation begins 1517 Machiavelli, *The Prince* Columbus comes to the "New World" Cortez conquers the Aztecs Mughal empire in India founded	Henry VIII becomes Supreme Head of the Church of England 1534 Copernicus declares that the planets revolve around the sun Magellan circumnavigates the globe

In the Italian town of Padua around the year 1300, a simple chapel was built alongside a palace. Because an ancient Roman amphitheater had once occupied that site, the chapel became known as the Arena Chapel. Its plain, unassuming exterior seems to make it an unlikely site for one of the most important achievements of Western civilization. But an extraordinary experience awaits those who enter the chapel because the flat, unadorned walls were transformed between the years 1305 and 1310 by one of the pivotal figures in the history of art, an artist named Giotto.

Initiating a return to visual realism, Giotto almost singlehandedly created the Renaissance style of painting. In *Lamentation* (12-1), one of the frescos in the Arena Chapel, we can see a sculptural solidity that had not been seen for more than 1,000 years. There is weight to the figures, bulk, and flesh; they are rooted to the ground by gravity. They are solid people on a solid earth. If we compare this fresco to Berlinghieri's *Saint Francis Altarpiece* (11-37) done eighty years earlier, the change becomes very apparent. No longer are sacred stories being arranged to make a design. Giotto has a new way of telling stories; rather than multiple scenes in one panel, he chooses one significant moment. He tries to imagine how the holy scene might have really looked. The spaces between the figures seem natural. Figures are in true proportion to each other. They are placed in a natural setting.

More importantly, Giotto tries to imagine how his characters felt. Real human emotion is being displayed as the Virgin Mary and Christ's followers mourn over the dead body of Jesus. The viewer can empathize with each person and understand what he or she is feeling because Giotto has created a unique pose and facial expression for each one of them. Even the ethereal angels experience human emotions of grief and anguish, each in their own way (12-2). Giotto's characters are not generic

ART

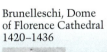

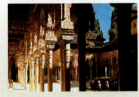

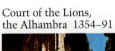

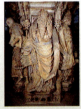

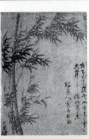

Giotto, *Lamentation* 1304

Court of the Lions, the Alhambra 1354–91

Claus Sluter, *The Well of Moses* 1395–1406

Wu Chen, *Bamboo in the Wind* 14th century

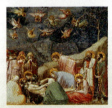

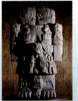

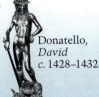

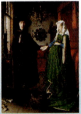

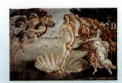

Brunelleschi, Dome of Florence Cathedral 1420–1436

Donatello, *David* c. 1428–1432

van Eyck, *Giovanni Arnolfini and His Bride* 1434

Botticelli, *The Birth of Venus* c. 1482

Coatlicue, Aztec 15th century

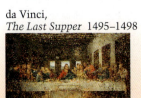

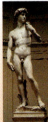

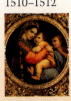

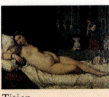

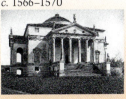

da Vinci, *The Last Supper* 1495–1498

Raphael, *Madonna della Sedia* 1510–1512

Palladio, *Villa Rotonda* c. 1566–1570

Michelangelo, *David* 1501–1504

Titian, *Venus of Urbino* 1538

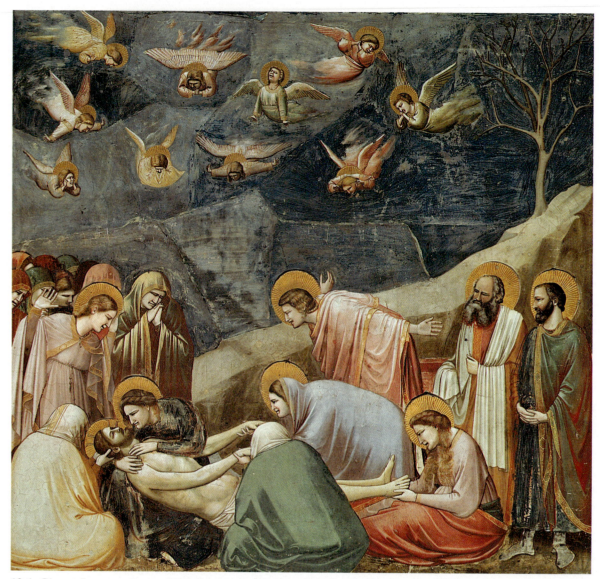

12-1 Giotto, *Lamentation, c.* 1305. Fresco. Arena Chapel, Padua, Italy.

people copied from a pattern book or people pictured by symbols of their roles in society. Now each is an individual first, a unique person. Giotto literally brought religious art down to earth.

Giotto was revolutionary in another way—he was a *famous* artist. For the past fifteen hundred years, since the Greeks, an artist was thought of as just another craftsperson, like a carpenter or a barrel-maker (Gislebertus being a rare exception). But Giotto's genius was recognized almost immediately; his services were in great demand by the most powerful leaders of fourteenth-century Italy. Dante, his contemporary and friend, mentions Giotto's dominance of the art world in the *Divine Comedy*.

Beginning with Giotto and the Renaissance, the history of art is the history of great and famous artists.

THE IDEA OF THE RENAISSANCE

The historical period known as the **Renaissance** is generally considered to mark the beginning of the modern world. During this period Europe underwent significant economic, political, social, and cultural changes, changes that led to the development of world civilization today. Capitalism, the rise of the nation-state, scientific investigation, individualism,

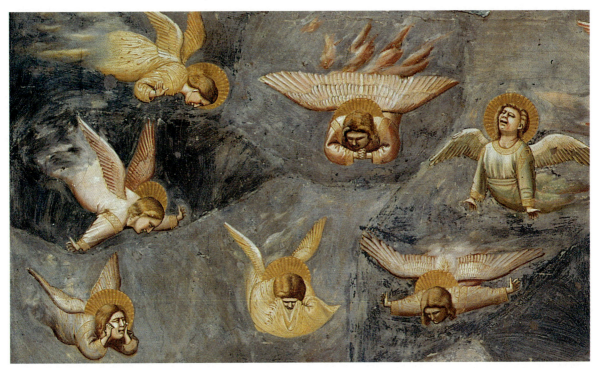

12-2 Detail of figure 12-2

the idea of progress—all have their roots in the Renaissance. The term, which means "rebirth," was coined by the people of fifteenth-century Italy. They saw their own age as an exciting flowering of art and culture after what they considered the darkness of the Middle Ages. For the leading thinkers of the fifteenth and sixteenth century, the medieval period was a barrier, a dark period between themselves and the grandeur of ancient Rome. The poet Petrarch wrote, "After the darkness has been dispelled, our grandsons will be able to walk in the pure radiance of the past." The Renaissance view of the medieval period has colored general opinion to this day.

The possibilities of life in medieval Europe *had* been limited. People were controlled by their place within the political system of feudalism, by the rigid rules of the Christian Church, and by a rural, agricultural economy that limited mobility and tied most people to the land for their whole lives. The world of an average person—a peasant—was restricted to the distance that could be walked in a few days.

Then, beginning as early as the twelfth century, but flowering dramatically in the fourteenth century in Italy and reaching the north in the fifteenth century, western Europe experienced an economic revival. This rebirth fostered trade and the growth of cities; it also resulted in an increase in wealth, learning, and sophistication that had not been seen since the greatest days of the Roman Empire, a thousand years earlier. This explosion of energy sparked the "Age of Exploration" and took Western peoples all over the world. A direct result is today's global culture.

But above all, the Renaissance is famous for advances in art and architecture. In fact, it is the only historical period known primarily for its artists and only secondarily for its political and religious leaders. Leonardo da Vinci, Michelangelo, Raphael—these names are familiar to everyone. The greatest of their works, such as the portrait of Mona Lisa and the ceiling of the Sistine Chapel in the Vatican, have never been matched and may never be surpassed in fame. The art of the Renaissance is the starting point of all later art in the West.

EARLY RENAISSANCE SCULPTURE AND ARCHITECTURE

During the Renaissance, Italy was divided into many city-states, each ruled by a powerful and wealthy family. By the beginning of the fifteenth century, Florence was in the midst of

an economic boom and had become one of the most prosperous cities in Europe. A wealthy, cultured society revolved around the ruling family, the Medici—international leaders in banking, as well as great patrons of the arts. There was a great deal of building—schools, hospitals, and especially churches. Artists from all over Italy were coming to Florence, attracted by the many commissions.

One famous competition was held to design the doors of the city's baptistery. The finalists, both in their twenties, were Filippo Brunelleschi and Lorenzo Ghiberti. Each was required to execute a specific tale from the Old Testament, Abraham's Sacrifice of Isaac (12-3, 12-4), where the old patriarch was asked by God to prove his faith by killing his only son. The theme was chosen for the challenge of representing a variety of subjects—figures young and old, clothed and nude, as well as animals and landscape—and because it was thought to foreshadow the sacrifice of Christ by his own father. In both relief sculptures, Abraham is

about to cut his son's throat when an angel of God rushes in and stops the sacrifice. Surrounding the main action are the donkey who carried Abraham and Isaac to the mountaintop, two servants, and a ram who appeared miraculously and was sacrificed as a replacement for the young man.

Ghiberti's design was selected. Brunelleschi's seemed more cluttered, with too many distractions from the main action. The figures do not seem to be in true proportion; Isaac is small and his father seems to be almost twisting his head off. Ghiberti's, on the other hand, is a masterful composition. He has separated the main action from the rest of the scene with a diagonal cliff. He draws attention to the sacrifice by having Abraham's elbow stick out of the panel, so the viewer follows his arm down to the edge of the knife and then to Isaac's neck. Ghiberti's angel enters more dramatically than Brunelleschi's. Rather than coming from the left side in profile, the angel comes hurtling toward us from deep space.

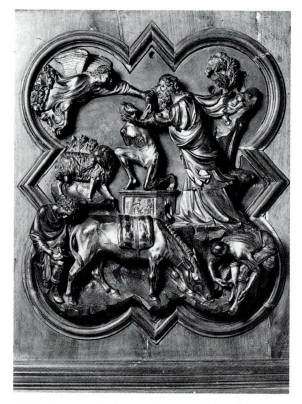

12-3 Filippo Brunelleschi, *The Sacrifice of Isaac,* competition panel for the east doors of the baptistery of Florence, 1401–1402. Gilt bronze relief, 21″ x 17″. Museo Nazionale del Bargello, Florence.

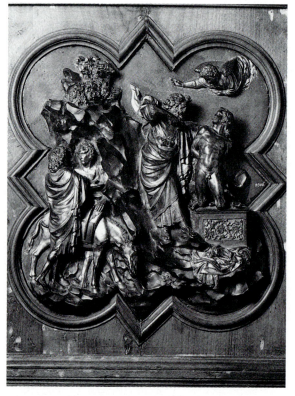

12-4 Lorenzo Ghilberti, *The Sacrifice of Isaac,* competition panel for the east doors of the baptistery of Florence, 1401–1402. Gilt bronze relief, 21″ x 17″. Museo Nazionale del Bargello, Florence.

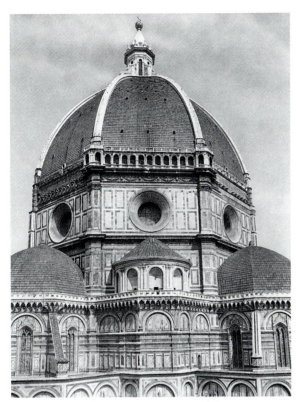

12-5 Filippo Brunelleschi, Dome of the Florence Cathedral, 1420–1436

What may have clinched his victory, however, was the beautiful figure of Isaac. His nude form was reminiscent of the perfectly proportioned statues of the ancient Greeks and Romans. A fascination with the Classical Age was to be one of the strongest influences on Renaissance thought.

While Brunelleschi would lose again to Ghiberti when a second set of baptistery doors was offered to competition, he would have a greater triumph—as an architect. The world renowned *Dome of the Florence Cathedral* (12-5) is his creation. The cathedral itself, originally begun in 1296, had a tower designed by Giotto and was nearly complete when Brunelleschi began work in 1420. Even the octagonal base for the dome was already built. But the open space to be covered was 140-feet wide, much too wide for any of the known building methods. A dome presents a unique engineering challenge—how to support a great weight over a great distance with support only at the roof's edges. While the Pantheon's dome (10-32) covered approximately the same expanse as the cathedral in Florence, the methods of the ancient Roman engineers had been lost during the Dark Ages. But after his two humiliating defeats to Ghiberti, Brunelleschi had gone to Rome to study the ruins of the ancient buildings. By using the results of his studies, combining them with medieval techniques, and by inventing many new ones, Brunelleschi was able to solve the problem that baffled all his countrymen.

It was the *beauty* of the dome that was even more overwhelming. A herringbone pattern of red bricks was framed by eight white ribs that reached up to a lantern at the peak. The dome of the cathedral became the focal point of the city of Florence and remains so today. Once it was built, Brunelleschi became the most famous architect of his day. He made many trips to Rome to study the classical architecture of the ruins and helped initiate the revival of interest in the culture of ancient Greece and Rome. These ruins would become an important source for Renaissance artists, and a "pilgrimage" to Rome would become a required part of an artist's education for centuries. Brunelleschi's use of the forms of classical architecture in an imaginative way, in order to achieve harmony and beauty, would be an example followed for the next five hundred years by almost every architect. Brunelleschi's study of the ancient monuments of the Greeks and Romans and Giotto's concern for the individual were the two main ingredients of **humanism,** the predominant philosophy of the Renaissance and catalyst for the period's great achievements.

DONATELLO

When Brunelleschi went to study the ruins of Rome, he went with his friend, Donatello, a young man who would become the greatest sculptor of his time. Donatello had been a student of Ghiberti, but his achievements far surpassed his teacher, almost single-handedly creating the Renaissance style of sculpture. *Saint Mark* (12-6) was done when he was twenty-five years old. It shows he already had great understanding of anatomy and form. We can see how the body shifts its weight at the hips, reminiscent of Greek statues like *Doryphoros* (10-20) nearly two thousand years earlier. Donatello's advance from the medieval style is very apparent when compared to what was naturalistic in its own time,

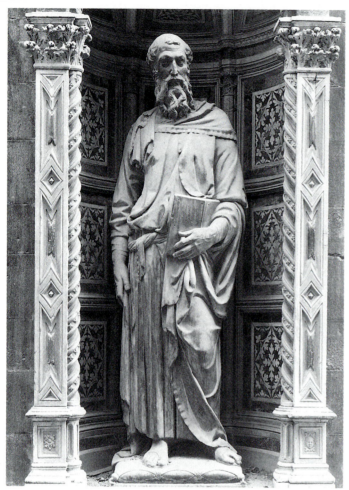

12-6 Donatello, *Saint Mark*, 1411–1413. Marble, approximately 7'9" high. Or San Michele, Florence.

Pisano's *Annunciation* (11-36). Rather than a crowded scene with many stories, we have a freely moving individual. We can see not only Donatello's mastery of the real features of a human body but also his ability to give a sculpture personality. Unlike Greek sculpture, Donatello's is not godlike but human. Saint Mark is dignified and thoughtful, his features strong but not perfect. He is a man who has lived on our earth and seen much; his hair is thinning and his brow is wrinkled.

The statue was commissioned by the Linen Drapers Guild of Florence, whose patron saint was Saint Mark. It is therefore not surprising that Donatello put an extraordinary amount of attention to the drapery on his statue. The fabric seems to flow naturally with the body as in the ancient *Venus de Milo* (10-21) and is even inscribed with detailed embroidery.

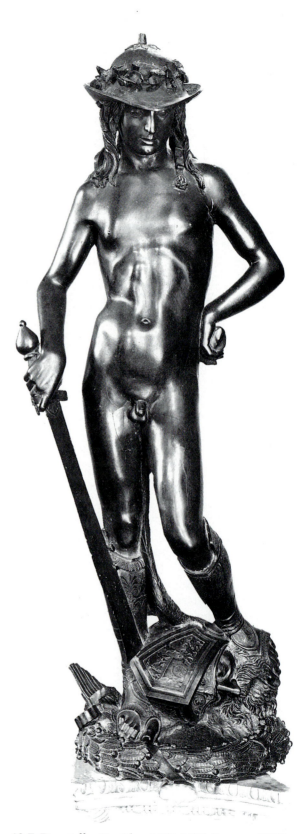

12-7 Donatello, *David, c.* 1428–1432. Bronze, 62¼" high. Museo Nazionale del Bargello, Florence.

The Linen Drapers Guild was not one of the wealthier ones in Florence, so *Saint Mark* was made of marble rather than the more expensive cast bronze. A more affluent patron, probably a member of the ruling Medici family, commissioned *David* (12-7). It was the first freestanding life-size bronze figure since ancient times. Donatello was one of the first artists of the Renaissance to work from live models and to follow the Greek style by portraying David nude. For Donatello and other Renaissance artists, nudity was no longer shameful, as in the medieval period, but beautiful and capable of representing humanity's highest ideals.

Donatello's David is barely an adolescent, a boy who seems incapable of such a tremendous deed. He is almost effeminate; his muscles seem too weak to even lift Goliath's sword. Yet below him is Goliath's severed head, which the young boy is rolling around with his foot. How could this child defeat the giant Goliath? Donatello's answer to this riddle is also the meaning of the Old Testament tale: Miracles can be accomplished only with the assistance of God. If Donatello had created a muscle-bound David, the miraculous nature of the story would be lost. Yet the boy seems unaware of divine intercession; instead, he is proud of

12-8 Andrea Mantegna, ceiling of the *Room of the Newlyweds*, 1474. Fresco. Ducal palace.

his own accomplishment. Pride would remain David's flaw even as king of the Israelites.

EARLY RENAISSANCE PAINTING: MASTERING PERSPECTIVE

Brunelleschi's discovery of the mathematical rules of perspective (see Chapter 2) transformed two-dimensional art. With perspective, drawing and painting were now raised to the level of science. In the ceiling of the *Room of the Newlyweds* (12-8), Andrea Mantegna, however, utilizes perspective in a playful way. He creates with paint a skylight with carved marble grillwork and fills the scene with people, cupids, a beautiful sky, and even a peacock (a symbol of fertility). It is said this was intended as a wedding-night surprise for the newlyweds. Happy family members peer down to encourage the young couple in a true tour de force of illusion.

12-9 Andrea Mantegna, *The Dead Christ*, c. 1501. Tempera on canvas, approximately 26″ x 31″. Pinacoteca di Brer, Milan.

In his grim *The Dead Christ* (12-9), Mantegna, following Giotto's lead in painting, tried to represent the events of the New Testament as realistically as possible. Unlike Giotto, however, he does not seem concerned with the inner emotion of his characters. He looks with a colder, less sympathetic eye. Mantegna's *Dead Christ* seems to be an eyewitness report. He depicts the wounds of Jesus with almost cruel accuracy. The mourners at the left are anything but idealized. Mary is not young and innocent as usually depicted but an old woman with leathery skin who cannot control her weeping. Still, the viewer is not allowed to be emotionally disengaged. Mantegna places us at Jesus' feet and forces us to examine what mankind has done.

A LOVE OF LEARNING AND *GRAZIA*

Mantegna, like the leading intellectuals of his time, considered the Middle Ages an era of superstitious thought. They felt it was time to see once again clearly and rationally as the Romans had. It was this desire to see clearly that was the source of the cold, unemotional eye of Mantegna's *Dead Christ*, as well as the mathematical vision of Piero della Francesca's *View of an Ideal City* (2-27).

Towards the end of the fifteenth century, there was a reaction to this coldness: a call for pictures with a sense of grace—referred to in the Renaissance as **grazia.** Sandro Botticelli's greatness was his ability to bring beauty and harmony to pictures that also embrace scientific and classical ideals. While filled with scholarly allusions, they do not weight his pictures down. In fact, his figures float—they hardly touch the ground. Learning from the ancients was mixed with a graceful line and rhythm.

Botticelli's *The Birth of Venus* (12-10) is popular today because of its sweetness and the innocent quality of Venus as she floats in a fantasy world. Yet it is also a work of serious study, demonstrating that the artist was a scholar of ancient myths. The tale of Venus's birth is found in Hesiod's *Theogony*. When

12-10 Sandro Botticelli, *The Birth of Venus, c.* 1482. Tempera on canvas, approximately 5'8" x 9'1". Galleria degli Uffizi, Florence.

ART NEWS

THE BIRTH OF MODERN ANATOMY

The medieval schematic of the muscle system (12-11) dates from the same period in which Giotto was painting. It is one of the earliest attempts to show the inner structure of the human body. Surprisingly, it is based on the work of Greek physicians. While the art of Greece had beautiful representations of the human form, it was truly a superficial understanding—they did not know what lay beneath the skin. Dissections were forbidden in ancient and medieval times so there were not many opportunities to learn the details of the human inner structure. Inner organs were revealed only after terrible accidents or wounds, probably not the best moments to make detailed studies.

However, in the early Renaissance, lawyers had an important role in increasing the knowledge of the human body, because they began requesting autopsies for their cases. By the end of the 1400s, dissections of cadavers were permitted, and anatomy was an officially recognized part of the university curriculum. Still, the study of anatomy made little progress because professors would never actually touch a cadaver. Their knowledge was not based on any actual study but on readings of ancient medical texts. In their anatomy classes, they would sit on a throne and lecture in Latin (the traditional language of the universities). Assistants (usually a local butcher)

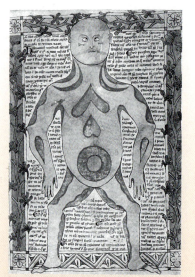

12-11 Medieval schematic of the muscle system, Ashmolean Codex 399, folio 22R, early 1300s. Bodleian Library, Oxford.

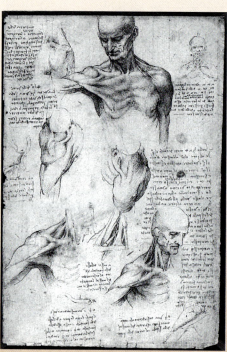

12-12 Leonardo da Vinci, anatomical muscle studies, late fifteenth or early sixteenth century. Royal Library, Windsor, England (19003 Recto).

Cronus (the god of time) castrated his father Uranus (the sky god), he tossed his father's genitals to earth, which fell into the sea. From the foam of the splash, Venus was born. Botticelli's painting shows Zephyr, the god of the wind, blowing her to shore. In his arms is his wife Chloris, the goddess of spring, who blows flowers toward the newborn goddess. The symbolic meaning of the picture is that love triumphs inevitably over brutality,

because out of the most brutal of acts, the goddess of love was born.

In the centuries since the fifteenth century, Botticelli's Venus has continued to symbolize ideal beauty. Yet if we look closely at her, we will see that she is not in perfect proportion. Her neck is quite long with a steep incline along the shoulder. Her left arm is also exceedingly long. But these distortions are intentional; they do not make for a deformed

would do the carving. Another assistant would point with a stick to the area the professor was describing; however, he knew little about anatomy and usually did not understand Latin.

It was an artist who made the first serious study of anatomy: Leonardo da Vinci (12-12) turned his incredible curiosity to the exploration of the unknown territory of the body. Obsessed by detail, he believed that detail revealed God's design. He did many anatomical studies, dissecting more than thirty cadavers before Pope Leo X barred him from sneaking into the mortuaries at night. By then, he had described the circulation of the blood (one hundred years before its official discovery). He was also the first person to study the reproductive system of women.

However, Leonardo's notebooks were the private records of an artist (see p. 4). Vesalius was the first scholar to publish detailed studies of the human body (12-13). Vesalius was a zealous scientist (obtaining cadavers from graveyards, mortuaries, and the gallows), and his illustrations are works of art. When he became a professor at the University of Padua (the day after he earned his medical degree there), he disregarded the old traditions and did the dissections himself. His drawings are very accurate despite the serious handicaps he faced. Since the corpses he worked on were not preserved with formaldehyde, he had to work fast and have a photographic memory for details. Vesalius was a very popular lecturer and traveled to universities all over Italy to demonstrate dissections. At the University of Pisa, the crowds were so dense that the outdoor theatre collapsed—evidence of the universal love of learning in Renaissance Italy.

Vesalius's and Leonardo's research avoided a pitfall of the unconditional admiration in the Renaissance of the ancient Greeks and Romans. Modern anatomy could only be born when the old texts were abandoned and self-reliant scientists conducted truly scientific research on their own.

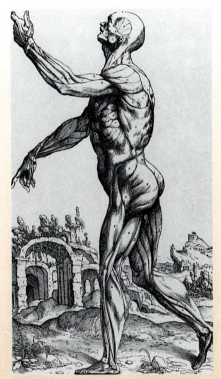

12-13 Vesalius, "The Muscle System," from *De Humani Corporis Fabrica Libri Septem*, 1543. Yale Medical Library, New Haven Connecticut.

goddess of love. In fact, they help create a more graceful image than any realistic picture could. Distortion can sometimes create greater beauty.

LEONARDO DA VINCI

During the Renaissance, artists joined scholars in a search for the fundamental cosmic truths of proportion, order, and harmony. At the beginning of the era, the medieval tradition of looking to the authors of the past for these truths remained (see box above). Ancient masters like Aristotle were considered to have almost sacred authority, second only to the Old and New Testaments. Leonardo da Vinci questioned the old texts. Unlike most of his contemporaries, he wanted to find out things for himself. If he came across a problem, he would not look for the answer in books—he would devise experiments to solve it.

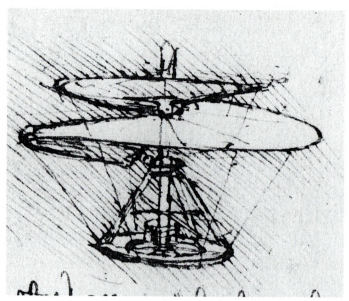

12-14 Leonardo da Vinci, *Flying Machine*, detail from MS B folio 83 verso, *c.* 1490. Pen on paper, 9¼" x 6½" high. Institut de France, Paris.

Leonardo was a leader on a new path—to nature and imagination, and a scientific approach to knowledge. He believed in observation and analysis. For example, to learn about flying, he would watch birds, not read books. The method he used is called **inductive reasoning**, where one observes phenomena directly and then uses information gathered to develop general rules. The medieval method is known as **deductive reasoning**, where already accepted general rules determine how you explain natural phenomena.

Da Vinci is the embodiment of the term "Renaissance man" because he worked in so many fields: anatomy, aeronautics, hydraulics, military engineering, and urban planning. During his long lifetime, he invented helicopters (12-14), armored vehicles, air conditioning, brakes, and transmissions. Among his many discoveries are how water flows, how birds fly, and that the heart pumps blood. Yet Leonardo never thought of himself as a scientist; he was first and foremost an artist. He believed that observation and investigation of the laws of nature were necessary for an artist to have a true understanding in order to produce works of art. But, of course, it was more than that. As revealed in his notebooks full of detailed drawings, Leonardo, like many of his contemporaries, was in love with the act of seeing. He epitomized the Renaissance's enthusiastic rediscovery of the natural world.

THE HIGH RENAISSANCE

Leonardo's *The Virgin of the Rocks* (12-15) marks a new period in art—the *High Renaissance*. Compare it to a work of thirty years earlier, Mantegna's *The Dead Christ*. Mantegna's picture seems stiff. Its cold clarity seems impoverished when contrasted with the liquid atmosphere and subtle muted light of Leonardo's picture. In this painting, hard edges are nonexistent. While it looks real, it is more like a dream, a vision. The figures of the Virgin Mary; the infant Jesus; his cousin John the Baptist; and the angel are not entirely of our world, nor should they be.

The Virgin of the Rocks shows the perfect ease and accomplishment, the effortlessness— the *grazia*—that Renaissance artists were looking for. But underlying the softness is a new structural innovation, a geometrical underpinning, which will be used throughout the Renaissance—the **figure triangle**. Leonardo also used a new medium that had been developed in northern Europe—oil painting. The smooth and subtle transitions between light and dark are made possible by this revolutionary medium (see Chapter 4). As seen in Chapter 1, Leonardo also revolutionized portraiture. His *Mona Lisa* has movement and life beyond any seen before.

For the dining hall of a monastery in Milan, Leonardo painted *The Last Supper* (12-16). To make the event vivid to the Dominican brothers, he placed Christ's table in line with the tables of the monks. All the figures are life-size. The moment he chose to portray is when Christ discloses to his followers: "One of you will betray me." The apostles react to the announcement in different ways, according to their character. Some recoil in horror. Others discuss who could have betrayed their master. One gentle soul asks Jesus if it could have been himself. Judas, the only figure whose face is in darkness, pulls back from Jesus and clutches his bag of silver. *The Last Supper* shows a masterful use of perspective and symmetry. Leonardo used Christ's head as the vanishing point, so all parallel lines on ceiling and walls lead directly to the center of attention. While no halo is actually painted above Christ's head, the pediment above creates one, and the light from the center window creates an aura around him.

Unfortunately, the masterpiece began to deteriorate almost immediately. Leonardo,

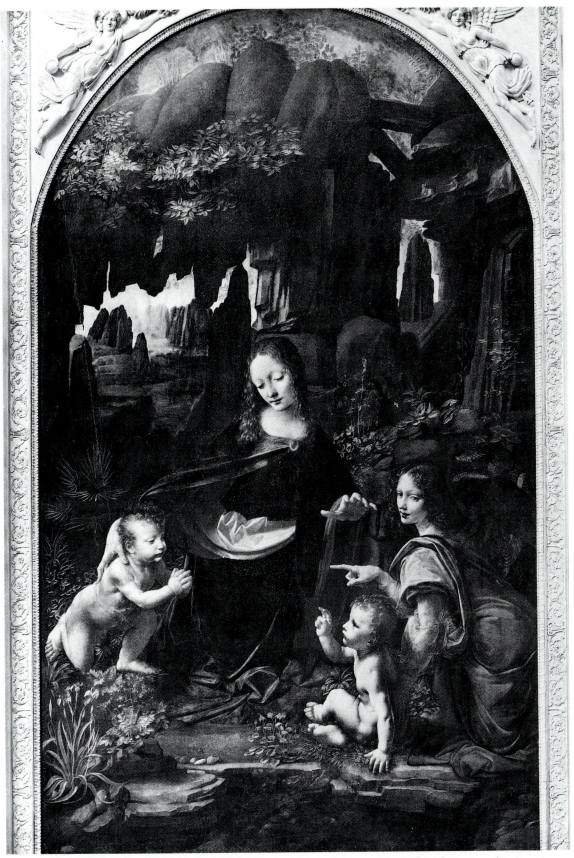

12-15 Leonardo da Vinci, *The Virgin of the Rocks, c.* 1485. Oil on wood (transferred to canvas), approximately 6′3″ x 3′7″. Louvre, Paris.

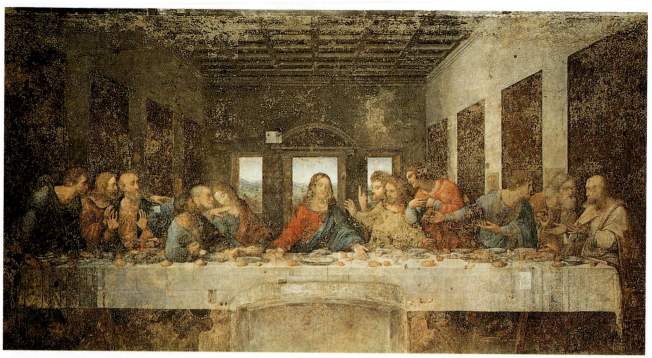

12-16 Leonardo da Vinci, *The Last Supper, c.* 1495–1498. Fresco (oil and tempera on plaster). Refectory, Santa Maria delle Grazie, Milan.

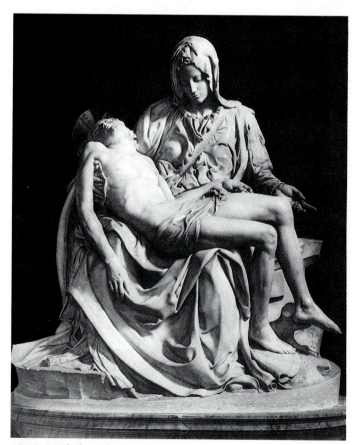

12-17 Michelangelo Buonarroti, *Pietà,* 1499. Carrara marble, 69″ high. Saint Peter's, Rome.

incessant experimenter that he was, had altered the traditional chemistry of fresco to allow more opportunities to make changes. The experiment was not a success. Even in Leonardo's own time pieces of the paint began to fall off the wall. Today, a tedious restoration is under way to preserve what remains—thought to be no more than 20 percent of the original.

Because of his genius, Leonardo, the child of a peasant, was given a high social position and became familiar with kings and queens. The king of France even threw his mother out of her chateau so Leonardo could stay there. But toward the end of his life, Leonardo, acknowledged as the great artist of his time, felt the challenge of a younger man, one who would become the predominant artist of the High Renaissance.

MICHELANGELO

Giorgio Vasari, a painter, is best known for his *Lives of the Artists,* a contemporary biography of the important Renaissance artists (many of whom he knew). He introduced his chapter on Michelangelo Buonarroti with a description that seems more like the birth of a god than a man. After noting the achievements of Giotto and his followers, he says:

the great Ruler of Heaven looked down and, seeing these vain and fruitless efforts and the presumptuous opinion of man more removed from truth than light from darkness resolved, in order to rid him of these errors, sent to earth a genius universal in each art, to show single-handed the perfection of line and shadow, and who should give relief to his painting, show a sound judgment in sculpture, and in architecture . . . He further endowed him with true moral philosophy and a sweet poetic spirit, so that the world should marvel at the singular eminence of his life and works and all his actions, seeming rather divine than earthly.

Michelangelo was a child prodigy. As a young man, it was said no pose was too difficult for him to draw (see 3-8). When he was only twenty-three years old, he was hired by a cardinal to sculpt the *Pietà* (12-17) for Saint Peter's in Rome. The marvelous but melancholy *Pietà* shows the dead body of Christ after having been removed from the cross, lying across his mother's lap. Mary is sad but dignified, the gesture of her left hand signifying acceptance. The unusual proportions (he is smaller than she) remind us that no matter what the age of Jesus was at his death, we are looking at a mother whose child has died. As in Botticelli's *The Birth of Venus*, imaginative distortion increases his art's power.

After his success in Rome, Michelangelo returned home to Florence to work on an 18-foot block of marble that had been prepared for Donatello but left unused for decades. When Michelangelo transformed the enormous stone into the finished statue of *David* (12-18), the city fathers decided to put it in the Piazza Vecchio, the main square, as the symbol of Florence. The statue shows David before he killed Goliath. David is tense but confident, sling across his shoulder, his right hand loosely fingering the stone. His eyes stare intensely as if he is choosing the right moment for his attack. Unlike Donatello's version (12-7), this David is not a child but a powerful young man, a worthy symbol of the youthful vitality of Florence.

When Michelangelo was thirty years old, Pope Julius II summoned him to Rome for his first papal commission: sculpting the pope's tomb. With youthful enthusiasm, Michelangelo designed an enormous tomb with forty bigger-than-life statues. Michelangelo left Florence for Rome and spent several months picking out the marble. He spent so much time because of his

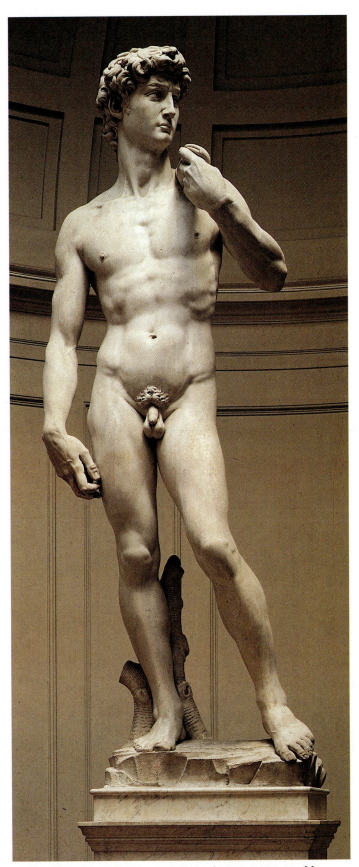

12-18 Michelangelo Buonarroti, *David*, 1501–1504. Marble, approximately 13'5" high. Galleria dell'Accademia, Florence.

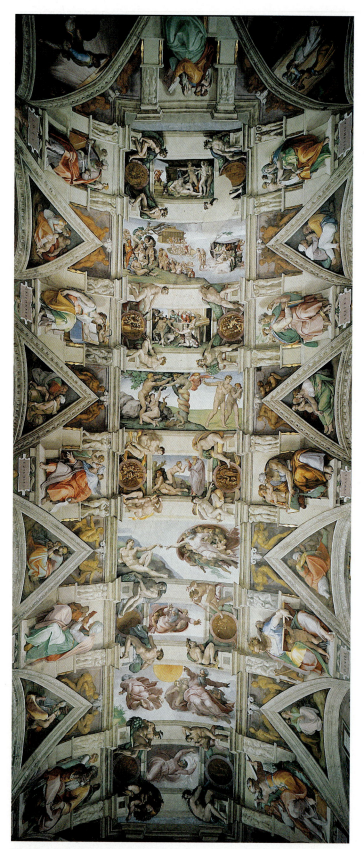

12-19 Michelangelo Buonarroti, the ceiling of the Sistine Chapel, Rome, 1508–1512. Fresco.

singular approach to the sculptural process. He felt when he selected the right block of stone, he need only remove the excess to release the figure within.

Michelangelo returned from his months in the quarries and filled half of Saint Peter's square with his stones. However, the pope was no longer interested in the tomb. He did not tell Michelangelo, but he had decided to tear down the old Saint Peter's, the most venerated building in the Christian world, and replace it with a new one, a massive undertaking (see Chapter 8). Michelangelo was furious and told Julius II (known as "the terrible pope" for his temper) he was leaving Rome, and he would never have any dealings with him again. Rather than hunting down Michelangelo and executing him, as might have been expected, emissaries of the pope began negotiations through the leaders of Florence for Michelangelo to return to Rome. The pope had a new commission for Michelangelo—to cover the ceiling of a tremendous chapel adjoining Saint Peter's (the old ceiling had developed cracks). It was 5,800 square feet, blue covered with gold stars.

Michelangelo was not interested in this new commission. First, he wanted to complete the project for the tomb he had spent so much time planning, and second, he told the pope, he was a sculptor not a painter. He finally agreed after many heated discussions because the pope promised he could finish the tomb afterward. What this "sculptor" created was the famous masterpiece, the ceiling of the *Sistine Chapel* (12-19).

Working on scaffolding seventy feet from the floor, it took Michelangelo about four years to complete this project. At first, eager to finish quickly and begin again on the tomb, he planned to paint only the corner spaces, making portraits of the twelve apostles in each of them. However, the word "ambitious" is hardly sufficient to describe what became his ultimate plan. Michelangelo decided to represent the history of the world before Moses, from the first event in Genesis—the separation of light from darkness—to the story of Noah. Surrounding the main scenes are prophets who predicted the coming of Christ. Supporting every subject and scene are realistically painted architectural elements and nude figures who react to the scenes they frame. The Sistine ceiling contains more than three hundred figures, all

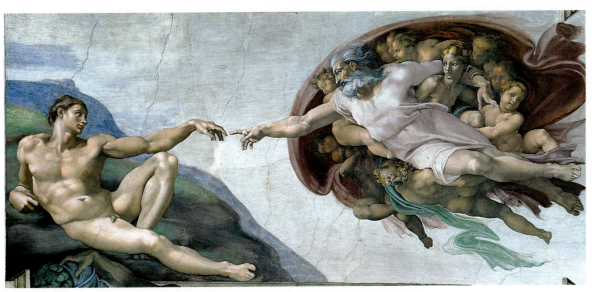

12-20 Michelangelo Buonarroti, *The Creation of Adam* (detail of figure 12-19)

in an incredible variety of poses and actions and all depicted as fully rounded three-dimensional forms, as one would expect from the hand of a sculptor (see "The Chapel Restoration" in Chapter 18). Pope Julius II, while reputed to be impatient, cooperated with just about all of Michelangelo's requests. Special scaffolding was built to his specifications, pigments he required were imported from Turkey, and he hired, it is believed, thirteen assistants. No one else was permitted in the chapel while Michelangelo was at work.

While it is filled with philosophical and religious references, generally, the story Michelangelo tells over the length of the ceiling is the movement to pure spirit from the physical. He began painting in reverse chronological order. The first important scene shows Noah, his spirit numbed by alcohol, naked before his children and ridiculed by them. The next scene is *The Flood,* the torrents of rain and water sweeping the earth. Michelangelo realized after this scene that he had underestimated the effect of the height of the ceiling and began painting larger figures, starting with the *Expulsion from Eden.* After that comes *The Creation of Adam* (12-20), the most famous of the scenes, where a powerful and compassionate God (who resembles the ancient god Zeus) brings a still weak Adam the spark of life. *The Creation of Eve* shows her pulled from the side of a sleeping Adam by a simple gesture of God.

Moving back further in time, we are shown God racing back and forth across the heavens in *Creating the Sun, Moon, and Planets* and *Congregating the Waters.* The climax of the ceiling is the first moment of creation—the *Separation of Light and Darkness.* With *Jonah and the Whale* (symbolizing Christ's resurrection) just over the altar, they announce the inevitable triumph of the spirit over the physical world.

RAPHAEL

As you can imagine, this masterpiece had a profound effect on the artists of the Renaissance. Perhaps the biggest effect was on Raffaello Santi, the artist we call Raphael. In 1508, the pope called on Raphael (only twenty-five years old) to decorate his private library in the Vatican, now known as the "Stanza della Segnatura." Because this was his first great commission, Raphael chose a great humanistic subject. Raphael decided to sum up all learning; each of the four walls would represent one discipline: theology, law, literature, and philosophy.

While decorating these walls, he managed to see Michelangelo's unfinished work on the Sistine ceiling. Legend tells us that he bribed the guards to let him see the ceiling while Michelangelo was away. He slipped into the chapel, climbed up the scaffolding, and was stunned by the masterpiece. Raphael immediately realized that his pictures in the library

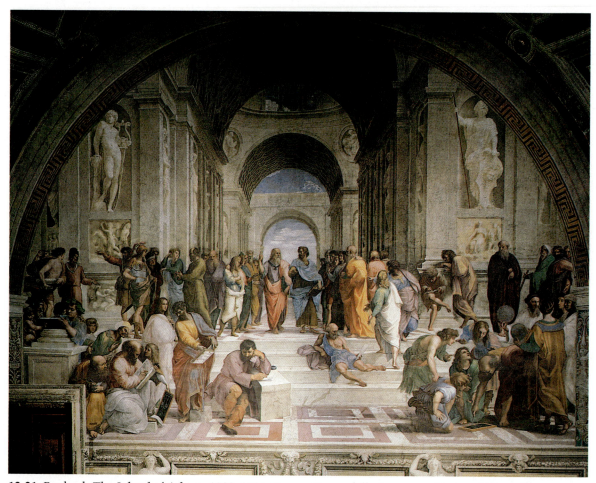

12-21 Raphael, *The School of Athens*, 1509–1511. Fresco. Stanza della Segnatura, Vatican Palace, Rome.

seemed backward compared to Michelangelo's and quickly redesigned and repainted all his pictures.

The School of Athens (12-21) is the most famous wall of the Stanza. It is a picture of a heavenly world of knowledge, the Elysian (or "delightful") Fields spoken of by the Greek poets. We see the greatest philosophers of the classical period in discussion, thinking, teaching, and arguing. In the center is Plato, pointing upwards to the ideal, and Aristotle, pointing downward to reality. On the lower left, Pythagoras, a Greek philosopher and mathematician, is writing; at right, Euclid, the Greek founder of geometry, is surrounded by many students.

The connection felt between those ancient times and the Renaissance of Raphael is given visual form by the artist's choice of models for the philosophers. Plato is also a portrait of Leonardo da Vinci, for example. Euclid is the architect Bramante who designed the new Saint Peter's. In the foreground, alone and moody, is Michelangelo as Heraclitus,

known as the "weeping philosopher." At the farthest right, a sign of his modesty, is Raphael himself, posing as a student of Euclid.

Preparatory sketches were always important for Raphael, but he never made more than he did for this project. *The School of Athens* is known for its perfect composition and perspective. Unity is achieved by the repetition of arched (elliptical) shapes throughout. Even the figures themselves form a large ellipse. As in Leonardo's *The Last Supper*, the vanishing point is placed at the center of attention—Plato and Aristotle. Notice how the seemingly casual form of the reclining Diogenes on the steps also points at the central figures. Even though it is more complicated than Leonardo's picture, *The School of Athens* remains a vision of order and dignity. Raphael achieves a harmonious composition of freely moving figures, something artists have admired in his work throughout the centuries.

The School of Athens shows Raphael's formal, mathematical side, but his *Madonna della Sedia* (12-22) shows his sweet and

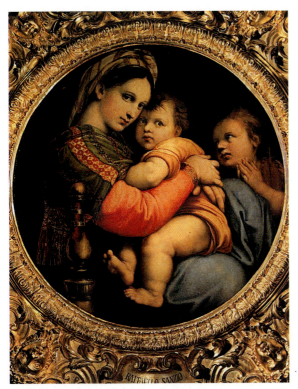

12-22 Raphael, *Madonna della Sedia*, 1510–1512. Panel painting, tondo, 28" diameter. Pitti Gallery, Florence.

loving side. It is the sheer, ideal beauty of his pictures of the Madonna and Christ child that has made Raphael famous. Over the centuries, Raphael's *Madonna della Sedia* has been seen as artistic perfection. One cannot imagine a more loving expression of family. As a modern critic has said, it would be recognized as a masterpiece even if it were found dusty and unlabeled in an attic. It is in a circular format called a *tondo*, which means in Italian "simple," yet it is probably the most difficult form for a painting compositionally because of a tendency to seem unbalanced and rolling. Raphael secured the scene by providing the strong vertical of the chair post.

Those who lived at the peak of the Renaissance believed the power of the mind made anything possible. The world seemed good and understandable. Raphael, one of the greatest masters of the Renaissance, managed to achieve its highest goals: *beauty, proportion, grace,* and a *sense of human virtue.*

THE RENAISSANCE IN VENICE

In the medieval period, bright colors were used for decorative and symbolic purposes; artists were not concerned with reproducing actual colors or even realistic forms. Partly in reaction to that art, the Florentines of the Renaissance were most interested in drawing issues, such as the realistic depiction of forms. Perspective and composition were the things that fascinated them: color was a secondary interest.

However, color was not a mere adornment for the artists of Venice but central to their work, giving energy and movement to their pictures. The greatest colorist and painter of the Venetian Renaissance was Titian. Unlike the geniuses of Florence and Rome, Titian's sole interest was painting; he was not an architect or a scientist. He mastered the medium with a single-mindedness that was unique for his time. He developed new techniques—for example, **impasto**, where thick layers of paint are built up for added richness (see Chapter 4). Titian would vary the texture of the paint itself, sometimes scratching into it with his fingers. His surfaces are full of energy.

Sensuality became a hallmark of Venetian painting, and the *Venus of Urbino* (12-23) probably epitomizes the Venetian love of sensual delight better than any other work. Here is Titian's ideal beauty—and she is very different from Raphael's or Leonardo's. She is an openly sexual woman, lying on cool sheets on a hot day. The purpose of this picture is not to give moral or religious instruction but to give pleasure. Notice how Titian uses color as a compositional element. The large red pillow (the hue is known as either Venetian or Titian red today) in the foreground is balanced by the red skirt in the background. The white

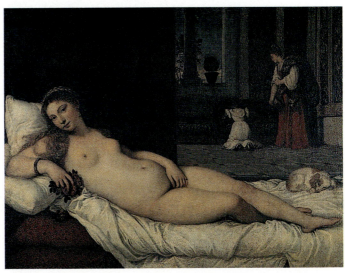

12-23 Titian, *Venus of Urbino*, 1538. Oil on canvas, approximately 48" x 66". Galleria degli Uffizi, Florence.

shapes of the pillow and arm form triangles that lead back into the background. Titian had created a new type of image, one that would be borrowed by artists for centuries. Romantics, Classicists, Realists, and Impressionists would all choose to continue the *tradition of the reclining nude.*

PALLADIO AND ARCHITECTURE

While Leonardo, Michelangelo, and Raphael engaged in architectural projects, architecture never was a primary interest for them. The quintessential Renaissance architect was Andrea Palladio. His most influential building, the *Villa Rotonda* (12-24), has been a model for architects in every century since it was built, in the mid-1500s. It is the essence of calm and harmony, a study of the purest geometrical forms. The building is perfectly symmetrical, with four identical facades designed like a Roman temple on each side. A circular hall topped by a dome is the center of the building, making Palladio's design a circle within a square. This private retreat of a wealthy landowner rests on a hillside outside the city of

Vicenza and provides four different views of the countryside from each of the entrances. Many classical-style statues on the pediments and stairways share the lovely views, which the occupants could choose from, depending on time of day, weather, or whim.

Palladio was a scholar of ancient architecture and like his predecessor, Brunelleschi, made many trips to Rome to study the ruins there. His influential treatise, *The Four Books of Architecture,* was written to encourage the construction of buildings that would bring the world into an ideal state. With floor plans and drawings, the book systematically explained classical architecture. Palladio also included the designs for his buildings, thereby putting his own work on the same level as the greatest architecture of the past. His treatise became the primary source of information on the buildings of the Greeks and Romans and was widely circulated. The familiarity of the Palladian style of architecture testifies to his treatise's acceptance as the authoritative guide to ideal architecture. Among many others, he would influence architects of the early American republic like Thomas Jefferson (see Chapter 8).

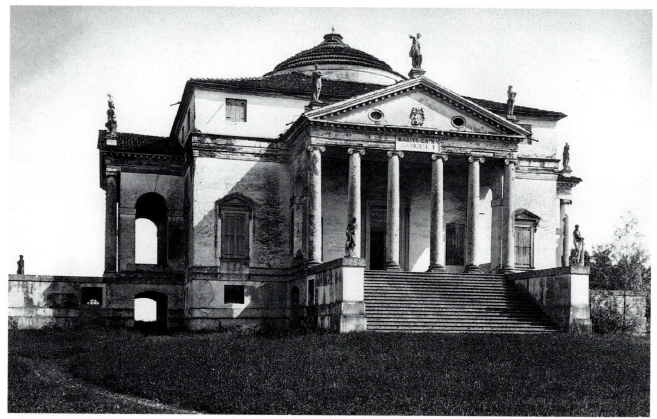

12-24 Andrea Palladio, Villa Rotonda (formerly Villa Capra), near Vicenza, Italy, *c.* 1566–1570

THE END OF THE HIGH RENAISSANCE IN ITALY

Unlike Raphael, who was only thirty-seven when he died, Michelangelo had a long, full life (living until the age of eighty-nine). Despite his immense talent, Michelangelo ended his life a frustrated and angry old man. Many of the projects he began (like the tomb of Pope Julius II) were left unfinished. By the 1530s, he could see the age of the High Renaissance was ending, never to return.

In 1534, Michelangelo returned to the Sistine Chapel to paint an enormous fresco on the wall behind the altar. Thirty years had passed since he had completed the ceiling of the chapel. Since then, his beloved Italy had become a battleground, the victim of many invasions from the north. Rome itself had been sacked in 1527, leaving it in disarray. In Florence, the Medicis, once his patrons, had become tyrants who were propped up by the Spanish king. All across Europe, there was change. The Protestant Reformation (see page 274) had split Christianity. Michelangelo became deeply concerned about the fate of humanity. He felt the world had gone mad. He worried about the fate of his own soul.

Even though they share the same room and were done by the same artist, *The Last*

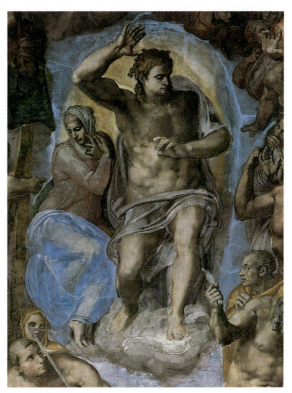

12-26 Detail of figure 12-25

Judgment (12-25) has a very different mood from the Sistine ceiling. On a dark and turbulent Judgment Day, Christ has come, but his arm is lifted in damnation as if he is destroying the world (12-26). Mary, his mother, turns her head away; she cannot bear to see his judgment. The heavens are in chaos. Ideal beauty and perfection no longer have a place in Michelangelo's painting. At the end of his life, using ugliness and terror for their expressive power, the greatest artist of the High Renaissance moved beyond its ideals.

THE BEGINNING OF THE NORTHERN RENAISSANCE

The Renaissance did not take place only in Italy. In the early 1400s, a century after Giotto but long before the birth of Michelangelo, it had also begun in northern Europe. As in the Italian Peninsula, growing cities made more powerful by trade altered the structure of society. The new wealthy courts in the Netherlands, Germany, France, and England became centers for art. Unlike Italy, however, the cultures of northern Europe had flowered during the Middle Ages. The Medieval Era, for example, was the era of the great Gothic

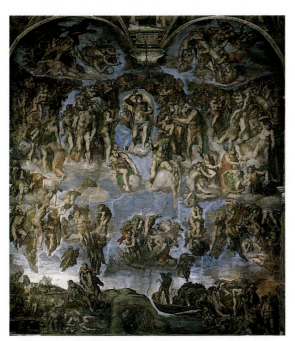

12-25 Michelangelo Buonorotti, *The Last Judgment*, fresco on the altar wall of the Sistine Chapel, 1534–1541

churches and stained-glass windows in France. Therefore, the difference between medieval art and that of the Early Renaissance in the north is not as clear-cut as it was in Italy. However, gradually during the fifteenth and sixteenth centuries, the ideas of the Italian Renaissance began to be assimilated in the north.

ART IN THE COURTS OF THE DUKE OF BURGUNDY

Based in both Dijon, France, and Flanders (now Belgium), the courts of the duke of Burgundy were two of the most significant artistic centers in the north by the end of the fourteenth century. This French duke had inherited the Netherlands, one of the most prosperous lands in northern Europe, from his father, the king. By the end of the Renaissance, the Netherlands would replace Florence as the center of European finance.

The French felt that the artists of the Netherlands were the best in Europe. Therefore it is not surprising that in 1395, Philip the Bold, the duke of Burgundy, sent for the Flemish artist Claus Sluter to design a huge crucifixion for a church in his capital of Dijon. Originally 25-feet tall, the statue's base is all that remains intact. Today it is called *The Well of Moses* (12-27) because it was originally placed over a fountain. It is an extraordinarily naturalistic sculpture, with life-size portraits of individuals who seem only to be leaning against the backgrounds temporarily. The Old Testament prophets Moses, David, Jeremiah, Zechariah, Daniel, and Isaiah look as if they are about to leave the fountain, walk into the congregation, and begin to preach. Each is a unique character, and every part has been sculpted by Sluter with careful attention to realistic detail. Notice how the heavy cloth of Moses' robes is held to his waist by a precisely delineated belt. As realistic as the statues seem today, originally they were even more so, because they were not bare stone but painted. Moses wore a blue robe with golden lining. Jeremiah even had on a pair of metal spectacles.

JAN VAN EYCK

Another Flemish artist, Jan van Eyck, was the favorite artist of a later duke of Burgundy, Philip the Good. While we do not know much

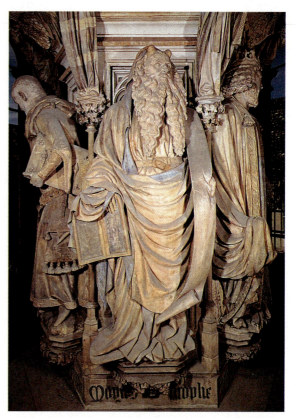

12-27 Claus Sluter, *The Well of Moses,* 1395–1406. Figures approximately 6′ high. Chartreuse de Champmol, Dijon, France.

about this artist's life, his sober, realistic style was most likely influenced by Sluter's. Like Sluter, he lived in Brussels but also traveled widely as a diplomat of the duke.

While the Italian Renaissance artists like Leonardo da Vinci were pursuing naturalism with the technique of sfumato light, van Eyck used a different approach to reach a similar goal. As seen in his *Virgin with the Canon van der Paele* (2-16), van Eyck used detail upon detail to carefully re-create nature. This obsession with detail is common in northern Renaissance painting and one of the clearest ways to differentiate it from the art of the south. If the painting is concerned with the beautiful surface of things, then it is most likely from the north.

Giovanni Arnolfini and His Bride (12-28, 4-4) is van Eyck's most famous work and shows the marriage ceremony between an extremely wealthy Florentine banker who lived in Flanders and the daughter of a rich family. At this time, civil marriages (versus

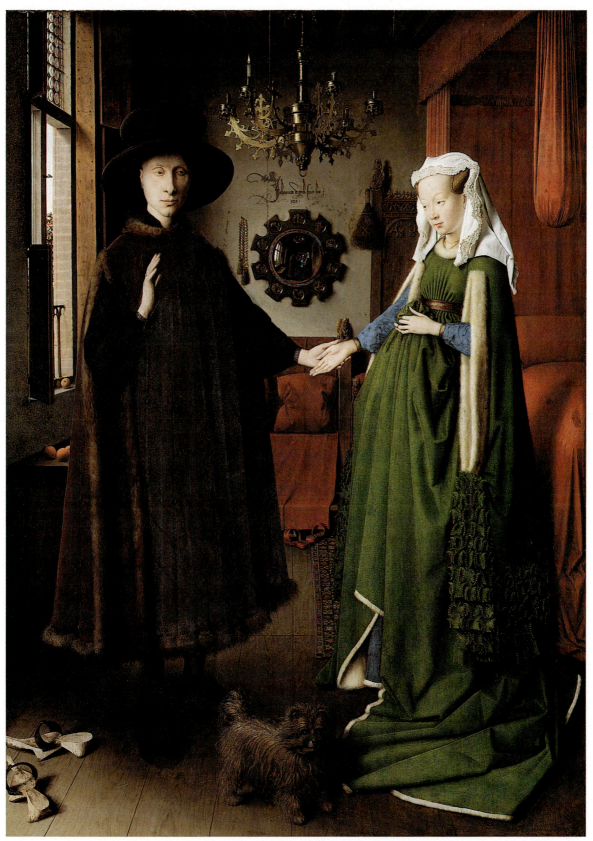

12-28 Jan van Eyck, *Giovanni Arnolfini and His Bride,* 1434. Tempera and oil on wood, approximately 32″ x 23½″. Reproduced by courtesy of the Trustees of the National Gallery, London.

church ceremonies) were permitted as long as they were witnessed by a government official. Since the painter was an appointed official of the duke, the painting served as both portrait and official document. On the back wall, between the bride and groom, is his elaborate signature—"Jan van Eyck was here 1434."

Van Eyck's painting is a good example of **secondary symbolism**. Medieval artists loved to make symbolic puzzles out of pictures, and van Eyck continues the practice. It was part of a desire to give realism even greater meaning by making each detail meaningful. The dog, for example, symbolizes Fidelity (Fido). Peaches ripening on the desk and windowsill suggest fertility. The chandelier has only one candle—the nuptial candle, carried during the ceremony and by tradition blown out right before going to bed on the wedding night. The ceremony is not totally secular. The main participants have removed their shoes because it

is sacred ground. The mirror (with tiny scenes of the Stations of the Cross around its edge) probably represents the eye of God witnessing the ceremony (12-29). In it we can see the backs of the couple as well as van Eyck and his assistant. A rosary hangs to its side. The entire scene, while very naturalistic, symbolizes the holy sacrament of marriage.

ALBRECHT DÜRER

Van Eyck mastered detail, color, texture, and realistic portraiture, but knowledge of mathematical perspective had not yet come from Italy. Like his fellow northern Renaissance artists, he accepted what he saw but did not search for underlying universal laws. One man took it upon himself to bring the ideas of the High Renaissance to northern Europe—the German artist, Albrecht Dürer. Dürer became known as the "Leonardo of the North" because of the variety of his interests: writing treatises on painting, perspective, human proportions, fortifications, and many other topics. Like Leonardo, he did many sketches from nature, studying its most delicate details.

Dürer is probably the first artist to paint pictures devoted solely to a self-portrait. His *Self-Portrait* (12-30) in 1500 shows him at the age of twenty-eight, after his return from Italy where he studied the great works of the Italian Renaissance and became determined to bring this knowledge north. While the careful detailing of his fur collar is very typical of the northern style, his interest in High Renaissance composition is revealed by the pyramid construction of the picture. If you look closely, you will discover, in fact, that the composition contains several triangles. The portrait's striking resemblance to European images of Christ is conscious but not blasphemous; Dürer is saying he is a creator, too (note his hand's position).

Despite the exceptional skill demonstrated in his self-portrait, Dürer's greatest talent was not as a painter but as a printmaker. His graphic work, such as the *Four Horsemen* from his *Apocalypse* series (5-2), made him rich and famous in his time and maintains his reputation even today. Dürer's technical skill and inventive mind are equally demonstrated in his metal engravings. He inherited his skill from his father, a goldsmith, who trained him. His technical mastery was com-

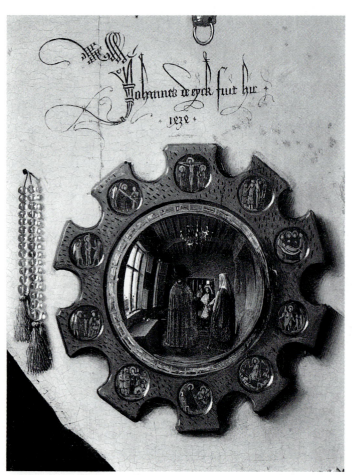
12-29 Detail of figure 12-28

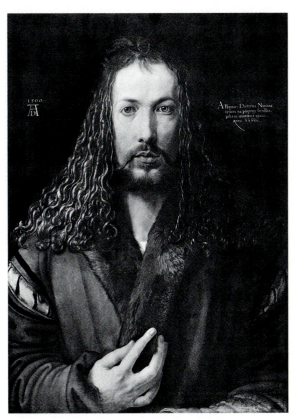

12-30 Albrecht Dürer, *Self-Portrait*, 1500. Panel, 26½″ x 19¼″. Alte Pinakothek, Munich.

HANS HOLBEIN AND THE PROTESTANT REFORMATION

In one of his many treatises Dürer included among a painter's most important responsibilities: "to preserve the appearance of men after their death." A younger German, Hans Holbein, made that his main occupation and become one of the greatest portraitists who ever lived. He came from a family of painters and began his career after Dürer's mission to spread the influence of the Italian Renaissance had taken hold. Like Dürer, he traveled to see the great Italian masterpieces firsthand, and by the time he was thirty years old, he had assimilated the learning of the Renaissance. Settling in Switzerland, he painted beautiful altarpieces and was on his way to becoming the leading painter of the German-speaking world when that world, and Europe, suddenly changed profoundly.

bined with a marvelous eye for detail and the patience to render detail upon detail. *The Knight, Death, and the Devil* (12-31) contains an incredible variety of textures and shading. In it a Christian knight rides without fear through the Valley of Death with his faithful dog. Death, riding a horse, attempts to distract the hero with an hourglass, pointing out the shortness of life. He, along with the Devil—whose head is a grotesque collage of beasts—are ignored as the knight moves by on his way to glory and salvation.

Dürer demonstrated that effects once thought possible only in paint could be accomplished by a master printmaker and helped make the print the equal of any other fine art form. He was recognized as being among the greatest masters even in his own time. In a discussion with the Holy Roman Emperor Charles V, Michelangelo said of Dürer: "I esteem him so much that if I were not Michelangelo, I should prefer to be Albrecht Dürer than Emperor Charles V."

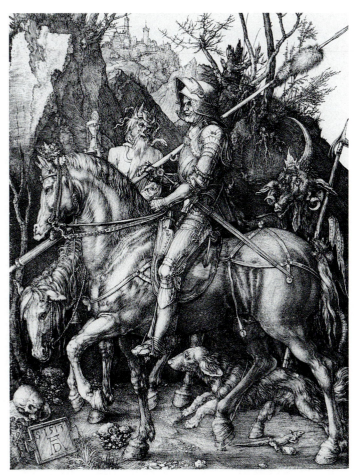

12-31 Albrecht Dürer, *The Knight, Death, and the Devil*, 1513. Engraving on paper, 9¾″ x 7½″. British Museum, London.

The Protestant **Reformation** led by Martin Luther turned Europe upside down and had deep and pervasive effects on the art world, too. The rebellion against the Roman Church was sparked by the church's practices, like the sale of indulgences (which Pope Julius II had zealously promoted to pay for his new Saint Peter's). Northern Europeans were outraged by the idea that Christians could buy their way into heaven. Luther and his followers preached that Christians needed only faith and a knowledge of the Bible to reach salvation. But with the Protestant Reformation came a wave of **iconoclasm**—the destruction of religious imagery (Luther, a close friend of a painter, was horrified by this development). Many Protestants associated imagery not only with the Roman Church but, like the early Christians, with idolatry. All over northern Europe, Protestant mobs swept into churches destroying altarpieces, decapitating statues, and burning crucifixes. The lack of decoration

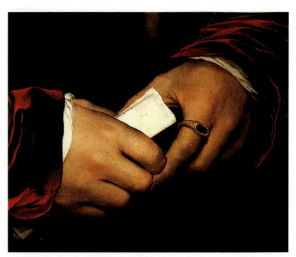

12-33 Detail of figure 12-32

in most Protestant churches today is a result of this darker side of the Reformation.

While most of Holbein's religious paintings were being destroyed, he looked for a safe haven where he could continue his career. He sailed to England and was given refuge by Sir Thomas More, a world famous writer, scholar, and political leader. His *Portrait of Sir Thomas More* (12-32) was painted soon after Holbein's arrival when More was Speaker to the House of Commons. With meticulous detail, it shows an intelligent, dignified, and successful man wearing the symbol of his high office. The picture provides sensual pleasures as well. Holbein masterfully reproduces a variety of textures—More's soft hands, the stubble of his beard, red velvet, black satin, gleaming gold, and fur (12-35). Underlying all Holbein's work is his marvelous drawing ability. We believe every detail without question; we are convinced this is how Sir Thomas More looked.

When the Reformation came to England, even powerful friends like More could not prevent the end of Holbein's career as a painter of religious art. But More helped Holbein become Henry VIII's court portraitist (see his portrait of the king in Chapter 1). He was a prolific painter, so even though he died of the plague at the age of forty-six, we have an almost firsthand acquaintance with the many members of the Tudor court.

If we compare Holbein's portrait of Sir Thomas More to Leonardo da Vinci's *Mona Lisa* (1-1, painted less than twenty-five years earlier), we can see some of the characteristic differences between northern and Italian

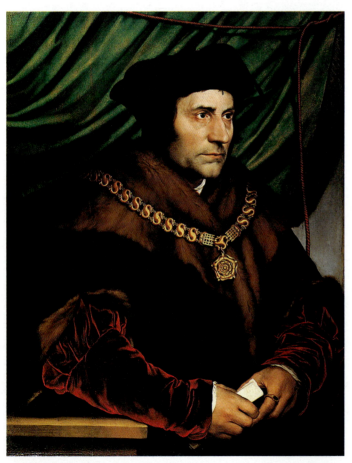

12-32 Hans Holbein the Younger, *Portrait of Sir Thomas More*, 1527. Panel, 29½" x 23 ¾". Copyright The Frick Collection, New York.

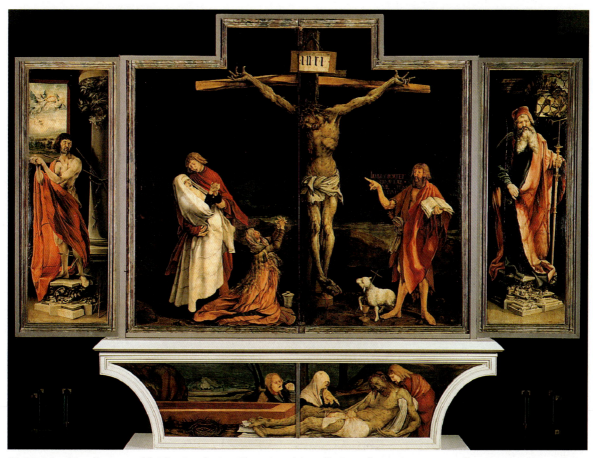

12-34 Matthias Grünewald, *The Isenheim Altarpiece* (closed), Crucifixion (center panel), *c.* 1510–1515. Oil on wood, center panel 9′9½″ x 10′9″, each wing 8′2½″ x 3′½″, predella 2′5½″ x 11′2″. Musée d'Unterlinden, Colmar, France.

Renaissance painting. Northern artists accentuated detail and crispness of edges, while in the south, a soft diffuse light—sfumato— eliminated definite edges. Interest in delineating fabrics, textures, and patterns precisely was the common feature in northern Renaissance art.

NORTHERN RENAISSANCE: THE DARKER SIDE

There are other differences between the two European Renaissances. Nobility of gesture, perfect proportion, and harmony were far from the goals of Matthias Grünewald, for example. His *The Isenheim Altarpiece* (12-34) would have horrified an artist like Raphael. Because it was designed for a hospital, the suffering patients could identify and pray to a crucified Christ who seemed to express all possible human torments in his sickly-colored flesh and broken body. No matter what physical tortures

they may have felt, this cruel masterpiece seems to say that Christ had already suffered the same. His body hangs heavily on the cross and his feet twist painfully; his expressive hands reach up in anguish. Grünewald portrays a massive crown of thorns upon his head and dried blood running down his sore-covered body.

Yet the crucifixion scene is only part of the altarpiece, which was made to unfold and open to reveal a series of images. Inside the picture of suffering and death is one of rebirth and resurrection (12-35). Here, Christ's body— now glowing white rather than sickly green— rises dramatically out of the grave. He holds out his hands with their **stigmata** (bloody signs of the nails that held Christ to the cross) as if proving that he is unhurt by his ordeal. These wounds are no longer sources of pain but now sources of light. All the torture of the first scene has been replaced with triumph. Christ's face glows like a rising sun. Here, in

Grünewald's *Isenheim Altarpiece,* you have the essence of the Christian doctrine of God's suffering and rebirth, the victory of good over evil. For the hospital's patients, it was meant to replace fear of illness and death with a vision that inspired faith and hope.

During this period, there lived another northern artist whose pictures are among the most fantastic, weird, bizarre, and visionary of any age—Heironymus Bosch. We know little of his life, except it was quite unlike the experiences of the educated city dwellers Dürer and Holbein. His was the world of northern villages before the Reformation, where alchemy was an accepted practice, superstitions were unquestioned, and the Roman Church had its hands full trying to control the widespread use of magic. Preachers used pornographic images to make their points, and prostitutes could be seen at work in the churches.

Bosch cared little for the new ideals of Renaissance painting. He was interested in creating visions that taught moral lessons and used the achievements of the Renaissance only to help make his visions look more real. Most of Bosch's pictures are very symbolic and difficult to decipher. *The Garden of Earthly Delights* (12-36) is probably his greatest painting and certainly his most famous, but scholars are still trying to understand it. The left

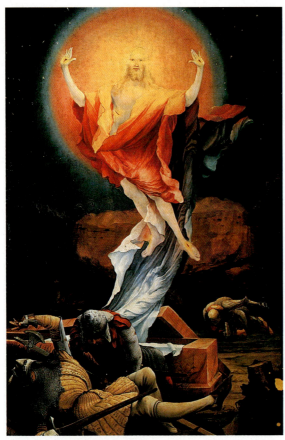

12-35 Matthias Grünewald, *Resurrection,* detail of the inner right panel of the first opening of *The Isenheim Altarpiece.* Approximately 8′8⅜″ x 4′6¾″.

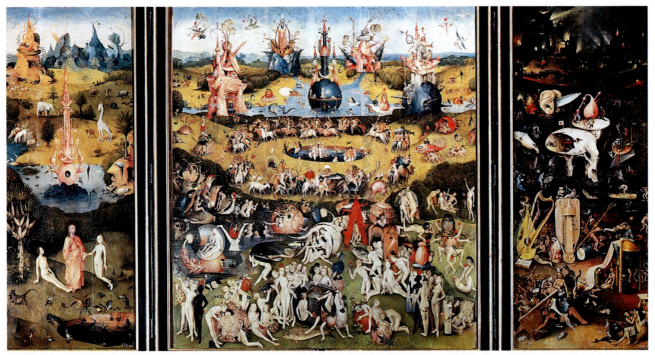

12-36 Hieronymus Bosch, triptych of *The Garden of Earthly Delights, Creation of Eve* (left wing), *The Garden of Earthly Delights* (center panel), *Hell* (right wing), 1505–1510. Oil on wood, center panel 86⅝″ x 76¾″. Museo de Prado, Madrid.

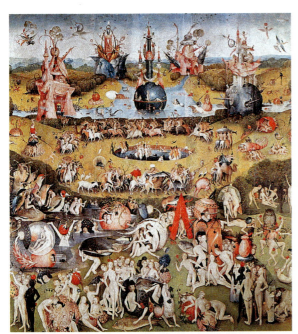

12-37 Central panel of figure 12-36, *The Garden of Earthly Delights*

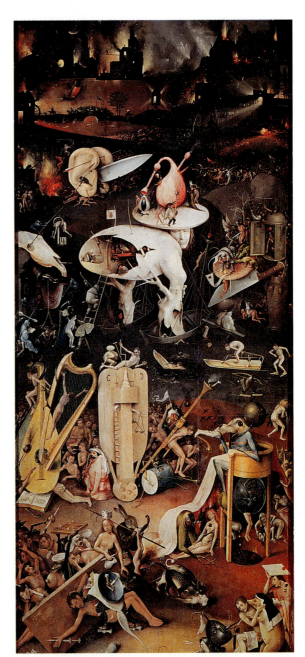

12-38 Right panel of figure 12-36, *Hell*

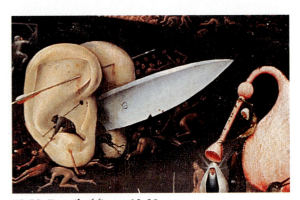

12-39 Detail of figure 12-38

panel shows Christ introducing Adam and Eve in the garden of Eden before the Fall. The central panel (12-37) gives the triptych its name, showing the world after the Fall and symbolizing Bosch's era. The setting seems to be a park where nude men and women are indulging in pleasure, enjoying free and open sexuality. But Bosch is not celebrating this scene. What he wants to show is a false paradise. Bizarre acts are rampant, as revelers engage in acts restricted only by the limits of Bosch's fertile imagination.

After an orgy of false pleasures comes the right panel—*Hell* (12-38), a nightmare from which sinners can never wake. There is torture of all the senses and emotions. Buildings explode into flame in the background. In the foreground, a rabbit carries a victim on a pole, and blood spurts out of the victim's belly. A proud lady is forced to admire her reflection on the backside of a demon. Victims are crucified on a harp or stuck to a lute. A man tries to balance on a giant skate and heads straight for a hole in the ice. A pair of ears with a giant knife proceeds like a tank, slicing up the damned (12-39). The dreamlike reality of the scene is most apparent in the Treeman, who has sinners in his hollow chest and arms rooted in the foundation of Hell. Is he Hell's monarch or another victim?

Surprisingly, the *Garden of Earthly Delights* was an altarpiece for a church. It was a kind of "Last Judgment" in an age when the Apocalypse was thought to be near. Bosch showed the results of humanity lost to sin and warned that if people continued to live as they did, no one would be saved. Yet one can see little hope for humanity; lost in temporary pleasures, the people in the *Garden of Earthly Delights* give no thought to consequences or repentance. Michelangelo had a similar pessimistic vision thirty years later in his *Last Judgment* (12-25).

GENRE: SCENES FROM ORDINARY LIFE

While Pieter Bruegel began his career with Bosch-inspired work, he eventually developed his own unique subject matter. The paintings for which Bruegel is best known are scenes of country life. His *Landscape with the Fall of Icarus* (12-40) is an unusual retelling of the ancient Greek myth in a sixteenth-century Flemish setting. Icarus was the son of Daedalus, a clever artisan imprisoned by King Minos of Crete in a fabulous labyrinth (or maze) Daedalus himself had designed. To escape, the father fashioned wings of wax and feathers for his son and himself. He warned his son not to fly too close to the sun, but Icarus ignored him. When his wax wings melted, Icarus fell into the sea and was killed. Usually understood as a cautionary tale about youth and reckless ambition, Bruegel presents the myth quite differently. Almost all of the picture is devoted to a scene of a typical day in the fields of Netherlands alongside the sea. The central figure is busy plowing; the plow is shown actually cutting and turning the heavy earth. This is far from the classically inspired mythological paintings of the Italian Renaissance, such as Botticelli's *The Birth of Venus* (12-10) or Raphael's *The School of Athens* (12-21). Imagine how an Italian artist would have portrayed the myth—a marvelous-looking boy filling the canvas as he tumbles through glorious sun-drenched skies. But here the plunge of Icarus to his death in the sea seems almost incidental to the picture. All we see of Icarus is two tiny legs making a small splash in the water. No one seems to notice the cosmic

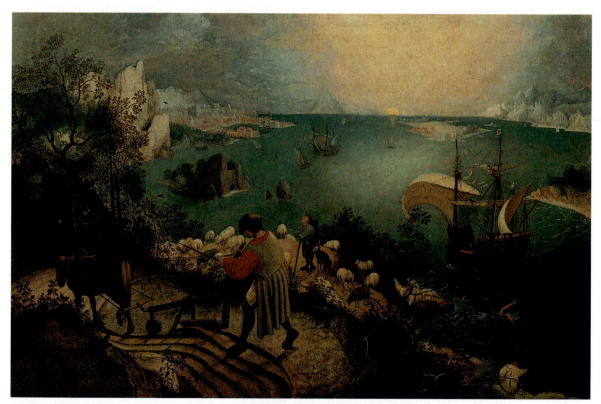

12-40 Pieter Bruegel the Elder, *Landscape with the Fall of Icarus*, c. 1554–1555. Oil transferred from wood to canvas, 29" x 44⅛". Musées royaux des Beaux-Arts de Belgique, Brussels (photo Speltdoorn).

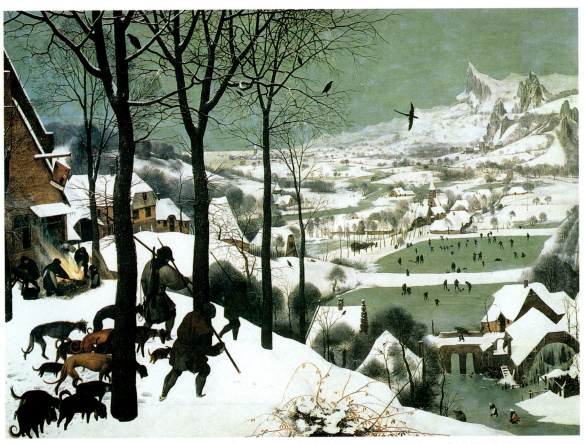

12-41 Pieter Bruegel the Elder, *Hunters in the Snow*, 1565. Oil on wood, approximately 46″ x 64″. Kunsthistorisches Museum, Vienna.

event. One man is busy looking the wrong way; the rest are just busy living their lives.

Bruegel's work is one of the first to use **genre** (ordinary and commonplace) subject matter. Bruegel is not only saying that our world is worth portraying but that it is much more significant than an ancient myth. For most people, cosmic events have less importance than their own everyday concerns.

In *Hunters in the Snow* (12-41), a variety of everyday winter activities is depicted: hunting with dogs, cooking on outdoor fires, and skating on the frozen pond. Bruegel's painting exhibits an almost perfect balance between the depiction of a subject—in this case, winter as experienced by Flemish peasants—and the formal arrangement of lines, shapes, and colors into a totally satisfying visual experience. The dark silhouettes against the pale snow of hunters, dogs, and trees create a wonderful rhythmic pattern; the icy blue and white of the landscape contrast with the glowing red fire.

The line of the trees and the birds leads the viewer's eye irresistibly past the tired hunters and down the hill to the town below. We are able to share the temperature and tones of a winter day from four centuries ago because of Bruegel's mastery. He has allowed us to connect to the lives of people long gone and reminds us that we are all in a cycle of life. We feel that our experiences, like trudging along in the snow, were experienced by past generations and will be for generations to come.

While it is very different from Leonardo's or Michelangelo's masterpieces, one still feels *Hunters in the Snow* is not too distant from the work of Giotto that began the Renaissance. More than two hundred fifty years later, as the Renaissance comes to end in Europe, Bruegel's pictures bring to a profound realization the humanistic advances of the old Italian master. It would be difficult to find finer examples of realistic space, true emotion, and above all, honestly portrayed human beings.

CHAPTER

13

DRAMA AND LIGHT: MANNERISM, THE BAROQUE, AND ROCOCO

PERIOD		HISTORICAL EVENTS	
1530–1585	End of the Renaissance Italian Mannerism Court of Benin Mughal period in India	Council of Trent begins the Counter Reformation Spanish Inquisition Vasari publishes his *Lives of the Artists*	Mercator publishes map of the world for navigators Turks declare war on Venice
1585–1650	The Baroque	Slaves from Africa brought to North America Edo (Tokyo) becomes capital of Japan Shakespeare, *Hamlet* 1600 Reign of Elizabeth I Rule of Emperor Jahangir in India Rise of the Dutch Republic	Descartes, "I think therefore I am." Buried Roman city of Pompeii discovered 1592 Galileo ordered to abandon scientific work by Catholic Church Plymouth colony founded
1650–1715	The Baroque Classicism	Reign of Louis XIV Peter the Great tours Western Europe under a false name Isaac Newton explains gravity	Parthenon damaged during Venetian attack 1687 Peace treaty between William Penn and Native Americans
1715–1790	Rococo	The American Revolution The French Revolution	Handel, *Messiah* 1741 J.S. Bach, *The Brandenburg Concertos* 1721

By the 1530s, with Raphael dead and Michelangelo returning to Florence, Rome was in the hands of a new generation of talented young men. Yet it was a difficult time for these artists. The goals of the High Renaissance, already accomplished by Raphael and Michelangelo, did not seem to leave much room for other artists to become outstanding. The young men realized they could not repeat what had already been done, and even if they did, they would find it almost impossible to compete with those great masters. Italy itself was in a period of serious economic decline. Italian society had been disrupted by repeated invasions from northern Europe. Raphael's achievement of beauty, proportion, grace, and a sense of human virtue no longer seemed appropriate to the troubled times. The young artists decided to abandon the old goals and go beyond nature.

MANNERISM

In Parmigianino's *Self-Portrait in a Convex Mirror* (13-1), the young artist is clearly fascinated with the distortions of a mirror. Still, even if the results include a bizarrely oversized hand, the picture appears to be an objective re-creation much as Leonardo might have done. But in his *Madonna dal Còllo Longo* or *Madonna of the Long Neck* (13-2) there is a great deal that would have shocked Leonardo. The space is nothing like the realistic and accurate space created by Renaissance artists. Many of the figures are distorted, and true proportion is seemingly abandoned at whim (notice the tiny prophet at the bottom right). An unfinished column supports nothing. Even more disturbing is the image of the Virgin Mary, an aristocratic figure who holds the infant Jesus at a cool distance. Warmth and

ART

Parmigianino, *Madonna dal Còllo Longo* c. 1535

Michelangelo, *The Last Judgment* 1534–1541

Bologna, *Rape of the Sabine Women* 1583

Plaque showing king mounted with attendants, Benin 16th century

El Greco, *Purification of the Temple* post-1600
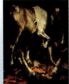

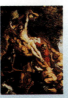
Caravaggio, *The Conversion of Saint Paul* c. 1601

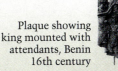
Rubens, *The Elevation of the Cross* 1610

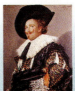
Bernini, *David* 1623

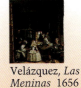
Hals, *The Laughing Cavalier* 1624

Poussin, *Et In Arcadia Ego* c. 1655
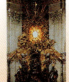

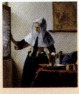
Bernini, *Throne of Saint Peter* 1656–1666

Vermeer, *Young Woman with a Water Jug* c. 1665
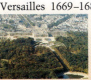

The Palace of Versailles 1669–1685
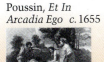

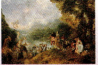
Velázquez, *Las Meninas* 1656

Fragonard, *The Swing* 1766

Vigée-Lebrun, *The Artist and Her Daughter* c. 1785

Watteau, *Return from Cythera* 1717–1719

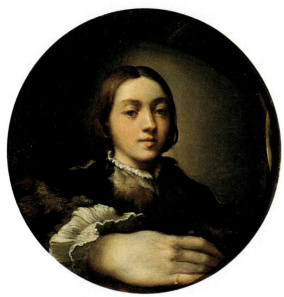

13-1 Parmigianino, *Self-Portrait in a Convex Mirror*, *c.* 1523. Oil (?) on wood sphere, 15⅜″ diameter.

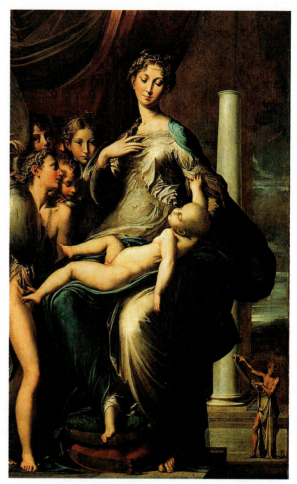

13-2 Parmigianino, *Madonna dal Còllo Longo*, *c.* 1535. Oil on wood, approximately 7′1″ x 4′4″. Galleria degli Uffizi, Florence.

love, traditional to this theme, are noticeably absent. The smooth-skinned angels seem like servants. The Christ child seems cadaverous and deformed.

Commissioned for a church in Bologna, but never actually presented to his patrons, Parmigianino's strange 7-foot-tall painting is characteristic of a new style—called **Mannerism**. Instead of picturing inner and outer realism, Mannerist artists produced demonstrations of their inventiveness and refinement. Their highest aim, which Parmigianino exemplified, was elegance. In Mannerist works, such as Bologna's *Rape of the Sabine Women* (7-4, 7-5, 7-6), the subject is rarely important and functions only as an excuse for a painting or sculpture. Emotions are ignored for the sake of elegance and what was called "style." The perfect balance of High Renaissance painting was exchanged for unique, strange compositions, a kind of artful choreography.

One artist of the time wrote:

> in all your works you should introduce at least one figure that is all distorted, ambiguous and difficult, so that you shall thereby be noticed as outstanding by those who understand the finer points of art.

The Mannerists believed the body was most elegant when posed so the limbs and torso resembled the letter *S*. They called this pose the **serpentinata**, or the twisting of a live snake in motion. In Bologna's *Rape of the Sabine Women*, we see him using the *S* as a design principle over and over again. Many of the distortions in the *Madonna dal Còllo Longo* are due to the characters being forced to conform to *S*-like shapes.

Federico Zuccaro's portal of the *Palazetto Zuccari* in Rome (2-34) is an example of the Mannerist spirit in architecture. The wild conception of an entrance as a giant mouth leading into a long gullet of a hallway was the kind of idea that intellectuals of the time would call "the modern way."

THE COUNTER-REFORMATION AND TINTORETTO

Mannerism disappeared at the start of the **Counter-Reformation**, the Roman Catholic

Church's attempt to combat the Protestant Reformation that had swept through much of Europe during the early sixteenth century. In 1545, Pope Paul III convened the *Council of Trent* to recommend changes in church policy and new initiatives. Abuses of the past were eliminated, such as the sales of indulgences. Because the arts were considered one of the most important arenas for fighting against Protestantism, the Catholic Church encouraged a new vitality in Christian art and decoration. It proclaimed the need for art that would entertain and electrify the faithful.

Pictures like the *Madonna dal Còllo Longo*, not surprisingly, were considered offensive and decadent by religious leaders concerned with the revival of Catholic values. While short-lived, still, Mannerism served as an important link between the Renaissance and the next great period of art—the **Baroque**. The Venetian artist Jacopo Robusti, known as *Tintoretto*, also bridges this gap and reflects the dynamic spirit of the Counter-Reformation. Elegance and beauty were not enough for this painter—he wanted his pictures to be exciting, to make the biblical stories live. His goal was to combine Titian's rich color with the vigorous drawing and design of Michelangelo.

His pictures are dramatic. His *The Last Supper* (13-3) is not a typical mannerist composition, such as *Madonna dal Còllo Longo*, with effete, elongated figures arranged in limp poses, but full of energy, opposing motions, and swirling lines. Tintoretto was known as "il furioso" for his speed as a painter; this nickname is appropriate to the spirit of his works, too. If we compare Tintoretto's *Last Supper* to Leonardo's (12-16), we will see clearly the difference between an early Baroque and a Renaissance interpretation of the same subject. Leonardo's fresco, painted almost one hundred years earlier, is harmonious and balanced. The light is natural. The geometry of the room is stressed, and the composition arranged so Christ is at its perfect center. The table on which the story of the last supper is being acted out is a simple horizontal band; the focus of the picture is on the poses of the characters, which seem frozen in time. Leonardo chose to illustrate the human side of the story, the moment when Christ predicts his betrayal by one of his apostles.

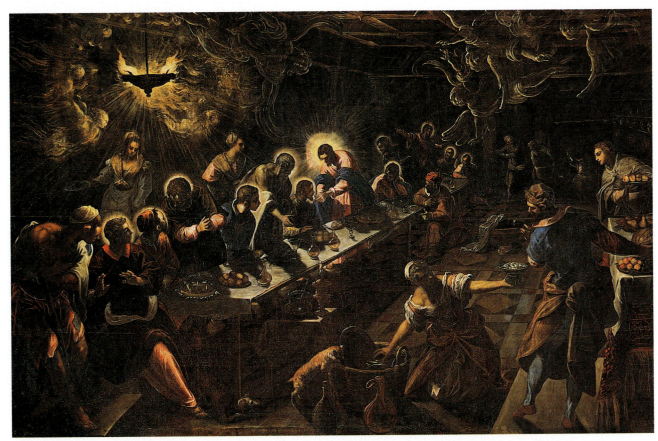

13-3 Tintoretto, *The Last Supper*, 1594. Oil on canvas, 12' x 18'8". Chancel, San Giorgio Maggiore, Venice.

Tintoretto's version is totally different. The first visual element we notice is the energetic diagonal of the table, plunging back into space. Christ is not a static, stationary figure, nor is he the clear center of the composition. He stands about halfway down the table, handing out bread. We can distinguish him because his halo bursts forth from his head like a sun (Leonardo's Christ has no painted halo). The heads of disciples also glow against the rich, smoky darkness of the room. The only natural, rather than supernatural, light source is a hanging lamp that emits twisted tongues of flame and coils of smoke. This smoke is transformed into angels, outlined only in white paint, as if drawn on a chalkboard. In the foreground of the picture, Tintoretto has added everyday events, like the servants clearing away food and a cat looking into a basket. This normal scene makes the rest of the picture seem even more miraculous by contrast.

In his painting, Tintoretto has chosen to focus not on the human drama of the betrayal of Judas but on the supernatural meaning of the Last Supper (13-4). As he passed out the bread at his last meal with the disciples, Jesus said: "This is my body which is given for you;

do this in remembrance of me." This theme was particularly important at the time of the Reformation, because the Protestants claimed that during the Mass (communion service), bread and wine only symbolized Christ's body and blood and were not miraculously changed into his actual body and blood, as the Catholic Church taught.

We can see in the work of Tintoretto many of the attributes that were new to the Baroque movement: its dramatic use of light and dark, its preference for dynamic movement and theatrical effects, and the inclusion of elements of ordinary life in religious scenes.

THE BAROQUE PERIOD

The period of the Baroque (generally thought to cover the years 1575–1750) was one of great confusion. Everything from the place of the earth in the universe to the place of the individual in society was being reconsidered. People questioned authority in religion, in government, in science, and in thought. One of the great thinkers of the time was the Frenchman René Descartes, who began his philosophical inquiry by doubting the existence of anything, including himself. The scientist Galileo used a telescope to study the heavens and declared in 1632 that the earth was not the center of the universe. The Catholic Church was so upset by his discoveries, which appeared to contradict the wisdom of the ages and the Bible itself, that he was forced to renounce them on pain of possible torture and death. England, a Protestant country, was more open to scientific discoveries. There, Sir Isaac Newton began a new era in science when he published his *Principia* in 1687, which announced, among other important physical laws, his discovery of the laws of gravity.

The great age of exploration and discovery was coming to a close, but an exciting period of colonization and world trade followed. Borders were changing. Great conflicts were taking place in Europe: bloody wars, rebellions, intense religious disputes, and persecutions.

EL GRECO

When Domenikos Theotokopoulos, known as El Greco, arrived in Spain around 1576, the Spanish Empire was at its very height as a great

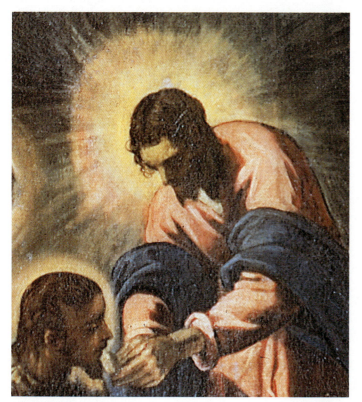

13-4 Detail of figure 13-3

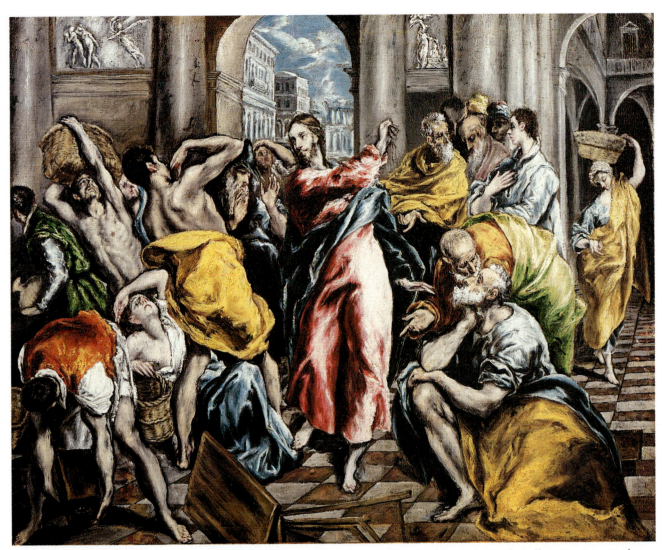

13-5 El Greco, *Purification of the Temple*, after 1600. Panel, 16½″ x 20⅞″. Copyright The Frick Collection, New York.

military and colonial power, but its art was backward and provincial. There had been no great Spanish artists during the Renaissance. Born on the Greek island of Crete, he was as a young apprentice trained to make icons, or religious images, in the centuries-old Byzantine style. At the age of twenty, Domenikos Theotokopoulos went to Venice, where he absorbed the lessons of the great Venetian masters Titian and Tintoretto: their light, color, and energy. He then visited Rome and fell under the influence of Mannerism—especially its elongated, distorted figures. Like Tintoretto, El Greco is sometimes categorized as a Mannerist and, like Parmigianino, he had certainly learned to use the tool of distortion. But his work is not cool and refined; it is intensely emotional and wholeheartedly committed to the goals of the Counter-Reformation.

The *Purification of the Temple* (13-5) is a good example of his mature style. Christ comes thundering in to purify the temple in Jerusalem. The figures on either side pull away and are distorted, as if by the shock waves of Christ's anger. On the left are the lower-class peddlers who react physically to Christ, cringing and trying to protect themselves. Their limbs are arranged in sharp angles; they take strange and twisted poses. On the right are the Jewish elders who react mentally rather than physically—intensely discussing Jesus' actions. The entire picture stresses dynamic diagonal lines rather than the calmer verticals and horizontals favored by Renaissance artists.

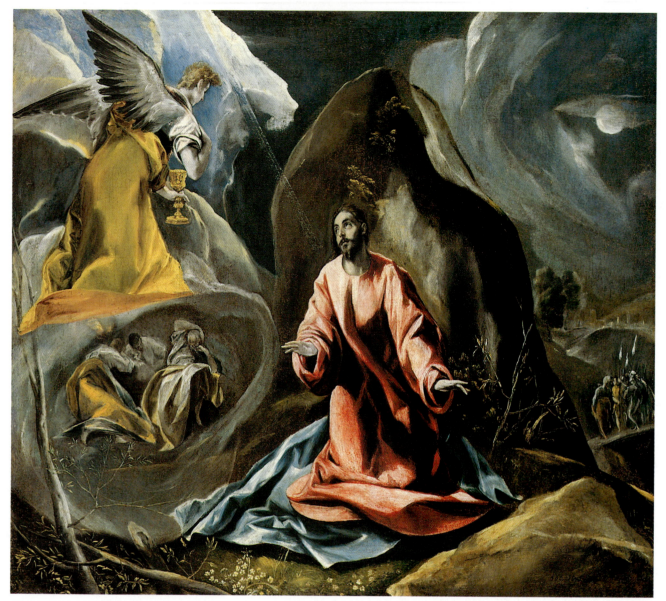

13-6 El Greco, *The Agony in the Garden, c.* 1590–1595. Oil on canvas, 40¼" x 44¾". The Toledo Museum of Art, Toledo, Ohio (purchased with funds from the Libbey Endowment, gift of Edward Drummond Libbey).

Even the folds of the costume's drapery are angular and sharp. El Greco's brushstrokes are bolder than those of his contemporaries, giving his paintings a rough, active surface rather than smooth and calm.

In some of El Greco's paintings, reality is almost completely ignored in favor of a spiritual world. These visions appear modern to our eyes, and, in fact, El Greco became more famous and popular in the twentieth century than he was in any of the intervening centuries since his own time. In *The Agony in the Garden* (13-6), deep religious feeling seems to heave up the very ground on which Christ kneels. The figures are wrapped in strange, swirling cocoons—rocks, clouds, drapery all resemble each other, framing and isolating Christ, the angel, and the sleeping disciples. El Greco gave up the truth of the eyes for an inner truth. The Renaissance is now far behind us.

CARAVAGGIO AND NATURALISM

As Mannerism declined in Rome, a new artist emerged who would be a brilliant innovator. This painter had grown up in northern Italy,

where painting traditions were less influenced by the Renaissance desire for perfection and harmony, and a style of greater realism prevailed. Michelangelo de Merisi, called *Caravaggio* after the small town where he grew up, would become the greatest Italian painter of the seventeenth century and one of the most influential of the entire Baroque period.

He was orphaned at the age of eleven and came to Rome when he was seventeen. This exceptionally talented artist was also an outsider and considered a violent, unpredictable rebel. In *The Supper at Emmaus* (13-7), Christ and his attendants are depicted as real working-class people, with torn clothing and worn faces. The New Testament story takes place after Christ's resurrection, but before his followers realize that he has truly risen from the dead. Two of the disciples were on the road

to Emmaus, a small town outside Jerusalem, and were joined by a stranger whom they did not recognize because "their eyes were kept from recognizing him." Stopping in the village, they urged their fellow traveler to stay with them overnight. As they sat down to eat, Christ "took bread, and blessed it, and broke it, and gave it to them" in a re-enactment of the Last Supper. At this point "their eyes were opened, and they knew him." It is this very moment of illumination that Caravaggio chose to illustrate.

The architecture of the room, so important in Renaissance paintings, has been eliminated here in favor of the flat backdrop of a wall. The viewer is quite close to the figures, who make dramatic gestures that almost seem to reach out of the picture into real space. For instance, the man on the left, whom we see from the rear (a favorite visual device of

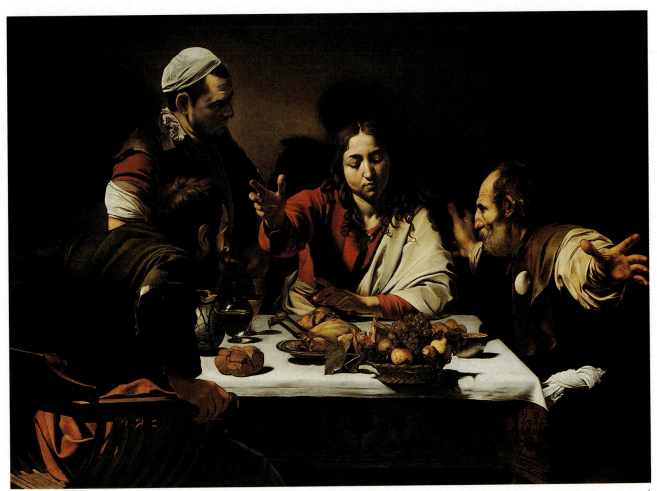

13-7 Caravaggio, *The Supper at Emmaus, c.* 1598. Oil on canvas, 55½″ x 77¼″. Reproduced by courtesy of the Trustees of the National Gallery, London.

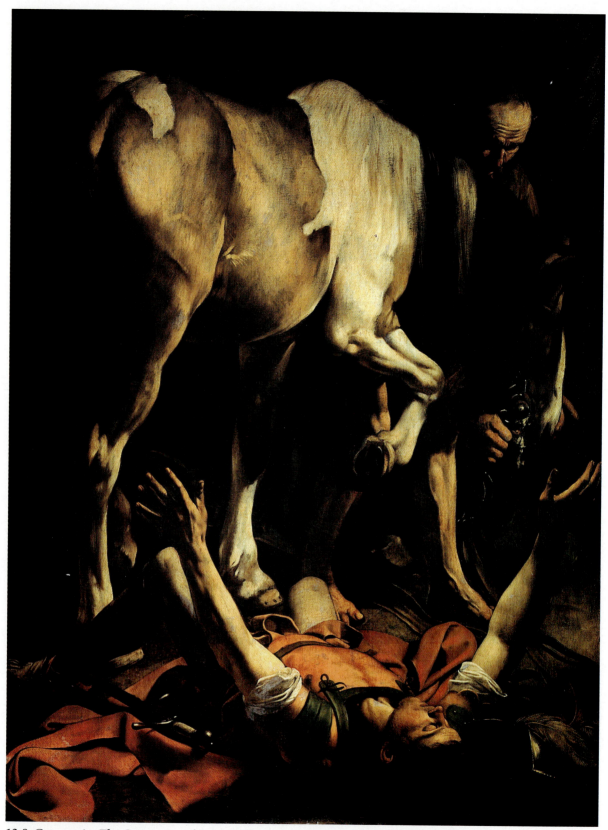

13-8 Caravaggio, *The Conversion of Saint Paul, c.* 1601. Oil on canvas, approximately 7′6″ x 5′9″. Cerasi Chapel, Santa Maria del Popolo, Rome.

Carravagio's, allowing us the illusion of peeking into a real scene) is about to push his chair backwards, and his elbows jut towards us as if about to break through the canvas. On the right, an elderly apostle thrusts out his hand in a dramatic gesture, like an actor on the stage. But the most theatrical effects are provided by the stark lighting—illuminating the face of Jesus, accentuating the wrinkles of the careworn faces, focusing our attention on the most important gestures, and casting dark shadows on the wall behind Christ's head in a "reverse" halo.

Consider how different this painting is from the work that preceded it, even the work of Tintoretto and El Greco. Here, although a miraculous event is taking place, there are no supernatural halos or angels, no distortions, just ordinary people painstakingly observed. Caravaggio shares with Titian and El Greco, however, his taste for dramatic and theatrical effects, a taste that is typically Baroque. In *The Conversion of Saint Paul* (13-8), he topples the figure of the saint directly toward the viewer, his head almost touching the bottom edge of the canvas. The dramatic action of the scene seems to be frozen by a flash of light—the horse's hoof is shown in midair.

Saul was a Roman citizen who delighted in persecuting the early Christians. On the road to Damascus, a city in Syria where he was headed to continue his persecutions, he experienced a vision. In his own words: "Suddenly there shown from heaven a great light all about me, and I fell to the ground." Then Saul heard the voice of Jesus asking, "Why do you persecute me?!" and directing him to go to Damascus. Blinded by his experience, Saul had to be led into the city, where he met a devout Christian and was converted and baptized. He took the name of Paul and became the greatest leader, writer, and theologian of the early Christian Church.

Here we see a mystical moment portrayed with high realism. Saul has just hit the hard ground and lies as if in a trance, listening to the voice of Jesus. The New Testament account states that although they saw the light, the men who accompanied Saul could not hear this miraculous voice. True to the story, Caravaggio pictures a horse and servant drawing back in surprise, unsure of what is going on (detail, 13-9). Miraculous light is a perfect subject

13-9 Detail of figure 13-8

for Carravagio, who, as we saw in *The Supper at Emmaus* and in *The Incredulity of Saint Thomas* (2-11), had been using the power of light symbolically in his paintings to indicate supernatural happenings. Caravaggio's use of **chiaroscuro**, the dramatic contrast of light and dark, would influence many artists and would be copied throughout Europe.

Caravaggio was condemned by the art critics of his time as a "naturalist," while his religious paintings were condemned by the clergy. Some said that his way of painting meant the end of painting. They felt that his use of working class people to portray the apostles and Christ himself was offensive, even sacrilegious, despite the fact that Christ and his followers had actually been poor, simple men and women. The controversy over Caravaggio's pictures reflects a difference of opinion about what the correct style for Counter-Reformation painting should be. While some admired his revolutionary honesty and directness, other critics felt that Caravaggio's work did not serve to promote the Catholic faith. The most powerful members

of the Roman establishment—the papal court, for example—preferred artists who simply glorified the church and its saints.

Caravaggio lived only thirty-nine years (he died of malaria after being exiled from Rome by the pope), but he left behind a great body of work that influenced artists during the entire Baroque period. His revolutionary naturalism and dramatic use of chiaroscuro light would prove to be one of the strongest legacies in the history of art. Among the many great artists who learned from his work were Velázquez in Spain, Rubens in Flanders, and Rembrandt in Holland—but first we will discuss his direct influence on another Italian painter, Artemisia Gentileschi, who also suffered from the prejudices of Roman society, though for different reasons.

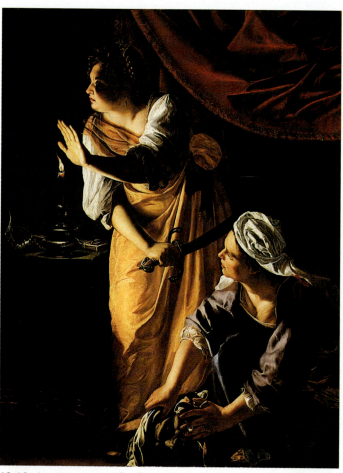

13-10 Artemisia Gentileschi, *Judith and Maidservant with the Head of Holofernes, c.* 1625. Oil on canvas, approximately 6' x 4'8". Detroit Institute of the Arts (gift of Leslie H. Green).

ARTEMISIA GENTILESCHI: THE SPREAD OF "TENEBROSO"

Most women artists of the Baroque period were the daughters of painters; for example, Tintoretto had a favorite daughter who acted as an assistant on many of his huge canvases. Artemisia Gentileschi's father, Orazio, was a talented follower of Caravaggio and taught her many of his techniques. Most of Gentileschi's pictures show women as biblical or mythological heroines. One reason Gentileschi specialized in the female figure was that she was easily able to find models and to study female anatomy in great detail. It would have been considered improper for her to study the nude male figure; this limitation hampered female artists until the twentieth century.

The Old Testament story of Judith and Holofernes was one that Gentileschi painted most often. To save her town from the attacking general Holofernes, Judith dressed up in her most beautiful garments, then with her maid crept behind enemy lines. They were soon captured and taken to the tent of the general. He was attracted to Judith and invited her to dine. She drank with him until he was unconscious, and when he passed out, she took his sword and, with the help of her maid, chopped his head off. Judith and the maid then escaped and the next morning displayed the head of Holofernes on the city walls, sending his invading army into panic and retreat.

Some critics speculate that Gentileschi's attraction to this theme of feminine revenge was the result of an unfortunate experience in early life. When she was a young woman, her father arranged for her to be tutored in perspective by another painter named Tassi, who raped her several times, then promised to marry her. Her father took this man to court, not only for raping his daughter, but also for stealing some of his pictures (Tassi had already been convicted of arranging the murder of his wife). During the trial, Artemesia was tortured on the witness stand with thumb screws—a primitive type of lie detector. To add to her humiliation, the rapist was jailed only a few months, then eventually acquitted. After the trial, Gentileschi married a man from Florence and left Rome for the next ten

years. Strangely, because of this episode in her life, throughout history she has had the reputation of a wanton woman.

Many critics dismiss the importance of her early traumatic experience and point out that the subject of Judith and Holofernes was a common one of the period for male and female painters. No one can deny, however, that Gentileschi brought an unusual passion and realism to her versions of the theme (she painted at least six). In an earlier version, Gentileschi chose the gruesome moment of the actual decapitation. In the later picture, considered her masterpiece, *Judith and Maidservant with the Head of Holofernes* (13-10), the artist chose instead to imagine the time after the general has been murdered, when Judith and her maid are waiting to escape from the enemy stronghold. It is a huge work, more than 6 feet tall, so the figures are more than life-size. Gentileschi has used a single light source—a candle flame—then interrupted it with Judith's raised hand, so it throws weird shadows on her figure. The mood is suspenseful. We glimpse the figures as they pause in the midst of their secret crime, perhaps hearing a sound and fearing discovery. Judith covers the candlelight calmly, holding her sword in readiness, while the maid tries to cover the head.

This is a painting in the **tenebroso,** or dark manner. The followers of Caravaggio who specialized in such night scenes were known at the time as "Caravaggisti." Gentileschi was not only one of the "Caravaggisti" but also spread the style throughout Italy as she moved from Rome to Florence, back to Rome, and on to Naples, visiting Genoa and Venice as well. Through the influence of Caravaggio and his followers, the Baroque style became truly an international art movement.

BERNINI

In contrast to the unfortunate Caravaggio, Gianlorenzo Bernini was a highly successful and internationally famous architect and sculptor. Only Michelangelo was ever held in as high esteem by popes, the powerful, wealthy art patrons, and other artists. Like Michelangelo, Bernini was a brilliant sculptor in marble, but he was also a painter, architect, and poet. Unlike Michelangelo, Bernini was

known for his great charm and wit; he was fond of people and a good husband and father.

Bernini was only twenty-five or so when he sculpted *David* (13-11), one of his masterpieces. Just as the contrast between Tintoretto's *Last Supper* and Leonardo's illustrated the differences between Renaissance and Baroque painting, one can see the changes in sculpture by comparing Bernini's *David* with Michelangelo's (12-18). Both were tours de force, carved when the artists were in their twenties. Unlike Bernini, Michelangelo strived

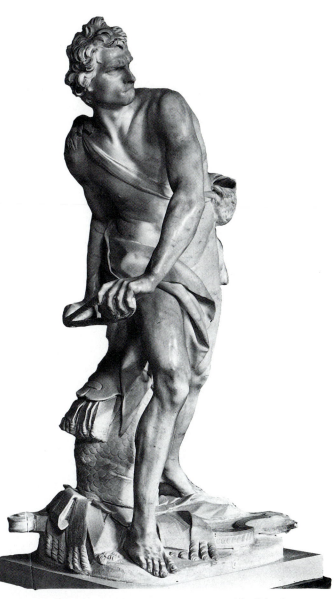

13-11 Gianlorenzo Bernini, *David*, 1623. Marble, life-size. Galleria Borghese, Rome.

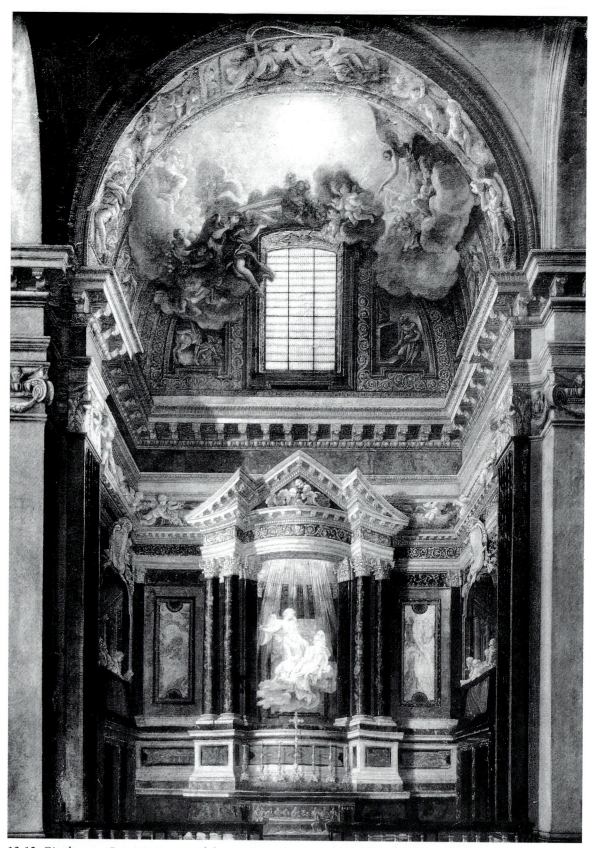

13-12 Gianlorenzo Bernini, interior of the Cornaro Chapel, 1645–1652, Santa Maria della Vittoria, Rome. Eighteenth-century painting, Staatliches Museum, Schwerin, Germany.

for harmony and the ideal beauty of a perfect young man. His enormous statue (more than 14 feet tall) is in elegant proportion; the figure stands motionless, self-contained. But Bernini's *David* is captured at a specific moment—the split second before he flings his slingshot at the giant Goliath. There is great dynamic energy in this figure, the first version of David to show the subject in motion. He is a mature man who contorts his less-than-ideal features in a grimace of concentration as he puts total effort into his coming shot. The statue's gaze is so intense that the unseen Goliath becomes part of the sculpture. In this way Bernini breaks down the barrier between art and the real world. Realistic details also make the biblical event convincing. As in his *Apollo and Daphne* (7-17), Bernini skillfully creates a variety of textures in stone (flesh, drapery, leaves, and hair), as well as incredibly minute work like the taut rope of the sling. The differences between the two Davids are reminiscent of the contrast between calm and balanced Classical sculpture, such as the *Doryphoros* (10-20), and the writhing motion typical of later Hellenistic sculpture like the *Laocoön* (10-24).

The type of work for which Bernini became most famous was not the sculpting of individual statues, however powerful, but the creation of total artistic "environments." *The Ecstasy of Saint Theresa* (13-12, 13-13), which combines sculpture with architecture and painting, was designed for a chapel in the small Roman church of Santa Maria della Vittoria. The materials include white marble, colored marble, gilded bronze, stucco, fresco, and stained glass. Here, the effect of the whole is far greater than the sum of the parts. The ceiling of the chapel is decorated with a fresco of angels frolicking on billowing clouds. To the sides, statues of the Cornaro family members observe the scene from boxes, as if at the opera. At center stage is Bernini's marble statue of Saint Theresa in ecstasy.

Saint Theresa of Avila was a sixteenth-century Spanish nun and mystic who lived about the time that El Greco was painting in Spain. Through her widely circulated writings she became an important saint of the Counter-Reformation. Many of these writings describe her personal, mystic visions. For this chapel, Bernini illustrated a spectacular vision of a visit from an angel. She wrote:

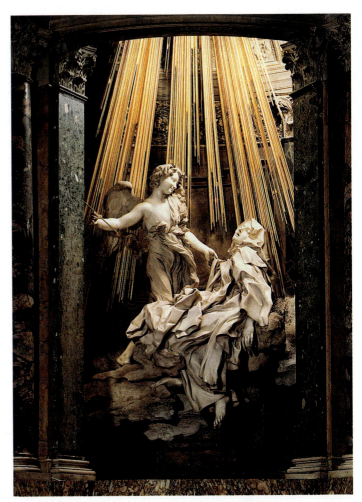

13-13 Gianlorenzo Bernini, *The Ecstacy of Saint Theresa*, 1645–1652. Marble, group 11′6″ high. Cornaro Chapel, Santa Maria della Vittoria, Rome.

In his hands I saw a great golden spear and at the iron tip there appeared to be a point of fire. This he plunged into my heart . . . again and again and left me utterly consumed by the great love of God. The pain was so acute that I groaned aloud several times; yet the pain was so sweet that no one would wish to have it go away.

Bernini mixes realism and illusion here just as he mixes media. He shows Saint Theresa's spiritual passion as physical: Her head lolls to one side in rapture, her body falls back limp, her bare foot escapes from beneath her voluminous habit. Even her clothing writhes in excitement. The intensity of this realism rivets our attention. But Bernini is also a great master of light and illusion. By flooding his statue in a stream of

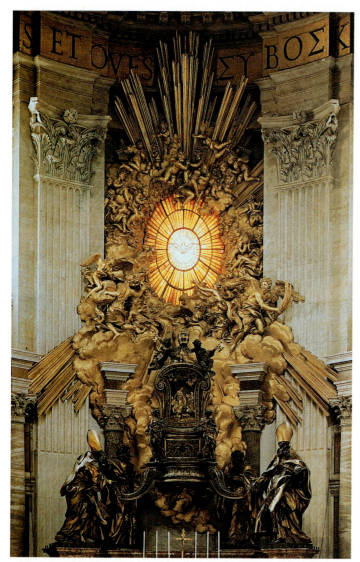

13-14 Gianlorenzo Bernini, *Throne of Saint Peter*, 1656–1666. Gilded bronze, marble, stucco, and stained glass. Saint Peter's, Rome.

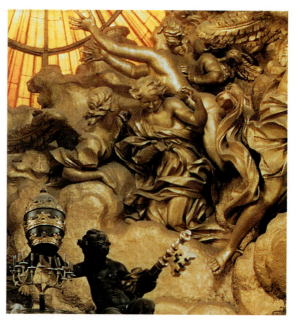

13-15 Detail of figure 13-14

For example, the *Throne of Saint Peter* (13-14, 13-15) brings a heavenly host of angels and cherubs down into the church. Constructed of gilded bronze, marble, stucco, and stained glass, it is the visual climax of Saint Peter's. The throne is a reliquary, enshrining what was supposed to be the actual throne of Peter. As in Bernini's vision of Saint Theresa, light streams onto the sculpture through a stained glass window, which shows the dove of the Holy Ghost. Saint Augustine and Saint Ambrose, the two fathers of the Catholic Church, support the front of the throne, while two fathers of the Greek Orthodox Church are relegated to the back. Because of the immense scale of Saint Peter's, Bernini's colossal work actually manages to make Saint Peter's more human.

The theatricality and energy of Bernini and his dramatic use of light and space are attributes we have seen in the paintings of El Greco, Tintoretto, and Caravaggio. There was a love of illusion, gorgeous materials, and exuberant effects in the Baroque period. Artists of the Baroque era used architecture, sculpture, and painting together to give reality to the visions they were trying to create. Through these works they allowed the faithful to see heaven, not just imagine it, and actually attempted to bring heaven down to earth.

"heavenly" light from above (through a hidden window of yellow stained glass), he sets the statue of saint and angel off in a special space—a miraculous, visionary dream world.

Bernini's greatest impact was on Saint Peter's Basilica, seat of the popes. As we learned in Chapter 8, Bernini designed the enormous courtyard or **piazza** (8-40) in front of the basilica that set Saint Peter's off from the surrounding confusion and created a courtyard that is calm, orderly, and logical.

While Bernini's design altered the effect of the Saint Peter's exterior considerably, his influence inside Saint Peter's was even greater.

BAROQUE NATURALISM IN SPAIN: VELÁZQUEZ

The greatest master of Spanish painting and one of the greatest painters of the Baroque was Diego Velázquez. Inspired by the simple, realistic paintings of Caravaggio, his approach to art would fly in the face of the flamboyant trends popular in his day and go even further in the direction of "naturalism." Surprisingly, when he was twenty-four, the honest realist was appointed the court painter to the king. More surprisingly, Velázquez succeeded in his new role without changing his approach. Even though he never flattered the royal family, he

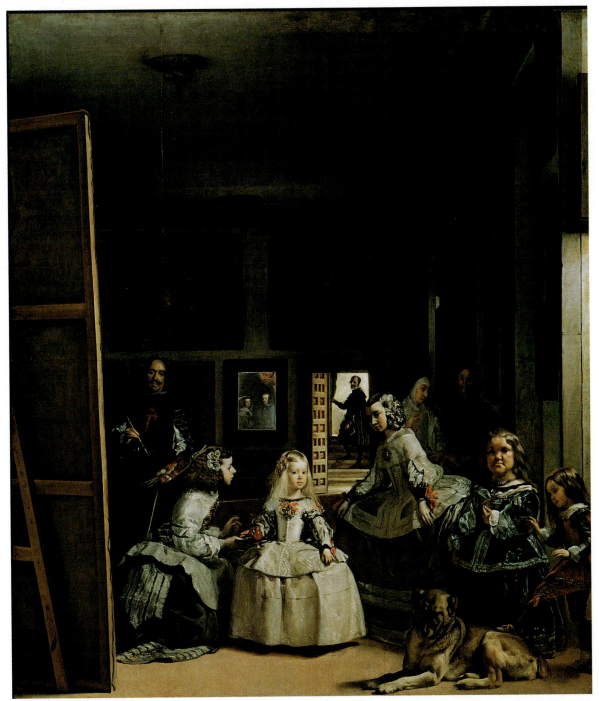

13-16 Diego Velázquez, *Las Meninas*, 1656. Oil on canvas, approximately 10′5″ x 9′. Museo del Prado, Madrid.

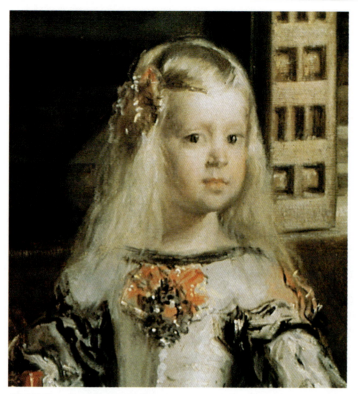

13-17 Detail of figure 13-16

Perhaps he felt that his situation was not so different from their own. In the background, a court official pauses to glance back through the doorway. Notice how the painter honors the viewer by giving us the same viewpoint as the king and queen.

Velázquez, unlike the northern Renaissance artists van Eyck and Holbein, did not attain realism by observing and copying minute details. Instead, he captures the impression of realism through suggestive brush strokes, a method that would influence not only other Baroque painters but also the Impressionists of the nineteenth century. His dog looks much more real than the dog in van Eyck's *Giovanni Arnolfini and His Bride*, even though he has not taken the trouble to paint it hair by hair. He paints what he sees rather than what he knows intellectually is there (we do not see every hair on a dog from across the room). In this way, he can create an illusion of reality actually more vivid than an enormously detailed work.

THE BAROQUE PERIOD IN THE NETHERLANDS

The fortunes of Spain and its territory, the Netherlands, were linked during the Baroque period. The Netherlands was particularly important to the Spanish Empire because it had many important centers of trade. But the Protestant cities of the Netherlands longed for political independence and religious freedom from their devout Catholic rulers. In the 1620s, the Netherlands was plunged into civil war. The rebellion ultimately succeeded in driving the Spanish from the northern half of the Netherlands, which became the *Dutch Republic*, an independent Protestant state. The south, *Flanders*, whose people were predominantly Roman Catholic, remained a territory of Spain. This division of the Netherlands is approximately the division of Holland and Belgium of today (see map).

RUBENS

During this period, an artist from Flanders, Peter Paul Rubens, spent months in the Spanish court as a diplomat and befriended the younger painter Velázquez. They studied the Spanish royal art collection together.

was made a court chamberlain and given the rare honor of a home attached to the palace with its own studio. For thirty years he painted King Philip IV, his family, and members of the court.

Las Meninas (13-16) is Velázquez's great masterpiece, a huge work, 10½ x 9 feet tall. It demonstrates a mastery of realism that has seldom been surpassed. Here he shows a moment in the life of the court. As Velázquez himself is an important member of that court, he shows himself painting a picture. But what is he painting? There are two possible answers. It is a portrait of the princess, who is in the center of the picture (and therefore the painting we are looking at), or it is the king and queen, whose reflections we can see in the mirror at the back of the room. In either case, it is a life-size portrait of the royal family and their attendants. At the center are the Infanta Margarita (detail, 13-17) with her maids of honor, a dog, a dwarf, and a midget. The Spanish royal family had a tradition of keeping dwarves and midgets around them, almost as toys, for entertainment. Velázquez always portrayed them with sympathy and respect, rather than as victims or clowns.

Velázquez felt honored to accompany the man he thought of as the model of a learned painter. Besides being the most learned, Rubens was also the most popular, most successful, and most internationally famous artist of the Baroque age.

Like many northern painters, Rubens gloried in the textures of real things and portrayed in fine detail leaves, flesh, and clothing. But he was profoundly influenced by a trip to Italy when he was twenty-three. He would stay eight years, filling his notebooks, many of which have survived, with studies of the great masters. *The Elevation of the Cross* (13-18) was painted soon after Rubens returned to Flanders. We can recognize the rich color of the Venetians and the active, muscular figures of Michelangelo, as well as the dramatic lighting of Caravaggio—a potent combination. As the men strain and pull, they exhibit extraordinary muscular vitality. The strong diagonal of the cross itself and the many directions of activity are brought to a dynamic equilibrium by the young master.

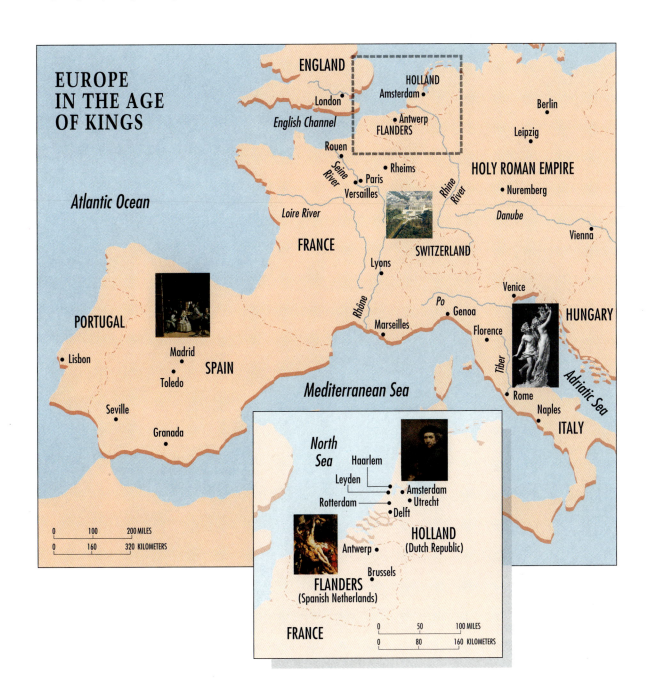

EUROPE IN THE AGE OF KINGS

ENGLAND

HOLLAND
Amsterdam

London

English Channel

Antwerp
FLANDERS

Berlin

Leipzig

Rouen

Seine River

Rheims

Paris
Versailles

Rhine River

HOLY ROMAN EMPIRE

Atlantic Ocean

Loire River

Nuremberg

Danube

Vienna

FRANCE

SWITZERLAND

Lyons

Venice

Po
Genoa

HUNGARY

Rhône

Marseilles

Florence

PORTUGAL

Tiber

Rome

Adriatic Sea

Lisbon

Madrid

SPAIN

Naples

ITALY

Toledo

Mediterranean Sea

Seville

Granada

0 100 200 MILES
0 160 320 KILOMETERS

North Sea

Haarlem

Leyden

Amsterdam

Rotterdam

Utrecht

Delft

HOLLAND
(Dutch Republic)

Antwerp

Brussels

FLANDERS
(Spanish Netherlands)

FRANCE

0 50 100 MILES
0 80 160 KILOMETERS

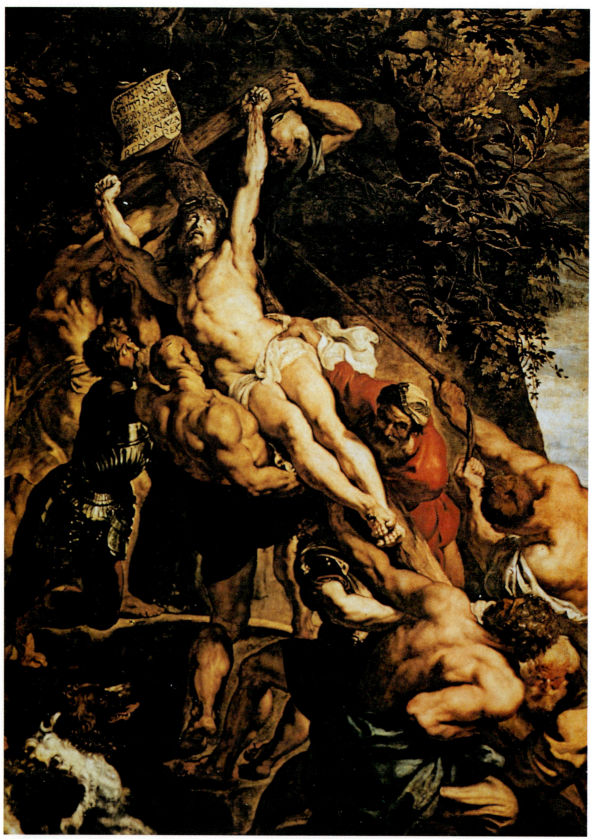

13-18 Peter Paul Rubens, *The Elevation of the Cross*, 1610. Oil on canvas, 15′2″ x 11′2″. Antwerp Cathedral, Belgium.

Rubens finished Albrecht Dürer's mission of a century earlier and created a synthesis of the northern and southern European painting styles. Before Rubens, painters in the north had mostly painted on a small scale. *The Elevation of the Cross*, like much of his work, is enormous, more than 15 feet tall. Rubens's powerful religious pictures suited the Catholic Church's desire to regain its past strength during the Counter-Reformation.

Rubens's art has a buoyant energy, a love of splendor that also made it perfect for the rich and aristocratic courts of Europe. He had commissions from all the Catholic monarchs in Europe and was even knighted in England. The *Arrival of Marie de' Medici at Marseilles* (13-19) shows why his work was so popular with the powerful. The arrival of a young princess in Marseilles to marry King Henry IV is extravagantly pictured. Rubens makes it a mythic, exciting event. The swirling figures and the decoration give the picture great vitality. There are no Christian symbols, even though it celebrates the union of Henry and the Catholic princess Marie de' Medici. In-

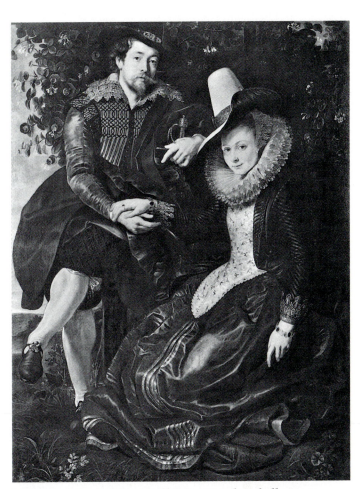

13-20 Peter Paul Rubens, *Self-Portrait with Isabella Brant*, 1609–1610. Oil on canvas, 69" x 53½". Alte Pinakothek, Munich.

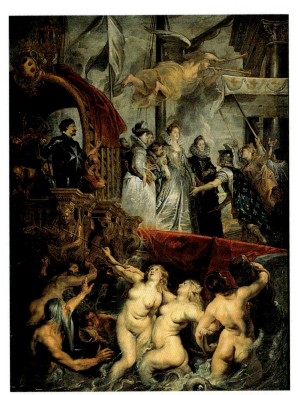

13-19 Peter Paul Rubens, *Arrival of Marie de' Medici at Marseilles*, 1622–1625. Oil on canvas, 61" x 45⅔". Louvre, Paris.

stead, pagan gods and goddesses surround the scene as if they arranged the union. Fame flies above trumpeting the great news.

Rubens lived like no painter before him. He had an excellent education and spoke many languages fluently. When he traveled from country to country in Catholic Europe, besides painting portraits, he acted as an official diplomat for Flanders and the Spanish king on matters of the highest importance. Respected and successful, he was a very rich and happy man who dominated the Catholic art world. Rubens was also a loving husband and father who recorded his family in many pictures. *Self-Portrait with Isabella Brant* (13-20) was painted on the occasion of his wedding. Modest in comparison with the mythic arrival of Marie de' Medici, it portrays a young couple of substantial means whose relationship combines love and mutual pride.

Their hands touch gently as they sit surrounded by honeysuckle whose textures are delicately portrayed.

Rubens was a painter who loved not only the souls of women but also their flesh. In terms of today's standards of athletic slimness, his females may appear unattractively pudgy, but in the world of the seventeenth century, starvation was more to be feared than excess flesh. Plumpness was a sign of wealth and upper-class status. For Rubens, it was also a glory of nature. Today, these proportions are often described as "Rubenesque." In the *Garden of Love* (13-21), his pink-cheeked, double-chinned, dimpled females seem to promise all the delights of the flesh to their devoted swains. Some even glance provocatively at the viewer, almost enticing one to enter the world where they recline languorously on the grass or stroll with their arms about each other's waists. There is nothing pornographic or openly erotic in this scene, yet it is clearly a celebration of physical rather than spiritual love. At the time he painted this picture, the widower Rubens (in his fifties) had just married his second wife, a lovely girl of sixteen. You can see them at the left of the picture, where a cupid pushes her into his arms.

Rubens's home in Antwerp (pictured in the *Garden of Love* and still standing) looks like a palace. Attached to it was a huge workshop with many assistants, functioning like a painting factory in Rubens's time. He charged clients by the size of each painting and how much he had worked on it. Because the quantity of commissions he was offered could never have been accomplished by a single man in one lifetime (or even three), most of the talented artists of Flanders worked in the Rubens workshop.

THE DUTCH REPUBLIC

The art world of the Dutch Republic was very different from the one Rubens dominated. The art of the Protestants of northern Netherlands was entirely different, as was their art market. The Protestant Church did not patronize artists, and there was not a large wealthy aristocracy. Holland was governed by a bourgeois, middle-class society of merchants. In this atmosphere an art reflecting middle-class life began to flourish. Dutch painting became concerned with the everyday life of the towns, and with portraits. In Holland, the humanistic development of art that began in the fourteenth century with Giotto reached its climax in a profound naturalism. One of the most accomplished masters of the beauty of simple scenes was Jan Vermeer.

In Vermeer's work, as in that of his fellow countryman's, the Renaissance painter Bruegel, we see an everyday event raised to a high artistic plane. *Young Woman with a Water Jug* (13-22) is an extraordinary work of art. The subject of a woman standing at a window holding a pitcher in her hand is utterly simple, and one Vermeer used more than once. What is unique about this painting is the combination of vivid realism and idealism. The realism is seen in the artist's ability to depict textures flawlessly. The rug appears thick and shaggy; the design is clearly woven into the fabric rather than drawn on top. The silver of the pitcher and bowl reflect the rug exactly as they would in real life. The woman's plain headdress is absolutely readable as stiff, wrinkled linen. Still, the face and costume of the figure seem to have been simplified. The pale blue light from the window bathes the picture in a beautiful cool radiance. The simple geometric volumes of her head, along with the repeated curves of the bell-shaped collar and skirt, create a quiet, harmonious, almost spiritual, image.

In the Dutch Republic, artists, like other merchants, sold their wares independently,

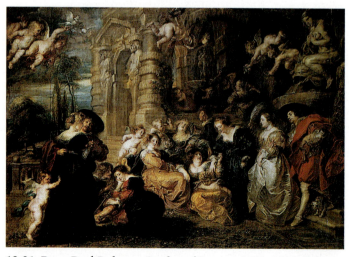

13-21 Peter Paul Rubens, *Garden of Love, c.* 1632–1634. Oil on canvas, 6'6" x 9'3½". Museo del Prado, Madrid.

and success was ruled by the marketplace. Many Dutch artists, to be more easily identifiable in the marketplace, specialized in one kind of painting. Vermeer's specialty was interiors. Others specialized in still lifes, animals, or the new, popular subject of landscapes.

Portraits were Frans Hals's specialty. While he was one of the most prominent of the first generation of artists in the new Dutch Republic, we know very little about him. Most of the surviving documents mentioning his name are records of debts and

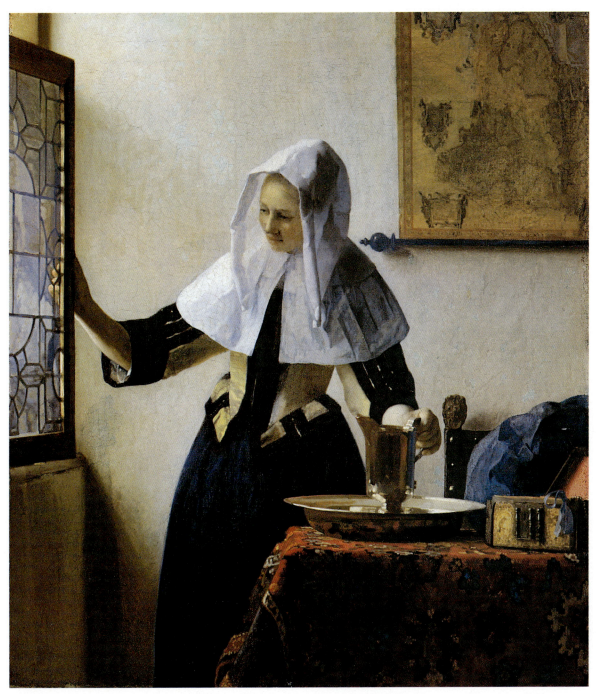

13-22 Jan Vermeer, *Young Woman with a Water Jug, c.* 1665. Oil on canvas, 18″ x 16″. The Metropolitan Museum of Art (gift of Henry G. Marquand, 1889, Marquand Collection).

loans to repay debts. He must have been a very careless manager of money because he had an excellent reputation and many commissions. His *The Laughing Cavalier* (13-23) engages us as few pictures do. It looks much more casual than most posed portraits. It seems as if the dashing man posed only for an instant and was impatient to move again. The energetic brushstrokes in the hair, in the mustache, in the collar add to the liveliness of the scene.

Hals was painting in Holland at the same time Rubens was working in Flanders. They share a lively, optimistic approach, but Hals's subjects are very far from the aristocrats and goddesses of Rubens. The ordinary, even lower-class characters he portrayed against simple backgrounds identify Hals as a follower of Caravaggio. In a later portrait, *Malle Babbe* (13-24), Hals demonstrated an even more

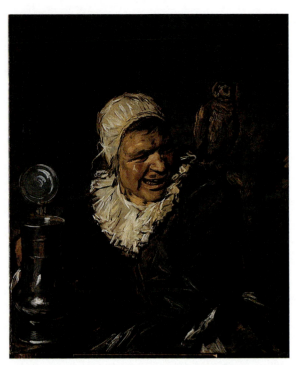

13-24 Frans Hals, *Malle Babbe (Mad Babbe)*, *c.* 1650. Approximately 30″ x 25″. Staatliche Museen Preussischer Kulturbesitz, Gemäldegalerie, Berlin.

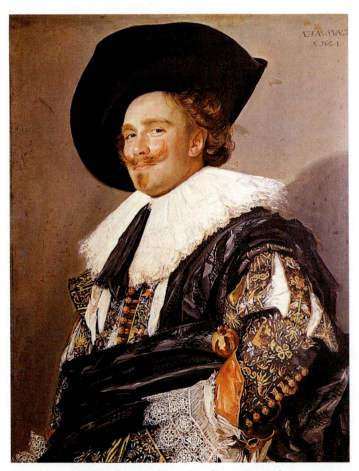

13-23 Frans Hals, *The Laughing Cavalier*, 1624. Oil on canvas, 33¾″ x 27″. Reproduced by permission of the Trustees of the Wallace Collection, London.

spontaneous and looser style. There is more expression in his brushwork, which is filled with feeling and is almost electric. There is also the illusion of great speed, as if Hals could dash off a painting in a few minutes. With a series of rapid spontaneous marks, Hals captures the wild drunkenness of a mad woman, probably an object of ridicule in her town. This style of painting is called **alla prima**. Previously, oil paintings were built up layer by layer over a long period of time with a series of glazes. Instead, Hals's picture is done quickly and at one sitting, *alla prima*, meaning "at the first." This daring and spontaneous way of painting would have a great influence on the Impressionists of the nineteenth century.

Judith Leyster was a friend of Hals whose pictures were similar in several ways (see "Art News"). But *The Proposition* (13-26) has a seriousness and understanding that is noticeably absent in Hals's work. The bold lighting and the lack of glamour in the scene shows the influence of Caravaggio more profoundly. In the painting, a man is hanging over a seated woman and offering her money in an effort to convince her to become a prostitute. The

◆ART NEWS

JUDITH LEYSTER REDISCOVERED

For three hundred years, *The Jolly Toper* (13-25) was thought to be a masterpiece by Frans Hals. Not an unreasonable assumption, since it does resemble his subject matter and style. Yet when the picture was cleaned by a twentieth-century restorer, an important discovery was made—two initials had been painted over. They were not "F. H." but "J. L." While *The Jolly Toper* may look superficially like the work of Hals, it is actually the work of a woman named Judith Leyster. It is not unusual for a woman artist's work to be attributed to a more famous male artist. Sometimes this has been done unintentionally or out of ignorance, or because of wishful thinking, but often it has been done so pictures could sell for a higher price. In this case, the signature may well have been hidden by a dishonest dealer.

Hals and Leyster shared an interest in portraying happy drunkards, so the confusion might have been natural. Since she was listed as a witness at the baptism of one of his children, we can assume they were friends. If we compare Leyster's picture to Hals's *Laughing Cavalier* or *Malle Babbe*, we notice other similarities. The figures are cut off below the chest, there are plain flat backgrounds, and they share an immediate, snapshot quality. Leyster, however, does not use loose, active brushwork. The texture of the paint is not meant to be noticed. What is important to her is creating a clear, honest portrait.

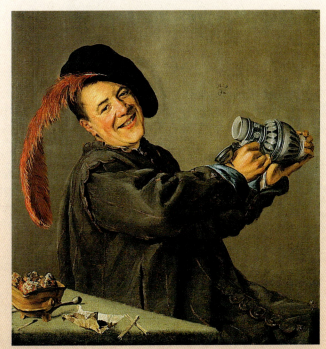

13-25 Judith Leyster, *The Jolly Toper*, 1629. Oil on canvas, 35" x 33½". Rijksmuseum, Amsterdam.

woman seems modest and embarrassed, uninterested in the proposition. She is trying to ignore the leering "gentleman," pretending not to hear, as if she were too absorbed in her sewing to notice.

The theme of a proposition is a common one of the period, but Leyster's picture is untraditional. Generally, when men had portrayed this theme, the woman would be dressed provocatively and smiling in a drunken, lusty way. The woman in *The Proposition* is dressed modestly and is clearly uncomfortable. Leyster counters male fantasies with realism.

REMBRANDT

While Hals seems to effortlessly capture the personality of the sitter and go no further, Leyster brings depth to her approach. Rembrandt van Rijn also attempts something more profound—to reveal the sitter's soul. The *Self-Portrait as a Young Man* (13-27) was done in his thirties. Rembrandt would do many self-portraits during his lifetime, like the Renaissance painter Albrecht Dürer. But Rembrandt never represented himself as Christ (12-30). He portrayed people, even

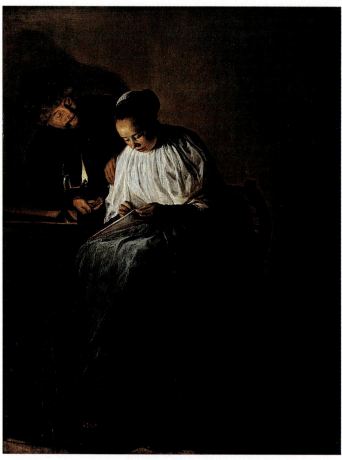

13-26 Judith Leyster, *The Proposition*, 1631. Oil on canvas, 11⅞″ x 9½″. The Mauritshuis, The Hague.

shadow. His drawings and prints are held in the same high regard as his paintings.

In the 1640s, the ambitious Rembrandt was Holland's most popular portrait painter and had become quite wealthy. Yet his dream was to be a painter, like Rubens, of impressive historical and biblical scenes. The *Sortie of Captain Banning Cocq's Company of the Civic Guard* (13-28), known traditionally as the *Night Watch*, marks a turning point in his career. The large painting (it is more than 14 feet long) was commissioned by a company of officers under the command of Captain Frans Banning Cocq. The artist knew them and had probably watched them leave for patrol many times, since he lived on the same street as their headquarters. Each of the eighteen men depicted paid one hundred guilders and expected, in return, a traditional portrait. Rather than show everyone equally, however, Rembrandt decided to have a more imaginative composition. Some figures, like the captain, are featured, but others are almost hidden. For example, one soldier, at the right, had the bad luck to have his face blocked by an arm

himself, with great honesty and no intent to flatter. Rembrandt's devotion to Caravaggio's naturalism, as well as his understanding of chiaroscuro, is apparent in this early self-portrait. They will remain his principle means of expression throughout his career.

Rembrandt was born in a small Dutch village, the son of a miller. At an early age, he was recognized as an artistic genius. A painting done when he was only twenty-four was said to be "a work that could be compared with anything in Italy and with any of the beauties and marvels that have survived from the remotest antiquity." Underlying his talent is his remarkable skill as a draftsman, which can be seen in both his drawings and prints. His *Woman at a Window* (3-12) is a drawing that captures in only a few strokes a personality and a scene. His *Faust in His Study* (5-9) is an etching of great complexity and imagination, a masterly orchestration of light and

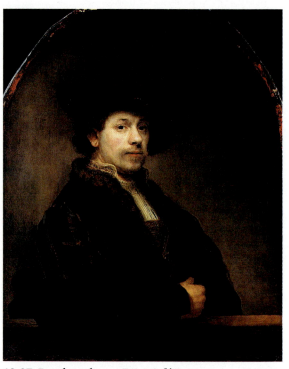

13-27 Rembrandt van Rijn, *Self-Portrait as a Young Man*, 1639. Oil on canvas, 40⅛″ x 31½″. Reproduced by courtesy of the Trustees of the National Gallery, London.

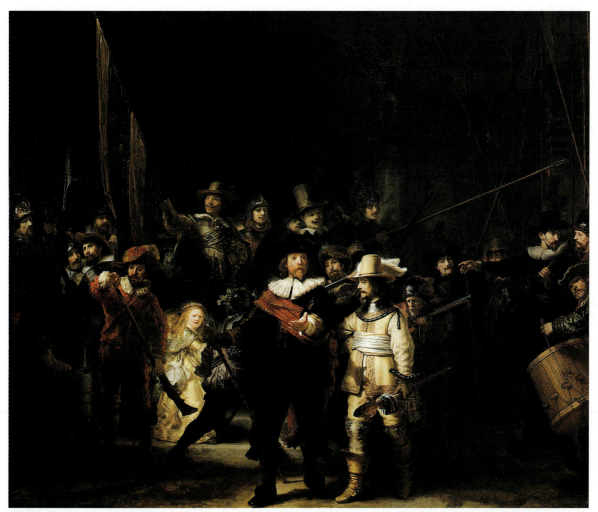

13-28 Rembrandt van Rijn, *Sortie of Captain Banning Cocq's Company of the Civic Guard,* 1642. Oil on canvas, 12'2" x 14'7". Rijksmuseum, Amsterdam.

pointing to the center (detail, 13-29). Some people are also concealed by heavy shadows because, rather than using a dull, even light, Rembrandt used dramatic chiaroscuro. The final result was impressive, but, not surprisingly, many of his subjects were unhappy. After the portrait was unveiled, Rembrandt's commissions began to decrease. The year 1642 marked another sad turning point in his fortunes: His beloved wife and model, Saskia, died after giving birth to their son, Titus. In the *Sortie*, she appears as a small ghostly presence just to the left of center.

The loss of Saskia also meant the loss of her trust fund, which he had become dependent on despite his success. Unfortunately, Rembrandt had early in his career developed a taste for the finer things in life. He also liked to drink and eat well. As his fortunes

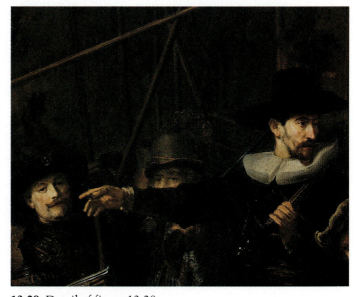

13-29 Detail of figure 13-28

declined, he found it impossible to restrain his free-spending ways.

Rembrandt's art came under attack in the 1650s. As the Dutch Republic aged, it became richer and more conservative and less concerned with honesty and realism. Patrons wanted a more classical-looking art, reminiscent of Raphael and ancient Greek statues. This new taste was developing, not only in Holland but also all over Europe. Like Caravaggio before him, Rembrandt was criticized for his naturalism. It was said his pictures were too dark; they contained too many ugly and vulgar types. Rembrandt refused to change.

Even though he was a Protestant in a Protestant country, Rembrandt thought of himself as the natural heir to Rubens, the great painter of the Catholic Baroque. Therefore, unlike Hals, Leyster, and Vermeer, he

painted many religious subjects. Yet Rembrandt's approach was more spiritual and personal than the grandiose extravaganzas of Rubens. *Jacob Blessing the Sons of Joseph* (13-30) not only illustrates a story from the Old Testament but also is a touching family scene. Encircled by utter darkness, the family of Jacob surrounds the old man in a gentle world of love. Jacob's family is probably not unlike Rembrandt's own, who helped him endure continuing troubles and became his shelter from the storm. He was near financial ruin and harassed by creditors at the time because of his extravagant spending (he owed more than 17,000 guilders—more than most Dutch then could earn in a lifetime).

Rembrandt's biography is told in his many self-portraits. The man seen in the self-portrait of 1660 (13-31) is much changed from the confident young man of twenty years

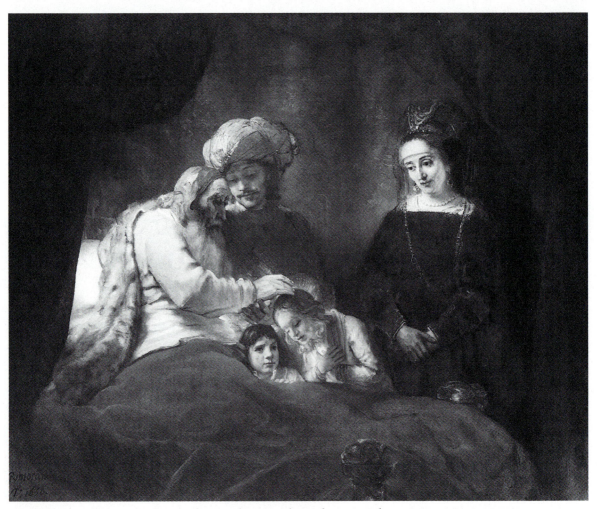

13-30 Rembrandt van Rijn, *Jacob Blessing the Sons of Joseph*, 1656. Oil on canvas, 5'8½" x 6'11½". Gemäldegalerie, Kassel, Germany.

earlier. In the intervening decades, his self-portraits had shown a tattered but defiant, almost confident Rembrandt. By 1660, his will was broken, and with the death of his second wife, his only refuge had fallen apart. Only overwhelming fatigue and sadness was left. The self-portrait is a painfully vivid portrayal of the loneliness of old age.

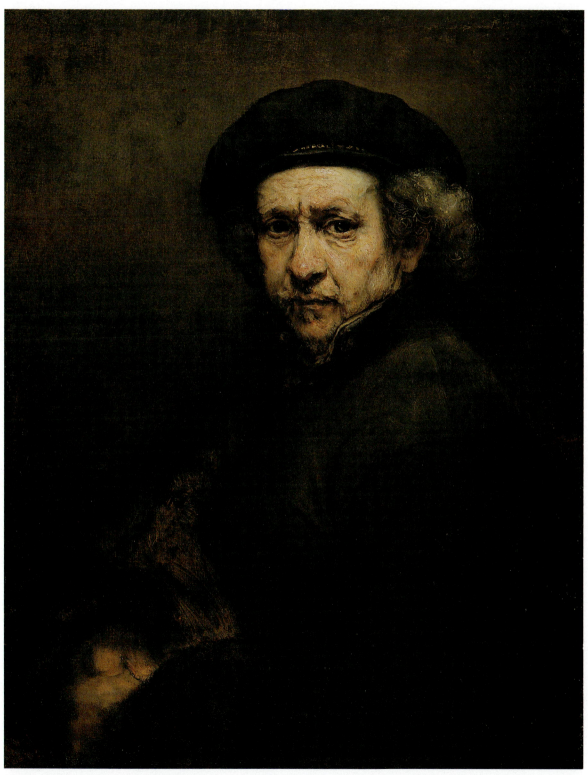

13-31 Rembrandt van Rijn, *Self-Portrait*, 1659. Oil on canvas, 33¼″ x 26″. National Gallery of Art, Washington, D.C. (Andrew W. Mellon Collection).

Rembrandt's dedication to his principles and resistance to Classicism cost him dearly, but his contribution to art was immense. If the Renaissance can be seen as the beginning of the rise in the importance of the individual, then Rembrandt's work can be seen as an important new development of that idea. In his pictures, *his* own unique impressions and thoughts became even more important than realistic depiction of his subjects. This is the beginning of an important part of the modern approach to art—where the sensibility of the artist is now a crucial element of the subject matter. In other words, not only imitation was to be valued but also expression.

THE BAROQUE IN FRANCE

In Chapter 11, France was discussed as the birthplace of Gothic art. But it would not be an important art center again until the Baroque period in the seventeenth century. France's power increased rapidly until it became the most powerful nation in Europe and the virtual capital of Western art, a position it would hold for nearly three centuries, until World War II.

Classicism, the same movement that ruined Rembrandt's career, was centered in France. Nicolas Poussin was the emperor of Classicism—his ideas and career helped formulate the basic doctrines of the new international movement. He lived for many years in Rome, the mecca of the Classicists. There he made copies of the works of his heroes, the Renaissance masters, along with drawings of ancient Greek and Roman sculptures. His approach to learning would form the basis of the traditional course of study in the French Royal Academy of Painting and Sculpture founded in the seventeenth century. It was

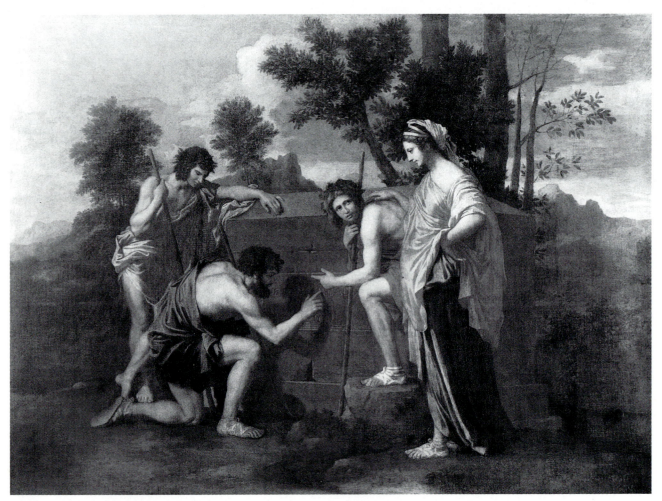

13-32 Nicolas Poussin, *Et in Arcadia Ego, c.* 1655. Oil on canvas, 34″ x 48″. Louvre, Paris.

the model for academies of art all over Europe, where students were taught the following doctrines of **Classicism**: reject Naturalism, especially the portrayal of authentic emotions; the highest aim of a work of art is to represent noble and serious thoughts; an artist should make images with logic and order—not as things really are but as they should be; true art should depict great themes and raise viewers up by appealing to their reason, not their base emotions. These doctrines were inscribed in a treatise by Poussin and became the bylaws of the movement, a major force in Western art for centuries.

The paintings of Poussin reflect his belief in an art based on ideals, not naturalism. The shepherds in *Et in Arcadia Ego* (13-32), for example, are not portrayed as peasants but are closer to the statues of archaic gods. It is in fact set in an ideal ancient past, as are all his works. The light and color are not dramatic but calm, as in the Madonnas of Raphael. The shepherds are reading and reflecting on the words carved into a tomb, "Et in arcadia ego," or "even in Arcadia I am." "Arcadia" was an ancient mythical land, a rustic paradise that symbolizes perfect earthly life. "I" refers to death. The inscription therefore means that even in an ideal pastoral landscape, death rules supreme. The spirit of death is at the right, in the form of a goddess. She calmly puts her hand on one of the shepherds, perhaps announcing the end of his life. All elements of the picture are carefully staged to create a sense of Classical serenity, a dignified world ruled by logic and understanding.

Louis XIV and Versailles

The dominance of France during the seventeenth and eighteenth centuries was not just artistic but military and political, too. Its pre-eminence was due to its king, Louis XIV, the most important figure of the baroque period. After a childhood made insecure by civil war and factional strife, he created a new kind of nation-state based on his absolute rule with divine authority. His most famous quote, "L'état, c'est moi" ("The state, it is myself"), characterizes perfectly his attitude towards governance. Known as the *Sun King*, he was the most powerful monarch in Europe and ruled for seventy-two years.

In his official portrait by Hyacinthe Rigaud (13-33), the sixty-three-year-old Louis is sur-

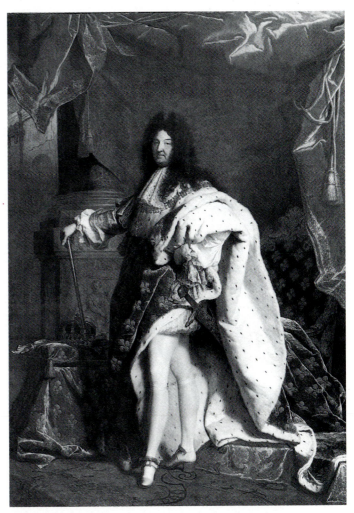

13-33 Hyacinthe Rigaud, *Louis XIV*, 1701. Oil on canvas, 9′2″x 6′3″. Louvre, Paris.

rounded by sumptuous fabrics and classically inspired architecture. As was characteristic of everything Louis XIV was associated with, his portrait is gigantic and larger than life, more than 9 feet tall. It looms over the viewer and is meant to impress one with its absolute power. The pride with which he reveals his slim legs may seem ridiculous today but simply reflects a change in fashion. The large, jeweled sword hilt seen just above his stockings should remind us he was a man of immense power.

In the mid-1600s, the king grew dissatisfied with the Louvre, his palace, and decided to make a new one away from the crowds of Paris (whose population had doubled in eighty years), which he began to find distasteful and which reminded him of the political strife of his youth. Hundreds of architects, decorators,

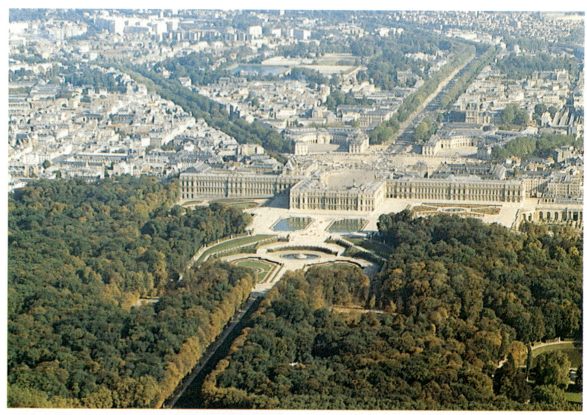

13-34 Aerial view of the Palace of Versailles, France, and the surrounding park, 1669–1685

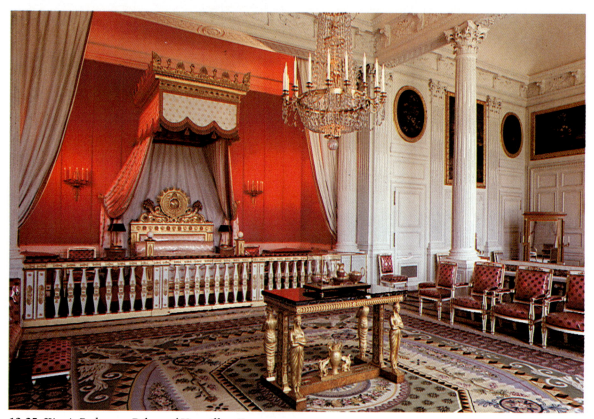

13-35 King's Bedroom, Palace of Versailles, France

sculptors, painters, and landscape designers were sent into the countryside to convert the royal hunting lodge into a palace so grand that it would be capable of glorifying the most powerful ruler in Europe.

Because of the astounding size of Louis XIV's *Palace of Versailles*, no one photograph can capture it, even one taken from an airplane (13-34). A city was created, attached to its grounds, to house all the court and government officials, the military, clergy, and thousands of servants. It is a world all to itself, cut off from the distractions of city life. Its famous gardens literally extend for miles (see pp. 174–75, Chapter 9).

The palace is a combination of both Classical and Baroque elements. Among the hundreds of rooms inside, for example, the *King's Bedroom* (13-35), decorated in gold-and-silver brocade, was the center of activity in the palace. All roads in Versailles led to it, and most of the important official business was conducted there. The great event of each day was the rising or *levée,* of the Sun. As the

sun would appear above the horizon, the Sun King would rise from his bed. Once dressed he would push open his elaborately carved bedroom door. It opened into the *Hall of Mirrors* (13-36), which would reflect bright sunlight around Louis XIV as he progressed down the hall with his courtiers by his side.

The hall extends the entire width of the central wing's second floor, and the windows provide a fine view of the marvelous gardens. In daytime, the seventeen grand mirrors reflect the light of the large windows across from them, making the hall bright without any artificial lights. Besides mirrors, the walls are covered with marble of many colors, and the ceiling tells of the magnificent accomplishments of the king. As beautiful and elaborate as it is today, compared to Louis's time it is rather bare. It was once filled with gold-and-silver chairs and trees covered with jewels. This and other halls were open to the public to impress visitors with the majesty of Louis XIV. Versailles was the center of many festivals that took place in this hall: comedies, balls,

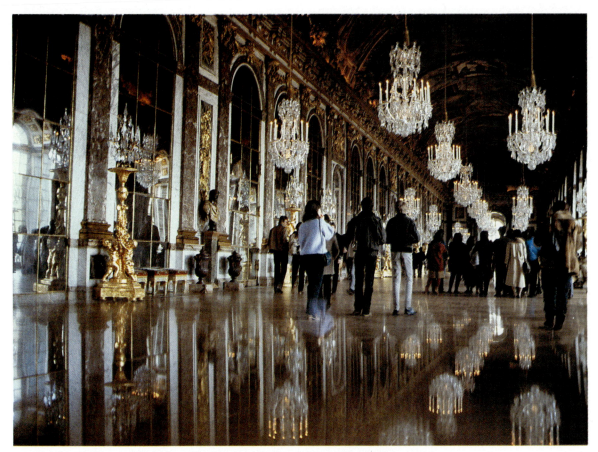

13-36 Jules Hardouin-Mansart, Hall of Mirrors, Palace of Versailles, France, 1680

music, fireworks, and suppers by torchlight. The mirrors would reflect and magnify the magnificence of the great *fêtes* or parties, some lasting for days.

Louis XIV's era was a bloody one in Europe, and he bears a large responsibility for this. He loved war and owed much of his power to it. Attached at one end of the Hall of Mirrors is the *Salon de la Guerre* (war room, 13-37), where he made his plans to crush France's neighbors. The central feature of the room is a marble relief that shows him on horseback trampling his enemies in triumph. Around the room are such pictures as "Germany on her knees" and "Denmark surrendering." At the other end of the hall, his queen built a "Salon de Paix" (peace room) to balance her husband's ferocity. Sadly, it never seemed to have its intended effect. Still, Versailles captured the imagination of Europe, and soon there was building everywhere. It was as if every member of the European nobility had to build his own little Versailles.

THE ROCOCO IN FRANCE: THE ARISTOCRACY AT PLAY

Much to the relief of Europe (and France—which was almost bankrupt after over a half century of extravagance and wars), Louis XIV finally died in his glorious bedroom in 1715, after ruling for seven decades. When he died, a new period began whose characteristics were not formality and grandeur but lighthearted, playful decoration, as if artists along with the rest of Europe heaved a deep sigh, relaxed, and began to enjoy themselves.

This new period in art is called the **Rococo** and Antoine Watteau was its preeminent painter. Born in Flanders (a nation Louis XIV had conquered), he only lived to be thirty-seven, but in his short life he painted many scenes—of parties and picnics and love—that typify the Rococo spirit. His style was influenced by his countryman, Rubens. Notice the similarities between Rubens's *Garden of Love*

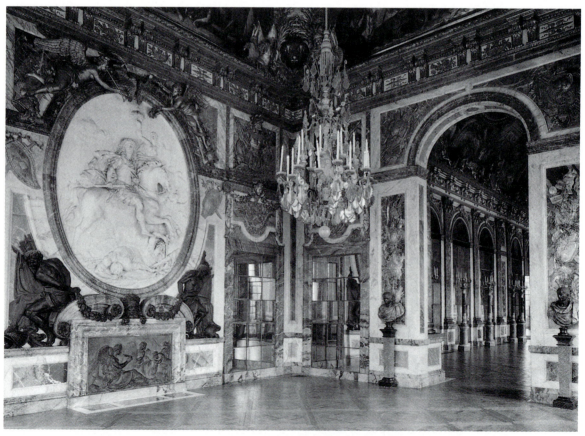

13-37 Salon de la Guerre, Palace of Versailles, France, 1683–1685

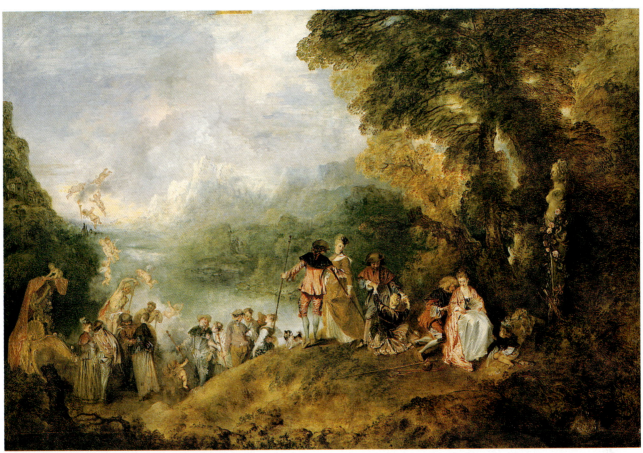

13-38 Antoine Watteau, *Return from Cythera*, 1717–1719. Oil on canvas, 4'3" x 6'4". Louvre, Paris.

and Watteau's masterpiece *Return from Cythera* (13-38). Curving *S* shapes and the theme of love reign in both. Each show a variety of actions. The differences, however, draw a distinction between the Baroque and the Rococo. Because it is set in the midst of a large landscape, the *Return* seems much more peaceful than the *Garden of Love*. The characters are distant, rather than pushed close to the viewer. The lighting is soft and gentle. Watteau's picture is therefore not nearly as intensely energetic as Rubens's. While Rubens made many pictures on a grand scale, most Rococo pictures are more modest. One of Watteau's largest, the *Return from Cythera* is a bit more than 6 feet long; many of Rubens's are twice that.

In Watteau's painting, a group of lovers are about to leave Aphrodite's isle of Cythera, a mythical island where love never dies and one never grows old. We can see that the lovers find it hard to leave this idyllic island; many look back sadly. Every figure is paired in a couple, some almost swooning in rapture. As in many of Watteau's pictures, a Classical sculpture of a bust of Aphrodite, the goddess of love, keeps a watchful eye over lovers, protecting them. Cupid, her son, has left his arrows at its base, because they are unnecessary here. He tugs at one woman's dress, trying to get her attention and tell her that it is time to leave. Swarms of cupids tumbling in the air surround the gondolas at the right, preparing to lead them back to the real world beyond the sweet blue mountains.

As romantic and lovely as it is, there is a sadness in this and many of Watteau's paintings, as if the wonderful days of youth and love are passing too fast. He may have known he was dying of tuberculosis (or "consumption") when he painted this picture. Perhaps he is telling us he does not want to leave just yet. Ten years after his death, the Rococo style had swept Europe; even the clothing worn by his characters in the *Return* had become *the* style for the aristocracy.

The visual idea of love in a garden was especially popular in the France of Louis XV, where the court was dominated by the king's mistresses and intellectual life flourished in the salons of famous female hostesses. French aristocrats of the eighteenth century seemed to be bound by no moral scruples; extramarital affairs and illegitimate children were

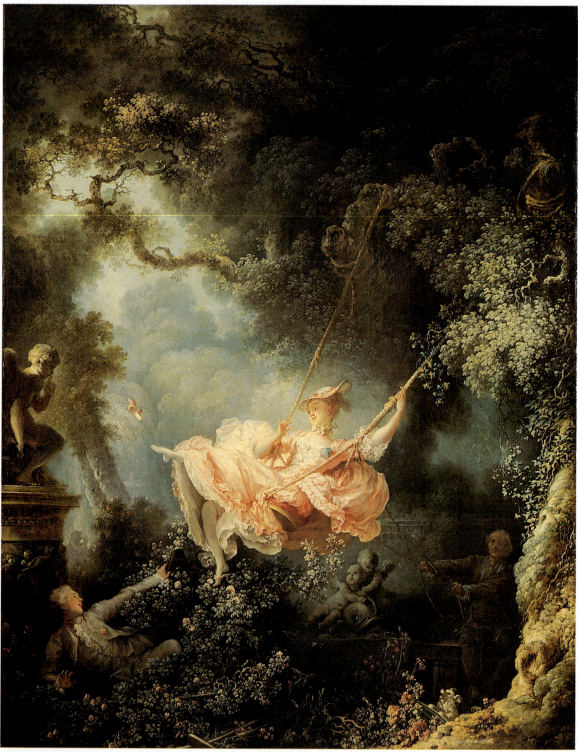

13-39 Jean Honoré Fragonard, *The Swing*, 1766. Oil on the canvas, approximately 35″ x 32″. Reproduced by permission of the Trustees of the Wallace Collection, London.

common. Romantic love was the theme of many works of art, especially those painted to decorate the rooms of wealthy ladies. One of the most famous is *The Swing* by Jean-Honoré Fragonard (13-39). The mood of this picture is light and playful; love is a game, courtship an art. We see a tastefully dressed young woman swinging above her would-be lover, who is hiding in the bushes. The young man has paid an elderly bishop (seen in the shadows) to bring his beloved to this spot and swing her higher and higher so he can peek up her skirt. The young lady is well aware of her admirer's trick and plays along with it, going so far as to kick off one of her shoes. Even the statues of cupid partake of the intrigue; one holds his fingers to his lips as if to say, "Sssh! It's a secret."

The French aristocracy turned to Fragonard for images to hang in their boudoirs but to Marie Louise Élisabeth Vigée-Lebrun for their portraits. A child prodigy, she supported her widowed mother and brother from the time she was fifteen years old. By the time she was age twenty, Vigée-Lebrun commanded the highest portrait prices in France. Her success was enhanced by the patronage of the queen of France, Marie Antoinette, whom she painted more than twenty times. Vigée-Lebrun's *The Artist and Her Daughter* (13-40), painted on the eve of the French Revolution, illustrates how the new Classicism even had begun to influence the work of a painter devoted to portraying the aristocracy. In the next chapter, we will see how this style was a factor in the coming upheaval.

The success of Watteau, Vigée-Lebrun, and Fragonard was due in part to the desire of the aristocracy to be cut off from the cares of everyday life and ordinary people. Their pictures, devoted to the elegant lifestyles of upper-class pleasure, simply ignore the existence of any other classes. As the eighteenth century came to an end, however, social and political changes would make it impossible to ignore the outside world. Because of her close association

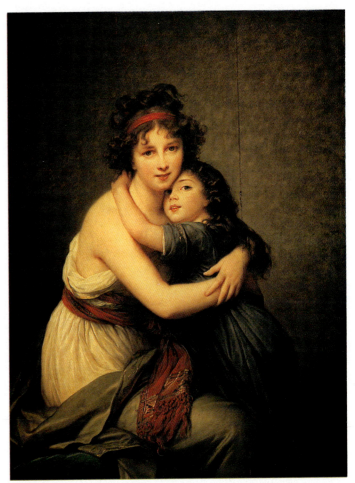

13-40 Marie Louise Élisabeth Vigée-Lebrun, *The Artist and Her Daughter, c.* 1785. Oil on canvas, 51″ x 371″. Louvre, Paris.

with the royal family, Vigée-Lebrun was forced to flee during the Revolution and spent her most productive years visiting the capitals of Europe, a figure of international stature patronized by the crowned heads of Europe. As for Fragonard, he stayed in France. After the Revolution, grace and charm were no longer considered admirable qualities, and his career would sink along with his clients, the nobility.

THE MODERN ERA

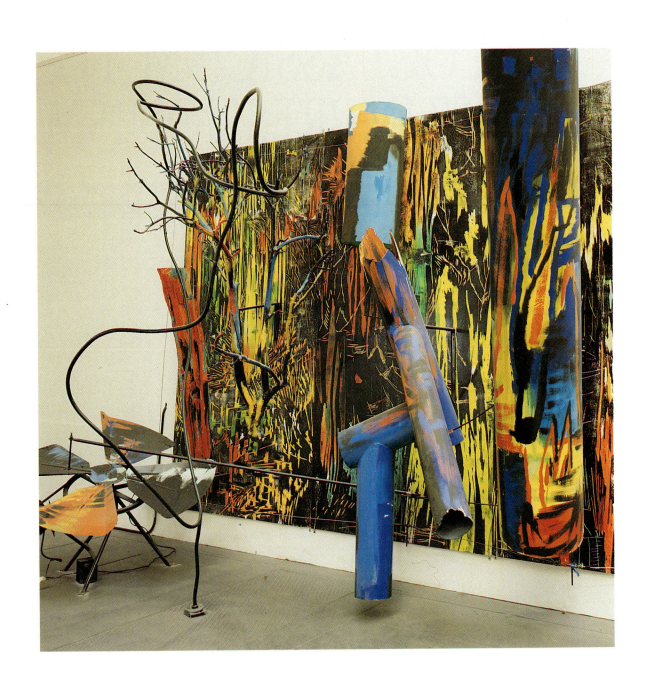

CHAPTER

14

THE BIRTH OF MODERN ART: NEOCLASSICISM TO POSTIMPRESSIONISM

PERIOD		HISTORICAL EVENTS	
1660–1776	The Enlightenment begins Georgian Age in England Neoclassicism	Great Fire of London 1666 Milton, *Paradise Lost* 1667 Newton, *Principia* introduces the law of gravitation 1687 Locke, *Essay Concerning Human Understanding* 1690	Formation of academies and societies for arts and sciences Excavations at Herculaneum and Pompeii 1748 Diderot, *Encyclopedia* 1751 Voltaire, *Candide* 1759
1776–1860	The Age of Revolutions The Industrial and Transportation Revolutions Beginning of the Victorian period in England Romanticism in art and literature The Hudson River School — First school of American painting Realism in art and literature	Jefferson, *Declaration of Independence* 1776 French Revolution 1789–1799 Wollstonecraft, *Vindication of the Rights of Women* 1792 Napoleon becomes Emperor 1804 Beethoven, *Eroica* 1804 Scott, *Ivanhoe* creates taste for historical novels 1819	South American republics break away from Spain Invention of photography 1839 Marx and Engel, *Communist Manifesto* 1848 Japan forced to open trade with the West 1854 Darwin, *Origins of Species* 1859
1860–1900	The late Victorian period Impressionism Postimpressionism	American Civil War 1861–1865 Slaves freed in America (and serfs freed in Russia?) 1865 Franco-Prussian War 1870–1871 Edison invents incandescent lamp 1879	

The birth of Modern Art was a slow one, with many parents over the centuries. The word *modern* was first used to describe art that was wild and imaginative during the Mannerist period. The Renaissance conception of genius and Rembrandt's emphasis on the artist's personal expression also played parts in the defining of modernity. In the eighteenth and nineteenth centuries, the last elements were introduced. If you were modern, you believed new was always better, that progress was inevitable; you were optimistic and confident. Ironically, those in the eighteenth century who valued reason above all would play a part in a movement that would later include artists like van Gogh and Picasso.

THE ENLIGHTENMENT

It was the **Age of Reason** or the **Enlightenment** that stressed the value of rationality over faith, senses, and emotions. The Enlightenment was an age of great scientists and mathematicians who attempted to unlock the secrets of the universe using the powers of the human intellect. The foremost thinkers of the time embraced the idea of progress—that the world was getting better and that humans were capable of improving their own lives. Beginning in England, this intellectual movement spread to France, which in turn spread its influence throughout Europe by the end of the eighteenth century. An important catalyst was the rebuilding of London after the great fire of 1666, which destroyed more than three-quarters of the old city. Christopher Wren's *Saint Paul's Cathedral* (14-1) put a new face on the London skyline, one that reflected the best of the Classical, Renaissance, and Baroque traditions. He personally directed the construction of fifty-two new city churches. It was the start of an era that would see for the first time the emergence of an influential native British art.

ART

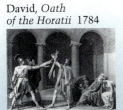
Saint Paul's Cathedral 1675–1710

Gainsborough, *The Blue Boy* 1770

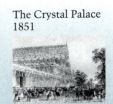
Jefferson, Monticello 1770–1806

David, *Oath of the Horatii* 1784
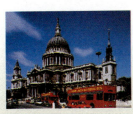

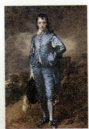
Géricault, *Raft of the Medusa* 1818–1819

Hokusai, *The Great Wave* c. 1822
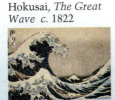

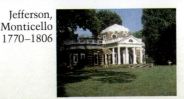
Delacroix, *Liberty Leading the People* 1830

The Crystal Palace 1851

Manet, *Le Déjeuner sur l'herbe* 1863
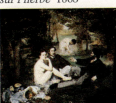

Rodin, *The Thinker* 1880

van Gogh, *Self-Portrait* 1889

Monet, *Grainstacks (End of Summer)* 1891

Degas, *Woman with a Towel* 1894

14-1 Christopher Wren, new Saint Paul's Cathedral, London, 1675–1710

ENGLISH ART BECOMES RESPECTABLE: REYNOLDS

A career in art in England during the eighteenth century became respectable because of Sir Joshua Reynolds. Reynolds would become known as an intellectual figure as well as an artist. Through the interest of wealthy patrons, he was able to study in Italy, an experience that profoundly influenced his outlook. When he returned to London, he immediately became a great success in polite society and the city's most fashionable portrait painter. When the Royal Academy was founded by King George III in 1768, Reynolds became its first president. From this post he was able to dominate "official" art and disseminate his views on aesthetics and the proper training for young painters.

Reynolds taught that all artists should base their work on the Old Masters. He dedicated the Royal Academy to preserving the traditions of the past and believed that an artistic education should begin with technical training, progress to a study of great works of art, and only then attempt to imitate the natural world. Like the French academic and classical artist, Poussin, Reynolds believed that great art should concern itself with the ideal rather than the real to express "great and noble ideals." His views were thus directly opposed to those of William Hogarth (5-7), who believed in useful art that reflected reality.

In his portrayal of the greatest English actress of the period, in *Mrs. Siddons as the Tragic Muse* (14-2), Reynolds painted a symbolic **allegory** (a form of art in which human characters personify certain qualities or ideals). Because Sarah Siddons was famous for her brilliant acting of tragic roles, particularly Lady Macbeth, Reynolds shows her as the classical muse of tragedy. The actress's pose is copied from that of one of the prophets Michelangelo had painted on the

even a bit of Gainsborough's friendly rivalry with Reynolds, who had once painted a boy in a similar brown costume. A popular legend states that it was painted just to disprove one of Reynolds's many aesthetic theories—that it would be impossible to make a great painting using blue as the dominant color.

Despite his fancy dress costume, Jonathan Buttall looks boldly at the viewer and appears vigorously alert and alive. The design is simple and striking. The blues of the costume contrast dramatically with the warm reddish-brown tones of the background. Gainsborough's handling of paint varies from the crisp impasto used to detail the suit to the wispy, feathery lines in the trees and sky.

The two most important English painters of the eighteenth century represented different approaches to art. Reynolds, looking to the artistic models of the past and attempting to portray the ideal rather than the real, was a

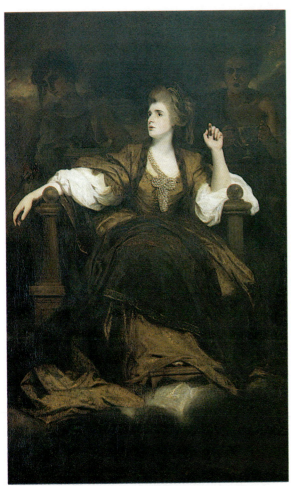

14-2 Sir Joshua Reynolds. *Mrs. Siddons as the Tragic Muse*, 1784. Oil on canvas, 93″ x 51½″. Henry E. Huntington Library and Art Gallery, San Marino, California.

Sistine ceiling, while the dramatic lighting and theatrical contrasts are reminiscent of Rembrandt and Gentileschi. Reynolds's color scheme has a typically reddish brown "old masters" tone that contrasts with the fresher and more natural colors of his rival, Thomas Gainsborough.

THOMAS GAINSBOROUGH

The Blue Boy (14-3) is not only Gainsborough's most famous painting but also probably the best-loved picture in English art. Rather than a mythic figure, the boy in the picture is Jonathan Buttall, the son of a wealthy hardware merchant and a friend of the artist. However, the true subject of *The Blue Boy* is a love of painting and perhaps

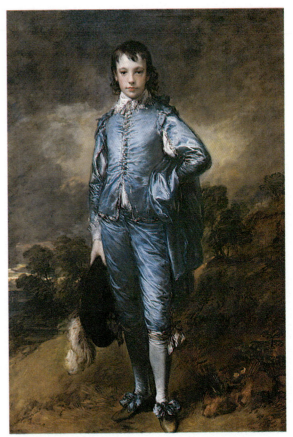

14-3 Thomas Gainsborough, *The Blue Boy*, 1770. Oil on canvas, 70″ x 48″. Henry E. Huntington Library and Art Gallery, San Marino, California.

typical Classicist. Gainsborough, however, introduced many of the attitudes of the movement that later became known as **Romanticism**—a deep love for nature and the landscape and an emphasis on his own personal viewpoint rather than adherence to Classical rules. The contrast between these artists is representative of the conflict between two art movements for the next one hundred years in Western art: Romanticism and Neoclassicism.

NEOCLASSICISM

The **Neoclassical** style was a visual expression of the ideals of the Enlightenment. Enlightenment thinkers, both scientists and philosophers, valued above all order and rationality. Similarly, Neoclassical painters rejected both the high drama and murky atmosphere of Baroque art and the misty sentimentality of the Rococo. They searched for clarity of line, color, and form, admiring the simplicity of Greek art.

The supreme object of the Neoclassical artist was to paint a moral lesson that would educate and improve the viewer—what were called "history paintings," generally scenes from the ancient past. They dreamed of creating large works of art that could be used to educate the public to civic virtues, much as stained-

glass windows educated peasants in the Middle Ages. In the words of Denis Diderot, an eighteenth-century French philosopher and art critic: "To make virtue attractive, vice odious, ridicule forceful: That is the aim of every honest man who takes up the pen, the brush, or the chisel."

An excellent illustration of this moralizing style of art can be seen in the work of an artist of international reputation, Angelica Kauffman. Like Artemesia Gentileschi, she was trained by her artist father; like Bernini, she was considered a prodigy. As a young woman she traveled to Florence and Rome, where she met other Neoclassical artists. A good friend of Sir Joshua Reynolds, Kauffman was one of only two women who became founding members of the British Royal Academy. She later settled in Rome.

Cornelia Pointing to Her Children as Her Treasures (14-4), created in 1785, is a typical Neoclassical painting that both tells a story and points to a moral. Cornelia, a Roman widow, is being visited by a friend who shows off her jewelry. When she asks her hostess to display her own jewels, the proud mother points to her children—two boys on the left and her daughter on the right. Thus the picture demonstrates several values prized by Neoclassicists—modesty, frugality, and pure maternal love. The content and feeling of this painting contrast dramatically with Rococo works about aristocratic sexuality, such as Fragonard's *The Swing* (13-39). Responsibility has replaced frivolity.

The style of the painting reinforces the ideas it expresses. Kauffman's figures are crisp and clean, their outlines set against a plain backdrop. Like other Neoclassical artists, Kauffman prefers clear, bright colors to murky or suggestive shades. Since this is a painted lesson, there is no place for mood, emotion, or atmosphere.

DAVID AND THE FRENCH REVOLUTION

During the eighteenth century, France had lost some of the glory and preeminence she had enjoyed under Louis XIV. Rococo art, patronized by the mistresses of Louis XV, was a style of the boudoir, not the halls of government. Toward the end of the century, the frivolous and playful Rococo was criticized as an art of decadence. French Neoclassical

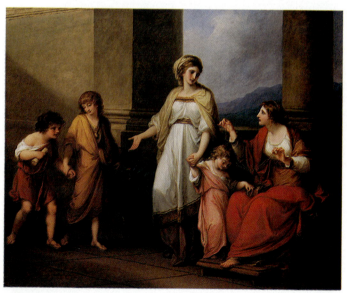

14-4 Angelica Kauffmann, *Cornelia Pointing to Her Children as Her Treasures,* c. 1785. Oil on canvas, 40" x 50". Virginia Museum of Fine Arts, Richmond (Adolph D. and Wilkins C. Williams Fund).

art, modeled more directly on Greek and Roman art than the work of either Poussin or Reynolds emerged as a powerful force that seemed to express a new, more serious moral purpose. This Classical revival was also inspired by recent excavations at Pompeii and Herculaneum.

Though Neoclassicism appealed to many artists throughout Europe and the United States, it found its most perfect expression in the work of the French artist, Jacques-Louis David. David took Neoclassical ideals and followed them to their logical conclusions, concentrating their power. His style of painting appeared absolutely brutal when it first appeared. All the fluidity and elegance of the Rococo, echoes of which had remained in the work of Kauffman, were replaced by a new icy hard surface. In their crystalline purity, David's figures seem to be carved rather than painted. In his enthusiasm for the new Neo-classical style, he revolutionized academic painting.

Success did not come easily to David. When he was denied the prestigious Prix de Rome (a prize of a year's study in Rome given to the most promising student in the French Academy), he even attempted suicide. Happily, Fragonard took pity on him and transferred an important commission to the young artist. Eventually, David did win the prize to study in Rome, which is where his first great masterpiece, *Oath of the Horatii* (14-5), was painted.

As in other Neoclassical history paintings, David's painting tells a moral story and seeks to teach proper values. It is based on a legend about the early years of the Roman Republic, when the Romans were about to go to war with the Albans. On the eve of battle, it was decided that the outcome would be decided by single combat in three individual

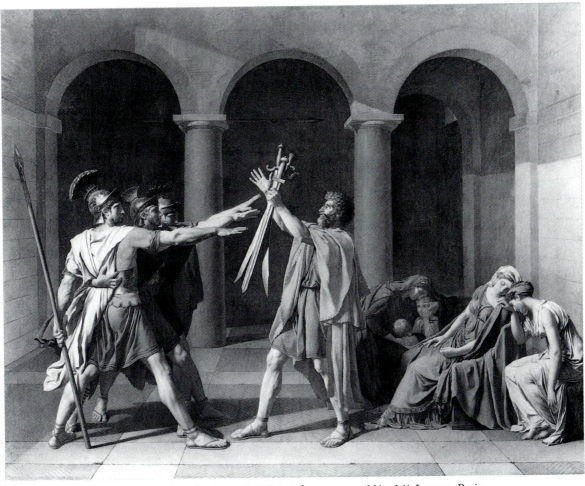

14-5 Jacques-Louis David, *Oath of the Horatii*, 1784. Oil on canvas, 11' x 14'. Louvre, Paris.

contests. The three brothers of the Horatii family swore to defend the Roman state against three brothers of another family, one of whom was engaged to their sister. David chose to depict the moment when the father calls on his sons to swear to sacrifice their lives, if necessary, for the good of the country. Two brothers would die; so would their sister's fiancé. Thus the virtues David emphasized were patriotism, self-sacrifice, and fidelity to a higher purpose.

The *Oath of the Horatii* shows David's mastery of composition. The geometry of the design is clear: The space is divided by three arches, in front of which are arranged three distinct figure groupings—the sons, the father, and the women. Silhouetted against the simple, darkened background, three arms reaching toward three swords catch the light. David sets up a powerful rhythm of legs, arms, and swords by repeating each form with slight variations. The outlines of the male figures are rigid and strong, in contrast to the soft, melting outlines of the females.

Although the *Oath of the Horatii* was painted before the Revolution, its style and content put David at the forefront of art and convinced the revolutionaries that he was one of them in spirit. His utter rejection of the Rococo style was seen as an equally strong condemnation of the old regime. Indeed, David became not only a firm supporter of the Revolution but also one of its leaders, its artist, spokesman, and historian. He organized revolutionary holidays and celebrations. He abolished the Royal Academy and replaced it with what was called the Commune of Art. It was David who took the Louvre, the newly vacant royal palace, and transformed it into a public art museum. As curator, he named his former benefactor Fragonard, who might otherwise have been in danger because of his past association with aristocrats.

Now David painted contemporary events with the same reverence he had used for historical pictures. Like the ancient Roman Republic, the new French state had heroes and martyrs. What was different was that David himself knew these men and women; they were his associates and friends. For this reason, *Death of Marat* (14-6) has a great immediate impact. Marat was a revolutionary leader who was forced to spend hours in the bath because of a painful skin disease. Because he spent so much time soaking, Marat was

accustomed to working and even receiving visitors while in his therapeutic tub. One visitor was a young woman named Charlotte Corday. A revolutionary who disagreed with Marat's policies, she stabbed him while he was at work. The stark painting combines David's emotional intensity with the simplicity of the Neoclassical style. Like a religious painting by Caravaggio, nothing in the background distracts from the pale corpse of the martyr Marat. With his white, marblelike flesh, Marat is shown as a mythic hero, not a suffering human.

Before Marat's death, the series of public executions known as the "Reign of Terror" had begun and along with it the long chain of events that would lead to the collapse of the Revolution. David was imprisoned as a traitor, but his life was spared. Then, with the rise of Napoleon Bonaparte, David found a new patron. For him, Napoleon became the hero who would bring France back to glory, and he painted his new hero many times.

But Napoleon was a very different kind of leader from Marat. He was a military man. In a dozen years he had not only fought off

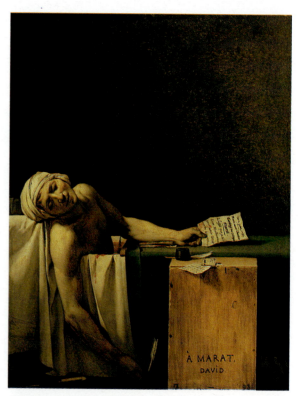

14-6 Jacques-Louis David, *Death of Marat*, 1793. Oil on canvas, approximately 63" x 49". Musées royaux des Beaux-Arts de Belgique, Brussels.

France's enemies but also conquered much of Europe. This difference in models is obvious when we compare *Napoleon at Sainte-Bernard* (14-7) with *Death of Marat* and *Oath of the Horatii*. Rather than exhibiting classical restraint and purity, David fills his canvas with the dynamic form of a rearing horse. Horizontals and verticals, which create a feeling of stasis, have been replaced by strong diagonals, suggesting movement. Cool harmony and balance were now supplanted by a theatricality more reminiscent of Baroque art—foreshadowing the coming Romantic movement.

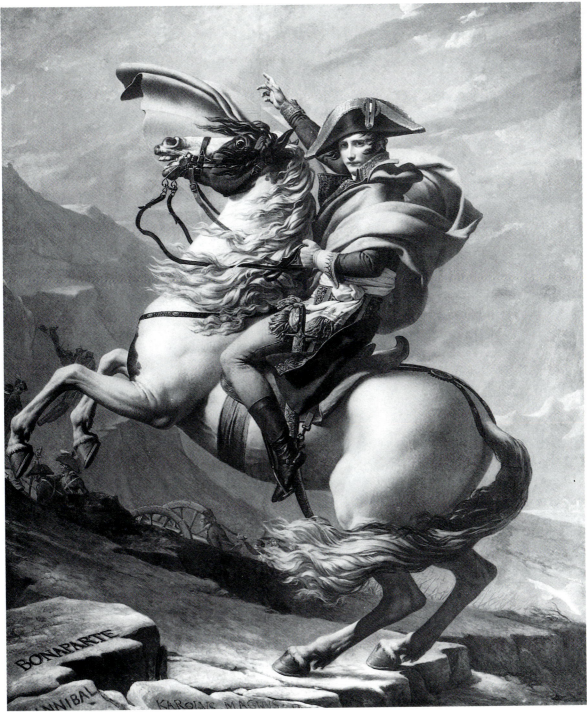

14-7 Jacques-Louis David, *Napoleon at Sainte-Bernard,* 1800. Oil on canvas, 8'11" x 7'11". Musée National du Château de Versailles.

GOYA AND THE ROMANTIC REACTION

The saga of David's career contrasts vividly with that of the first great Romantic artist we will consider, the Spaniard Francisco Goya. Goya's ambition always was to become a painter to the court. His road to success took many years; he was not elected to the Royal Academy of Spain until the age of thirty-four. He was forty-three when finally elected to the coveted post of president of the Royal Academy and First Painter to the King, the same position his idol, Velázquez, had held approximately one hundred fifty years earlier. Unfortunately, Spain no longer enjoyed the same power and prestige she had known under Philip IV.

Shortly after reaching his goal of becoming the premier painter in Spain, Goya experienced a personal crisis. For a year he became so ill that he could not paint, and when he recovered he was completely deaf. Ironically, as his work became more bitter and critical, he became a far greater artist. Goya's personal problems were echoed by Spain's political disasters. In 1804, Napoleon took advantage of Spain's weak rulers and installed his tyrannical brother on the Spanish throne.

In the war that followed, Goya saw many real events that confirmed his morbid view of humanity. One of the most infamous was a massacre of innocent, unarmed Spanish civilians by French soldiers, a scene that the painter immortalized in *The Third of May, 1808* (14-8). A faceless firing squad is shown

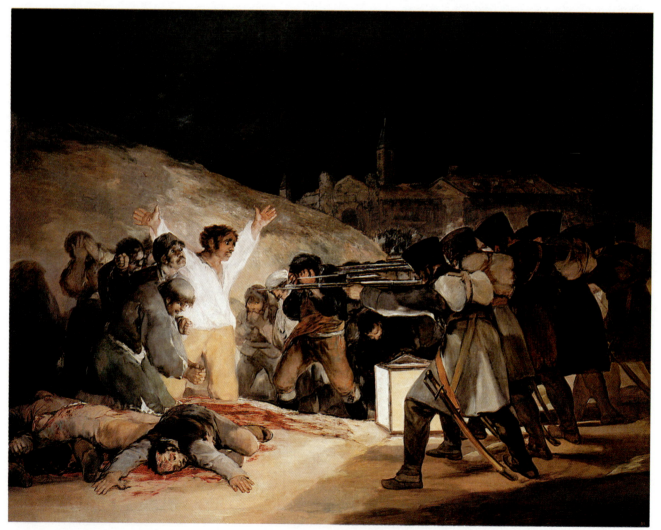

14-8 Francisco Goya, *The Third of May, 1808*, 1814. Oil on canvas, approximately 8'8" x 11'3". Museo del Prado, Madrid.

in the midst of its butchery; one victim lies in a pool of blood on the ground, while others wait their turn in terror. The central figure is illuminated as if by a harsh spotlight, his arms spread wide in a crucifixion-like pose (detail, 14-9).

Goya's masterpiece is a mixture of both brutal realism and passionate Romanticism. It appeals not to measured reason but to the viewer's emotions. For David, Napoleon's army was heroic; for Goya, they were made up of inhuman creatures who followed orders blindly. *The Third of May, 1808* is one of the most convincing, powerful, and influential portraits of suffering ever painted. The timeless image reminds us of similar acts of political repression and cruelty in our own century.

Goya's style of painting is as far from David's as were his politics and subject matter. David's technique was flawlessly controlled; the surfaces of his paintings were smooth as glass, revealing no touch of the human hand or brush. Goya's technique was deliberately rough and coarse. Emotion has infused the artist's brushwork—the strokes could be described as wild. It is this conscious abandonment of control, as well as his fascination with horrifying subject matter, that mark Goya's work as Romantic.

Even more gruesome are images from a series of prints known today as *The Disasters of War* (14-10). They record what Goya saw as he walked the countryside, and to this day, the images are unbelievable and horrible to contemplate. Before the war, the enlightened thinkers of Spain, Goya among them, had always looked to France for inspiration. France had been the home of a revolution for liberty and justice. But the French did not bring grand ideals to Spain. The butchered remains of Spanish patriots tied to a tree in *Great deeds—against the dead!* serve as a reminder that humanity is capable not only of reason and compassion but also of vicious cruelty.

THE BIRTH OF ROMANTICISM

It is not surprising that the movement of Neoclassicism gave birth to an opposing artistic style. Neoclassicism itself had appeared as a reaction to the playful Rococo;

the Rococo had developed in contrast to the formal classicism of the Age of Louis XIV. What is surprising is that almost from its conception Neoclassicism was challenged by what might be described as an equal and opposite force—that of Romanticism. Both movements shared certain characteristics, such as a strong sense of moral purpose and a passionate adherence on the part of their supporters. But they differed utterly on what values they idealized.

Romanticism was a movement that rejected much of the logic and order of Neoclassicism. Instead of searching in past models for universal values, Romantic artists looked inside themselves to discover truth. When the German painter Caspar David Friedrich

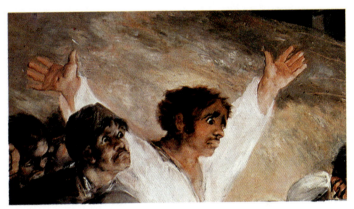

14-9 Detail of figure 14-8

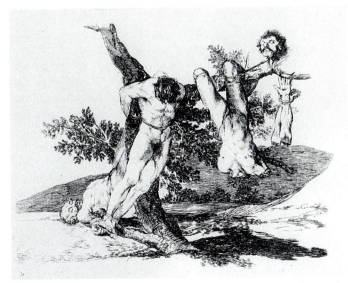

14-10 Francisco Goya. *Great deeds—against the dead!* from *The Disasters of War*, 1863. Etching, 5½" x 6⅞". Norton Simon Museum, Pasadena, California.

(see 2-19) stated, "The artist should paint not only what he sees before him but also what he sees within him," he expressed one of the seminal ideas of Romanticism. It is an idea that continues to influence the art world up to the present day. When Romantic artists discovered their own tumultuous nature, it also opened their eyes to nature's own power.

Nature, for a Neoclassicist, was an unthinking force that could and should be controlled by humans. The Romantics sensed that nature could never be controlled. Where Neoclassicists set their pictures in classical temples or peaceful landscapes, the Romantics were attracted by the savage, untamed aspect of the natural world. Neoclassicists prized civilization above all; Romantics often chafed under the regulations of society.

The subjects of Friedrich's work could not have been more different from the subjects preferred by Neoclassicists. In place of historical or mythological scenes, Friedrich painted seascapes, forests, and mountains. These wild scenes were often entirely devoid of human figures. At other times, Friedrich showed a solitary traveler silently contemplating the infinity of nature, as in *Wanderer above a Sea of Fog* (14-11). A feeling of delicious melancholy pervades many of his evocative images, a sense of yearning and the quest for life's meaning.

THE ENGLISH LANDSCAPE AND ROMANTICISM

England produced great Romantic poets and painters. The works of both groups were centered around nature and the English landscape. J. M. W. Turner's vision of nature was similar to that expressed by Caspar David Friedrich, who gloried in the grandeur and power of the natural world—what was known to the early nineteenth century as the *sublime*. Turner's brilliant career began early. By the age of seventeen, Turner was able to support himself by painting, and he was elected to the British Royal Academy of Art when he was only twenty-four. Turner's favorite themes were dramatic views of storms, fires, sea battles, and sunrises and sunsets over the sea. In *Slave Ship* (14-12), Turner exhibits Romanticism of both subject and style. The picture's complete title is *Slave Ship (Slave Throwing Overboard the Dead and*

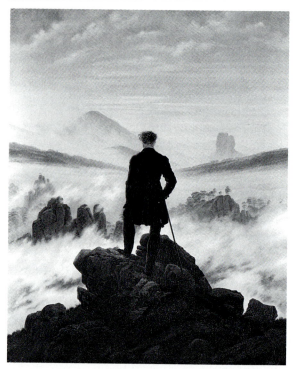

14-11 Caspar David Friedrich, *Wanderer über dem Nebelmeer (Wanderer above a Sea of Fog)*, 1818. Oil on canvas, 37" x 29". Kunsthalle Hamburg, Germany.

Dying, Typhoon Coming On). Turner has chosen to show a disaster caused not simply by the destructive power of nature but also by human greed and fear. Here, the slave traders have tossed their human cargo overboard in an attempt to save themselves as the typhoon approaches. The helpless captives sink in the churning waters; on the lower right a chained ankle is visible on a single leg surrounded by swarming fish. *Slave Ship* is the ultimate Romantic scene of wild beauty mixed with horror. But at the same time, Turner conveys a strong anti-slavery message that appealed to English patrons of the period; England was the center of a strong antislavery movement.

By the end of his career, Turner focused entirely on the raw power of nature and the primal elements of earth, wind, fire, and water. In works like the *Snow Storm* (4-5,4-6), he created startling imaginative images, almost totally abstract compositions of color, rich layers of paint, and vigorous brushstrokes that today cannot fail to remind us of the work of the Abstract Expressionists more than a century later.

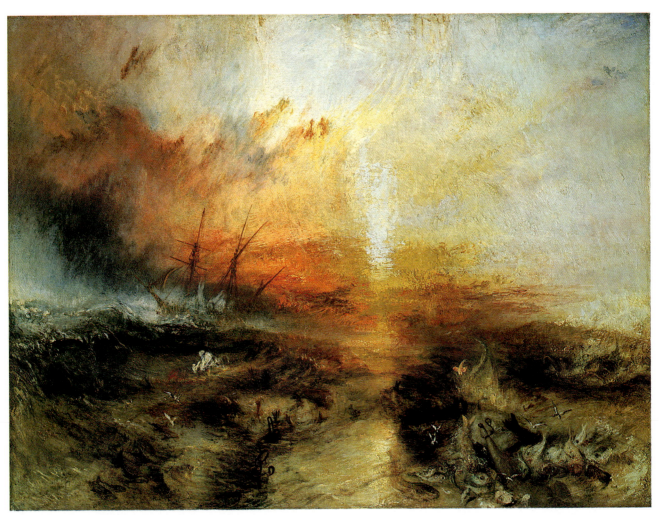

14-12 J. M. W. Turner, *Slave Ship (Slave Throwing Overboard the Dead and Dying, Typhoon Coming On)*, 1840. Oil on canvas, 35¾″ x 48¼″. Museum of Fine Arts, Boston (Henry Lillie Pierce Fund).

ROMANTICISM AND POLITICS IN FRANCE

Théodore Géricault was a young French artist who adopted the Romantic lifestyle. Like the English Romantic Lord Byron, whose poetry he admired, Géricault embraced excess—passionate political convictions, passionate opinions about art, and a passionate taste for adventure. Trained in the academic, Neoclassical style of painting, Géricault traveled to Rome at the age of twenty-five. What caught his attention there were the late works of Michelangelo, especially his *The Last Judgment* (12-25), and the paintings of Caravaggio.

The year Géricault visited Rome, 1816, was also the year of a dramatic historical disaster that caught his imagination and made his reputation. In July *La Méduse*, a French ship bound for Senegal, was wrecked off the West African coast. The captain and officers boarded the only seaworthy lifeboat and began towing the rest of the one hundred fifty passengers and crew on a raft built from the ship's timbers. After a couple of days, those on the lifeboat cut loose from the raft and abandoned it. By the thirteenth day after the wreck, when the survivors were finally rescued, only fifteen remained alive. The others had died of hunger, thirst, and exposure from the blazing sun as the raft became a living hell where desperate men sickened, became insane, and even ate human flesh.

Géricault threw himself into the immense project of capturing the shocking horror of this event on canvas with enormous energy. In the

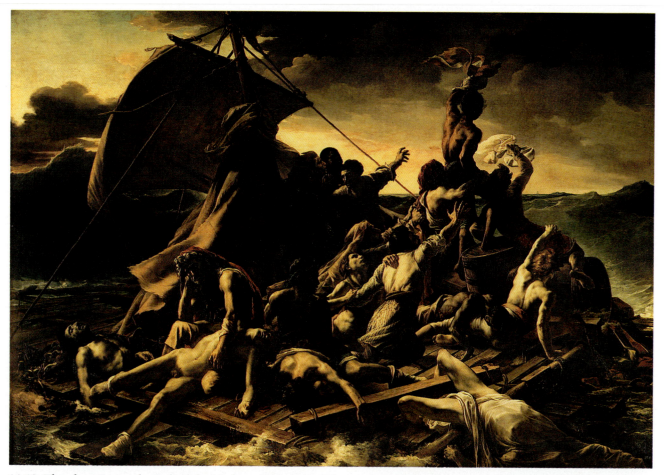

14-13 Théodore Géricault, *Raft of the Medusa*, 1818–1819. Oil on canvas, approximately 16′ x 23′. Louvre, Paris.

interest of realism, he had a duplicate raft built for him in his studio. He interviewed survivors and learned all he could about the disaster. Then he visited hospitals to observe the sick and dying. Yet the final result, the *Raft of the Medusa* (14-13), has a unity that overrides incidental details and transforms the picture into an epic statement of the beauty and danger found in humanity and nature.

Searching for the most dramatic moment in the story, Géricault decided to illustrate the instant when the pitiful remnant of survivors finally caught sight of the ship that would rescue them. The dramatic impact of his canvas is the result of a strong, dynamic composition. The figures are arranged in a pyramid that thrusts from the lower left- and right-hand corners to the figure of a black man waving a flag (detail, 14-14). Thus the climax of the story is conveyed visually as the viewer's eye is swept swiftly to the peak of the pyramid.

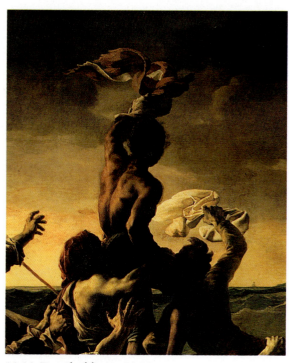

14-14 Detail of figure 14-13

When Géricault died at the age of thirty-four as the result of a fall from a horse, the leadership of the Romantic movement passed to Eugène Delacroix. (Delacroix had not only studied in the same studio as Géricault, but he had posed for the central, face-down figure in *Raft of the Medusa*.) Like the *Raft of the Medusa*, Delacroix's *Liberty Leading the People* (14-15) is an epic painting based on an important contemporary event. In 1830, Paris rose in a three-day revolt against a repressive regime that was attempting to reinstate prerevolutionary abuses, such as strict censorship of the press. Delacroix felt a great sympathy for this popular movement.

Like Géricault, Delacroix based his composition on a strong pyramid, but instead of receding into the background, the figures march out of the picture, into our space. This is a visual translation of the idea of progress, of victory. It is almost as if *Raft of the Medusa* had been turned around; a bare-breasted female (the allegorical representation of liberty) replaces the barebacked black man at the center of Géricault's earlier picture. Instead of looking at the action from the outside, we seem to be in the midst of the battle, with smoke swirling around us and bodies under our feet. In both pictures triumph is juxtaposed directly with suffering and death.

Delacroix in later years developed a freer style more suitable to his subject matter. His *The Abduction of Rebecca* (14-16) is based on a story from Sir Walter Scott's romantic novel *Ivanhoe*, set in medieval England during the reign of Richard the Lionhearted. The

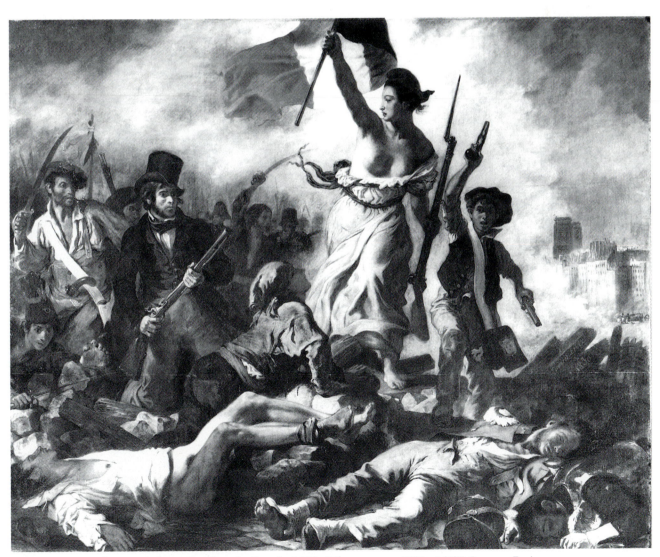

14-15 Eugène Delacroix, *Liberty Leading the People*, 1830. Oil on canvas, 8'6" x 10'8". Louvre, Paris.

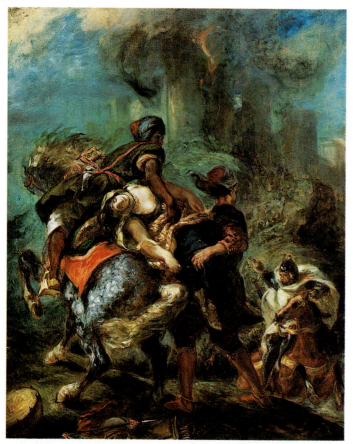

14-16 Eugène Delacroix, *The Abduction of Rebecca*, 1846. Oil on canvas, 39½″ x 32¼″. The Metropolitan Museum of Art (Wolfe Fund, 1903. Catharine Lorillard Wolfe Collection).

rump. Delacroix's free and brilliant use of color would be an important influence on the Impressionists.

INGRES AND LATE NEOCLASSICISM

Popular as it was, Romanticism did not replace Neoclassicism. In France, the Neoclassical tradition of David continued in the work of his student Jean Auguste Dominique Ingres, who consciously opposed the Romantic style of his artistic rival Delacroix. The Romantic Delacroix was a colorist; Ingres insisted that beautiful line was more important than dramatic sweeps of color and tone. We have already seen his mastery of line in the lovely portrait of his wife in Chapter 3.

Ingres had been one of David's students and won the Prix de Rome at the age of twenty-one in 1801. He would ultimately remain in Italy eighteen years, first in Rome, then in Florence. It was during his early years in Italy that Ingres painted *Oedipus and the Sphinx* (14-17), based on a Greek myth about the

beautiful Rebecca loves the hero Ivanhoe but can never be married to him because she is Jewish. Her persecutions make up a large part of the plot; in Delacroix's painting she is shown being thrown over a horse and carried away by the slaves of an evil knight who desires her.

The tempestuous subject and lively composition are well matched. The design is made up of many swirling curves, reminiscent of the work of Rubens, whom Delacroix greatly admired. But Delacroix's colors are more intense, his drawing and brushwork looser. Notice the variation of brushstrokes, the sense of urgency expressed in the flamelike mane of the rearing horse versus the evocative background of a burning castle billowing smoke and fire. Delacroix liberates color from old restraints. Notice how a color like turquoise will appear in many places—not just the sky but a turban, the ground, and even the horse's

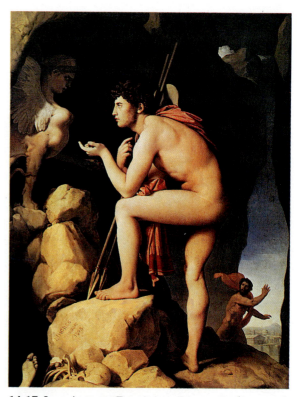

14-17 Jean Auguste Dominique Ingres, *Oedipus and the Sphinx*, 1808. Oil on canvas, 74⅜″ x 56⅝″. Louvre, Paris.

tragic hero Oedipus (whose fate was to un-knowingly murder his father and marry his own mother). The Sphinx was a monster with the body of a lion, the wings of a bird, and the face of a human woman. If Oedipus had failed to answer her riddle, she would have eaten him. (Notice the skeleton at the bottom left of the painting.) However, according to legend, Oedipus did guess the answer, and the Sphinx committed suicide in her fury at being outwitted.

Like the English Classicist Reynolds, Ingres hoped to make his reputation by mythological and historical paintings such as *Oedipus and the Sphinx*, but he actually gained greater fame from the portraits he did to support himself. One of the most beautiful of these is his portrait of Louise, the Countess of Haussonville (14-18), the wife of a diplomat, and a brilliant society hostess, as well as a writer and amateur artist.

Ingres pictures his subject in her own home, an elegant and fashionable setting. The painting of the still-life objects (such as the vases and flowers) and the costume reveal Ingres's brilliant ability to re-create realistic details of texture and pattern. Despite the collection of precious art objects and rich fur-nishings, however, the focus of the painting remains on the countess who stands at its center in a graceful pose. Her expression and the touch of her finger to her chin suggest that she is intelligent and thoughtful as well as beautiful (detail, 14-19). Ingres was not just a master of detail, but also of harmonious composition. The oval of the countess' face is echoed in the oval formed by her shoulder and forearm; all the lines that describe her figure are gently curved. Everything about her is refined, delicate, and aristocratic—even slightly cool. Compare this portrait to Raphael's *Madonna della Sedia* (12-22), which Ingres admired above all other pictures. Although Ingres has studied Raphael's line and composition, his view of womanhood is far less sensual—far more typical of nineteenth-century upper-class morality.

THE FRENCH ART WORLD DIVIDED

Ironically, the French artists who most admired Ingres's early work were Delacroix and the Romantics. But when Ingres returned to France from his studies in Italy in 1824, he took up

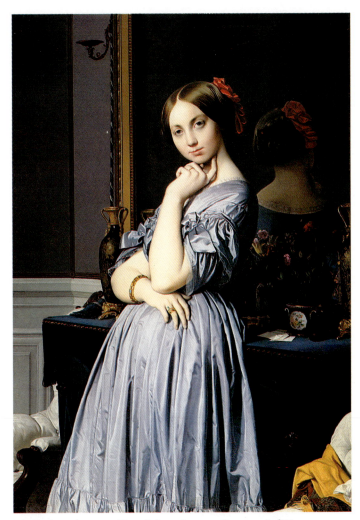

14-18 Jean Auguste Dominique Ingres, *Comtesse d'Haus-sonville,* 1845. Oil on canvas, 4'5½" x 3'¼". Copyright The Frick Collection, New York.

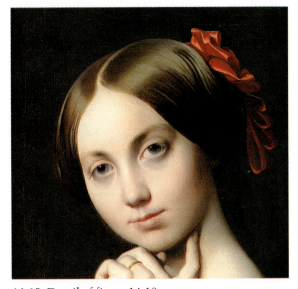

14-19 Detail of figure 14-18

the fight against Romanticism with great fervor. The French art world divided into two camps. While Ingres led the new Classicists, who celebrated the Renaissance artists like Raphael, the Romanticists were headed by Delacroix, who revered the Baroque painter, Rubens. Ingres was particularly bitter in his condemnation of the Romantic Rubenistes and all they stood for. He would not even allow his students to *look* at Rubens's paintings in the Louvre. He called Rubens "that Flemish meat merchant." Ingres felt called on to preserve what he saw as the timeless and true values represented by Neoclassicism. The rivalry between Delacroix and Ingres was fought not only in the Salons but also in the press. Each style had its supporters, patrons, critics, and students.

A cartoon of the time (14-20) shows the artists jousting in front of the Academy, the older Ingres wielding a pen and Delacroix hoisting a brush. While it mocks both artists, it also grasps one of the major differences between Ingres's Classicism and Delacroix's Romanticism—the distinction between what is called **painterly** and **linear styles** of painting. A linear artist like Ingres (or David, Raphael, or Poussin) draws with sharp outlines, clearly defined forms, and relatively solid areas of color. A painterly artist like Delacroix

(or Turner or Rembrandt) paints with broader strokes, without distinct outlines between shapes, with gradual gradations of light to dark tones, and with colors blended into each other. The clarity of the linear style clearly has many attractions for the Neoclassical painter, who wishes to portray universal truths and appeal to the intellect of the viewer. The painterly style is more suitable for conveying mystery and mood and thus appealed to many Romantic artists who hoped to reach their viewers' emotions as well as their minds.

AMERICAN ROMANTICISM: THE HUDSON RIVER SCHOOL

As Romantic art swept Europe in the nineteenth century, the winds of change reached the new nation of the United States, where the Romantic spirit created the first real American school of painting. (The term school, when used in art, refers not to a real art school but to a group of painters working in a similar style.) Founded by Thomas Cole, this movement was named the **Hudson River School** after the wide and beautiful river that runs through New York State. The romantic "Hudson River" artists saw in America a new, unspoiled land of great promise. They translated their vision into art by depicting many views of the Hudson Valley and other wilderness areas in the Northeast. The strong horizontal of the horizon line in Cole's *View on the Catskill, Early Autumn* (14-21), for instance, creates a calm, reflective mood. The winding river seems to meander slowly through a sunny world, fertile with possibilities.

Cole had many admirers and followers but only two pupils. One of these, Frederick Edwin Church, went on to become the most famous and successful American painter of his period. Born to a wealthy Connecticut family, Church surprised his parents by his desire to become an artist. They were eventually won over by his success, a success that allowed him to live a comfortable, even luxurious life and finally to build a kind of dream castle of his own design on a hillside overlooking the Hudson (see *Olana*, Chapter 9). In a sense, Church was the greatest example of a Hudson Valley painter; in another sense, he went beyond Cole and the other members of the school. He traveled throughout the world searching for romantic landscapes. Church was even able to transform the

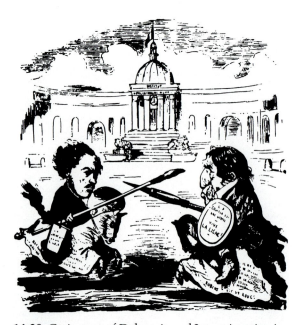

14-20 Caricature of Delacroix and Ingres jousting in front of the Institut de France. Delacroix: "Line is color!" Ingres: "Color is Utopia. Long live line!" (After a nineteenth-century print.)

symbol of Classicism into a Romantic ruin in his painting of the Parthenon (10-15). Church specialized in views of breathtaking grandeur, magnificent sunsets and sunrises, majestic mountains, waterfalls, volcanoes, and icebergs.

In works like *Twilight in the Wilderness* (14-22), he reveals his continuing interest in the symbolic power of landscape painting to excite human imagination and yearning for the infinite—as in the works of Friedrich and Turner. The dramatic, sweeping clouds that dominate the picture were painted with the new cadmium pigments: brilliant reds, oranges, and yellows then available for the first time. Contrasted against the green of the mountains and reflected in the mirrorlike blue lake, these luminous magentas and pinks convey the majesty of the American wilderness through their spectacular visual impact. At the same time, the vast sky with its glowing light seems to translate the idea of America as God's country—a land under special divine protection—into visual terms. Yet in 1860, the American wilderness was already

disappearing. Viewers who flocked to see Church's work at special exhibitions (where his paintings were displayed surrounded by curtains, like windows into another world) in New York City appreciated not only the

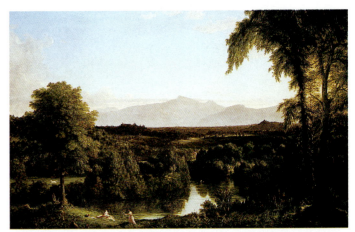

14-21 Thomas Cole, *View on the Catskill, Early Autumn*, 1837. Oil on canvas, 39" x 63". The Metropolitan Museum of Art, New York (gift in memory of Jonathan Sturges by his children, 1895).

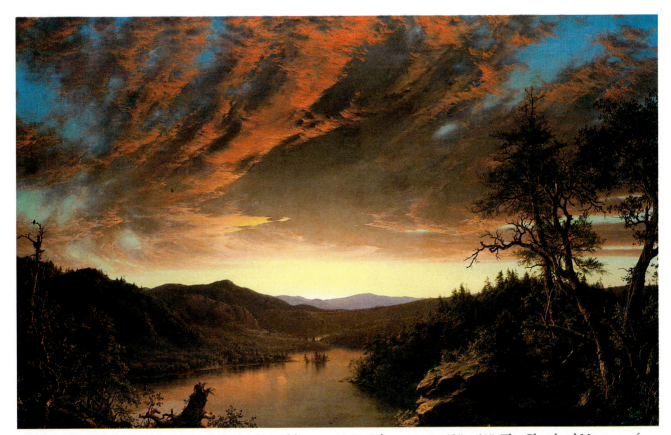

14-22 Frederick Edwin Church, *Twilight in the Wilderness*, 1860. Oil on canvas, 40" x 64". The Cleveland Museum of Art (Mr. and Mrs. William H. Marlatt Fund, 65.233).

grandeur of the American landscape but also the nostalgic sense that such an unspoiled wilderness was already disappearing. The late nineteenth century was, indeed, *Twilight in the Wilderness.*

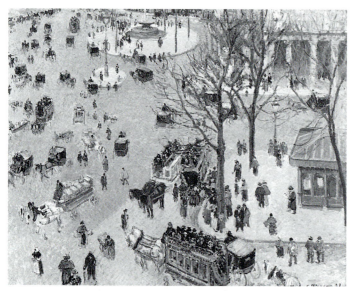

14-23 Camille Pissarro, *La Place du Théâtre,* 1895. Oil on canvas, 28½" x 36½". Copyright © 1992 Museum Associates, Los Angeles County Museum of Art. All rights reserved (Mr. and Mrs. George Gard de Sylva Collection).

A New Audience in the Modern City

The nineteenth century witnessed the creation of the modern city. Cities like Paris, London, and New York grew into huge metropolises. In the past, the royal court or the church had most often been the center of art patronage. But with the growth of the middle class in towns and cities, a new audience for art began to emerge. Newspapers and magazines commented on art and artists and reported on public opinion about the arts. The modern art market was born. No longer were most paintings done "to order" for wealthy collectors. Instead, artists created artworks in their studios, then attempted to sell their wares in galleries. Some became incredibly successful and wealthy; most struggled to make a living.

But most artists shared one thing—they lived in urban centers, where they could interact with each other and be part of an art world that included gallery owners and critics, as well as artists and collectors. The life of the city had a vital impact on these mid–nineteenth-century artists.

Nowhere was this more true than in Paris (14-23). The capital of France, once deserted by

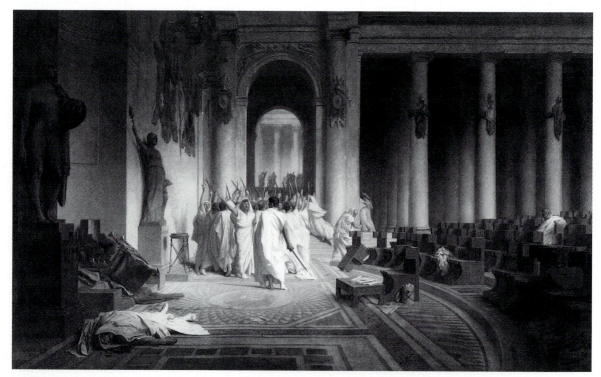

14-24 Jean-Léon Gérôme, *Death of Caesar,* 1859. Oil on canvas, 33⅝" x 57¼". Walters Art Gallery, Baltimore.

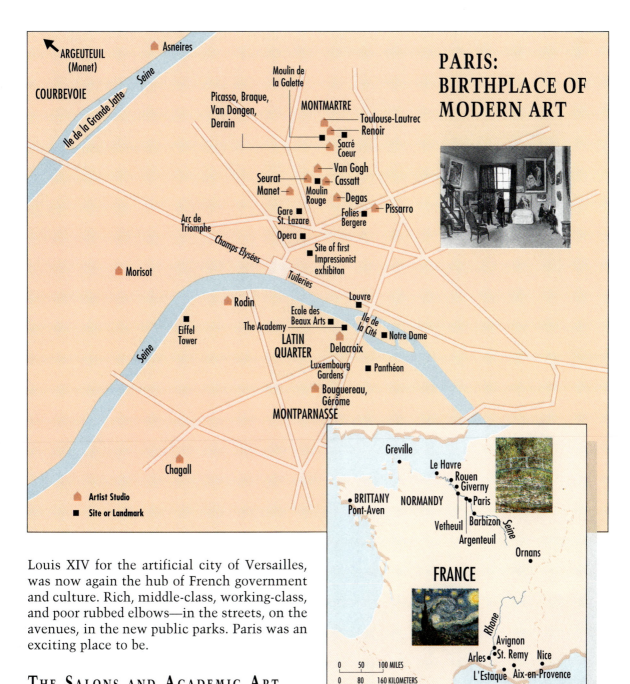

PARIS: BIRTHPLACE OF MODERN ART

Louis XIV for the artificial city of Versailles, was now again the hub of French government and culture. Rich, middle-class, working-class, and poor rubbed elbows—in the streets, on the avenues, in the new public parks. Paris was an exciting place to be.

THE SALONS AND ACADEMIC ART

Yet, in a very important way the art market in France had not changed. Begun in 1737, the annual **Salon** exhibitions in Paris, which were chosen by members of the French Academy and officially sanctioned contemporary art, remained the only important public exhibition available to artists. Although generally competently drawn and composed, academic painting had become largely a repetition of historical, mythological, literary, and exotic subjects, all presented in a similar style. Large canvases on epic historical and literary

themes like Jean-Léon Gérôme's *Death of Caesar* (14-24) were praised by the Academy as contemporary masterpieces.

But not all artists were satisfied with repeating the formulas of the past. Once again, a new generation rose up to challenge old doctrines and propose new solutions. What was unusual was not so much the challenge itself; we have seen others before: the Mannerists versus the High Renaissance, or the

Neoclassicists versus the Rococo. But the bitterness of the earlier battles was nothing compared to the hostility inspired by the radical art movements of Realism, Impressionism, and Postimpressionism. In part, this happened because, as these styles evolved, they began to challenge the most important premises of Western art. It was in the nineteenth century that the ideals of Renaissance artists were overthrown and a new world of possibilities opened up for what would be known as Modern Art.

REALISM: ART AND POLITICS

The work of the French Realist Honoré Daumier in the 1830s was already a dramatic departure from the official art of the Salon. Daumier began his career as an illustrator but soon became a political cartoonist whose work was published in a number of satirical journals.

Caricatures showing King Louis Philippe as *Gargantua*, a greedy giant swallowing up the people's earnings (14-25), and another picturing his face as a fat pear landed the artist in jail for six months.

Although Daumier shared liberal political views with Romantic artists like Delacroix, his work is far more direct and realistic. In *Rue Transnonain* (14-26), like Delacroix, Daumier was recording a battle between the people in Paris and the government. In this case, workers joined in a week-long protest against a new law that prohibited unions. One night, a lone sniper in a working-class apartment shot and killed a soldier. The remaining soldiers stormed the residential building and massacred the families they found inside.

In Daumier's lithographic print, it dawns on the viewer only slowly that a terrible tragedy has occurred—an entire family has been murdered. Unlike Delacroix, the Romantic, who chose the tone of an enthusiastic sup-

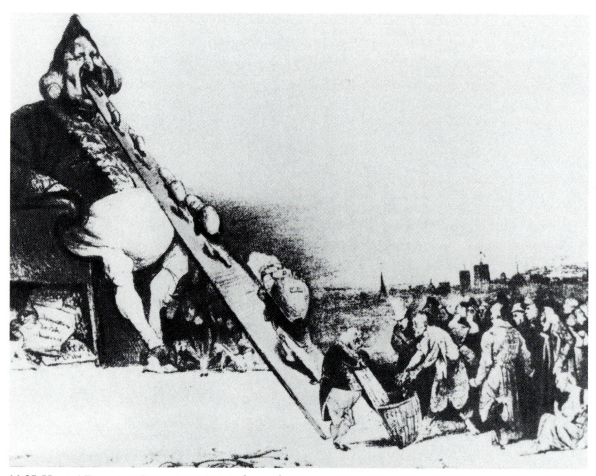

14-25 Honoré Daumier, *Gargantua*, 1831. Lithograph.

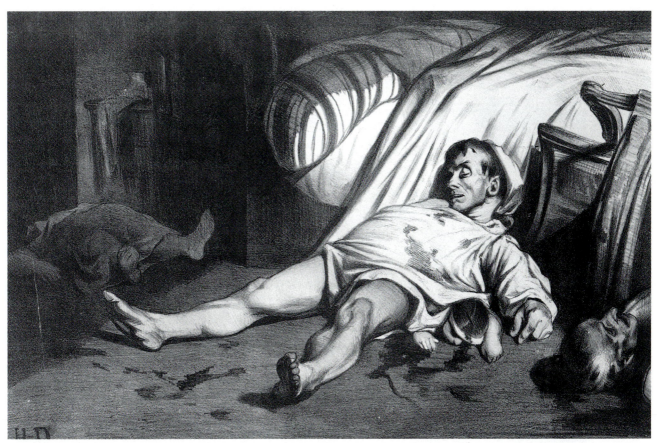

14-26 Honoré Daumier, *Rue Transnonain*, 1834. Lithograph, 11¼″ x 17⅜″. Philadelphia Museum of Art (bequest of Fiske and Marie Kimball).

porter to show a revolt's heroic elements, Daumier, the Realist, honestly depicts the tragic aftermath of unjust violence. Rather than viewing the tragedy as heroic, Daumier stresses the bloody, messy, and also almost ordinary aspect of death.

Despite his challenges to governmental authority, Daumier was not the most controversial of French Realists. The most famous of the French Realists was Gustave Courbet, an artist who was not content simply to caricature society but who actively set out to offend it. As a result of his radical political views, Courbet began exhibiting pictures that shocked the conservative Salon. On huge canvases, he painted ordinary working people— not just working-class people but people actually doing work, like his *The Stone Breakers* (14-27). Critics recognized the antibourgeois and anticapitalist message of this new art and considered his annual entries to the Salon insults to its traditions and values.

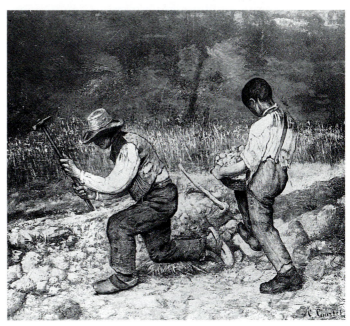

14-27 Gustave Courbet, *The Stone Breakers*, 1849. Oil on canvas, approximately 65″ x 94″ (painting lost during World War II).

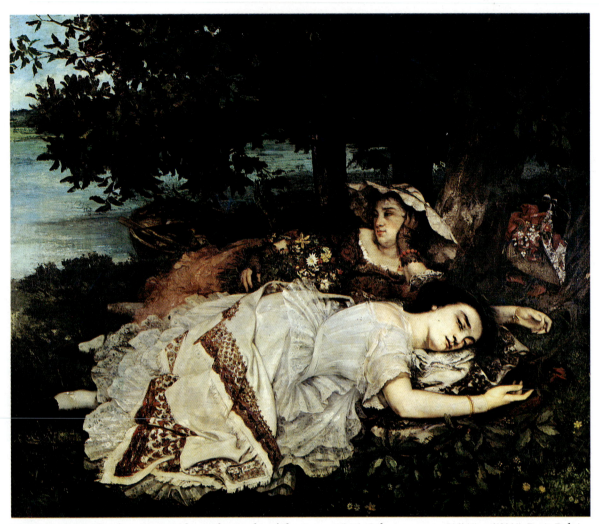

14-28 Gustave Courbet, *Two Girls on the Banks of the Seine*, 1856. Oil on canvas, 5′6½″ x 6′9⅛″. Petit Palais, Paris.

For example, in 1857 Courbet presented the Salon with a picture of two young women openly lounging on the banks of the Seine (14-28). (The girl in the foreground has taken off her dress and is lying openly in her underwear, a corset and petticoat.) Whether they were prostitutes or simply young working women, they were clearly not respectable. Courbet had taken a real scene from Paris life—a scene from which proper middle- and upper-class people would have turned their eyes—and glorified it by immortalizing it on a large canvas. Now these same people could no longer pretend "not to see" the seamy side of Parisian life. Visitors coming into the Salon to contemplate uplifting historical and mytho-logical subjects would discover a slice of life they would rather ignore.

A picture such as this appeared grace-less and ugly to most mid–nineteenth-century viewers, who either did not understand or did not agree with what Courbet wanted to accomplish. Popular taste called for women to be shown as goddesses and nymphs like *Nymphs and Satyr* by Adolphe William Bouguereau (14-29) or at least pure and unat-tainable like *Comtesse d'Haussonville* by Ingres. But it was against this kind of idealiza-tion that he, as a Realist, struggled.

The Realist painter Jean François Millet's inspiration came from rural life rather than the city. Millet had grown up among farming

at the edge of the field. Millet's method of handling paint seemed as rough as his subjects. Instead of creating the smooth, glazed surface favored by the French Academy, Millet almost piled his paint on the canvas. Areas of colored pigment became dense and heavy. His colors were most often earth tones or grayed neutrals.

According to critics, his pictures were socialistic and ugly; one even said they had the odor of those who did not change their linen. Millet probably did not consider this an insult.

IMPRESSIONISM

THE SALON DES REFUSÉS AND MANET

In 1863, four thousand artists were refused by the official Salon. The rejections became such a scandal that the French emperor, Napoleon III, sponsored an alternative exhibit—known to history as "The Salon des Refusés." For the first time, the state had sponsored a show not approved by academic juries. Artistic freedom of speech was now officially supported. Of all the pictures on display, one in particular excited the liveliest debate and most bitter condemnation. Painted by a young artist named Édouard Manet, it showed a naked woman picnicking with a group of well-dressed

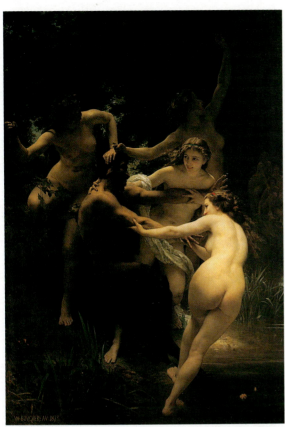

14-29 Adolphe William Bouguereau, *Nymphs and Satyr*, 1873. Oil on canvas, 102⅜" x 70⅞". © 1989 Sterling and Francine Clark Art Institute, Williamstown, Massachusetts.

people. After a decade of living in Paris, where he received academic training, he returned to the countryside. From the first, Millet was attracted to the theme of work and workers. In the past, artists had often shown peasants as humorous or picturesque subjects. Millet made them monumental. With bent backs, his workers (male or female) seem to have been shaped from the earth they tend. In *The Gleaners* (14-30), which was displayed at the Salon of 1857, Millet shows three women gathering the "gleanings," or leftover grains, from a field that has already been harvested. These are the poorest of the poor—landless peasants who must toil all day in what was literally backbreaking labor just to collect a few grains. To translate this reality into pictorial terms, the artist shaped the women almost like lumps of clay and echoed the placement of their figures in the haystacks

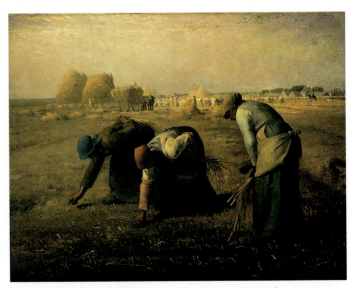

14-30 Jean François Millet, *The Gleaners*, 1857. Oil on canvas, 33" x 44". Louvre, Paris.

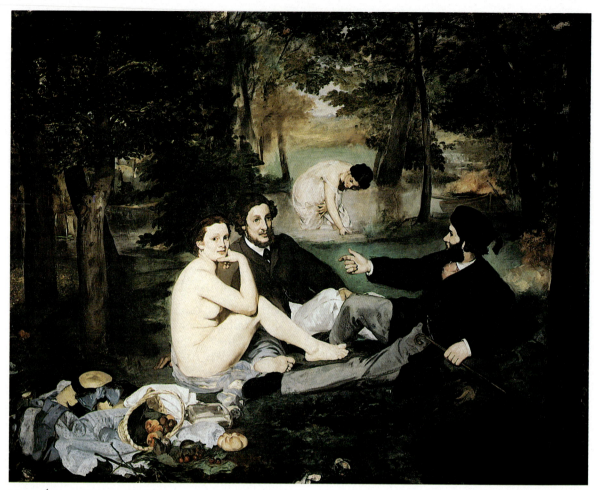

14-31 Édouard Manet, *Le Déjeuner sur l'herbe*, 1863. Oil on canvas, 7′ x 8′10″. Musée d'Orsay, Paris.

middle-class gentlemen in a park. Both the subject and the way it was painted were criticized at great length in the press. Indeed, the art public experienced *Le Déjeuner sur l'herbe* (Luncheon on the grass; 14-31) as a slap in the face. Many art historians have called it the first example of Modern Art.

Manet was a wealthy member of the Parisian *bourgeoisie* (upper middle-class) and had not deliberately set out to be the same kind of radical artist as Courbet. However, as an art student he had shown little interest in the academic tradition. He said when he went to class, it was like entering a tomb.

Le Déjeuner sur l'herbe was meant by Manet to be seen as a painting in the academic tradition—a nude reclining in a landscape, a theme that had been popular since the Renaissance—but reinterpreted in a modern, realist fashion. However, because Manet clothed his

gentlemen in contemporary dress, Parisians found that the scene had many of the same shocking sexual overtones they had objected to in Courbet's *Two Girls on the Banks of the Seine*. Manet's woman appeared not to be a classical goddess, simply a prostitute. To show such a naked, shameless creature in the midst of dallying with young men scandalized the bourgeoisie. Some wondered if he were joking.

The way Manet painted was considered just as offensive as his choice of subject. To many viewers this immense canvas seemed like an unfinished sketch. The nude was particularly criticized for lacking beauty. She had been painted boldly, in high contrast without transitional tones or shades (14-32). The stark contrast between her pale body and the dark background also appeared crude and awkward, as if the artist did not know how to do any better. The figure, however, does not reveal

14-32 Detail of figure 14-31

incompetence but Manet's fascination with the new media of photography. Early photographs showed Manet that extremely realistic images could be made even if one eliminated most detail and subtle shades.

Manet's style also owed something to past masters. The Baroque master, Velázquez, was a lifelong influence. Velázquez (see detail of *Las Meninas*, 13-17) had created his realism by suggestion, not with precise details but by capturing the way light hit surfaces. Under his influence, Manet began to paint in strong and defining strokes, creating bold and flat shapes. As Manet developed as an artist, the very arrangement of these strokes of paint, their placement on the canvas, was becoming an important part of the painting itself. That is, the *way* in which Manet used paint was becoming as important to him as his subject matter—it actually was becoming the subject of his work. This would become one of the central ideas of Modern Art.

OUT OF THE STUDIO AND INTO THE LIGHT

Manet became a symbol for the young painters of Paris. Although Manet never took part in the exhibits arranged by these radical young artists, who would soon be known as the **Impressionists**, he came to be seen as the "father" of the new movement. The younger

painters were interested in working outdoors, directly from nature. They were assisted by a new invention of the 1840s—the packaging of oil paints in metal tubes—which made oil paint portable for the first time. Previously artists had mixed hand-ground pigments with oils in the studio—a painstaking, time-consuming procedure. For this reason, outdoor sketches were done in pencil, chalk, or watercolor and only later transferred to oil on canvas, an indirect method of portraying reality.

This new generation of artists drew from their experiences around Paris. While sharing the goal of the Realists to show ordinary contemporary life, their palette was much brighter. As Manet began to work alongside these younger painters, particularly Claude Monet (see the next section), his colors also became brighter and lighter. Inspired more by Japanese prints (see "A Global View," p. 358) and the life of the city around him and less by past masterpieces, Manet's work began to resemble that of his Impressionist followers. Air, color, and light entered his work.

In 1874, a little more than a decade after he electrified the art world with *Le Déjeuner sur l'herbe*, Manet painted a Parisian couple boating on the Seine (14-33). Here we can see the influence of the younger Impressionists on his style, especially in the choice of lighter, brighter colors, broken brushstrokes (as in the

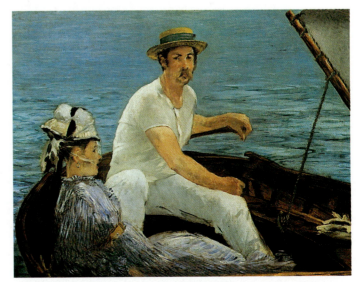

14-33 Édouard Manet, *Boating*, 1874. Oil on canvas, 38¼" x 51¼". The Metropolitan Museum of Art, New York (bequest of Mrs. H. O. Havemeyer, 1929. The H. O. Havemeyer Collection).

woman's dress and the water), and the immediate, split-second view. In comparison, Manet's earlier painting seems dark and old-fashioned, with its small figures set in the midst of a traditional landscape. Retaining his strong sense of design and bold handling of paint, by the mid-1870s Manet expressed himself confidently in the new Impressionist style.

MONET, THE PURE IMPRESSIONIST

To truly understand the essence of the Impressionist movement, one must examine the work of Claude Monet. Monet not only painted the picture that gave Impressionism its name, he also represents the purest example of the Impressionist method, subject matter, and spirit. In the 1860s, there was a fresh breeze in the air. The word for it was "modern." To be modern was to be alive, youthful, and optimistic. The most modern city was Paris, and young

artists streamed to it filled with enthusiasm. They painted the outdoor life of the city, its suburbs, and popular resorts. At the floating restaurant and dancing pavilion known as *La Grenouillère* (14-34), artists, writers, musicians, and dancers—male and female—came from Paris (the trip took less than an hour) to fish, row, swim, eat, drink, dance, and relax.

In his view of the restaurant, Monet achieved heightened color effects by placing colors side by side rather than mixing them. The water in the foreground, for instance, is made up of rough, overlapping, unblended strokes of sky blue, white, and black, with dabs of gold ochre added to suggest the reflection of the floating pavilion on the ripples of the river (14-35).

In 1872, Monet completed a painting that was destined to give an ironic title to the whole new movement that he and other painters had begun. *Impression: Sunrise* (14-36) was a

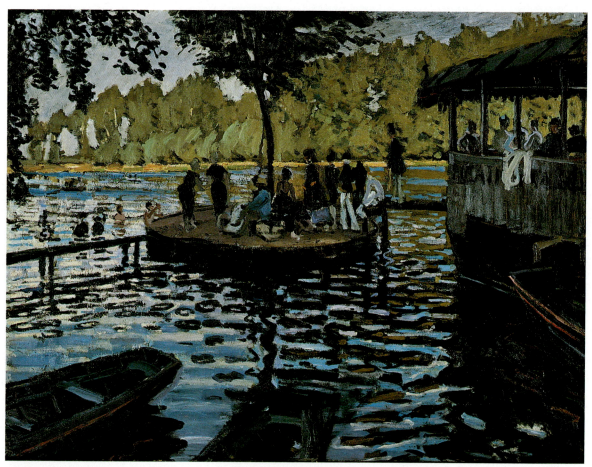

14-34 Claude Monet, *La Grenouillère*, 1869. Oil on canvas, 29⅜" x 39¼". The Metropolitan Museum of Art, New York (bequest of Mrs. H. O. Havemeyer, 1929. The H. O. Havemeyer Collection).

14-35 Detail of figure 14-34

view of the French port of Le Havre with the sun just visible over the horizon. Its vivid colors and lack of detail or outline convey an immediate impression of a place and time of day. This painting was part of the first independent exhibit organized in 1874 by Monet and his friends. They called themselves the *Société Anonyme* (or Incorporated Society) of Artists, Painters, Sculptors, Engravers, and so on. The exhibit was not well received. The paintings lacked the "finish" that the public associated with great art, were "too freshly painted," and seemed to resemble sketches rather than completed works of art. "Wallpaper in its embryonic state is more finished than this seascape," wrote one critic of *Impression: Sunrise*. Noting the title of the work, he titled his review, "Exhibition of the Impressionists"; with that name they became known to their contemporaries, and to history.

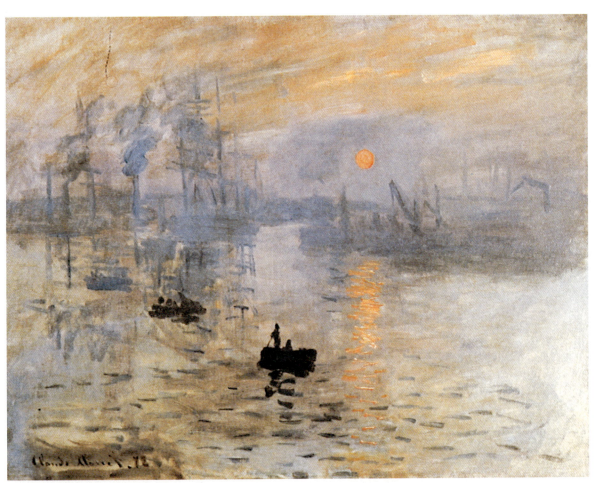

14-36 Claude Monet, *Impression: Sunrise*, 1872. Oil on canvas, 19⅝" x 25½". Musée Marmottan, Paris (Collection Donop de Monchy).

MONET IN GIVERNY

Several more Impressionist exhibitions occurred, all receiving negative reviews. Most of the artists lived a hand-to-mouth existence. But by 1883, Monet had managed to sell some of his work. He rented a farmhouse in Giverny, a small village on a river outside Paris. Now living in the French countryside, he began to explore new visual themes—rivers, trees, and fields. As the years passed, Giverny became more and more central to Monet's work. Eventually he purchased the property, which became not only a family home and studio but also the setting for his famous gardens and the subject of much of his later work.

In 1888, he began the first of his famous series paintings with several views of the muffin-shaped stacks of wheat in a neighbor's field. Repeating the same subject, popularly known as "haystacks," over and over, Monet painted dozens of views in different conditions of weather and different times of the day. As he worked, Monet became sensitive to minute and subtle differences in his subject over short periods of time—in as little as twenty minutes or half an hour, he discovered that the light had changed. Thus he set up a series of canvases and worked on each one only as long as the view remained the same. Eventually twenty-five paintings were completed.

In *Grainstacks (End of Summer)*, 14-37, Monet shows the long shadows and golden light of late afternoon. In comparison with his earlier work, the colors are richer and the brushstrokes heavier, laden with creamy, thick paint. Monet uses paint to create a purely pictorial texture, a texture that boldly states that we are looking at paint on canvas, not a photograph of reality. Yet, at the same time, Monet is attempting to convey something about the natural world—a quality of light and atmosphere—through his color. The setting sun has turned the grainstacks orange and pink, warm against the bluish shadows. The Impressionist use of such vibrant colors reflects nature and the way we see. Lights are

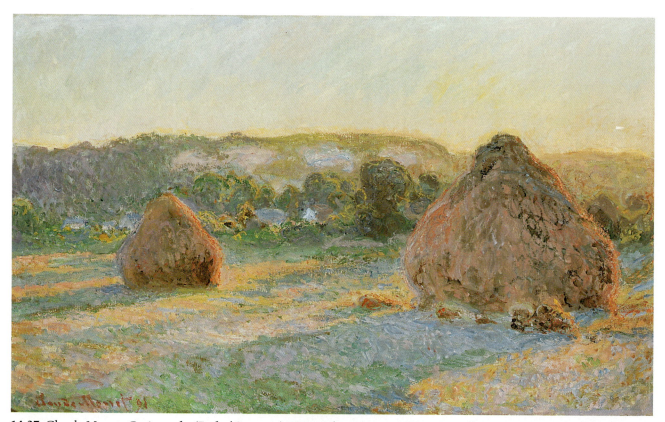

14-37 Claude Monet, *Grainstacks (End of Summer)*, 1891. Oil on canvas, 23½" x 39". The Art Institute of Chicago (Arthur M. Wood in memory of Pauline Palmer Wood, 1985.1103). Photograph © 1993, The Art Institute of Chicago. All rights reserved.

not made up of white alone, nor darks of black and gray; in reality, lights and shadows vibrate with color. This had always been part of the Impressionist technique; now Monet pushed further, exaggerating natural colors for a heightened effect.

With the money he made from his new work, Monet created his own natural paradise at Giverny. He designed and planted a lush garden where water reflected beautiful and exotic flowers. In addition to landscaping the grounds and designing the plantings, Monet added touches such as a Japanese footbridge (14-38). All of this became the subject of his late work.

During the last twenty years of his life, Monet created his most radical work—paintings that appeared dramatically new even when compared to works by the much younger Picasso and Matisse (see Chapter 15). His final project was a series of panels of the water lilies that bloomed in his gardens (14-39). He called them decorations and planned that each would be 6½ feet high by 14 feet long. The resulting paintings remain his most famous and popular works. Although the subject—water lilies in a pool that also reflects the sky and gardens around it—can be recognized, it seems almost incidental to the beauty and power of the densely painted image. Three-dimensional form has finally dissolved into pure color, texture, and paint. Vibrant purples and greens float across the canvas; the visual play of color and painted line, the variations of painted texture, the creation of a purely pictorial space built up from individual strokes of color (see detail,

14-40)—the Impressionist style had evolved into something dramatically modern, unprecedented in the history of Western art.

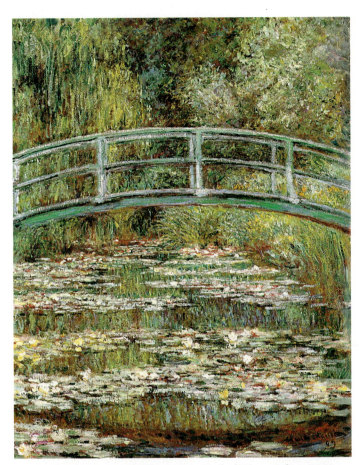

14-38 Claude Monet, *Bridge over a Pool of Water Lilies*, 1869. Oil on canvas, 36½" x 29". The Metropolitan Museum of Art (bequest of Mrs. H. O. Havemeyer, 1929. The H. O. Havemeyer Collection).

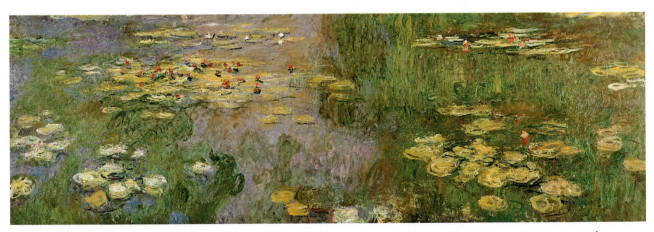

14-39 Claude Monet, *Nympheas (Water Lilies)*, 1920–1921. Oil on canvas, 77^{15}/$_{16}$" x 234^{7}/$_{8}$". Carnegie Museum of Art, Pittsburgh, Pennsylvania (acquired through the generosity of Mrs. Alan M. Scaife, 1962).

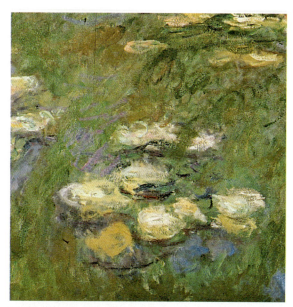

14-40 Detail of figure 14-39

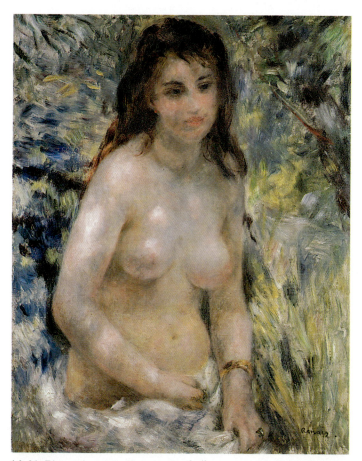

14-41 Pierre-Auguste Renoir, *Study* (known as *Nude in the Sunlight*), 1875. Oil on canvas, 32" x 25½". Musée d'Orsay, Paris (Galerie du Jeu de Paume, bequest of Gustave Caillebotte, 1894).

RENOIR

Another artist whose pictures infuriated the critics, although they seem quite beautiful to modern eyes, was Monet's friend, Pierre-Auguste Renoir. They had met as students, and abandoning their formal training, often painted side by side. They shared bread and the insults of critics. The year after *Nude in the Sunlight* (14-41) was completed, 1876, a well-known journalist wrote that the second Impressionist exhibit was made up of "five or six lunatics" attempting "the negation of all that has made art what it is." Another critic compared the flesh of Renoir's nudes to "a mass of decomposing flesh with those purplish green stains which denote a state of complete putrefaction in a corpse." Yet, more than one hundred years later, Renoir's portraits of women are tremendously popular (see *La Loge*, 1-37).

Like all the Impressionists, Renoir wanted to show the life he saw around him in Paris. But even more than the others, he was concerned with human interactions and moods. While Monet retreated from Paris to the fields and gardens of Giverny, Renoir always remained (in his own words) "a painter of figures." One of his most successful figure compositions, and one that seems to express all the lighthearted gaiety of Parisian life, was *Le Moulin de la Galette* (14-42). The subject was a popular outdoor cafe where young middle-class couples could eat, drink, and dance. Renoir used several of his friends as models for the figures sitting at the tables or whirling around the dance floor.

The dappled light, broken brush strokes, and bright colors are typical of Renoir's Impressionist style. Pinks are often contrasted with cool blues, yellows set against darks—but the darks themselves are vibrating with strokes of different colors. Somehow Renoir evokes not only the light of a late spring afternoon as it filters through the trees but also the movement of the dancers, the flutter of the breeze, the murmur of the crowd, the music and conversation, the taste of the wine—the pleasures of this particular place and time.

MORISOT

If the press was outraged by radical male artists, it found a female working in the bold

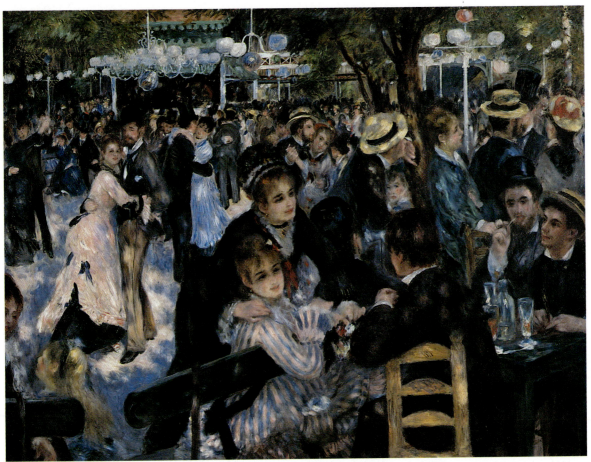

14-42 Pierre-Auguste Renoir, *Le Moulin de la Galette*, 1876. Oil on canvas, 51″ x 68″. Musée d'Orsay, Paris.

new style even more appalling. Wrote one critic of Berthe Morisot: "There is also a woman in this group, as there nearly always is in any gang . . . and she makes an interesting spectacle. With her, feminine grace is retained amidst the outpourings of a mind in delirium." In *Villa at the Seaside* (14-43), Morisot painted the typical Impressionist subject of a popular resort but with the added intimacy of a mother and child in the foreground. The loose handling of paint throughout the scene clearly shows the influence of Manet. In some areas, like the woman's shawl and veiled hat, Morisot's brushstrokes practically become abstract slashes with no relationship to reality. As her style developed, Morisot painted more and more freely and used a lighter and lighter palette. The basic ideas behind Impressionism were in harmony with her own—"to set down something as it passes, oh, something, the least of things!"

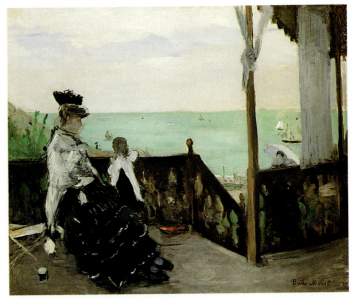

14-43 Berthe Morisot, *Villa at the Seaside*, 1874. Oil on canvas, approximately 19¾″ x 24⅛″. Norton Simon Art Foundation, Pasadena, California.

DEGAS AND CASSATT

If Monet, Renoir, and Morisot were the most typical of the Impressionists, Degas would seem to be the least. Most of his paintings are far from the open-air bustle of happy middle-class Parisian life that the public identifies as "Impressionism." First, Edgar Degas was not a member of the bourgeoisie but a wealthy, rather snobbish young man from an aristocratic family. Second, while most of the Impressionists consciously rejected academic drawing, Degas truly admired the Neoclassicist Ingres (see Chapter 2). The beauty of Degas's line remained one constant throughout his career.

Like Renoir, Degas recorded the everyday life of the Parisian capital. He rarely painted outdoors but was particularly fascinated by the pictorial opportunities he found in the world of the theater and ballet—rehearsals, performances, or backstage. Despite his preparation of many preliminary drawings, his pictures do not appear formalized and stiff but like candid snapshots. In fact, photo-

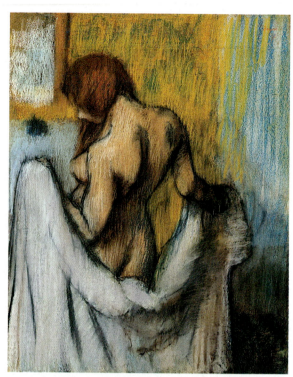

14-45 Edgar Degas, *Woman with a Towel*, 1894. Pastel on paper, 37¾" x 30". The Metropolitan Museum of Art, New York (the H. O. Havemeyer Collection, bequest of Mrs. H. O. Havemeyer, 1929).

graphy added an important element to Degas's masterful and innovative compositions. For instance, in *The Orchestra of the Paris Opera* (14-44), Degas shows the opera ballet on stage but arbitrarily cuts their heads out of the picture. The cropping gives a quality of immediacy to his observations. Such novel arrangements made the impact of his images seem more alive.

In his late years, pastel became Degas's favorite medium. Where his oil paintings are often darker than the rest of the Impressionists, the colors he used in his pastels like *Woman with a Towel* (14-45) were vibrant, applied to the paper unmixed. At the same time, Degas combined these bold colors with his taste for strong design and beautiful lines. Notice how the composition is based on the complementary curving lines of the woman's shoulders and back contrasted to the U-shape of the towel. He allowed the strokes of the chalk to remain visible, clearly showing the viewer how he constructed his picture from lines of color. The color scheme places gold against turquoise, orange against green. The

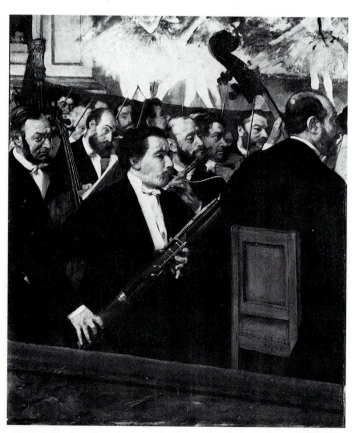

14-44 Edgar Degas, *The Orchestra of the Paris Opera*, 1868–1869. Oil on canvas, 22" x 18". Louvre, Paris.

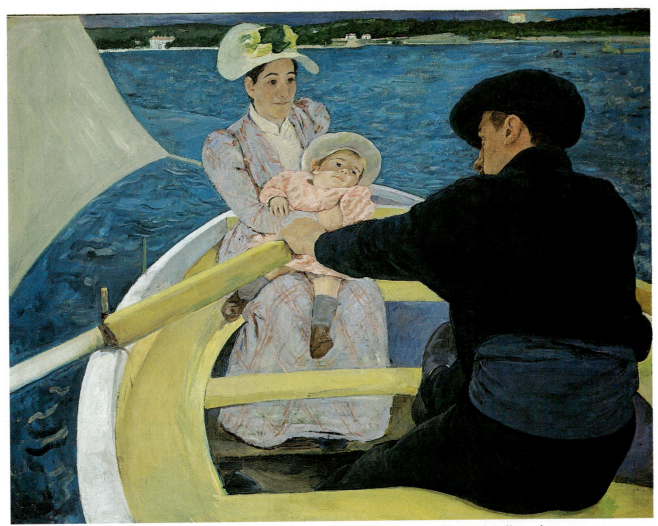

14-46 Mary Cassatt, *The Boating Party*, 1893–1894. Oil on canvas, 35½" x 46⅛". National Gallery of Art, Washington, D. C. (Chester Dale Collection).

drawing has been greatly simplified, and the fussiness of detail is lacking. Degas's art draws its power from a fusion of Ingres's line, the solid form and composition of the great Renaissance masters, and the spontaneous realism of Impressionism.

Although Degas often used women, especially working-class women, for his subjects, he said more than once that he detested females. Despite this prejudice, Mary Cassatt won his respect and became a pupil and eventually a close friend. Born of a wealthy family from Pittsburgh, Cassatt studied art in Philadelphia before coming to Europe and eventually settling in Paris. Although her father supposedly said that he would rather see her dead when she first proposed going abroad to study art, her family provided enough money

to be sure that she would never suffer the privations of Monet's early years.

Like Degas, Cassatt was more interested in line than the other Impressionists, and her work was also strongly influenced by Japanese prints (see 5-10 and "A Global View," p. 358). Her favorite subjects were women and children shown in unguarded moments. Most nineteenth-century artists would have sentimentalized this theme of a mother and her sleepy child on a boat ride in *The Boating Party* (14-46). Instead, Cassatt uses the everyday incident as the basis of a dynamic composition. The strong horizontal seats of the rowboat, the thrusting diagonal of the oar, the broad expanse of the sail contrasted with the flat surface of the water, the opposing curves of the boat's gunnel and the back of the rower all

create an almost abstract composition of flat shapes and lines balanced against each other. The boldness of her shapes and colors—an acid lime-green against bright blue—are another reminder, as in Monet, Degas, and Renoir, that the Impressionists never stopped developing. For most of these revolutionary artists, the Impressionist period of 1872–1886 was followed by an era of searching for new discoveries, new solutions to artistic problems.

RODIN'S TOUCH

The prolific nineteenth-century genius Auguste Rodin combined a love of past forms with an Impressionist sensitivity to artistic materials, along with a Romantic sensibility. Trained as a craftsman, Rodin showed an incredible sensitivity to his sculptural materials. In his hands marble became as sensuous as flesh, and cast-bronze figures like his *Walking Man* (7-13) showed the rough thumbprints of their original clay models. In this sense, much of his work (like that of the Impressionists)

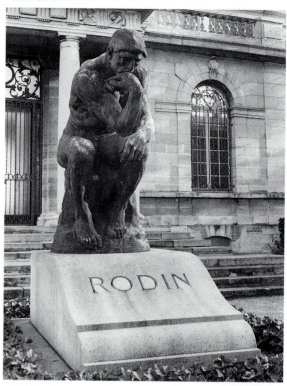

14-48 Auguste Rodin, *The Thinker*, 1880. Bronze, 70½" high.

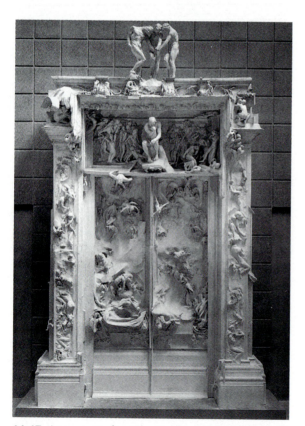

14-47 Auguste Rodin, *The Gates of Hell*, 1880–1917. Intended to be cast in bronze, fully assembled in plaster, 21' high x 13' wide x 3' deep. Musée Rodin, Paris.

appeared unfinished to viewers who expected flawless, almost mechanical smoothness in their statues.

However, Rodin's work was generally well received, and he won important commissions. *The Gates of Hell* (14-47), for instance, were originally designed as a doorway to be cast in bronze for a new Museum of Decorative Arts in Paris. With this immense door Rodin hoped to rival the greatest sculptures of the past, such as Ghiberti's bronze doors for the baptistery in Florence (Chapter 12). Rodin took his inspiration from Dante's poem "Inferno" (one book of *The Divine Comedy*). In a sense, the long shadow of Michelangelo (the artist Rodin most admired) also falls over *The Gates of Hell*. They are a kind of sculptural equivalent of *The Last Judgment* (12-25). Yet, despite all references to the past, Rodin's interpretation of the subject was completely modern. Out of a pulsating surface of metal are drawn twisted, tortured, isolated figures. Rodin envisions humanity as both eternally damned and forever lonely—the bodies that emerge out of darkness are imprisoned in their own pain. Above it all, the famous figure of *The Thinker* (14-48) sits, pondering the scene.

THE POSTIMPRESSIONISTS

Almost all of the artists who came to be known as the *Postimpressionists* began working in the avant-garde style of their time, Impressionism. However, each became dissatisfied with Impressionism and developed a new approach. The most important figures of this new generation of artists were Toulouse-Lautrec, Georges Seurat, Paul Gauguin, Vincent van Gogh, and Paul Cézanne.

TOULOUSE-LAUTREC

Henri de Toulouse-Lautrec was an aristocrat of distinguished lineage and an adoring admirer of Edgar Degas. However, the older artist refused to associate with him. This was because Toulouse-Lautrec was a peculiar aristocrat who enjoyed the seamier side of French night life, the houses of prostitution, and the "cancans" (theatres where a risqué dance took place). He lived in an artificially lit world devoted to sordid pleasures. He came to live such a life because he suffered from dwarfism. Seen as "deformed" by his proper (and callous) father, he was treated as a humiliation to his family. Toulouse-Lautrec left his home as a young man and found acceptance among the prostitutes and cabaret artists of Paris. His childhood talent for drawing lead him to his career.

A comparison between Renoir's *Le Moulin de la Galette* (14-42) and Toulouse-Lautrec's *At the Moulin Rouge* (14-49) can help us understand the striking contrast between the

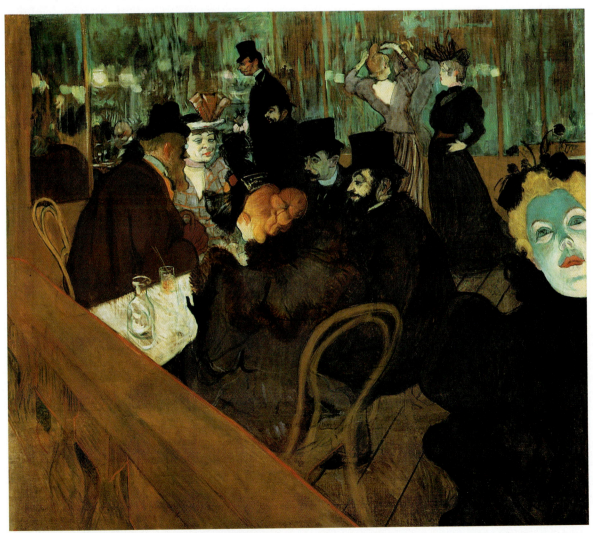

14-49 Henri de Toulouse-Lautrec, *At the Moulin Rouge*, 1892–1895. Oil on canvas, 4' x 4'7". The Art Institute of Chicago (Helen Birch Bartlett Memorial Collection, 1928.610). Photograph © 1993, The Art Institute of Chicago. All rights reserved.

Impressionist point of view and Lautrec's. In Renoir's cafe, the people are young and happy, celebrating the innocent pleasures of city life. In Toulouse-Lautrec's, the people are tired and ugly; we can almost smell the stale odors of cigarette butts and spilled liquor. One cafe is outdoors and filled with sunlight and color; the other is indoors and claustrophobic. In the friendly Impressionist painting, a pair of dancers look toward the viewers as if to invite us in. In contrast, the horrifying green-faced woman at the right of *At the Moulin Rouge* pushes directly toward the viewer, as if to say, "Do you belong here?" It should not be surprising then that Toulouse-Lautrec was never accepted into the Impressionist group and that Degas said that "all his work stinks of syphilis."

SEURAT AND POINTILLISM

A painter of the highest ambition, Georges Seurat wanted to use Impressionism to re-create the timeless, classical feel of Millet and achieve the modern equivalent of Greek art. Seurat worked for two years on his *A Sunday on La Grande Jatte* (14-50). Its size, 7 by 10 feet, puts it on the scale of the grand canvases of David and Géricault. But his subject is entirely different. There is no pomp, suffering, or tragedy. He shows us the pleasures of a warm Sunday afternoon.

The subject, the colors, and the light could have been painted by most of the Impressionists. However, *La Grande Jatte* is unlike a typical Impressionist picture in that it is the result of many drawings and oil sketches. For months, Seurat went daily to the island of La Grande Jatte to make studies. His concentration was so fierce that he did not respond to friends who tried to get his attention. Seurat was assembling a composition of perfect stillness with figures as solid as statues.

La Grande Jatte is Seurat's most famous picture and justifiably so. Its nearly 70 square

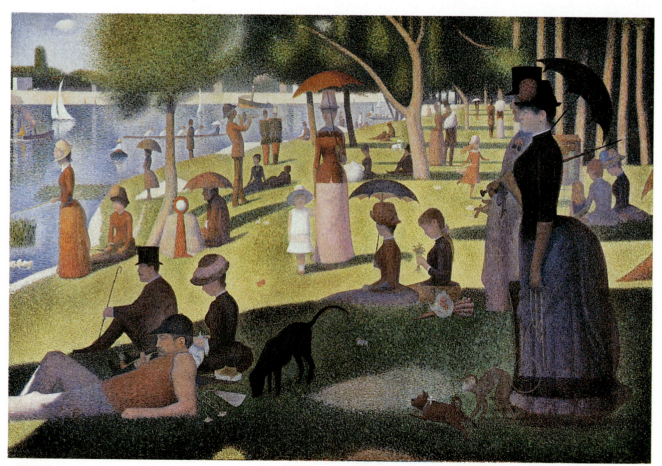

14-50 Georges Seurat, *A Sunday on La Grande Jatte*, 1884–1886. Oil on canvas, 6'9" x 10'. The Art Institute of Chicago (Helen Birch Bartlett Memorial Collection 1926.224). Photograph © 1993, The Art Institute of Chicago. All rights reserved.

feet of canvas is completely covered with tiny dots of color (see detail, 14-51), a method that was the result of years of experimentation. Seurat had noticed that, paradoxically, the smaller his brushstrokes, the more solid the form and the greater the intensity of the colors. His new method of painting, called *Pointillism*, helped him achieve what he had been searching for—more brilliance and light, as well as a sense of permanence.

The final form of the painting was created by a three-stage process. First, Seurat simplified the forms (people, trees, animals) until they were almost silhouettes and their basic geometrical shapes could be seen (his drawing, *L'écho*, 2-12, is a good example). Second, he arranged the forms into a satisfying composition, altering them when necessary to help them integrate with one another. Third, he painted the design in a Pointillist manner.

Pointillism was based on new scientific studies of seeing. Artists had always known that mixing colors in paint reduced their colors' intensity. These studies revealed that, by using colors only in their purest state and letting the viewer's eye *optically* mix them, an artist could increase the luminosity of the colors. This principle of color theory had been understood intuitively by Delacroix and Monet. They all had painted passages in their pictures where pure colors were set side-by-side rather than mixed to form a smooth blend. But Seurat was the first to utilize dots so the colors could optically mix more easily. The dots become virtually invisible when a viewer steps away from *La Grande Jatte*.

But it is not just a scientific method that makes this a great painting; there is also its subject. Seurat shows modern people living in the modern world. Despite the crowds of people and the many activities, there is very little interaction. They are all together yet all apart. This kind of privacy and loneliness is unique to the modern city.

GAUGUIN AND THE SEARCH FOR PARADISE

Paul Gauguin's life story brought him fame before his art did. He had been a successful stockbroker and banker who drew and painted for relaxation. He collected the work of the Impressionists and was friendly with them. The Impressionists liked his work well

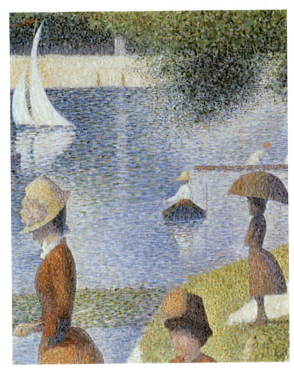

14-51 Detail of figure 14-50

enough to ask him to show with them. As a result, what began as a hobby began to take over his life. In 1883, he suddenly quit his job and decided to make a living as a painter. He abandoned his wife and children for a life of adventure, self-indulgence, and art. His story was what made him a celebrity in his own time.

Gauguin's ideas about art became as radical as his change in lifestyle. He felt that European art needed new life; its old vitality was gone. The Europeans had become too civilized; modern life was corrupted by cynicism. What was missing, he decided, was the energy of primitive art. To recapture the great powers of the universe that had been lost to intellectualism, he decided to become a primitive man himself. In essence, Gauguin was looking to return to the Garden of Eden. If he could find an unspoiled primitive paradise and enter it, it would rejuvenate him. And then he would be able to rejuvenate European painting.

At the world's fair of 1889 in Paris, Gauguin saw beautiful dancers from Java. He became convinced that the paradise he was looking for was in the tropics of the South Seas. In 1891, he went to Tahiti to escape from the decadence of Europe. There he lived

among the natives and painted their world. He lived in a shack, took a native girl as a wife, and eventually had a son.

Spirit of the Dead Watching (14-52) shows Gauguin's native wife lying on her bed, terrified of the dark. It is based on a conversation he had with his wife after he had left her alone for a night. The next morning she told him that in the darkness she had seen a dead spirit watching her. To capture the mood, he painted a solid young woman surrounded by an imaginary world. The space is confusing, the colors mysterious. Still, Gauguin could not entirely escape Western culture. The format is in the old tradition of the reclining nude established centuries before by Titian (see his *Venus of Urbino*, 12-23).

While Gauguin's life made him a celebrity among the general public, his art was what interested other artists. His idea of using primitive art to invigorate European art influenced many artists. So did his use of bright, powerful colors to present an inner, emotional truth. He freed color from the bonds of reproducing visual reality.

VAN GOGH:
FATHER OF EXPRESSIONISM

Before he left for Tahiti, Gauguin shared a house for a short period of time with a quiet man, one who would ultimately be much more

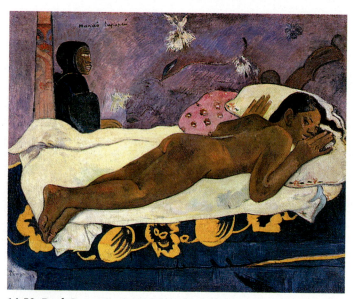

14-52 Paul Gauguin, *Spirit of the Dead Watching*, 1892. Oil on burlap mounted on canvas, 28½″ x 36⅜″. Albright-Knox Art Gallery, Buffalo (A. Conger Goodyear Collection, 1965).

famous—Vincent van Gogh. As a young man, he left his native Holland and worked as a preacher among miners. While there, he gave all his clothes, his money, even his bed to the impoverished. The authorities were frightened by his zealousness and forbid him to preach anymore. It was not until van Gogh worked in an art gallery owned by his uncle that he found his true mission. Seeing the work of Millet there, he suddenly decided to become a painter at the age of twenty-seven. In Millet, van Gogh found a sympathetic soul because he, too, wanted to portray the innate goodness in the hardworking lower class. Van Gogh was not a promising artist at first. He was a poor draftsman; his pictures were crude and clumsy. But he was stubbornly devoted to his mission and worked very hard, religiously, and made slow improvement. His *The Potato Eaters* (14-53) show people who keep God in their hearts. They have little else. The dark, depressing blacks and browns make this a gloomy scene. Yet light falls on their faces, revealing the simple goodness of this family. Despite the obvious clumsiness in van Gogh's technique, we can see his ability to transmit strong feelings. This will always be an important strength in his work.

Van Gogh went to Paris to study art, but life there proved difficult. Exposed to all the most dramatic advances in art, he began to feel the strain. Van Gogh left for the south of France, where the warmth of the sun would rejuvenate him. When he got on the train, he did not know where he would get off. He finally stopped in Arles, which he later called "the country of the sun." There he would have the most productive period of his life. The bright colors of the south would fill his work. He wrote, "I think that after all the future of the new art lies in the south."

In the space of three years, van Gogh went from being a clumsy amateur to a master of line (see 3-10). After ceaseless practice, his drawing had become sure, his lines rhythmic. Some of his advances were due to his study of Japanese art, which he had discovered in Paris (see "A Global View," p. 358). In the house that he rented in Arles, the walls were covered with Japanese prints. Working feverishly, van Gogh would paint for hours, then collapse and sleep for days.

Van Gogh secretly dreamt of a "school of the south" that he would create in Arles. In

June of 1888, he invited the living artist he most respected, Paul Gauguin, to come live there with him. Gauguin arrived in October, planning to stay a year, but the visit lasted only nine weeks. At first the men worked well together; they would work all day, and in the evening, exhausted, go off to a cafe. But Gauguin was not an easy man to get along with; neither was van Gogh. Tension soon developed between them, and they began to argue. A darker world now entered van Gogh's work. He wrote: "In my painting of *The Night Cafe* (14-54), I have tried to express the idea that the cafe is a place where one can ruin oneself, go mad, or commit a crime." Van Gogh stayed up three nights to paint this picture, sleeping only during the day. The contrast with his earlier interior, *The Potato Eaters*, is considerable. Dark browns and

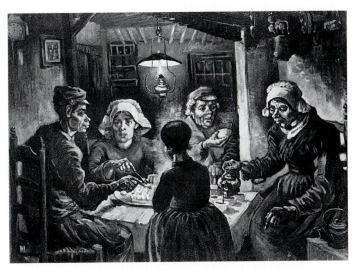

14-53 Vincent van Gogh, *The Potato Eaters*, 1885. Oil on canvas, 32¼" x 44⅞". Vincent van Gogh Foundation/Van Gogh Museum, Amsterdam.

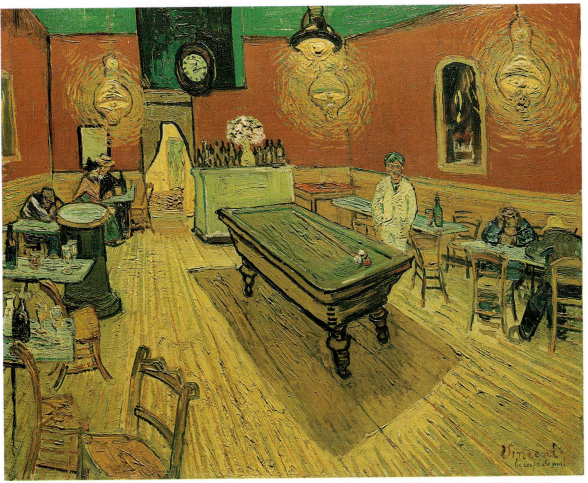

14-54 Vincent van Gogh, *The Night Cafe*, 1888. Oil on canvas, approximately 28½" x 36". Yale University Art Gallery, New Haven, Connecticut (bequest of Stephen Carlton Clark, B. A. 1903).

 A Global View

JAPONISME: PICTURES OF THE FLOATING WORLD

Twentieth-century art owes much to the dissatisfaction and desire for change felt by French artists of the late nineteenth century. Academic art, living on the vestiges of the Renaissance tradition, seemed tired and worn out to artists like Manet, Degas, and Monet. They and others were looking for a new way of making pictures.

It was at the same time that a fresh source, uncontaminated by Western culture, made its first appearance in Paris—Japanese prints. It was a propitious coincidence. These prints were to be crucial to the creation of Modern Art. To understand them, it is necessary to get a sense of the history and the culture that created them.

Japan in the 1500s was a land of rigid structures and rules. An official class system included (in rank order) the emperor and his family, the military dictators or shoguns, the samurai warriors, scholars, farmers, and tradespeople. In their rigidly structured society, the rich merchants had very little freedom. Since they were unable to buy power or influence, they could only spend their money on luxuries and pleasure. A hidden culture therefore developed, where the powerless could spend their yen. This underworld, located in Edo (now Tokyo), was known as *Ukiyo,* "the floating world," a place obsessed with rapidly changing fads, pleasure, and little thought for tomorrow. The art made for the floating world was known as **Ukiyo-e** or "pictures of the floating world." This art would later have a powerful impact on European artists and set off a wave of **Japonisme,** or the love of all things Japanese, in Western culture.

A whole section of Edo was filled with brothels and was known as the pleasure quarter. It was the only place in Japan where there were no class barriers. Utamaro's print (14-55) shows a variety of clients

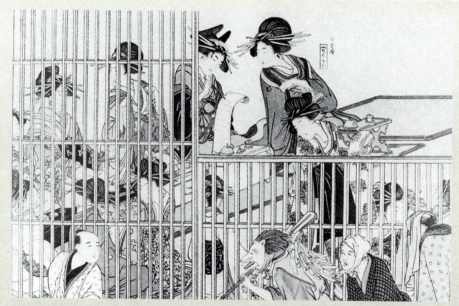

14-55 Kitagawa Utamaro, *Courtesans Waiting and Entertaining Themselves behind Sliding Grilles,* reproduced in S. Bing, *Le Japon Artistique,* September 5, 1888. Woodcut, 12⅝" x 8¾".

waiting for permission to enter a "green house." The casual, ordinary quality of Utamaro's scene was one of the most important reasons Japanese prints were so admired by Europeans. The battle of the Impressionists with the French Academy was not just a matter of new techniques and composition but over what subject matter was appropriate for art. After hundreds of years of the Academy prescribing lofty subject matter, images of everyday life seemed like a breath of fresh air. Degas's interest in documenting the seemingly trivial events of life, like *Woman with a Towel,* then can be traced to the influence of Japonisme. One of the most important types of Ukiyo-e were scenes of life at home.

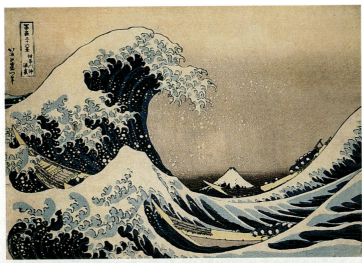

14-56 Katsushika Hokusai, *The Great Wave,* from *Thirty-Six Views of Mount Fuji, c.* 1822. Woodblock print, 10″ x 14¾″. Museum of Fine Arts, Boston (Spaulding Collection).

The composition of Japanese prints also inspired Western artists. Hiroshige's *Maple Leaves at the Tekona Shrine* (2-30) is an excellent example of how elements are cropped and arranged to design the empty space in a structure that ignores perspective. In essence, in Japanese prints everything is arranged for a decorative effect. Edgar Degas's use of cropping and unusual views in pictures like *The Orchestra at the Paris Opera* and Mary Cassatt's print *The Letter* (5-10) are more easily understood when one is familiar with Japanese prints.

The most famous and influential of the Japanese print designers on Europeans was a man named Hokusai, whose drawing we saw in Chapter 2. *The Great Wave* (14-56) is the most famous Japanese print in the West. The print is from *Thirty-Six Views of Mount Fuji,* a travel series that portrays Mount Fuji, a religious shrine, from different vantage points and seasons and in all kinds of weather. Hokusai is known for the power of his simple, almost abstract designs. All inessentials are removed. His drawing is strong and clear, with boldly defined outlines and strong, flat colors.

A final reason the Japanese prints remained so popular is because they were so cheap. Even a poor artist like van Gogh was able to amass a fine print collection. In fact, he stated that all his work was "founded on Japanese art" and went to the south of France under the impression that because of the warm sun there, the people were like the Japanese. He later wrote to Gauguin about his train ride, "I kept watching to see if I had already reached Japan!" While van Gogh tended to overstate his enthusiasms, it is quite clear when one looks at Impressionist and Postimpressionist art that the striking characteristics of Japanese prints—strong contour lines, flat color shapes, unusual cropping, and decorative patterns—had a major impact on the development of Modern art.

blacks have been replaced by intense colors. The red walls clash against the green ceiling. The floor is a sickly yellow; the lamps cast a dim light that hovers around them like moths.

One night, after a particularly violent argument, Gauguin stormed out of the house. Later that night van Gogh, a little drunk, a little mad perhaps, went into a local house of prostitution and handed his favorite girl a box. Attached to it was a note: "Keep this object carefully." Inside was part of his ear. He almost bled to death. He had severed an artery and was discovered in his bed unconscious. He lay in a coma for three days. Van Gogh had gone mad. From then on he would paint only in his occasional lucid moments. His *Self-Portrait* of 1889 (14-57) is a courageous representation of a man trying to be strong while fighting mental illness. It was painted in the asylum; the world is a confusing mass of blue-green swirls.

In another lucid moment at the asylum, van Gogh painted his greatest picture, *The Starry Night* (14-58). We are on a hill, looking below to a small town whose tallest feature is the steeple of a little church. In the distance are mountains. The stars have come out—with a vengeance. Large swirling balls of fire fill the sky. The ground the town rests on is unstable; it rolls as if in an earthquake. A large, dark cypress tree rises from the foreground like a brown tongue of fire. All the spiraling shapes are painted by van Gogh with thick lines of paint, sometimes squeezed directly out of a tube (14-59). *Starry Night* is a vision, a picture of his mental state. Van Gogh was not satisfied with an imitation of the world but wanted an intense re-creation of feeling.

Just two months after he had been discharged from an insane asylum, van Gogh completed his last painting, then shot himself. He was thirty-seven years old. It had been less than five years since he had painted *The Potato Eaters*. His best work was done in little more than two years. Yet his popularity, fame, and influence would be greater than all but a few artists. When van Gogh declared that artists should "paint things not as they are, but as they feel them," he articulated what would become one of the most important doctrines in twentieth-century art.

CÉZANNE'S REVOLUTION

Still, the Postimpressionist who would have the biggest impact on twentieth-century art was Paul Cézanne. Of all the Postimpressionists, Cézanne's work may be the most difficult to appreciate. This is because he *redid the way pictures were made*—a method developed slowly with years of painstaking work. His subject matter was far from revolutionary; he used three of the most ordinary types of painting: still lifes, portraits, and, the favorite of the Impressionists, landscapes. However, if we examine *Still Life with Apples* (14-60) closely, what appears at first to be a pleasant still life with some awkward passages proves to be more imaginative. Notice the distortion in the fruit bowl. Its back is tilted forward unnaturally. What you are seeing is not simply a clumsily drawn object. It is a sign that Cézanne is no longer obeying what artists had followed since the beginning of the Renaissance—the mathematical rules of perspective (see Chapter 2).

Cézanne was scrupulously honest. He believed that what the eye saw was the truth,

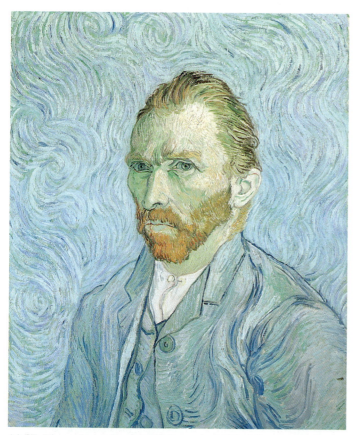

14-57 Vincent van Gogh, *Self-Portrait*, 1889. Oil on canvas, 25½″ x 21½″. Musée d'Orsay, Paris.

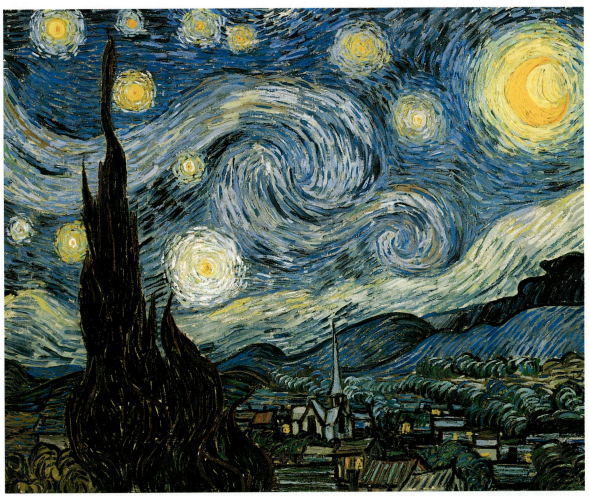

14-58 Vincent van Gogh, *The Starry Night*, 1889. Oil on canvas, 29″ x 36¼″. The Museum of Modern Art, New York (acquired through the Lillie P. Bliss Bequest).

and he realized that perspective was a lie. We do not really see in perspective. We are not one-eyed cyclopes, looking in one direction and one direction only. Cameras "see" like that, but people do not. People move their heads and their eyes when they are looking at something. Perspective, however, had been a very useful lie. It had helped organize paintings and given them the illusion of reality. What could replace it? Cézanne had the courage to try to find out, to go beyond perspective and try to re-create the way we actually see. This is what gives his pictures their fragmented look. His eyes were looking not at the whole scene but at each part separately. That is how we all see; we look from part to part, never really taking in the scene as a whole. Eventually we accumulate a sense of the scene. In fact, the world we know is a carefully constructed web of relationships—

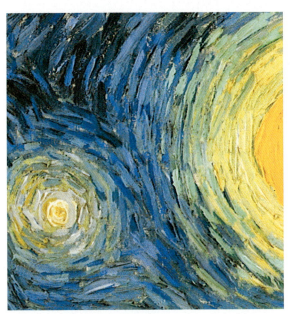

14-59 Detail of figure 14-58

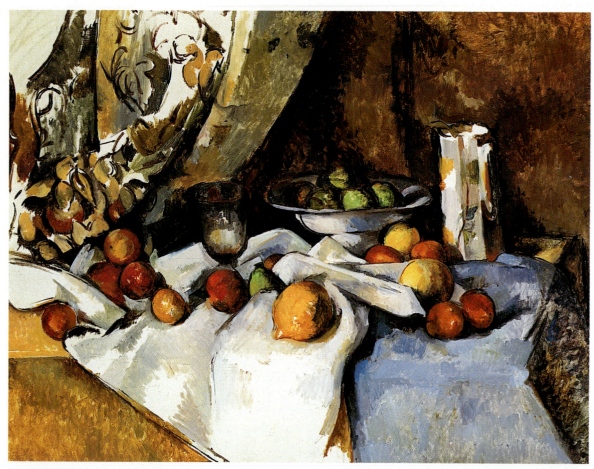

14-60 Paul Cézanne, *Still Life with Apples,* 1895–1898. Oil on canvas, 27″ x 36½″. The Museum of Modern Art, New York (Lillie P. Bliss Collection).

approximations of what is there. For example, look at the white of the vase on the right. Its white is actually the white of the canvas (14-61). The vase is formed in large part by the dark colors of the background; it is nearly an empty area on the canvas. Cézanne, through his study of color relationships, noticed that we see objects only when they contrast with what is around them.

It is impossible to look at Cézanne's pictures and not be aware of the painter himself. That is part of Cézanne's honesty—he does not conceal his brushstrokes; he reveals how all the parts of his picture were made. Cézanne used color, not lines, to create forms. He shared with the Impressionists a distaste for conventional drawing, which they associated with the antiquated French Academy. So Cézanne's shapes are constructed by little planes of solid color lying next to each other.

In *Boy in a Red Waistcoat* (14-62), you can see how Cézanne would narrow his focus to

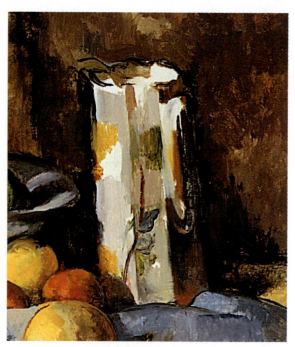

14-61 Detail of figure 14-60

study a specific relationship without paying attention to what could be seen elsewhere. Notice how the arm on the right is much longer than the one on the left. Cézanne never thought of the whole arm; he examined the relationship of each part of the vest to the adjacent part of sleeve. After he worked his way down and reached the end of the vest, he probably noticed that the boy's arm was unnaturally long. Most artists would at that point make corrections and make sure that the arm was in proportion to the rest of the body. But to Cézanne that would be dishonest. It was more important to record what he had seen than to have a "logical" picture.

Cézanne's pictures mark the end of the naturalistic approach that Giotto began in the 1300s. By rejecting perspective, the cornerstone of art since the Renaissance, Cézanne opened up a Pandora's box in our century. Artists became free to pursue their own vision and ignore the fundamental rules of academic art. His influence on the painters of the next generation is profound. The work of the two most important painters of the twentieth century, Henri Matisse and Pablo Picasso (see next chapter), would not be possible if Cézanne had not lead the way. His relatively small pictures with the most ordinary of subject matter changed the course of art history.

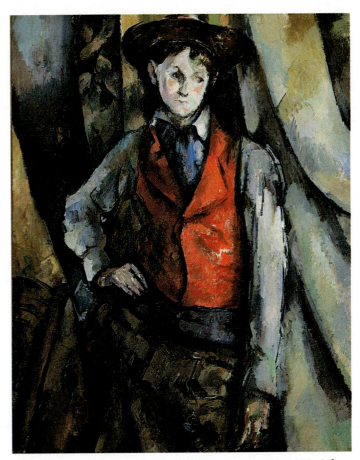

14-62 Paul Cézanne, *Boy in a Red Waistcoat*, 1888–1890. Oil on canvas, 35¼" x 28½". Collection of Mr. and Mrs. Paul Mellon, Upperville, Virginia.

CHAPTER

15

THE REAL WORLD ON TRIAL: THE EARLY TWENTIETH CENTURY

	PERIOD	HISTORICAL EVENTS	
1880–1900	Expressionism Art Nouveau Japonisme	San Francisco earthquake 1892 Wireless invented by Marconi 1895 Pierre and Marie Curie discover 　radium 1898	Freud, *The Interpretation 　of Dreams* 1900 Tchaikovsky, *Swan Lake* 1895
1900–1914	Die Brücke (German Expressionism) Fauvism Picasso's Blue Period Analytical Cubism Futurism Photo-Secession	Death of Queen Victoria 1901 Wright Brothers' first powered 　flight 1903 Einstein, *Special Theory of 　Relativity* 1905 Henry Ford's Model T 1908 Marinetti, *Futurist Manifesto*	Sun Yat-Sen founds Chinese 　Republic 1911 *Mona Lisa* stolen from Louvre 1911 Stravinsky's *Rite of Spring* causes 　riot in Paris 1913 The Armory Show in New York 　City 1913
1914–1920	Dada The New Objectivity	World War I 1914–1918 Russian Revolution 1917 Treaty of Versailles 1919	Black Sox scandal in baseball 1919 Women's suffrage in U.S. 1920
1920–1940	Synthetic Cubism Surrealism Mexican mural movement	T.S. Eliot, *The Waste Land* 1922 Robert Goddard ignites first liquid 　fueled rocket 1926 Stock market crash	Depression in Europe and 　the United States Rise of Adolph Hitler in Germany Spanish Civil War Beginning of World War II 1939

THE BIRTH OF A NEW CENTURY

The end of the nineteenth century ushered in a wave of optimism in Western civilization. A new and better modern world was coming in the new century, an era of progress on all fronts. The emblem of modernism had just been constructed at Western culture's center: the *Eiffel Tower* in Paris (15-1). It was like a beacon, attracting forward-looking young people, the vanguard or **avant-garde** of Europe, North America, even Asia. Remnants of the old way of life were being torn down not just by artists and writers but by scientists like Marie Curie and Albert Einstein. Sigmund Freud was even changing our view of the human mind.

The tower itself was built as the main attraction for the International Exhibition of 1889 celebrating the one hundredth anniversary of the French Revolution. Gustave Eiffel proposed to build the tallest edifice in the world as a "dazzling demonstration of France's industrial power." When it opened visitors lined up every day, waiting an hour or more to take the long elevator ride to the top. Once there, they were greeted by a godlike view—the panorama of Paris, with electricity, now truly the City of Light. Before the tower was built, only a few balloonists had ever seen such a view. It would not be an overstatement to say that the Eiffel Tower changed the way people perceived reality. Celebrated in paintings, prints, sculptures, and photographs, it articulated the spirit of the times.

MUNCH: "INNER PICTURES OF THE SOUL"

This exciting atmosphere attracted a young man, Edvard Munch, from Norway to Paris in 1889. Dissatisfied with his native land's pleasant, superficial art, Munch was searching for

ART

Eiffel Tower 1887–1889

Horta, staircase in the Tassel House 1893

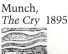
Munch, *The Cry* 1895

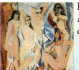
Picasso, *Les Demoiselles d'Avignon* 1907

Matisse, *Red Room (Harmony in Red)* 1908–1909

Marc Chagall, *I and the Village* 1911

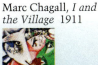
Stieglitz, *The Steerage* 1911

Boccioni, *Unique Forms of Continuity in Space* 1913

de Chirico, *Mystery and Melancholy of a Street* 1914

Kirchner, *Self-Portrait as Soldier* 1915

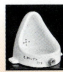
Duchamp, *Fountain* 1917

Brancusi, *Bird in Space* 1928?

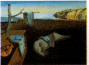
Dali, *The Persistence of Memory* 1931

Oppenheim, *Object (Le Déjeuner en fourrure)* 1936

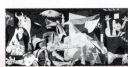
Picasso, *Guernica* 1937

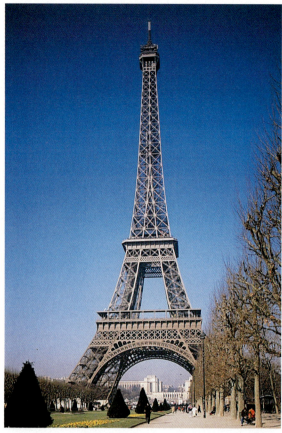

15-1 Gustave Eiffel, *Eiffel Tower*, Paris, 1887–1889. Cast Iron, 985' high.

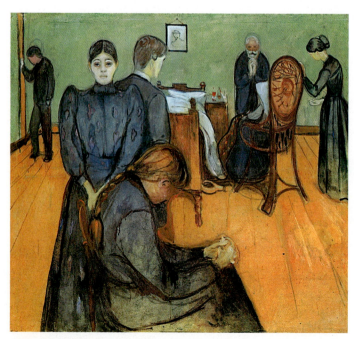

15-2 Edvard Munch, *Death in the Sick-Room, c.* 1893. Tempera and oil pastel on canvas. Nasjonalgalleriet, Oslo. Copyright Munch Museum, Oslo 1993.

the means to create pictures that explored what lay beneath the strict social conventions of Norwegian society. He wanted Norwegians to abandon their cold formality and puritanical attitudes, to open their eyes and face life. Like van Gogh a decade before him, he left Paris skilled in new techniques and dedicated to revealing the underlying emotions of life.

Munch had been marked by a painful childhood. His mother died when he was five years old, and his youngest sister Sophie died of tuberculosis when he was fourteen, a disease that almost killed him, too. In *Death in the Sick-Room* (15-2), Munch re-created his sister's last days. We can observe the illness's effect on Munch and his family, not by studying their faces (only one is shown clearly) but by each one's posture. Each expresses grief in his or her own way. A brother at the far left chooses to suffer alone and sags against a wall. Munch is at the center, looking towards the dying Sophie, his back just touching his older sister who confronts the viewer with her weary, tearstained face. In the foreground, another sister sits hunched over, hands clenched, trying to control her feelings. Dark and drab tones, thinly painted, evoke the feeling of a sickroom.

Munch confronted straitlaced Victorian attitudes toward sexuality with works of startling honesty. In his painting *Puberty* (15-3), he explored the mysterious oncoming of sexual impulses in a child. In it, a young girl sits alone, naked, with her arms folded protectively over her thighs. The look on her face is frightened and she seems completely vulnerable. Her shadow can be seen in two ways: It is a ghostly presence and herself as a long-haired, grown woman.

Munch's most famous image depicts a state of high anxiety. It is usually called *The Scream* or *The Cry* (15-4) in English, but a better translation would be "the shriek." This woodcut re-creates the psychological terror Munch himself experienced one day when walking across a bridge. He wrote about the event:

> I walked along the road with two friends. The sun went down—the sky was blood red—and I felt a breath of sadness. I stood still tired unto death—over the blue-black fjord and city lay blood and tongues of fire. My friends continued on—I remained—trembling with fright, and I felt a loud unending scream piercing nature.

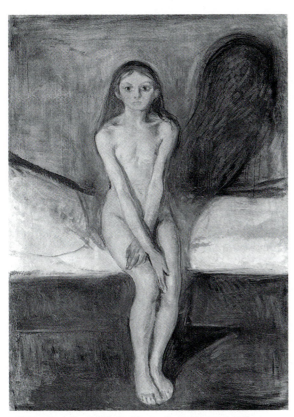

15-3 Edvard Munch, *Puberty*, 1894–1895. Oil on canvas, 59⅝" x 43¼". Nasjonalgalleriet, Oslo. Copyright Munch Museum, Oslo 1993.

The swirling of the curving lines that fill the work do not create a sense of pleasant harmony with nature but quite the opposite. Packed tightly and crowding the central figure, they become ripples of tension. Nature is threatening; life is unbearable. *The Cry* depicts not only a shattering sound wave but is also a representation of the inner life. Munch's statement, "Nature is not only that which is visible to the eye—it also includes the inner pictures of the soul," echoes the ideas of the nineteenth-century artists Caspar David Friedrich and van Gogh. Making inner feelings (as dark and deep as they may be) visible would be the aim of many artists in the new century and would be known as **Expressionism**.

GERMAN EXPRESSIONISM

By 1905, followers of van Gogh and Munch in Germany produced paintings that generated an intense emotional effect by their use of powerful colors and vivid contrasts of light and dark. The acknowledged leader of these young artists was Ernst Ludwig Kirchner. With friends he met at architectural school, Kirchner formed the group called *Die Brücke*, or "the Bridge," in 1905. Abandoning architectural studies, the group was dedicated to the renewal of German art by paintings and prints that captured the essence of modern life and culture. By expressing emotions honestly and directly, they hoped to encourage others to abandon the stale hypocritical attitudes of their elders.

Despite their insistence on the "new," Kirchner and other members of *Die Brücke* studied Gothic art and hoped for a rebirth of the medieval guilds. For them, German medieval art was what Japanese prints were for the Impressionists and Postimpressionists—a new inspiration, a non-Renaissance

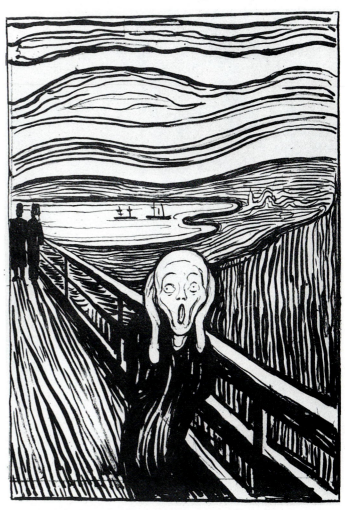

15-4 Edvard Munch, *The Cry*, 1895. Lithograph, 20" x 15³⁄₁₆". (Clarence Buckingham Collection). © 1993, The Art Institute of Chicago. All rights reserved.

model. Also inspired by Munch's woodcut *The Cry*, Kirchner made woodcuts and experimented with outlining forms forcefully and simply with a few bold lines. By the time he painted *Self-Portrait with Model* in the early 1900s (15-5), his exploration with prints had led him to a crude approach to drawing. The heavily outlined space is nearly flat. With the addition of vibrant colors, the result is similar in effect to medieval stained-glass windows.

The clashing hues, strong lines, and aggressive spirit make Kirchner's picture, though, a very modern one. The artist is pushed towards the viewer and looks out with an expression that is both confident and casual.

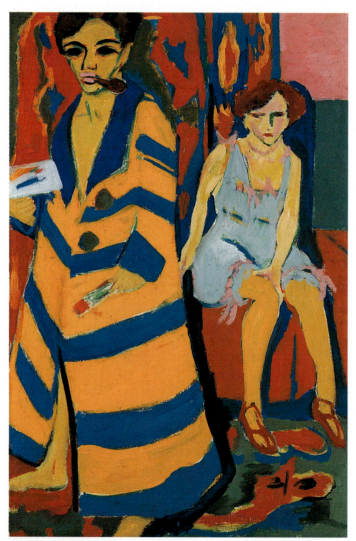

15-5 Ernst Ludwig Kirchner, *Self-Portrait with Model, c.* 1910. Oil on canvas, 59" x 39⅛". Kunsthalle Hamburg, Germany.

The artist's nearly open robe and the half-dressed model behind him imply a recent intimacy, debunking the conventional notion of detached relationships between artists and their models. Because of its style and its statement of modern sexual openness, the picture was a declaration of new attitudes toward art and life.

Independently, Emil Nolde had also been pursuing the goal of a native German art, pictures that would be "so sharp and genuine that they never could be hung in scented drawing rooms." He acknowledged that the influences of van Gogh and Munch had led him to his method—the use of the direct expressive power of color and form. In a letter paying tribute to his "tempests of color," *Die Brücke* invited the older artist to join them.

In his thirties, Nolde went to study in Paris and saw Impressionist works for the first time. However, the sunlit landscapes of Monet and Renoir did not appeal to him. He was irritated by their "sweetness" and "sugariness," disgusted that Impressionism was "the elected darling of the world." Nolde's preoccupation was not capturing momentary effects of light but "an irresistible desire for a representation of the deepest spirituality, religion, and fervor." Color was the gateway to our inner nature because "every color harbors its own soul."

Nolde's *The Last Supper* (15-6) was the first of a series of religious pictures. It is quite different from da Vinci's version. Rather than a carefully composed Renaissance scene, we witness a tribal rite. Paint was applied in thick, textured layers. The drawing is raw, the colors unmixed and intense. Jesus is performing the eucharist (the sacred transformation of wine and bread into Christ's blood and body) as if he is in a trance. Nolde accentuates the magical nature of the rite, and Christ's followers huddle around him as if they were a loving clan of cave dwellers. Powerful religious emotion fills the painting. Like Caravaggio three centuries before him, Nolde reread New Testament stories, rejected stereotypical images, and presented them in original and powerful ways. Like Paul Gauguin, he wanted to return to a purer, more primal experience of life—to paint like a primitive man. In Nolde's own words, he wanted "to render sensations with the intensity of nature at its most powerful," uncontaminated by logical thought.

FAUVISM

Artists have loved and known the power of color since the time of cave painting; its exploration is far from a twentieth-century phenomenon. But in the early twentieth century, newly invented synthetic pigments enabled artists to use brighter, more intense colors than ever before. Just as the invention of paint tubes was essential for the Impressionists and their work outdoors, the invention of brighter artificial pigments by chemists turned out to be an important catalyst for early twentieth-century artists.

France had a long tradition of innovation in color: from the Romantic painter, Delacroix, to the Impressionists, then Gauguin and van Gogh. In 1900, Henri Matisse and André Derain met while taking art classes in Paris. After studying the adventurous pictures of the Postimpressionists, these young painters began a dialogue that would ultimately have a lasting effect on twentieth-century art. Painting side by side in the countryside, each goaded the other into more radical experiments with color. Enlisting fellow students and friends on their return, the **Fauves** (or the "wild beasts") were born. Like the German Expressionists, they rejected the need to copy color from the natural world. But for them using pure color was not a method of exploring dark, primal passions but an exhilarating experience, a source of pleasure. Their ultimate concern was with

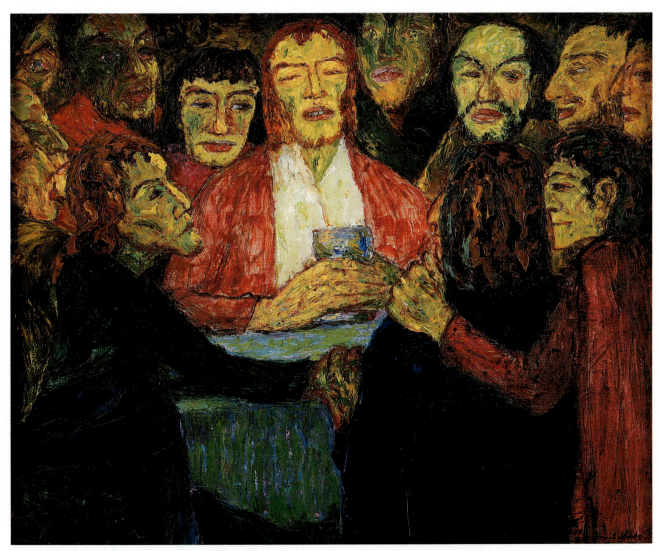

15-6 Emile Nolde, *The Last Supper*, 1909. Oil on canvas, 33⅞″ x 42⅛″. Statens Museum for Kunst, Copenhagen.

what takes place on the canvas itself. This is what makes their pictures seem surprisingly fresh and modern even today.

In *Landscape* (15-7), Derain retained the typical subject matter of the Impressionists but his approach was quite different. Derain filled the picture with unique color combinations, exploring the potential of colors used uninhibitedly. Rather than using light and dark shading to model forms, as Monet had, Derain eliminated shadows and used colors and rough thick lines to delineate them. While real, momentary light (as in Monet's *Grainstacks*) is ignored; nevertheless, *Landscape* is filled with light because of its brilliant colors. Visual excitement is produced by the intensity of strongly contrasting, even clashing colors: blue against orange, red against green. Because of their almost uniform brightness, each colored area moves forward in *Landscape* and flattens the space. Fauvist pictures, therefore,

were one more modern assault on traditional Renaissance perspective. In such unorthodox pictures, equilibrium was achieved through design, balancing the raw hues by their arrangement in the picture.

MATISSE

French critics were not sympathetic to the Fauves, describing their pictures as "the uncouth and naive games of a child playing with a box of colors." Yet, the original ideas of Fauvism, manifested in many forms, would occupy the strong-willed Henri Matisse his entire life. He would ultimately become one of the most influential artists of the twentieth century. Matisse had trained to be a lawyer as a young man. While he was in the hospital recuperating from appendicitis, his mother gave him a box of watercolors. She may have regretted it, because soon afterwards he aban-

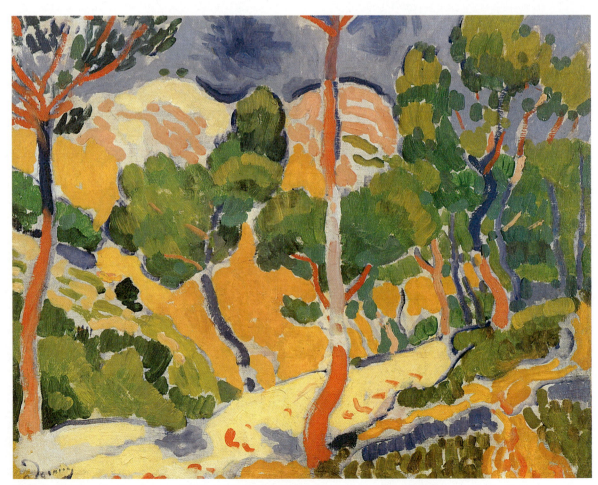

15-7 André Derain, *Landscape,* 1905–1906. Oil on canvas mounted on board, 20″ x 25½″. San Francisco Museum of Modern Art (bequest of Harriet Lane Levy).

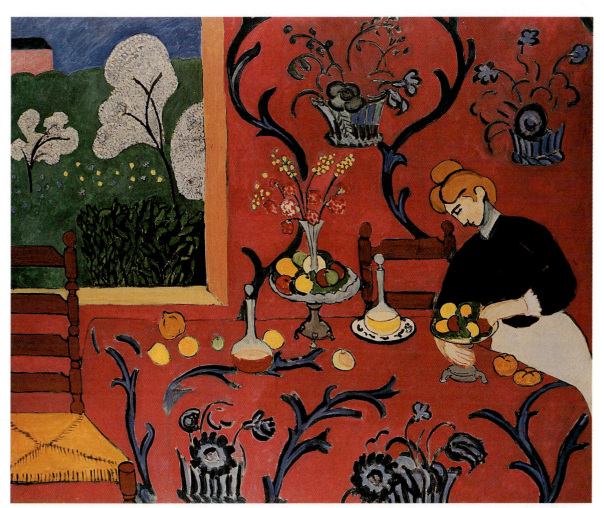

15-8 Henri Matisse, *Red Room (Harmony in Red)*, 1908–1909. Approximately 5′11″ x 8′1″. State Hermitage Museum, St. Petersburg, Russia.

doned the legal profession. Matisse wrote of his change of heart:

> In everyday life I was usually bored and vexed by the things that people were always telling me I must do . . . When I started to paint I felt transported into a kind of paradise.

In *Red Room (Harmony in Red)*, 15-8, Matisse reinterpreted an interior through the free use of color and design. Using color at its maximum strength, he let the need to balance pattern and colors determine his design. He found that areas of color could balance a composition, just as the Baroque artist Rubens had used dramatic diagonals and limbs pulling in different directions. So the field of red that dominates three-quarters of his canvas holds the picture together. As in a tapestry, the strength of that large color field allows him to

place many lively decorative elements within it without creating a chaotic scene.

Matisse had discovered that colors and shapes, once liberated from their obligation to literally re-create objective reality, could imbue paintings with extraordinary energy and life. By escaping the requirements of realistic drawing and using his fertile imagination simply to respond to the natural world, he was able to explore the extraordinary beauty of what he called "a living harmony of colors, a harmony analogous to a musical composition."

During the winters of both 1911 and 1912, at the age of forty-two, Matisse visited the then French colony of Morocco. Drawn by his interest in the decorative patterns of Islamic tiles and rugs, he fell in love with the sense of peace there and North Africa's bright, steady light and exquisite colors. His fascina-

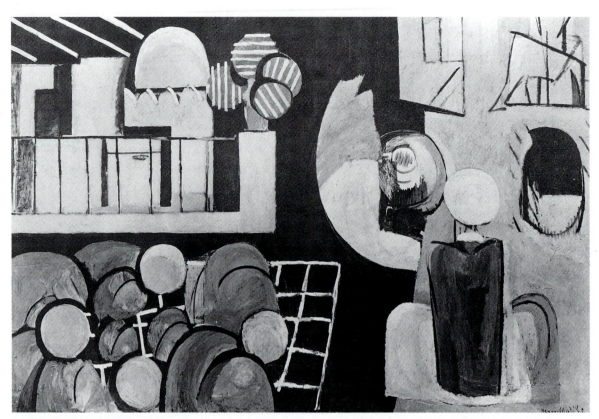

15-9 Henri Matisse, *The Moroccans*, Issy-les-Moulineaux, November 1915 and summer 1916. Oil on canvas, 71⅜" x 9'2". The Museum of Modern Art, New York (gift of Mr. and Mrs. Samuel A. Marx).

tion with Islamic architecture and design resulted several years later in *The Moroccans* (15-9). This painting evokes a series of experiences like a multiple-exposure photograph. Structurally, Matisse took even more liberties than before with conventional drawing, scale, and perspective. At the left, we can see a floating balcony, and behind it, a mosquelike building. At far right is a large, cross-legged Arab with his back to us. Notice how the shapes can suggest more than one meaning. For example, the green shapes at bottom left can be read as either the leaves of plants or the bodies of Muslims at prayer. The orange circles are either fruit or turbans.

In *The Moroccans* there is no struggle, no shock, no tension. Soft pastels of pink and lavender create a pensive mood very far from the anxieties of Munch's Expressionist masterpiece *The Cry*. The picture, though very large, is not designed to intimidate the viewer like so much of modern art. Open and friendly— it is the twentieth-century version of **grazia** (see Chapter 12). The simplicity—the free and easy feeling—in Matisse's pictures was actually hard won; he labored on version after

version of each subject on a canvas. Day after day, unsatisfactory work was scraped and wiped off so a new attempt could be made. The process might take months, but Matisse wanted to ensure that each picture would look like it was done at one sitting with the greatest ease. Matisse said that he struggled to reach "an art of balance, of purity and serenity . . . something that calms the mind."

PICASSO AND CUBISM

Pablo Picasso is, without question, the most famous and celebrated artist of the twentieth century. A child prodigy, Picasso told a story about how he surpassed his father, a respected art instructor at the School of Fine Arts in Barcelona, before he was ten years old. According to this legend, the young Picasso was already working as an assistant to his father when he was asked to paint a small bird on a large canvas his father was working on. When his father saw what his son had done, he was stunned. He gave Picasso his brushes and said, "You take them; you already are better than me." Whether the story is actually

true or not, it reflects the absolute confidence and talent Picasso already had as a young man. By 1900, at the age of nineteen, having mastered academic technique, he went to Paris in search of greater challenges. Always a quick study, Picasso assimilated the most advanced early styles of Modern Art in just a couple of years. His early work from Paris includes pictures in the manner of Toulouse-Lautrec, Seurat, and Gauguin.

The Old Guitarist (15-10) was done in Picasso's first original style, known today as his *Blue Period.* The world of the urban poor, the depressed, and those weak from hunger were painted in somber hues of blue, brown, and black. The old guitarist is emaciated; the length and thinness of his arms accentuate this. He is blind, but his blindness is like the Greek poet Homer's; it symbolizes wisdom. Like many artists and writers who had come to Paris, Picasso was young and struggling, not sure where his next meal was coming from.

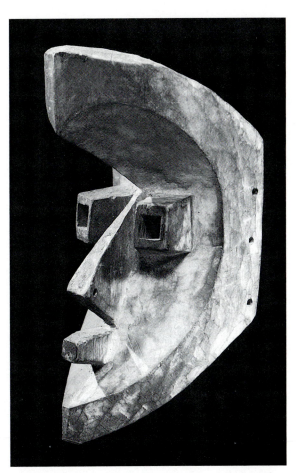

15-11 Mahongwe mask, Gabon, Africa, nineteenth century. Wood and pigments, 14″ high x 39″ wide. The Brooklyn Museum, New York (purchase from Mr. Frederick R. Pleasants and Frank L. Babbott Fund).

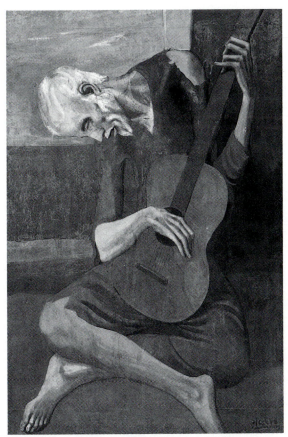

15-10 Pablo Picasso, *The Old Guitarist,* 1903. Oil on panel, 47¾″ x 32¼″. (Helen Birch Bartlett Memorial Collection). © 1993 The Art Institute of Chicago. All rights reserved.

But these pictures of the Blue Period established Picasso as an artist to be watched. In 1906, when the famous art dealer Ambroise Vollard (who represented Degas, Renoir, and Cézanne) visited the young artist's studio, he purchased every painting. Success would now follow the young Spaniard for his entire life.

Just as Gauguin became fascinated with primitive art in the previous generation, a taste for magical artifacts was developing among the young avant-garde. Introduced by Derain to African masks (15-11), Picasso felt the visual and psychological power in their simple, oversized geometrical forms. While Derain could never successfully incorporate their influence into his art, Picasso would in a way no one else could ever have imagined.

Only a year after his success with Vollard, Picasso made a picture that shocked not only his new dealer and the older artists of

Paris but also the avant-garde. It was a product of his study of African masks and the then legendary but rarely seen work of Paul Cézanne. In 1907, there had been a Cézanne retrospective in Paris that opened the eyes of the younger generation. In later years, Picasso would say of the Postimpressionist master: "Cézanne is my father; he was the father of us all." The imaginative combination of these two influences resulted in the most revolutionary picture of our century, *Les Demoiselles*

d'Avignon (the women of Avignon), 15-12. Picasso had leapt into the unknown with this picture, making a more radical break with Renaissance art than any previous artist. His women are prostitutes who display themselves to the viewer as if to a customer. But they are hardly enticing. Their bodies have been broken up into geometrical fragments and flattened. The fragments are reminiscent of the small panes of color Cézanne had used, but now he has made them bold and geometrical

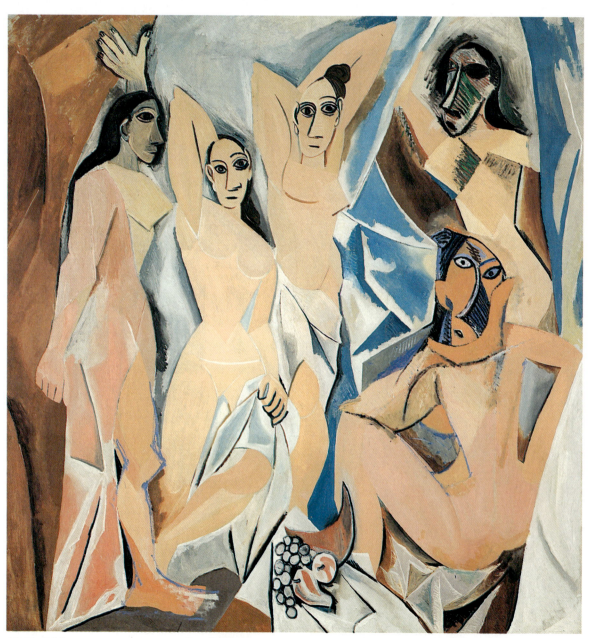

15-12 Pablo Picasso, *Les Demoiselles d'Avignon*, Paris, June–July 1907. Oil on canvas, 8′ x 7′8″. The Museum of Modern Art, New York (acquired through the Lillie P. Bliss Bequest).

like the shapes of African masks. The composition of *Les Demoiselles d'Avignon* creates a new kind of space—everything, including the background, seems to press forward. There is no conventional negative space. All is foreground. The placement and design of shapes and space seem to be determined merely by the whim of the artist. In the same way that the Fauves declared color could be arbitrary, now Picasso was declaring shapes and space could be as well. In his *Les Demoiselles d'Avignon*, a melon becomes flat with points as sharp as a knife, or a breast becomes a shaded square.

The painting is brimming with ideas and a variety of styles. There are even four different methods for the heads. Two seem clearly influenced by African masks, but the most bizarre is the head at bottom right (detail, 15-13). The parts of her face have been redesigned and reassembled as if she is being viewed from several angles at once. Picasso is deliberately ignoring one of the oldest design principles—a picture must be consistent to be successful. Is life coherent? he might ask. The fragmentation of this painting has been said to reflect the fragmentation of modern life, making *Les Demoiselles d'Avignon* a very twentieth-century picture.

Picasso's friends and supporters were stunned and hated the painting. "A horrible mess," said one. Matisse said it was "repulsive." Many thought Picasso had gone insane. Derain said it would not be long before Pablo would be "found hanging behind his canvas." The youngest of the Fauves, Georges Braque, had also been among those who were initially horrified by the "monstrous" painting. Later, Braque began to see that because *Les Demoiselles d'Avignon* blew apart many of the old conventions, it was rich with possibilities. Braque soon abandoned Fauvism and joined Picasso in one of the most famous collaborations in the history of art. Together they explored the consequences of this landmark picture, the first of **Cubism** (see Chapter 2).

Both artists had studios in the same building in an artist quarter in Paris. Soon their pictures were so similar that, without signatures, it would be nearly impossible to distinguish who had done which. To study their new structure, Picasso and Braque initially limited color in their work, a style called **Analytical Cubism**. The first Analytical

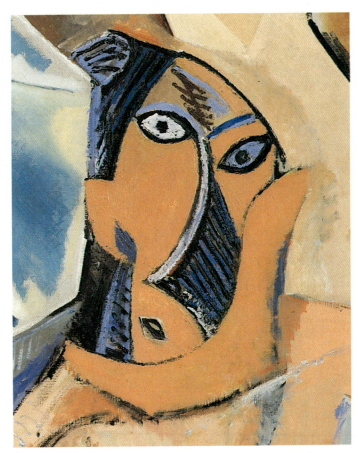

15-13 Detail of figure 15-12

Cubist pictures are a collection of views from different angles fused into a balanced design. Like Cézanne, they wanted to present a truer picture of the way we see, with eyes moving from one part to another. But as Picasso and Braque explored Cubism further and further, their work became more and more abstract; the arrangement of shapes became less like the source objects (see Braque's *Violin and Palette*, 2-28), and the design of the many shapes in the picture itself became more important than any representational function.

What Picasso and Braque had created was a new reality, one that existed only in the painting. Picasso declared that a picture should "live its own life." The Cubists were posing once more the crucial question of Modern Art—should art be chained to visual appearances? Their answer, as seen in their works, is a loud "no!" Art can give us experiences that reality cannot, they would say. It is time for the artist to be liberated from the old requirement of re-creating what anyone can

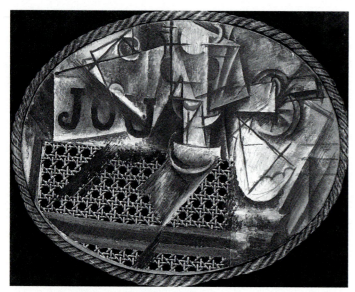

15-14 Pablo Picasso, *Still Life with Chair-Caning*, 1911–1912. Oil and pasted paper simulating chair-caning on canvas, 10⅝″ x 13¾″. Musée Picasso, Paris.

The same year, Picasso began translating Cubist space into three dimensions with Cubist **assemblages** (three-dimensional collages). Because one curving side of his *Guitar* of 1912–1913 (15-15) is larger than the other, we get the sense of Picasso moving back and forth as he looked at different parts of the guitar. We also get a sense of Picasso's perception and thought processes—the top of the guitar reminded him of a triangle; the center hole, a cylinder. Like so many Cubist works, *Guitar* is a report from the artist about what he saw and what he thought as he looked closely at an object.

While no one would be fooled into believing this collection of sheet metal and wire was an actual guitar, it is easy to identify. By 1912, the visual symbols he made for the things he saw were becoming more playful, imaginative, and easily understood and marked the opening of a new phase called **Synthetic Cubism**. Less than a decade after its creation, the painstaking investigation of the

see. While much of the public remained horrified by Cubist pictures, Cubism spread like wildfire in the next few years through the avant-garde in Europe and beyond.

Yet by 1912, Picasso wanted to find a way to bring the real world more directly into Cubist pictures. He did it by literally attaching bits and pieces from everyday life—inventing **collage** (see Chapter 4). The first was *Still Life with Chair-Caning* (15-14), where cubist painting mixed with a printed pattern of chair caning on it. Picasso used collage to play fast and loose with visual reality, to question its nature. In the picture, some letters from the French paper *Le Journal* appear as simulated collage—but they were actually painted on the canvas. This kind of deception forced viewers to examine his art closely, because one cannot always be sure what is paint and what is collage. Sometimes he and Braque might carefully re-create wood grain in paint, but in other pictures they would attach some actual wood. In later collage-paintings, Picasso openly used real materials that had little to do with what is portrayed—a glass made of newspaper, for example. While these tricks keep the viewer in doubt, they also allow the viewer to enjoy surprises, to share in something like the artists' joy of invention. Picasso is constantly reminding us that art is by nature deceptive: an illusion constructed from materials, whether paint, stone, or wallpaper.

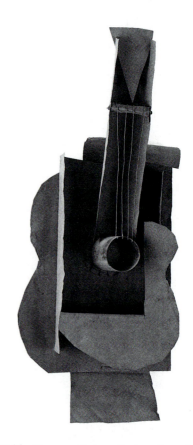

15-15 Pablo Picasso, *Guitar*, Paris, winter 1912–1913. Construction of sheet metal and wire, 30½″ x 13⅛″ x 7⅝″. The Museum of Modern Art, New York (gift of the artist).

possibilities of *Les Demoiselles d'Avignon* was over, replaced with the more open, even comical approach of the *Three Musicians* (15-16). In Synthetic Cubism, lively color reentered Picasso's pictures and expression, too. In the years to come, Cubism proved to be a very flexible style. Picasso would use it to create a variety of moods. His *Three Musicians* is playful and light, his *Girl before a Mirror* (2-8) loving and erotic. Yet Pablo Picasso's monumental *Guernica* (15-17) is universally acknowledged as one of the most forceful protests against war ever created.

While the painting's message is timeless, its catalyst was a single event. On April 26, 1937, during the Spanish Civil War, the small town of Guernica was attacked by German bombers supporting the Fascist armies of Generalissimo Franco. The town was still controlled by the republican government of Spain but had little military significance. Adolf Hitler's Luftwaffe used the attack as a test of the effects of saturation bombing—in preparation for World War II. The effects were catastrophic: much of the town was leveled; thousands died. Newspapers reported that those who ran from the town were machine-gunned by planes.

Living in France, but emotionally tied to his native Spain, Picasso responded to the atrocities with the largest canvas he had ever painted, more than 25 feet long and 11 feet high. Picasso's *Guernica* is not a re-creation of a specific event but a universal message about the suffering of the innocent in war. Women, children, and animals are the main subjects, their bodies twisted and distorted by cubist structure. Many look to the sky (toward God or bombers?), screaming. The space is confused; we seem both indoors and outdoors.

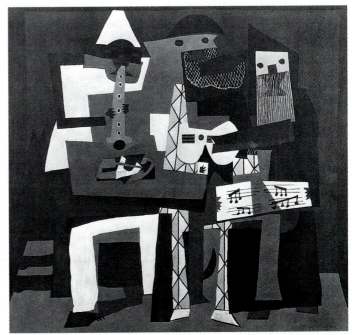

15-16 Pablo Picasso, *Three Musicians*, Fontainebleau, summer 1921. Oil on canvas, 6'7" x 7'3¾". The Museum of Modern Art, New York (Mrs. Simon Guggenheim Fund).

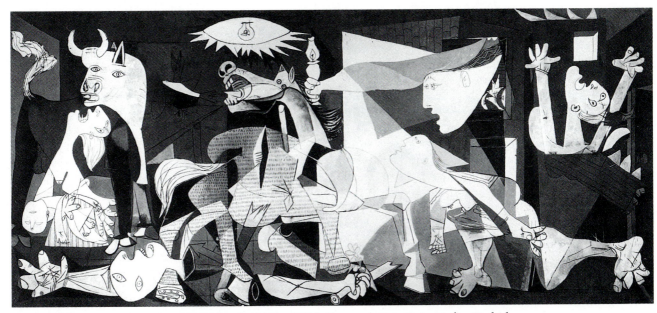

15-17 Pablo Picasso, *Guernica*, 1937. Mural, 11'6" x 25'8". Centro de Arte Reina Sofia, Madrid.

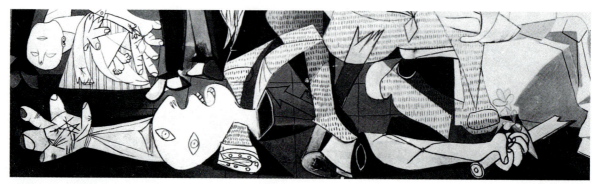

15-18 Detail of figure 15-17

Figures bump into one another. The Cubist style actually seems, in the hands of its master, to be peculiarly suited to express the victims' anguish, confusion, and panic. Only one soldier is present, a broken Roman sculpture symbolizing the end of the ancient heroic ideals of war (15-18).

Picasso is the dominant artist of the twentieth century. His productivity, imagination, and range of interests redefined what being an artist meant. Up to the day he died in 1973, he was producing a stream of paintings, drawings, sculptures, etchings, woodcuts, lithographs, and ceramics (see photograph in Chapter 1, 1-41). He became the most famous and richest artist who ever lived. More important, Cubism was the bridge to most of the radical art of our century. His innovations of mixing media and exploring the artistic value of everyday objects would be exploited by Dadaists, Surrealists, and Pop Artists, among others. Yet, as revolutionary as Picasso's career may have been, it was never completely removed from the visual legacy he inherited. In his seventies and eighties, he revisited the great masters of the past, painting Cubist versions of pictures by Delacroix, Manet, and even Rembrandt. It seems symbolic that he chose to live his old age and to be buried at the base of Mount Sainte Victoire—a mountain near the home of Paul Cézanne—as if to reaffirm his debt to the man Picasso called his father and to place himself firmly in the Western tradition.

ABSTRACTING SCULPTURE: BRANCUSI

Like painting, much of the sculpture in our century has also gone in the direction of abstraction. We have seen this already in the Cubist sculpture of Picasso. One aspect of abstraction—refining form to achieve purity and clarity—was the driving force in the seminal sculptural abstractions of the Romanian artist, Constantin Brancusi (see photo 7-1).

Brancusi was born in a tiny peasant village in Romania where as a young boy he was a shepherd. When the villagers saw his skill in carving (he had made a violin out of a crate), they raised the money necessary to send him to a school of crafts. After he graduated, Brancusi left for Paris, the magnet of his generation. However, he made his way more slowly than most, walking from Munich after his funds ran out. He later described this walk as one of the happiest experiences of his life. Fed by peasants in the villages, he sang all the way. Brancusi said that he learned on this walk how good it was to be alive and to be able to see the wonders of nature.

Brancusi arrived in Paris in 1904 at the age of twenty-eight and lived virtually the rest of his life there. For a short time, he worked as an assistant to Rodin but soon left to work on his own, saying "nothing grows under the shade of great trees."

Like many other modern artists, Brancusi was interested in the art of primitive and non-Western people, not just African but Egyptian, Buddhist, and Cycladic art as well. Their art showed him that simple abstract forms had great visual and psychological power. He decided that

What is real is not the external form, but the essence of things. Starting from this truth it is impossible for anyone to express anything essentially real by imitating its exterior.

Or, put even more succinctly, "The sculptor is a thinker, not a photographer." He set out to

create sculptures that were universal and stripped to the essentials.

Perhaps the greatest example of Brancusi's desire for purity can be found in his *Bird in Space* (15-19). Brancusi once wrote: "All my life I have been working to capture the essence of flight." *Bird in Space* is the last in a series of sculptures Brancusi made on this

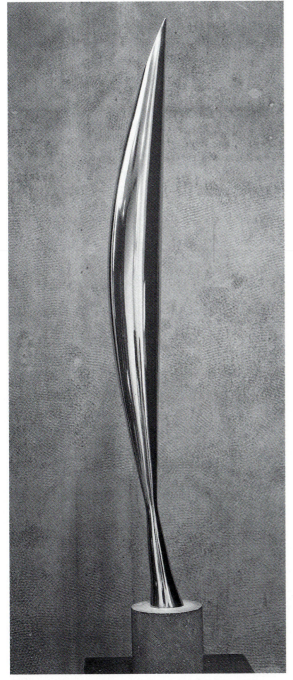

15-19 Constantin Brancusi, *Bird in Space,* 1928?. Bronze (unique cast), 54" x 8½" x 6½". The Museum of Modern Art, New York (given anonymously).

theme. The series was begun in 1910; early versions were called "Maiastra," after the beautiful golden bird in Romanian folktales. As this series evolved, each bird in succession was more abstract, more refined; in each, Brancusi came closer to showing the essence of flight. In the final version, we can see only the desire to move upward, to escape the force of gravity. Here he used bronze with a high degree of polish, so it seems machined rather than handmade. In fact, when *Bird in Space* was sent to the United States to be shown in a museum, customs officials confiscated it because they suspected it was military hardware.

Brancusi's clear, streamlined design inspired not only sculptors but also the industrial designers of the Bauhaus (see Chapters 9 and 12) and the pure, metallic symmetry used by International Style architects.

"ALL THINGS ARE RAPIDLY CHANGING": FUTURISM AND SPEED

The idea of a modern age was celebrated not only by visual artists but also by philosophers and writers. The high priest of international modernism was Filipo Tomasso Marinetti, an Italian poet, playwright, and professional agitator, known as "the caffeine of Europe." Independently wealthy, he preached the virtues of the new world created by technology. In 1909, he wrote the "Manifesto of **Futurism**," coining a new term that was instantly in the mouths of avant-garde artists throughout Europe. Futurism was the credo of those who did not look back, who celebrated the age of the machine. Among the declarations in his manifesto were

> We affirm that the world's magnificence has been enriched by a new beauty: the beauty of speed . . . A roaring car . . . is more beautiful than the Victory of Samothrace [see figure 10-23].

Marinetti and his followers were nationalists and felt Italy's devotion to ancient greatness left it no more than a tourist mecca, preventing it from rising to new greatness:

> For too long has Italy been a dealer in second-hand clothes. We mean to free her from the numberless museums that cover her like so many graveyards.

The solution Marinetti called for was brutal—Italians should flood the museums and burn the libraries:

> We will destroy the museums, libraries, academies of every kind . . . Come on, set fire to the library shelves! . . . Oh the joy of seeing the glorious old canvasses bobbing adrift on these waters, discolored and shredded! . . . We want no part of it, the past, we the young and strong Futurists!

Marinetti was a master publicist and his ideas spread like wildfire throughout Italy. He traveled from city to city, organizing "evenings" in theaters designed to provoke violent responses from the conservative members of the audience. Crowds were drawn by posters advertising "opening nights." What they found instead was a mixture of art and politics, a series of challenges to their "mediocre bourgeois" values. An evening was considered successful when it ended in shouted insults, fistfights, flung rotten vegetables, and police intervention.

Umberto Boccioni was one of many young Italian artists who joined the new movement. His *The City Rises* (15-20), finished in 1911, shows how the Futurist painters adapted Cubism to create waves of muscular energy, each motion a series of steps reminiscent of multiple-exposure photography. The sweeping surges of movements make the whole picture a dynamic dance celebrating the building of the urban utopia. Man and animal pull the great enterprise into being.

Often, the ideology of the Futurists was ahead of their actual works of art. Marinetti's manifesto of 1909 declared a speeding car to be more beautiful than the Victory (or Nike) of Samothrace. No Futurist sculpture, however, had been made yet that could even challenge that masterpiece of the Greeks until Boccioni created his *Unique Forms of Con-*

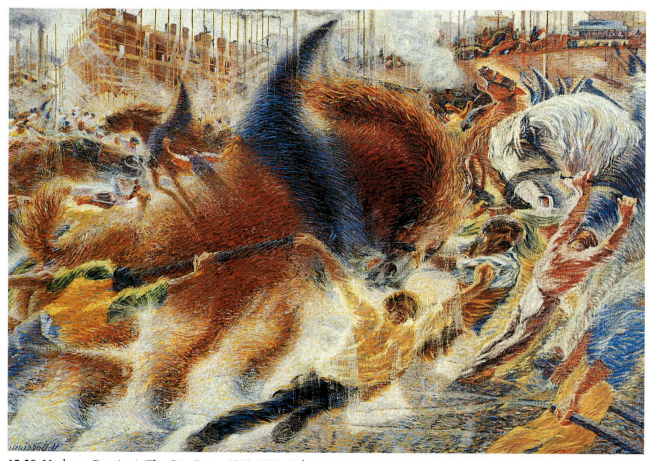

15-20 Umberto Boccioni, *The City Rises,* 1910–1911. Oil on canvas, 6'6" x 9'10". The Museum of Modern Art, New York (Mrs. Simon Guggenheim Fund).

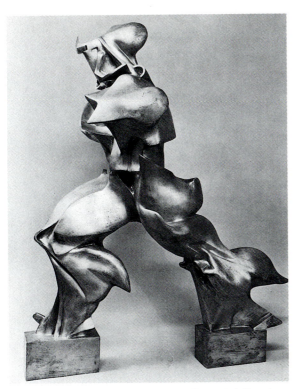

15-21 Umberto Boccioni, *Unique Forms of Continuity in Space*, 1913. Bronze (cast 1931), 43⅞″ x 34⅞″ x 15¾″. The Museum of Modern Art, New York (acquired through the Lillie P. Bliss Bequest).

tinuity in Space (15-21) four years later. Here the complexity and variety of movements seen in *The City Rises* were translated into three dimensions. Inner and outer forces pull at the solid figure, shaping it. Moving like a twentieth-century gladiator, this machine-like man is built of bronze; his head is a helmet and his arm a shield. His stride is confident, surging forward, but the memory of his past movements linger on, drag on him. Here is the Futurist hero for the technological age, shedding past remnants and moving to battle and victory.

Calling for war was also part of the Futurist manifesto. Marinetti declared in 1909: "We will glorify war—the world's only hygiene—militarism, patriotism . . . beautiful ideas worth dying for." When war came in 1914, the Futurists joined eagerly, plunging into what would become a European holocaust, with the same speed they plunged into all of their actions.

Like European culture as a whole, Futurism was never the same afterwards. Still, the Futurist spirit left a lasting legacy for twentieth century art; their call for "courage, audacity, and revolt" replaced the nineteenth century's "liberty, equality, and fraternity" as bywords for the Modern Art movement.

MODERN WARFARE FOR A MODERN WORLD: WORLD WAR I

Clearly, a widespread desire for change charged the air at the turn of the century. After a leisurely progression of art movements that lasted centuries, suddenly an explosion of many art movements occurred in a very short period. These reflected the thrill of progress as the world entered a new technological era and the shared excitement of young people (exemplified by the Futurists) over a future that seemed limitless in potential. The confident and enthusiastic mood was shaken profoundly by the events that followed June 28, 1914.

On that day Archduke Francis Ferdinand, heir to the Austro-Hungarian Empire, was assassinated. His murder precipitated, through a complex series of political alliances, the drawing of the entire Western world into the bloodiest conflict ever seen, now called the *First World War*. In this conflict, the glorious modern machinery beloved by the avant-garde was transformed into awesome modern weapons of destruction. Submarines, poison gas, and air, tank, and trench warfare all made their first appearance in World War I. Battleships, barbed wire, machine guns, and heavy artillery were used on an unprecedented scale.

Few sensed the horrors to come at the war's outset. After nearly forty-five years of peace, the declarations of war filled the young and old of Europe with eagerness. Nationalism seemed to swell the hearts of all; heroic thoughts were in the soldiers' minds. When the brave warriors got to the front lines, they entered a labyrinth 450 miles long, known as the "western front." There, the horrifying conditions of the grim trenches shattered their naive illusions. Soldiers were stuck below ground for months on end, knee deep in mud and water, listening to regular bombardments and the screams of the wounded, waiting for the murderous poison gas. Above them was a landscape covered with barbed wire and

ART NEWS

MODERN ART INVADES AMERICA— THE ARMORY SHOW

In 1913, the most important exhibition in the history of the United States took place. Called "The International Exhibition of Modern Art," the show had been conceived initially as a large exhibition of a group of advanced (for America) artists who lived in New York City. Later the organizers decided to make the show a complete survey of Modern Art by showing Europeans. They accumulated so much artwork that a National Guard Armory in Manhattan was chosen as the only place large enough to accommodate them. More than thirteen hundred works by three hundred artists were exhibited in what would come to be known as the "Armory Show." Even though only one-quarter of the exhibition was devoted to European artists, to the chagrin of the Americans, the foreigners stole the show. Their work outraged America and became front-page news. More than half a million people came to see the show, many as curiosity seekers, of course. But for the first time, Modern Art gained the attention of the New World.

In an exhibition that introduced Gauguin, Cézanne, van Gogh, Munch, Monet, Picasso, and Braque, there was much to shock the public. The *New York Times* said the whole show was "pathological." But it was Marcel Duchamp's *Nude Descending a Staircase (No. 2)*, 15-22, that was the scandal of the show. To anyone familiar with Futurism (which few Americans were), the picture does not seem so radical. Duchamp was using a Cubist approach to explore motion. He also was influenced by the then

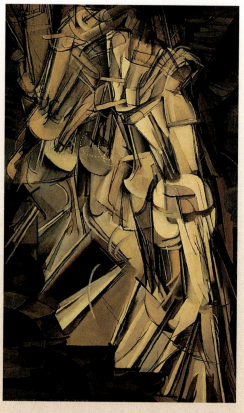

15-22 Marcel Duchamp, *Nude Descending a Staircase (No. 2)*, 1912. Oil on canvas, 4'10" x 2'11". Philadelphia Museum of Art (Louise and Walter Arensberg Collection).

craters. According to Robert Graves, a novelist and British soldier:

> The Western Front was known among its imbittered inhabitants as the Sausage Machine because it was fed with live men, churned out corpses, and remained firmly screwed in place.

The final cost of this miserable "Great War" was 16 million dead, and 20 million more wounded, maimed, or missing. The Allied victory, according to Winston Churchill, was "bought so dear as to be almost indistinguishable from defeat." The young (better described as "once young") who survived became known as the "lost generation." The dream of progress was dead by the war's end.

DADA: TO ONE MADNESS WE OPPOSE ANOTHER

Idealism could be said to have been one of the earliest casualties of the war. By 1915, Zurich, Switzerland, had already become a sort of refugee camp for intellectuals, artists, Communists, and anarchists who had seen the uselessness of the war and had lost faith with their political leaders. The small, proper

new multiple-exposure photographs that revealed the many aspects of movement. Most viewers were genuinely puzzled by Duchamp's work (at least those who could get close enough to see it once it became notorious and surrounded by crowds). The American magazine *ArtNews*, tongue-in-cheek, offered a prize for the best explanation of it. One critic described it as an "explosion in a shingle factory." Ridicule was common; the *Evening Star* mocked it in its *The Rude Descending a Staircase* (15-23), but at least the editorial cartoonist had understood the painting.

It became almost a patriotic cause to attack these foreign intruders. Offended artists and critics, high school teachers, and ministers called the art immoral and indecent. Even former president Theodore Roosevelt felt obliged to comment on the exhibition. Like most, he criticized almost all of the exhibited work, but he also showed some understanding:

> There was one note missing . . . and that was the note of the commonplace . . . There was no stunting or dwarfing, no requirement that a man whose gifts lay in new directions should measure up or down to stereotyped and fossilized standards.

He seemed to be suggesting that perhaps Modern Art contained something close to the American ideal.

The show, despite or because of its notoriety, turned out to be a financial success in terms of sales. But to the American artists' lasting humiliation, most of the sales were made by the scandalous Europeans. The most innovative American work now appeared cautious and old-fashioned. For the next three decades, forward-thinking American artists would turn their eyes toward Europe.

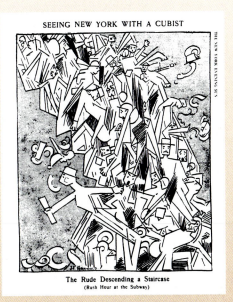

15-23 *The Rude Descending a Staircase,* a cartoon that appeared in the *New York Evening Sun* on March 20, 1913.

provincial town in a neutral country had been transformed into a hotbed of avant-garde activity and the birthplace of an international movement called **Dada.**

Convinced that the war was "horrible and stupid," the Dadaists wanted to launch their own war—a war on the conventional way of thinking that had guided Europe into the conflict. They believed that the "Great War" demonstrated that old beliefs and ideals were worthless and could only lead to disaster. It was time for the world to begin again; all traditional ways of thinking had to be shattered by poetry and painting. Or, as the chronicler of the movement and artist, Hans Arp, said: "Losing interest in the slaughterhouses of the world war, we turned to the fine arts."

Why the name *Dada*? According to Arp: "It means nothing, aims to mean nothing, and was adopted precisely because it means nothing." A Dada handout offered a reward "to the person who finds the best way to explain Dada to us."

Dada art was anarchic and humorous but also deadly serious. Following the Futurist model, performances were organized and designed to frustrate and confuse audiences. One of the more notorious performances came after running an ad in a local newspaper that Charlie Chaplin was appearing for $3 at a

theatre. Once the large audience had become impatient for the famous actor's arrival, the Dada artists came on stage and chanted

> No more aristocrats, no more armies, no more police, no more countries, enough of these imbecilities, no more nothing, nothing, nothing.

Dada manifestos called for the destruction of all values—the end of art, morality, and society. This "anti-art" was an effort to evolve a new way of thinking, feeling, and seeing. Their pictures, writing, and performances were an invitation to utter confusion, a series of blows against accepted values. Dadaists were not interested in intellectual responses; they preferred violent ones. Dada performances typically ended with yelling insults from the stage at the disappointed listeners, who often responded in kind. Fistfights were deliberately instigated. This was because the dadaists equated anarchy and chaos with true freedom.

MARCEL DUCHAMP AND INTERNATIONAL DADA

When Marcel Duchamp arrived in New York City in 1915, he was already a notorious figure in the United States because of his contribution to the Armory Show (see p. 382). However, Duchamp's early controversial painting, *Nude Descending a Staircase (No. 2)*, 15-22 (box), would seem rather conventional when compared to his next scandalous work, one of the seminal objects of Dada. In 1917, Duchamp was one of the organizers of an exhibit at the Society of Independent Artists in New York City. Secretly, Duchamp submitted *Fountain* (15-24), a porcelain urinal signed "R. Mutt 1917." The work was literally thrown out of the show. Pretending to be appalled by the conservatism of his supposedly avant-garde fellow artists, Duchamp immediately resigned from the society and published a spirited defense of the work, entitled "The Richard Mutt Case." In his essay, he responded to their charges of plagiarism and immorality:

> whether Mr. Mutt [actually the name of a plumbing fixture manufacturer] with his own hands made the fountain or not has no importance. He CHOSE it. He took an ordinary article of life, placed it so that its useful

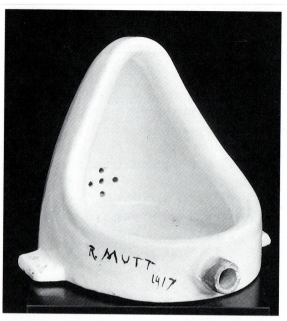

15-24 Marcel Duchamp, *Fountain*, 1917. Selected object, 12" x 15" x 18". Courtesy Sidney Janis Gallery, New York.

significance disappeared under the new title and point of view—he created a new thought for that object . . . Mr. Mutt's fountain is not immoral, that is absurd, no more than a bathtub is immoral. It is a fixture that you see every day in plumbers' show windows.

Fountain was what Duchamp called a "ready-made," art that asserted a new right for the artist: Anything an artist says is art is art. Because of this, Duchamp opened up the possibility that countless everyday items could be art. The genre art of Bruegel, where ordinary life was declared a new subject for great artists, had now evolved into an art of household objects. Duchamp's exhibited ready-mades ran the gamut from bottle drying racks to snow shovels (called *In Advance of a Broken Arm*).

Perhaps the quintessential Dada work was his *L.H.O.O.Q.* of 1919 (1-23). By scribbling a moustache and goatee on a cheap postcard of the *Mona Lisa*, Duchamp defiled and ridiculed what the cultured public generally acknowledged as the "greatest" artwork ever made. That simple act was intended to dynamite the pillars of culture, declaring the urban renewal of the entire Western tradition. Like Futurism, Dada pronounced the icons of the past (exemplified by da Vinci's masterpiece) worthless rubbish to be discarded.

The Dada aesthetic motto was "beautiful as the chance encounter on an operating table of a sewing machine and an umbrella." *Gift* (15-25) is an example of the motto put into practice. By creating an unusual combination of everyday items, tacks and an iron, Man Ray, an American friend of Duchamp's, produced a visually powerful creation. His use of **juxtaposition**—a technique where unrelated objects are taken out of their normal context and joined together, producing a new unique object—opened a new area for artistic exploration. Man Ray called such objects either "indestructible objects" or "objects to be destroyed" and often did smash them. This was the ultimate Dada act, subverting the old notion of art being permanent and deriding the value of immortality. It made the guards in the museums and the notion of masterpieces ridiculous. Other Dadaists caught the iconoclastic mood. The German Max Ernst (see "Surrealist Collage," p. 388) even attached an ax to one of his sculptures with a note encouraging viewers to take a swing at his artwork.

By 1922, there were active centers of Dada activity in Berlin (see Hannah Höch, 6-14), Paris, Zurich, and New York City. The movement, however, had already crested. The ensuing rapid disintegration of Dada might be seen as the natural culmination of its own manifesto. If anarchy was one's supreme goal, then how could one belong to a movement? Some Dadaists even took actions to encourage its dissolution (for example, sending unsigned insulting letters to their colleagues). By 1923, there were only a few scattered members left in Europe and the United States. The Dada moment had passed.

THE NEW OBJECTIVITY

Embittered by the shattering ordeal of World War I, German Expressionism's very nature changed. Ernst Ludwig Kirchner, its leader, suffered a mental breakdown during the war and was hospitalized. Compare his *Self-Portrait as Soldier* (15-26) to his earlier portrait with a model. The composition is similar: The artist

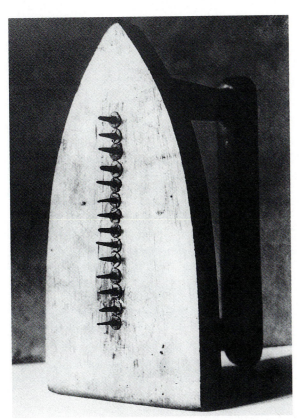

15-25 Man Ray, *Gift,* replica of lost original of 1921. Flatiron with nails, 6½" high. Collection of Mr. and Mrs. Morton G. Neumann, Chicago.

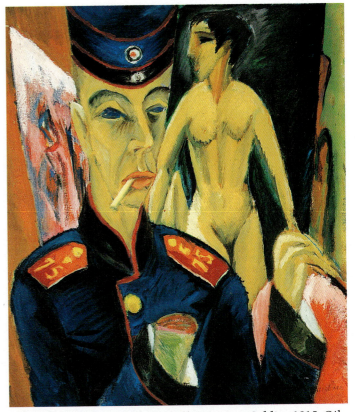

15-26 Ernst Ludwig Kirchner, *Self-Portrait as Soldier*, 1915. Oil on canvas, 27¼" x 24". Allen Memorial Art Museum, Oberlin College, Ohio (Charles F. Olney Fund).

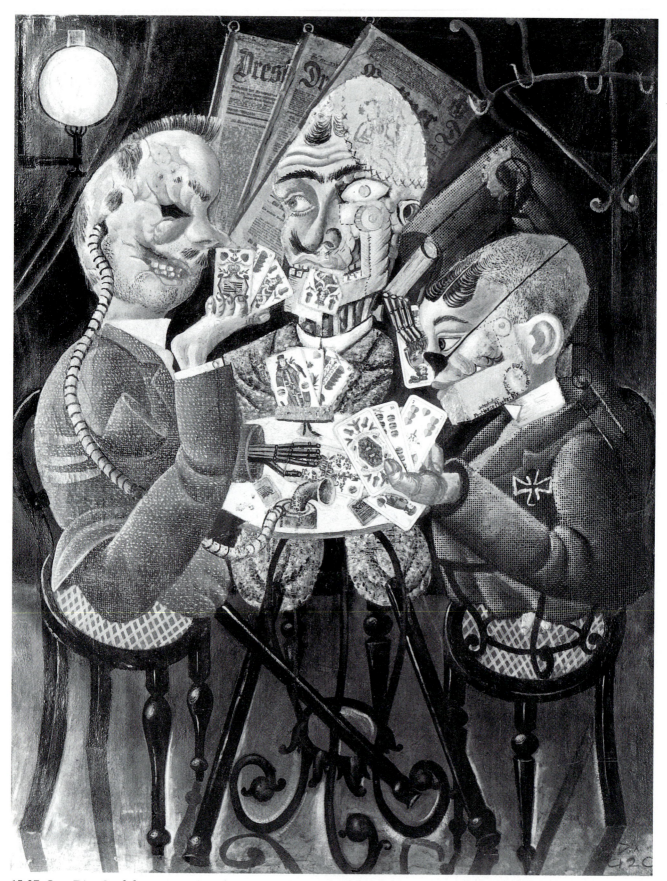

15-27 Otto Dix, *Cardplaying War-Cripples*, 1920. Oil on canvas with montage, 43¼ x 34¼″. Private collection.

pushed forward on the left with his model behind him on the right. But the toll of the war is now very apparent. The confident, pipe-smoking young bohemian has been replaced by a pale, sunken-cheeked soldier with a butt hanging from his lips. He has aged far more than eight years; his eyes are empty, his look cynical. He holds his painting arm, whose end is a cleanly cut stump, up to the viewer. The only sign of life is the model who now stands shamelessly naked. But she no longer stares lovingly at the symbolically emasculated artist. Kirchner's painting reminds us that the wounds he and many others suffered were both physical and spiritual.

In 1914, Otto Dix had been an "enthusiastic volunteer" of twenty-three. Trained as a machine gunner, he served four years in the front lines. There, Dix was able to see firsthand the results of modern weaponry as the enemy died in his spray of bullets. Like many other veterans who returned from the war, Dix was shocked to see that his homeland seemed unaware of what he had experienced. His countrymen were all too eager to return to the illusions of the previous happier age. In response, Dix became a leading member of a recast Expressionism called "The New Objectivity." Their goals, he said, were to "show human being in all its grandeur, but also in all its depravity, indeed its brutishness." These Expressionists would have "the courage to portray ugliness, life as it comes."

With *Cardplaying War-Cripples* (15-27), Dix confronted his fellow Germans with the real consequences of the "Great War" and cruelly mocked modern science's pathetic attempts to rebuild the maimed young survivors. The card players in this picture are alive but less human than before. Little more than repulsive half-robots, with clumsily sewn eye sockets and tubes stuck in their faces, they are the useless refuse of war; their lives are over. Dix's grotesque images were meant to cut through the atmosphere of self-delusion and denial among the German populace that he felt was suffocating him.

Käthe Kollwitz (see *Self Portrait*, 3-4), unlike Dix, was an artist who engaged in the struggles of her time as an outspoken advocate, not as a bitter outsider. She wrote:

I believe that there must be an understanding between the artist and the people. In the best ages of art that has always been the case . . . I want to have an effect on my time, in which human beings are so confused and in need of help.

Many of Kollwitz's drawings were designs for posters to be used by humanitarian and socialist organizations. Like Dix, Kollwitz illustrated the suffering that the German government tried to ignore. This did not go without notice. When she won a prestigious prize, a government official canceled it, declaring her work "gutter art."

In the 1920s, Germany had its great depression. Devastated financially by the First World War, Germany experienced overwhelming inflation that forced a large part of the population into poverty. There were food riots and starvation. In *Bread!* (15-28), Kollwitz shows a mother whose children are hungry but who has nothing to offer them. Kollwitz was unique in her ability to translate abstract social problems into the real burdens that human beings were facing. These problems, unfortunately, remain widespread, which accounts for the enduring power of her art.

15-28 Käthe Kollwitz, *Bread!*, 1924. Lithograph. Staatliche Museen Preussicher Kulturbesitz, Kupferstichkabinett, Berlin.

SURREALISM

With the disintegration of the Dada movement, many former Dadaists reorganized under a different flag. Once again they searched for an alternative to a conventional view of reality. They found inspiration in the work of the Viennese psychiatrist, Sigmund Freud, whose discovery of the unconscious and the meaningfulness of dreams had changed the twentieth-century picture of the human mind. This new movement was called **Surrealism**, a word meaning "more real than reality," an art of dreams and the irrational unconscious.

Freud contended that beneath our veneer of rationality, in the unconscious portion of our minds, there lies a world of intense, barely suppressed desires (especially sexual urges). Our dreams, however, give us ways to express feelings that ordinarily have to be suppressed in a symbolic way. So rather than being simply

confusing and irrational, dreams are rich in meaning once their symbols are analyzed. In dreams and irrationality, the Surrealists found a fertile world of fantasy and imagination. The unconscious, according to Freud, was also the key to our creativity and emotions. By giving our unconscious a "voice," the Surrealists intended to complete our picture of the world and gain access to the source of imagination. They were therefore confronted with a challenge: How to visualize the irrational unconscious, the unexplainable? How could they make an art of dreams?

The Surrealists of the 1920s found a forerunner of their movement in a relatively unknown Italian painter, Giorgio de Chirico. Without access to the works of Sigmund Freud, he had intuitively created what he called "Metaphysical Pictures" even before World War I. By setting his paintings in landscapes that did not follow the rules of perspective but were painted in a recognizable manner, he was able to evoke the seemingly real but ultimately confusing nature of the dream state. In *Mystery and Melancholy of a Street* (15-29), the mathematical certainty of the Renaissance arcade on the left becomes uncertainty when compared to the one on the right. These arcades lead to two irreconcilable vanishing points (see "Perspective," Chapter 2). An empty boxcar sits in the foreground, enhancing the eerie loneliness of the scene. The frightening quality of a dream is evoked by the interplay between the small girl at play and the long, dark shadow of a figure with a spear above her.

SURREALIST COLLAGE

Max Ernst found the Cubist method of collage particularly suitable for creating an irrational world. He carefully integrated portions of various Victorian engravings, mixing images never meant to be connected. By juxtaposing conventional imagery in illogical ways, he seduces us into believing in his vision but at the same time puts our usual frames of reference in question. His collages seem strangely familiar but cannot be, as in dreams.

The Surrealists were committed to the liberation of sexual impulses ("amorous memories") as the first step in building a better world. A collage, *People in a Railway Compartment* (15-30), from a book called *Une*

15-29 Giorgio de Chirico, *Mystery and Melancholy of a Street,* 1914. Oil on canvas, 34¼" x 28⅛". Private collection.

Semaine de bonté on Les Septs éléments capitaux is permeated with desire and frustration. To analyze it as Freud might a dream: Our hero is bound up by confusion. Before him lies the object of his desire, vulnerable and helpless. He is not alone, however. On either side of him are powerful representatives of the two sides of his consciousness. On the left is a soldier with a Classical head, representing rationality. On the right, another soldier with a lion's head represents the animal desires in his unconscious. Caught in the midst of conflicting demands, the main character anxiously turns his head back and forth unable to make a decision. His predicament has no resolution.

Using simple juxtaposition, Meret Oppenheim created an unforgettable Surrealist sculpture—*Object (Le Déjeuner en fourrure)*, often known as *Luncheon in Fur* (15-31). By covering a common cup, saucer, and spoon with fur, she altered them profoundly and released many troubling associations. Think of

15-31 Meret Oppenheim, *Object (Le Déjeuner en fourrure)*, 1936. Fur-covered cup, saucer, and spoon; cup, 4⅜″ diameter; saucer, 9⅜″ diameter; spoon, 8″ long; overall, 2⅞″ high. The Museum of Modern Art, New York (purchase).

15-30 Max Ernst, *People in a Railway Compartment* from *Une Semaine de bonté on Les Septs éléments capitaux*, 1934. Collaged engraving, 11″ x 8⅛″.

using the fur cup in a conventional way. The connection of two primal urges (thirst and sex) underlies what at first seems only a humorous object but is actually much more disturbing.

DALI

One of the eerie qualities of dreams is that they look so real while we are asleep. To show dreams in vivid reality, some Surrealists ignored the revolutionary techniques of modern times and returned to the precise techniques of the Baroque masters of Holland and Spain. Salvador Dali was the greatest master of this style of Surrealism. By bringing a superb realistic technique to Surrealism, he could make bizarre images seem believable.

The setting of Dali's *The Persistence of Memory* (15-32), as in most of his pictures, is a lovely and timeless Mediterranean. In this pleasant landscape reside several strange objects. From left to right, we see a pocket watch with ants crawling on it; a flaccid watch, melted as if made of wax; and another watch hanging limply from a dead tree. An even more disquieting object is placed in the center of this vision—another melted watch hangs over what seems to be a piece of flesh. Complete with eyelashes, it looks as if someone has torn

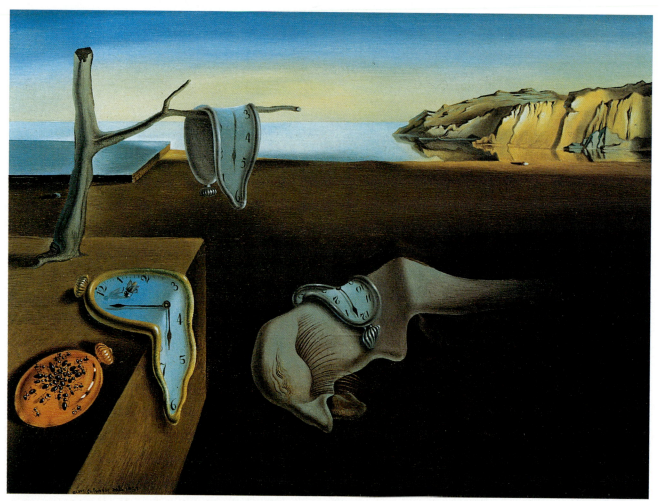

15-32 Salvador Dali, *The Persistence of Memory*, 1931. Oil on canvas, 9½" x 13". The Museum of Modern Art, New York (given anonymously).

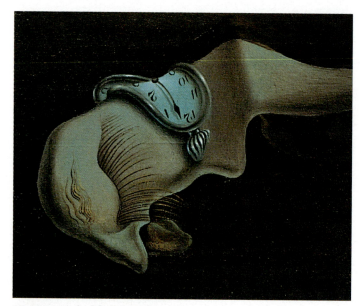

15-33 Detail of figure 15-32

off the side of his or her face and left it on the sand, like a dead fish (15-33). In addition to the irrational juxtaposition of these strange objects, their size and scale are confusing, as things often are in dreams.

What does Dali's picture mean? The artist did not offer much assistance:

My enemies, my friends and the general public allegedly do not understand the meaning of the images that arise and that I transcribe into my paintings. How can anyone expect them to understand when I myself, the "maker," don't understand my paintings either. The fact that I myself, at the moment of painting, do not understand their meaning doesn't imply that they are meaningless: On the contrary, their meaning is so deep, complex, coherent, and involuntary that it eludes simple analysis of logical intuition.

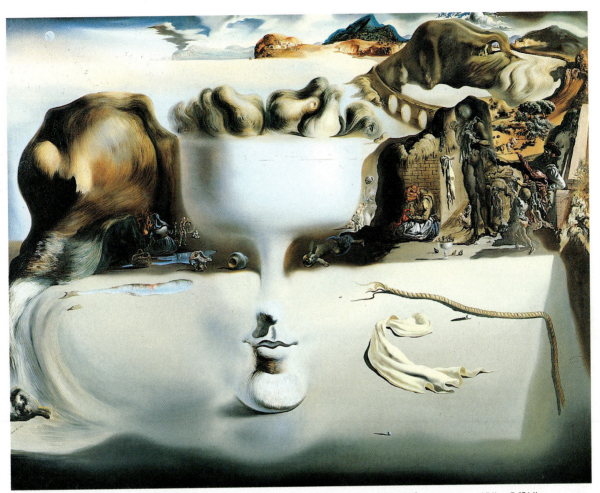

15-34 Salvador Dali, *Apparition of Face and Fruit-Dish on a Beach*, 1938. Oil on canvas, 45″ x 56⅞″. Wadsworth Atheneum, Hartford (Ella Gallup Sumner and Mary Catlin Sumner Collection). © Wadsworth Atheneum.

In other words, one should not be surprised that successfully irrational pictures should be incomprehensible. Otherwise, they would not be "images of concrete irrationality."

One of Freud's discoveries in dream analysis was that events and objects could have several meanings at once. Dali was able to create the visual equivalent of this idea in his *Apparition of Face and Fruit-Dish on a Beach* (15-34). Although it may not be initially perceptible, the entire picture is filled with a giant dog. His eye is also a cave (15-35), his body also a fruit bowl. The fruit bowl is also a face. Once we understand Dali's method, this entertaining puzzle manages to lift us out of ordinary existence. We are able to look at the picture with fresh, searching eyes and do not take any part of the image at face value. That is the liberation of Surrealism.

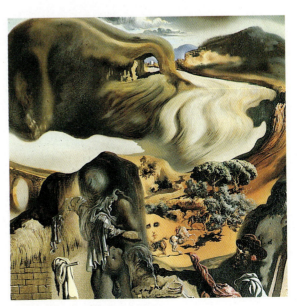

15-35 Detail of figure 15-34

MAGRITTE:
THE REAL WORLD ON TRIAL

René Magritte offered liberation to his viewers by undermining their confidence in the most ordinary things. *The Treachery (or Perfidy) of Images* (15-36) borrows the format of a typical children's book. Written below the simple image of a pipe is the sentence *Ceci n'est pas une pipe* that translated reads "This is not a pipe." Magritte explained that his titles "were chosen to inspire a justifiable mistrust of any tendency the spectator might have to over-ready self-assurance." Magritte wanted to make the viewer conscious of the limitations of signs, labeling, and language. For example, snow has various qualities, so the Eskimos have many names for its different types. Yet in English we lump them all under the word "snow." What do we miss when we generalize? What have we, by habit, become blind to when we say the word "snow" or "pipe" and stop looking? Simple identification is a prison that prevents us from seeing our world fully.

Magritte felt that our sense of what is "normal" constrains us. True freedom cannot exist until the fabric of normalcy is destroyed. Like Dali, Magritte also pictured the impossible realistically. But unlike Dali's, Magritte's scenes are set not in a distant ideal landscape

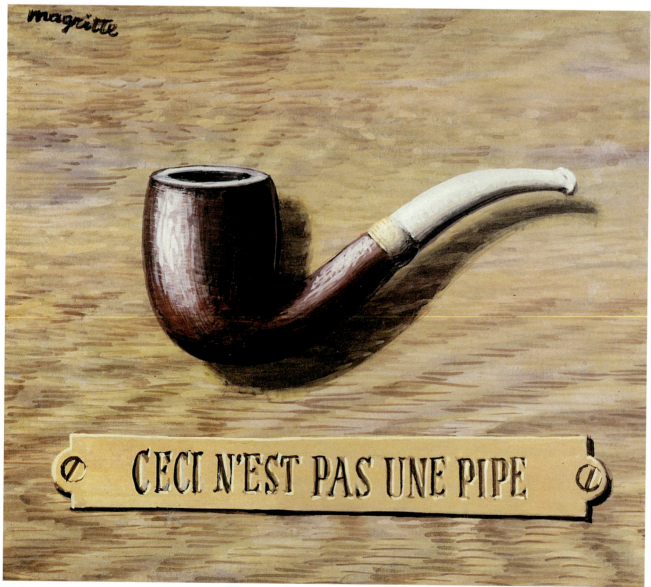

15-36 René Magritte, *The Treachery (or Perfidy) of Images*, 1948. Gouache, 23¼" x 31½". Private collection.

but a familiar, almost banal world. In 1939, Magritte explained his approach:

> I painted pictures in which objects were represented with the appearance they have in reality, in a style objective enough to ensure their upsetting effect.

In *L'Empire des lumières* (The Empire of Light), 15-37, for example, it is nighttime at street level, but above the trees it is day. Both parts of the picture are absolutely convincing, and the transition between the times of day even seems completely natural. What is portrayed looks normal but cannot be. In this surreal world, nothing is for certain, and things cannot be explained logically. Like ours, perhaps.

When René Magritte undermined language, signs, and conventional perceptions, he undermined all that makes us feel secure. Like many of the artists of the early twentieth century, he felt obligated to question what was once unquestionable, or, in his words, he was "putting the real world on trial." Along with the other artists in this chapter, he did this not simply to disturb us but to open our eyes to "an infinity of possibilities now unknown in life." His challenge to all of us is to see with fresh eyes, without prejudice. His aim was to return to us the full power of seeing.

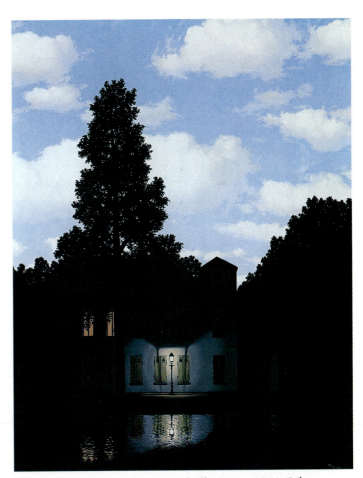

15-37 René Magritte, *L'Empire des lumières*, 1954. Oil on canvas, 4'11½" x 3'8⅞". Musées royaux des Beaux-Arts de Belgique, Brussels. © 1993 C. Hercovici/ARS, New York.

CHAPTER

16

THE INVISIBLE MADE VISIBLE: ABSTRACT AND NONREPRESENTATIONAL ART

PERIOD	HISTORICAL EVENTS	
1910–1930 Nonrepresentational art De Stijl The Bauhaus The International Style	World War I 1914–1918 League of Nations founded Regular radio broadcasts Gershwin, *Rhapsody in Blue* 1923 Kafka, *The Trial* 1925	James Joyce, *Ulysses* 1922 Louis Armstrong joins King Oliver's band Mahatma Gandhi leads independence movement in India
1930–1945 The International Style Straight photography Documentary photography Surrealist photography	Steinbeck, *The Grapes of Wrath* 1939 World War II 1939–1945 Attack on Pearl Harbor Penicillin discovered 1943 Mao Tse Tung leads Communist forces in China	Exodus of artists and intellectuals to the United States Nuclear bombs exploded over Hiroshima and Nagasaki
1945–1965 Abstract Expressionism The New York School Color-Field Painting The International Style	United Nations founded Marshall Plan in Europe Beginning of Cold War Building of Berlin Wall Independence movements in Africa, Asia	Discovery of DNA 1953 Television supplants radio Samuel Beckett, *Waiting for Godot* 1952

CROSSING THE FRONTIER

Art lovers who followed the avant-garde art movements of the early twentieth century witnessed some shocking changes. Traditional manners of representation that had been considered the essence of art for centuries—beauty, logic, realistic space, literal color, solid objects—were discarded enthusiastically. While many artists broke fresh ground, few were more revolutionary than Pablo Picasso. His treatment of color and form demolished barriers that had seemed impregnable only a few years before. Yet even he respected one ultimate barrier. While some of his Analytical Cubist compositions were very abstract, Picasso never made a completely nonrepresentational picture. All his art referred to the real, visible world in some way. It was his primary source of inspiration. As a young man, Picasso had seen that Paul Cézanne's work was pointing toward a new,

more radical direction for painting—the style of Cubism. Beginning around 1912, other artists began to see that Cubist pictures were pointing toward an even more revolutionary type of art—an art that would be completely liberated from the visible world, that could be created only out of pure colors, lines, and shapes. What appeared to be the last frontier for artists was about to be explored.

No one can deny that nonrepresentational art is challenging to the viewer. However, by looking at its first practitioners closely, we will be able to understand the natural progression that led to its creation.

THE SPIRITUAL PATH TO NONREPRESENTATION

Even early in life, Vasily Kandinsky had extraordinary sensitivity to color. When he heard music that moved him, he would close his eyes and see the music in colors. When the

ART

Breuer, *B33 Side Chair* 1927–1928

O'Keeffe, *Abstraction Blue* 1927

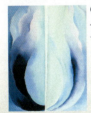

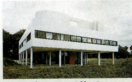

Le Corbusier, Villa Savoye 1929–1931

Mondrian, *Composition with Red, Blue, and Yellow* 1930

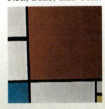

Weston, *Snag, Point Lobos* 1930

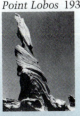

Man Ray, *Le Souffle* 1931

Lange, *Migrant Mother, Nipomo Valley* 1936

Wright, Kaufman House (Fallingwater) 1936–1939

Pollock at work 1951

de Kooning, *Woman and Bicycle* 1952–1953

Johnson and Mies van der Rohe, Seagram Building 1956–1958

Smith, *Cubi XII* 1963

young Kandinsky saw a show of Claude Monet's paintings for the first time, he noticed only the colors and did not realize that the pictures were landscapes until he read the catalog. It was one of his first hints that a subject from the visible world would not be necessary for all art.

Kandinsky wanted to show the "inner mystical construction of the world." The lat-est discoveries in physics seemed to support his own intuition that an underlying invisible force holds our universe together—something called by the physicists "energy." Kandinsky felt that *color* could show this energy. In paintings like *Blue Mountain* (16-1), Kandinsky simplified his drawing to open up wider areas for bright colors. Life's intensity was evoked by using unmixed, brilliant hues of

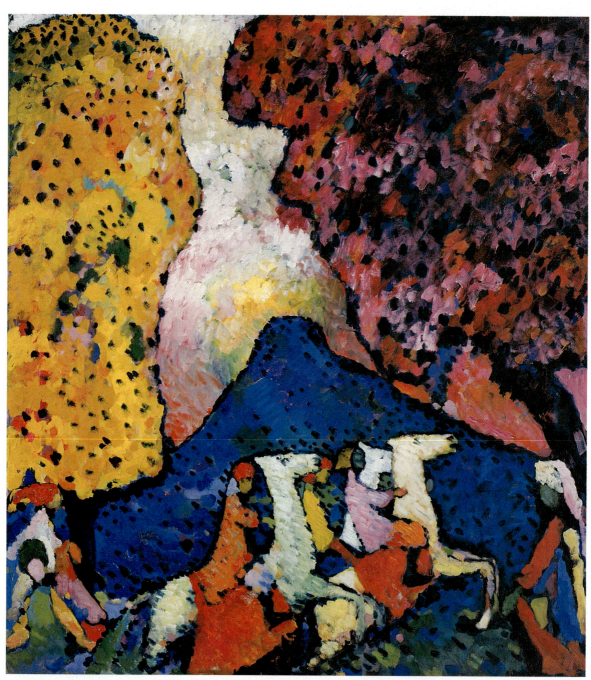

16-1 Vasily Kandinsky, *Blue Mountain*, 1908. Oil on canvas, 41¼" x 37¾". Solomon R. Guggenheim Museum, New York (gift of Solomon R. Guggenheim, 1941).

yellow and red in the trees against the blues of the mountain itself. These colors vibrate vividly together. Despite the obvious power in colorful canvases like *Blue Mountain*, Kandinsky remained dissatisfied. He realized, little by little, that to show the spiritual nature of the cosmos he needed to abandon all reference to the physical world.

Between 1909 and 1913, elements of the visual world were slowly transformed into more and more abstract symbols. During 1913, Kandinsky painted the first pictures in which lines, shapes, and colors are independent elements and no longer refer to the real world (16-2). Each appears to have a life of its own; lines and shapes move in many directions and almost shove each other aside in an attempt to be noticed. Our eyes are pulled in many directions, and it is difficult to focus on any part of the composition for very long. We are witnessing Kandinsky's own struggle to organize his pictures, to orchestrate energy. His first abstract pictures seem chaotic, because he is painting in a new world where

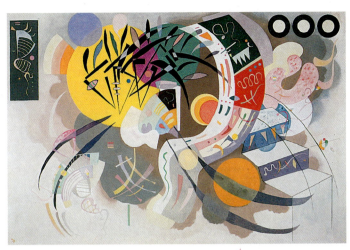

16-3 Vasily Kandinsky, *Dominant Curve (Courbe dominante)*, April 1936. Oil on canvas, 50 ⅞″ x 76 ½″. Solomon R. Guggenheim Museum, New York.

none of the old rules seem to apply. Suddenly, the issue was no longer how to obtain absolute freedom but how to control it.

Light in Heavy (2-25) demonstrates how Kandinsky found ways to organize nonrepresentational painting. He used a single background color, in this case brown, to unify the picture. To make sure the brown remained in control, he kept the other pictorial elements relatively small in relation to the background. By using geometrical lines and shapes, and repeating curves and straight lines, Kandinsky made a more formal, calmer picture. Although *Light in Heavy* is a totally nonrepresentational picture, it does have a "natural" feeling to it. The geometrical shapes shift like microscopic organisms through mud. They exude the warmth of living creatures.

At the end of his life, Kandinsky was in complete command of a totally abstract art. Pictures like *Dominant Curve (Courbe dominante)*, 16-3, are celebrations. Each line, color, and shape has its own mood, its own personality. These pictorial elements dance around, floating freely, like many characters joined together in harmony.

MONDRIAN: A LOGICAL APPROACH TO NONREPRESENTATION

The variety in Kandinsky's paintings demonstrates that he had discovered a fertile field for exploration. The Dutch artist Piet Mondrian also created a totally abstract art, nearly

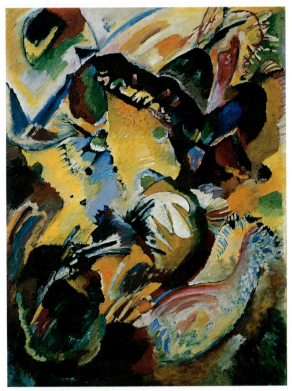

16-2 Vasily Kandinsky, *Painting No. 199*, 1914. Oil on canvas, 64⅛″ x 48⅜″. The Museum of Modern Art, New York (Nelson A. Rockefeller Fund, by exchange).

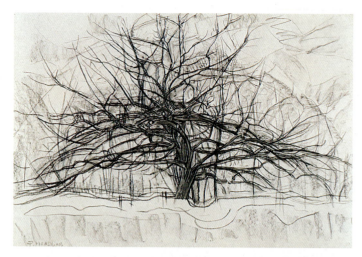

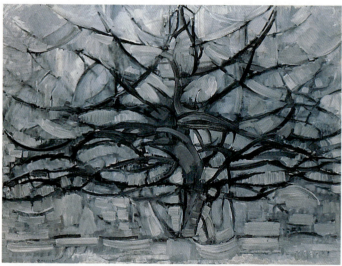

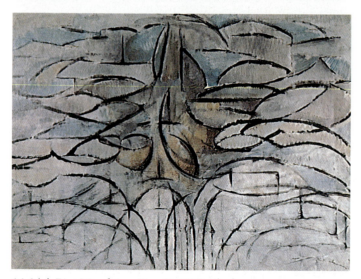

16-4 (*a*) Piet Mondrian, *Tree II*, 1912. Black crayon on paper, 22¼″ x 33¼″. Haags Gemeentemuseum, The Hague. (*b*) Piet Mondrian, *The Gray Tree*, 1912. Oil on canvas, 30½″ x 42″. Haags Gemeentemuseum, The Hague. (*c*) Piet Mondrian, *Flowering Apple Tree*, 1912. Oil on canvas, 27½″ x 41¾″. Haags Gemeentemuseum, The Hague.

simultaneously with Kandinsky. By studying a series of pictures Mondrian made during 1912 (16-4), we can see the logical progression of his work toward abstraction. In a search for nature's underlying geometry, he broke down the trees into lines and planes, converting them into abstract patterns. To bring more order to his canvases, he replaced curves with horizontal and vertical lines, utilizing a grid-like system. In the process, Mondrian learned that composition and harmony were more important to him than recording the details of an ordinary subject. Although admiring and learning from Picasso, he felt the Cubists had lacked the courage to follow their discoveries to their logical conclusion. He would not hesitate to go further.

Mondrian wanted to make a painting that could be universally understood by people of any culture on earth—a pure painting that would make sense to an Australian aborigine as well as to a European (unlike *The Last Supper*, for example). To create his universal painting, Mondrian decided he needed to simplify visual art to its essence and create perfect images that reflected pure visual harmony. It would have to be an art that depended on no illusions like depth but was flat and direct. He wrote that

> All painting is composed of line and color. Line and color are the essence of painting. Hence they must be freed from their bondage to the imitation of nature and allowed to exist for themselves.

In the early 1920s, his lines became bolder and firmer, his colors were pure primaries, and his compositions more simplified (16-5). To many viewers, all Mondrian's pictures from this era look exactly the same. However, when they are studied with a sensitive eye, it becomes clear that many different pictures and different feelings can be created even with the simplest elements. While Mondrian reduced art to its pure basics, for him the weight of each line and color had its effect on the whole mood of the painting. Although there is a mathematical feel to his art, Mondrian despised formulas. He believed that artists had to be intuitive and approached all his paintings with that attitude.

In 1940, Mondrian left his native Holland to escape the impending Nazi invasion and came to New York City. It was love at

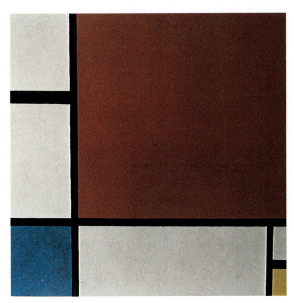

16-5 Piet Mondrian, *Composition with Red, Blue, and Yellow*, 1930. Oil on canvas, 20″ x 20″. Collection Mr. and Mrs. Armand P. Bartos, New York.

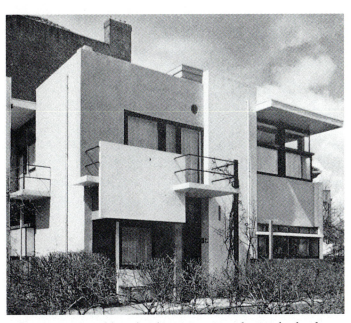

16-6 Piet Mondrian, *Broadway Boogie Woogie*, 1942–1943. Oil on canvas, 50″ x 50″. The Museum of Modern Art, New York (given anonymously).

first sight. He adored Manhattan: the rectangular shapes of its skyscrapers, the way its streets were laid out in a grid. He must have been struck with the similarity of the city's appearance with the design of his pictures. In his New York studio, Mondrian kept a record player on which he played loud "boogie-woogie" music (jazz) while he painted; its upbeat tempo affected his last paintings. The calm and stability of his earlier pictures was replaced by a new spirit, the tones of the modern metropolis. One can almost hear the honking taxi cabs in *Broadway Boogie Woogie* (16-6).

DE STIJL

In Holland, just before World War II, Mondrian's ideas and approach to art were translated by followers into a movement called *De Stijl* ("the style"). The Dutch artists proposed "finding practical solutions to universal problems" and believed a pure universal style in art and architecture could be the solution to humanity's misery. They declared that "art and life are no longer two separate domains . . . we demand the construction of our surroundings according to creative laws." De Stijl artists designed furniture and buildings using flat geometric areas filled with primary colors, like Mondrian's paintings.

Gerrit Rietveldt's *Schröder House* (16-7) is one of the best examples of De Stijl architecture, a three-dimensional equivalent of Mondrian's pictures. Built in 1924 in Utrecht, Holland, it follows the strict vertical and horizontal orientation of Mondrian's most pure work, but Rietveldt's design has a fluidity that

16-7 Gerrit Rietveldt, Schröder House, Utrecht, Netherlands, 1924

much of Mondrian's work lacked. The rectangular panels seem to float in front of equally rectangular dark windows. All forms are balanced asymmetrically, and a portion of the flat roof seems to move out from the building towards the street. As we look at it, the building seems almost to be in the process of arranging itself. In fact, the interior spaces were designed to be flexible; sliding panels could be moved to accommodate the needs of the occupants. While it seems very modern even today, to really understand its impact in 1924, however, imagine the shocking contrast made by this building painted in white, gray, and primary colors in a neighborhood of nineteenth-century homes.

THE INTERNATIONAL STYLE

The Schröder House and De Stijl would be eventually included in a worldwide movement called the **International Style**. Other architects in Europe and the United States shared the Dutch artists' desire for a pure modern counterpart for the Machine Age—constructions that utilized a new language for the arts.

The **Bauhaus**, founded by Walter Gropius (see Chapter 9), was designed to be a home for this new language. Gropius's dictum that "the complete building is the final aim of the visual arts" was one of the central tenets of the movement, and his influential design for the new *Dessau Bauhaus* (view from the northwest), 16-8, epitomizes many of the qualities that would characterize the International Style for decades to come. Finished in 1926, it was the new home for the school after political changes made it impossible for the Bauhaus to remain in its first location.

The building was the antithesis of the heavily ornamented style taught in architectural academies. Flat-roofed and made of modern materials (concrete, steel, and glass), it was free of any superfluous decoration. Boxlike and practical, all spaces were designed for efficient organization. It followed Gropius's directives for the new architecture in 1923:

> We want a clear, organic architecture, whose inner logic will be radiant and naked, unencumbered by lying facades and trickeries; we want an architecture adapted to our world of machines . . . whose function is clearly recognizable in the relation to its form.

The building was supported by an outer skin of glass and steel, what would be known as a **"glass curtain"** (a forerunner being the Crystal Palace, 8-24). Notice Gropius's handling of the corners of the building. Instead of the typical heavy stone piers, there was only a sharp edge formed by the meeting of transparent panes of glass. Light poured into the large, open classrooms. The glass curtain walls also allowed those on the outside to see the activities inside, breaking the age-old tradition of separation between interior and exterior spaces. All aspects of the building were designed and built by instructors and students, from the lamps (see Marianne Brandt, 9-31) to the furniture in the dining rooms. Its integration of interior and exterior design became the new tradition for modern architects.

After the Bauhaus was finally closed by the Nazis, Gropius and many of his instructors came to the United States and continued teaching and designing. Their influence on the training of young American artists and architects helped make Modern architecture and design the dominant style for the rest of the century. One measure of their influence is that the Bauhaus building at Dessau seems like an ordinary building today.

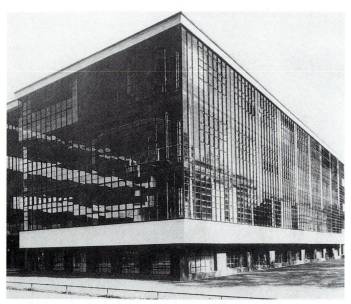

16-8 Walter Gropius, Dessau Bauhaus (view from the northwest), Germany, 1925–1926

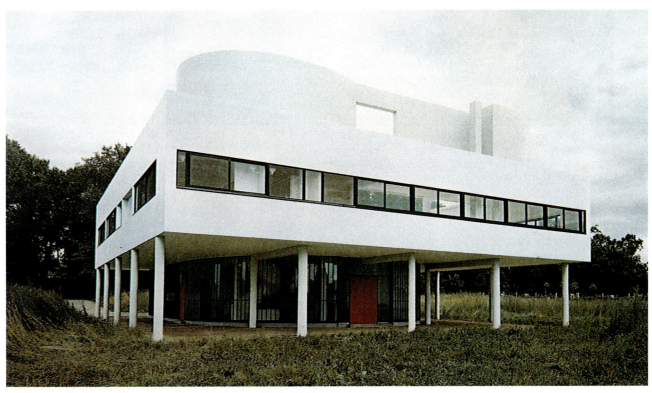

16-9 Le Corbusier, Villa Savoye, Poissy, France, 1929–1931

LE CORBUSIER: MASTER OF THE "NEW SPIRIT" IN ARCHITECTURE

Le Corbusier's *Villa Savoye* (16-9), however, still seems radical more than a half-century after its construction. Built in 1931 as a weekend house in the suburbs of Paris, it has long since been seen as the embodiment of the International Style. Resting at the top of a hill supported by concrete columns, with horizontal windows providing views in all directions, it is the twentieth century's *Villa Rotonda* (12-24) or *Monticello* (8-41). Unlike Palladio or Jefferson, however, Le Corbusier utilized no Classical elements or historical references. An architectural purist, he believed that Modern buildings should be more rational and scientific than previous styles. According to him, a house was "a machine to be lived in."

In the Villa Savoye, the columns that support the building not only provide a fine view inside and on top but also a convenient place to park one's car. A pure, undecorated skin of windows and smooth stucco surround its inner frame. Inside, ramps lead through large, open, and well-lit rooms and up to a secluded roof garden—a pleasant idiosyncrasy of his buildings. Along with most of the buildings in the International Style, Le Corbusier's buildings have come to be seen as dehumanizing, but that was not their original intention. Like Gropius, Le Corbusier dreamed of an architecture that could create a better world. By utilizing and preaching a new international style, what he called the "New Spirit," Le Corbusier hoped that old nationalist boundaries could be broken down, and a new world order devoted to humanitarian goals could be achieved. His "Plan for a Contemporary City for 3 Million Inhabitants" (9-45) was one of a lifetime's worth of projects designed to resolve the intransigent social problems of poverty, homelessness, and class divisions. Le Corbusier imagined such reforms could be achieved through an orderly and perfected architecture. Despite his extraordinarily creative mind (Gropius once said it would take an entire generation of architects to explore all Le Corbusier's ideas), most of his projects were never built. In the twentieth century, however, this was no longer a hindrance to fame. Because he lived in an age of easily made

reproductions, Le Corbusier's blueprints were circulated worldwide, and a younger generation of architects spread his plans and the International Style throughout the world by modifying his ideas and making them less radical.

FRANK LLOYD WRIGHT

Frank Lloyd Wright epitomized the American approach to modern architecture before World War II. Wright, who became the most famous American architect, designed modern buildings that have many similarities to the Bauhaus model but are based on profoundly different ideas. Still his motto—"Form follows function"—learned in his apprenticeship from the architect Louis Sullivan, remains a slogan of the Modern Art movement.

Wright was born in the beautiful hills of rural Wisconsin just after the end of the Civil War. He learned the lessons of nature, which he called "a wonderful teacher," on his uncle's farm. As a young architect in Chicago,

the messages of his childhood were translated into an ideal he would later call "organic architecture": functional buildings designed to work with nature, built from the creative arrangement of simple forms.

For his entire life Wright refused to be associated with what he felt was the essentially European International Style. In 1932, Wright said of Le Corbusier: "I believe Le Corbusier [is] extremely valuable, especially as an enemy." Wright's *Kaufman House (Fallingwater)*, 16-10—see also drawing and plans in Chapter 8—built in 1936, makes a striking comparison with the Villa Savoye. Both homes are designed as country retreats, but their underlying attitudes are quite different. The utter logic and machinelike quality of Le Corbusier's design is opposed by the free forms and natural materials favored by Wright. Wright's building is designed to blend into nature; in fact, it sits on a ledge where a waterfall actually passes under the house. Le Corbusier's villa stands on columns that distance it from nature; its boxlike form has

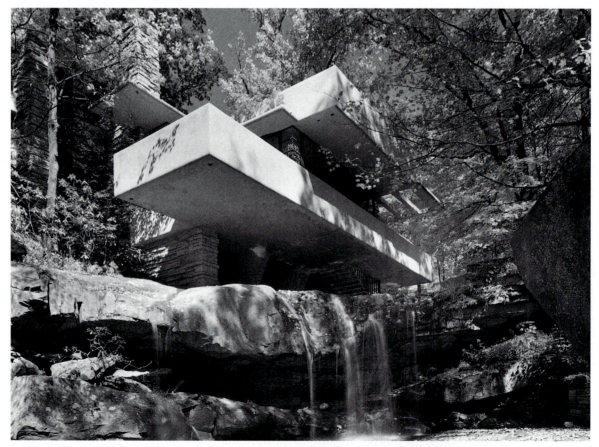

16-10 Frank Lloyd Wright, Kaufman House (Fallingwater), Bear Run, Pennsylvania, 1936–1939. Ezra Stoller © Esto.

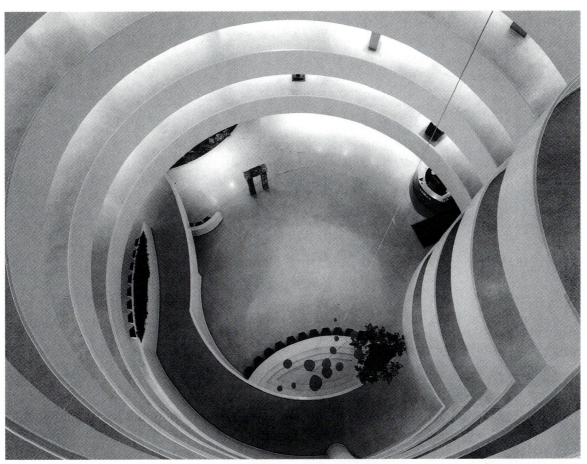

16-11 Frank Lloyd Wright, main rotunda of the Solomon R. Guggenheim Museum, New York, 1943–1959

nothing to do with its surroundings. While both architects used concrete to shape simple, geometric forms, Wright's open slabs reach out to nature, while Le Corbusier's box resembles a fortress.

Still, both architects shared the modern aesthetic. They believed in the elimination of unnecessary ornament, in letting the function of the building determine its design. Neither approved of the use of historical references. Both believed interiors should be as open as possible. Above all, they were committed to the idea that architects should design every aspect of a building, from the overall plan to the furnishings within. We have already seen in Chapter 8 one of the most beautiful results of this aesthetic, Wright's exploration of round shapes at the Circle Gallery in San Francisco (8-5, 8-6). However, the spiral was refined and expanded in his *Solomon R. Guggenheim Museum* in New York City (16-11). In a building that is almost a modern sculpture itself, art lovers move smoothly and gradually along a spiral ramp

from the top to the ground level without interruption.

Wright was the first American architect to have a truly international influence. While he probably never achieved his intention of being "not only . . . the greatest architect who has ever lived, but the greatest who will ever live," during the middle decades of the twentieth century there were many in his field who believed he had.

ABSTRACT ART IN AMERICA: O'KEEFFE

Georgia O'Keeffe was another American original. Like Wright, O'Keeffe was born in rural Wisconsin and first attracted attention in the early years of the century. In her old age, she also became a larger-than-life figure in the art world. She said she knew as a child that she wanted to be an artist even though she had very little idea what that meant. In the early 1900s, however, most American women who wanted a career in art were expected to

become teachers; higher ambitions were not considered practical or proper. After years devoted to the study of art, followed by teaching in public schools and colleges, she felt rather discouraged. As she wrote many years later,

> One day I found myself saying to myself, "I can't live where I want to. I can't even say what I want to." I decided I was a very stupid fool not to at least paint as I want to.

She discovered a deep well of inspiration in the abstraction of nature, its creations, and its forces—her most dominant theme during a career that lasted nearly seven decades. *Two Calla Lilies on Pink* is a good example of her sensuous style of synthesizing natural forms (see 2-40).

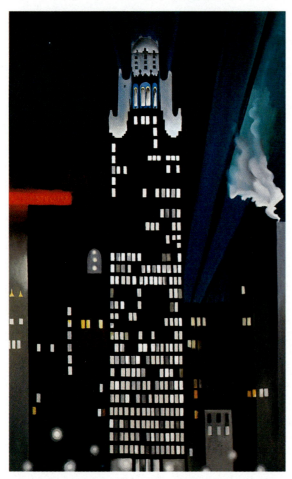

16-12 Georgia O'Keeffe, *Radiator Building—Night, New York*, 1927. Oil on canvas, 48" x 30". The Carl van Vechten Gallery of Fine Arts, Fisk University, Nashville, Tennessee (Alfred Stieglitz Collection).

Radiator Building—Night, New York (16-12) was painted in 1927, when she was living in New York City. O'Keeffe focused on the unique experience of artificial light at night in the modern city—a manufactured world filled with unnatural experiences. The home of the American Radiator Company rises like a beacon at the center of the picture; the skyscraper's windows form a grid of whites and grays. Searchlights illuminate an undulating cloud of steam that rises from a rooftop; street lights glow like stars and float mysteriously.

Throughout her career, O'Keeffe followed a pattern that she established at its beginning: taking inspiration from the world around her and reworking it into a personal statement. Sometimes her pictures were quite literal; at other times they would become totally abstract. The simple purity of O'Keeffe at her most nonrepresentational is seen clearly in *Abstraction Blue* of 1927 (16-13). What once may have been the interior of a flower is now a series of rounded forms. Arranged symetrically, they are all brought together in a quiet balance that gives an impression of monumentality. With *Abstraction Blue*'s sharp edges and blue palette, one might have expected it to seem harsh and cool. But O'Keeffe mitigates this sharpness with soft gradations of blue and pink. Such gradual blendings of color combined with crisp edges are hallmarks of her style. Her pictures are accessible to the general public in a way that is rare among the nonrepresentational artists of the twentieth century. In 1986, a year after her death at the age of ninety-eight, a retrospective of her art in Manhattan drew enormous crowds and solidified O'Keeffe's reputation as one of the most important American artists of the century. As she predicted, when explaining why she made her flowers so big, "I will make even busy New Yorkers take the time to see what I see of flowers."

STRAIGHT PHOTOGRAPHY

When comparing the work of the painter, O'Keeffe, and the photographer, Edward Weston, it seems surprising that they were not close friends. His closely studied vegetables and shells, sculptural and almost abstract, cannot fail to remind one of similar pictures by O'Keeffe. He also shared with O'Keeffe a

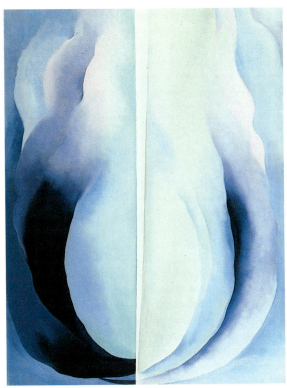

16-13 Georgia O'Keeffe, *Abstraction Blue*, 1927. Oil on canvas, 40¼" x 30". The Metropolitan Museum of Art, New York (acquired through the Helen Acheson Bequest).

love for the wide spaces of the American West. Born in Chicago, he visited California for the first time at the age of twenty and stayed virtually for his entire life.

Like many other artists discussed in this chapter, Weston attempted to capture the eternal. But he insisted on doing this "honestly." Disturbed by photographers who tried to imitate painters by using soft focus and other "trickery," he resolved in the 1920s "to present clearly my feeling for life with photographic beauty . . . without subterfuge or evasion." He thus became one of the fathers of "straight photography" (see Chapter 6).

Dismissing interesting accidents produced by rapid shooting, Weston believed photographers should decide on each image they took. Using a large-format camera that allowed him to see exactly what was in the lens, he "previsualized" each image before pressing the shutter release. A time-consuming process, Weston would wait all day if necessary to reveal the "deepest moment of perception." His camera made negatives that were 8 x 10 inches, and all his prints were *contact* prints, made directly from a negative without enlargement or reduction. This provided images of the utmost clarity and purity. These prints were also *uncropped* (printed "full-frame"), a tradition established by Weston and followed to this day by many photographers. For him, the need for any alteration to his images implied that he had failed.

Snag, Point Lobos (16-14) is ample proof that Weston's patience paid off handsomely. Point Lobos is a state park on the coast of California near Weston's home and one of his favorite sites. The vivid description of the textures on a piece of weathered wood could not be seen so clearly with any other photographic method. It fulfills Weston's ambition to show "the greater mystery of things revealed more clearly than the eyes can see." Photographed against a clear sky, the aged wood seems like an ancient monolith.

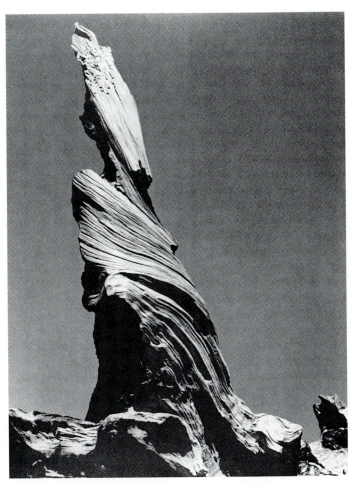

16-14 Edward Weston, *Snag, Point Lobos*, 1930. Gelatin silver print.

THE CENTER OF WESTERN ART SHIFTS

In the 1930s, storm clouds were gathering in Europe that were harbingers of its coming decline. The closing of the Bauhaus by Adolf Hitler's government in Germany was just one small part of his organized plan of censorship, repression, and terror. After Hitler's armies began their attempt at world domination in the 1940s, Europe was no longer capable of providing a nurturing ground for advanced artists. While Picasso and Matisse would stay in France, many artists fled from Europe, looking for a place where they could pursue their art in freedom. Mondrian, Max Ernst, and Salvador Dali were among the many artists who left Europe for America. They joined other important European artists like Marcel Duchamp, who had already emigrated to the United States before the war.

Their combined presence had a profound effect on American Art, especially in New York City where most of them found a home. New York City became the world capital of art in the 1940s and 1950s, replacing Paris which had been the center of Western Art since the age of Louis XIV. The land of Norman Rockwell had been invaded by Modern Art.

ABSTRACT EXPRESSIONISM: MODERN ART CREATED IN AMERICA

Willem de Kooning, born in Holland, came to this country as a young man. De Kooning's early paintings were portraits, influenced by Picasso but already with a dramatic command of line. Then, in the late 1940s, de Kooning

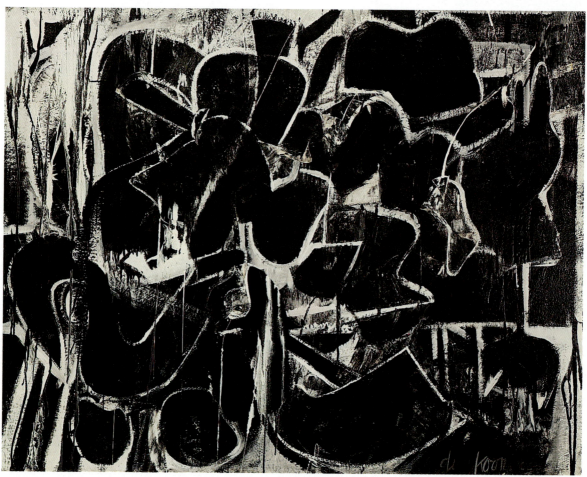

16-15 Willem de Kooning, *Painting,* 1948. Enamel and oil on canvas, 42⅝″ x 56⅛″. The Museum of Modern Art, New York (purchase).

began a series of black-and-white paintings that were totally original (16-15). Loose, expressive lines described very complicated and interlocked abstract spaces. It is not clear which shapes are coming forward and which are behind. This was intentional; like the Cubists, de Kooning did not want these pictures to have a conventional background and foreground. His mastery of a gestural, calligraphic line creates powerful rhythms all by itself.

These nonrepresentational, energetic pictures were some of the first of a new kind of painting that would become known as **Abstract Expressionism**. Like many art historical labels, it is a loosely defined one, describing art that combines the potent psychological content of Expressionism with an abandonment of any clear reference to the visual world.

Throughout his career de Kooning would paint both pictures that referred to the visible world (like *Woman and Bicycle*, 1-38) and those that were more or less completely abstract. He, along with his fellow Abstract Expressionists, believed it was more important to be an honest painter than to stick to a single-minded theory of art. If, while painting, his picture began to look like a woman, why should he deny it? If, as in Figure 16-16, it reminded him of looking out a door towards a river, why shouldn't he have the freedom to recognize it? Paintings like *Door to the River* (16-16) can be admired either as an imaginative interpretation of a scene or understood on a totally abstract level. The confident, wide, thick brush strokes and harmony of the colors communicate on a direct emotional plane. The sense of a landscape is intuitive.

POLLOCK'S ACTION PAINTING

There were two fathers of this new movement: de Kooning and an American painter, born in Wyoming, Jackson Pollock. Pollock was influenced by the Surrealist artists who came to New York during World War II. He was particularly inspired by the way they gained access to their unconscious through a method called "automatic picturemaking," where all marks were made instinctually, without planning or thought.

Pollock transformed this approach into a revolutionary and nonrepresentational way of painting that would be called his "drip tech-

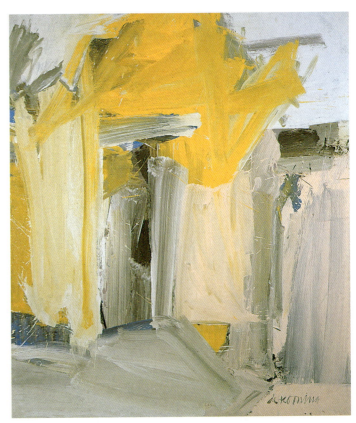

16-16 Willem de Kooning, *Door to the River*, 1960. Oil on canvas, 80" x 70". Collection of Whitney Museum of American Art, New York (purchased with funds from the Friends of the Whitney Museum of American Art, 60.63).

nique" (see photo, 16-17). On a length of canvas rolled onto the floor of his studio, Pollock would instinctually drip long lines of paint with brushes and sticks. He would hover over his canvas, sometimes stepping into it, moving constantly. While he was working, his picture would not really have a top or bottom. Not until he was finished would he determine the picture's final size (by cutting the canvas) or where its bottom was (by signing it). His lines were unique not only because of his technique, but also because they did not do what lines had always done in art—describe spaces or shapes. His lines were independent and active, each a lively experience.

The design of a "drip" painting was also original—an "all over" picture. This meant that, unlike all previous paintings, in Pollock's work no one part or section dominated the others. No part could be called the subject. All over the canvas everything was equal in impact.

Pollock is the artist most identified with the term *action painting* because of the energy in his new technique. Pollock's action paintings, according to witnesses, were done in fits of intense and often violent activity. He was known to spit at and burn parts of his pictures. Their great size was not due to any

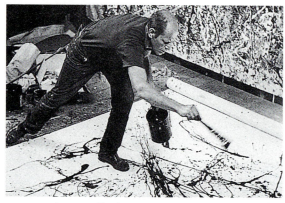

16-17 Jackson Pollock at work, 1951. Photograph by Hans Namuth.

artistic theory but Pollock's sense that he needed room to work in. Wall-sized, heroic pictures would become one of the identifying characteristics of Abstract Expressionism. By looking at *Number 1, 1950 (Lavender Mist)* and a detail of it (16-18, 16-19), we can see that, whether it is seen at a distance or close up, Pollock has created an entirely new kind of space. Nets of lines laid one over another produce a sense of infinity. Looking at a huge Pollock painting is like looking up at a sky full of stars on a clear night.

Jackson Pollock opened the door for the success of other Abstract Expressionists. Before Pollock's acclaim in the 1950s, they were largely a group of unknown artists living in low-rent apartments in lower Manhattan, barely surviving. As part of a conscious effort to re-create the exciting atmosphere of cafe life in Paris, they would meet in bars after painting all day and discuss art. Between drinks, they would offer each other consolation and camaraderie—so necessary for the

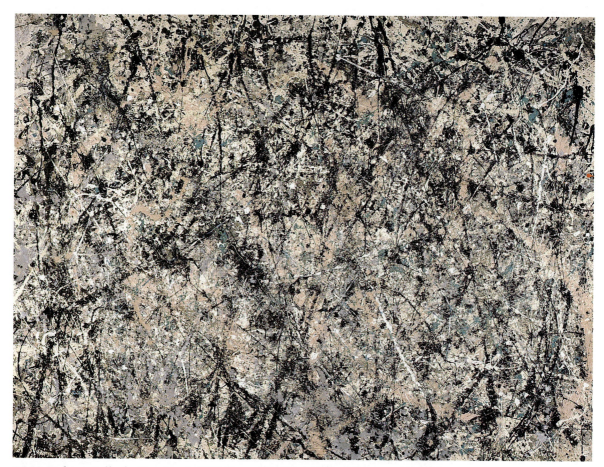

16-18 Jackson Pollock, *Number 1, 1950 (Lavender Mist),* 1950. Oil, enamel, and aluminum on canvas, 88" x 119" x 1½". The National Gallery of Art, Washington, D. C. (Ailsa Mellon Bruce Fund).

16-19 Detail of figure 16-18

essentially lonely act of making art. Sales were few and far between. But the news media got excited about Jackson Pollock. He was known as a wild man, a real cowboy; when he got drunk he often was violent. His life-style and his unusual method of painting transformed Pollock from an unknown to a celebrity. An art critic described Pollock as Picasso's heir, saying he had taken the old master's ideas and made them "speak with an eloquence and emphasis that Picasso himself never dreamed of." For the first time, Pollock was able to survive solely on the sale of his paintings. The paintings of other Abstract Expressionists, such as de Kooning, began to sell, also. With the attention of the art world and the media, Abstract Expressionism became the dominant style of art worldwide by the late 1950s.

While de Kooning and Pollock were the most influential of the Abstract Expressionists, other members of this group developed their own individual styles. The Abstract Expressionists did not have an all-encompassing style like earlier movements in art history. What they shared was a belief in individual freedom. This individualism is often said to be uniquely American. It may also be seen as a reaction to the totalitarian forces in Europe that led to the horrors of World War II. These artists did not want to share a manifesto, because they believed artists should operate freely.

COLOR-FIELD PAINTING

Mark Rothko was another member of the original group of Abstract Expressionists. Like Pollock, he explored automatic picture making—his early pictures containing totemic or symbolic shapes produced from the unconscious. In the late 1940s, he generated a new kind of picture, where large areas of color were more dominant than any particular shape. This new way of painting would become known as **Color-Field Painting.**

Rothko had not abandoned his earlier interest in the unconscious. He was simply approaching it from a different direction, by exploring the psychological and spiritual effects of color. In pictures like *Green on Blue* (16-20), Rothko creates a living, breathing color field. He applied his colors in thin transparent layers, one over another. The edges between the rectangular areas are not hard but soft, and they seem to shift, producing a sense of gentle movement.

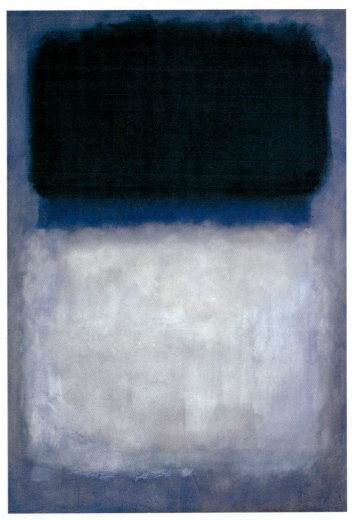

16-20 Mark Rothko, *Green on Blue*, 1956. Oil on canvas, 89¾" x 63¼". Collection of The University of Arizona Museum of Art, Tucson (gift of Edward J. Gallagher, Jr.).

Many of Rothko's pictures are more than 10 feet tall. He wanted viewers to be surrounded by his pictures. It was only on this scale, he felt, that his Color-Field paintings would come alive and affect the spirit of the viewer. He wrote: "I paint large pictures because I want to create a state of intimacy. A large picture is an immediate transaction: It takes you into it."

While it was an important aspect of the Baroque period, the combination of architecture and other media—such as painting or stained glass—to create a total religious visual experience is rare in the art of our century. One of Rothko's last works, however, was for a small, nondenominational chapel at Rice University in Houston, Texas (16-21). The deep, dark, wall-size pictures were designed to create a mood of serenity and contemplation. These paintings, like all his mature work, evoke a sense of tranquillity in the viewer.

TEACHER TO THE NEXT GENERATION

Hans Hofmann is known primarily as the teacher of the next generation of American Abstract Expressionists. His career in teaching began in his native Germany, and he also lived in Paris where he witnessed the birth of Fauvism and Cubism. In 1932, he arrived in New York and began teaching. His reputation as a great teacher brought him many students who would become important artists and teachers themselves.

Hofmann believed in what he called "pure painting," which according to him was the only honest painting, "the true realism." What he meant by "pure painting" was art that would have no reference to the visible world, like his *Memoria in Aeternum* (16-22). According to Hofmann, painting had moved beyond illusionism, which was only a cheap trick. There was more to nature than visual

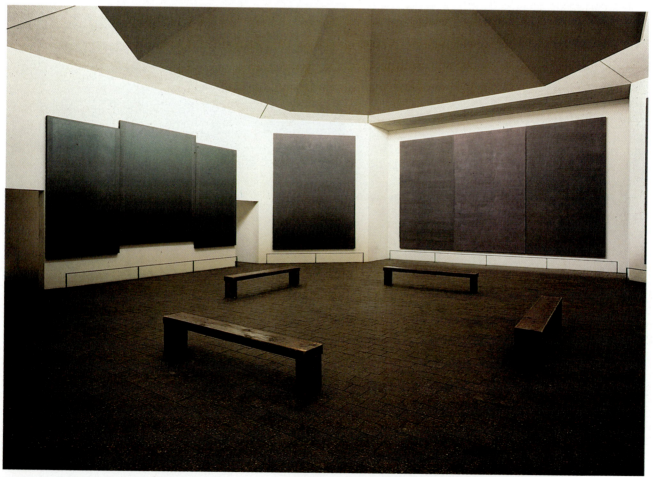

16-21 Mark Rothko, North, Northeast, and East wall paintings in the Rothko Chapel, Rice University, Houston, 1965–1966. Chapel design by Philip Johnson.

reality. The activity and excitement on the surface of the painting were enough of a subject for any artist. He talked about "push, pull": how the addition of, say, a rectangle of color creates a whole new dynamic in a picture. It would "push" the other elements around, necessitating a balancing "pull" to bring the other parts of the picture into a sense of equilibrium. This "push, pull" balancing act was what artists, according to Hofmann, had been doing for centuries. It was only with a totally abstract art that the essence of painting could be revealed honestly.

Most of the second generation of Abstract Expressionists were fervent believers in

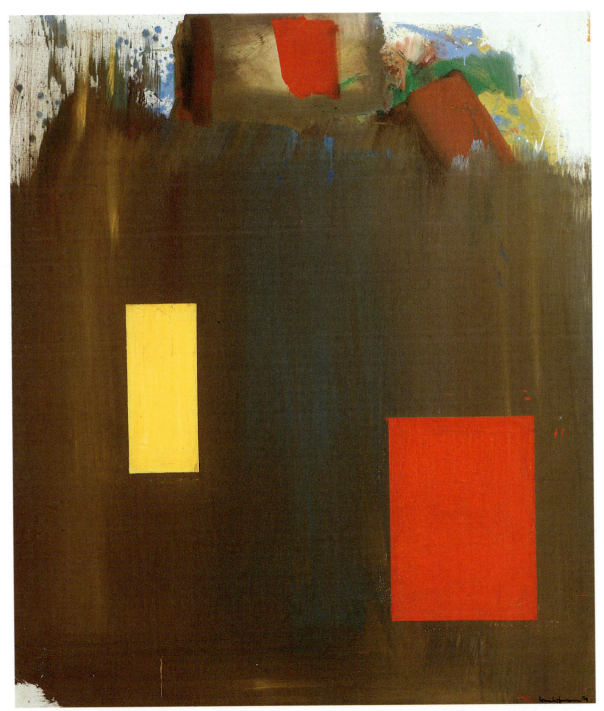

16-22 Hans Hofmann, *Memoria in Aeternum,* 1962. Oil on canvas, 7′ x 6½″. The Museum of Modern Art, New York (gift of the artist).

Hofmann's ideas. They believed representational art was dead as fine art, and it should be left to the commercial illustrators. Abstract Expressionism, by the mid-1950s, was the most powerful force in Western art. Its next generation would build on the foundation its creators had built.

THE NEW YORK SCHOOL

Helen Frankenthaler was a student of Hans Hofmann and one of the leaders of the next generation (sometimes called *The New York School*). The turning point in her career came during a visit to Jackson Pollock's studio. She watched him at work, spreading his canvas on the floor, circling his picture, painting from every side. She later said, "It was as if I suddenly went to a foreign country but didn't know the language, . . . [I] was eager to live there . . . and master the language."

In 1952, she began to paint in a new way. She spread raw canvas on the floor and began pouring paint from coffee cans, letting it soak into the unprimed canvas. (Most painters *prime* their canvases, which means applying a coat of paintlike gesso that seals the fabric.) Her colors stained the canvas, creating unusual effects. The result she called *Mountains and Sea* (16-23), a painting more than 10 feet tall. Its title came from the colors that reminded her of the Nova Scotia coast she had just visited. Despite its title and great size, there is a sense

of intimacy. Because of its soft, gradual transitions, it seems more like watercolor than an oil painting. Unlike "normal" oil paintings where the paint is clearly on top of the surface, in Frankenthaler's the paint seeped into the canvas, becoming an integral part of it. While she remembers that many who saw her first canvas thought it looked like a "large paint rag," she was convinced she had discovered a new way of working that was rich in possibilities.

She observed that accidents were bound to happen in both her and Pollock's method. Rather than trying to avoid them, she found them to be an important creative stimulus that opened up important new questions for artists. Is all life planned? Doesn't it take true creativity to deal with accidental circumstances, in life and in art? Perhaps an accident would lead her to ideas she would have never thought of on her own. This concept, called *"happy accidents,"* continues to be a popular one among contemporary artists. One should not think, however, that Frankenthaler made no attempt to control her paintings. On the contrary, she spent a great deal of time working with her poured paint. She would manipulate the wet areas with brushes, or by blotting. Sometimes she would pour enough paint to create puddles of color—all to create a variety of textures. These different textures gave her work an unusual sense of space, a space that was neither Renaissance nor Cubist.

As mentioned in Chapter 4, Frankenthaler later shifted from oils to the new acrylic polymer paint (see Figure 4-9). This eliminated a faint oily stain that had surrounded each color area in her early work. It also permitted her to experiment with flatter and purer color fields versus the relatively gestural *Mountains and Sea*. These simpler fields would be very influential on later Color-Field painters and the Minimalists of the 1960s and 1970s (see Chapter 17). No matter the medium, her work has a calm, sensuous beauty that sets it apart from the generally anxious works of Abstract Expressionism.

ABSTRACT SCULPTURE

Few artists have created a whole new form of art. Most have made their contributions by innovating in traditional forms. In our century,

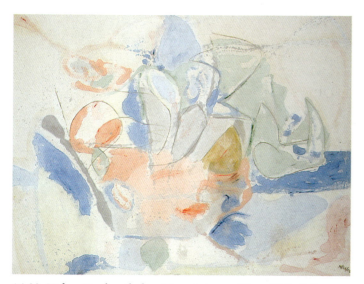

16-23 Helen Frankenthaler, *Mountains and Sea,* 1952. Oil on canvas, 7'2⅝" x 9'9¼". National Gallery of Art, Washington, D. C. (on loan, collection of the artist).

however, two new forms have been invented by artists: Picasso's invention was **collage,** and Alexander Calder's was **kinetic sculpture,** or the *mobile.*

Sculpting was a family tradition for the Calders. His father and grandfather were both successful in the field, his grandfather being best known for the statue of William Penn atop Philadelphia's City Hall. Alexander's first sculptures were not much more than drawings with wire (2-5), but they have a sense of fun and playfulness that was endearing and helped make him one of the most popular artists in the United States and Europe. His miniature circus "performances," with figures made of wire and corks that swallowed knives and walked a tightrope, were the talk of Paris.

His **mobiles,** discussed in Chapter 7, are the sculptures with which he is usually identified. Later in his career, Calder built mobiles on an enormous scale in response to public commissions. For example, his mobile designed in the 1970s for the central court of the National Gallery of Art in Washington, D.C. (16-24), spans more than 6 feet and weighs more than 900 pounds. But its gentle movements are able to bring harmony to the vast empty space it floats in.

He also made large sculptures he called *stabiles,* like *La Grande Vitesse* (16-25), which can be seen in public spaces all over the United States. Despite their huge size and weight, they are also never imposing. Calder's work is always cheerful; his pleasure in making them is contagious. Their names rarely mean much; Calder said, "I make the things without any references, but it's necessary to have names, just like cars have license plates." Because of the prevalence of his public work, Calder probably did more to make

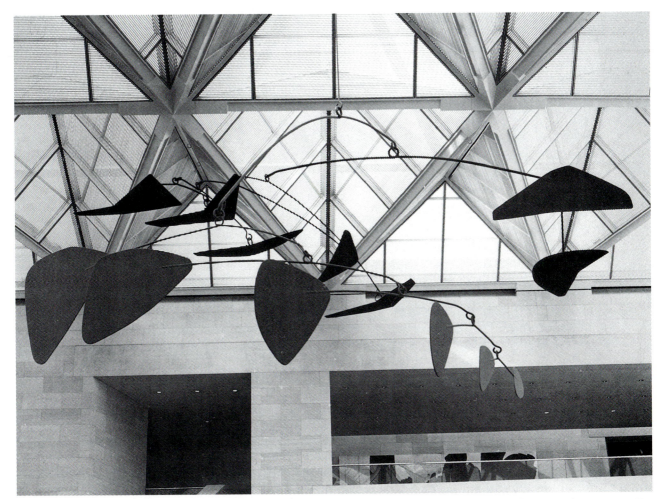

16-24 Alexander Calder, *Untitled,* 1976. Aluminum and steel, 29'10½" x 76'. National Gallery of Art, Washington, D. C. (gift of the Collectors Committee).

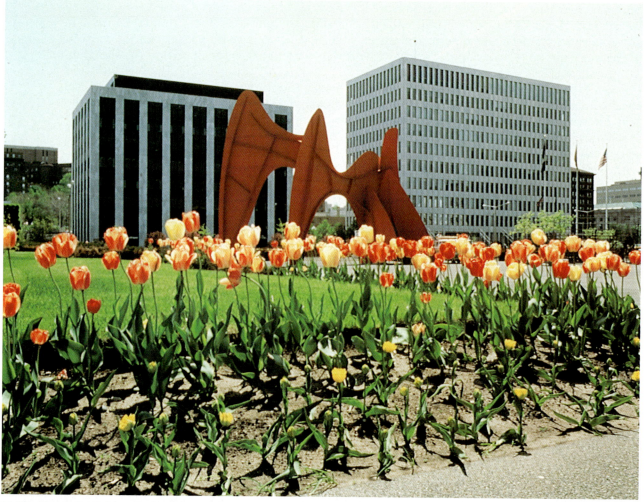

16-25 Alexander Calder, *La Grande Vitesse,* 1969. Painted steel plate, 55′ high. Calder Plaza, Vandenberg Center, Grand Rapids, Michigan.

nonrepresentational art acceptable to the general public than any other artist. The mobile, like Picasso's collage, has become one of the standard art forms. Today, both are even practiced by children in their "arts and crafts" classes.

The Abstract Expressionist movement in American art during the late 1940s and early 1950s would find its expression in sculpture in the work of David Smith. He began his artistic career as a painter and was friendly with all the leading Abstract Expressionists in New York. He shared many of their concerns, especially those of eliminating artificial constraints to artistic freedom and the necessity for an artwork to evolve as it is being made. Smith eventually developed a totally abstract art based on manipulating large geometric solids (see 7-19). Unlike the work of Brancusi and Calder, no associations with the visible world are possible. Like many paintings by nonrepresentational artists, *Cubi XII* (16-26) must be examined on its own terms. The only story it tells is about itself. While the sculpture weighs a lot (it is made of steel and is 9 feet tall), the delicate balance of the forms deny its great weight. Part of the success of the composition is the creation of an empty (or *negative* space) between the boxes that is as interesting as the solids that Smith juggles. In this way, his sculptures reach into their natural surroundings, making new relationships with them.

One of the wonders of Smith's work is how tons of metal are treated lyrically rather than ponderously. His skill as a welder

helped him create sculptures that demonstrated that steel can be as flexible a material as the more traditional bronze, stone, and wood. It is now an accepted and popular medium for sculptors.

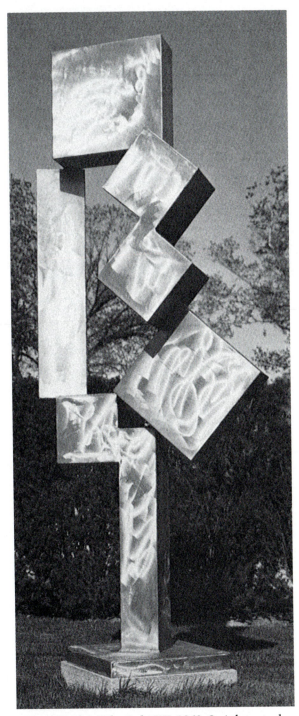

16-26 David Smith, *Cubi XII*, 1963. Stainless steel , 109⅝″ x 49¼″ x 32¼″ . Hirshhorn Museum and Sculpture Garden, Smithsonian Institution, Washington, D. C.

ARCHITECTURE: THE GLASS BOX

In the twentieth century, modern architects have explored the use of glass in ways that would have stunned architects of the past. As a building material, glass has quite different aesthetic possibilities than the traditional media of stone, earth, and metal. Because glass is both transparent and reflective, the standard division between inside and outside is challenged by a building with glass walls. This quality was explored by the American architect Philip Johnson when he built himself an all-glass house in the late 1940s (16-27). Except for a central brick core that houses the bathroom, the whole interior space is open, without walls or room dividers. All of the exterior walls are made of glass (though there are built-in shades to be used if desired), so the experience is one of living in the midst of nature, weather, and the trees that surround the site.

The experience within the glass house is far from sleeping under the stars. It retains a building's traditional role of shelter and its design puts considerable psychological distance between the dweller and nature. Because of Johnson's strict adherence to the tenets of International Style, every aspect of its interior and exterior is integrated, logical, and civilized. The building's purity of design and use of modern materials provide a formal, intellectual vantage point from which to contemplate nature.

For obvious reasons of privacy, as well as expense, solid walls of glass have been more popular for commercial rather than domestic architecture. We associate glass walls with modern office buildings, towers where glass covers a skeleton of steel. Philip Johnson, during his long and distinguished career, has designed many fine examples of these goliaths of the International Style, perhaps none better than the *Seagram Building* (8-34), a collaboration with his mentor, Mies van der Rohe (the director of the Bauhaus when it closed). In the 1950s, 1960s, and 1970s, the International Style of architecture dominated large-scale public and corporate architecture around the world, putting an enduring stamp on urban life. Its orderly, disciplined forms are no longer seen as controversial but, in fact, as

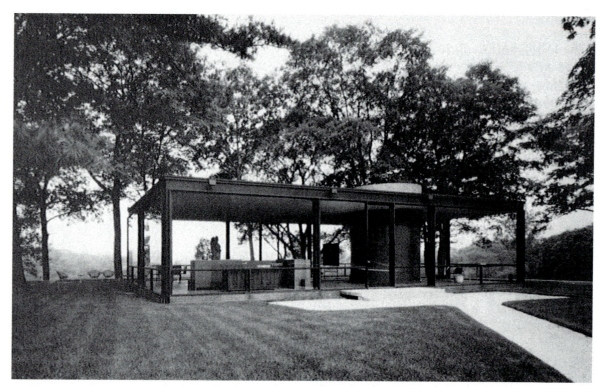

16-27 Philip Johnson, Glass House, New Canaan, Connecticut, 1949

neutral and nonpartisan. A glass box lacks political or social overtones. Its absence of ornament was also a plus because, as even Johnson in later years admitted, it made building a skyscraper much cheaper.

ORGANIC ABSTRACTION

Nonrepresentation has been pursued in two general directions: the geometric and the organic (see Chapter 2). Johnson's Glass House is a collection of pure right angles, while Buckminster Fuller's geodesic dome (2-9) is a hemisphere, and David Smith's sculptures juggle cubes and cylinders. Those who make geometric works are often interested in evoking pure, transcendent existence, a kind of refined Neoclassical abstraction. Organic abstraction, as in Henry Moore's *The Archer* (2-14), tends to be less cerebral and more spiritual, evocative of natural forces or living things. It could be called a kind of Romantic abstraction.

In the first half of the century, the highly geometrical buildings of Le Corbusier epitomized the beliefs of the International Style and the glorification of the machine. No wonder that the architectural community was stunned by what appeared to be a startling

reversal by one of the founding fathers of the International Style in 1950. Le Corbusier's *Notre Dame du Haut* (16-28), a small chapel in Ronchamp, France, seems the polar opposite of his earlier buildings meant to foster a marriage of art and technology and nearer to Moore's sensual sculpture. In the organic, flowing Notre Dame du Haut, right angles have been replaced by soft curves, rational order with intuitive placement. There is no clear glass curtain filling an interior with even light; instead small windows with colored glass are placed in deep cuts in the heavy concrete walls (interior, 16-29).

Le Corbusier had actually given an earlier warning of his change of heart. In 1936, disappointed with the lack of imagination among fellow architects eager only to refine his ideas rather than to go beyond them, he wrote to a group of young architectural students:

> How are we to enrich our creative powers? Not by subscribing to architectural reviews, but by undertaking voyages of discovery into the inexhaustible domain of Nature!

Le Corbusier's chapel is more like a sculpture than a building. It is placed on a hill

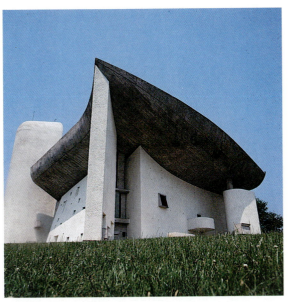

16-28 Le Corbusier, Notre Dame du Haut, Ronchamp, France, 1950–1955

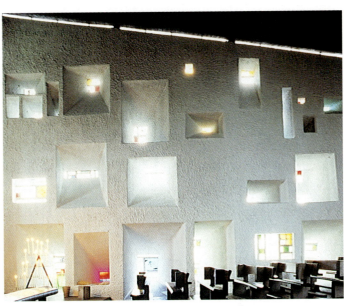

16-29 Le Corbusier, interior of Notre Dame du Haut

that looks out on a river, a site with a long religious history, from the early Christians to pre-Roman pagans. As if challenging less daring followers of the International Style, Le Corbusier exploits the flexibility of concrete with great imagination. The walls are curving, tilted forms that lean towards the center. The roof, shaped like the headdress of a French nun's habit, floats above the outer walls, perched on small columns. It is a building of many original spaces with a dark, bare inner chapel, as well as an open-air one. An absolutely unique work of architecture, it is extraordinarily free of historical references. Concrete has rarely seemed so sensual or unfettered. Le Corbusier's lesson is that in the hands of creative people, abstract and nonrepresentational art has no boundaries.

THE CHALLENGE OF NONREPRESENTATIONAL ART

Nonrepresentational art has been in existence for more than seventy-five years, the logical development of changes in art during the 1800s. Many of the first totally abstract canvases are antiques; their paint is cracking from the passage of time. Yet abstract art is still often seen as weird or strange.

Most viewers feel more comfortable with artworks that refer to the world they know; many prefer art that tells a story. Nonrepresentational art can do these things, but not in a conventional way. Each work is an expression of the ideals, personality, and mood of the artist. The "world" they refer to is an inner one. We have seen many artists, all working abstractly, create very different artworks. Some seem passionate and violent, some absolutely logical and calm. If you look closely, there are significant differences even between two "emotional" abstract expressionist artists.

By looking even more closely, one can imagine a "story." Each element—each line, shape, volume, and color—is a separate character having its own weight and impact. The tale is one of the relationship of these elements. Who will dominate? Which is weak? How do they connect? Will they ever reconcile their differences? Nonrepresentational artwork is a veritable soap opera. Approach it with an open mind and look carefully; totally abstract paintings and sculptures have scenarios without limit.

CHAPTER

17

A STORM OF IMAGES: ART IN THE CONTEMPORARY WORLD

PERIOD	HISTORICAL EVENTS	
1945–1960 Abstract Expressionism The New York School The International Style	Jean-Paul Sartre and Existentialism Soviet satellite states created in Eastern Europe India and Pakistan become independent 1947	Korean War New York becomes center of world art 1950s
1960–1975 Pop Art and Happenings Minimalism Earth Art Performance art Video art	Space race between U.S.S.R. and the United States Civil Rights march on Washington 1963 Assassination of President Kennedy 1963	Vietnam War 1960–1975 Killing of students by National Guard at Kent State 1970 First Earth Day 1970 Watergate, President Nixon's resignation
1975–present Pluralist era Superrealism New Image Neoexpressionism Postmodern art and architecture Illusionistic photography Feminist art Electronic and Computer art Installation art Contemporary Nonrepresentation	Feminist demonstrations throughout Western world 1970s and 1980s Reagan presidency 1980–1988 Rise of Islamic fundamentalism in Mideast Japan becomes a dominant economic power	Last remaining European colonies in Africa receive independence AIDS first identified 1981 Crumbling of Soviet Empire Release of Nelson Mandela in South Africa 1990

On February 2, 1977, Paris celebrated the opening of a new museum of Modern Art, the *Georges Pompidou National Arts and Cultural Center* (17-1). Huge crowds gathered in an open square to witness the important event; politicians officiated. Built with public funds, it seemed only natural to the French government that Paris, the site of so many of the crucial developments in the twentieth century, should have the preeminent showcase for Modern Art in the world. The architects, Renzo Piano of Italy and Richard Rogers of England, envisioned the building as an ultramodern cultural center, a reflection of an age of new media and scientific advances. It houses the National Museum of Modern Art, a public library, the Industrial Age Design Center, dance workshops, underground theatres for drama and the Music Research Center, all utilizing the most advanced technology of the information age.

Unlike typical buildings, the "Beauborg" (nicknamed after its Parisian neighborhood)

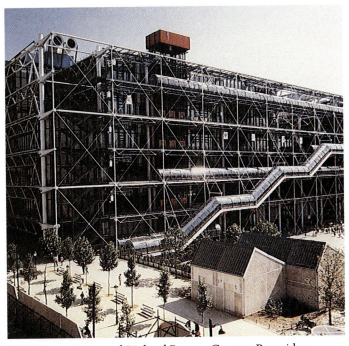

17-1 Renzo Piano and Richard Rogers, Georges Pompidou National Arts and Cultural Center, Paris, 1971–1977.

ART

Johnson, Glass House 1949

Kline, *New York, New York* 1953

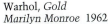

Knoll, showroom in San Francisco 1957

Giacometti, *Walking Man II* 1960

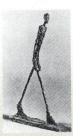

Warhol, *Gold Marilyn Monroe* 1962

Judd, *Untitled* 1966–1968

Smithson, *Spiral Jetty* 1970

Paik, *TV Buddah* 1974–1982

SITE, Best Products Indeterminate Facade Showroom 1975

Moore and Hersey, Piazza d'Italia 1978

Skoglund, *Radioactive Cats* 1980

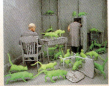

Lin, Vietnam Veterans Memorial 1981–1983

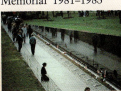

Murray, *Kitchen Painting* 1985

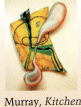

Lasseter, et. al, *Luxo Jr.* 1986

exposes its inner workings—nothing is hidden. The glass walls are surrounded with a network of white columns and scaffolding. The tubular main escalator is attached to this metal grid, rising up the outside like a mechanical glass worm. The Beauborg's life-support system of pipes and ducts (for plumbing, electricity, air circulation, and heat) is not only visible but also boldly announced, painted in bright colors. Walls are all moveable; even the floors can be adjusted. Large video screens and banners can be attached to the grid of pipes anywhere on the building.

The Pompidou Center was created not just to serve the public but to regain the high place France had once held in Western culture. Just as the United States became the dominant force in world affairs after World War II, so had the artists and cultural institutions of America dominated the art world. The New York School of Abstract Expressionism had dethroned the School of Paris; the Beauborg and the French were facing an uphill battle.

GIACOMETTI AND EXISTENTIALISM

Born at the very beginning of the century, Alberto Giacometti created sculpture that evokes Europe's anxieties and confusion after World War II. As a young man, Giacometti was heartbroken when he had to abandon the lively cultural life of Paris as war broke out. Soon after the war's end in 1945, he returned to his beloved Paris. There he rejoined the cafe life, as exiled writers, poets, and intellectuals gathered in the former intellectual center of Western culture.

But the tone of the discussions had changed. Much of Europe had been left in rubble. In Paris, no one could erase from memory the German occupation or the images of Hitler's concentration camps and the unbelievable cruelty and suffering that took place there. The inescapable question was, "How could God allow such terrible events?" A rethinking of the meaning of life began. Giacommeti's friend, Jean-Paul Sartre, became one of the leading thinkers of the postwar world. His philosophy, **existentialism**, declares that all people are essentially alone, that there is no God in the universe. Each of us must face the ultimate meaninglessness of the universe with responsibility and decide how to live our own lives independently.

Giacommeti's *Head of a Man on a Rod* (17-2) seems to epitomize the existential belief that we are isolated in a meaningless universe. The sculpture evokes the anxiety produced by life without a belief in God. Detached from its body, a terrified, skull-like head stares into the void. A slender rod connects the floating head to a heavy base, but instead of anchoring it, the rod seems almost to be pushing the head away, dividing it from its support. We can see the pressure of living a life with no easy answers in the weathered head's frozen features: the open but silent mouth and forever searching eyes.

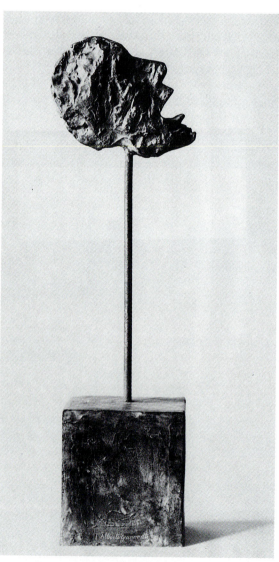

17-2 Alberto Giacometti, *Head of a Man on a Rod*, 1947. Bronze, 23½" high, including bronze base 6⅜" x 5⅞" x 6". The Museum of Modern Art, New York (gift of Mrs. George Acheson).

ALTERNATIVES TO ABSTRACT EXPRESSIONISM: RAUSCHENBERG AND JOHNS

In 1954, Robert Rauschenberg met a shy young artist from rural South Carolina, Jasper Johns. Rauschenberg had grown up in Texas, in a bustling port surrounded by oil refineries, far from the intellectual centers of Paris or New York City. He and Johns became close friends and rented studios in the same building in downtown Manhattan. Like Picasso and Braque during their Analytical Cubist period, for the next few years the two young men worked feverishly and saw each other every day—engaging in an intense dialogue on the nature of art and life. In New York City, the young artists joined in the camaraderie of Pollock, de Kooning, and others. Rauschenberg later said he learned more from drinking with these artists in the taverns of Manhattan than from any of the art schools he attended. But Rauschenberg also witnessed the chilling effect Abstract Expressionism was having on younger artists. Born as a movement to open up new territories for art, it had since been embraced by critics and academics. Abstract Expressionism had became codified as the only way to make serious art. Rauschenberg thought that the complete exclusion of our daily visual experience of the world was too high a price to pay for what was said to be a purer, more honest art. He wondered how to get the real world back into painting without totally abandoning the power or achievement of Abstract Expressionism.

Rauschenberg proposed that "a picture is more like the real world when it's made out of the real world" and began the reintroduction of everyday objects as Picasso had—by using the medium of collage, or what Rauschenberg called "**combines**." At the same time, he continued to use the great colorful gestures and dripping paint of Abstract Expressionism. In *Small Rebus* (17-3), he pulled art and life together by adding photographs, stamps, a map, and fabric to the canvas. Despite his use of ordinary materials (some might say junk), notice how Rauschenberg still balances his picture according to the principles of design. For example, the circle around the photograph of the running athlete focuses attention on him but also interacts with the curve of the track. A drawn clock on the left and the circu-

lar chart at bottom right are placed carefully to balance the visual weight.

Jasper Johns's work, like his personality, was more restrained than Rauschenberg's; it also challenged the basic premises of Abstract Expressionism. Rather than filling his art with a confusing array of images, Johns tended to focus on only a few simple objects with stark, graphic impact. What interested Johns were "things the mind already knows," subjects that were instantly recognizable. For example, his *Flag* (17-4) was part of a series of more

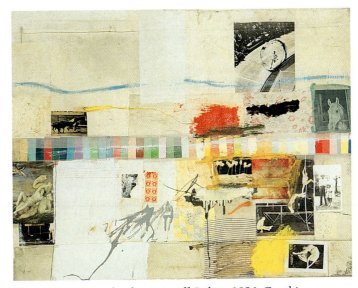

17-3 Robert Rauschenberg, *Small Rebus*, 1956. Combine painting, 35" x 46". The Museum of Contemporary Art, Los Angeles (The Panza Collection).

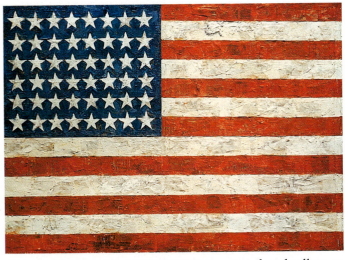

17-4 Jaspar Johns, *Flag*, 1954–1955. Encaustic, oil, and collage on fabric mounted on plywood, 42¼" x 60⅝". The Museum of Modern Art, New York (gift of Philip Johnson in honor of Alfred H. Barr, Jr.).

than twenty-five paintings and many drawings and prints using the same subject. Johns would vary size, number, color, and materials, but the essentially flat flag would be the same in each. Most flags were built by painting thickly over a collage of newspapers, resulting in a very textured surface. The flag paintings seemed to follow the rules of Abstract Expressionism and to slyly undermine them at the same time. Like a typical Abstract Expressionist picture, Johns's images were absolutely flat and nonillusionistic and covered with lively, gestural paintstrokes. But they also had subjects; they were unquestionably, instantly recognizable as flags.

In direct opposition to the romantic search for inner truth found in the action paintings of Pollock and de Kooning, Johns's flag paintings were impersonal. He explains that he chose flags precisely because they are "things which are seen and not looked at, not examined." By using them in atypical ways, Johns is encouraging the viewer to go beyond the conventional reading of flags to see them freshly. He warns of the tendency we all have of thinking we know at one glance what we see. One should be open to new ways of understanding or new uses of ordinary things. His "message" is reminiscent of René Magritte's *The Treachery (or Perfidy) of Images* (15-36), a surrealist work where the illustration of a pipe is subtitled with a message that it is not a pipe.

Done at the peak of Abstract Expressionism's dominance in the late 1950s and early 1960s, Rauschenberg and Johns's work shocked many artists and critics. They reopened the visual world and legitimized borrowing objects and symbols from popular culture. By repeating familiar symbols in lengthy series, Johns had also discarded one of the oldest tests of an artwork's value, one particularly important to the Abstract Expressionists—originality or uniqueness. That, along with the cool tone of Johns's works, appealed to a considerable group of artists who would focus more directly on common household objects and the products of the booming post-war American economy. Their works have become known as **Pop Art**.

POP ART

The most famous and influential of the Pop artists was Andy Warhol. His early painting, *Two Hundred Campbell's Soup Cans* (17-5), announced that no kind of subject matter was more important than any other. The 6-foot canvas seemed to mock the central precepts of Abstract Expressionism, still the dominant force in the art world. When Pollock and Rothko had worked on a large scale, they were announcing that their inner searches and new approaches were important. Few could question the powerful and heroic impact they had. Warhol reminded viewers that anything made large will have a dramatic effect, even soup cans.

The viewer is confronted by a wall of products. In stark contrast to the emotional, gestural brushstrokes of Abstract Expressionism, Warhol attempted to minimize any sign of having made the painting with his own hand. *Two Hundred Soup Cans* looks manufactured rather than painted. While Jasper Johns's cool attitude seemed revolutionary just a few years earlier, Johns had still applied gestural brushstrokes almost lovingly to his flags and targets. Warhol's approach was more than cool, even neutral. He later said: "I want to be a machine . . . I think everybody should be a machine."

Following the success of his first works, Warhol began producing images of celebrities that implied their connection to his images of packaged products. Multiple images of Elvis Presley, Jacqueline Kennedy, and Marilyn

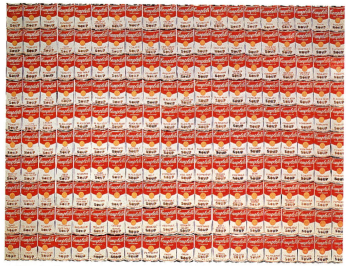

17-5 Andy Warhol, *Two Hundred Campbell's Soup Cans*, 1962. Synthetic polymer paint on canvas, approximately 72" x 100". Private collection, courtesy Leo Castelli Gallery, New York, © 1993 The Andy Warhol Foundation for the Visual Arts, Inc.

Monroe (17-6) were given the same treatment as Brillo and Coca-Cola. Even the *Mona Lisa* has become a glamorous commercial product according to Warhol (see Chapter 1). To achieve a more convincing, mechanical look, Warhol used photographically created silkscreens of his subjects and printed them directly onto his canvases. His large studio in New York City came to be known, appropriately, as "the Factory." Assistants were reported to be producing his pictures.

Warhol himself became a celebrity. The Factory was filled every night with famous people and those seeking fame. The artist generally remained silent but listened to conversations and drew inspiration from them. After being shown a dramatic headline and gruesome front-page photograph of a horrible airplane crash, Warhol began his *Disasters* series. Gory automobile wrecks and racist beatings were reproduced several times on single-color canvases. In *Orange Disaster* (17-7), a dramatic

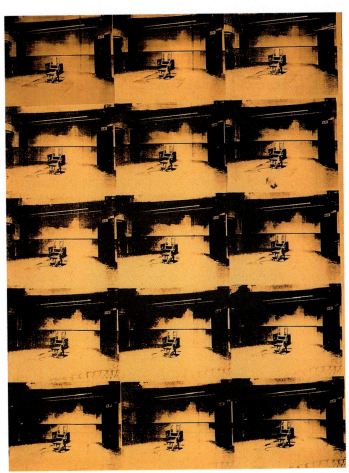

17-7 Andy Warhol, *Orange Disaster*, 1963. Acrylic and silkscreen enamel on canvas, 106" x 81½". Solomon R. Guggenheim Museum, New York (gift, Harry N. Abrams Family Collection, 1974).

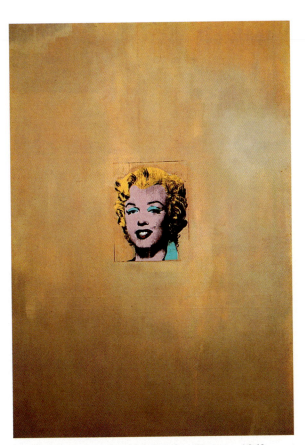

17-6 Andy Warhol, *Gold Marilyn Monroe*, 1962. Synthetic polymer paint, silkscreened, and oil on canvas, 6' 11½" x 57". The Museum of Modern Art, New York (gift of Philip Johnson).

photograph of the death chamber in a prison is repeated fifteen times. Alone, the electric chair and the small sign that calls for "silence" could move the viewer, but multiplied it loses its effect. The *Disasters* series illustrates the numbing effect that the daily storm of images has on us. When seen over and over again, even the most shocking pictures lose their impact. The Warhol canvases of the 1960s that treat celebrities, tragedies, famous paintings, and products as the same thing recreate the daily experience of watching television news. All are equivalent in importance, each given its few minutes of air time.

By focusing on the things we see everyday, Pop Art was following the mandate of Robert Rauschenberg and closing the gap between art and our everyday experience of life. Claes Oldenburg went one step further and called for an art "that does something else

than sit on its ass in a museum." He was a founder of *Happenings*, an attempt to use "real" materials and locations as art—theatrical events intended to break down the distance between art and audience, to become, as one artist said, an "all-encompassing art experience." Audiences would actively participate in loosely scripted events. In *Store Days*, for example, Oldenburg rented an abandoned storefront in New York City and filled it with life-size plaster reproductions of hamburgers, cakes, dresses, hardware, and other standard merchandise. Each object was loosely painted in bright colors with drips running over them, a parody of action painting. When the audience entered, they were encouraged to behave like customers. When a sculpture was purchased, in contrast with the custom in fine art galleries, the buyer was permitted to take the object home immediately. Oldenburg replaced sold items from his studio in the back, which served as a storeroom.

Store Days was an examination of the relationship between art and money, an increasing concern among many American artists after World War II. As the American art market gained prominence, art seemed to be becoming more and more a commodity like stocks or precious metals. For the artists who achieved success in the 1950s, the struggle for acceptance, the years spent trying to make ends meet was part of what gave an artist integrity. They felt that money and early success endangered the honesty and independence of any artist. Not surprisingly, Andy Warhol did not share the older artists' views. He did not find financial rewards disturbing and said "being good in business is the most fascinating kind of art."

Shortly after *Store Days*, Oldenburg's objects began to grow larger in scale. In his one-man exhibition of 1962, the small plaster hamburgers had expanded to soft-cloth ones 4 feet tall. The gallery was filled with enormous ice cream cones and slices of cakes. Viewers were treated to an Alice-in-Wonderland experience, as if they had shrunk to miniature size. By enlarging the things we see every day to

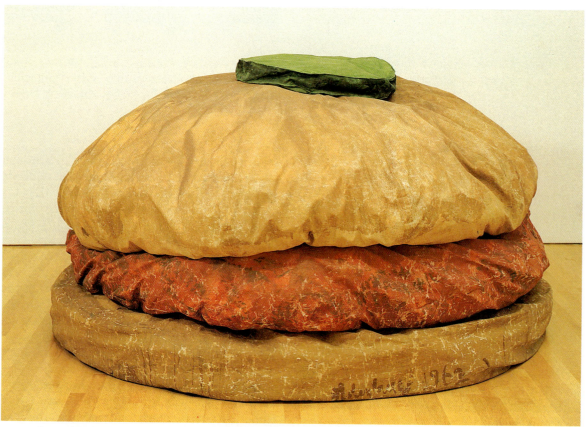

17-8 Claes Oldenburg, *Giant Hamburger*, 1962. Painted sailcloth stuffed with foam, 52" high x 84" diameter. Art Gallery of Ontario, Toronto (purchase 1967).

gigantic dimensions, Oldenburg altered their reality and made them strangers to us. This allowed the viewer to examine them freshly, as if seeing them for the first time. The similarity between the shape of a hamburger and a bean-bag chair (17-8), for example, becomes apparent when they are the same size. Another strategy was to shatter conventional seeing by changing the materials of commonplace objects. In *Soft Toilet* (17-9), the artist substitutes stuffed vinyl for porcelain, and now the familiar bathroom item collapses as if it is fatigued. By making it soft, the toilet is humanized—one can even move its parts around and reshape it.

By 1965, Oldenburg had increased the scale of his projects to monumental. At first these were simply-drawn fantasies, but eventually he prepared formal architectural proposals and submitted them to various public and private institutions. In 1967, for example, he proposed to replace the Washington Monu-

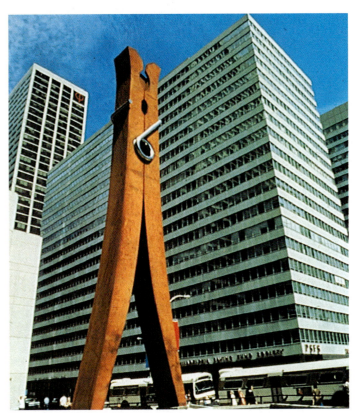

17-10 Claes Oldenburg, *Clothespin*, Philadelphia, 1976. Steel, 45'.

ment with mammoth scissors that would open and close. Oldenburg has even been successful in realizing some of his monumental dreams. A 45-foot clothespin now graces a city square in Philadelphia (17-10), and a nearly 100-foot-tall baseball bat is in Chicago.

VENTURI: POP ARCHITECTURE

Just as Abstract Expressionism became the standard form of painting and sculpture in the postwar years, the **International Style** dominated architecture. The buildings and theories of Gropius, Le Corbusier, and Philip Johnson (see Chapter 16), which called for pure, logical designs and prohibited unnecessary ornament or decoration, were the preeminent models for most serious architects around the world. Mies van der Rohe, chief architect of the *Seagram Building* (8-34) and a director of the Bauhaus, spoke for his generation of architects when he said, "Less is more."

Robert Venturi's response, however, was, "Less is a bore." The ideology of the International Style, according to Venturi, was a failure

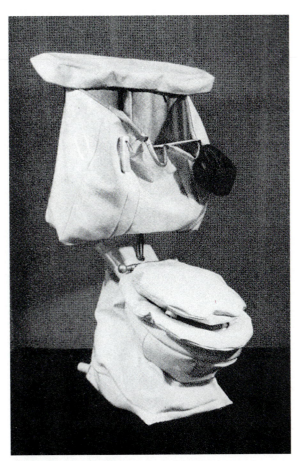

17-9 Claes Oldenburg, *Soft Toilet*, 1966. Vinyl, Plexiglas, and kapok, 55" x 28" x 33". Collection, Mr. and Mrs. Victor W. Ganz, New York.

because it ignored the local culture of the locations where its buildings stood. No building could be successful that ignored the interests of the clients and the surrounding architecture. Buildings like the *Villa Savoye* (16-9) were more like alien structures than homes. They spoke a language that no one except sophisticated architectural scholars could understand and had a destructive effect on their environments.

Like the Pop Artists, Venturi felt architects should embrace popular styles of architecture, finding ways to utilize what he called "honky-tonk elements" that spoke in a language anyone could understand. Venturi put his ideas into practice in a design for a firehouse in Columbus, Indiana (17-11). Although the simplicity of its form is certainly more reminiscent of the International Style than a Gothic cathedral, several aspects of the building were considered a kind of heresy at the time. Venturi used a variety of windows with different sizes and designs, depending on the needs of the occupants rather than any geometrical rules. A loud contrast between glossy white and red brick creates an irregular, not uniform, design. At the top of a seemingly functionless tower (it actually is used for drying hoses), he placed an equally loud sign that announced in bold graphics "FIRE STATION 4" to the public.

Venturi felt strongly that the International Style made a mistake when it rejected the past. The public service nature of his *Fire Station #4* is easily understood because its tower is connected to clock towers and church steeples of the past. It fits into its neighborhood because it is a brick building with a flat front and ordinary glass-windowed garage doors. The front is really a thin facade (17-12), an approach Venturi called "the decorated shed . . . a modest building with a big sign," used by supermarkets, department stores, and other commercial buildings all over the country. So unlike the metal-and-glass skyscraper, the Seagram Building, Fire Station #4 is a truly American building designed to hold its own and live with the billboards and gas stations found along any main street or highway. It has what Venturi called the "messy vitality" that the International Style had attempted to eliminate.

THE END OF ART: MINIMALISM

Pop Art was not the only alternative to Abstract Expressionism advanced in the 1960s. A group of serious, intellectual artists disgusted with the emotional outpourings of the Abstract Expressionists and the vulgarity of Pop Art began to make high minded and refined art known as **Minimalism**. Minimalist art is art stripped down to the essentials, or as one artist said: "what you see is what you

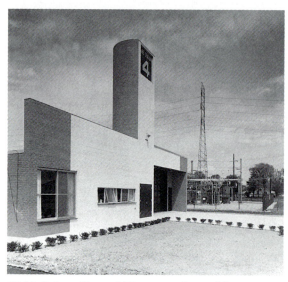

17-11 Robert Venturi (Venturi and Rauch), Fire Station # 4, Columbus, Indiana, 1965–1967

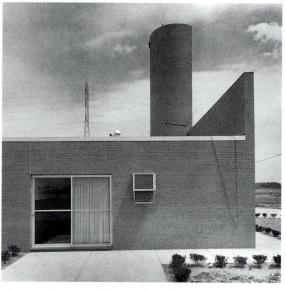

17-12 Side view of figure 17-11

see." It is paintings and sculptures that are self-sufficient and have no subject matter, content, or meaning beyond their presence as objects in space. Lauded by some as a return to purity and high ideals, others called Minimalism the end of art. What was occurring was a replay of a battle that we have seen before: the battle among Romanticism, Realism, and Classicism, now in the arena of nonrepresentational and Pop art. On one side, once again, were the defenders of emotions and expressiveness, on another, ordinary life, and on the third, purity and logic.

One of the foremost creators and theorists of Minimalism was—and still is—Donald Judd. As an art critic in New York City, the Missouri-born Judd became concerned that art made it difficult to perceive reality. It bothered him that, while contemplating works of art, viewers are inevitably drawn into illusions, emotions not their own, and references to the past. The only way to reconnect the viewer with reality, Judd felt, was to produce works of art with no expressive techniques, free of associations, that could be seen to be simply what they were—plain and honest "matters of fact":

> I wanted work that didn't involve incredible assumptions about everything. I couldn't begin to think about the order of the universe, or, the nature of American society.

Beginning in 1962, Judd made sculptures that were controlled and completely logical, designed to cleanse viewers of whatever concerns or preconceptions they brought into the gallery and allowing them to focus on the situation the artist had created there.

Untitled (17-13) is a good example of how Judd resolved his interest in a direct, honest work of art. It is made of six virtually identical boxes constructed from stainless steel and Plexiglas attached to a wall with even spacing. Because it is internally logical, it is relatively unaffected by what surrounds it. To eliminate any sign of the human hand (which might evoke emotions), Judd had his sculptures manufactured in factories, based on his drawings. Industrial fabrication assured that his sculptures were also well constructed and as perfect a re-creation of his concepts as possible. His boxes were open at two sides, with Plexiglas permitting light to enter so no aspect of their structure was hidden or mysterious. Since *Untitled* contains no allusions or illusions, viewers can focus on what they are truly experiencing. They become aware of being in a unique kind of situation—what Judd would call "art space," an isolated place separated from the commotion of their everyday experience. In such a space, viewers realize the limits of their vision. Although you know logically that each box is the same, as you slowly pass by the work in

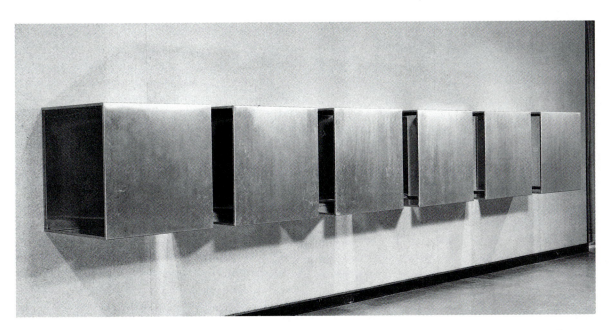

17-13 Donald Judd, *Untitled*, 1966–1968. Stainless steel and amber Plexiglas, six 34" units at 8" intervals. Milwaukee Art Museum (purchase, Layton Collection).

the gallery, your changing spatial relationships alter its appearance moment by moment. This is what Judd would call a true, unadulterated art experience.

Minimalism appeared to be the final chapter in the refining of purity and truth in the visual arts, a search with a long history, from Ancient Greece to Mondrian. Art had been reduced to one simple, essential experience—the relationship between object and viewer. Yet in Modern Art's long history of radical changes, probably no other movement opened such a wide chasm between the artist and the ordinary viewer. Shell-shocked observers were further startled when one Minimalist artist, Carl Andre, exhibited a pile of 120 bricks called *Equivalent VIII* (17-14). The ordinary, mass-produced bricks were neatly arranged, two high, in a rectangle on the gallery floor. In such artwork the conceptual background—the artist's ideas about what art should be—was far more important than any visual attribute. But where would artists go from here, if anywhere?

EXPANDING MINIMALISM

Although Minimalist artists like Judd and Andre continue working within their narrowly devised confines, since 1970 the word *Minimalist* has been enlarged to include a much wider variety of art forms than Judd and Andre would accept. The term is generally used today to refer to any work of art that is refined, simple, and abstract with no references to any subject.

For example, the sculptures of Eva Hesse are described as being fundamentally Minimalist, even though they are much more evocative than Andre's 120 bricks. For example, the forms seen in *Repetition 19, III* (17-15) are geometrical and nearly as repetitive as a Judd sculpture, but because Hesse used fiberglass, a more flexible material, to make them, they take on a more personal and evocative quality. The translucent shapes in *Repetition 19, III* bend and sag in a naturalistic way. One can see little bubbles in them. While the forms begin as essentially similar, each form becomes unique as it hardens, since fiberglass dries unpredictably. Placed closely together, the columns seem like alien beings interacting. By constructing geometrical forms out of materials like hoses, latex rubber, or cord wrapped in fiberglass, Hesse brought a more textured and suggestive aspect to Minimalism. She also helped bridge the gap between crafts and fine arts, laying the groundwork for a more serious evaluation of crafts like ceramics and fibers in the 1970s.

RETURN OF REPRESENTATION: SUPERREALISM

Until Pop Art, for a century the predominant trend in Western art had been away from literal representation towards abstraction. In a related development in the late 1960s, many artists trained as Abstract Expressionists betrayed their teachers with a 180-degree turn towards realism. **Superrealism** (or **photorealism**) was a movement that re-created in two dimensions the look of photographs and in three dimensions used casting to achieve the utmost fidelity to reality. Like the Realists of the nineteenth century, most of the Superrealists avoided drama and concentrated on ordinary life.

At first look, Superrealism appears to be the polar opposite of Minimalism. Richard Estes's *Central Savings* (17-16) is an impressive demonstration of the painter's technical skill. Rather than a flat, nonillusionistic canvas, one sees depicted in oil paint a bewildering number of layers of depth, reflection upon reflection of the world behind and within a city restaurant's plate-glass window. However,

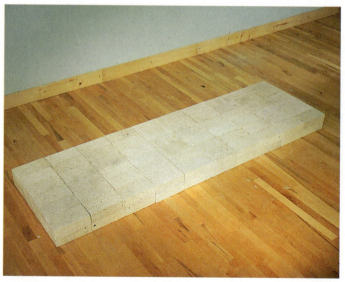

17-14 Carl Andre, *Equivalent VIII*, 1966. View of installation. Tate Gallery, London.

Central Savings does share some qualities with Minimalist art. While Estes's picture is very representational, notice that he is not expressing his feelings about this scene. In a methodical way, he is imitating the way a camera records reality—utilizing the harsh contrasts and precise focus of mechanical vision. Like Minimalist pictures, Superrealist pictures are cool and calculated performances.

Precise images like *Central Savings* are not just technical achievements but compositional ones as well. Estes's design of dense, layered spaces is imaginative: complex but balanced. His subjects are always drawn from the world he lives in, typical American metropolitan scenes. But he never imposes his personal viewpoint or glorifies his cityscapes. As with the Pop Artist Warhol and the Minimalist Judd, for Estes "cool" is better

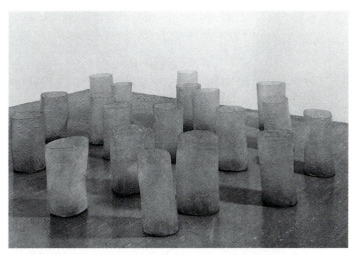

17-15 Eva Hesse, *Repetition 19, III*, 1968. Nineteen tubular fiberglass units, 19″ to 20¼″ high x 11″ to 12¾″ diameter. The Museum of Modern Art, New York (gift of Charles and Anita Blatt).

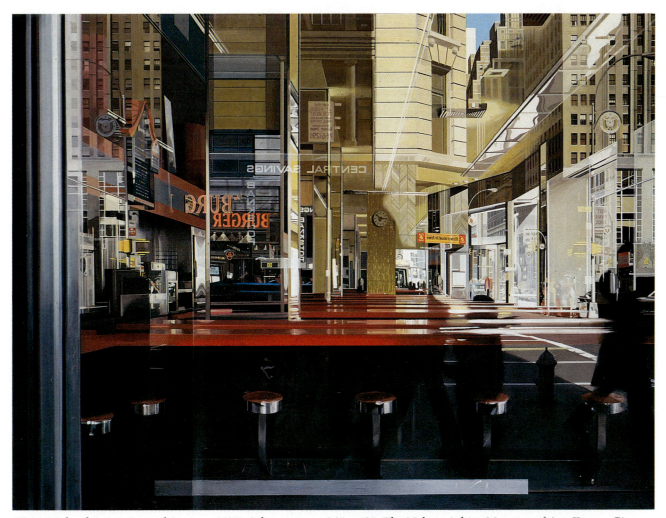

17-16 Richard Estes, *Central Savings*, 1975. Oil on canvas, 36″ x 48″. The Nelson-Atkins Museum of Art, Kansas City, Missouri (gift of the Friends of Art), F75-13. © The Nelson Gallery Foundation. All reproduction rights reserved.

than emotional. It is probably no coincidence that in the 1960s "cool" first came to mean "good."

Audrey Flack was one of the pioneers of Superrealism. After working in Abstract Expressionism, she realized during the 1960s how much she wanted to paint in a way that spoke more clearly to viewers. She believed "people have a deep need to understand their world and . . . art clarifies reality for them." Flack saw that the conventions of a photographic image provided an easily under-stood visual language—in stark contrast to the private, mysterious language of Abstract Expressionism.

While Estes works traditionally, Flack uses an airbrush to re-create the soft edges of a photograph. She also projects slides directly on a canvas, copying them in vibrant colors. Although Flack was using the visual language of photography, her paintings were nothing like snapshots or photojournalism. Each composition was carefully constructed. One of her best-known works, *Marilyn* (17-17), is a

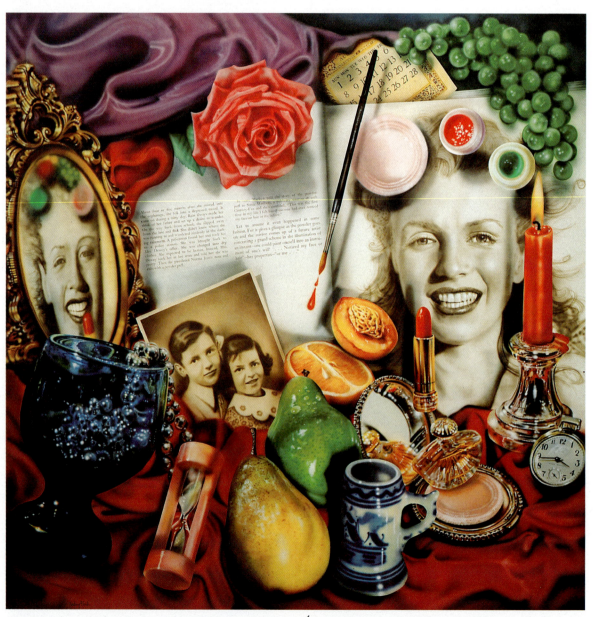

17-17 Audrey Flack, *Marilyn*, 1977. Oil over acrylic on canvas, 96" x 96". Collection of The University of Arizona Museum of Art, Tucson (museum purchase with funds provided by the Edward J. Gallagher, Jr., Memorial Fund).

symbolic treatment of screen star Marilyn Monroe's tragic life. A picture from her unhappy youth as Norma Jean Baker is surrounded by traditional symbols of feminine beauty and glamour—makeup, perfume, and jewelry. The pocket watch, hourglass, candle, and a page from a calendar refer to life's shortness. The ripe fruit and perfect rose, though beautiful for a brief time, will inevitably wilt, like the film star's own youth and looks. *Marilyn* is from a series she called "Vanitas," a reference to Baroque still lifes that used symbols to comment on the fleeting nature of life and the folly of people's desire for wealth and beauty.

Another artist who shares Flack's interest in breaking down the barriers between artist and viewer is Duane Hanson. Born in rural Minnesota, he wanted to make an honest art that could communicate with anyone who saw it and not "something that looks nice to hang on a wall." He said, "If art can't reflect life and tell us more about life, I don't think it's an art that will be very lasting." By pouring polyester resin into casts made directly from his models and adding real hair, glass eyes, and clothing, Hanson has managed to develop perhaps the most naturalistic sculptures ever created. It is a rare museum goer who has not been startled by one of Hanson's realistic figures.

Since 1970, Hanson has chosen to portray one or two subjects in the midst of an ordinary day. He said, "You can't always scream and holler . . . sometimes a whisper is more powerful." *Janitor* (17-18) is typical of his mature works that speak about the emptiness and loneliness of modern life. The janitor's pose reflects exhaustion and dissatisfaction; he was dressed in soiled clothing. When seen in a museum from as little as a few feet away, *Janitor* appears to be just another employee. As one approaches it, one senses that the figure has a natural territory like any living being. However, because it is a sculpture, we are permitted to enter his personal space and stare at him in a way no polite person would ever do. The power of Hanson's sculpture is not limited to his craftsmanship or the verisimilitude of his figures or even his messages. His work taps into the voyeuristic nature of art, the fascination of carefully studying another person and gaining access to his or her private world.

17-18 Duane Hanson, *Janitor*, 1973. Polyester, fiberglass, polychromed in oil, 65½" x 28" x 22". Milwaukee Art Museum (gift, Friends of Art).

ALTERNATIVE ARCHITECTURE

In the late 1960s, a sculpture instructor at New York University, James Wines, became dissatisfied with the direction Modern Art was taking—especially the isolation of artists from the general public. After discovering that he was not alone with this disenchantment, he began meeting regularly with like-minded artists and architects. In 1970, *SITE* (Sculpture in the Environment) was formed to establish a new relationship between art, architecture, and the public. Their goal was to search for a "more . . . socially significant content, a new

◆ ART NEWS

PAINTING AS URBAN RENEWAL: RICHARD HAAS

The love of illusion is one of the oldest pleasures of visual art. We are all fascinated by **trompe l'oeil**, art that fools our eyes. Richard Haas and his team of assistants have been creating Superrealist illusions on a grand scale for two decades. His unique form of urban renewal began in 1974, in lower Manhattan's Soho district (an area of old warehouses revitalized by artists and now home to some of the world's most important galleries). Haas was distressed by a building in his neighborhood that had an elegant cast-iron facade with columns on the front but only a blank wall with two windows on another side. He realized what it needed was a mural that illusionistically continued the design on the front. When finished (in only two weeks), it instantly became a well-loved city sight and revived what was formerly a deteriorating street corner. The once empty side was painted as if the cast-iron ornaments were illuminated on a bright sunny day, so it is perpetually cheerful.

Since then, Haas has been offered commissions all over the United States and even some in Europe. His first mural was relatively straightforward compared to the imaginative retranslations of the past he does today. His 1983 *Brotherhood Building* (17-19) in Cincinnati was the product of serious historical research and creativity. He sees all his murals as "reinventions of things that didn't deserve to die … of concepts and traditions that answer very definite needs today." Painting on what was originally a nearly blank wall facing a parking lot, Haas balanced the wall by matching the real details on the left with painted ones on the right. In the center, however, the artist transformed an ordinary locale into a classical fantasy based on the ancient Roman temple of Vesta. A whole new space seems to have opened up by Haas's use of perspective and shadow. The additions of a dramatic staircase and an altar whose ritual fire snakes up through the oculus of a Pantheonlike dome transforms the dull city parking lot into a majestic environment.

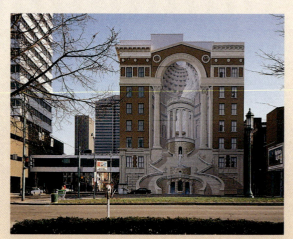

17-19 Richard Haas, facade of the *Brotherhood Building*, The Kroger Company, Cincinnati, 1983.

public imagery drawn from a more integrated fusion of the arts."

SITE members were determined not to use references to the past but to "search for sources of content in the present." Their challenge was to "identify an appropriate iconography for a society with no universal symbols." Their first important commissions were showrooms all across the United States for one of the nation's largest catalog merchandisers, Best Products. Few successful architects would have been enthusiastic about this kind of job—a renovation of a typical box-shaped building in a shopping center along a

highway. But the earnest SITE artists went to work analyzing the problem. The challenge would be to find a way to attract the attention of motorists who were speeding down the highway. Wines and his associates realized that drivers only pay attention to things that are out of the ordinary, that break the pattern of normal life.

Built in 1975, the *Best Products Indeterminate Facade Showroom* (17-20) in Houston, Texas, is one of their most famous works. By building a white brick facade higher than the structure's actual roof line (like Venturi's firehouse), the designers gave themselves room

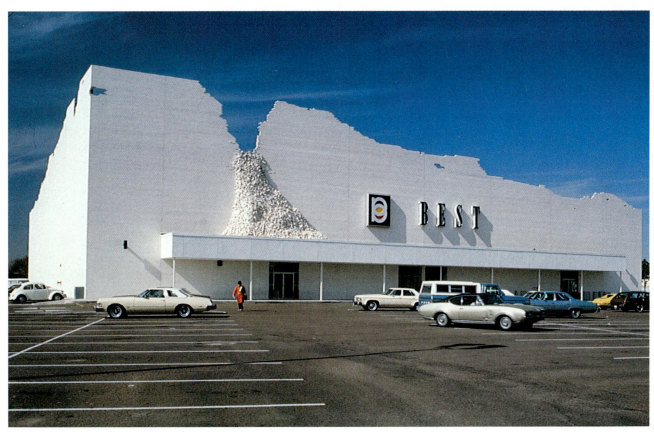

17-20 SITE, Best Products Indeterminate Facade Showroom, Houston, 1975

for imagination. The startling result was a new building that looks as if it is crumbling into ruin. In the tradition of disaster movies, the edges of the facade have become ragged and broken. Bricks tumble down onto the canopy in front, threatening imminent collapse. The doomsday look of the showroom was hard to ignore; it attracted customers even as it gave notice that American consumer culture was in the process of decay.

By looking freshly at architectural problems with an artist's eyes, by ignoring academic approaches but not customer needs, James Wines and SITE have created a people-oriented architecture that is stimulating, engaging, and artful.

GOING BEYOND THE ART WORLD: EARTH ART

Robert Smithson was one of the artists who had joined in the early discussions when SITE was formed. Never a formal member of the group, he shared their disdain for a proudly isolated art world, cut off from ordinary people's concerns. He wrote:

> Museums, like asylums and jails, have wards and cells . . . neutral rooms called 'galleries.' A work of art when placed in a gallery loses its charge and becomes a portable object or surface disengaged from the outside world . . . Once the work of art is neutralized, ineffective, abstracted, safe and politically lobotomized, it is ready to be consumed by society.

Smithson is best known as the foremost theoretician of **Earth Art**, where the landscape itself is reshaped by the artist's vision. His *Spiral Jetty* (17-21), constructed in 1970, remains the most famous and archetypal earthwork. Attracted to the Great Salt Lake in Utah because of its pink coloration (caused by microorganisms that live in the salt flats), Smithson was looking for a site along the shore when he had a vision while walking in the hot sun. He imagined a "rotary that enclosed itself in an immense roundness."

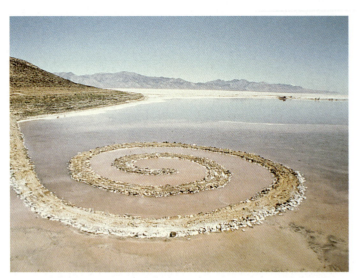

17-21 Robert Smithson, *Spiral Jetty*, April 1970. Black rocks, salt crystal, earth, red water, algae, 1500' long, 15' wide. Great Salt Lake, Utah.

Thus was born the idea of an enormous spiral ramp extending out into the lake. With the financial help of a gallery owner, and a crew of men, a tractor, and dump trucks, Smithson built his *Spiral Jetty*. It was 15 feet wide and 1,500 feet long. Like most earthworks it is horizontal in character and constructed from materials found at the site—in this case, basalt, limestone, and earth.

Smithson was pleased to learn that salt crystals also have a spiral shape, so "The *Spiral Jetty* could be considered one layer within the spiraling crystal lattice magnified trillions of times." While that concept is intellectually satisfying, it was the colossal scale of *Spiral Jetty* that assured the sculpture's impact. Reminiscent of ancient monuments like Stonehenge in England, Earth Art is admirable as a feat of engineering and art impossible to ignore. Unlike most art, no earthwork has to compete with the storm of images in ordinary life; most are placed in isolated sites, so they can be contemplated without distraction. Part of land art's beauty is that its visual impact is constantly changed by nature. One's impression will be different depending on the light, weather, and seasons. Earthworks are also rarely permanent. Nature ultimately recycles the materials. Today, the *Spiral Jetty* is only visible in photographs and film. It lies below the Great Salt Lake, whose waters have risen since 1970.

Tragically, Smithson did not have the opportunity to fulfill his many plans. In 1973, the thirty-five-year-old artist was killed in a plane crash while scouting a possible site in Texas.

His widow, Nancy Holt, is an important Earth Artist in her own right. Her *Sun Tunnels* (17-22, also 7-22) in the Utah desert is a good example of how manufactured materials can be made to work with nature. The concrete tubes provide both shelter from the desert's hot sun and views of the landscape. The holes drilled into the tunnels admit patterns of sunlight by day and provide a view of the stars at night. They are structures, Holt says, to "focus our perception" and to get a firmer sense of our own relation with the universe.

Because he makes environmental art that does not shy away from populated areas, the Bulgarian-born artist Christo has achieved more widespread fame than either Smithson or Holt. Christo's early efforts were concerned with wrapping objects like cans and oil barrels in cloth and seeing how they were changed by the process. He became an international celebrity when his wrappings grew to a monumental scale; he wrapped the Museum of Contemporary Art in Chicago and a mile-long section of the Australian coast (17-23).

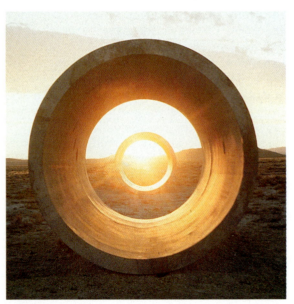

17-22 Nancy Holt, *Sun Tunnels*, 1973–1976 (detail of figure 7-22). Sunset at the summer solstice viewed through one of the tunnels. Great Salt Lake Desert, Utah.

For Christo, *Wrapped Coast* of 1969 was a success because it allowed viewers to see nature more clearly by drawing a human-made contrast to it. His even more ambitious *Running Fence* (17-24) of 1976 was planned to draw attention to the glories of the California landscape. Four years in preparation, the final result was an 18-foot-high white nylon barrier that extended for twenty-four and one-half miles across pastures and roads and into the Pacific Ocean. This monumental undertaking cost the artist $3 million, which paid for materials, a team of lawyers, environmental consultants, engineers, workers, and a building contractor. As with all Christo's environmental works, the funds were entirely his own, raised mostly from the sale of Christo's photocollages and drawings describing the project. Because it was hung on steel poles with cables for only two weeks, many questioned the high cost of such a temporary art work. Much of the four years were taken up convincing environmental groups that his plan was safe. Why would Christo be willing to go to all this trouble? He says:

> Just as religion was important [in the Renaissance] so are economics, social problems, and politics today . . . Knowledge of these areas should be an important part of one's work.

The final result *was* breathtaking. Nature cooperated with art by providing innumerable gorgeous settings—sunlight and wind, rolling hills and rocky shore, grazing sheep and grasslands made *Running Fence* a spectacle to behold.

CHANGING THE NATURE OF THE GALLERY SPACE: PERFORMANCE ART

Performance art (see Chapter 7) is another way twentieth-century avant-garde artists tried to provoke viewers into a reappraisal of art and life. The Futurists, Dadaists, and the Pop Artists all performed art. Some performance art has been very successful in reaching the general public, like the multimedia concerts of Laurie Anderson (7-10), who began performing on streets wearing ice skates embedded in a block of ice while playing cowboy songs on a

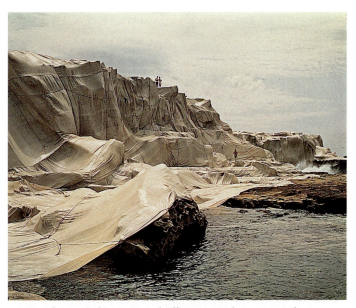

17-23 Christo (Christo Javacheff), *Wrapped Coast*, Little Bay, Australia, 1968–1969. One million square feet of erosion control fabric and 36 miles of rope. Copyright Christo 1969.

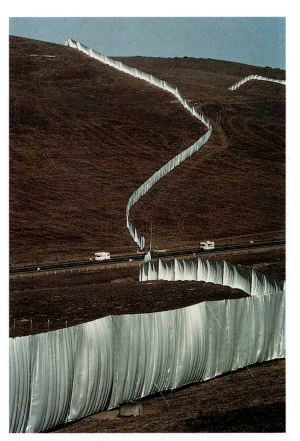

17-24 Christo (Christo Javacheff), *Running Fence*, Sonoma and Marin Counties, California, 1972–1976. Two million square feet of woven nylon fabric and 90 miles of steel cable, 2,050 steel poles, 18' high x 24½ miles long. Copyright Christo 1976.

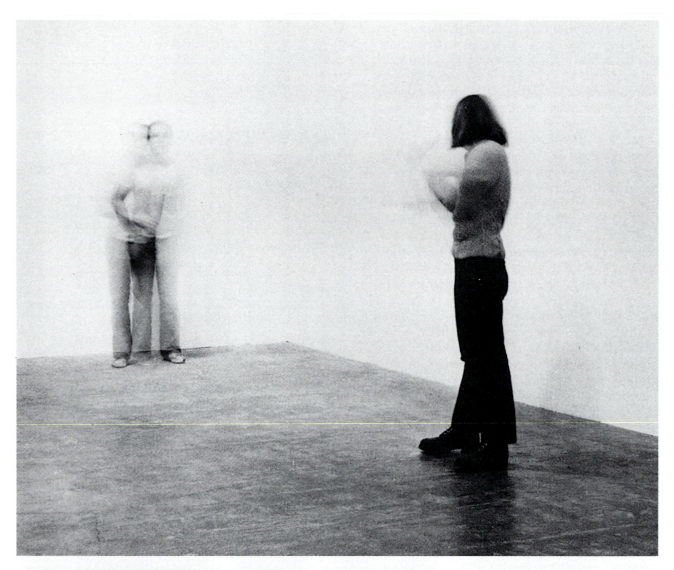

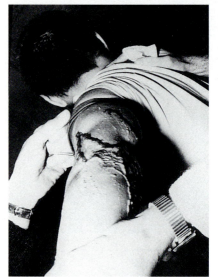
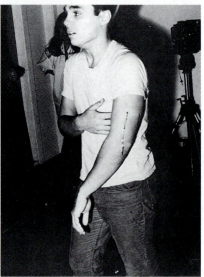
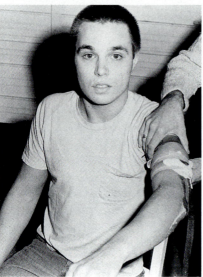

17-25 Chris Burden, *Shoot,* performed at F Space on November 19, 1971. "At 7:45 P.M. I was shot in the left arm by a friend. The bullet was a copper jacket .22 long rifle. My friend was standing about fifteen feet from me."

violin. Joseph Beuys even became a political force in Germany (7-9) as a leader in European environmental and peace movements. Performance artists are interested in producing unexpected repercussions, even dangerous ones.

The Los Angeles artist Chris Burden drew attention to his concepts with works that deliberately tested his own psychological and physical limits. His most famous (or infamous) work was *Shoot* (17-25) in 1971. Because Burden believes we live in a culture that is deadened by seeing violent acts portrayed everyday on television and in films, he decided to explore and reveal the reality of violence. With inconceivable calm, Burden stood against a wall while a friend only 12 feet away shot him in the arm with a rifle. While the plan called for the bullet to simply graze him, the bullet punctured the center of his arm just above the elbow. This did not faze Burden because the performance was about

Being shot at to be hit . . . it's something to experience. How can you know what it feels like to be shot if you don't get shot? It seems interesting enough to be worth doing . . . It was horrible but it was interesting.

Two years later, Burden reenacted the ancient legend of Icarus in a modern way (see Breugel's *Fall of Icarus*, 12-40, for an explanation of the myth). In front of invited spectators, he lay on the floor of his studio naked with a long piece of plate glass balanced on each of his shoulders. Two assistants poured gasoline across the glass and then threw matches at the end of the glass until the gasoline was ignited. In seconds, Burden leapt up and the pieces of fiery glass crashed to the floor.

Burden's horrifying performances are meant to set up an "energy" between him and his audience. They bring a vividness to danger and violence that he feels our culture has lost. Like many of the artists in this chapter, he is concerned with reestablishing art as a vital, living presence in people's lives. He does this by creating memorable events that challenge our basic assumptions about what an artist is supposed to do and what is art.

James Luna reminds us that Native Americans are real, living human beings rather than primitive, innocent tribespeople from a distant past. His *The Artifact Piece* (17-26) was exhibited among the collections of Native American artifacts in the Museum of Man of San Diego in 1987. Inside a glass case was the artist himself resting on sand with his name on one label and his scars from injuries listed on three others. Other cases contained ceremonial objects from his reservation. Viewers who had come to the museum to

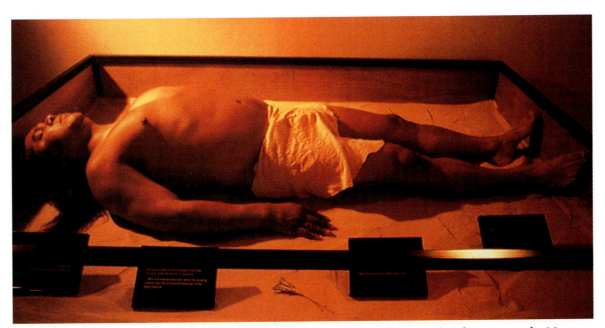

17-26 James Luna, *The Artifact Piece* (detail), 1987. Mixed media installation and performance at the Museum of Man, San Diego.

admire the beauty of American Indian culture could not leave without considering the life many contemporary Native Americans live.

The Polish artist Krzysztof Wodiczko's performances, while not dangerous or personal, are simple and effective subversive acts. He projects huge images onto public buildings, which transforms the character of the buildings instantly. For example, in 1985 the respectable architectural facade of South Africa House in London was suddenly disrupted one night when Wodiczko beamed a Nazi swastika to its peak (17-27). No passerby could ignore the comparison between Nazi

policies and legalized racism in South Africa. The police were called, but no appropriate charges for illegally projecting photographs could be found.

THE ART WORLD BECOMES GLOBAL: POSTMODERN ART AND THE NEW IMAGE

In the 1970s, Western Europe had finished its recovery from the devastation of World War II, and new hubs of economic power had emerged, one of the most important being Germany, which returned to its prewar importance in art. The most significant German artist of the past quarter-century, Anselm Kiefer, was a student of Josef Beuys. Beuys had urged young artists to begin to meet "the task facing the nation," to confront the "terrible sins and indescribable darkness" and "consummate a process of healing." Even though he was born just as the war was ending for Germany, Kiefer knew the Nazi past was an inescapable part of his heritage. He vowed to deal with the "terror of history" so he would no longer be dislocated from the past and could regain the valuable parts of his culture as well. Kiefer's work is a search for identity, both personal and national.

Märkische Heide (17-28) of 1974 focuses on the German landscape. Landscape had been a traditional theme of great German painting since the Romantic Era (see Caspar David Friedrich in Chapter 14). But Kiefer's scene is a desolate panorama. March Heath, southeast of Berlin, has been the site of battles for centuries. Because "you cannot just paint a landscape after tanks have passed through it," Kiefer puts the viewer in the midst of a scorched and blackened land with bare trees. The vista is huge, as is the picture itself (nearly 9 feet long). The sky is distant and gray; the road is broken. Kiefer painted his image on burlap, the roughest, lowest grade of canvas; the surface is dense and complex like a work by Jackson Pollock. On top of the layers of acrylic and oil paint is thick black shellac that runs like blood over the clods of earth.

Because Kiefer combines vigorous paint strokes with emotion-laden imagery, his pictures have been labeled **Neoexpressionist,** or a

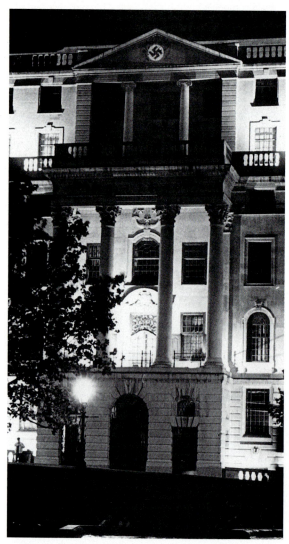

17-27 Krzysztof Wodiczko, *Projection on the South African Embassy,* London 1985. Slide projection image on building facade, dimensions variable. Courtesy Hal Bromm Gallery, New York.

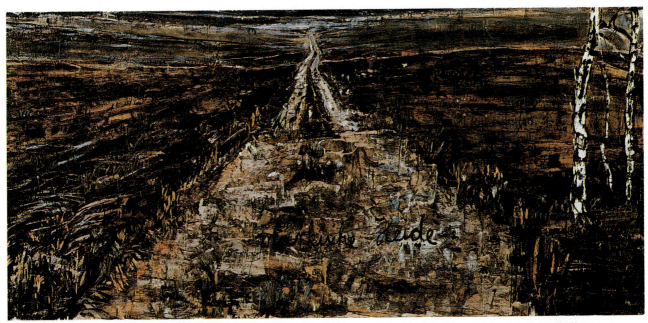

17-28 Anselm Kiefer, *Märkische Heide*, 1974. Oil on canvas, 46½" x 100". Stedelijk Van Abbemuseum, Eindhoven, Netherlands.

revival of Expressionism. However, unlike the emotionally direct German Expressionists of the early twentieth century (Chapter 15), Kiefer combines references to many eras of his country's history at once. At the time of its painting in 1974, the area known as March Heath was one of the lands that had been lost in the split of Germany into East and West. It was meant to remind viewers of the price of militarism. German viewers would also associate the title with a song of the same name that Hitler's armies had marched to.

It has been said that Anselm Kiefer's work is not really Modern at all, but what is called **Postmodern Art**. The dominant trends of Modern Art—a rejection of the past, a steady movement towards abstraction, and a disinterest in the average viewer—have been reversed by many vanguard artists of the last quarter-century. Postmodern artists like Kiefer are interested in rediscovering the past, not rejecting it. They aim to speak in clearer images and see history as a vast menu from which to select. They certainly draw on the Modern movement, but they see it as just one historical movement among many consecrated in museums and not the only choice or even the most important one. Kiefer, along with several other German artists, is also seen as a

pioneer in what has been labeled **"The New Image"**—a return to imaginative and meaningful representational painting, which many modern artists and critics had said was no longer possible in Western art. The Italian artist Francesco Clemente (3-7) has also been linked with this movement. He shares with Kiefer an interest in myths and a search for spiritual meaning, but his work is more personal, some suggest narcissistic. We see in his art, he says, "my fantasies, my private musings."

NEW FORMS FOR AUTOBIOGRAPHY

There has been a renewed interest in the self-portrait and self-exploration among many contemporary artists. Many, like Clemente, have transformed traditional media into surprising new forms. Louise Bourgeois is unlike most of the artists who came to prominence in the 1970s. Nearly thirty-five years older than Kiefer and Clemente, she met the French Surrealists (who she describes as "father figures") as a young woman growing up in Paris. Throughout her career, Bourgeois has worked in a variety of styles and materials. While her *Blind Man's Buff* (2-10) is smoothly polished marble, her other sculptures have been made of wood, plaster, or even rubber.

Bourgeois says that she uses her art to help rid herself of fears and anger. Her sculptures are therapy of a kind, necessary because

The unconscious is something which is volcanic in tone and yet you cannot do anything about it. You had better be its friend, and accept it or love it if you can, because it might get the better of you. You never know.

The Destruction of the Father (17-29) is a room-size re-creation of a violent fantasy and one of her most powerful works. Bourgeois describes it as "a very murderous piece, an impulse that comes when one is under too much stress and one turns against those one loves the most." It seems to prove Sigmund Freud's theory that old conflicts never die if they are not brought out into the open and resolved. At the age of sixty-three, Bourgeois still remembered in anger her father's bullying ways and how he betrayed her mother with

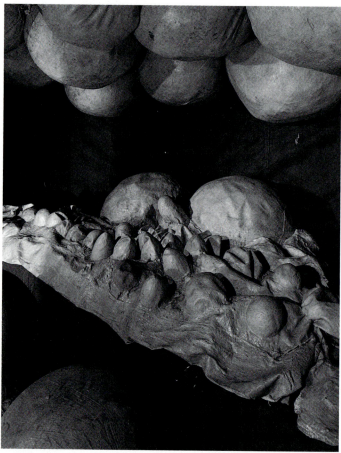

17-29 Louise Bourgeois, detail of *The Destruction of the Father*, 1974. Plaster and mixed media, 93⅝" x 142⅝" x 97⅞". Courtesy Robert Miller Gallery, New York.

many mistresses. As a child she had fantasized one day at the dinner table when he was "going on and on, showing off" and forcing his family to listen, that she, her mother, sister, and brother suddenly grabbed her father, tore him limb from limb, and ate him. *The Destruction of the Father* is set in a frightening cave (inspired by a visit to Lascaux, site of the prehistoric cave paintings, 1-11) with drooling alligator jaws and scattered organic shapes that look like shredded body parts. Huge breastlike sacks loom overhead like a crowd of women exacting their revenge. In a corner of the installation is a round shape suggesting a man's head. To build this horrible environment, Bourgeois poured and shaped liquid latex over plaster and wood forms. After a half-century, Bourgeois exorcised her childhood anger, guilt, and fear with the building of a scene of nightmarish retribution.

In the early 1970s, Lucas Samaras was one of a group of artists selected by the Polaroid Corporation to experiment with SX-70, a new instant film it had developed. The new film, he discovered, had one major difference from conventional film—its soft chemical emulsion was malleable for a few minutes before it dried. By scratching and pushing it, he could achieve bizarre effects that were most likely not on the Polaroid scientists' minds when they developed the film. For the SX-70 experiments, Samaras set the camera on a tripod and put on the timer to allow himself to enter a scene of his own devising. *Phantasmata* (17-30) required a great deal of planning. Set in his kitchen, Samaras poses for the camera with a polka-dot sheet behind him. To the right, dark shadows of limbs have been attached to the wall, and the room is bathed in red light. Reaching up his arms in a position of surrender, the photographer grips a blue blanket in his mouth. By playing with the emulsion at the center of the picture, Samaras created the illusion that the blanket is a dark pedestal and he is a living sculpture. His legs appear to have melted into the blanket/pedestal, which has now also fused with his torso.

Like Sandy Skoglund's *Radioactive Cats* (6-12), the carefully planned environments of the "phototransformations" debunk the old truism that "the camera never lies." Samaras was an innovator not only in staging scenes but also in making the manipulation of the

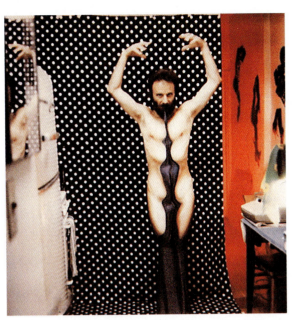

17-30 Lucas Samaras, *Phantasmata* series, 1976. SX-70 Polaroid print, approximately 3″ x 3″. Pace/MacGill Gallery, New York. Reprinted with permission of the artist.

physical photograph itself a part of the repertoire of illusionistic photography.

Cindy Sherman has spent her entire career reimagining herself in roles such as the murder victim seen in Chapter 6 (6-13). In her most recent works, Sherman has extended her subject matter to women of the past, including those from fairytales and myths. To pose as the eighteenth-century *Madame de Pompadour* (17-31), she used fake cleavage and elaborate period costume. She also moved beyond her very large prints to a new material—fine china. The famous mistress of King Louis XV adorns a Rococo-inspired porcelain plate made by the same French factory she once patronized. It is as if Sherman is saying that centuries-old images affect how women perceive themselves just as much as today's stereotypes do. One must understand the archetypes of our cultural heritage to understand how one sees oneself.

POSTMODERN ARCHITECTURE

Cindy Sherman's works are additional evidence of what is becoming one of the dominant trends of the late twentieth-century Postmodernism. With the easy access artists now have to both fine art and popular art images of every period and culture, artworks can assume a variety of guises, depending on their goals. In the mid-1960s, the buildings and theories of Robert Venturi had given architecture a head start on the Postmodern notion of exploiting rather than rejecting history. Since then a more complete definition of Postmodernism in architecture, as well as the other media, has evolved. Postmodernism is a movement that prefers improvisation and spontaneity to perfection (ideas reminiscent of sixteenth-century Italian Mannerism). Instead of one style, the Postmodern artist combines several contradictory styles with wit. It is not considered important if they do or do not ultimately make a resolved whole. As we saw in the work of James Wines and SITE, a Postmodern building is not simply functional, it is also like a sculpture by the architect.

One of the icons of Postmodern architecture is Charles W. Moore's *Piazza d'Italia* (17-32) designed with William Hersey. Moore, a California architect and well-respected professor, was hired to design a city square as part of a plan to help revitalize a struggling neighborhood in New Orleans. Since most of the local people in this part of the city are of Italian heritage, Moore devised a very American rendition of Italian architectural history. The Piazza is built on a circular site and is

17-31 Cindy Sherman, *Madame de Pompadour*, 1992. Limoges porcelain 30-piece limited edition dinner service after the original design commissioned by Madame de Pompadour in 1756; image transferred onto porcelain by photo silkscreen.

the setting for an annual festival. A geometric map of Italy that pedestrians can walk on juts out like a pier into a pool of water serving as the Mediterranean Sea. As the neighborhood is mostly Sicilian, the island of Sicily is at the center, surrounded by a pattern of concentric circles. Italy is topographic; the elevation of the map rises as one approaches the northern

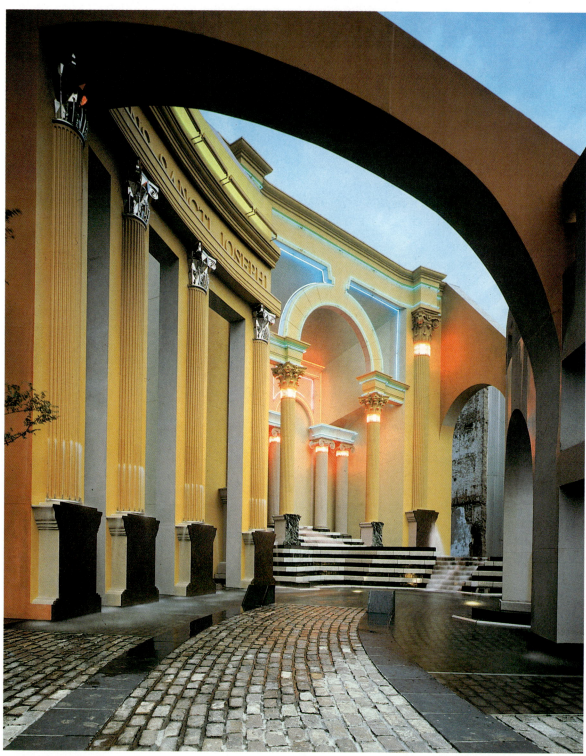

17-32 Charles W. Moore and William Hersey, *Piazza d'Italia*, New Orleans, 1978. Photo © 1978 Norman McGrath.

Alps and the vertical columns and arches. The series of colonnades have three functions: They call attention to the site from a distance, contain an elaborate fountain, and provide a background for Italy by wrapping around its "northern" side, layered like stage sets. All the classical orders are represented (see Chapter 8), but they are treated in a fanciful way: Running water forms the body of some of the columns. Metal, marble, and colored stone vie for the viewer's attention. Over one of the arches are a pair of fountainheads, self-portraits of the architect that spout water. Moore has highlighted many of the architectural details with multicolored neon lights; after dark, their reflections on the water make the Piazza a marvelous vision, an extravaganza of history and gaudy night life.

CONTEMPORARY NONREPRESENTATION

In our pluralistic era, it is important to keep in mind that Postmodernism is only one, albeit important, approach. There continue to be many serious practitioners of nonrepresentational art, both young and old. Richard Diebenkorn, until his death in 1993, was the elder statesman of contemporary nonrepresentational painting. The *Ocean Park* series (17-33) was a nearly twenty-five-year exploration of the radiant Southern California light. While the series is certainly totally abstract, Diebenkorn admitted, "temperamentally, I have always been a landscape painter." As in his drawings (3-13), nothing is hidden; the viewer can follow the artist's struggle to resolve the composition through the thin, almost transparent layers of paint. His achievement is that he has managed to fuse the rigors of abstraction with the serene pleasures of the landscape.

A combination of sincerity and a sense of peace also characterizes the abstract sculptures of Martin Puryear. While recognition has been slow to come to him (he did not have a solo show in New York City until he was forty-six years old), his selection to represent the United States at the Sao Paulo Bienal in 1989, and his first-prize award, mark him as one of the most important contemporary sculptors. Puryear grew up in Washington, D.C., but has had a truly international education. After graduating from college in 1963, he joined the Peace Corps. His African assign-

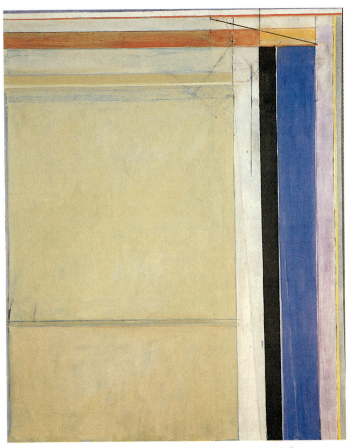

17-33 Richard Diebenkorn, *Ocean Park #83*, 1975. Oil on canvas, 18" x 14". In the collection of The Corcoran Gallery of Art (museum purchase with the aid of funds from the National Endowment for the Arts, The William A. Clark Fund and Margaret M. Hitchcock).

ment in Sierra Leone had a profound effect on the young black artist. Even though he was there primarily as a teacher, he learned a great deal, too. He experienced tribal art-making firsthand, studied the methods of the traditional wood carvers, and saw, he said, "a level beyond" realism. Puryear found that abstraction could be more alive than representational art; it could have a magic quality. After his term was over, he went to Stockholm and researched Scandinavian woodworking methods. He has since studied traditional Japanese and Mongolian crafts.

Puryear's sculpture has been described as "Postminimalist" because of the simple nature of their forms. But he dislikes the label. "I was never interested in making cool, distilled pure objects. Although idea and form are

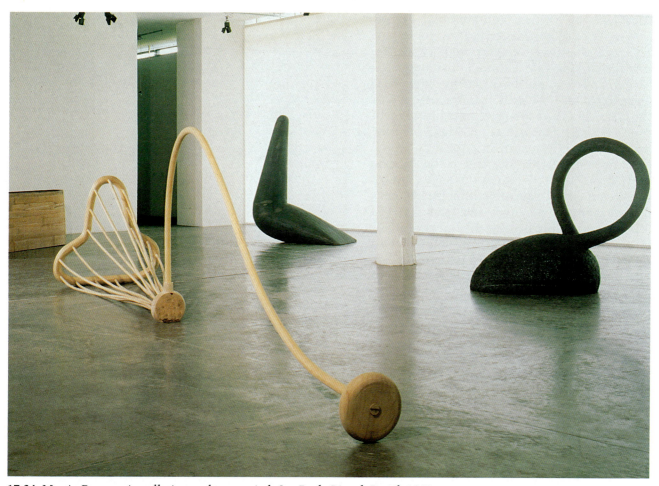

17-34 Martin Puryear, installation at the twentieth Sao Paulo Bienal, Brazil, 1989

ultimately paramount in my work, so are chance, accident, and rawness." The free-standing sculptures exhibited at the Sao Paulo Bienal (17-34) are part of a series he calls *Decoys.* Knowing the title helps the viewer see that Puryear has drawn inspiration from ducks and swans, rudders, and other things you might find on a boat. One can also see the influence of Brancusi (15-19) in the purity of the forms. At a distance, the decoys seem carefully refined and sanded. However, up close one can see that, like Diebenkorn, Puryear does not cover up the signs of the process he used to construct his art. In contrast to Judd's minimalist boxes, these are clearly handcrafted sculptures. Puryear says, "I enjoy and need to work with my hands." The marks of the staples that held the wood together during gluing are still there. He never sands his woodwork, but planes it, leaving a rougher surface.

Each of Puryear's sculptures seems to change its personality as you walk around it. From one angle, it might look like a pole for a basketball hoop that has been knocked over, from another, the long sweeping neck of a graceful swan. A heavy rudder becomes the tail of a duck as it reaches down into the water. Like much Postmodern art, Puryear's work carries many associations from different artists and cultures. But he has also managed to fuse these diverse sources into coherent, whole, earthbound sculptures. This may explain why his organic abstractions have a gentle, calming effect on the viewer.

RECENT INSTALLATIONS

Betye Saar, whose boxed assemblage *The Liberation of Aunt Jemima* we saw in Chapter 1, is one of many sculptors who have recently moved from relatively small-scale sculptures

to gallery installations. However, her motivation was unusual. *House of Gris Gris* (17-35) is a 1990 collaboration with her daughter, Alison, who is a sculptor most comfortable working on a large scale. The house is a tin shanty with chicken-wire walls filled with brush, leaves, and moss. Within the house are painted ceilings and floors. The name is from an African charm, and the entire installation is a collection of African-American ritual objects from Africa, Haiti, Mexico, and the South. For example, the tree branch with bottles at the entrance is known as a "spirit tree"; the empty bottles can capture souls. The hanging wings and oversized body parts outside the shack signify healing. The overall tone of *House of Gris Gris* is ordinary and metaphysical.

The installations of Kenny Scharf are as richly filled as the Saars's but provide an entirely different atmosphere. Selected in 1985 for the Biennial Exhibition at Whitney Museum in New York City, one of the most important exhibitions of contemporary art, Scharf chose to decorate the passageway to the restrooms with a combination of painting and sculpture (17-36). He moved into the museum, sleeping overnight on a couch in the women's restroom, and covered the walls in Day-Glo paints (later lit by black-light lamps), mixing cartoon characters like Fred Flintstone with wild patterns. Many objects (which he calls "trash") were stuck to the walls and hung from the ceiling, including portable tape play-

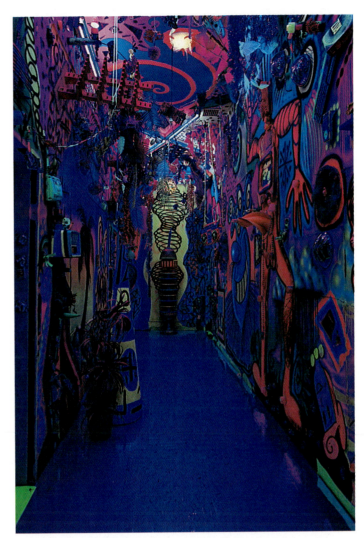

17-36 Kenny Scharf, installation view of *Closet, No. 7*, 1985. Mixed media. From the 1985 Biennial Exhibition at Whitney Museum of American Art, New York, March 13–June 9, 1985.

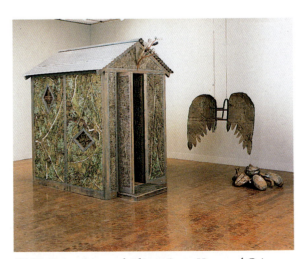

17-35 Betye Saar and Alison Saar, *House of Gris Gris*, 1990. Mixed media installation at the UCLA Wight Art Gallery, Los Angeles.

ers that blasted loud music. The installation included decorating the phone booths at the end of the corridor with paint, glitter, and fake fur, as well as the restrooms themselves. Scharf transformed a minor hallway in a major museum into a Postmodern, raucous funhouse.

NEW ELECTRONIC MEDIA

In the last thirty-five years, new electronic media have been added to the list of artist's materials, providing visual artists with tools that apparently have endless possibilities. Electronic media is a rapidly changing area of exploration that includes video art, electronic

signs (see Jenny Holzer, 7-12), and computer art. These types of electronic art are often combined with each other and more traditional media. While video art is the oldest of these new media, it can still be said to be in its infancy. As the Korean-American artist Nam June Paik (who originated this art form in 1963) reminds his audiences, it was a long time after the invention of the printing press before there was a Shakespeare.

Paik was born in Korea in 1932, but his family was forced to leave in 1949 during the Korean War. At this time, Paik was a talented young music student. He has since lived in Hong Kong, Tokyo, Germany, and the United States. In 1963, Paik's love affair with television began. For his first solo exhibition, called "Exposition of Music—Electronic Television," he filled a German gallery with 13 used television sets, along with pianos covered with found materials like doll's heads and photo-

graphs. Joseph Beuys entered the gallery and demolished a piano with an axe. Intentionally or not, that act signified the conversion of Paik from musician to electronic artist.

Conceptually, some of Paik's most thought-provoking (and humorous) work concerns the relationship of television imagery to reality. In *TV Buddha* (17-37) a traditional sculpture of the Buddha appears to be watching his own "live" image intently on a monitor. The Buddha contemplates his electronic self, apparently mesmerized by television like any child in America. Oddly, the effect is not only comic but peaceful; the empty setting and unchanging nature of the image is reminiscent of the Zen Buddhist goal of attaining nonbeing.

Paik's video art has not been limited to simple ("single channel") images of sculptures. If television is now the common language of our global culture, Paik is its playful poet,

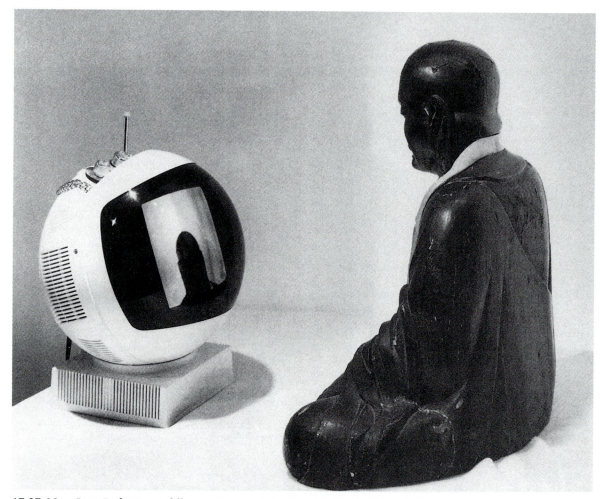

17-37 Nam June Paik, *TV Buddha*, 1974–1982. Mixed media, 55" x 115" x 36".

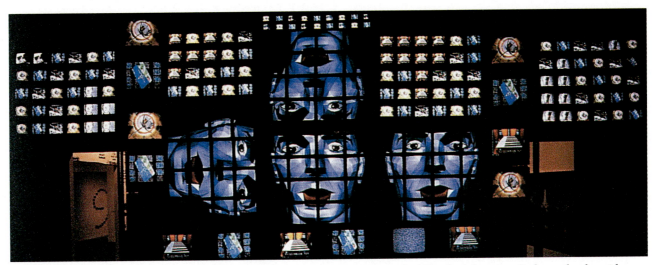

17-38 Nam Jun Paik, *Fin de Siècle II*, 1989. Video installation, approximately 300 television sets, 3-channel color video with sound, dimensions variable. Private collection.

an artist constantly expanding its vocabulary. Working with electronic engineers, he has always been at the "cutting edge," developing equipment to create more and more complex video imagery. In the 1960s, he was already using the color synthesizers and editors that are now in regular use by conventional broadcast television. In 1989 in New York City, his *Fin de Siècle II* ("end of the century," 17-38) introduced the Whitney Museum's exhibition "Image World—Art and Media Culture." Visitors entering the black room were confronted with a wall of about 300 television sets launching a barrage of rapidly changing pictures with a loud collage-like soundtrack. The images were a visual stream of consciousness: people dancing, abstract computer imagery, David Bowie singing. At times, groups of 12 or 16 televisions formed larger pictures, like four three-dimensional computer-generated heads that turned jerkily 90 degrees at a time. Sometimes the soundtrack connected with the pictures; at other times it became just a clash of white noise and a hundred voices. There was no beginning or end, just the endless bombardment of stimuli that seems to characterize our visual environment, a storm of images.

Today's storm began with a trickle when the printing press was invented in the fifteenth century. Television is just the most recent development in a centuries-long history of more and more images becoming available to more and more people. The death of art announced in many obituaries written by artists and art critics during the heyday of Minimalism in the 1960s has come and gone. We are now in what is called a Postmodern and pluralistic era, a period of exploration of seemingly endless possibilities. Artists are now justifiably suspicious of anyone who announces that there is only one logical style or approach to the making of art. The history of the twentieth century, in fact the whole history of art, is littered with the remains of generations of "true" art. When Nam June Paik claims that traditional media are going to be replaced by video because it can make pictures

as precisely as Leonardo
as freely as Picasso
as colorfully as Renoir
as profoundly as Mondrian
as violently as Pollock

the knowledgeable observer of art should respect and admire his enthusiasm for his new medium but take a wait-and-see attitude. To wait and see what the legions of artists will produce is one of the most pleasurable parts of the power of art today.

CONTEMPORARY ISSUES IN ART

The Modern era swept away so many of the traditional barriers and restrictions for artists that it is not unreasonable to ask today, as the Postmodern era begins, if there are any limits left. Of course, one might be hesitant to suggest limits for fear of finding oneself years from now in the same position as the nineteenth-century critic who declared the Impressionists were "making war on beauty." Yet are we willing to say that artists should have absolute freedom of expression?

The last few years have been filled with enough intense controversies to suggest that even in a democratic country in the midst of a pluralistic age many issues related to artistic freedom of expression are not yet settled. Recent stormy debates have brought into focus the conflict between artistic freedom and public standards and expectations. What is an artist's social responsibility? How much assistance should a government provide to its artists? When does reasonable restriction end and censorship begin? What does obscenity mean, and can something obscene be art?

With a series of case studies based on recent events, we will consider what the proper role of the artist should be in today's society, as well as whether women have been given equal opportunities in the visual arts and how we can preserve, and still keep accessible to the public, our masterpieces. Our aim in this final chapter is not to dictate the answers to these questions but to allow you to participate in the dialogue that is currently taking place.

CAN ART BE OBSCENE?

The questions of what is obscene and whether art should be banned if it is obscene have haunted modern artists for more than a century. Many important works of art that were once condemned as obscene in the past—for example, Manet's *Le Déjeuner sur l'herbe* (14-31)—are now considered masterpieces. Even in this century, art has been put on trial because of sexual content. In literature, the bannings of James Joyce's *Ulysses* and D. H. Lawrence's *Lady Chatterly's Lover* were battled in the courts and ultimately overturned. The verdicts were seen as important victories for individual civil liberties and artistic freedom. Today, the books are considered modern classics and are traditional parts of college and university curricula.

MAPPLETHORPE

More recently, the photographs of Robert Mapplethorpe brought national attention to the conflict between artistic freedom and what community standards call obscene. Although relatively few Americans have seen his pictures, Mapplethorpe's name became a notorious household word in 1990. Mapplethorpe was brought up in a middle-class Catholic home in suburban New York. Early in his art career, he was already exploring the limits of conventional morality by collaging

sexually explicit photographs into sculptural frames that he made. As he developed as an artist, he became a successful commercial photographer. Few have questioned his marvelous technical skills. His prints bring an almost glamorous quality to whatever he portrayed, whether nudes or flowers. It is his photographs' erotic atmosphere that has disturbed many viewers.

In *Ken Moody and Robert Sherman* (18-1), Mapplethorpe idealizes his subjects; they are living men but seem like statues. Their flesh looks as if it is carved out of the purest black and white marble. The directional lighting envelops them in a soft, glowing light. The geometric composition is uncomplicated and dramatic, a formal progression of simple forms from white to gray to black. The image has a timeless, Classical quality.

A man and a woman, or two women posed in the same manner by Mapplethorpe, would probably have not been controversial. But Mapplethorpe shows two men who appear to be naked and who are from different races as well. Despite the serene beauty of the photograph, the sexual feeling and interracial nature of the image has aroused a great deal of hostility. Many cannot accept a male artist's loving attitude toward other men.

A pair of self-portraits are also disturbing to many. In one of the self-portraits, Mapplethorpe is a 1950s-style rebel in a leather jacket (18-2). In the other, he is more a sweet, feminine clown with white makeup and lipstick and his hair brushed out (18-3). There is an

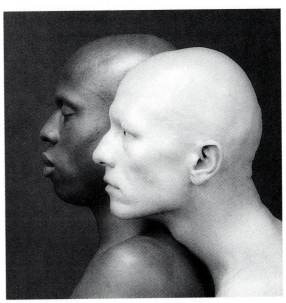

18-1 Robert Mapplethorpe, *Ken Moody and Robert Sherman*, 1984. Gelatin silver print, 7¾" x 7¾". Copyright © 1984 The Estate of Robert Mapplethorpe.

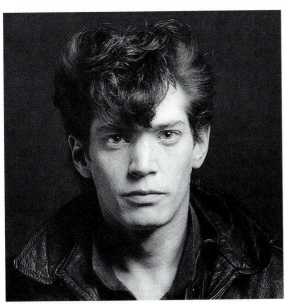

18-2 Robert Mapplethorpe, *Self-Portrait*, 1980. Gelatin silver print, 7¾" x 7¾". Copyright © 1980 The Estate of Robert Mapplethorpe.

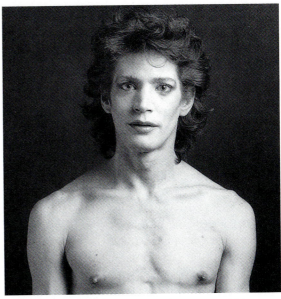

18-3 Robert Mapplethorpe, *Self-Portrait*, 1980. Gelatin silver print, 7¾" x 7¾". Copyright © 1980 The Estate of Robert Mapplethorpe.

ART NEWS

AESTHETICS BECOMES A PUBLIC (AND LEGAL) ISSUE

In 1990, the question "What is art?," normally the interest of aestheticians and scholars, became the responsibility of jurors, some of whom had never entered a museum. Dennis Barrie, the director of Cincinnati's Contemporary Art Center, had been arraigned on obscenity charges for exhibiting the photographs of Robert Mapplethorpe. If convicted, Barrie faced a $2,000 fine and a year in jail and an additional fine for his museum of $10,000. The indictment came on the opening day of the Mapplethorpe exhibition, which had attracted the largest attendance to an art show in Cincinnati history, even though the museum had restricted it to adults. The day was also marked by the closing of the museum by two dozen city police officers. The police cleared the building of several hundred visitors and collected evidence for the obscenity trial. Cries of "Tiananmen Square!" and "Gestapo go home!" were heard.

Before the Cincinnati museum's shutdown, the local county prosecutor asked the museum to voluntarily take down seven particular Mapplethorpe photographs, which included children whose genitals were exposed and some portraying homosexual acts between adults.

Before the trial, it was generally understood that whatever was exhibited in an art museum was considered art and not liable to prosecution for obscenity. The Supreme Court had ruled in 1973 that artwork was protected by the First Amendment and could not be considered obscene unless "taken as a whole [it] lacks serious literary, artistic, political or scientific value." To convict Barrie and the museum, the prosecutors were also required to prove that Mapplethorpe's photographs appealed to prurient interests according to the "average person applying contemporary community standards." It would be up to the jurors to decide whether the photographs were art or pornography.

While the Cincinnati museum had some confidence that it could win its case, it was facing tens of thousands of dollars in legal costs. Barrie, the director, said before the trial:

implicit message that he, like all of us, has both a male and female side, aggressive and submissive inclinations. Sigmund Freud said the same thing at the beginning of the century, but it remains a message that is often rejected with vehemence. Even more controversial were photographs of male sadomasochistic lovers and an innocent child in a park who seems unaware that anyone cares that she wears no underwear.

The controversial nature of Mapplethorpe's images became a national issue when a retrospective of his work was organized with funds from the National Endowment for the Arts (NEA). The exhibition traveled through many cities in the United States and became the subject of intense public scrutiny. A museum director was even put on trial for allowing the exhibition to be shown in Cincinnati (see "Art News" above).

Mapplethorpe's pictures challenge the morality of his viewers. He brought the same glamorous and artful approach to whatever he portrayed, including graphic sexual acts and "kinky" paraphernalia. What many expect to remain hidden the photographer openly exhibited as beauty, without apparent shame. One question for viewers is whether Mapplethorpe transformed his subject matter into art, or is this subject matter so taboo that it is not possible art material? What is the line between an artist's rights to explore and exhibit his or her interests and the need to protect society from what is obscene? The Mapplethorpe retrospective controversy raised important new questions: Should public funds support artists who make works that some consider obscene? Should morality enter into funding decisions? What is the proper role for taxpayer dollars in the support of the arts?

Even if the charges are dismissed or if we win a jury trial, we will have gone through the anguish and financial strain of fighting something that should not have been brought to court in the first place.

Most museums are nonprofit organizations, perhaps rich in terms of valuable collections but with little financial resources beyond the costs of running a museum. What effect would this prosecution have in the future? Would museums shy away from controversial art in fear of criminal charges that might destroy their institutions financially, even if ultimately found innocent? During the two-week trial, the defense did not dispute the prosecutor's claim that the pictures were disturbing but said that they were serious art. Several art experts testified to the brilliance of Mapplethorpe's works. None could be found to testify against the pictures except one with a Ph.D. in speech communications. Instead, the prosecution focused on the shocking nature of only a few photographs from the exhibition. Over the protests of the defense, the prosecutor was able to convince the judge that the jurors should not be permitted to see any of the others, which would have allowed them to be considered in the context of the entire exhibition. The jurors were also not allowed to see the originals but lower-quality copies. Two of the photographs showed sadomasochistic homosexual acts. At closing, the prosecutor waived the pictures in front of the jurors and asked, "Are these van Goghs, these pictures? Is this art?" He accused the museum and the experts of "putting themselves above the law" and "saying they're better than us."

None of the jurors said they attended museums regularly but they took only two hours to return their verdict—"Not guilty on all counts." In effect, they said the photographs *were* art. After the trial, Barrie said, "This was a major battle for art and for creativity, for the continuance of creativity in this country." His lawyer warned people who try to tell "people what they can say and what they can see" that "they better realize there is protection out there, and it is the greatest document ever written." He referred to the United States Constitution.

WHAT IS THE PROPER RELATIONSHIP BETWEEN AN ARTIST AND THE GOVERNMENT?

The public debate over what is art and what is obscene did not end with the trial in Cincinnati. The National Endowment of the Arts became the next battleground over artists' rights and responsibilities. Questions were raised over federal funds being used to support what some consider pornographic and sacrilegious art. The National Endowment for the Arts was established by Congress in 1965 to encourage and support national progress in the arts. In the more than quarter-century since its founding, the NEA has become the largest single supporter of the arts in the United States. In the visual arts, it has distributed grants to museums, arts organizations, and individual artists in cities and small towns across America. It also supports dance, music, film, video, and public broadcasting. Its founding legislation prohibited any interference with the content of art it supports. In light of the controversy over the Mapplethorpe exhibition and others, congressional amendments were proposed to change the charter's goal of noninterference by establishing limits to the content of the art the NEA could support. Many in Congress felt they had the responsibility to determine what art taxpayers' dollars supported. They said that not giving grants to controversial art was not the same as censorship. Artists would remain free to do what they wanted, just not at public expense.

In the arts community, there was widespread fear of a chilling effect on artists and art organizations similar to the McCarthy era

in the 1950s. Would artists be less daring than before? Would museums only show "safe" art? Which was more dangerous, someone being offended or censoring freedom of expression? Ultimately, in the summer of 1990, the Senate and the House reached a compromise when both agreed to cut $45,000 from the NEA budget, the amount used to fund the Mapplethorpe and another controversial exhibition, and to, in effect, punish it for its decision to fund them (it also killed an amendment with much graver cuts). The NEA (capitulating to pressure or returning to common sense, depending on your point of view) changed its procedures, requiring anyone who was awarded a grant to sign an oath stating their work would not be obscene:

> Including, but not limited to, depictions of sadomasochism, homoeroticism, the exploitation of children, or individuals engaged in sex acts.

PUBLIC COMMISSIONS: ARTIST AND PUBLIC OR ARTIST VERSUS PUBLIC? THE TILTED ARC CONTROVERSY

The government, the general public, and the art world have been entangled in controversy several times in recent years and not only on the issue of obscenity. In the 1980s, an artwork in which no one could find any sexual, or even representational, content became a lightning rod for discussion on whether public opinion should be allowed to dictate whether public art should be destroyed or preserved. The ultimate fate of Richard Serra's *Tilted Arc* (18-4), an outdoor sculpture commissioned by the federal government, would take nine years of bitter debate and court battles to resolve.

In 1979, Richard Serra, a Minimalist sculptor, was chosen by a panel of experts to design a sculpture for a plaza in front of a federal building complex in New York City. Serra is a well-known and critically acclaimed sculptor who had already designed sculpture for plazas in Berlin, St. Louis, Barcelona, and Paris. The French president, François Mitterand, was so impressed with the Paris sculpture that he made Serra a "Chevalier," the modern equivalent of being knighted.

Serra's New York commission was part of the "Art in Architecture" program supervised by the General Services Administration

(GSA) of the federal government. Established in 1963 by the Kennedy administration, "Art in Architecture" sets aside one-half of 1 percent of the monies allocated for new federal buildings towards the purchase of public art designed for the site. At the time of the commission, the federal buildings were already completed. The semicircular plaza in front of them already had a fountain at its center and was regularly traversed by thousands of federal employees.

After many consultations with engineers and the design review board of the GSA, the chief administrator of GSA in Washington, D.C., gave Serra the go-ahead for his design. It was completed and installed in 1981 and greeted with immediate hostility. *Tilted Arc* was both tall and menacing, graceful and impressive. Constructed of Cor-Ten steel (which is used for bridges) 12 feet tall and 120 feet long, it swept across almost the entire plaza between the fountain and the entrance.

The sculpture formed a very gradual arc that crossed and balanced the opposing curves of the circular paving stones of the plaza. The wall of steel also tilted at a slight angle towards the central building.

Serra had decided not to embellish the fountain and buildings but to alter the whole experience of the plaza. "After the piece is created," Serra said, "the space will be understood primarily as a function of the sculpture." In other words, he wanted to make his sculpture the focus of the entire area. He succeeded in fulfilling his intention but with a reaction he never imagined. Workers dubbed the new sculpture "the Berlin Wall of Foley Square." Instead of walking directly across the plaza as they had in the past, they were forced to walk around the sculpture (18-5). Rather than confronting and contemplating the artwork as Serra hoped they would, the workers were simply irritated by its placement. While it made a strong abstract composition when seen from the building's windows at ground level, it also blocked their view of the fountain. Angry letters flooded local newspapers and magazines, and thirteen hundred employees at the federal complex signed a petition demanding its removal.

In 1985, the head of the GSA's New York office organized three days of public hearings on the *Tilted Arc*. Testimony was heard from office workers who described the sculpture as

"garbage," "an irritation," "rusted junk," and "hideous" and demanded its removal. A few asked for help in understanding it before they made a decision. It was clear that no one had considered consulting the occupants of the Federal Plaza even though they would have to live with the sculpture every day. Museum curators, art scholars, critics, and artists like Donald Judd testified in favor of the work. It was suggested that the GSA put some effort in "building public understanding" of the art it had commissioned. Serra attempted to explain his sculpture to the public:

> *Tilted Arc* was constructed to engage the public in dialogue . . . The sculpture involved the viewer rationally and emotionally . . . The viewer becomes aware of himself and his movement through the plaza. As he moves, the sculpture changes. Contraction and expansion of the sculpture results from the viewer's movement. Step by step, perception of not only the sculpture but the entire environment changes.

Listeners familiar with Minimalism would recognize in Serra's statement the movement's devotion to creating a real rather than imaginative experience of art, a confrontation with the clarity of sculptural form in space without comforting illusions. He wanted his work to be equal in impact to the buildings, space, and city life it was surrounded by, not subservient to them.

Coincidentally, a similar controversy had just been concluded in Washington, D.C., over the *Vietnam Veterans Memorial* designed by Maya Ying Lin. After significant negative response from some public figures and veterans groups, as described in Chapter 1, a compromise was reached after bitter debate, with the placement of a realistic statue nearby. But Serra's sculpture met a different fate. The judgment of the panel who held the open hearing was that it should be removed. Shocked at first, Serra responded with a $30 million lawsuit, charging that the GSA had deprived him of his constitutionally protected rights of free speech and due process of law, along with breaching his contract. Serra argued that his contract called for a permanent sculpture. He had designed it specifically for the site, so it would not work in the same way in any other location. Its removal would destroy it. A judge ruled in 1987 that since the GSA had purchased the sculpture from Serra, he had no

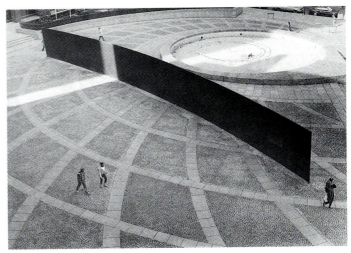

18-4 Richard Serra, *Tilted Arc*, 1981. Hot-rolled steel, 120′ long. Federal Plaza, New York.

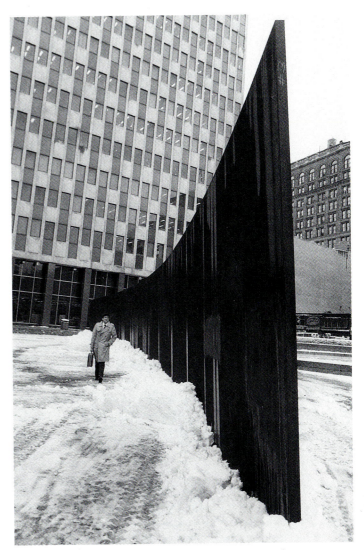

18-5 Detail of figure 18-4, © 1985 Edward Hausner/NYT Pictures

further rights connected with it. It was up to the government whether to keep it in the plaza, move it, or destroy it.

In March of 1989, in the middle of the night, construction workers used jackhammers and cranes to disassemble the *Tilted Arc*. Broken into three pieces, the remains of the sculpture were taken to a city parking area and stacked while the GSA looked for another site. Serra publicly announced that he would never cooperate with the government in its search. It seems unlikely that *Tilted Arc* will ever be seen intact again.

Because of the controversies surrounding their works, Maya Ying Lin and Richard Serra would likely agree that artists can no longer trust the commitment that the government makes for permanent displays of art. If an artist must fear immediate public outrage, isn't it likely that he or she will use safe, conventional approaches to commissions rather than ambitious ones? Will caution decorate our public places instead of imagination? The judge's ruling was particularly unsettling to artists. Can the government destroy any of its thousands of artworks? What about private citizens? Are property rights always going to prevail over the preservation of works of art?

On the positive side, awareness of the need to involve the general public in decisions on public art has increased. The GSA itself has instituted new policies that reflect the need for social responsibility in the designs it chooses. Artists are not given commissions after sites are finished but work with the architects during the planning stages. Concerned citizens are also invited into the planning process. Education of the community is considered an integral part of any plan to bring art to civic places. As proved by the *Vietnam Veterans Memorial*, public art can be an important part of our country's cultural life.

WHY ISN'T A WOMAN'S PLACE IN THE MUSEUM?

For the past five centuries an unstated, unofficial, but apparent censorship of the artwork of more than half the population in the West has occurred. Despite the fact that they have been making art as long as it has existed, women have been systematically excluded from museums and art histories. As women's status

rose in the last 150 years, so have the number of professional women artists. Yet, a visitor to United States museums or readers of art history texts of just fifteen years ago would have seen the virtual absence of any sign of art created by women. Recently, the censorship of women has begun to slowly subside due mostly to the efforts of women themselves.

JUDY CHICAGO

In 1970, an art instructor at Fresno State College in California placed a statement at her solo exhibition that read:

> Judy Gerowitz hereby divests herself of all names imposed upon her through male social dominance and freely chooses her own name, *Judy Chicago*.

In the same year, she offered a feminist art class that excluded men, in a studio away from her college. The young women not only made works of art but also learned how to use tools. It was the beginning of a career devoted to forcing the inclusion of women in the art world.

The young Judy Cohen grew up in Chicago and was raised in a family that taught equality. So it was a shock for her to learn that America in the 1950s did not share her family's values. Early in her art career, she worked in a Minimalist style (she described this as trying to be "one of the boys") while living in Los Angeles. It was not until 1970 that Chicago made a clean break with the male art world and began making symbolic works using imagery based on female genitalia. During the 1970s, Chicago was a key figure in the birth of the women's movement, organizing "Womanspace," a gallery, and the "Women's Building," a center for women's culture in Los Angeles. The building housed a multidisciplinary program, called the "Feminist Studio Workshop (FSW)" where Chicago taught. The FSW encouraged women to explore what it meant to be female and translate their experience as women into subjects for artworks. The curriculum included traditional studio classes in art, writing, and video, along with consciousness-raising groups. While the traditional art world was slow to accept the work being done there, Los Angeles became a magnet to talented women

from all across the United States and was known as one of the leading centers of the growing feminist movement, and eventually as a world art center. Chicago's participation in the creation of collaborative artworks that dealt with feminist issues culminated in her most famous work, a room-sized installation called *The Dinner Party* (18-6) that was four years in the making. The artist led a team of more than one hundred women in the creation of a triangular table, 48 feet on each side. On it were 39 place settings that symbolized the contributions of great women of the past from prehistoric times to Georgia O'Keeffe. The table rested on a tiled platform that had the names of 999 women written in gold. *The Dinner Party* utilized crafts media that in the past had been denied consideration as fine art (see later discussion). Each porcelain plate was a symbolic portrait of the woman honored, and her era was evoked in the design of an embroidered runner. Weaving and needlepoint were also employed. The plates all contain Chicago's characteristic vaginal imagery that aims to "make the feminine holy" (18-7). A companion book was written to tell about the women represented and to explain the symbols used.

In 1978, *The Dinner Party* was exhibited at the San Francisco Museum (it broke all previous attendance records) and then traveled across the country. At the Brooklyn Museum

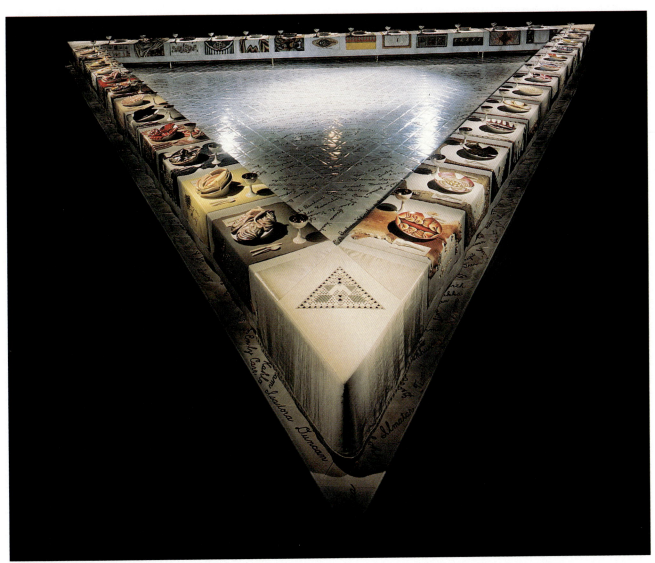

18-6 Judy Chicago, *The Dinner Party*, 1979. Mixed media, 48' x 48' x 48' installed. © Judy Chicago, 1979.

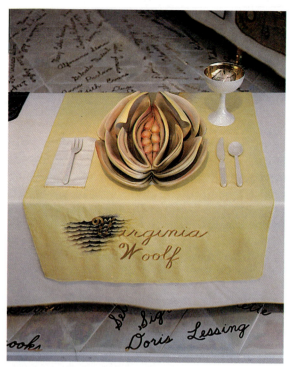

18-7 Detail of figure 18-6 (place setting for Virginia Woolf), © Judy Chicago, 1979

in 1980, more than seventy-five thousand visitors saw it. Chicago explained the purpose of her work as

> A people's history—the history of women in Western civilization . . . This information, however, was . . . certainly unknown to most people. And as long as women's achievements were excluded from our understanding of the past, we would continue to feel as if we had never done anything worthwhile. This absence of any sense of our tradition as women seemed to cripple us psychologically. I wanted to change that, and I wanted to do that through art.

WHAT IS THE DIFFERENCE BETWEEN ART AND THE CRAFTS?

An unfortunate consequence of the division of art into fine arts and lower-status crafts was the loss of appreciation of media in which women traditionally were occupied. Weaving, embroidery, pottery, baskets, needlework, and quilts were all relegated to the decorative, or

minor, arts. Some would say that this was no coincidence. It is hard to imagine such careful distinctions being made by prehistoric tribes, the Egyptians, medieval culture, or for that matter, throughout most of history. The separation of art and craft is a Western concept, only five centuries old, and began in the Renaissance. In Asia, no distinction or difference in rank between fine and decorative arts exists. Divinity can be found in painting, sculpture, weaving, architecture, cooking, even horsemanship, if they have the flavor of their heavenly models. All are the products of skilled and knowledgeable craftspeople. In Japan, it is not surprising to find a maker of swords and a painter, who uses ink and brush, both labeled "national treasures."

In the West, the revival of appreciation of these "crafts" as fine arts in recent decades is a consequence of a rise in the overall status of women artists. Magdalena Abakanowicz has played an important role in eliminating the distinctions between craft and fine art materials, or as she calls it, escaping "from the world of categories." Born in Poland, she felt most comfortable in nature while growing up and would spend hours canoeing in a river filled with tall grass. She would collect natural materials like stones and twigs. Even today, she says, she feels "safer with nature than with people" and returns to it to "fuel my battery." After World War II, Abakanowicz studied at the Academy of Fine Art in Warsaw but was frustrated by the official Social Realist style taught there and received poor grades for being too expressive. After finally graduating, she worked privately on imaginative, naturalistic drawings and paintings while working as a designer for a tie factory. In 1960, she began to weave because she "wanted to get as far as possible from all established forms . . . We find out about ourselves only when we take risks." Her weaving was initially of tapestries but became more and more sculptural in the following years. The series *Abakans* (18-8) also began winning international prizes.

Today Abakanowicz does not use looms any longer but shapes natural fibers with her hands or by pressing them in molds. *Embryology* (18-9) is a room-sized installation whose naturalistic forms vary from small stonelike shapes to enormous menacing ones. Each was individually stitched, soaked, and dried. The artist's arrangement evokes the rubble of

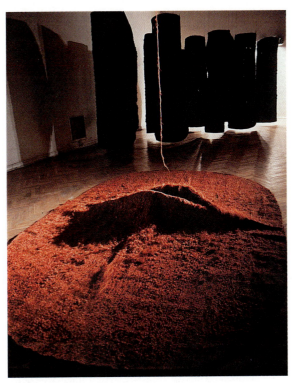

18-8 Magdalena Abakanowicz, *Abakans* from Retrospective Exhibition, Warsaw, 1975. Includes *Orange Abakans*, 1970, sisal, 157¼″ x 157¼″ x 116⅛″ and *Black Environment*, 1969–1973, black sisal, 118⅛″ x 39⅜″ x 39⅜″.

avalanches and a small creature's view of pebbles on the shore. By using organic materials, Abakanowicz feels she connects with the substances of which all living creatures are made. "We are fibrous structures . . . Handling fiber, we handle mystery."

MAKING ROOM FOR WOMEN

The face of the art world was changed by the works of Judy Chicago, Magdalena Abakanowicz, and many other women artists. Not only have the numbers of women artists grown but the kinds of art and strategies they pursued in the 1970s have become important ones for all artists. Political art, collaborative art, performance art, photographing constructed environments, art that deals with the self and fantasy, and appropriation were all unconventional paths originally taken by creative women artists. However, the traditional measures of success—solo shows in galleries, retrospectives in prominent museums, representation in scholarly works and texts—have been slow in coming. For example, before 1987, the National Gallery of Art in Washington, D.C., had had only one retrospective of a woman artist in its history, Mary Cassatt.

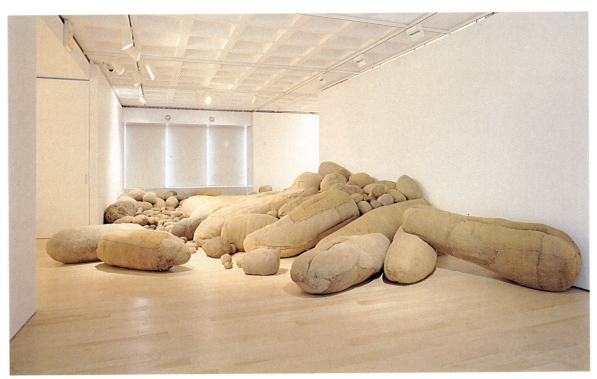

18-9 Magdalena Abakanowicz, *Embryology*, 1978–1981. 600 pieces of burlap, cotton, gauze, hemp and sisal, from 1⅝″ to 98″.

Until 1986, the most successful college art survey text in the country did not include the work of a single woman despite having more than one thousand illustrations. The author stated that unfortunately there had been no women "great enough to make the grade." After his death, his son included twenty-one women in the 1986 edition.

The Guerrilla Girls (18-10) are a coalition of artists whose goal is to keep continued pressure on the art establishment to eliminate bias against women. Formed in 1985, they describe themselves as "the conscience of the art world." They work secretly, under cover of darkness, plastering posters around Manhattan. Their identities and overall number are unknown; all photographs show them wearing large gorilla masks. They receive mail at a post office box and conduct interviews by phone. With simple, well-designed posters (18-11), the Guerrilla Girls give status reports on the art world's acceptance (or lack of it) of women. Their first poster listed forty-two of the most well-known contemporary male artists and asked, "What do these artists have in common?" The answer was, "They all allow their work to be shown in galleries that show no more than 10 percent women or none at all." The feminist activists were not going to allow male artists to escape responsibility for their galleries' exclusionary policies. Other posters point out that in one year the four major New York City museums had only one retrospective for a woman. Another reminds us that "Women in America earn only ⅔ of what men do. Women artists earn only ⅓ of what men do." A 1989 poster directed to collectors asked:

> When Racism & Sexism are no longer fashionable, what will your art collection be worth? The art market won't bestow megabuck prices on the work of a few white males forever. For the 17.7 million you just spent on a single Jasper Johns painting, you could have bought at least one work by all of these women and artists of color:

A list followed with the names of sixty-seven artists, most very well-known and respected, from the Renaissance to the present, including Artemisia Gentileschi, Judith Leyster, Élizabeth Vigée-Lebrun, Angelica Kauffman, Eva Hesse, and Georgia O'Keeffe.

While few would admit it, the posters seem to be having their affect on the prominent art institutions they have targeted. The Whitney Biennial, for example, the most important national survey of contemporary art, had only a 24 percent representation for women in 1987. Two years later, it was 40 percent.

Still, equality and an end of sexual discrimination remain distant goals. A 1989 study that covered seventeen years showed that although approximately 40 percent of the artists in the United States are women, they receive very few grants (review boards are dominated by men), are hired for less than one-third of the college-level teaching positions, and, if hired, are more poorly paid than men, have a small representation in art textbooks, and account for only 15 percent of

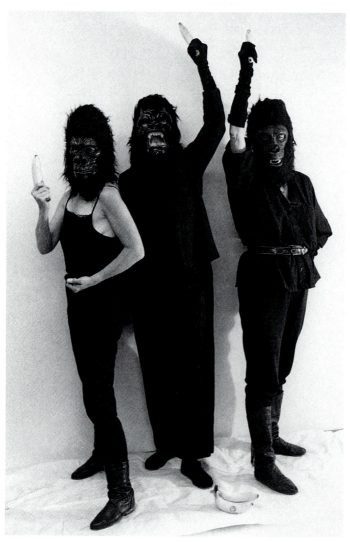

18-10 Guerrilla Girls, 1985

those selected for invitational exhibitions. In exhibitions that are juried "blind" (artists are unknown to jurors, who only see the works of art), the representation of women reflects the percentage of women who applied. Unfortunately for women, blind-juried exhibitions are rare compared to invitational ones. The Guerrilla Girls recently reported that major museum exhibitions include an average of 5 percent women. A West Coast chapter, while noting general progress, also discovered that the percentage of women in the permanent collection of the San Francisco Museum of Modern Art had actually decreased in 1989 to 9 percent. While statistics are clearly not the whole story, the Guerrilla Girls have taken the lead in documenting what is an important issue in art today—the fair treatment of women and minority artists. If their numbers are accurate, it seems as if the Guerrilla Girls will be busy for many years to come.

18-11 Guerrilla Girls, poster, *c.* 1987

PRESERVING THE PAST: A RACE AGAINST TIME

The late-twentieth century finds the art world in the midst of a crisis. The worldwide effects of pollution threaten our cultural heritage. Architectural monuments, outdoor sculptures, stained glass, and paintings are slowly but steadily being damaged by dangerous chemicals in the atmosphere. But it is not just our industrial world that is harming our landmarks; it is our curiosity. The prehistoric caves at Lascaux, France, were closed in 1963 because the breathing and perspiration of a constant stream of tourists (more than a million since its discovery) had resulted in mold growing on the paintings. Shocked experts watched as pictures virtually undamaged for seventeen thousand years began to deteriorate quickly (surprisingly, when a replica of the caves opened nearby in 1983, it also became so crowded that visitors have had to be limited). The monoliths at Stonehenge, in England, are disintegrating from air pollution caused by hundreds of tour buses. In Mexico, emissions from oil wells are causing the Mayan temples of the Yucatan to crumble. The Leaning Tower of Pisa may finally collapse in twenty to thirty years if preservationists cannot find a way to shore up its foundations.

In Egypt, the Great Sphinx guarding the pyramids has deteriorated more in the last fifty years than in all its forty-five hundred years. A portion of its right shoulder fell off in 1988. The head is the most damaged because, for many centuries, the Sphinx had been buried to its chest in sand that protected it. However, because it is now entirely exposed to desert winds and air pollution, the limestone of the chest has begun flaking and crumbling to an alarming extent. Tour buses are no longer allowed to run their engines near the monument because of the fumes they give off. While there is no current danger, there has been concern that eventually the chest will be so weakened that the head may fall off. Even if the Sphinx can be saved, it is believed that Egypt has ten thousand other threatened sites.

The buildings of the Acropolis, over Athens, have had more than their fair share of troubles (18-12). Air pollution from the city is eating into the marble in a process that is nearly impossible to stop. Sulfur-dioxide fumes from burning heating and diesel oil combines with humidity and rain water to form sulfuric acid. When the acid falls on marble, it bonds with it and makes gypsum. Whenever it rains, the gypsum is washed away and another thin layer of the precious surface of the Parthenon has been lost. Planes are now forbidden to fly over the Acropolis.

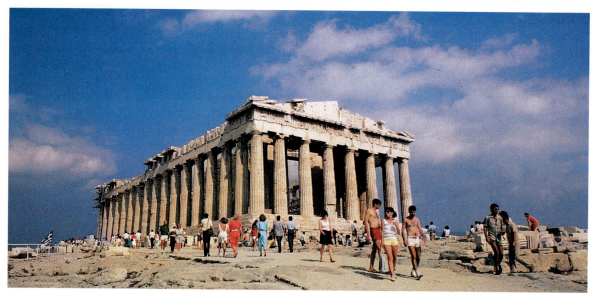

18-12 Tourists on the acropolis, Athens

Athens is trying to eliminate the use of oil for heating and to replace diesel public vehicles with electric ones, but that will take time. In the meantime, the remaining relief sculptures on the buildings are being removed to the safe, controlled environment of the Acropolis Museum. Concrete casts are being put in their place.

Another problem the Parthenon faces is the rusting of steel reinforcements imbedded in its marble as part of a restoration in the early years of this century. As the steel rusts, it expands and cracks the marble. Rain gets into the cracks and freezes in winter, splitting the stone. Pieces of ancient marble are falling off. The six thousand tourists a day (four million a year) at the Acropolis have had their impact, too. The marble steps are wearing away, forcing authorities to replace them with concrete or wooden walkways. Ancient inscriptions are disappearing, along with the old pathways. The Parthenon interior is now closed to visitors to protect it. The Greek government is facing a real dilemma. Tourism is its biggest industry, but the cost of repairing the Parthenon was estimated at $15 million nearly twenty years ago. The 1975 study itself cost $1.6 million. UNESCO's International Council on Monuments and Sites is spearheading a worldwide effort to raise funds "to save cultural treasures, which, although they belong to the heritage of Greece, are also part of the shared inheritance of mankind."

THE SISTINE CHAPEL RESTORATION

When it is announced that beloved masterpieces are about to be restored, art lovers around the world hold their breath and hope that nothing goes wrong. History is filled with the destructive mistakes of well-meaning experts. In 1980, the Vatican announced it had authorized four men to lead a team of restoration experts on an extraordinary mission—the cleaning of Michelangelo's Sistine ceiling frescos. By the time the team had finished nearly ten years later, they had not only removed centuries of grime but also had attracted the ire of many art experts around the world. More importantly, they forever changed the way the ceiling and its artist will be seen.

Before beginning the restoration, computers were used to map every single inch of the 2,732-square-foot ceiling—cracks, dirt, and all. Gamma-ray, infrared, and thermal photographs were entered into the computer to reveal the many layers of the fresco. A huge movable scaffold was built (with an elevator) and was attached to the same spots that Michelangelo used for his scaffold in the early years of the sixteenth century (18-13). Many tests would be made before an area was cleaned—a square foot at a time. First, the dust would be wiped off the area. Then a sponge with pure, distilled water was used. After that a gooey chemical solvent was applied with a brush—and then the miracle began. In

three minutes, it loosened and mixed with four centuries of soot, varnish, and grease from candles, glues, and old restorations, leaving a soft mixture to be wiped away with a sponge and water. Figure 18-14 illustrates the startling transformation that the restorers' solvent made on one small part of Michelangelo's masterpiece.

The restorers have gained an intimate knowledge of Michelangelo's working procedures and built a valuable data bank in the computers that shows his progress day by day. Except for the paintings on the sides, which were painted from his imagination without drawings, Michelangelo would scratch a fairly detailed sketch into the wet plaster before painting. Close up, one can almost see Michelangelo at work. One sees parts of the ceiling where the artist ignored original plans as a new idea occurred to him. Restorers even discovered hairs from Michelangelo's brushes still imbedded in the original painting.

The familiar dark and serious Sistine ceiling no longer exists; it has been replaced by a brightly colored, lively one. Before the cleaning, Michelangelo was known as a master draftsman, capable of foreshortening figures in a marvelous variety of poses. But he was also considered an indifferent colorist, more concerned with creating sculptural forms in paint than strong color statements. No longer. The vivid colors discovered in the cleaning provided a new picture of the genius of Michelangelo. The darkness of the painting was largely a result of animal glues used in varnishes by past restorers. The varnishes were used to brighten the painting but would inevitably deteriorate, making the painting even darker than before the varnish was applied. Over time, Michelangelo's fresco became darker and darker. By this century, the dark Sistine ceiling was the only one remembered. So it is not surprising that scholars around the world were shocked to see the new one. Many criticized the restorers, accusing them of removing not only dirt and old varnish but also a second coat of paint they believed Michelangelo had used to soften the colors. Some said the Sistine ceiling had been destroyed. Others say that the unhappy critics are having difficulty adjusting to Michelangelo's original, colorful pictures. The sooty ceiling was an aged and well-loved friend that they miss.

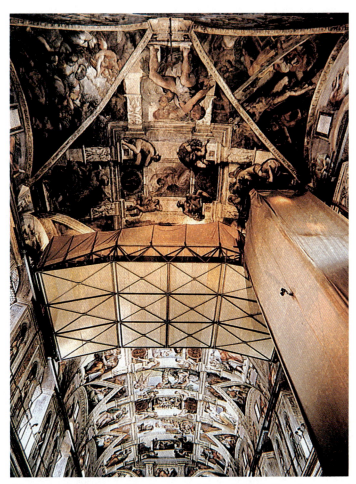

18-13 Scaffolding used in the restoration of Michelangelo's frescoes, Sistine Chapel ceiling, Vatican, Rome

At the completion of the Sistine ceiling restoration, the Vatican announced that the restorers would next work on the even darker, terrifying *Last Judgment* by Michelangelo. It is believed to be more damaged than the ceiling because it is much closer to the floor. Could its darkness be caused by its proximity to the torches once used to light the chapel and the centuries of candles burned over the altar? Or was it part of Michelangelo's conception? The answers are on their way; the restorers' research has just begun.

The Sistine Chapel cleaning has already cost several million dollars. Tens of millions of dollars will likely be spent on restoring the Acropolis, millions more on the damaged medieval stained glass in France (see "Art News" in Chapter 11). The costly and time-consuming restoration of paintings, sculptures, quilts, pottery, and buildings occupies tens of thousands of people around the world. How

can such expenditures be justified in a world with so many problems, where children go to bed hungry and families have no home? It must be that people believe that, just as we have a responsibility to preserve our natural environment for the sake of future generations, we must preserve our cultural environment, the harvest of the best efforts of centuries of men and women.

This is the idea behind museums, restoration, and textbooks like this one. Even if it is a difficult and often expensive one, the preservationist's race against time is also for the future. Nature and the waste products of our technology have combined in the twentieth century to be the most powerful forces of decay and erosion ever seen. But because of what art has meant to us since we lived in

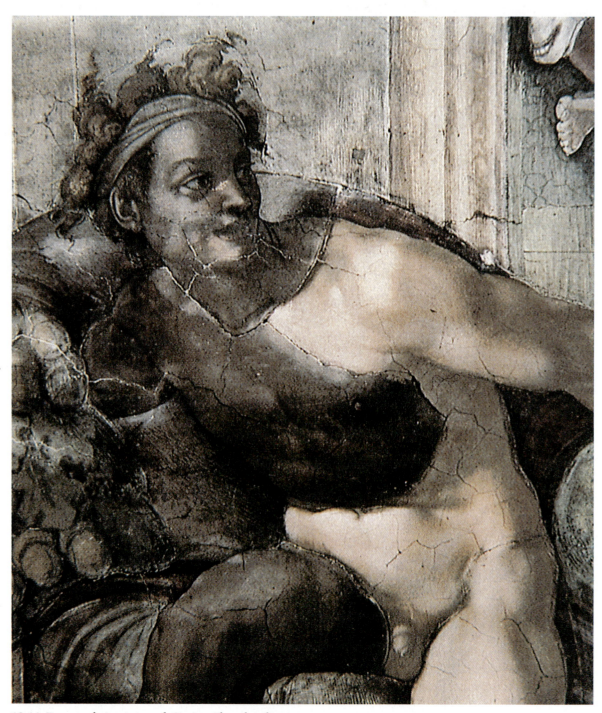

18-14 Frescoes being restored, Sistine Chapel ceiling

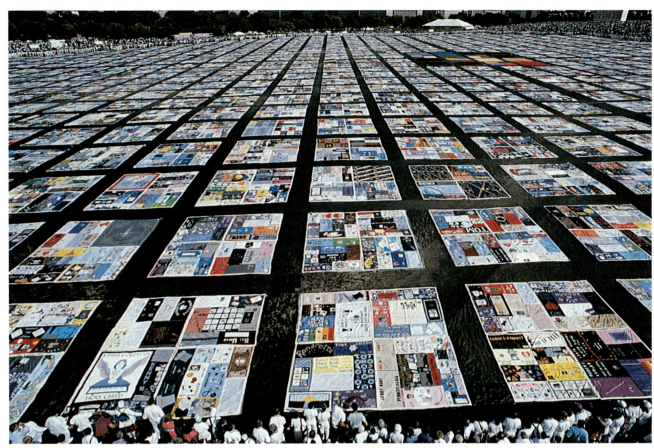

18-15 The NAMES Project AIDS Memorial Quilt being exhibited in Washington, D.C., December 1992

caves, we must struggle to reverse the damage. Who wants to see the Parthenon or the Sphinx crumble and disappear? Shouldn't future generations share the pleasure of the marvelous windows of Chartres or the magnificence of the Sistine Chapel? Who could put a price on such things? How could we not try to save them? Jacques Barzun, an American writer and educator, understood the nature of art well when he said:

> Art is power. It influences the mind, the nerves, the feelings, the soul. It carries messages of hope, hostility, derision, and moral rebuke. It can fight material and spiritual evils, and transmit ideals of a community now living, long past, or soon to be born . . . Art is deemed universally important because it helps [us] to live and to remember.

In October 1992, the latest and possibly last exhibition of the NAMES Project *AIDS Memorial Quilt* (18-15), devoted to memory, was laid out on The Mall in Washington, D.C. It had been traveling the nation for years, ever

growing in size—just like the epidemic disease it speaks of—and now it is believed to be too large to exhibit in one location again. Like the nearby Vietnam memorial, the AIDS quilt memorializes the dead. But rather than a stark list of names, it is a many-faceted affirmation of creativity, a reflection of the power of art for both maker and viewer. More than thirteen acres, as far as the eye could see, were covered with quilted panels, each made by those who had loved someone lost. Some sections were simple, some complex, some serious, others witty. One saw beautiful colors or their grim absence. Although no single Michelangelo worked on this tapestry, just like his Sistine ceiling, it has a breathtaking impact. Its diversity forms a whole, reflecting humankind's faith in art to express our most powerful and complex emotions. It is an example from our time of what was felt by Stone Age artists working in caves, Roman generals, monks and nuns copying medieval manuscripts, and the carvers of the Colossal Buddha—an enduring faith in the timeless power of art.

GLOSSARY

Abstract Expressionism An American art movement that began in the 1950s. Large-scale art that combined Expressionism's potent psychological content and the gestural application of paint with an abandonment of any clear reference to the visual world.

abstract shapes Representational organic or geometric shapes that have been simplified. Even when they have been reduced to their basic underlying forms, distorted or exaggerated, the original sources of abstract shapes remain recognizable.

academic art Art officially sanctioned by the national academies (schools of art) in Europe. In the eighteenth and nineteenth centuries, the academies upheld traditional approaches, encouraging art in Classical or Renaissance styles with epic historical and literary themes. In the modern era, it has come to mean conservative and unimaginative art.

acrylic A water soluble paint that dries quickly and can be applied to most surfaces. Originally made for industrial use in the 1950s, its medium is plastic polymer made from resins.

Action Painting The energetic brushwork of Abstract Expressionism, apparently done in fits of intense and almost violent activity.

additive sculpture As opposed to subtractive, sculpture that is *built up*, such as by modeling a flexible material like clay or plaster, or by building an installation.

adobe A kind of sun-dried brick made of clay mixed with straw, used for building by native tribes of the Southwest and parts of South America.

Age of Reason See **Enlightenment.**

airbrush A spraying device that uses an air compressor to propel paint mist through a nozzle.

alla prima Paintings done quickly and at one sitting, with little or no preparation. Means "at the first."

allegory A form of art in which human characters personify certain qualities or ideals.

analogous colors Hues adjacent on the color wheel; when placed together, they form pleasant harmonies because they are closely related. An example would be green, blue-green, and blue.

Analytical Cubism The first phase of Cubism. A collection of views from different angles fused into a balanced design with limited color.

aperture (or **diaphragm**) An adjustable opening that controls the amount of light entering a camera.

applied arts The useful media of the visual arts, such as architecture, design, and illustration.

appliqué In quilting, fabric silhouettes cut out and stitched onto the background of another fabric.

appropriation A twentieth-century method where imagery from other sources (photographs, past masterpieces) is taken and turned into a new work of art, sometimes with little or no alteration.

aquatint An intaglio printmaking process that creates tonal areas. When powdered resin is applied to a metal plate and then heated, each particle becomes a dot that will resist acid. As with etched lines, the longer an area of aquatint is in the acid bath, the deeper the etch and the darker the tone in the print.

arbitrary colors As opposed to naturalistic or realistic colors, colors that are the invention of the artist.

arcade A covered walkway.

arch A semicircular construction (usually of stone) that both supports the weight of a building and provides an opening. Used extensively during the Roman Empire, it allowed far wider spaces between columns than post-and-lintel construction. Also known as *rounded arch*.

art nouveau A late nineteenth-century style utilized for furniture, architecture, interiors, and graphic design and characterized by elaborate, rhythmic, and organic decoration. It was the first modern international design style.

assemblage Three-dimensional collages.

asymmetrical balance An intuitive balance of visual weights that results in a more dynamic equilibrium than radial or symmetrical balance.

atmospheric perspective A method of creating a sense of deep space in two-dimensional art based on the effect our atmosphere has on things seen at a distance. Distant forms are portrayed vaguer and closer to the color of the sky than near ones.

avant-garde Literally the "advance guard"; the vanguard or leaders of new directions in the arts.

balance Visually satisfying stability in a work of art. It is created by adjusting the placement of art elements in a field.

Baroque The period in the seventeenth century that included art with dramatic use of light and dark and preferences for dynamic movement and theatrical effects, as well as intense naturalism and the inclusion of elements of ordinary life in religious scenes.

barrel vault A rounded arch that when extended allowed for large and long public spaces in stone buildings, particularly cathedrals built during the Middle Ages.

Bauhaus ("the house of building") A German school devoted to the cause of integrating the arts and modern technology and to transcending the boundaries among craft, design, and art. Founded in 1919 by the architect Walter Gropius, the school stressed a simple, modern, geometrical style.

bearing wall An architectural construction using the walls themselves to support the weight of the roof and floors above.

binder A glue-like substance that holds pigment together, the type of which determines the nature of the medium; for example, oil is the binder in oil paint. Used in all the colored media.

Buddhism A religion founded by Siddhartha Gautama, a prince from Nepal who lived in the sixth century B.C. Through the revelation that all life is an illusion and that the only way to escape pain is to renounce all desires, he attained **nirvana** and became the Buddha.

Byzantine The eastern Roman Empire founded by Constantine. Also an art style of the civilization centered in Constantinople (now Istanbul) during the Middle Ages that was less naturalistic and more symbolic, stylized, flat, and decorative than before the fall of the Empire.

camera obscura Literally meaning "dark room," initially a room-sized camera. By preventing all light from entering a room and then cutting a small hole in a shade over a window, a person could project an inverted image of the outside onto the opposite wall. By the 1700s, a table model of the camera obscura with lens and mirror became available, providing a right-side-up projected image on a screen that artists could use for tracing.

capital The crown of an architectural column.

cartoon A preparatory drawing for larger work, such as tapestries or murals.

casting A process that makes one or several lasting copies of sculpture. Often the casts are made of bronze, though other metals or plaster may be used.

ceramics Objects made from clay fired in a kiln for lasting hardness and strength.

chiaroscuro A technique in drawing and painting where a dramatic contrast between light

and dark areas creates a convincing illusion of three-dimensional forms. The Italian Baroque painter Michelangelo da Caravaggio is noted for using this technique.

Classical Age The flourishing of Greek culture during the fourth and fifth centuries B.C. Classical Greek art expressed ideals of clarity, order, balance, proportion, harmony, and unity.

Classicism A seventeenth-century movement that, inspired by the Classical art of Greece and Rome, taught that the highest aim of a work of art is to represent noble and serious thoughts. It called for a logical, orderly art with great themes so as to raise viewers up by appealing to their reason, not to their base emotions.

collage The combination of cut-and-pasted paper, photographs, and other materials on a two-dimensional surface.

colonnade A row of columns, usually supporting a roof.

Color-Field Painting A kind of Abstract Expressionism characterized by large areas of color that are more dominant than any particular shape.

color wheel Primary and secondary colors arranged in a circle. The primaries are placed equidistant from each other, with their secondary mixtures between them.

complementary colors Colors that are directly across from each other on the color wheel, such as red and green. When placed together, they accentuate each other's intensity. Considered opposites, or *complements*.

conté crayon A versatile drawing crayon developed in the late 1700s. It comes in a variety of degrees of hardness and can be used to create both subtle tones and dense blacks.

contour lines Lines that describe the edge of a form, sometimes emphasized by changes in weight or width.

cool colors The family of colors based on blue, purple, and green; colors that are associated with calm, order, the sky, and the ocean.

They tend to recede away from the viewer.

Counter-Reformation The Roman Catholic church's attempt to combat the Protestant **Reformation** of the sixteenth century. As part of this campaign, the church supported art that would entertain and rouse the faithful.

crayon A colored drawing medium with a waxy or oily binder that adheres to paper; does not require fixative.

cross-hatching A drawing technique used to make forms appear three-dimensional. A series of parallel lines cross in a net-like fashion, describing the contours of a surface.

Cubism An alternative to linear perspective organization of space developed by Pablo Picasso and Georges Braque in the early twentieth century. Built from a collection of observations, objects are seen from several angles simultaneously. Each part is equal in importance—there is no conventional foreground and background. The result is a significantly shallower space compared to linear perspective, as well as a less naturalistic appearance.

Dada A meaningless term for an international art movement that began during World War I. Dada manifestos called for the destruction of all values—the end of art, morality, and society. This "anti-art," which took the form of bizarre performances and exhibition of found objects, or "ready-mades," was an effort to evolve a new way of thinking, feeling, and seeing.

daguerreotype The first permanent photographic image, invented by Louis-Jacques-Mandé Daguerre in 1839, utilizing silver foil made light sensitive with chemicals. After the foil was exposed to light in a camera, the image was made permanent by bathing in a salt solution.

deductive reasoning The medieval scientific approach to explaining natural phenomena using accepted general rules. Compare to **inductive reasoning.**

design The organization of visual elements into a composition that is visually satisfying.

Die Brücke Literally "the Bridge," a group of German Expressionist artists led by Ernst Kirchner in the early 1900s. By expressing emotions honestly and directly, they hoped to encourage others to abandon the stale hypocritical attitudes of their elders. Clashing hues, strong lines, and aggressive spirit typified their work.

digitize To translate two-dimensional images (with scanners) and three-dimensional objects (with video cameras) into numbers that a computer can read so the images can appear on the computer's screen.

Earth Art Large-scale environmental sculpture outside of a gallery or museum; interacts directly with nature.

edition The limited number of prints made directly from an image created by an artist on a block, plate, stone, or screen. Once the last print of an edition is "pulled," the block, plate, or other source is destroyed.

egg tempera See **tempera.**

elevation An architectural drawing that shows front and side views of a planned structure on a vertical plane.

engraving The oldest form of intaglio printmaking, developed in Europe during the 1400s. Cuts and scratches dug with tools into a metal plate are filled with ink and print directly onto paper as lines.

Enlightenment An intellectual movement that began in England and spread to France, then spread throughout Europe by the end of the eighteenth century. Great scientists and mathematicians stressed the value of rationality over faith and embraced the idea of progress.

environment See **installation.**

etching An intaglio process using acids rather than tools to cut the metal plate. An acid-resistant wax coating, or **ground**, is applied to the plate. An image is made by cutting through the ground. Then the plate is put in a tray of acid that "bites" into the metal where the wax ground was removed. After the plate is washed with water, it is inked and printed just like an engraving. Lines can be made lighter or darker by the amount of time the plate is in acid.

existentialism A post–World War II philosophy that began in France. It declares that all people are essentially alone, that there is no God in the universe. Each one must face the ultimate meaninglessness of the universe and decide independently how to live one's own life.

Expressionism A Modern Art movement that went beyond an imitation of the world toward an intense re-creation of feeling. Making inner feelings (as dark and deep as they may be) visible was generally achieved with powerful (often clashing) colors and vivid contrasts of light and dark.

facade The outer side of an architectural structure; usually refers to the front of a building.

Fauves Literally the "wild beasts," a group of French artists led by Henri Matisse in the early 1900s. They ignored perspective and used bright colors freely as a source of pleasure.

figure-ground ambiguity A design whose positive and negative forms are so balanced that it is unclear which part should be called *figure* and which should be called *ground.*

figure triangle Common in Renaissance compositions, a triangular arrangement of elements, often figures.

fine arts The visual arts customarily considered in Western civilization a "high" form of artistic production (in other words, not useful like the **applied arts**). They have traditionally included drawing, painting, and sculpture, but in the last two hundred years have also included outstanding examples of printmaking, photography, design, decorative arts, and crafts.

fixative A spray of shellac or plastic polymer used in charcoal and pastel drawings to ensure a permanent bond to the paper.

flying buttress In a gothic church, an exterior support for stability.

flying logo Via computer animation, a kind of **logo** seen on television that appears to spin in three dimensions and come toward the viewer.

foreshortening In two-dimensional art, the apparent diminishing in size of forms as they seem to recede from the viewer.

forged Metal shaped by heating.

frame or ballon-frame construction A supporting skeleton made of vertical and horizontal wooden supports nailed together; used in architectural constructions.

free-standing sculpture Sculpture in the round that the viewer must circle to see completely.

fresco A permanent wall-painting technique in use since ancient times. Pigment and water is brushed directly into fresh, wet plaster (fresco means "fresh" in Italian). As the plaster dries, the pigment is bound into it and literally becomes part of the wall itself.

Futurism An early twentieth-century Italian Modern Art movement led by the poet Filippo Marinetti. A celebration of the age of the machine, it called for a complete and utter rejection of the art of the past.

genre Ordinary and commonplace subject matter; scenes from everyday life.

geometric shapes Enclosed spaces formed by straight lines or curved ones that progress evenly. Squares, rectangles, triangles, and circles are all examples of this kind of two-dimensional shape. Three-dimensional examples are the cube, box, pyramid, and sphere. Sometimes called *hard-edged* shapes.

gesso A thick paint applied to prepare surfaces like wood or canvas for painting. It produces bright white surface impermeable to liquids. Traditionally, a thick paste of gypsum and animal glue, although today many artists replace the glue with an acrylic medium.

glass blowing A craft that transforms hot, molten glass into a finished art object. The glass is picked up in a small spherical blob at the end of a long metal pipe, then blown into bubbles of various shapes, shaped with tools or by rolling on a hard surface, and removed from the pipe to cool slowly.

glaze 1. Paint diluted and made transparent. Often built up in layers on top of **underpainting** to create the illusion of three-dimensional forms. 2. In ceramics, a paint that melts into and fuses with clay while being baked in a kiln.

Gothic Elaborately decorative medieval building style of the twelfth through fifteenth centuries, whose unique features were the **pointed arch**, the ribbed vault, exterior **flying buttresses**, high ceilings, and stained-glass windows.

gouache An opaque watercolor made by adding chalk to pigment and gum arabic. Unlike watercolor, it can be applied more thickly, covers well, and permits changes.

graphic design Once known as "commercial art," it is the manipulation of **typography** and images for advertisements, magazines, books, posters, packages, **logos**, and signs.

grazia During the Renaissance period, art that was beautiful, graceful, and seemingly effortlessly achieved.

groin vault The intersection of two barrel vaults at right angles.

ground 1. The visual plane where art elements (or figures) are organized. When elements are added to the ground, it becomes, in itself, a shape (called the negative form), and must be consciously dealt with. 2. The surface of a two-dimensional work of art. 3. A wax coating that resists acid; used in etching.

Hellenistic Age An age that began with the reign of Alexander the Great (356–323 B.C.) in Greece. During this time, Greek sculpture became more naturalistic and illusionistic, appealing less to the rational mind and more to the senses than the restrained works of the Classical period.

Hinduism An ancient polytheistic religion native to India in which believers accept that

humans experience an unending cycle of birth, life, death, and rebirth. *Karma* determines one's fate; the deeds of one lifetime influence one's status in the next.

horizon line The same as the viewer's eye level, it is where the sky and the earth appear to meet. In linear perspective, it is where parallel lines converge.

Hudson River School A group of nineteenth-century American Romantic painters. These artists saw in America an unspoiled land of great promise and painted many views of the Hudson Valley and other wilderness areas in the Northeast.

hue The name of a color on the color wheel or in the spectrum. For example, violet and green are two different hues.

Humanism The predominant philosophy of the Renaissance and catalyst for the period's great achievements. Its two main ingredients were the study of the ancient cultural achievements of the Greeks and Romans and respect for the individual.

iconoclasm The destruction of religious imagery.

impasto Thick paint that reveals the action of brushstrokes.

Impressionism A Modern Art movement that began around 1870 in France. Based on the idea of conveying an immediate impression of a place and time of day. Impressionist painters worked outdoors, directly studying the moment's light and color. Their typical style achieved heightened color effects by placing colors side by side rather than mixing them.

Impressionists A group of artists who met in cafes and studios and exhibited together in Paris from the 1870s to the end of the nineteenth century. While some, like Claude Monet, worked in the characteristic Impressionist style, others simply joined a rebellion against the dominant academic style of their time.

inductive reasoning A medieval scientific approach where one observes phenomena directly and then uses the gathered information to develop general rules. Compare to **deductive reasoning.**

industrial design The design of manufactured objects such as telephones, typewriters, and automobiles.

installation A room-sized multimedia sculpture constructed in a gallery, museum, or public space. It is meant to surround the viewer with a unique artistic experience. Also known as an *environment.*

intaglio A printmaking method: lines cut into the surface of a metal plate become receptacles for ink after the plate is inked and its surface wiped off. Damp paper and plate are then run through a press; the heavy pressure forces the paper into the ink-filled grooves, and the image is transferred.

intensity The vividness of a particular hue.

International Style The dominant twentieth-century architectural approach in Europe and the United States. The antithesis of the heavily ornamental style taught in nineteenth-century architectural academies, its buildings were flat-roofed, made of modern materials (concrete, steel, and glass), and free of any superfluous decoration. Boxlike and practical, all spaces were designed for efficient organization.

Islam Religion founded by the prophet Mohammed (A.D. 570–632). The teachings of Mohammed are recorded in The Koran, which tells of the revelations of God through the angel Gabriel. The name "Islam" means "submission to the will of God."

Japonisme The love of all things Japanese, a wave that swept over cultured Western society in the late nineteenth century.

juxtaposition A technique invented by the Dadaists where unrelated objects are taken out of their normal context and joined together, producing a new unique object.

kiln An oven used for drying and baking clay sculptures or ceramics.

kinetic sculpture Sculpture with moving parts.

lens In cameras, the clear, rounded glass or plastic that focuses the light onto the film.

linear perspective The principal means of creating the illusion of the third dimension or depth in Western two-dimensional art since the Renaissance. All parallel lines appear to converge at points in the distance, called **vanishing points.** Forms that seem closer appear larger than those meant to be farther from the viewer. See also **one-point perspective, foreshortening.**

linear style A Neoclassicist approach; typically paintings drawn with sharp outlines, clearly defined forms, and relatively solid areas of color.

lithography A printmaking process where images are drawn or painted directly in grease on a flat stone or metal plate. After the surface is chemically treated and moistened with water, ink will only adhere where there is grease. Wax crayons, soap, and black pigment with *tusche*, a greasy liquid that can be applied with a brush or sprayed on, are the most common materials used to make the images.

local color The general color of anything we see, without considering the effect of lighting or adjacent colors.

logo A symbol or trademark of an organization that is meant to be instantly recognizable.

loom A machine for weaving fibers into cloth.

lost wax method A method, in a series of steps, of using molds to cast hollow metal sculpture or jewelry.

mandala In Buddhist art, an intricate, geometrical design of deities depicted in concentric circles that represent the cosmos.

Mannerism A sixteenth-century Italian art movement that was a reaction to Renaissance ideals. Mannerist artists used distortion to demonstrate their inventiveness. Their highest aim was elegance.

maquette A sculptural model in clay or wax of a planned larger work or cast work.

matte A dull, nonreflective finish as opposed to a glossy finish.

media, medium Artists' materials, such as oil paint or clay.

metalpoint Drawings with pure, precise lines made by a thin metal wire in a holder; the wire is usually silver, but other metals including lead have been used.

mihrab A niche for prayer in a **mosque,** oriented to face in the direction of Mecca.

minaret A slender tower on the exterior of Islamic buildings.

Minimalism An American art movement that began in the 1960s. Art is stripped down to the essentials; paintings and sculptures are self-sufficient and have no subject matter, content, or meaning beyond their presence as objects in space.

mixed media A twentieth-century method that mixes materials (manufactured, natural "found objects," as well as conventional art media), often using them in unusual ways, without respect for the traditional borders between two- and three-dimensional media.

mobile A hanging kinetic sculpture, originated by Alexander Calder in the twentieth century, whose parts are moved by air currents.

monotype A one-of-a-kind print made by applying ink or paint directly to a metal plate and then running it through a press with paper. It can also be made without the press by rubbing the back of the paper.

morphing A computer-aided transformation where one image gradually becomes another.

mosaic Picture made of tiles of colored stone, ceramic, or glass.

mosque An Islamic place of worship.

naturalistic Art that is realistic. For example,

animals are drawn as if they were alive.

nave The large, central space in a medieval church.

negative form The shape of the space or ground around art elements.

Neoclassicism A reaction to Rococo art and the visual expression of the ideals of the Enlightenment of the eighteenth and nineteenth centuries. Its characteristics include clarity of line, color, and form. Its artists sought to create universal moral lessons that would educate and improve the viewer.

Neoexpressionism An international revival of Expressionist methods that began in the 1970s. Combines vigorous paint strokes with emotion-laden figurative imagery.

neutral colors White, black, and gray. Added to colors, they make tints and shades, changing the values but not the hue.

nirvana In Buddhism, a state of eternal bliss.

nonobjective shapes See **nonrepresentational shapes.**

nonrepresentational shapes Shapes that are not meant to refer to anything we can see in the real world. They are sometimes called *nonobjective* or *abstract*. These shapes can be either organic (soft-edged) or geometrical (hard-edged).

oculus "Eye"; round opening or window at the top of a dome.

one-point perspective A system of linear perspective invented by the Renaissance artist Filippo Brunelleschi. All parallel lines appear to converge at one point in the distance, the *vanishing point*, which is exactly on the **horizon line**. As in all linear perspective, the sizes of objects shrink as they increase in distance from the viewer.

Op Art A nonrepresentational style, introduced in the 1960s, that explored optical illusions.

organic shapes Enclosed spaces formed by uneven curves. They are sometimes called

naturalistic, biomorphic, or soft-edged. Examples are shapes that look like amoebas or treetops.

painterly style An approach to painting promoted by the nineteenth-century Romantics, utilizing broad strokes, indistinct outlines between shapes, and colors blended into each other. It is a style intended to reach viewers' emotions rather than their minds.

pastels Colored chalks in sticks that are a combination of loose dry pigment and a **binder** of paste or methylcellulose.

Pax Romanus Roman peace during the reign of Augustus, when citizens could travel safely anywhere within the Roman Empire.

performance art Twentieth-century events designed to be ephemeral, lasting only in memory.

perspective An architectural drawing that gives a three-dimensional impression of a new building in its setting.

photomontage The imaginative combination of more than one photographic image.

photorealism See **Superrealism.**

piazza Large courtyard.

picture plane A flat two-dimensional surface within which art elements are organized.

plastic Moldable material, like wet clay, rather than rigid.

pointed arch A Gothic arch that allowed larger openings in the outer wall and higher ceilings in the interior than the Roman rounded arch.

pointillism The Post impressionistic style developed by Georges Seurat. By placing small spots of pure color side by side, Seurat let the viewer's eye optically mix the colors and thereby increase their luminosity.

Pop Art An American and English art movement of the 1960s that celebrated the commodities and celebrities of the time.

porcelain Clay baked at a high temperature transformed into a material of glasslike hardness, sometimes known as "china."

positive form The shape of an art element.

Postimpressionism Separate expressions of dissatisfaction with Impressionism at the end of the nineteenth century by artists who had initially worked in that style. The most important figures of this new movement were Georges Seurat, Paul Gauguin, Vincent van Gogh, and Paul Cézanne.

post-and-lintel A form of architectural construction in which posts or columns support horizontal lintels (cross beams).

Post-Modern Art A contemporary movement that began in the 1980s. The dominant trends of Modern Art—a rejection of the past and of decorative elements and a steady movement towards nonrepresentational images—are reversed. Post-Modern Artists are interested in rediscovering the past, not rejecting it, and see history as a vast menu from which to select.

primary colors Red, yellow, and blue, the three colors that cannot be made from any others, and that are the sources for all other colors.

proportion The relative sizes of the parts of an object to each other.

quill Pens made from bird feathers, most commonly goose. Variation in the pressure applied to the pen will smoothly change a line's width. Popular since the medieval period.

radial balance All elements revolve around a central point.

raku Hand-shaped Japanese ceramics associated with the tea ceremony. Irregular and asymmetrical, with glazes thick and rough, their imperfection is prized as a mark of mastery.

Realism A nineteenth-century movement that rejected the idealized historical and mythological subjects of academic Neoclassicism; instead it focused on unembellished ordinary contemporary life as the source of truth and meaning.

Reformation A rebellion led by Martin Luther against the Roman Catholic church in the sixteenth century resulting in the creation of Protestantism.

registration In color prints, the proper alignment of each color with the other inked colors.

reinforced concrete (or **ferroconcrete**) Concrete reinforced with thin iron rods to provide added strength. It enables architects to design structures with dramatic shapes.

relief printmaking A method of printmaking where the negative spaces of a design are cut away, leaving the positive areas raised. The print's marks are made from inking what is left in "relief" on the block. Woodcuts, linoleum cuts, and rubber stamps fall into this category.

relief sculpture A sculptural image that projects from a flat, two-dimensional background. The back of a relief sculpture is not meant to be seen; the entire design can be understood from a frontal view.

Renaissance Meaning "rebirth," a period famous for art and architecture and generally considered to mark the beginning of the modern world. Spanning the fourteenth to sixteenth centuries in Europe, it was marked by renewed interest in Classical culture as well as the development of capitalism, the rise of the nation-state, scientific investigation, and individualism. Also known as the "Age of Exploration."

rhythm Repetition of similar shapes, as in *patterns*.

Rococo An eighteenth-century lighthearted and decorative style of art whose subject matter is typically about lovers. It was a reaction to the formality of Classicism.

Romanesque Medieval building style of the ninth through twelfth centuries based on the Roman round arch. Heavy stone geometric buildings were supported by thick walls with few windows and dark interiors.

Romanticism A nineteenth-century reaction to **Neoclassicism**, by rejecting logic and order

and looking for the inner truth of intuition and passions. Romantic artists admired the untamed power of nature and used a **painterly** style.

rotunda A completely round building or a circular interior with a dome.

Salon An annual exhibition in Paris, begun in 1737, of art chosen by members of the French Academy. It was the only important public exhibition available to artists in the mid-nineteenth century.

saturated colors Colors that have a high level of intensity.

scale The relative size between an object and a constant, usually the size of the average person.

secondary colors Orange, green, and purple, created by mixing two primary colors.

secondary symbolism Common in Medieval and Northern Renaissance art, where details have additional meanings, such as a white lily in a vase representing the Virgin Mary.

serpentinata In Mannerism, the most elegant pose for a body—when the limbs and torso resembled the letter "S." It refers to the twisting of a snake.

sfumato lighting In Italian, "the soft mist of a fountain." Soft lighting in Renaissance paintings originally used by Leonardo da Vinci. It makes both edges and details unclear. The lack of definite edges forces viewers to use their imagination, making portraits like the *Mona Lisa* seem more lifelike.

shades Hues that have been darkened by the neutral color black. Navy blue is a very dark shade of blue.

shutter The part of the camera that is triggered by the photographer and controls the time of the exposure.

silkscreen (or **serigraphy**) An inexpensive method of producing very large editions of prints. A stencil is attached to silk tightly stretched over a wooden frame. Paper or cloth is placed underneath the screen and ink is spread across the screen with a rubber blade or squeegee. The areas of silk not covered with a stencil let the ink come through and print onto the medium.

simultaneous contrast The effect of two colors meeting. Differences between them are accentuated; their similarities are not apparent.

steel frame (or **cage construction**) A form of architectural construction developed in the 1890s using a steel interior skeleton that resembles a bird cage. Used today for building skyscrapers. Its facade is often a simple "skin" of glass.

stigmata Bloody signs of the nails that held Christ to the cross.

De Stijl ("the Style") Early twentieth-century Dutch artists who believed a pure universal style in art and architecture could be the solution to humankind's misery. Followers of Piet Mondrian, they designed furniture and buildings using flat geometric areas filled with primary colors.

stoicism A Greek philosophy that encouraged dignity, rational thought, and control over one's emotions.

stupa A Buddhist religious shrine in the shape of a mound. Pilgrims walk around it, symbolizing the Path of Life around the World Mountain. The walking is a form of meditation and worship.

subtractive sculpture As opposed to **additive**, sculpture carved out of materials such as wood or stone.

Superrealism (or **photorealism**) A movement that began in the 1970s that in two dimensions, re-creates the look of photographs. In three dimensions, casting is often used to achieve the utmost fidelity to reality.

Surrealism An art movement begun in the 1920s that depicted dreams and visions of the irrational unconscious and was inspired by Sigmund Freud's theories.

symmetrical balance Sometimes known as *bilateral symmetry*, a balance where there is

general equivalence of shape and position on opposite sides of a central axis; if folded in half, the forms would match.

Synthetic Cubism The second phase of Cubism, where more colorful and playful visual symbols replaced the limited colors and angular planes of analytical cubism.

tempera A painting medium in which pigments are mixed with egg yolks (sometimes called **egg tempera**).

tenebroso Literally, the "dark manner." A technique of the followers of Michelangelo da Caravaggio.

terra-cotta Clay baked in a kiln and hardened to a rich red-earth tone.

texture mapping In computer art, the wrapping of a texture around a wire-grid form drawn by an artist to create a realistic or imaginative surface.

three-dimensional space The kind of space we actually live in. It contains objects that can be viewed from all sides, objects that have height, width, and depth. Sculpture and architecture are examples of three-dimensional art forms.

throwing The action of a potter using a wheel to build a round vessel. A lump of clay is lifted and shaped by hand as the wheel turns.

tints Hues that have been lightened by the neutral color white. Pink is a pale tint of red.

transept In a medieval church, the short rectangular space that ran perpendicular to the **nave**, forming the Latin-cross floor plan.

trompe l'oeil Art that fools our eyes into believing that what we see is real.

trumeau The central pillar of the main doorway of a church.

two-dimensional space Flat space that can only be viewed from one side. Anything that exists in this space will have height and width but no depth. However, two-dimen-

sional art forms often create the *illusion* of depth. Drawing and painting are examples of two-dimensional art forms.

typography The manipulation and selection of styles and sizes of letters *(type)* in graphic design.

Ukiyo-e Literally "pictures of the floating world"; Japanese woodcut prints that depicted brothels, the theater, and scenes of travelers and ordinary life among the middle class of Japan. The style and subjects of these prints influenced the development of Impressionism and Postimpressionism.

underpainting Painting done as a foundation for subsequent transparent glazes. Usually establishes basic composition and tonal relationships.

unity A sense of coherence or wholeness in a work of art. Unity alone is unlikely to sustain the interest of a viewer. It must be balanced with *variety*.

value The relative lightness and darkness of a color.

vanishing point In linear perspective, a point where parallel lines appear to converge on the horizon, like railroad tracks meeting at a point in the distance.

visual weight The relative importance of an element in a picture plane. Visual weight is dependent on the position, color, size, shape, or texture of the element.

volume A three-dimensional shape, although sometimes implied, such as a drawing of a vase.

volute A decorative spiral on a column.

warm colors The family of colors based on yellow, orange, and red; colors that are associated with extreme emotions, chaos, fire, and the sun. They tend to advance towards the viewer.

warp In weaving, vertical parallel threads arranged in a **loom.**

wash Diluted ink applied with a brush to add tonal values to a drawing.

watercolor Transparent paint that is a quick-drying combination of pigment and gum arabic. Diluted with water, it is usually applied to paper.

weft (or **woof**) In weaving, horizontal parallel threads passed at right angles to the **warp** and interlaced with them in a **loom.**

wood engraving A relief process similar to **woodcut**, but that uses the endgrain on blocks of hard wood. The endgrain's density permits very fine, precise lines to be created, and, compared to woodcuts, many more prints can be made before the block begins to deteriorate.

woodcut A type of **relief printmaking** made by carving directly into a smooth piece of wood and removing any parts of the surface not meant to be part of the image.

wrought Metal shaped by hammering.

Photo Credits

17-23 Photo Harry Shunk
17-24 Photo Wolfgang Volz
17-25 Courtesy of the artist
17-29 Photo Peter Moore
17-30 Courtesy Pace Gallery
17-31 Artes Magnus America
17-34 Photo Thor Crespi, courtesy of United States Information Agency; *also timeline*
17-35 Photo Grey Crawford
17-36 Courtesy Holly Solomon Gallery, New York

17-37 Photo Bruce C. Jones; *also timeline*

CHAPTER 18

18-4 Susan Swider, © 1985
18-5 Edward Hausner/NYT PICTURES
18-6 Photo Donald Woodman
18-7 Photo Donald Woodman
18-8 Courtesy Marlborough Gallery, New York, photo Jan Kosmowski
18-9 Courtesy Marlborough Gallery, New York, photo John Lamka
18-10 Courtesy Guerilla Girls, West
18-11 Courtesy Guerilla Girls, New York
18-12 © Margaret Gowan/Tony Stone Worldwide
18-13 © Nippon Television Corporation
18-14 © Nippon Television Corporation
18-15 © Jeffrey Markowitz/ Sygma

Index